The Photography Cultures Reader

D0774917

The Photography Cultures Reader: Representation, Agency and Identity engages with contemporary debates surrounding photographic cultures and practices from a variety of perspectives, providing insight and analysis for students and practitioners.

With over 100 images included, the diverse essays in this collection explore key topics, such as: conflict and reportage; politics of race and gender; the family album; fashion, tourism and surveillance; art and archives; social media and the networked image. The collection brings together essays by leading experts, scholars and photographers, including Geoffrey Batchen, Elizabeth Edwards, Stuart Hall, bell hooks, Martha Langford, Lucy R. Lippard, Fred Ritchin, Allan Sekula and Val Williams. The depth and scope of this collection is testament to the cultural significance of photography and photographic study, with each themed section featuring an editor's introduction that sets the ideas and debates in context.

Along with its companion volume – *The Photography Reader: History and Theory* – this is the most comprehensive introduction to photography and photographic criticism.

Includes essays by: Jan Avgikos, Ariella Azoulay, David A. Bailey, Roland Barthes, Geoffrey Batchen, David Bate, Gail Baylis, Karin E. Becker, John Berger, Lily Cho, Jane Collins, Douglas Crimp, Thierry de Duve, Karen de Perthuis, George Dimock, Sarah Edge, Elizabeth Edwards, Francis Frascina, André Gunthert, Stuart Hall, Elizabeth Hoak-Doering, Patricia Holland, bell hooks, Yasmin Ibrahim, Liam Kennedy, Annette Kuhn, Martha Langford, Ulrich Lehmann, Lucy R. Lippard, Catherine Lutz, Roberta McGrath, Lev Manovich, Rosy Martin, Mette Mortensen, Fred Ritchin, Daniel Rubinstein, Allan Sekula, Sharon Sliwinski, Katrina Sluis, Jo Spence, Carol Squiers, Theopisti Stylianou-Lambert, Ariadne van de Ven, Liz Wells, Val Williams, Judith Williamson, Louise Wolthers and Ethan Zuckerman.

Liz Wells, curator and writer, is Professor in Photographic Culture, Faculty of Arts and Humanities, University of Plymouth, UK. She edited *Photography: A Critical Introduction* (2015, 5th ed.) and co-edits *photographies*, Routledge journals. Publications on landscape include *Land Matters, Landscape Photography, Culture and Identity* (2011). She is series editor for *Photography, Place, Environment*.

The

Photography

Cultures Reader
Representation, Agency and Identity

Edited by

Liz Wells

Routledge
Taylor & Francis Group

LONDON AND NEW YORK

First published 2019
by Routledge
2 Park Square, Milton Park, Abingdon, Oxon OX14 4RN

and by Routledge
52 Vanderbilt Avenue, New York, NY 10017

Routledge is an imprint of the Taylor & Francis Group, an informa business

British Library Cataloguing-in-Publication Data
A catalogue record for this book is available from the British Library

Library of Congress Cataloging-in-Publication Data
Names: Wells, Liz, 1948– editor.
Title: The photography cultures reader : representation, agency and identity / edited by Liz Wells.
Description: Abingdon, Oxon ; New York, NY : Routledge, 2018. | Includes bibliographical references and index.
Identifiers: LCCN 2018042744 | ISBN 9780415749190 (hardback : alk. paper) | ISBN 9780415749206 (pbk. : alk. paper)
Subjects: LCSH: Photographic criticism. | Photography—Social aspects.
Classification: LCC TR187 .P55 2018 | DDC 770—dc23
LC record available at https://lccn.loc.gov/2018042744

ISBN: 978-0-415-74919-0 (hbk)
ISBN: 978-0-415-74920-6 (pbk)

Typeset in Perpetua and Akzidenz-Grotesk Pro
by Apex CoVantage, LLC

Contents

List of illustrations x
Notes on contributors xiv
Acknowledgements xx

General introduction 1

PART ONE
The photographic gaze 7
 INTRODUCTION 8

1 **Roberta McGrath**
 RE-READING EDWARD WESTON: FEMINISM,
 PHOTOGRAPHY AND PSYCHOANALYSIS 11

2 **Jan Avgikos**
 CINDY SHERMAN: BURNING DOWN THE HOUSE 22

3 **Sarah Edge and Gail Baylis**
 PHOTOGRAPHING CHILDREN: THE WORKS OF
 TIERNEY GEARON AND SALLY MANN 27

4 **Lucy R. Lippard**
 DOUBLETAKE: THE DIARY OF A RELATIONSHIP WITH AN IMAGE 42

5 **Catherine Lutz and Jane Collins**
 THE PHOTOGRAPH AS AN INTERSECTION OF GAZES:
 THE EXAMPLE OF *NATIONAL GEOGRAPHIC* 53

6 Ariadne van de Ven
 THE EYES OF THE STREET LOOK BACK: IN KOLKATA
 WITH A CAMERA AROUND MY NECK 73

7 Theopisti Stylianou-Lambert
 TOURISTS WITH CAMERAS: REPRODUCING OR
 PRODUCING? 90

8 Louise Wolthers
 SURVEILLING BODIES: PHOTOGRAPHY AS CONTROL,
 CRITIQUE AND CONCERN 110

PART TWO
Reportage: image as agent 117
 INTRODUCTION 118

9 John Berger
 PHOTOGRAPHS OF AGONY 123

10 Fred Ritchin
 OF THEM, AND US 126

11 Francis Frascina
 "FACE TO FACE": RESISTANCE, MELANCHOLY,
 AND REPRESENTATIONS OF ATROCITIES 132

12 Liam Kennedy
 FRAMING COMPASSION 141

13 Sharon Sliwinski
 ON PHOTOGRAPHIC VIOLENCE 153

14 Ariella Azoulay
 THE ETHIC OF THE SPECTATOR: THE CITIZENRY
 OF PHOTOGRAPHY 165

15 Elizabeth Hoak-Doering
 A PHOTO IN A PHOTO: THE OPTICS, POLITICS AND POWERS
 OF HAND-HELD PORTRAITS IN CLAIMS FOR JUSTICE
 AND SOLIDARITY 176

16 André Gunthert
 DIGITAL IMAGING GOES TO WAR: THE ABU GHRAIB
 PHOTOGRAPHS 194

17 **Ethan Zuckerman**
 CURATING PARTICIPATION 205

18 **Mette Mortensen**
 WHEN CITIZEN PHOTOJOURNALISM SETS THE
 NEWS AGENDA: NEDA AGHA SOLTAN AS A
 WEB 2.0 ICON OF POST-ELECTION UNREST
 IN IRAN 210

PART THREE
Image and identity 223
 INTRODUCTION 224

19 **David A. Bailey and Stuart Hall**
 THE VERTIGO OF DISPLACEMENT 229

20 **Rosy Martin and Jo Spence**
 PHOTO-THERAPY: PSYCHIC REALISM AS A
 HEALING ART? 236

21 **George Dimock**
 "THE NEGRO AS HE REALLY IS": W.E.B. DU BOIS
 AND ARTHUR RADCLYFFE DUGMORE 245

22 **bell hooks**
 IN OUR GLORY: PHOTOGRAPHY AND BLACK LIFE 265

23 **Annette Kuhn**
 PHOTOGRAPHY AND CULTURAL MEMORY:
 A METHODOLOGICAL EXPLORATION 273

24 **Lily Cho**
 CITIZENSHIP, DIASPORA AND THE BONDS OF AFFECT:
 THE PASSPORT PHOTOGRAPH 287

PART FOUR
Snapshot culture and social media 301
 INTRODUCTION 302

25 **Patricia Holland**
 FAMILY SNAPS, INTRODUCTION: HISTORY, MEMORY
 AND THE FAMILY ALBUM 305

26 Martha Langford
 STRANGE BEDFELLOWS: APPROPRIATIONS OF
 THE VERNACULAR BY PHOTOGRAPHIC ARTISTS 318

27 Geoffrey Batchen
 OBSERVING BY WATCHING: JOACHIM SCHMID
 AND THE ART OF EXCHANGE 339

28 Lev Manovich
 WATCHING THE WORLD 344

29 Daniel Rubinstein and Katrina Sluis
 A LIFE MORE PHOTOGRAPHIC: MAPPING THE
 NETWORKED IMAGE 349

PART FIVE
Medium and mediations 367
 INTRODUCTION 368

30 Roland Barthes
 ORNAMENTAL CUISINE AND THE NEW CITROËN 371

31 Judith Williamson
 TIFFANY, PORSCHE PANAMERA AND MICROSOFT CLOUD 374

32 Yasmin Ibrahim
 THE PORNOGRAPHY OF FOOD IMAGING: THE AESTHETICS
 OF CAPTURING FOOD ONLINE 380

33 Karin E. Becker
 PHOTOJOURNALISM AND THE TABLOID PRESS 393

34 Carol Squiers
 CLASS STRUGGLE: THE INVENTION OF PAPARAZZI
 PHOTOGRAPHY AND THE DEATH OF DIANA, PRINCESS
 OF WALES 411

35 Karen de Perthuis
 THE SYNTHETIC IDEAL: THE FASHION MODEL AND
 PHOTOGRAPHIC MANIPULATION 443

36 Ulrich Lehmann
 CHIC CLICKS: CREATIVITY AND COMMERCE 458

37 Val Williams
A HEADY RELATIONSHIP: FASHION PHOTOGRAPHY
AND THE MUSEUM, 1979 TO THE PRESENT 469

PART SIX
Contexts: art, archives, education **489**
INTRODUCTION 490

38 Douglas Crimp
THE MUSEUM'S OLD, THE LIBRARY'S NEW SUBJECT 495

39 Thierry de Duve
ART IN THE FACE OF RADICAL EVIL 500

40 Allan Sekula
READING AN ARCHIVE: PHOTOGRAPHY BETWEEN LABOUR
AND CAPITAL 518

41 Elizabeth Edwards
PHOTOGRAPHS: MATERIAL FORM AND THE DYNAMIC ARCHIVE 528

42 Liz Wells
WORDS AND PICTURES: ON REVIEWING PHOTOGRAPHY 540

43 David Bate
ART, EDUCATION, PHOTOGRAPHY 547

Index 555

Illustrations

Frontispiece: Screen with Loading, courtesy of Shutterstock xxiv

Part 1 Cindy Sherman, *Untitled Film Still, #21*, 1978 7

Part 2 Jean-Marc Bouju, *US Army POW Center, near Najaf, Iraq,*
31 March 2003. [Original in colour] 117

Part 3 Joy Gregory, *Eiffel Tower, Paris*, 2001 223

Part 4 Instagram 301

Part 5 Phil Poynter, *I Didn't Recognise You with Your Clothes On,*1998 367

Part 6 Jorma Puranen, *Gens Lapponum*, 1995 489

1.1 Edward Weston, *Pepper No. 30*, 1930 13

1.2 Edward Weston, *Nude, New Mexico*, 1937 16

1.3 Edward Weston, *Valentine*, 1935 19

4.1 Mary Schäffer, *Sampson Beaver, Leah Beaver,
and baby Frances Louise,* postcard, 1906 44

5.1 Robert Madden, National Geographic, *photography of
a Venezuelan diamond transaction,*1976 55

5.2 Lowell Thomas Jr., National Geographic, *photograph
showing colonial social relations*, 1960 62

5.3 O. Louis Mazzatenta, National Geographic, *being
photographed for pay*, 1982 66

6.1 Ariadne Van de Ven, *Elliott Road A*, 2008 78

6.2 Ariadne Van de Ven, *Elliott Road B*, 2008 79

6.3 Ariadne Van de Ven, *Elliott Road C*, 2008 79

6.4 Ariadne Van de Ven, *Sovabazar Street*, 2010 80

6.5 Ariadne Van de Ven, *Durgacharan Banerjee Street*, 2007 81

6.6 Ariadne Van de Ven, *Outside New Market*, 2010 81

7.1 Postcard of Rock of Aphrodite 99

7.2	John Thurm, *Photo of Beach*, 2011	99
7.3	Theo Groen, *Photo of Tourists on Rock of Aphrodite from Flickr*	101
7.4	Theopisti Stylianou-Lambert, *Posing as Aphrodite*	103
7.5	Theopisti Stylianou-Lambert, *Love Stones*	104
10.1	Don McCullin, *Father and child wounded when U.S. Marines dropped hand grenades into their bunker, Tet Offensive, Hue, Vietnam*, 1968	127
10.2	Horst Faas and Michel Laurent, *Guerrillas in Dacca, Bangladesh*, 1971	128
12.1	Larry Burrows, *Nguyen Thi Tron at the National Rehabilitation Institute*, 1968	143
12.2	Jean-Marc Bouju, *US Army POW Centre, near Najaf, Iraq*, 2003	148
13.1	Unknown, *Blood and Honey*, 1996	154
15.1	Elizabeth Hoak-Doering, *Berlin-Nicosia Motorcycle Rally*, 1997	177
15.2	William Harvery Doering, *Baker's Jubilee, Philadelphia, PA, USA*, 1898	179
15.3	Andreas Manolis, *Ledra Palace Roadblock*, 1970s	184
16	Abu Ghraib Collection. *The publishers would like to bring attention to the graphic nature of the images in this collection.*	195
17.1	Mehmet Kacmaz, *Protesters holding a sign calling for the resignation of Turkish Prime Minister Recep Tayyip Erdoğan during protests in Gezi Park, Istanbul*, 2013	206
17.2	Boniface Mwangi, *Man with Bow and Arrow*	207
17.3	David Mutua/Boniface Mwangi, Installation view of *Picha Mtaani*	207
19.1	Rotimi Fani-Kayode, *Bronze Head*, 1987	233
19.2	Rotimi Fani-Kayode, *Sonpponnoi*, 1987	234
20.1	Jo Spence, 'Headless Doll', 1986	238
20.2	Rosy Martin, c.1988, *Unwind the Lies that Bind, internalised oppressions*	241
21.1	Unknown, *W.E. Burghart Du Bois*, 1901	246
21.2	A.R. Dugmore, *The Author Photographing a Wild Bird on His Hand*, 1900	246
21.3	A.R. Dugmore, *A Friend of George Washington*, 1901	248
21.4	A.R. Dugmore, *Negro Woman Ploughing in a Cotton Field*, 1901	254
21.5	A.R. Dugmore, *Big House and Negro Quarters*, 1901	256
21.6	A.R. Dugmore, *Learning to Shuffle Early*, 1901	257
21.7	A.R. Dugmore, *In the Cobbler's Shop*, 1901	259
21.8	A.R. Dugmore, *At Work Making Brooms*, 1901	259
23.1	Annette Kuhn, *Mother and Child*	277

23.2	Annette Kuhn, *Writing*	278
24.1	Shelly Low, *Self Serve A*, 2006	294
24.2	Shelly Low, *Self Serve B*, 2006	295
24.3	Shelly Low, *Self Serve C*, 2006	295
25.1	Pat Holland, *Montage of Family Photos*	306
25.2	Pat Holland, *Wedding Photos*	308
25.3	Pat Holland, *Pontin's, Beefeater* and *Mothercare* brochures	310
25.4	Pat Holland, *Kodak Images*	312
25.5	Pat Holland, *Tourist in Africa*	315
26.1	Christy Johnson, *This is My Body*, 2007	319
26.2	Christy Johnson, *Souvenir de ma Première Communion*, 2007	325
26.3	Fiona Tan, detail from *Vox Populi, Norway*, 2005	327
26.4	Hans-Peter Feldmann, detail from *Porträt*, 1994	328
26.5	Hans-Peter Feldmann, detail from *Ferien*, 1994	329
26.6	Bruno Rosier, detail from *Un état des lieux ou La mémoire des parallèles. Argentine, Chutes d'Iguaçu, 1948* (above) and 2001 (below).	331
26.7	Dimple F. Snow and Michael Snow, detail from *Scraps for the Soldiers*, 2007	334
26.8	Dimple F. Snow and Michael Snow, detail from *Scraps for the Soldiers*, 2007	336
27.1	Joachim Schmid, *From Other People's Photographs: Parking Lots*	340
27.2	Joachim Schmid, *From Other People's Photographs: Cleavage*	340
27.3	Joachim Schmid, *From Other People's Photographs: Currywurst*	342
27.4	Joachim Schmid, *From Other People's Photographs: Self*	342
28.1	Jay Chow and Lev Manovich, *Every Shot from Dziga Vertov's film 'Man with a Movie Camera' (1929)*, 2012	346
28.2	David Crandall, Lars Backstrom, Dan Huttenlocher, Jon Kleinberg, *Mapping the World's Photos*, 2009	346
28.3	Eric Fisher, *Locals and Tourists, London*, 2010	347
34.1	Marcello Geppetti, *Jayne Mansfield*, early 1960s	422
34.2	Marcello Geppetti, *Anita Ekberg*, 1961	423
34.3	Marcello Geppetti, *Elizabeth Taylor and Richard Burton*	426
34.4	Marcello Geppetti, *Princess Diana*	435
35.1	Grandville, *Fashionable people represented in public by their accoutrements*, 1844	448
35.2	Alexei Hay, *Total and Fatal For You*, 2001	451
35.3	Alexei Hay, *Total and Fatal For You*, 2001	452
35.4	Alexei Hay, *Total and Fatal For You*, 2001	453

37.1	*Shots of Style: Great Fashion Photographs* chosen by David Bailey	470
37.2	*The History of Fashion Photography,* 1979, Alpine Book Co.	472
37.3	*Cecil Beaton's New York*, 1938	473
37.4	*Beaton Portraits*, 1968	474
37.5	*John French: Fashion Photographer*, 1984	477
37.6	*Imperfect Beauty* cover, 2000	484
37.7	*Fashioning Fiction in Photography since 1990*	486
39.1	*Prisoner at Cambodia's S-21 Prison*, 1978	502
39.2	Alexander Gardner, *Lewis Payne/Powell on Death Row*, 1865	507
39.3	Richard Avedon, *Napalm Victim*, 1971	515

Contributors

Jan Avgikos is an adjunct Assistant Professor at Columbia University and New York University, and a Contributing Editor for *Artforum International.*

Ariella Azoulay, author, curator and documentary film-maker is Professor of Comparative Literature and Modern Culture and Media, Brown University, USA.

David A. Bailey, MBE, is a British Afro-Caribbean curator, photographer, writer and cultural facilitator, living and working in London.

Roland Barthes (1915–1980) essayist and semiologist, taught at the École des Hautes Etudes en Sciences Sociales, Paris. His critical writings ranged widely; key writings on photographs include *Camera Lucida* (1981/1984 English); 'The Photographic Message' and 'The Rhetoric of the Image' in *Image, Music, Text* (1977); *Mythologies* (1957/1972 English).

Geoffrey Batchen, writer and curator, is professor in art history and photography at Victoria University, Wellington, New Zealand. He has authored many books including *Emanations: The Art of the Cameraless Photograph* (2016); *Forget Me Not: Photography and Remembrance* (2004); *Each Wild Idea: Writing, Photography, History* (2001); *Burning with Desire: The Conception of Photography* (1997).

David Bate, artist and writer, is Professor of Photography, University of Westminster, UK, where he supervises PhD work and teaches on the MA Photography Arts programme. Publications include *Photography, Key Concepts* (2016, 2nd ed.); *Art Photography* (2015); *Photography and Surrealism: Sexuality, Colonialism and Social Dissent* (2002). He co-edits the international photography theory journal, *photographies.*

Gail Baylis lectures at University of Ulster where she teached the history and theory of photography, visual culture and gender studies. Publications include 'The photographic portrait: a means to surveillance and subversion' in *Early Popular Visual Culture,* Vol. 16, Issue 1, pp. 1–23.

Karin E. Becker is Professor emerita in Journalism, Media and Communication Studies, Stockholm University. Her research focuses on visual media forms and practices.

John Berger (1926–2017), novelist and critic, wrote extensively on photography and visual arts, including, 'The Spectre of Hope' with Sebastaio Salgado, BBC (2001); *Another Way of Telling* (1982); *About Looking* (1980); *Ways of Seeing* (1972).

Lily Cho's research focuses on diasporic subjectivity within Asian North American and Canadian literature. She co-edited *Human Rights and the Arts: Perspectives on Global Asia* (2014). She is Associate Professor, Department of English, York University, Toronto.

Jane Collins is Professor of Community and Environmental Sociology, University of Wisconsin at Madison, USA. Recent publications include *The Politics of Value* (2017). She is co-author of *Reading National Geographic* (1993, with Catherine Lutz).

Douglas Crimp is Professor of Art History, Visual and Cultural Studies at the University of Rochester, USA, and author of *"Our Kind of Movie": The Films of Andy Warhol* (2012) and *On the Museum's Ruins* (1993). Recent essays include "WAR IS TERROR," in Roxana Marcoci and Emily Hall eds., *Louise Lawler: Receptions: Why Pictures Now* (2017).

Thierry de Duve is a Belgian critic and curator who writes on modern and contemporary art theory. Publications include *Aesthetics at Large, Art, Ethics, Politics* (forthcoming, 2019); *Sewn in the Sweatshops of Marx: Beuys, Warhol, Klein, Duchamp* (2012). He is Evelyn Kranes Kossak Professor at Hunter College, City University of New York.

Karen de Perthuis researches material culture, cinematic costume design, fashion design, fashion photography and street style blogs. Publications include 'Beyond Perfection: The Fashion Model in the Age of Digital Manipulation, in Eugenie Shinkle (ed.) *Fashion as Photograph: Viewing and Reviewing Images of Fashion* (2008). She teaches in the School of Humanities and Communication Arts, Western Sydney University.

George Dimock's current research centers on photography in the USA at the turn of the twentieth century. He is Associate Professor of Art History, University of North Carolina, at Greensboro, USA.

Sarah Edge is Professor of Photography and Cultural Studies, University of Ulster. Recent publications include *The Extraordinary Archive of Arthur J. Munby: Photographing Class and Gender in the Nineteenth Century*, London: I B Tauris, 2017.

Elizabeth Edwards is a visual and historical anthropologist and Professor Emerita of Photographic History at De Montfort University, Leicester, UK. Publications include, *Photographs, Museums, Collections: Between Art and Information* (ed. with C. Morton) (2015); *Uncertain Images: Museums and the Work of Photographs* (ed. with S. Lien) (2014); *Camera as Historian: Amateur Photographers and Historical Imagination 1885–1912* (2012).

Francis Frascina is Emeritus Professor and member of the Research Institute for the Humanities, Keele University. His research interests focus on relationships between art, culture and politics, especially in America, since 1945. Publications include *Modern Art Culture: A Reader* (2009); *Pollock and After: the Critical Debate* (2000, 2nd ed.); *Art, Politics and Dissent: Aspects of the Art Left in Sixties America* (1999).

André Gunthert is Chair of Visual History at the École des Hautes Études en Sciences Sociales, Paris, and founder of the journal *Études Photographiques*. Publications include *L'image Partagée. La Photographie Numérique* (2015); *Paris 14–18. La Guerre au Quotidien. Photographies de Charles Lansiaux* (2014, with Emmanuelle Toulet).

Stuart Hall (1932–2014), cultural theorist and founder of *New Left Review*, was Professor of Sociology, The Open University, UK. His published contributions include many of the early texts of British cultural studies, work on 'Thatcherism' and, latterly, on race, ethnicity and cultural identity. See *Selected Political Writings: The Great Moving Right Show and Other Essays* (2017).

Elizabeth Hoak-Doering is an American independent scholar, artist and educator based in Nicosia, Cyprus. She represented Cyprus at the 54th Venice Bienale, 2011, and in 2016 was awarded a residency at Künstlerhaus Bethanien through the Internationales Atelierprogramm, Berlin.

Patricia Holland is a London-based writer, lecturer and researcher specialising in media and cultural studies, in particular television and photography. Publications include *The New Television Handbook (Media Practice)* (2016), *Picturing Childhood: the Myth of the Child in Popular Imagery* (2004) and 'SWEET IT IS TO SCAN . . . ' Personal photographs and popular photography' in Liz Wells ed. *Photography, A Critical Introduction* (2015, 5th ed.).

bell hooks, American author, feminist and social activist was formerly Distinguished Professor of English at City College, New York. Her many publications include *Yearning: Race, Gender and Cultural Politics* (2015, 2nd ed.); *Teaching*

Critical Thinking: Practical Wisdom (2009); *Outlaw Culture: Resisting Represen-tations* (1994); *Black Looks: Race and Representation* (1992).

Yasmin Ibrahim researches social media and digital technologies and writes on migration, Islam, visual culture and memory studies. She is Reader in International Business and Communications at Queen Mary, University of London.

Liam Kennedy is Professor of American Studies and Director of the Clinton Institute for American Studies at University College Dublin. Publications include *Afterimages: Photography and US Foreign Policy* (2016), *Susan Sontag* (1995).

Annette Kuhn, cultural historian, is Emeritus Professor of Film Studies, Queen Mary University of London, and a former co-editor of *Screen* journal. Publications on photography include *Locating Memory: Photographic Acts* (2006, co-editor, Kirsten Emiko McAllister) and *Family Secrets* (1995; 2002).

Martha Langford is Research Chair and Director of the Gail and Stephen A. Jarislowsky Institute for Studies in Canadian Art and Professor in Art History at Concordia University, Montreal. Publications include *Scissors, Paper, Stone: Expressions of Memory in Photographic Art* (2007); *Suspended Conversations: The Afterlife of Memory in Photographic Albums* (2001; and as editor, *Image & Imagination* (2005).

Ulrich Lehmann is Associate Professor of Interdisciplinary Arts at The New School in New York, a Professor of Fashion at the University for the Creative Arts at Rochester, a Research Fellow at the Victoria and Albert Museum, London, where he contributed as a curator to *Surreal Things: Surrealism and Design* (V & A 2007) and *Modernism, Designing a New World* (V & A, 2006).

Lucy R. Lippard is a writer, curator, activist, and author of twenty books on contemporary art and critical studies, including *On The Beaten Track: Tourism, Art and Place* (1999) and *the Lure of the Local* (1997).

Catherine Lutz is Professor of Anthropology and International Studies at Brown University, Rhode Island, USA. Publications include *Breaking Ranks: Iraq Veterans Speak Out against the War* (2010, with Matthew Gutmann); *Homefront: A Military City* and *The American Twentieth Century* (2001) and *Reading National Geographic* (1993, with Jane Collins).

Roberta McGrath has published widely on the history, theory and politics of photography. Publications include 'Passport No. 656336' in D. Forbes (Ed.), *Edith Tudor-Hart: In the Shadow of Tyranny* (2013) and *Seeing Her Sex: Medical Archives and the Female Body* (2002). Until 2015 she was Reader in Photographic History, Theory and Criticism at Edinburgh Napier University.

Lev Manovich writes on new media. Publications include *The Language of New Media* (2001), *Instagram and Contemporary Image* (2016) and, *Data Drift: Archiving Media and Data Art in the 21st Century* (2015, co-edited with Rasa Smite and Raitis Smits). He lectures in the Visual Arts Department at the University of California, San Diego. He is professor of Computer Science, City University of New York Graduate Center.

Rosy Martin is an artist-photographer, therapist, lecturer, workshop leader and writer based in London. She has exhibited and published widely since 1985, including 'Inhabiting the image: Photography, Therapy and Re-enactment Photo-therapy' in Loewenthal (ed.) *Phototherapy and Therapeutic Photography in a Digital Age* (2012) and 'Outrageous Agers – Performativity and Transgressions' in Dolan & Tincknell (eds.) *Ageing Femininities: Troubling Representations* (2012).

Mette Mortensen is an Associate Professor, Department of Media, Communication and Cognition, University of Copenhagen. Publications include *Social Media Materialities and Protest: Critical Reflections* (2018, co-edited with C. Neumayer and T. Poell); *Journalism and Eyewitness Images: Digital Media, Participation, and Conflict* (2015).

Fred Ritchin writes on photography and new media. Since 2014 he has been Dean of the School at the International Center of Photography, New York, and previously was Professor in Photography and Digital Imaging, Tisch School of the Arts, New York University. Publications include *Bending the Frame: Photojournalism, Documentary, and the Citizen* (2013); *In Our Own Image: The Coming Revolution in Photography* (1990, 1999, 2010) and *After Photography* (2008).

Daniel Rubinstein, artist and philosopher, is founding editor of the journal *Philosophy of Photography*. Publications include *On the Verge of Photography: Imaging Beyond Representation* (2013, co-edited with Johnny Golding and Andy Fisher). He is course leader, MA Contemporary Photography; Practices and Philosophies, Central Saint Martins, University of the Arts, London.

Allan Sekula (1951–2013), photographer, writer and critic, published and exhibited widely, including *Photography Against the Grain* (1984), *Fish Story* (1995), *Geography Lesson: Canadian Notes* (1997) and, as a film-maker, *The Forgotten Space* (2010 with Noel Birch). For many years he taught at California Institute of the Arts, Los Angeles.

Sharon Sliwinski is an associate professor, Faculty of Media and Information Studies, University of Western Ontario. Her research interests include the intersection of politics and aesthetics, the genealogy of key concepts in human rights discourse, and theoretical investigations in psychoanalysis and the terrain of the imaginary. Publications include *Human Rights in Camera* (2011).

Katrina Sluis is Curator (Digital Programmes) at The Photographers' Gallery, London, where she founded the online platform https://unthinking.photography/ and Senior Lecturer at London South Bank University where she is a founding Co-Director of the Centre for the Study of the Networked Image.

Jo Spence (1934–1992), photographer and cultural activist, was a founder member of the Half Moon Workshop, later Camerawork, in East London. Publications include *Putting Myself in the Picture* (1986) and *Family Snaps* (1991) which she co-edited with Patricia Holland.

Carol Squiers is a writer and curator at the International Center of Photography in New York. She has published extensively in journals, catalogues and books, most recently, *What Is a Photograph?* (2014) accompanying an exhibition of the same name. She teaches curatorial studies in the ICP-Bard MFA in Advanced Photographic Studies.

Theopisti Stylianou-Lambert is a researcher, visual artist and associate professor, School of Fine and Applied Arts, Cyprus University of Technology. Publications include *Photography and Cyprus* (2014) co-edited with Liz Wells and Nicos Philippou.

Ariadne van de Ven (1961–2017), writer and photographer, based in London, worked in publishing. In 1990, she co-founded the Women in Publishing International Committee.

Val Williams is Professor of History and Culture of Photography, at University of the Arts, London, and Director of the Photography and the Archive Research Centre, London College of Communications. She is a founding editor, *Journal of Photography and Culture*, and has published extensively including *When Photography Really Works* (2012) and *What Makes Great Photography: 80 Masterpieces Explained* (2012).

Judith Williamson is a writer living in London. She is the author of *Decoding Advertisements: Ideology and Meaning in Advertising* (1978), *Consuming Passions: the Dynamics of Popular Culture* (1986) and *Deadline at Dawn: Film Criticism 1980–1990* (1993). Her work has appeared in a wide range of publications, and includes a quarterly essay on contemporary advertising for *Source* from 2007–16.

Louise Wolthers is Head of Research and a curator at the Hasselblad Foundation, Gothenburg, Sweden. Exhibitions include *WATCHED! Surveillance, Art and Photography* (publication and touring exhibition 2016–2017).

Ethan Zuckerman is director of the Center for Civic Media at MIT, and an Associate Professor of the Practice at the MIT Media Lab. He is the author of *Rewire: Digital Cosmopolitans in the Age of Connection* (2013).

Acknowledgements

Jan Avgikos, 'Cindy Sherman: Burning the House Down', in *Artforum*, January 1993 © Artforum

Ariella Azoulay, 'The Ethic of the Spectator: The Citizenry of Photography', *Afterimage: The Journal of Media Arts and Cultural Criticism;* September/October 2005, Vol. 33 Issue 2, pp. 38–44. Reprinted by permission of Afterimage/Zone Books.

David A. Bailey and Stuart Hall, 'The Vertigo of Displacement', in Ten.8, Vol 2/3 (1990). Reprinted by permission of the Stuart Hall Foundation.

Roland Barthes, 'Ornamental Cuisine' and 'The New Citroën' in *Mythologies*. Reprinted courtesy of Farrar, Strauss and Giroux, LLC and Penguin Random House.

Geoffrey Batchen (2013) 'Observing by Watching: Joachim Schmid and the Art of Exchange', *Aperture* 210, Spring pp. 46–49. Reprinted by permission of *Aperture*.

David Bate, 'Art, Education, Photography', in *Hyperfoto* (1997). Reprinted by permission of the author.

Karin E. Becker, 'Photojournalism and the Tabloid Press', in P. Dahlgren and C. Sparks, *Journalism and Popular Culture* (London, Sage, 1992). Reprinted by permission of Sage Publishing Ltd.

John Berger, 'Photographs of Agony', in *About Looking* (London, Writers and Readers, 1980). Reprinted by permission of the author and Bloomsbury Publishing.

Lily Cho, Citizenship, 'Diaspora and the Bonds of Affect: The Passport Photograph', *Photography and Culture* 2(3), (2009) pp. 275–288. Reprinted by permission of the author and publisher. (Taylor & Francis Ltd. www.tandfonline.com)

Douglas Crimp, 'The Museum's Old, The Library's New Subject', in *On the Museum's Ruins* (Cambridge, MIT Press, 1993). Reprinted by permission of MIT Press.

Karen de Perthuis (2005) The Synthetic Ideal: The Fashion Model and Photographic Manipulation, *Fashion Theory*, 9:4, pp. 407–424. Reprinted by permission of the author and publisher. (Taylor & Francis Ltd. www.tandfonline.com)

George Dimock, '"The Negro As He Really Is": W. E. B. Du Bois and Arthur Radclyffe Dugmore', *Exposure* (2013) 46: 1, pp. 36–50. Reprinted by permission of The Society for Photographic Education's *Exposure* journal.

Thierry de Duve (2007) 'Art in the Face of Radical Evil'. *October*. pp. 3–23. Reprinted by permission of *October*.

Sarah Edge and Gail Baylis, 'Photographing Children: The Works of Tierney Gearon and Sally Mann'. *Visual Culture in Britain*, 5 (1), pp. 75–89. Reprinted by permission of the authors and publishers. (Taylor & Francis Ltd, www.tandfonline.com)

Elizabeth Edwards (2011) 'Photographs: Material Form and the Dynamic Archive' in Caraffa, C. (ed.) Photo archives and the photographic memory of art history. Berlin: Deutscher Kunstverlag. pp. 47–56. Reprinted courtesy of Deutscher Kunstverlag.

Francis Frascina, '"Face to Face": Resistance, Melancholy, and Representations of Atrocities', *Afterimage: The Journal of Media Arts and Cultural Criticism*, 'Aesthetics of Atrocity' Special Issue, Vol. 39, Nos 1 & 2, July/August and September/October 2011, pp. 49–53. Reprinted by permission of the author.

André Gunthert, (2008) 'Digital Imaging Goes to War: The Abu Ghraib Photographs', photographies, 1(1). Reprinted by permission of the authors and publishers. (Taylor & Francis Ltd, www.tandfonline.com)

Elizabeth Hoak-Doering, 'A Photo in a Photo: The Optics, Politics and Powers of Handheld Portraits in Claims for Justice and Solidarity', *Cyprus Review*, 27:2, Autumn 2015, pp.15–42 (edited selection). Reprinted by permission of the author.

Pat Holland, 'Introduction' in Jo Spence and Pat Holland, *Family Snaps*. (1991) Virago, pp. 1–14.

bell hooks, 'In Our Glory: Photography and Black Life'. © 1995 Art on my Mind by bell hooks. Reprinted by permission of The New Press, www.thenewpress.com.

Yasmin Ibrahim (2015), Article originally titled: 'Food Porn and the Invitation to Gaze: Ephemeral Consumption and the Digital Spectacle' in *International Journal of E-Politics*, Vol 6, No. 3, July-Sept. pp. 1–12.

Liam Kennedy, 'Framing Compassion', *History of Photography*, (2012) 36:3, pp. 306–314.

Annette Kuhn, 'Photography and Cultural Memory: a Methodological Exploration', *Visual Studies* (2007) 22:3, pp. 283–292. Reprinted by permission of the author and publisher. (Taylor & Francis Ltd. www.tandfonline.com)

Martha Langford (2008) 'Strange Bedfellows: Appropriations of the Vernacular by Photographic Artists'. *Photography and Culture* 1(1), pp. 73–94. Reprinted by permission of the author and publisher. (Taylor & Francis Ltd. www.tandfonline. com)

Ulrich Lehmann (2002) 'Chic Clicks: Creativity and Commerce' in *Contemporary Fashion Photography*. Boston: The Institute of Contemporary Art & Hatje Cantz. Reprinted by permission of the author.

Lucy R. Lippard, 'Doubletake: The Diary of a Relationship with an Image', in Steven Yates (ed.) *Poetics of Space: A Critical Photographic Anthology* (Albuquerque, University of Mexico Press, 1996). Copyright © 1995 University of New Mexico Press, 1995.

Catherine Lutz and Jane Collins, 'The Photograph as an Intersection of Gazes: The Example of National Geographic' in Lucien Taylor (ed.) *Visualizing Theory: Selected Essays from V. A. R. 1990–1994* (New York, Routledge Inc., 1994). Reprinted by permission of Taylor and Francis www.tandfonline.com.

Lev Manovich (2014) 'Watching the World' *Aperture*, 214, Spring, pp. 48–51. Reprinted by permission of *Aperture*.

Rosy Martin and Jo Spence, 'Photo-Therapy: Psychic Realism as a Healing Art?' [excerpted] in *Ten.8*, No. 30.

Roberta McGrath, 'Re-Reading Edward Weston: Feminism, Photography and Psychoanalysis' from *Ten 8*, no. 27 (1987).

Mette Mortensen, 'When Citizen Photojournalism Sets the News Agenda: Neda Agha Soltan as a Web 2.0 Icon of Post-Election Unrest in Iran'. *Global Media and Communications* (2011) 7(1), pp. 4–16.

Fred Ritchin, 'Of Them and Us', *Aperture* 214, Spring, pp. 42–47. Reprinted courtesy of *Aperture*.

Daniel Rubinstein and Katrina Sluis (2008) 'A Life More Photographic: Mapping the Networked Image'. *Photographies* 1(1) pp. 9–28. Reprinted by permission of Taylor and Francis www.tandfonline.com.

Alan Sekula, 'Reading Between Labour and Capital' in Patricia Holland, Jo Spence and Simon Watney (eds.), *Photography/Politics Two* (London, Comedia, 1986).

Sharon Sliwinski, 'On Photographic Violence', *Photography and Culture*, 2:3 pp. 303–315. Reprinted by permission of the author and publishers. (Taylor & Francis Ltd. www.tandfonline.com)

Carol Squiers (1999) 'Class Struggle: the Invention of Paparazzi Photography and the Death of Diana, Princess of Wales', in Carol Squiers, ed. (1999) *Over-Exposed*. NY: The New Press.

Theopisti Stylianou-Lambert, 'Tourists with Cameras', *Annals of Tourism Research*, Vol 39, No. 4, pp. 1817–1838, 2012.

Ariadne van de Ven, 'The Eyes of The Street Look Back: In Kolkata with a Camera Around My Neck', *photographies*, 4:2, pp. 139–155.

Liz Wells, (2002) 'Words and Pictures: On Reviewing Photography' in *The Photography Reader*. London: Routledge. [Original version published in *LightReading* 2, May 1992, Somerset: South West Independent Photographers Association.]

Val Williams (2008) 'A Heady Relationship: Fashion Photography and the Museum, 1979 to the Present', *Fashion Theory*, 12:2, pp. 197–218. Reprinted by permission of the author and publishers. (Taylor & Francis Ltd. www.tandfonline.com)

Judith Williamson, (2014) 'Tiffany', *Source* 81, Winter 2014/15; (2016) 'Microsoft Cloud', *Source* 85, Spring 2016 (2016) 'Porsche Panamera', *Source* 87, Autumn 2016. Belfast. The original images can be found on the Source website archive at www.source.ie

Louise Wolthers, 'Surveilling Bodies: Photography as Control, Critique and Concern in Framing Bodies', Art and Theory Publishing, 2015.

Ethan Zuckerman, 'Curating Participation'. *Aperture*, #214, Spring 2014. Reprinted by permission of *Aperture*.

The publishers have made every effort to contact authors/copyright holders of works reprinted in *The Photography Cultures Reader: Representation, Agency and Identity* to obtain permission to publish extracts and images. This has not been possible in every case, however, and we would welcome correspondence from those individuals/companies whom we have been unable to trace. Any omissions brought to our attention will be remedied in future editions.

Frontispiece Screen with Loading, courtesy of Shutterstock.

Liz Wells

GENERAL INTRODUCTION

Can you imagine going a whole day without encountering a photograph? In many parts of the world this is almost impossible, with pictures circulating via the iPhones in our hands as well as more traditionally, yet still ubiquitously, on street hoardings and posters, in books, catalogues, newsprint and magazines, not to mention tele-visual media. It follows that it is impossible to discuss photography as a single field of practices and contexts. Rather we experience the photographic as a heteroge-neous medium. Photographies dynamically permeate all aspects of our culture and, as such, exercise extensive influence over our ways of seeing and thinking about the contemporary world.

Photographic practices and the situations within which we encounter images are thus extremely diverse. This makes critical questioning of ways in which imagery circulates very challenging as we have to take into account not only the pictorial content but also the contexts within which we come across them, the effects of their material form, and their social, political and subjective import in terms of mean-ing and influence. As Irit Rogoff noted some two decades ago, our experience of visual culture is immersive and fluid, operating at various levels of cognition:

> In the arena of visual culture the scrap of an image connects with a sequence of film and with the corner of a billboard or the window dis-play of a shop we have passed by, to produce a new narrative formed out of both our experienced journey and our unconscious. Images do not stay within discrete disciplinary fields such as 'documentary film' or 'Renaissance painting', since neither the eye nor the psyche operates along or recognizes such divisions.[1]

Indeed, concern with image flow, its ubiquity and complexity, is not new. What has changed is that printed imagery is in an even more extensive and complex

interrelation with the online flow of photographic images. It follows that visual literacy in the form of the development of analytic and critical tools and awareness of the methodological implications of their application is yet more central to academic engagement in terms of meaning, interpretation and the significance accorded to systems and contexts within which we materially encounter visual information.

The Photography Reader was first published in 2003, bringing together a number of key contributions within twentieth-century debates on photographs, their uses, impact and contexts. Since then, there has been a burgeoning of writings on photographic practices (photography and digital imaging), on the accumulation and global flow of images, on what is photographed, and how, and on what is left out of the picture. The first edition of this collection was comprehensive, bringing together historical, theoretical and cultural texts that were wide-ranging in their compass. In order to update and extend the compilation, the original Reader has been developed into two separate collections, *The Photography Reader: History and Theory* and this companion volume, *The Photography Cultures Reader*. Reorganizing material within two separate publications has enabled me to significantly expand the number of essays or extracts included, whilst retaining the majority of the articles from the original edition.

The books are intended primarily for undergraduate students, although I hope they continue to prove more widely useful. This volume brings into focus aspects of twentieth-century and early twenty-first-century debates relating to photography. It centres on questions of representation, agency and identity. Given this theme, the various examples of critical investigations and reflections included in the volume implicate questions of power, and of our positions within varying hierarchies of influence. These range from the politics of gender, ethnicity and representation to reportage, social and personal identity, snapshot culture, commercial imagery and institutional contexts.

Given the ubiquity of photographs, thinking critically about photography implicates a range of academic arenas, including semiotics, psychoanalysis, art history, socio-political histories and questions of power and influence, the history of media technologies, aesthetics, philosophy and the sociology of culture in relation to specific images, genres, photographic practices and contexts of making and of encountering imagery. Thus, we may want to consider method and methodology in relation to specific fields of practice – documentary and photojournalism, personal photography, commercial practices, institutional contexts and so on. To do so is productive. This involves taking into account more general questions associated with each particular field. For instance, in examining portraiture of children – whether within the family album or as a more formal public commission – we would want to discuss the concept of childhood relating this to particular historical circumstances and cultural understandings. However, journeys down this path risk distracting us from that which is peculiar to photography as an act and as medium (whether chemical or digital) in terms of contexts of making images and, more particularly, processes of interpretation. We have to balance more general contextual and methodological concerns with more immediate investigation of the photographic.

The theoretical and political debates that informed and contextualized the final sections of the original *Photography Reader*, wherein the focus was primarily on photography and visual culture, and which drew primarily on essays from the final decades of the twentieth century, have, of course, moved on. We live in a different world, one that at the time of writing is characterized by debates over Brexit in the UK, border controls in the USA, and tensions relating to immigration in much of Southern and Eastern Europe, that in part reflect responses to a resurgence of radical Islam that has global implications and impact in many forms and in part suggests a retrenchment into nationalism in response to shifting global economic circumstances. Reflecting such concerns and developments, photography has become increasingly implicated in border surveillance, with extended use of CCTV and the introduction of eye recognition software at customs posts. Bringing together articles for this new collection has allowed us to respond to more recent events – for instance, through including essays on passport pictures in relation to ethnic identities or questioning the potential and risks of drone vision and other satellite technologies. Through satellite mapping and position recognition, we can devise routes for ourselves, forgetting that we are facilitating possibilities for others to track us. Underlying such debates, and many others, are questions of power, of whether those controlling such visual tracking systems are operating in line with our democratic interests.

In the latter part of the twentieth century, structuralist questions relating to the ontology of photographs and their indexical status were challenged by more general postmodern concerns to broaden debates from modernist notions of form, aesthetics and technology, to ensure that contexts of making and circulation of images were equally central to the agenda. Questions of the interrelation of content, aesthetics, context and point of view of course remain pertinent, both when reflecting on the photographer and her/his reasons for making images, whether professional or more casually, and when considering circulation and contexts of meaning and interpretation. Recently such discussions have been extended through a resurgence of interest in photographs as tactile phenomena, to be handled through holding paper, tapping a keyboard or scrolling a digital screen. More broadly, a phenomenological perspective questions the prioritization of vision over other senses, of which touch is the one most considered within the realm of photographic studies. It might also be noted that, within the spheres of family and social media communications, the case of slippage between still and moving imagery (on a phone as well as other cameras) not only introduces questions of tempo but also may implicate sound along with the visual and the tactile. In this formulation, photography is conceptualized as a more embodied experience than was previously acknowledged; the act of physical engagement sits alongside questions of image content, aesthetics and context of encounter. To explain this theoretical development as a reaction to the increased absence of physical paper objects and the apparent fragility of digital images as they seem momentary and subject to dissolution into the ether would be to over-simplify. It is, however, certainly the case that ongoing research into photography in phenomenological terms has been provoked in part as a response to the shifts in the material manifestation of imagery.

The Photography Cultures Reader maps some of these shifts and debates, philosophical and socio-political challenges, through the reproduction of essays which have made substantial contributions to ideas about photography and to photography criticism. As with the companion volume, *The Photography Reader* (2018), criteria for selection of essays in this collection varied; given the extensive amount that has been written about photography in differing contexts, the final selection was difficult. One aim was to introduce a range of authors, well known and less celebrated. Often, there was a choice between several excellent pieces of writing by the same author. It is important to note that selecting a single essay inevitably risks misrepresenting an overall position and new developments in a writer's body of work. In some cases, writings that 'speak' to each other through cross-reference or differing approaches to issues and debates have been included – for instance, samples of Roland Barthes' analyses of advertising in post-war France of the 1950s followed by Judith Williamson's recent instances situated more globally. Other essays are included because of their extensive influence both at the time of publishing and subsequently – for example, David A. Bailey and Stuart Hall's (1992) essay on identity, shifting photographic discourses, and access to the means of representation, or Douglas Crimp's (1993) reflections, in the light of postmodernist critiques, on ways in which the museums and libraries have 'framed' histories of photography and the extent to which actual uses of the medium refuse formal parameters. Such questions certainly continue to resonate now, given the enhanced ubiquity of photographic media and the informal fluidity of online media spaces.

Given the overall focus on representation, agency and context, a number of threads run through the book, across and between sections – for instance, questions of the power of the photographic gaze, or of the social effects and emotional affects of photographs. Sections are organized thematically, each including examples from late twentieth-century essays and more recent articles. Thus, the first section is concerned with the gaze; the following section, on reportage, is followed by a focus on identity relating in particular to gender and ethnicity. Parts 4 and 5 bring snapshot culture and commercial mediations into focus. The final section reflects on institutions and contexts. In many instances, images are crucial to the discussion. Some essays were originally more fully illustrated than has been possible here due to either copyright restrictions, availability or the overall limitation on numbers of illustrations.

In theorizing photography, we need to take into account specificities of purpose and context but also to transcend these. Several of the essays included reference specific fields of photographic practice, but have broader implications in terms of theory and methods of analysis. The contributions obviously reflect debates and assumptions of their era. A number of the authors have moved on from the positions, concerns and methods of analysis represented here. Nonetheless, fundamental questions about the nature and status of photographs and the act of photography echoed through much of the twentieth century and remain pertinent now.

For a reasonably substantial bibliography of publications on photography, students are advised to consult *Photography: A Critical Introduction* (Wells [ed.]

2015), which *The Photography Cultures Reader* complements in a number of respects (most particularly by reproducing some of the key texts referenced).

This book would not have been possible without the contributions of many people. First, I should like to thank all the contributors, and their publishers, for allowing their work to be reproduced. Attempts were made to contact each of the contributors to check for any comments or amendments they wished to suggest; particular thanks to those who responded with suggestions. It goes without saying that without the essays this collection could not exist. Second, I would like to thank Kate Isherwood for an extensive library journal search through which she identified, annotated and brought to my attention a number of key articles published since 2000. Third, I thank Routledge – in particular, Natalie Foster and Jennifer Vennall for entrusting and supporting me with the challenge of extending the original *Photography Reader* into two volumes. Finally, acknowledgement is due to Mandy Russell, arts librarian at Plymouth University, for her unfailing support. My grateful thanks to colleagues at the university and elsewhere, for many helpful comments and suggestions, and for general support.

July 2017/June 2018

Note

1 Irit Rogoff (1998) 'Studying Visual Culture' in Nicholas Mirzoeff (1998) *The Visual Culture Reader*, London and NY: Routledge, p. 16.

PART ONE

The photographic gaze

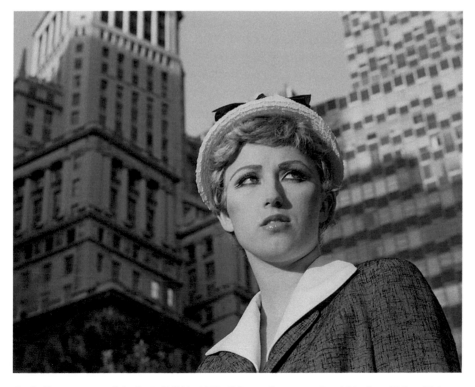

Cindy Sherman, *Untitled Film Still* #21, 1978. Gelatin silver print, 8 × 10 inches, 20.3 × 25.4 cm.
Courtesy of the artist and Metro Pictures, New York.

Introduction

> Men look at women. Women watch themselves being looked at. This
> determines not only most relations between men and women but also
> the relation of women to themselves.
>
> (Berger 1972: 47)

DEBATES ABOUT 'THE GAZE' in photography emerged from general femi-
nist theoretical perceptions and debates of the 1970s/1980s, now nearly half a
century ago. Discussing classic Hollywood narrative cinema, Laura Mulvey drew upon
psychoanalysis to argue that images of women on screen are constructed for the
gratification of the male spectator. Freud's discussion of voyeurism is premised on his
proposition that scopophilia – that is, the desire to look – is a primary human instinct.
In patriarchal cultures the male I/eye is central within discourse and woman is 'other';
in psychoanalytic terms she is complexly construed as simultaneously the object of
desire and a source of fears and insecurities. Mulvey noted that this objectification
of women is reinforced cinematically both through the use of the camera to frame
her image and through the audience being drawn into identification with the point of
view or 'look' of male characters within the fictional narrative (Mulvey 1975). It is this
formulation that Victor Burgin acknowledges and draws upon in his discussion of 'the
look' in photography (Burgin 1982). He later suggests that the effect of the 'still' of
the photograph, the permission for the eye to roam within the frame, and the apparent
artlessness or naturalism of the image – by contrast with, for instance, an oil painting –
also need taking into account (Burgin 1990). Thus, in considering what is sometimes
termed 'the phallic gaze of the camera' in relation to the still image, we need to con-
sider both specific characteristics of photographs and broader cultural attitudes.

Debates not only raise questions of gender. Discourses inter-sect. For instance,
articulated with gendered relations of looking are attitudes to age and ethnicity
whereby, for example, the idealized female image is, almost without exception,
young, slim, light-skinned. In photography, discussion focused on female represen-
tation; in particular, feminist critics argued that 'the nude' is a masquerade, a genre
in art which essentially acts as an excuse for contemplating nakedness, however
abstractly or pleasingly pictured. The female nude was thus reconceptualized as a
patriarchal fetish, whilst the homo-eroticism of male nudity in European classical
art was also acknowledged. It was in this context that, in the first essay included
here, Roberta McGrath analyzes the work of Edward Weston, drawing upon his
own daybooks, as well as upon feminist interrogations of the ambiguity of woman
as sign within patriarchal discourses.

Since the initial discussions of relations of power and powerlessness of the
surveyor and the surveyed in terms of gender there has been concern to develop
debates more complexly. As Anne Williams commented,

> Relations of looking, whether socially or in visual representations, are
> governed by conventions which unsurprisingly are structured according
> to the norms of masculinity and femininity – man the active subject of

the look, the looker, woman its passive object. A number of questions occur. How does the woman look? Is she forced to share the way of seeing of the man, or might there be a specifically female gaze? Can the man too be the object of the gaze? Can such a clear distinction be made between male and female, masculine and feminine?

(Williams 1987: 6)

Such debates have been extensively explored, including, for example, inter-rogating: the male nude in photography (Cooper 1990; Pultz 1995); the work of Robert Mapplethorpe; lesbian looking and the performative (Boffin/Fraser 1991; Bright 1999). Debates were also explored through practice – for instance, in Cindy Sherman's work, which has been considered as postmodern art, and in terms of image and identity. In the essay reproduced here, Jan Avgikos argues that Sher-man's practice is also founded in feminist perceptions.

Both Weston and Sherman are generally encountered in the context of the art gallery or art publications. Sarah Edge and Gail Baylis extend this discussion through examination of media responses to exhibitions of photographs of their own children by Tierney Gearon and by Sally Mann. They interrogate press headlines relating to 'child porn', arguing, through referencing questions of gender, sexuality, politics and aesthetics, that notions of what constitutes 'indecency' are inherently unstable and context-specific. Thus these critical discussions have broader implica-tions as questions of patriarchy, desire and voyeurism are equally relevant to analysis of commercial imagery, including advertising, fashion, erotica and the pornographic.

Extending from debates about the gaze in terms of gender and sexuality, rep-resentation and desire have been interrogations of ways in which, historically and now, the 'colonial gaze' implicates and reinforces privilege. Critiques of colonial attitudes not only brought into question the positivist pretensions of traditional anthropology but also articulated issues of exoticism and 'the other' (Green 1984; Graham-Brown 1988). Post-colonial theoretical perspectives encompass critical practices in which ethnic, regional and cultural differences were differently pictured, re-positioning and questioning otherness. Here interrogations take into account subjective positions and perspectives on the part of the photographer or critic as well as questioning issues of representation. For instance, in the fourth essay included here, taking a single photograph of a family group of Native Americans in Canada as a starting point, Lucy Lippard dissects layers of past and present rela-tions and assumptions, always noting her own reactions as viewer of the image.

Indeed, photographs can be conceptualized and productively examined as points of inter-section of multiplicities of gazes. Such an approach relates textual decoding to broader historical and cultural questions. Catherine Lutz and Jane Col-lins analyze examples from *National Geographic*, taking into account a regime of visibility whereby definitions of otherness mirror and contribute to, often problem-atically, conceptions of self (both in terms of individual subjectivity and in terms of nationhood). Images of the Greek goddess Aphrodite, centrally associated with Cyprus, offer a case study for Theopisti Stylianou-Lambert's critical discussion of cycles of cultural production and consumption wherein, she argues, tourists as

everyday photographers make images that reflect and reinforce pre-existing cultural attitudes and pictorial aesthetics. Focusing more specifically on issues in professional practice, Ariadne van de Ven reflects on her own experience in Calcutta working as a documentary photographer in collaboration with people pictured.

Finally, referencing Michel Foucault, in her contribution to the exhibition catalogue *Framing Bodies*, Louise Wolthers suggests that we all now submit to the gaze through becoming regularly subjected to varying modes of surveillance and racial profiling in operation at a range of checkpoints, from cash machines to passport control, in effect, a continuing government-sponsored, automatic monitoring of our location in time and space. What, we might ask, are the implications for personal freedom given the power relations implicated within not only subjection to the human gaze but also 'machine-readable bodies'?

Bibliography of essays in Part 1

Avgikos, J. (1983) 'Cindy Sherman: Burning Down the House', *Artforum*, January 1993. Reprinted in Liz Heron and Val Williams (eds.) *Illuminations*. London: I. B. Tauris.

Berger, J. (1972) *Ways of Seeing*. Harmondsworth: Penguin.

Boffin, T. and Fraser, J. (1991) *Stolen Glances: Lesbians Take Photographs*. London: Pandora Press.

Bright, D. (1999) *The Passionate Camera*. London: Routledge.

Burgin, V. (1982) 'Looking at Photographs', in Burgin (ed.) *Thinking Photography*. London: Macmillan.

Burgin, V. (1990) 'Perverse Space' in (1996) *In/Different Spaces*. Berkeley, CA: University of California Press.

Cooper, E. (1990) *Fully Exposed: The Male Nude in Photography*. London: Routledge.

Edge, S. and Baylis, G. (2004) 'Photographing Children: The Works of Tierney Gearon and Sally Mann', *Visual Culture in Britain*, Vol. 5:1. Publisher, pp. 75–89.

Graham-Brown, S. (1988) *Images of Women: The Portrayal of Women in Photography of the Middle East 1860–1950*. London: Quartet Books.

Green, D. (1984) 'Classified Subjects', *Ten*, Vol. 8:14, pp. 30–37.

Lippard, L. R. (1992) 'Doubletake: The Diary of a Relationship with an Image', in Lippard (ed.) *Partial Recall: Photographs of Native North Americans*. New York: New Press. Reprinted in Steven Yates (ed.) (1995) *Poetics of Space: A Critical Photographic Anthology*. Albuquerque: University of New Mexico Press.

Lutz, C. and Collins, J. (1991) 'The Photograph as an Intersection of Gazes: The Example of *National Geographic*', in Lucien Taylor (ed.) (1994) *Visualizing Theory: Selected Essays from V.A.R 1990–1994*. London and New York: Routledge.

Mulvey, L. (1975) 'Visual Pleasure and Narrative Cinema', Screen 16:3, Autumn. Widely reprinted including in her (1989) *Visual and Other Pleasures*. London: Macmillan.

Pultz, J. (1995) *Photography and the Body*. London: George Weidenfeld and Nicolson.

Stylianou-Lambert, T. (2012) 'Tourists with Cameras', *Annals of Tourism Research*, Vol. 39:4. Publisher, pp. 1817–1838.

Van der Ven, A. (2011) 'The Eyes of the Street Look Back: In Kolkata with Camera Around My Neck', *Photographies*, Vol. 4:2. Routledge Journals, pp. 139–155.

Williams, A. (1987) 'Re-viewing the Look: Photography and the Female Gaze', *Ten*, Vol. 8:25, pp. 4–11.

Wolthers, L. (2015) 'Surveilling Bodies: Photography as Control, Critique and Concern', in D. Vujanovic and L. Wolthers (2015) *Framing Bodies*. Stockholm: Art and Theory Publishing, pp. 18–30.

Roberta McGrath

RE-READING EDWARD WESTON
Feminism, photography and psychoanalysis

EDWARD WESTON IS, PERHAPS, UNUSUAL in that unlike many other photographers his work has been dominated by his own writing. In his diaries (published as *The Day Books* in 1961 and 1966)[1] he records his life through his photography, his sons, his appetite for women and health foods, and his dreams.

Despite this body of knowledge, his photographic work is most commonly accounted for in terms borrowed from modernist art criticism. Emphasis is placed firmly on formal qualities; a purifying of the visual vocabulary; and truth to the (photographic) medium. From such received and well-worn criticism we learn how Weston emerges from the murky depths of nineteenth-century pictorialism into the blinding light of twentieth-century modernism. The trajectory traced is that of a star. To quote Buckland and Beaton, Weston was 'a man ahead of his time',[2] who then arose from obscurity to fame via New York.

As the dominant ideological ruse of twentieth-century art criticism, modernism has functioned not only to suppress any concern for the wider social matrix of which all cultural production is part, but has also hidden issues of class and race and – crucially – those of gender.

For beneath all the fancy talk of the universal genderlessness of art, as women we know that such truths are meant for *men only*. Such knowledge is kept suppressed. How else could the illusion be preserved that the real meanings of art are universal, beyond the interests of any one class or sex?[3]

It is clear that a feminist art criticism cannot afford to have any truck with modernist discourse. Lucy Lippard has described the feminist contribution to modernism as precisely a *lack* of contribution.

It is therefore not accidental that in the title of this essay I place feminism before photography and psychoanalysis. The task which faces feminist practice is double-edged. On the one hand we must work to de-construct male paradigms, and on the other to construct female perspectives. Both are necessary if we are to change those traditions which have silenced and marginalised us.

To this end feminist scholarship has turned attention to a vast array of discursive practices as a means of understanding not just women's economic oppression but also our oppression within patriarchal culture. Much of this work has come about as a result of the women's movement in the late 1960s and early 1970s, and owes a debt not only to Marxism, but also to psychoanalysis and linguistics.

While Marxist analyses of culture have contributed greatly to an understanding of representations it must be recognised that as a body of theory it cannot answer all the questions. For feminists, of course, the problem is that Marxism takes no account of the sexual division of labour. The Marxist subject is a genderless and universal one. For psychoanalysis the problem is that the Marxist subject is alienated only in a capitalist society which supposedly prevents us from becoming 'whole' beings.

If Marxism proposes that struggle exists between classes (class division of labour) then feminism proposes that struggle exists between sexes (sexual division of labour); and psychoanalysis proposes that struggle exists within ourselves. The unconscious provides evidence of this. The psychoanalytic subject is one which instead of being coherent, whole, complete is always already alienated, split, fragmentary. Entry into the world is at a price. The human subject is one which is always lacking and hence always desiring to fill a gap which is, by very definition, unable to be filled.

Psychoanalysis has also been important for feminism in providing evidence that subjects are formed through sexuality. Sexual difference, masculinity and femininity, is not biologically determined but socially, psychologically and culturally constructed. For Simone de Beauvoir, 'one is not born a woman. But rather one becomes a woman'.[4] The question is 'not what woman is, but how she comes into being'.[5] Such ideas may seem to be a far cry from the work of Edward Weston. But as we shall see, within his work we can read the traces of such debates: we can read attitudes to Marxism and psychoanalysis as well as to women.

Having said that, there is no doubt that such theoretical accounts would have sat very uneasily with Weston himself. In his Day Books he records attending a John Reid Club meeting in the 1930s and the call to 'realise dialectical materialism'. This had little appeal for Weston who believed passionately that 'the individual adds more or combines more than the mass does. He stands out more clearly, a prophet with a background, a future and strength'. Weston was, of course, writing himself into art history, carving out the mould which others would diligently fill in. As such Weston becomes an artist, a genius – perhaps even a saint within orthodox photographic theology.[6]

But of all approaches to photography, the psychoanalytic was the most vehemently rejected – not just by Weston, but by the women who surrounded and defended him. For example, Nancy Newhall regarded his promiscuity as signal evidence that there were no sexual connotations in his work. 'His plethora of love shows that he had no need to seek erotic forms in his work'.[7]

And Weston's second wife and model Charis Wilson insisted that the inclusion of models' faces in the photographs of nudes would have reduced what she, and he, perceived to be a universal theme to a portrait of a particular individual: 'If the face appears, the picture is inevitably a portrait and the expression of the face will dictate the viewer's response to the body'.[8] This would interrupt what she and Weston believed to be the aesthetic appreciation of naked beauty. The *body* of the woman was, for them both, one of only three perfect shapes in the world. (The other two were the hull of a boat and a violin . . .) The compulsion to choose such forms as perfect

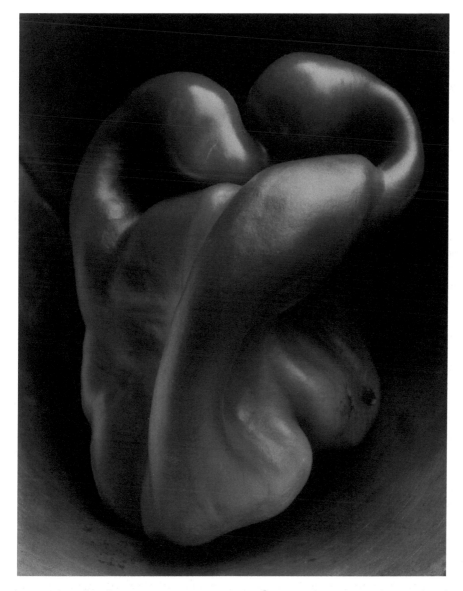

Figure 1.1 Edward Weston, *Pepper No. 30*, 1930. © Center for Creative Photography, The University of Arizona Foundation/Art Resource, NY.

was understood within the formalist aesthetics of modernism: We must never speak of *content*.

But the denial of the role of the unconscious and the psychological drives can in no way eradicate them. They are there to be seen, not so much in the pictures, but in the encounter, in the relationship, in the gap between artist and object, a gap which neither an art history nor a technological history can bridge. This is the place of production: both material work carried out in the darkroom and work carried out in that other dark space, the unconscious.

Precisely because psychoanalysis occupies a unique space between nature/culture, between the biological/the social, it can provide a way out of this stagnant binary logic of dominant photographic history, criticism and practice into an area which is less mapped out. After all, as Rosalind Coward says, 'The invisible is not simply anything at all outside the relationship between objects posited and a discourse. It is within the discourse, it is what the light of the discourse scans without picking up its reflection. In the fullness of the (photographic) text there are oversights. Lacunae'.[9]

Because photography is a medium which seems to be purged of all traces of its production and because it offers us so much to see, most writing on photography concentrates on this world as seen through photographs as if it were a transparent medium, rather than concentrating on *how* those images are *produced*. But what interests me here is precisely those gaps, those oversights. If we borrow a term from psychoanalysis (dream-work: condensation and displacement which underlies the dream) we could say that what is missing, what is rendered obsolete in photo-criticism is the *photo-work*. Of course, photographs are not dreams. They have an advantage in that they can satisfy the unconscious desires of many people. What I am suggesting is that psychoanalysis may provide a route out of this double-bind. I say *might* because it can only do so on one condition: namely, that it provides a materialist psychoanalytic understanding of the apparatus of photography. It is perfectly possible to produce idealist psychoanalytic interpretations. The revelation of latent content or the psycho-biography can be accommodated in art appreciation. Those are not my concerns here. It is not my intention to prove that Weston is in some way a 'perverse' rather than 'straight' photographer. Far more is at stake.

I now, therefore, want to turn to this photographic work and to the language of photography itself.

Close encounters

'Taking' a photograph is a way of making sense of the world. It imposes an order, a unity upon the world which is lacking. To take a photograph is to exercise an illusory control, a mastery which is characteristic of voyeurism. But the sexual connotations of the verb are also obvious: the slang for carnal knowledge. It implies a physical penetration of the other while the photograph is a penetration of the space of the other. For Weston this taking, whether photographic or sexual, was closely linked and well-documented.

In his Day Books he records how photographic sessions were frequently interrupted. The eye was replaced by the penis, making a photograph by making love. It is here that we begin to see an oscillation between photography/sex, (between the print/the real). But we need to pause over this because the penis and the eye are not interchangeable. The satisfaction of one must mean the denial of the other. However, for the male the eye is often a substitute for the penis since its satisfaction is intimately linked to the possibility of an erection.

Photography has an obvious role in this web of pleasures. The voyeur and the photographer must at all costs maintain a distance from the object and the photograph ensures this distance par excellence. To move too close, to touch would put an end to scopic mastery and lead to the exercise of the other drives, the senses of touch and

hence to orgasm.[10] Thus, the photograph acts not so much like a window on the world as a one-way mirror where the tantalising object of desire remains just out of reach so close, and yet. . . . (We should also note Weston's fascination with Atget's photographs of windows). Moreover, the photograph allows the voyeur to look without fear of retribution. Unlike the woman herself the photograph is portable, can be referred to at will, and is always a compliant source of pleasure. Without this scenario the camera is another device of denial and retention (which is always fully a part of pleasure). But there is a complication. The camera itself, 'the body', 'the lens' (eye), 'equipment' can become an object of love, a *fetish*, a re-assuring object that affords pleasure and that the photographer may know more intimately and with less danger than the woman who is likely, one way or another, to put an end to his erection. Weston often refers to his camera as his 'love', reminiscent of the traditional ascription of femininity to photography, as female as a 'hand-maiden', a box with an aperture that passively receives the imprint of an image – but only in negative.

In his diary Weston makes the following slip: 'I made a negative – I started to say nude. . . .' This analogy of negative to nude is significant since the implication for both is a certain lack: the minus sign, the horizontal, the hyphen or gap. It also suggests woman as less than, more incomplete; possessing, perhaps, only a negative capacity.

This lack is one which can be made good by photography. Weston describes photography as 'seeing plus'. Is it through the print, ('which will remain *faithful* to the negative') that he can compensate the woman/the world for their lack? Is this the vertical crossing through of the horizontal, the turning of this minus sign into the plus?

But in speaking of voyeurism and fetishism, I am getting ahead of my argument. And to understand them we need to introduce a third and even more unpleasant term: castration.

In 1938 Stieglitz wrote to Weston: 'For the first time in 55 years I am without a camera'. Weston replied, 'to be without one (to be what one might call cameraless) must be like losing a leg or *better* an eye.'[11] Not worse, *better*. Castration – and by analogy – death, are clearly in the air. It indicates Weston's desire (attested to elsewhere in the notebooks) to usurp Stieglitz the Father of Modern Photography. Weston visited Stieglitz in 1922 and it is well known that he never received the recognition from Stieglitz which he so desperately desired.

It also attests to Weston's own fears of castration: the loss of a leg or an eye (perhaps the third leg in Charis's description of Weston's Graflex camera as 'a giant eye on three legs').[12] This is a reference to the myth of Oedipus in which blindness is symbolic of castration. Within this scenario the mother is photography and Stieglitz and Weston are the rivals for her attention. This makes sense of the closing lines of the same letter in which Stieglitz wrote to Weston of his cameralessness. He continued: Waldo Frank said some years ago. 'Stieglitz, when you're dead, I'll write your biography'. I wondered how much he knew about me and why wait till I'm dead? But all I said was: Frank my biography will be a simple affair. *If you can imagine photography in the guise of a woman and you'd ask her what she thought of Stieglitz, she'd say: He always treated me like a gentleman. So you see that is why I am jealous of photography'.*[13]

Photography comes in the guise of a woman; and for woman the ultimate accolade is to be treated as an honorary man.

Castration, simply put, is a fear of damage being done to a part of the body (primarily the male body) which is considered to be a source of pleasure. In Freudian

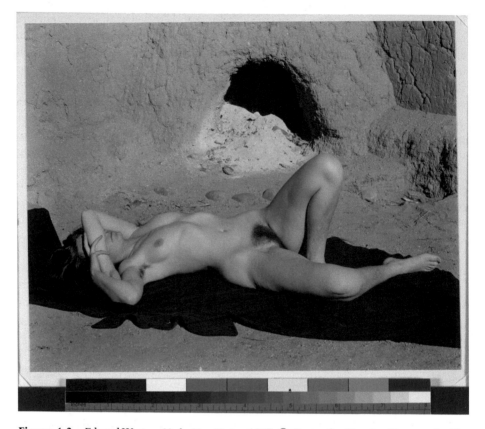

Figure 1.2 Edward Weston, *Nude, New Mexico,* 1937. © Center for Creative Photography, The University of Arizona Foundation/Art Resource, NY.

psychoanalysis the fear supposedly arises from seeing the mother's genitals and the realisation that some people do not have the penis. To the small boy who knows nothing about anatomy this provides evidence that castration is possible (he believes that his mother has had the penis and through some misdemeanour has lost it). This leads to the phantasy of the all-powerful mother (who does not lack) and to women as symbols of castration. This threat posed by women can be dealt with in two ways, through voyeurism (subjecting women to a controlling and unreturned gaze) *and* through fetishism (the displacement or substitution of the anxiety onto a re-assuring object which comes to stand in for the missing penis). The fetish, of course, has no value in itself. The reverence which the male feels for it is for the erection which it maintains. For Weston, photography in the form of the camera, was 'that pleasurable extension to the eye': both it and the faithful photographic print become fetishes; necessary props.

Voyeurism and fetishism are both inscribed on the photographic arrangement. Photographs themselves are curiously like fetishes requiring a disavowal of knowledge. We know that they are only flimsy scraps of paper but we over-invest them with meanings. Moreover, photographs come to stand in for the missing object. The condition for the photograph is precisely the absence of the real object.

The major benefit of interposing the camera between his eye and the nude was to gain a more fundamental knowledge of reality. According to Weston, 'The discriminating photographer can direct its (the camera's) penetrating vision so as to present

his subject in terms of its basic reality. He can reveal the essence of what lies before his lens with such insight that the beholder will find the re-created image more real and comprehensive than the actual object'. This is the search for the elusive and impossible real. In photography the infinite number of photographs, the quest for the 'one' attests to the drive to collapse signifier into signified, the photograph into reality: to make a photograph which has no other, a phantasy moment of suppression of separateness, which closes the gap – and the compulsion to close this gap becomes paramount. The pleasure and indeed the problem for the voyeur is one of how to maximise the pleasure of looking. This aesthetic requirement can partly be found by technical expertise. I mentioned earlier that 'taking' the photograph involved the penetration of the space of the other. The pleasure/problem is one of how to deepen this penetration; how to make the piece of paper more three dimensional and consequently real.

f/64

Weston belonged to a group of West Coast photographers who adopted the name f/64. This referred to a technical device – the aperture which achieves maximum depth of field with sharpest possible focus. It combines microscopic detail with telescopic depth. We could also describe it as a heightening of visual qualities which excite and invoke (without allowing) the sense of touch. Retention, we remember, is fully a part of pleasure.

This deeper penetration of the real could be further enhanced in the process of 'printing up'. By 1927 Weston was citing the advantages of using high gloss paper. It would 'retain most of the original negative quality'. Moreover, he went on, 'I can print much deeper without fear of losing the shadows'. He saw this as a logical step in his 'desire for photographic beauty'. Beauty frequently has its roots in sexual stimulus. The gloss of the paper mimicked the glassy quality of the plate negative, but shine also connotes a moistness which is associated with sex, and similarly, glossy paper seemed to adhere, bind with the image. It fused with the image in an imaginary moment of pleasure. This is what Weston means when he says, 'paper seems to compete with the image instead of becoming part of it'. Signalled here is the desire for a mythic fusion (as in sex) between photography and the real, the desire to suppress the gap between the subject and the object of desire, between the negative and the print, between the subject's own body and the other's body, ultimately the phantasy moment of orgasm. (The latest book on Weston is entitled *Supreme Instant*).[14]

Perhaps we can now begin to understand Weston's love of daguerreotypes: a mythic one-ness at the 'birth' of photography. We should not underestimate the language which photography has adopted. If we pursue the metaphor of the natural birth then Fox Talbot's paper negative marks the break-up of the dyadic relationship. And we can also understand Weston's favoured method of printing, what is referred to as contact printing. It was an attempt to preserve an aura of originality.[15] In this process the negative bonds with the paper, the hard surface of the glass plate with the softness of the paper and from this union the issue of a print. It was Jean Cocteau who coined the idea that art is born of an incestuous union of the male and female elements *within* the male. Weston felt that the role of women in his life was to 'stimulate me, fertilize my work'.[16] Ben Maddow, Weston's biographer, speaking of the

Weston/Wilson relationship claims that 'great nudes were born from this childless marriage'.[17] Weston was a prolific photographer having made some 60,000 prints of which, incidentally, nudes make up the largest category.

Honour, power and the love of women

According to Freud, the artist achieves what would otherwise remain phantasies, 'honour, power and the love of women'. It was Weston's work that enabled him to realise such invisible fantasies, brought to light through work done in the dark, under a cloth gazing at a ground glass screen, and work done later in the darkroom. Hollis Frampton has written that the work is of someone compelled to sexualise, even genitalise everything.[18] This makes sense of Freud's symbolic topography of genitalia in *The Interpretation of Dreams*. Landscapes, woods, trees, hills, caves, water and rocks come to 'stand in' although the gender to which they refer is by no means obvious (a cigar, as Freud says, is sometimes just a cigar). Freud names only two objects which are never confused (a box and a weapon); on the whole there is ambiguity. It is the context which provides meaning. Symbols tend to be hybrid, and those images which most satisfied Weston were those invoking the fusion of male and female. Excusado, The Nude Back, Shell and Pepper No. 30 achieve this status. It is worth noting that Pepper No. 30 was the all-time best-seller. The others are not so successful in concealing their origins. Weston described the pepper as 'a hybrid of different contractile forces . . . pulling against each other'. It is clear what this suggests. But Weston also ate these 'models' after he had lovingly polished and photographed them. It was part of the ritual consumption of flesh. He saw it 'not as "cannibalistic". They become part of me . . . enrich my blood'. Weston makes everything which constructs a world – 'girls to fuck. food to eat . . . trivia, oddities . . . earth to walk on . . . skies to put a lid on it all'.[19] This is also reminiscent of the way in which he talked about women, each in turn fertilising his work, but it also suggests another moment of imaginary unity: the phase prior to meaning when for the child separation from the m/other is temporarily suppressed by feeding the infant from the breast.

From voyeurism to fetishism

A similar unity is, of course, met in the single process of the daguerreotype. This marks the fetishistic axis of Weston's oscillation. Those early photographs were thought to have the power to see into the human character. For Weston, the camera 'searches out the actor behind the mask, exposing the contrived and the trivial for what they are', and 'all she wants is sex; all her gestures are directed by sex'. This is tinged with the language of punishment and investigation that is characteristic of voyeurism, Hence the oscillation in the work between the female body as form (pleasurable and complete) and the other axis; the sadistic cutting of the image. This latter aspect is achieved in numerous ways. In many of his photographs there is a literal cutting, the implication of cutting, the cutting of the frame, and the more subtle cutting produced by shadow. Enjoyment of the nudes is ensured through the erasure of the threatening gaze of the woman, either through a literal beheading, aversion or covering of the eyes, as if she did

not know that she was the object of your gaze. She does not look, pretends she is not being looked at, and at the same moment we know very well that she knows. She is the one to be looked *at* without looking herself. The denial to look is also, by implication the denial of woman's access to the production of knowledge. One of Weston's friends touches upon the importance of photographic *work*, of instruments when he asks for 'spectacles to see as you do, scissors such as you use to cut prints'.[20]

At work in all this is the story of the Medusa, and the implication for the protective, fetishistic print are clear. Like the Medusa herself, the camera has the power to suspend movement, to arrest life, to cause a sort of death by freezing a moment in time.

The woman must not return the gaze, and Weston cannot turn the camera's gaze upon himself. It is hardly surprising to find that there are *no* self-portraits. Weston keeps the symbolic register for himself. The Nude as a category is reserved solely for women (there are some of his sons but crucially before puberty.) We provide evidence of body, that natural, raw material which he will fashion into culture. Women are kept in the imaginary. How then can we begin to speak of the historically invisible, inaudible, the powerless; the position of women within patriarchal discourse? In psychoanalytic terms we are the 'nothing to be seen', or at best 'not all'. And yet the puzzle is not simply our exclusion from discourse but our very inclusion as both marginal (out of sight) and central (on display). As Mulvey states, 'the paradox of phallocentrism is that the idea of (the) castrated woman stands as lynch-pin to the system'.[21]

Figure 1.3 Edward Weston, *Valentine*, 1935. © Center for Creative Photography, The University of Arizona Foundation/Art Resource, NY.

There have been several feminist strategies in response to this problem. The first and the least interesting is the attempt to fill in some of the holes in the discourse; to paper over the cracks by inserting more women into the existing structure as phallic mothers who do not lack (honorary men). Such moves are largely a denial of sexual difference: a plea for access to the patriarchal structure: the most common result is to tack on a few more exhibitions or lectures on women photographers.

A second strategy is the refusal to contribute to patriarchal discourse: a rejection of the structure altogether as an attempt to build a specifically feminine discourse in opposition to patriarchy. This also poses problems. How can one know what that might be?

The feminine is not the same as feminist. How can we be certain that it will not simply construct a parallel ideology where 'men' has been replaced by 'women'? The recent Barbara Kruger poster suggests to us that 'we don't need another hero', but it could equally have read 'we don't need another heroine'. The task at hand is to understand first and foremost how 'woman' (as a sign) functions within patriarchal discourse, and this task is one of dismantling. While we can hardly claim that the edifice of patriarchal (photographic) discourse lies in ruins, the 'cracks' are starting to appear. Structurally, its foundations can no longer be said to be sound.

Original publication

'Re-Reading Edward Weston: Feminsim, Photography and Psychoanalysis', *Ten 8* (1987)

Notes

1 Unless otherwise stated, all quotes are Weston's from N. Newhall (ed.), *The Day Books of Edward Weston*, vols. 1 & 2, Aperture, 1973.

2 C. Beaton and G. Buckland, *The Magic Image*, Weidenfeld and Nicolson, 1975, p. 159.

3 C. Duncan, 'Virility and Domination in Early Twentieth Century Avant-Garde Art', *Art Forum*, December, 1973, p. 36.

4 E. Marks and I. De Courtivron (eds.), *New French Feminisms*, Harvester, 1980, p. 152.

5 S. Freud, 'Femininity', in *New Introductory Lectures on Psychoanalysis*, vol. 2, Pelican Freud Library, 1972, p. 149.

6 H. Frampton, 'Impromptus on Edward Weston, Everything in Its Place', *October*, no. 5, 1978, p. 49.

7 N. Newhall (ed.) op. cit., p. x.

8 C. Wilson, *Edward Weston Nudes*, Aperture, 1977, p. 115.

9 R. Coward, *Patriarchal Precedents*, Routledge and Kegan Paul, 1983, p. 1.

10 C. Metz, *Psychoanalysis and Cinema*, Macmillan, 1982, pp. 58–60.

11 F. Reyher (ed.), 'Stieglitz-Weston Correspondence', *Creative Camera*, October, 1975, p. 334.

12 C. Wilson, op. cit., p. 8.

13 F. Reyher (ed.), op, cit., p. 335. (It is also well known that it was Stieglitz who stressed the importance of 'straight' photography to Weston in 1922. '. . . a maximum of detail with a maximum of simplification, so Stieglitz talked to me and Jo (Hagemeyer) for hours', Weston File, MoMA, NY.

14 B. Newball, *Supreme Instants: The Photography of Edward Weston*, Thames and Hudson, 1986.

15 Photography has long been considered a mass-production medium from the standpoint of unlimited duplication of prints . . . not the mass-production of duplicates, but the possibility for the mass-production of original work', Weston File, MoMA, NY.

16 For Weston, woman was still in the realm of the imaginary. 'I was meant to fulfil a *need* in many a woman's life as each in turn fertilises etc.', N. Newhall.

17 B. Maddow, 'Venus Beheaded: Weston and His Women', *New York Magazine*, 24 February, 1975.

18 H. Frampton, op. cit., p. 62.

19 ibid., p. 68.

20 N. Newhall (ed.), op. cit., vol. 1, p. 151.

21 L. Mulvey, 'Visual Pleasure and Narrative Cinema', *Screen*, vol. 16, no. 3, 1975, p. 6.

Jan Avgikos

CINDY SHERMAN
Burning down the house

CONSIDER THE MANY GENRES Cindy Sherman has developed in her photographs – film stills, fashion photos, fairy tales, art-historical portraiture, scenes of dummies deployed in sex acts. Consider, too, the critical discourses engaged in her work – deconstructive post-Modernism, the photograph's dialectic of absence and presence, theories of representation. Consistently, Sherman's photography is positioned in the convergence of discourses, rather than squarely in any one of them; and in that convergence, the feminist content of her work emerges. Like her rehearsal and performance of permutations (her)/self, of the many feminisms that have been read into her work mirror both shifts in feminist thinking over the years and the current, internecine struggles over sexuality and representation that are erupting within our communities.

Skirting the fray of clashing feminisms, many critics still disclose an entrenched resistance to the idea that Sherman's motifs and thematics are embedded in feminist theory rather than incidental to it – they still recast her gender polemics as a grand concert of 'human' (and 'human' always. means 'male') desire. But the cleansing of feminist commentary from Sherman's photography is symptomatic of the very problematics that her work addresses. For example, if we acknowledge femininity as a discursive construction, how can we authentically construe a feminine esthetics and identity apart from the patriarchal framework upon which they are grounded? Rather than assuming a given femininity, Sherman dislodges the operations that have historically defined and imposed the feminine as a social category. Indeed her latest schlock-shock images displaying the broken-down merchandise of a medical-supply house – plastic mannequins endowed with anatomically correct genitalia macabrely animated in pantomimes of sexual fantasy – are emphatically interventional. Hardly indemnified by political correctness, these grimly humorous vignettes deep-throat the politics of pornographic representation. Yet despite their fun-house horrors of freakish hermaphrodites, postmenopausal Medusas, and decapitated Herculeses, these peep show pictures never stay put as clever carnal cartoons, or even as allegories of

alienation. Instead, the seemingly minor questions they raise – Can photos be porn if they don't pass the 'wet test,' if, indeed, the bodies are plastic? – are inseparable from larger, more urgent ones: is the social economy of pornography different from that of art? Is porn antithetical to feminism? Do women see 'differently'?

By framing such questions as dependent on distinctions between artifice and the real (distinctions on which she has long staged her investigations), and by inscribing them within the pornographic, Sherman integrates female identity, representation, contamination, and taboo. By presenting images that ask what's OK, and what's not, in picture-making, fantasy, and sexual practice, she opens wide the Pandora's box that polarizes contemporary feminism. The women crouching as if in fear of discovery, and the plundered female bodies abandoned to vacant lots, in the earlier series, and now the titillating p.o.v. shots of dry, cold sex can only partially be explained by moralizings on the victimization of women in society. For the problems of oppression and objectification that surround pornography do not reside exclusively in the image, but in the very act of looking, in which we ascribe sexual difference.

When we look at photographs, it is through the eyes of the photographer, understood as occupying a masculine position, that we see. The implicit aggression of the photographic act – *aiming* the camera, *shooting* the picture – is literalized when the image examines the female body. In Sherman's photographs, however, active looking is through a woman's eyes, and this ambiguity makes them both seductive and confrontational. Sherman demarcates no privileged space for the female spectator per se, yet the role in which she casts us, as both viewer and subject, parallels the defamiliarizing effects of plastic dummies having real sex. Automatic scopophilic consumption, whether narcissistic or voyeuristic, is interrupted. By rendering the body problematic, and exposing what is conventionally hidden, Sherman infuses the desirous look with a sense of dread and disease.

Sherman heightens the spectacle of the sexual act by isolating genital parts and coding them with fantasies of desire, possession, and imaginary knowledge. The instrumentality of these photographs lies in their tantalizing paradox: offering for scrutiny what is usually forbidden to sight, they appear to produce a knowledge of what sex looks like (hence Sherman's subtle humor in using medical dummies), but simultaneously are not real. The dummies diminish the sense of pliant flesh, distancing the spectator from the body, yet props such as luxurious fabrics focus sensuality. Positioned close to the picture plane, the models invite an intimate viewing relationship. And their placement in splayed, supine, or kneeling positions elicits a fantasy of sexual penetration, even though they are not real.

Many women feel that there is literally no place for them within the frame of porn. Perhaps the most extreme case against pornography is made by Andrea Dworkin, who holds 'pornographers' responsible for 'eroticizing inequality in a way that materially promotes rape, battery, maiming, and bondage' and for making a product 'that they know dehumanizes, degrades and exploits women.'[1] Would Sherman's photographs of dummies qualify as pornographic, even though they aren't 'real'? Actually, the 1986 report of the Meese Commission specifically links porn to what is unreal: it is 'representation' of sex that is the problem, not sex itself. To the writers of the report, as soon as sex is inscribed, as soon as it is made public rather than private, it changes in character, regardless of what variety of sex is portrayed.

The underlying logic, as Avital Ronell has remarked, is one of contagion, of 'exposing' people to a contaminant.[2] This is another way of stating the problem with mimesis: an imitation of reality produces the desire to imitate. It is 'representation' that contaminates, and from which women must be protected. The irony is that woman herself has long been identified with the problems of mimesis, representation, and contamination. And when it comes down to it, we know that what censorship really protects is the so-called majority's self-image of normalcy, and that woman, as Ronell observes, is merely a symptom of the law. We know, too, in Pat Califia's words, that within the narrow range of acceptable sexual behavior, nobody comes out looking normal once you know how they fuck and what they think about when they're doing it, and that the totalitarian insistence on sexual uniformity does hidden violence to all us dissidents and perverts, making us ugly before we have even seen ourselves.[3] Still, even for us, Sherman's images have enormous disruptive power.

Although strident compared to the docile female stereotypes of the 'Film Stills,' 1977–80, the deranged female creatures of the earlier fairy tales and mutilation series of the mid-to-late 1980s, while sometimes intimating the possession of secret powers, are nonetheless the offspring of earlier Sherman women suspended in passive states of waiting, longing, and abandonment. The current series shows what those women have gotten up to, so to speak, when left to their own dark fantasies. One mannequin willingly lifts her rear end, presumably for a spanking with the nearby hairbrush. Another spreads her cunt wide open to some form of penetration – wide enough for a fist. The implication of S/M practice, sex with inanimate objects, fascination with the perverse, and transgression of the 'nice girls don't – and feminists certainly don't' injunction are all personified by a glowering Medusa/whore/Venus/Olympia, who menacingly displays her startling red-foam vagina, the invitation promising pleasure for herself alone.

In the 1960s and 1970s, women using their bodies as subject and site of their art tended to explore feminine identity in relation to nature. Carolee Schneemann, Mary Beth Edelson, Ana Mendieta, and others displayed their sexuality as both natural and empowering. The problem, then as now, is the assumption that we were ever goddesses in the Garden, or, for that matter, that there is a pure state of nature to get back to, a state prior to our contamination by language, or representation, or law. The desire for an 'uncontaminated' expression of female sexuality appears in other guises today, particularly by women who seek to make 'sex-positive' pornographic images that in effect project backward to nature and purity. In adapting pornography for female audiences, this clean-up operation rejects the 'demoralizing' impurity of the excremental, the improper, the dangerous and disgusting.

Sherman's representation of female sexuality, in contrast, indulges the desire to see, to make sure of the private and the forbidden, but withholds both narcissistic identification with the female body and that body's objectification as the basis for erotic pleasure. Her mechanisms of arousal – rubbery tits, plastic pussies, assorted asses, dicks, and dildos – may deceive momentarily, but finally defeat the proprietary gaze of the spectator, whose desire can only partially be satisfied by the spectacle of artificial flesh. The convergence that Sherman establishes between female identity and artifice, desire, and disgust has been widely interpreted. Some see her sullying of the female form as an argument against the clichés of traditional feminine glamour. Others see it as a pedagogy against violent masculine sexuality, and against images that

may incite male aggression. And the idea of the instability of female identity – long a fascination of psychoanalytic theory – has been invoked to suggest that Sherman is ambivalent about her own womanhood.

All of these readings are too simple in isolation; the last of them misinterprets the function of the frame as one that absorbs Sherman herself. From this it is construed that because woman ('Cindy Sherman') is distinguished only by her lack, she can only abhor herself. This argument fails to take into account Sherman's control as director and producer of her own visual dramas. Fantasies of sexual perversion are forever getting confused with real life, but rarely so simplistically. Sherman's porn pictures express no blanket female self-hatred; rather, they engage the age-old designation of woman as essentially monstrous. More specifically, it is not just woman's identity (which, insofar as it is taken to be artificial and unstable, is sensed as antithetical to the rule of law) that is alarming, but her genitals, which emit the smell of death.

Look again at Sherman's images: the 'diseased' cunt, alarmingly red, flayed, unsavory; the severed female torso 'contaminated' by menstrual blood; the frightening Medusa/Olympia whose vagina excretes intestinal or phallic sausages; the doll whose vagina and anus merge into a dark, yawning emptiness. And look, too, at the photographer's enthusiasm for framing female perversity – at her will to disrupt. Sherman portrays no naive notion of pleasurability or purity: her images luxuriate in desire and disgust, which, as Georges Bataille reminds us, are inextricably linked. Marking her bodies as monstrous, she kills all nostalgia for an original state of things – whether the 'original' is identified with respect to distinctions between female and male desire, or is symptomatic of woman's fundamental and a priori 'lack.'

An interlocking network of fetishism and mutilation (a figure of castration) constellates around the body, multiplying the terror and situating the work more insistently in the locale of horror than of erotica. If the images evoke castration anxiety, what is their effect on the woman spectator, who, presumably, cannot lose what she never had? Metaphorically, they represent what is typically displaced, sublimated, or repressed. Sherman's pictures, in fact, flaunt accouterments immediately suggestive of fetishism. An eroticism ridden with menace is her lure, and artifice her entrapment and disease. In the register of nightmare, the impulse to debase and violate parallels the impulse to worship and adore.

Hélène Cixous insists that women should mobilize the force of hysteria to break up continuities and create horror. This is not to hark back to some 'natural' state – an effort that masks woman's censored hysteria as though it were an unwelcome disease – or to fall into some other form of 'political correctness,' and the guilt and repressed desire that it triggers. For some, Sherman's displacement of sex to a cartoon level may signal an area in which issues can be investigated from a position of safety. Yet the ugliness and hard-core explicitness of her pictures, part of a politics of demasking, also function on a political level – particularly with respect to feminism. Rather than making a 'sex-positive,' Edenic retreat from that which we think we should not think or do, Sherman complicates libidinal desire. There is nothing fake at all about her vision.

Original publication

'Cindy Sherman: Burning the House Down', *Artforum* (1993)

Notes

1 Andrea Dworkin, letter to the editor, *The New York Times Book Review*, 3 May 1992, p. 15.
2 See Avital Ronell, interviewed by Andrea Juno, *Angry Women*, San Francisco: Re/Search Publications, 1991, pp. 127–153.
3 Pat Califia, *Macho Sluts*, Boston: Alyson Publications, Inc., 1988, p. 16.

Sarah Edge and Gail Baylis

PHOTOGRAPHING CHILDREN
The Works of Tierney Gearon and Sally Mann

IN MARCH 2001 fifteen colour photographs of children were exhibited at the Saatchi Gallery in London, as part of the exhibition 'I Am a Camera'. The children's mother, Tierney Gearon, an apparently 'untrained' photographer, had taken the photographs. The exhibition had run for sixteen weeks when it was visited by the vice squad following claims, made by members of the public and journalists, that the photographs were 'indecent'. The police investigated the photographs under the 1978 Protection of Children Act and concluded that two of the photographs should be removed. One of the photographs deemed to be potentially 'offensive' depicted the artist's two young children, aged four and six, naked on the beach wearing masks, the other the photographer's son peeing in the snow on holiday. The accompanying exhibition catalogue was also removed from shops such as Waterstones.

The following day the incident was covered by the *News of the World* which reproduced on its front cover one of Gearon's photographs. This appeared, not in its original form, but with black boxes covering the children's genitals. The accompanying headline announced: 'Child Porn They Call Art'.[1] It is this headline that set the parameters for a complex debate around art, pornography and adult and child sexuality, which will be the subject for examination in this article. The headline is simple yet complex; it assumes that its readership has a clear understanding of what constitutes child porn as opposed to art and, perhaps more importantly, suggests that if something is the former then it cannot be the latter. It is also framed within a class-based argument that assumes that the 'they' referred to in the 'working-class' newspaper are the middle-class artists, gallery viewers, purchasers and gallery owners, as well as the critics who define what is seen as art. In this article we will examine how this headline is an indication of a current confusion over the definition of different types of photography. Furthermore, we will argue that this desire to stabilize the meaning of the photograph reveals a more complex concern with a slippage between what constitutes childhood (femininity), adulthood (masculinity) and sexual desire (paedophilia). Here, images of prepubescent boys are understood, as identified by Patricia Holland,

as carrying similar meanings to those of girls where their childlike, innocent qualities connect them to femininity and sexual availability, rather than dominant meanings of adult masculinity.[2] What we hope to reveal is that just as the meanings given to different types of photography are never fixed, the same is true of the differences between the child and adult, which are also discursive rather than material. In order to pursue this argument we will consider the media response to Tierney Gearon's images and contrast her work to that of the American photographer Sally Mann, who also exhibited photographs of her children, in the exhibition and publication *Immediate Family* (1992).

Media coverage of Gearon's photographs took its lead from the *News of the World* coverage cited above. The tabloids generally supported the claim that the images were 'child porn'. For example, on 13 March the *Daily Mirror* quoted from an interview with Andreas Whittam Smith (president of the British Board of Film Classification): 'I am not, by nature, a censor. But these images displayed in the name of art disturb me deeply'. The paper employed this comment to give authority to the charge that these images constituted child pornography. The *Daily Mirror* also reproduced the 'offending' photographs and, like the *News of the World*, felt the need to 'black out parts which may cause offence'. A black box was placed over the child's upper body even though no genitalia were visible; another photograph had two black boxes covering the child's whole body. This 'blacking out' visually confirms, if not actually constructs, the 'offensive' nature of the photographs. In contrast, the broadsheets tended to argue for the photographs as art and thus felt no need to visually 'censor' the images. The *Guardian* (also on 13 March) printed full reproductions of the two photographs and ran a feature called the 'Last Taboo, A Response from the Woman Photographer Tierney Gearon' in order to 'give the photographer the space to dispute the claims that these images are "pornographic"'. It also asked its readers to consider 'Where is the Sex?' The *Independent on Sunday*, which had part-funded the exhibition, reproduced all fifteen photographs on its front page under the headline 'There's nothing seedy about these pictures of my kids. They are not child porn' (*Independent on Sunday*, March 2001). Here we can witness, both in the text and in the manner in which the photographs were reproduced, confusion about how to interpret them. This confusion is reflected in the terms of the defence: by both the artist as mother and the broadsheets. Against their status as porn, the images are championed as innocent pictures of children rather than as art, and this is a crucial point.

A closer examination of the photographs reveals where this ambiguity over interpretation arises. This blurring of categorization, we propose, is not just about the difference between pornography and art but also about what 'type' of photographs they are. This uncertainty derives from the fact that the images depict ordinary children doing quite ordinary things: on their holidays, naked at the beach, weeing in the snow. While some have a slight stylistic difference to everyday domestic photography (for example the inclusion of a dead dog or use of a slightly odd angle), we would argue that these differences are not that marked, and that their visual signs seem to signify domestic photography rather than artistic production. Their status as domestic and 'unprofessional' was also favoured through the media promotion of Gearon as an untrained photographer 'who just took photographs of her kids'. This construction of the photographs as an exemplum of unmediated practice is also connected to well-established traditions about artistic creativity and gender. Consequently, in Gearon's

case, the artistic merit of the photographs is read as not the intention of the (female) maker but the province of the vision of the (male) art dealer/critic. These power relations surrounding issues of visuality were reinforced in media reportage, which emphasized how it was Charles Saatchi who first saw the fifteen snapshots and asked Gearon to enlarge them for inclusion in his exhibition.

What is also significant is the way in which the visual and promotional construction of the images as domestic and unprofessional was employed differently by the tabloids and the broadsheets. Those who argued that the photographs were not pornographic tended to defend them not through recourse to aesthetic discourses, but through the claim that they were just a set of family photographs. Implicit in this position is an evacuation of any consideration of intentionality. This resulted in the images being read in terms of dominant ideals of childhood and domestic innocence. In contrast, those who claimed they were pornographic tended to ignore their similarity to domestic photographs, because such an acknowledgement would, if pursued, have forced them into an uncomfortable consideration of the general sexualization of children in representations produced by adults. These are crucial points and ones which will frame our analysis of these photographs.

The photographs' similarity to domestic images poses another question. For if what we are looking at is just a set of family photographs, similar to the pictures we find in our own family albums, what are they doing being exhibited in the Saatchi Gallery in the first place? In order to answer this, it is important first to consider how the photograph communicates.

The message in the photograph

In his 'The Rhetoric of the Image' Roland Barthes explained how the 'photograph usually has three messages: a linguistic message, a coded iconic message and a non-coded iconic message'.[3] Barthes argued that it is this relationship between the coded and non-coded iconic messages that gives photography a particular veracity. What is of interest to us here is how that coded photographic message works. For instance, in order to understand the full meaning of any photograph we cannot just consider the specific genre of photography it falls into. We also have to consider how other factors affect those meanings. Here we are thinking not only of the linguistic message, that is the title or how the critic or others in the media write about them, but also the context of viewing, which in this case might be the family album, the gallery or the newspaper. For Barthes, 'all images are polysemous', they imply (via their signifiers) a 'floating chain' of signifieds, from which the reader is able to choose some and ignore others.[4] Polysemy poses a question over static or fixed meaning and this question always comes through as a dysfunction. Noting the disturbing nature of dysfunction, he went on to argue that 'in every society various techniques are developed intended to fix the floating chain of signifiers . . . to counter the terror of uncertain signs'.[5] This idea of dysfunction is important when considering the response to Gearon's photographs. We propose that it was precisely because the viewer was uncertain about how to interpret Gearon's photographs that a 'terror' became attached to them, one which links them to the widespread cultural need to 'fix' definitions in order to allay the anxiety of difference. For we need to remember that 'the image' is invariably

articulated within the picturing sensibilities of a 'wider culture'.[6] Here, as in other debates on types of sexualized photography, Jan Zita Grover reminds us that there is always a danger in paying 'too much attention . . . to what lies within the frame and too little to the establishing context that surrounds it'.[7]

By acknowledging how context works upon the meanings within a photograph we can return to a critical and historically located reading of Gearon's photographs (and there is an important historical dimension here). In order to fully appreciate how a mother's domestic photographs of her children found their way into this exclusive gallery site, it is necessary to consider their (unacknowledged) debt to the feminist art movement of the 1970s.

Feminist photographic practices

In their review of feminist art, Griselda Pollock and Rozsika Parker described the 'explosion of political energy' in the early 1970s, accompanied by burgeoning political movements: 'Out of the meeting together of women emerged new kinds of art, new forms of practice, and, for women, positive self-consciousness as feminist artists. No political movement of the 1970s other than the women's movement had a comparable effect on the visual arts'.[8] This active relationship between the political movement of feminism and cultural practices generated the idea that for women 'the personal was political'. In artistic terms, women began to make visible the hidden and undervalued areas of their personal lives. Such work can be split into three categories: work that reclaimed knowledge of women from the past that was previously hidden in patriarchal histories, as well as reinforcing material and craft techniques which, because traditionally associated with women, were undervalued in artistic terms. Judy Chicago's *The Dinner Party* (1979) is a good example here. Work that engaged with taboo made visible areas of women's lives and biology hidden by patriarchal culture; for instance the photographic work of Susan Hiller, *10 months*, 1977–79, and the performance *Menstruation*, by Cate Elwes in 1979. Finally, there is celebratory work where feminist artists turned their attention to areas of women's culture that were downgraded by patriarchy, for instance mothering, the domestic, housework, the family. In this respect feminism not only raised the public profile of women artists but also changed what was viewed as acceptable artistic content.

Domestic photography, as an area of cultural practice associated with the feminine, came under such a reexamination. Family photography emerged in the 1860s and was quickly constructed as an amateur form of photography precisely because it was connected to the private and personal, areas of life occupied by women/mothers. Historically, photography within the domestic sphere allowed women a space to explore areas of their lives that stood outside or challenged dominant discourses, including aesthetic discourses. The nineteenth-century photographer Julia Margaret Cameron used her children and immediate female relatives not only as subject matter but also as a means to engage with larger social discourses about literature, art and religion through allegory. The Victorian period was of course a key moment in the establishment of new discourses on motherhood, childhood and femininity. However, of specific relevance to us here are the place of the child, sexuality and its links to photography. It is now recognized that domestic photography, far from being innocent,

has always been heavily implicated in the construction of such discourses. Lyndsay Smith confirms how 'since the invention of the medium, concepts of the child and photography have been linked . . . the child's relation to the photograph has larger ramifications for contentious debates upon the constructions of childhood in the nineteenth century. Those debates centre upon questions of agency, identity, majority and consent'.[9] Smith gives the example (relevant to our discussion of Gearon's photographs) of how the 'respectable' photographs of young girls taken by Lewis Carroll in the 1860s, once they are placed in their historical context, reveal his concern with the social and legal debates over the age of consent, which at that time was ten.[10] This is a pertinent reminder that what adults understand as the sexuality of children is always defined by the adult world; in this view, childhood is not fixed but culturally produced. Consent, both sexual and visual, always operates in terms of relationships of power.

This academic and practical recognition that domestic photography is part of female culture, combined with feminism's critical interrogation of the personal, led many feminist artists and theorists to look at the family album. A number began to address questions about representation and how family photographs communicate. This investigation revealed that domestic photographs of children were no more innocent than any other form of photography. For, as Patricia Holland notes, 'Children, especially, have very little say over how they are pictured, and this discrepancy is the source of many of the conflicting emotions analyzed by recent writers on family photography'.[11] The feminist artist who most clearly addressed this was the photographer Jo Spence. In 1979 she held an exhibition in the Hayward Gallery entitled 'Beyond the Family Album'. This challenged the 'innocence' of family photographs and the questions she posed are linked to the questions we are asking here about the work of Tierney Gearon. Jo Spence, like Gearon, moved family photographs from their normal site (the family album) and placed them in the art gallery. However, Spence's understanding of how this shift in context (private to public) would alter the original meanings of the photographs was crucial, and issues concerning the function of a family photograph as a specific type of communication were the very subject matter of her exhibition. Gearon, in marked contrast, left her images in a semiotic 'no man's land', unable to signify in either space. The primary difference between Spence's and Gearon's work is that Spence anchored the 'floating signifiers'; family photographs of her growing up were hung in the gallery space to reproduce the narrative of the family album. Here the viewer sees traditional family-album photographs – happy, smiling children, babies, holidays and so on – and initially reads them as such. However, the accompanying text gives a different story. Spence explained how 'in my early photographs there is no record of my appalling health . . . no record of a broken marriage . . . no record of trying to please parents'.[12] Here the original meanings are put to work to create a new set of messages for the viewer in which she 'began to reverse the process of the way I had been constructed as a woman by deconstructing myself visually in an attempt to identify the process by which I had been "put" together'.[13] For the viewer this reveals clearly how a photograph, as Alan Sekula has argued, is always 'an incomplete utterance' where 'the meaning of any photographic message is necessarily context-determined'.[14] We can see therefore that what made this use of the domestic image 'artistic' was not just the shift of location and context (album to gallery) but also artistic intention, in which the artist Spence consciously made new meaning.

Spence's work had a significant impact on feminist photography and many artists continued to examine how domestic photography functions as a specific sign system. We would argue that without this history Gearon's photographs would not have been able to signify as 'art' in the first place. This debt to a critically informed feminist practice is, however, both unacknowledged and denied on a number of levels, first by Gearon, who seems to take little responsibility for understanding her actual practice as a photographer by claiming,

> I was so grateful when Charles chose my pictures, it was like a dream, but I didn't know what I was getting into. I never thought it would provoke such a reaction. It was so absurd, I couldn't believe it. How could anyone possibly be upset by those pictures? To me they were innocent, beautiful images. They were natural moments, funny moments, and real moments.[15]

Secondly, it was denied by the artistic world that shifted private family photographs from one context to another for their own gain. Charles Saatchi, as the curator, was also responsible for how Gearon's images came to be read. Saatchi was instrumental in the photographs' shift from private/domestic to public/art. He changed their scale and included them in an exhibition with the controversial and well-known works of Nan Goldin and Richard Billingham. On a more cynical level, perhaps he even anticipated how this shift of context would work upon the photographs to create controversy and to increase publicity and the value of the work. Finally, there was denial by the media, which engaged in a dispute over whether these photographs were porn or art and in the process displaced any consideration of how context alters the meanings of domestic imagery, particularly in the context of media reporting of paedophilia (for instance the recent reportage of the murder in 2002 of Jessica Chapman and Holly Wells where a family holiday snapshot of Holly in her swim suit was uncritically reproduced in the *Daily Express*).[16]

Immediate Family, by Sally Mann: a rehearsal

It is important to acknowledge that similar issues relating to 'artistic' photographs of children had already been raised in America in 1992 when Sally Mann exhibited a collection of photographs *Immediate Family* (later produced in book form). In many ways the debate over Mann's images can be seen as a rehearsal for the Gearon affair but with some significant differences. Mann's photographs of her three children were also read as pornographic; here again, the charge was that implicit in the photographs was an 'invitation' for paedophiliac pleasure. Chris Townsend noted how Mann was subject to stringent attacks over her representations of her children in America and was a target of censorship by British authorities responsible for child protection.[17] Accusations of irresponsibility were also levelled at the photographer in terms of her gender and specifically as the mother of the children represented. However, it is important to recognize that Mann had much more control than Gearon over the use of her images in terms of production, location and debate. Mann's reticence about discussing her intentions can be read not as a retreat, but as a strategy of control, a refusal to engage with the media's terms of reference.

In common with the media coverage of the Gearon photographs, a complex set of discourses interacted and, at points, contradicted each other in the press reportage of the photographs' meaning. All of this was, as with Gearon, deeply political, both in terms of feminist politics as an issue of the personal as political and specifically in the context of the US of the 1990s (the context in which *Immediate Family* was published) as an expression of the contest between the New Right and liberalism to win hegemonic control of the family. However, the debt to feminism that we have outlined, which was ignored by Gearon, is partially acknowledged in the work of Mann. This is because the cultural context in which Mann's images first circulated was directly implicated in feminist issues. The call for a 'return to family values' in the New Right's rhetoric was highly political in terms of the contest over the meaning of the image. For example, Randall Terry, an anti-choice activist, prior to leading the picketing of Barnes & Noble's bookstores and his call to the public to rip out from books 'offending' images (of which those by David Hamilton, Jack Sturges and Sally Mann were singled out), had already established a reputation for himself as an advocate and activist for blocking entrances to abortion clinics.

In Britain a parallel Thatcherite rhetoric endorsed parental responsibility in traditional terms, where the scapegoat figure of the single mother found her double in the American 'Welfare Mom'. This context meant that images such as Mann's could still be of concern to feminist cultural critics. For example, *Portfolio Magazine* (1993) ran a debate between a leading feminist cultural critic and a feminist photographic theorist on the meanings and implications of *Immediate Family*. In the early 1990s it was still possible to make the case that Mann's work deconstructed the family album (as Val Williams did in her defence of the photographer's intentions in *Portfolio Magazine*).[18] Although feminist critics were far from united in their responses to *Immediate Family* (Beatrix Campbell finding highly problematic the fetishistic adornment of the child body, which she claimed made the images pornographic) there was still space to consider the meaning of Mann's works in a feminist context. This cultural context, we propose, had disappeared by the time Gearon's images were circulated.

Public art/gendered parts

While Mann and Gearon are linked by the accusation that they produced sexualized images of their children, the two photographers are also distinguished through the discourse of art. At the most pedestrian level Mann's and Gearon's photographs differ in terms of their decision to represent their children in colour (Gearon) or black and white (Mann). Black and white photography has long been established as signifying art photography, documentary and serious investigative journalism, whereas colour is more readily associated with the snapshot, commercial images (advertisements, the commodification of the body [porn], the work of the amateur) and most ubiquitously the family album and domestic photography. In this, there is more at stake than purely aesthetic considerations: the codes of the snapshot – informality, the representation of 'life as it is', the rendition of the intimate and personal – are means of hiding ideologies behind the notion of capturing the moment. These discourses of course apply to the ideologies of the family but they also pertain to the ideologies of art, in which the snapshot is categorized as mechanical reproduction, ephemeral and commercial. We

see again how Gearon's status as an 'untrained' photographer implies no artistic intention whilst her former employment as a fashion photographer aligns her with commercial photography. Such categorization serves as a means of distinction between art photography and that of the amateur.

However, as Pierre Bourdieu pointed out, the terms on which the 'aesthetic gaze' (through supposedly purely aesthetic criteria) distinguishes itself from the 'naïve gaze' masks power relations.[19] The defenders of Mann stressed the number of prestigious awards she holds, the museums in which her works are held, her technical ability and her training as an artist. This professional and aesthetic discourse serves to impose a reading of the child nudity in the images as artistic and not pornographic. There is of course a deeper rationale behind this because if mere nudity constituted pornography then a lot of very famous photographs, sculptures and paintings could be also categorized as child pornography. The appeal to common sense in this position masks what is actually a relevant question to consider in terms of the ideologies of art and childhood, as revealed for instance in the historically located readings of the 'artistic' photographs of Lewis Carroll and the photographs of Edward Weston.[20]

What we see here is issues of gender being conflated with issues of aesthetic distinction. In this reading the trajectory Mann follows is that of Modernist aestheticization, where form, clarity and technique are emphasized. The roots of this tradition lie in the Western discourse of art in which notions of symmetry, control and order speak of man's attempt to control the unknown. As Simon Watney argued, the concept of the genius of the artist promotes the notion of 'the artist/photographer as someone somehow outside of this mass, untainted by its values, gazing onto the spectacle of the world, a privileged observer whose observations are supposedly of only "artistic" significance'.[21] In this tradition the nude signifies 'mastery': art not pornography. However, as Kobena Mercer reveals in his reading of Robert Mapplethorpe's nudes, the adoption of the generic code of the 'fine art tradition in Western art history', where 'the conventional subject of the nude is the (white) female body', produces specific effects. The effect, when the subject is the black male nude, is that the 'aesthetic, and thus erotic, objectification is totalising . . . as all reference to a social, historical or political context are ruled out of the frame'.[22]

By drawing on Mercer's critique we can consider more fully the significance of Mann's photographs having what is culturally recognized as the aesthetic-look of art. This is a 'look' recognized by both her defenders and her detractors. In terms of subject matter, Mann can be seen to be following in the tradition of Cameron. Like her predecessor she takes the domestic in order to reveal its sensuous potential, and by doing so unfixes notions of the private. This can be seen in the pictorial quality of the images, choice of camera and developing techniques. All the images in *Immediate Family* are taken with an 8 × 10 Viewfinder camera (Mann's preferred photographic medium). The result is large-format staged images. Because of the shallow depth of field of the 8 × 10 a pose has to be kept for longer than with modern cameras, the result being that the image reveals its own status as performance through the choice of medium. Other technical decisions such as cropping, shading, an attention to the details of flesh and sculptural rendition of the naked body all call attention to mediation and aesthetic intention. Shannah Ehrhart draws attention to how Mann's images repeatedly cite famous photographs – particularly those of Edward Weston, Julia Margaret Cameron and Dorothea Lange.[23] Such aesthetic referencing inevitably involves performance and

draws attention to the visual not as a reflection of the real but as representation, and this was employed by critics to either defend or 'attack' Mann's work.

For Richard B. Woodward, writing in the *New York Times*, Mann's technical decisions, combined with her photographic priorities, present obsessional – not casual or clinical – examinations that result in the objectification of children.[24] Beatrix Campbell sees the crucial problem in the effects of the condition of production which dissolves the evidence of parental bond, leaving us with representations that are at core no longer about childhood sexuality – but about adults and their desires.[25] In contrast, Chris Townsend analyses *Immediate Family* in terms of the feminine, claiming that 'Mann's work, no matter how sophisticated, no matter how technically "crafted", remains embedded in the traditions of the family album'. However, Townsend also acknowledges Mann's artistic use of the camera: 'It is not an instrument of spontaneity, carried in the pocket. The presence of the camera at the scene photographed implies duration as much as the picture itself. The "natural" flow of childhood is interrupted to fix a particular performance'.[26] So with Mann, and later Gearon, both positions (of those who claim the images are pornographic and those who claim they are art) fail to recognize that the family album has never been anything but an adult version of childhood.

However, an alternative argument can be made for a maternal way of looking that transposes both the domestic and the public (male) art discourse. One of the results of the play on aesthetic intentionality is, in Mann's case, to preclude a maternal relation. In this context it would seem, then, that the possibilities of an alternative agenda of the erotics of looking between mother and child is foreclosed by both Mann's defenders and her detractors. As Abigail Solomon-Gordeau points out, pornographic readings have been taken from photography since its invention: rather than 'attempting to empirically locate the analysis of the construction of any given image' we do better to 'attend to the erotics of looking'.[27] Reynolds Price raises the question of the effects on the viewer of knowing or remaining ignorant of the fact that the photographer is the children's own mother.[28] We suggest that it is precisely these effects that are foreclosed by the terms on which Mann's images were debated. What emerged in the media coverage of *Immediate Family* was a charge of pornography based on notions of maternal irresponsibility, but no opening up of a debate on what mother – child relations constitute as an alternative way of seeing and reading. Emily Apter's reading of *Immediate Family* in terms of 'maternal fetishism' is the exception rather than the rule.[29]

Public images/political retreat

Let us return to Roland Barthes, who claimed that one of the effects of the invention of photography was the 'explosion of the private into the public, or rather into the creation of a new social value, which is the publicity of the private'.[30] What we need to ask is 'What sort of public reading does this produce?' This question is crucial if we want to consider the terms on which Gearon's and Mann's private images become public property. Of course on a literal level both chose to make their images public by exhibiting them. But there is clearly a disjuncture here between the private context attributed by each photographer to her photographs and the public meanings

that circulated once the photographs became 'public' property. Furthermore, as we have already stated, the type of images of their children produced by both Mann and Gearon would not have been exhibited without nearly thirty years of feminism preceding them. In 1992 the only other woman's collection of photographic images that caused an equivalent public debate was Madonna's *Sex*. While media coverage of both *Immediate Family* and *Sex* focused on issues of pornography it was still possible, as we have established, to claim an alternative feminist reading of both texts. That these alternative meanings were foreclosed was in part a result of press coverage and in part the result of a historical shift away from feminism, now identified as the feminist backlash. However, it is important to recognize that both Mann and Madonna chose to emphasize the 'fantastic' and 'fictional' aspects of their art, thus aligning their representations with an individualistic rather than a political reading in terms of gender. In this, their choice can be seen in terms of a shift to what has now been termed 'lifestyle feminism'.[31]

As we have revealed here, there have been a number of cultural shifts between the appearance of Mann's photographs in 1992 and Gearon's in 2001, and these shifts have influenced how their photographs were interpreted. However, what they have in common is the way in which the media response both drew upon and played upon cultural anxieties about what constituted childhood in the late twentieth century.

In twentieth-century iconography (and now) childhood is constructed in terms of the need to protect children from what is perceived to be a hostile world. This concern is motivated by a number of cultural contexts. Nicci Gerrard argues that anxieties over childhood and what it signifies are related to shifts in the status of femininity and mothering brought about by the challenge of feminism. She explains how we have witnessed a displacement occurring between the traditional role assigned to women in a pre-feminist age (as guardians of certain values: 'purity, warmth, naturalness, gentleness, stability') which are now 'being registered on childhood'; this is 'coupled with adult anxieties about their ability to police childhood in a new age of technology'.[32] Whilst, in many respects, anxieties about new technology and control are nothing new, they have taken on specific cultural resonances since the 1990s which, as revealed in the work of Sarah Kember, are connected to childhood. Kember states that in contemporary society 'children are perceived not only to be more computer literate than most adults, but to be the perpetuators of computer crime (teenage hackers) and other excesses including addiction (gameboy junkies) . . . in relation to technology, children are seen not as being innocent but as worrying, dangerous, out of control'.[33] Contemporary culture's attitude to children is at best ambivalent, as witnessed by the splitting of the child into innocent and demon in the media representations of Jamie Bulger, aged 2, Robert Thompson and Jon Venables, aged 11, in Liverpool in 1993.[34] These shifts highlight how the power to represent and construct childhood lies not with the child but with the adult. We need to remember that the way childhood is represented always expresses the concerns of the adult world rather than the 'realities' of life as a child. It is in this context that we need to consider what made Gearon's photographs signify a 'sexuality' that was recognized by the adult world.

In her text *What Is a Child?* Patricia Holland revealed how the sexualization of young girls, far from being peripheral, is actually at the very centre of the organization of gender in our culture. She explained how 'the familiar typology of childhood includes the energetic boy and the seductive girl'.[35] Her research on popular cultural

images of boys and girls exposed an underlying binary system that reveals the impossibility of 'separating femininity from sexuality' where the 'little girl may be denied knowledge of sex, but as a feminine creature her image cannot fail to indicate sex'.[36] In this context the photograph of Gearon's son weeing, which was also deemed indecent, needs some explanation. Holland explains how images of young boys can also be read as childlike and innocent, meanings that connect them to femininity and sex in which 'young males are themselves in danger of being feminised by their relation to adult male power . . . in public imagery boys too, may be presented as soft and attractive'.[37] The display of the penis is connected to the interpretation of young boys as 'soft and attractive' and is misread as sexual.

Recently, in his *Striptease Culture*, Brian McNair has identified a significant shift in popular culture and proposes that 'from advertising to health education campaigns, sex and sexual imagery now permeate every aspect of advanced capitalist culture'.[38] This recent phenomenon McNair terms the 'sexualization' of culture. We argue that this sexualization has also come to rest on the body of the child. For instance, from the mid 1990s, girl bands such as The Spice Girls turned women's liberation into sexual liberation through a mantra that encouraged young girls to use their bodies to sexually entrap men. Their fan base began with pre-teen girls, and Germaine Greer remarked on how pre-teen magazines in Britain now offer young girls sexual advice on how to get a man, concluding that 'nobody observing the incitement of little girls to initiate sexual contact with boys can remain unconcerned'.[39]

Holland's study has revealed that the sexualization of very young girls in popular culture is not new. However, we would argue that what is troubling in these current representations is the appearance of overt rather than 'hidden' sexual meanings. This, coupled with factors like the media exposure of the widespread use of the internet by 'ordinary' men to view child porn (recently exemplified when a police family liaison officer from the Holly Wells and the Jessica Chapman murder case was charged though later cleared of downloading child pornography) is forcing society to acknowledge that a paedophilic interest, particularly in young girls, is not as uncommon as we have been led to believe. We argue that it is this current anxiety over the blurring of the boundaries between the child and the adult, innocent and temptress, deviancy and normality, that is concealed in the media response to Gearon's photographs. Mann's photographs were partially protected from such accusations through the discourse of art, which allowed for a significant if somewhat contradictory artistic debate to emerge around them, whereas Gearon's much more ordinary, garish and everyday photographs failed to create a similar artistic debate (this was exacerbated by the photographer's own claim that her images should not be read as anything more than 'snapshots' of her children). While Mann's artistic intention and control facilitated a connection to 'lifestyle' feminism (a popular ideology of the period), Gearon's were displaced from any connection to the past roots of feminism. There has been to date no feminist discussion or defence of her work in comparison to Mann's.

However, this refusal to acknowledge feminism requires some thought. In this article we have posed a number of questions in relation to the meanings that become attached to private 'family' photographs of children when they are moved into the public gallery space. While 1980s feminist artists, such as Jo Spence, made the gallery viewer question the way in which such photographs communicate, the backlash against feminism has meant that the art establishment now favours those female

photographers (such as Gearon) who choose to ignore this legacy. For feminists such supposedly 'personal' decisions have wider political implications. Gearon's refusal to connect with this history may be an indicator of a genuine lack of knowledge on her part. Nonetheless, the argument she used to defend her photographs is worrying. She is quoted in the *Guardian* as claiming, 'I don't see sex in any of those prints. If someone else reads that into them surely that's their issue'.[40] This refusal to engage with the ideological politics of the image negates years of feminist struggle aimed at revealing the constructive role of representations. It also re-circulates that 'age-old' (anti-theoretical) artistic adage in which the problem of misinterpretation lies not with the artist but with the viewer.

It was, however, the particular way in which these factors came together to work against seeing Gearon as an artist and her work as art that created the moral panic around the photographs. For even on the most basic level, taking Holland's research into account, there is no doubt that Gearon's photographs of her children carry sexualized meanings for the viewer (or that Mann's do also). Let us return to one of the two photographs selected for particular concern by the press. In this photograph Gearon's daughter wears a mask and faces the camera, her prepubescent body on display, one hand placed on her hip. Whether Gearon likes it or not, we have learnt to read these codes of pose elsewhere for, as Holland remarks, 'it needs only a slight adjustment, a tilt of the head to one side, to add a bashful self-awareness. Whatever her age, the imagery routinely bends the head of the young girl, sexualizes her image, distinguishes her from the mischievous boys who accompany her'.[41] Again we can see a difference with Mann that highlights the ordinariness of Gearon.[42] Women all unwittingly duplicate the poses that signify femininity in family albums, and of course it was the very political nature of these personal images that Jo Spence had already made so clear and that Gearon and many others now choose to ignore.

The initial question cited at the beginning of this article that was raised in the media response to Gearon's photographs – 'Are they porn or are they art?' is, as we reveal here, actually unanswerable. Art, porn, sexuality, childhood and adulthood are all cultural constructions that shift and change and as such have no fixed meaning. In this article we have not attempted to answer the question but rather to investigate what lay behind the desire to ask it. While, as we have suggested, the motivation could have been explained through recourse to artistic debates, Gearon's photographs just fail to signify in artistic terms. It is their very everydayness that disallows either an artistic displacement or feminist defence of their sexualized meanings. However, it is crucial to move beyond this 'artistic' debate to consider, as we do here, how their ordinariness signified in the gallery context because, as we have revealed, the moral panic engendered by the images in the media debate was actually connected to a more widespread concern over what now constitutes 'normative' sexual desire in a culture coming to terms with the overt rather than hidden sexualization of young children and the horrifying acknowledgement of the 'ordinariness' of paedophilic desire.

Original publication

'Photographing children: the Works of Tierney Gearon and Sally Mann', *Visual Culture in Britain* (2004)

Notes

1 'Child Porn They Call Art', *News of the World*, 11 March 2001.

2 See Patricia Holland, *What Is a Child? Popular Images of Childhood*, London: Virago, 1992. Whilst paedophilic 'looking' is by no means gender-restricted, there does seem to be a specific contemporary conflation of consuming the image of young girls and illicit sexualization. As Oliver James recently pointed out in an article that examines the increasing number of girls having 'under-age' sex, 'The creation of sexual pretensions among eight-to-10-year-olds just to sell clothes and magazines is especially worrying in a society which is supposed to be anti-paedophilia': (Oliver James, 'Sweet sixteen', *The Observer Magazine*, 7 September 2003, p. 71). Anne Higonnet makes a related point in relation to imbalance in gender power and the Romantic construction of the child, claiming that the infantilization of women reciprocally sexualizes the female child for the male gaze; see Anne Higonnet, *Pictures of Innocence: The History and Crisis of Ideal Childhood*, London: Thames and Hudson, 1998, p. 194.

3 Roland Barthes, 'The Rhetoric of the Image', in *Image, Music, Text*, London: Fontana, 1977, p. 37.

4 Ibid.

5 Ibid., p. 39.

6 Jessica Evans and Stuart Hall, 'What Is Visual Culture?', in Jessica Evans and Stuart Hall, eds., *Visual Culture: The Reader*, London, and Thousand Oaks, New Delhi: Sage Publications in association with The Open University, 1999, p. 7.

7 Jan Zita Grover, 'Dykes in Context: Some Problems in Minority Representations', in Richard Bolton, ed., *The Contest of Meaning: Critical Histories of Photography*, Cambridge, MA and London: The MIT Press, 1989, 6th edition, 1999, p. 167.

8 Rozsika Parker and Griselda Pollock, *Framing Feminism: Art and the Women's Movement 1970–1985*, London: Pandora, 1987, p. 9.

9 Lyndsay Smith, *The Politics of Focus: Women, Children and Nineteenth-Century Photography*, Manchester: Manchester University Press, 1998, p. 9.

10 Sally Mann engages in this debate in her 1988 photo series *At Twelve*, where the text anchors a reading of pubescent female sexuality, innocence and corruption through, amongst other things, histories of rape and abuse. Implicit in the series is a critique of the family and its role in protecting children.

11 Patricia Holland, '"Sweet It Is to Scan . . .": Personal Photography and Popular Photography', in Liz Wells, ed., *Photography: A Critical Introduction*, London and New York: Routledge, 1996, 2nd edition, 2000, p. 121.

12 Jo Spence, *Putting Myself in the Picture*, London: Camden Press, 1987, p. 82.

13 Ibid., p. 83.

14 Alan Sekula, 'On the Invention of Photographic Meaning', in Victor Burgin, ed., *Thinking Photography*, London: Macmillan, 1987, p. 85.

15 Tierney Gearon in *You* magazine, *Mail on Sunday*, 7 October 2001, p. 46.

16 *Daily Express*, 8 August 2002; see also the *Mail on Sunday*, 18 August 2002.

17 Chris Townsend, *Vile Bodies: Photography and the Crisis of Looking*, Munich and New York: Prestel, in association with Channel 4, 1998, p. 8.

18 Beatrix Campbell and Val Williams, 'Immediate Family', *Portfolio Magazine*, vol. 17, Summer 1993, pp. 12–16.

19 If we follow Bourdieu's analysis of how taste functions as a marker of class it becomes apparent that Gearon's colour snapshots place them in the *naïve* gaze, outside art and into the context of the everyday. (See P. Bourdieu, *Distinction: A Social Critique of the Judgement of Taste*, trans. R. Nice, London: Routledge and Kegan Paul, 1984 [1979]. Gearon's images are just too real; they do not hold the codes and conventions of the

'artistic' so they are 'placed' and what disturbs here is the place they occupy in the gallery.

20 For example, Mary Price describes Weston's series of photographs of his nude son purely in terms of painterly conventions. In this, she praises the photographer's stylized replication of classical Greek sculptural form, which she interprets as the quintessential statement of beauty and universalism. Through recourse to the discourses of art, Price removes the images from any pornographic context; see Mary Price, *The Photograph: A Strange Confined Space*, Stanford, CA: Stanford University Press, 1994, p. 80. However, it can be argued (as Lyndsay Smith does in relation to Lewis Carroll's photographs of little girls) that the use of space (Weston's placement of the child on the diagonal recessional plane, his position at the right-margin of the picture frame thus creating expansive space between the viewer and the subject, the contrast between dark backdrop and highlighted child body) serves to establish viewing relations wherein distance constructs the male gaze through objectification. See Edward Weston, *Nude*, 1922.

21 Simon Watney, 'On the Institutions of Photography', reprinted in Evans and Hall, *Visual Culture*, p. 154.

22 Kobena Mercer, 'Reading Racial Fetishism: The Photographs of Robert Mapplethorpe', reprinted in Evans and Hall, *Visual Culture*, p. 436.

23 Shannah Ehrhart, 'Sally Mann's Looking Glass War', in *Tracing Cultures: Art History, Criticism, Critical Fictions*, New York: Whitney Museum of American Art, 1994, pp. 52–56, quoted in Higonnet, *Picture of Innocence*, p. 196. Here it is worth recalling (as Higonnet does) that Mann's *Popsicle Drips* (1985), a photograph of her son's cropped naked body smeared with liquid (particularly in the area surrounding the genitalia and upper legs) self-references Weston's series of portraits of his son Neil, 1925, specifically in this instance. Where Higonnet reads the significance both in terms of the shifts of meaning from modernism to postmodernism (particularly with regard to Sherry Levine's 'appropriation') and in terms of 1990s cultural anxieties (Mann's images, pp. 133–137), we would emphasize how this contextualization allows a maternal discourse to emerge, particularly in Mann's insistence on the bodily (corporeality through viscosity) which challenges the distance of abstract aestheticism.

24 Richard B. Woodward, quoted in Campbell and Williams, 'Immediate Family', p. 14.

25 Ibid., pp. 13–14.

26 Townsend, *Vile Bodies*, p. 16.

27 Abigail Solomon-Gordeau, *Photography at the Dock: Essays on Photographic History, Institutions, and Practices*, Minneapolis: Minneapolis University Press, 2nd edition, 1995, pp. 220, 229.

28 Reynolds Price, 'Afterword: To the Family', in Sally Mann, *Immediate Family*, London: Phaidon Press Ltd, 1992.

29 Emily Apter, 'Maternal Fetishism', unpublished paper given at the University of Sussex, 1995, quoted in Townsend, *Vile Bodies*, p. 16.

30 Roland Barthes, *Camera Lucida*, London: Cape, 1981, p. 93.

31 Sally Mann claims that her family photographs (*Immediate Family*) are about the 'grand themes', about 'what it is to grow up' (in the 'Introduction' to *Immediate Family*). As a photographer, she also claims authority as a mother, arguing that *Immediate Family* records the 'ordinary things every mother has seen – a wet bed, a bloody nose, candy cigarettes' ('Introduction' to *Immediate Family*). Such claims would suggest that Mann's intention was to challenge the conventional idea of what images of the family signify. A case can be made that *Immediate Family* deconstructs the family album and, as such, follows in the lineage of feminist photographic practice but, if this is so, it is a heritage that is not acknowledged by the photographer. Whilst this is a case made by some feminist critics (though it must be recognized that feminist critics were far from united in their

responses to *Immediate Family*), without such an acknowledgement by the photographer the intentions of the producer cannot direct how the images will be read. With Gearon we seem to have lost any of the international engagement with the personal space of feminism.

32 Nicci Gerrard, 'Innocence on the Line', *The Observer Review*, 14 November 1999, pp. 1–2.

33 Sarah Kember, *Virtual Anxiety: Photography, New Technologies and Subjectivity*, Manchester and New York: Manchester University Press, 1998, p. 64.

34 Ibid., pp. 63–78.

35 Holland, *What Is a Child?*, p. 12.

36 Ibid., p. 138.

37 Ibid., p. 146.

38 Brian McNair, *Striptease Culture*, Manchester: Manchester University Press, 2002, Introduction.

39 Germaine Greer, *The Whole Woman*, London: Anchor, 2000, p. 410.

40 Matt Seaton, 'Where Is the Sex?', *Guardian*, 13 March 2001, Section '2', p. 2.

41 Holland, *What Is a Child?*, p. 136.

42 As is noted in Higonnet's study, it could be argued that Mann challenges the viewer with her 'knowing children' where children seem to 'control' their sexuality (Higonnet, *Pictures of Innocence*, pp. 194–196). In contrast, Gearon's ordinary images reveal no such discourse of knowingness. However, how this knowingness might be read in relation to the justification of paedophilic behaviour may be just as problematic.

Lucy R. Lippard

DOUBLETAKE
The diary of a relationship with an image

First take

> Sam[p]son Beaver and his Family. This lovely photograph of Stoney Indian
> Sam[p]son Beaver was taken by Mary Schäffer in 1906. She was a writer,
> naturalist, photographer and explorer who lived and worked in the Rockies
> for many years. Mary Schäffer is one of several notable women who visited
> the area early in the century and fell captive to the charm of the mountains.
>
> <div align="right">(Postcard caption)</div>

I AM SURPRISED BY THIS PHOTOGRAPH (Figure 4.1), which seems
so unlike the conventional images I've seen of Native people *taken* by white people.
It is simple enough – a man and woman are smiling warmly at the photographer,
while their little girl smirks proudly. The parents are seated comfortably on the ground,
the man with his legs crossed, the woman perhaps kneeling. The child stands between
them, closer to her father, holding a bouquet of leaves. Behind them are signs of early
spring – a tree in leaf, others still bare-branched.

I'm trying to deconstruct my deep attraction to this quiet little picture. I have
been mesmerized by these faces since the postcard was sent to me last month by a
friend, a Native Canadian painter and curator, who found it in a taxidermy and Indian
shop (he was bemused by that conjunction). Or maybe I am mesmerized by the three
cultural spaces that exist between the Beaver family and Mary Schäffer and me.

They are not vast spaces, although we are separated at the moment by a conti-
nent, national borders, and eighty-some years. They consist of the then-present space
of the subjects, the then-present but perhaps very different space of the photographer,
and the now-present space of the writer, in retrospect, as a surrogate for contempo-
rary viewers. Or perhaps there are only two spaces: the relationship between pho-
tographer and subjects then, and between me and us – and the photograph – now. I
wonder where these spaces converge. Maybe only on this page.

Good photography can *embody* what has been seen. As I scrutinize it, this photograph becomes the people photographed – not 'flat death' as Roland Barthes would have it, but flat life. This one-way (and admittedly romantic) relationship is mediated by the presence and absence of Mary Schäffer, who haunts the threshold of the encounter. I am borrowing her space, that diminished space between her and the Beaver family. She has made a frontal (though not a confrontational) image, bringing her subjects visually to the foreground, into the area of potential intimacy. The effect is heightened by the photograph's remarkable contemporaneity, the crisp presentness that delivers this image from the blatant anthropological distancing evident in most photographs of the period. The Beavers' relaxed poses and friendly, unself-conscious expressions might be those of a contemporary snapshot, except for the high quality of the print. At the same time they have been freed from the ethnographic present – the patronizing frame that freezes personal and social specifics into generalization, and is usually described from a neutral and anonymous third-person perspective. They are present in part because of their impressive personal presence. A certain synchronism is suggested, the 'extended present' or eternal present cited by, among others, N. Scott Momaday.

What would happen to the West, Johannes Fabian has mused, 'if its temporal fortress were suddenly invaded by the Time of its Other.'[1] I think I have been invaded: I feel as though I know these people. Sampson Beaver and his wife seem more familiar than the stiff-backed, blank-faced pictures of my own great grandparents, the two pairs who went West in the 1870s, among those pushing their way into others' centers from the eastern margins of the continent.[2] Two years ago, while I was despairing of ever finding the structure for a book about the cross-cultural process, I dreamed I was climbing a vast grassy hill toward a weather-beaten wooden cabin at the top; on the steps sat a row of Native people who were silently encouraging me to keep going. Although they were elderly, the expressions on their faces were those of the Beaver family in this photograph.

As I begin, I'm also looking at this triple portrait cut loose from all knowledge of the people involved – an aspect that normally would have informed much of my own position. With only the postcard caption to go on, my response is not neutral but wholly subjective. I'm aware that writing about a white woman photographing Native people is a kind of metaphor for my own position as an Anglo critic trying to write about contemporary Native North American art. I'd rather be Mary Schäffer, a courageous woman in long skirts, who seems to be trusted by this attractive couple and their sweetly sassy child. How did she find her way past the barriers of turn-of-the-century barbarism to receive these serene smiles? And I want to be Sampson Beaver and his (unnamed) wife, who are so at home where they are, who appear content, at least in this spring moment.

Second take

I showed the picture and my diary to a friend, who said she was convinced that the real relationship portrayed was between the photographer and the child, that the parents liked Schäffer because she had made friends with their little girl. Certainly the photograph implies a dialogue, an exchange, an I/eye (the photographer) and a You

Figure 4.1 Mary Schäffer, *Sampson Beaver, Leah Beaver, and baby Frances Louise*, postcard, 1906. Whyte Museum of the Canadian Rockies, whyte.org.

(her subjects, and we the viewers, if the photographer would emerge from beneath her black cloth and turn to look back at us). At the same time, the invisible (unknowable) autobiographical component, the viewpoint provided by the invisible photographer, the 'writer, naturalist, explorer, who lived and worked in the Rockies for many years,' is another factor that shaped what is visible here. I have written to the Whyte Museum of the Canadian Rockies in Banff for information about her.

The cultural abyss that had to exist in 1906 between the Beaver family and Mary Schäffer was (though burdened by political circumstances and colonial conditioning) at least intellectually unself-conscious. It may have been further diminished by what I perceive (or project) as the friendly relationship between them. The time and cultural space that usually distances me – self-consciously, but involuntarily – from historic representations of Another also is lessened here. Schäffer's photograph lacks the rhetorical exposure of authenticity. But neither are the Beavers universalized into oblivion as just folks. Their portrait is devoid of cuteness, and yet it has great charm – in the magical sense. It is only secondarily quaint, despite the inevitable but thin veneer of picturesqueness (totally aside from the subject matter: exotic Native people) imposed by the passage of historical time and the interval implied by the dress of almost ninety years ago. This is not, however, the Edward Curtis view of the Noble Savage, staring moodily into the misty past or facing the camera forced upon him or her with the wariness and hostility that has been appropriated by the cliché of 'dignity.'

It is now common knowledge that one of the hegemonic devices of colonialism (postcolonialism is hardly free of it either) has been to isolate the Other in another time, a time that also becomes another place — The Past — even when the chronological time is the present. Like racism, this is a habit hard to kick even when it is recognized. Schäffer's photograph is a microcosmic triumph for social equality as expressed through representation. The discontinuity and disjunctiveness that usually characterize cross-cultural experience are translated here into a certain harmony — or the illusion thereof. This is a sympathetic photograph, but it is not, nor could it be, empathetic. (Is it possible to honestly perceive such a scene as idyllic, within the knowledge of such a dystopian social context?) The three figures, despite their smiles and amicable, knowing expressions, remain the objects of our eyes. We are simply lucky that this open, intelligent gaze has passed into history as alternative evidence of the encounter between Native and European, of the maintenance of some human interaction in the midst or aftermath of exploitation and genocide.

The Beavers' portrait seems a classic visualization of what anthropologists call 'intersubjective time.' It commemorates a reciprocal moment (rather than a cannibalistic one) where the emphasis is on interaction and communication, a moment in which subject and object are caught in exchange within shared time rather than shouting across history from their respective peaks. The enculturated distance between photographer and photographed, between white and Native, has somehow been momentarily bridged to such an extent that the bridge extends over time to me, to us, almost a century later.

This is the kind of photograph I often have used as an example of the difference between images taken by someone from within a community and by an outsider. I would have put it in the former category. However, it was not taken by a Stoney, but by an adventurous white lady passing through the Northern Rockies, possibly on the quest for self (or loss of self) in relation to Other and Nature that has been a major theme in North American culture.

The Beaver family (I wish I knew the woman's and child's names) is clearly among friends, but the picture might still have been very different if taken by a Native insider. Of course we have no way to know what that image might have been. Photography, loaded with historical stigmas, has only recently become an accepted art form among Indian peoples; there are not many Native photographers working as artists even today. This has been explained from within the communities as a response to past abuses. Photography has been a tool by which to exploit and disarm, to document the disappearance of Indian nations, keep them in their place in the past, and make them objects of study and contemplation: 'Government surveyors, priests, tourists, and white photographers were all yearning for the "noble savage" dressed in full regalia, looking stoic and posing like Cybis statues. . . . We cannot identify with these images;' wrote Flathead Jaune Quick-to-See Smith, in her text for the first national Native American photography exhibition in 1984.[3] The press release from the American Indian Community House Gallery in New York also set out some distinctions between works of nonIndian and these Indian photographers, among them: 'These photos are not the universal images of Indians. They are not heroic, noble, stoic or romantic. What they do show is human warmth and an intimacy with their subject. . . .' This is the feeling I get from the Beavers' portrait. Am I just kidding myself or overidentifying with Mary Schäffer?

Another explanation for the avoidance of photography raises old taboos – the photos-steal-your-spirit-syndrome, which is not, in fact, so far off in this situation. The more we know about representation, the more obvious it becomes that photography *is* often a spirit snatcher. I *own* a postcard that permits me to have the Beaver family *living* in my house. The Oglala warrior, Crazy Horse, never allowed his photograph to be taken, and it was said of those leaders who did that 'they let their spirits be captured in a box' and lost the impetus to resistance. Contemporary American Indian Movement leader Russell Means has described the introduction of writing into oral traditions as a destructive 'abstraction over the spoken relationship of a people.'[4] The camera was another weapon in the wars of domination. As Dennis Grady observes,

> how fitting it must have seemed to the victims of that process – the natives of North America, whose idea of 'vision' is as spiritual as it is physical – when the white man produced from his baggage a box that had the power to transcribe the world onto a flat paper plane. Here was a machine that could make of this landscape a surface; of this territory, a map; of this man, this woman, this living child, a framed, hand-held, negotiable object to be looked at, traded, possessed; the perfect tool for the work of the 'wasi'chu,' the greedy one who takes the fat.[5]

Our communal memory of Native people on this continent has been projected through the above-mentioned stoic (numb is a better term), wary, pained, resigned, belligerent, and occasionally pathetic faces shot by nineteenth- and early-twentieth-century photographers like Edward Curtis, Edward Vroman, and Roland W. Reed – all men. Looking through a group of portraits of Indians from that period, I found one (*Indian with Feather Bonnet*, c. 1898) in which the expression was less grim, more eye-to-eye – the photographer was Gertrude Käsebier. The photographs by Kate Cory, a 'midwestern spinster' who came to Arizona at age 44, taken in the Hopi village where she lived from 1905 to 1912, also diverge from the general pattern, as do some of Laura Gilpin's works.[6] All of this suggests an empathetic relationship between race and gender lurking in this subject, though I can't explore it here.

Of course Mary Schäffer, although a woman and thereby also, though divergently, disenfranchised, was at least indirectly allied with the oppressors. She may have been an innocent vehicle of her culture and her times. She may have been a rebel and independent of some of its crueler manifestations. Although it is more likely that she was oblivious to anthropological scholarship, she might have known about the then-new comparative method, which permitted the *equal* treatment of human culture in all times and in all places (but failed to overturn the edifice of Otherness built by previous disciplines). She may have been an enthusiastic perpetrator of expansionism.

Perhaps this photograph was already tinged with propaganda even at the time it was taken. Perhaps Mary Schäffer herself had an axe to grind. She may have been concerned to show her audience (and who were *they*?) that the only good Indian was not a dead Indian. Perhaps this portrait is the kind of advocacy image we find in the production of Leftist photographers working in Nicaragua. The knowledgeable, sympathetic tourist is not always immune to cultural imperialism. I wonder if Mary Schäffer, like so many progressive photographers working in poorer neighborhoods and countries, gave her subjects a print of this photograph. Was it their first, their only image of

themselves? Or the first that had not disappeared with the photographer? Is a curling copy of this picture given a place of honor in some family photo album or on the wall of some descendant's house?

I'm overpersonalizing the depicted encounter. To offset my emotional attraction to this image, let me imagine that Schäffer was a flag-waving imperialist and try to read this image — or my responses to this image — in a mirror, as though I had taken an immediate dislike to it. Can I avoid that warm gaze and see in these three figures an illustration of all the colonial perfidy that provides its historical backdrop? Do Sampson Beaver and his family look helpless and victimized? They are handsome, healthy people, perhaps chosen to demonstrate that Indians were being treated well. They are seated on the ground, perhaps placed there because the photographer was influenced by stereotypical representations of the 'primitive's' closeness to the earth, to nature. The woman is placed at a small distance from her husband and child, like a servant. They are smiling; perhaps Schäffer has offered the child a treat, or the adults some favor. Nevertheless, it is hard to see these smiles as solely money-bought.

A virtual class system exists among the common representations of an Indian family from this period: the lost, miserable, huddled group outside a hut; the businesslike document of a neutrally ordinary family next to a tepee; or the proud, noble holdouts in a grand landscape, highlighted by giant trees or dramatic mesas. For all the separations inherent in such images, there is no such thing as objectivity or neutrality in portrait photography. Personal interaction of *some* kind is necessary to create the context within the larger frame of historical events. The Schäffer photo too is posed. And the pose is an imposition since Native people had no traditional way of sitting for a portrait or a photograph; self-representation in that sense was not part of the culture. But at least the Beaver family is not sitting bolt upright in wooden chairs; Sampson Beaver is not standing patriarchally with his hand on his wife's shoulder while the child is properly subdued below. Man and wife are comfortable and equal as they smile at the black box confronting them, and the little girl's expression is familiar to anyone who has spent time with little girls.

Today I received some scraps of information about the Stoney Indians (an anglicization of the word Assine, meaning stone), who were Assiniboine, offshoots of the Sioux. They called themselves Nakodah, and reached the foothills of the Rockies in the eighteenth century, fleeing smallpox epidemics. With the arrival of settlers and the founding of Banff, the Stoneys were forced into a life of relatively peaceful interaction with townspeople. In the late-nineteenth century, Banff was already a flourishing tourist town, boasting a spa and the annual 'Indian Days' powwow, begun in 1889. The Whyte Museum there has a massive archive of photographs of the Native people of the Rockies (including this one and one of Ginger Rogers, on vacation, sketching Chief Jacob Twoyoungman in a Plains headdress). Eventually forced to live off of tourism, the Stoneys were exploited but not embattled. And Mary Schäffer, for all her credentials, was a tourist herself.

Indians were the photogenic turn-of-the-century counterparts of today's lookouts — roadside scenic vistas: ready-made views; nature viewed from a static culture. The role of photography in tourism (or as tourism) started early. What looks to us today like a serious documentary photograph may just be the equivalent of *National Geographic* voyeurism, or a color print of a New York City homeless person taken for the folks at home. The egalitarianism (intentional or not) of Schäffer's photograph may

have irritated her audience, at least those Back East, where exaggeration and idealiza-
tion of the *savage* reigned unchecked. Even today, when Indians wear rubber boots
or sneakers at ceremonial dances, or an Apache puberty ritual includes six-packs of
soda among the offerings, tourists and purists tend to be offended. Such anachronisms
destroy the time-honored distance between Them and Us, the illusion that They live
in different times than We do. Anachronisms also may be somewhat threatening to
Our peace of mind, recalling how They got there, were put there, in a space that is
separated from Us by the barbed wire of what has been called 'absentee colonialism?'

But how did *we* get There – off-center – to the places where we are face to face
with those who do not apparently resemble us? Johannes Fabian distinguishes between
historic religious travel '*to* the centers of religion or *to* the souls to be saved' and
today's secular travel '*from* the centers of learning and power to places where man was
to find nothing but himself.'[7] The Sioux visionary, Black Elk, like the Irish, says that
anywhere can be the center of the world. We the conquerors have not thought so. We
travel to the margins to fulfill some part of us that is marginal to our own culture but
is becoming increasingly, embarrassingly, central.

Once at the margins, we are not welcomed with open arms. At dances we gawk
or smile shyly at the Indian people hurrying by, and they ignore us, or are politely aloof
when spoken to, so long as we behave ourselves. They don't need us, but we, some-
how, paradoxically, need them. We need to take images away from these encounters,
to take Them with Us. According to Dean MacCannell, tourists are trying to 'discover
or reconstruct a cultural heritage or a social identity. . . . Sightseeing is a ritual per-
formed to the differentiations of society.'[8] The same might be said of photography
itself. As the ultimate invasion of social, religious, and individual privacy, it is still
banned by many pueblos and reservations.

Last take

The books I'd ordered from Banff have finally arrived. I dove into them and of course
had to revise some of my notions.

The Beaver family photograph was taken in 1907, not 1906; not in early spring,
but in late September, as Schäffer was completing a four-month expedition to the
sources of the Saskatchewan River. Having just crossed two turbulent rivers, she and
her companions reached the 'Golden Kootenai Plains' (the Katoonda or Windy Plains),
and weaving in and out of yellowing poplars, they:

> spied two tepees nestled deep among the trees. . . . I have seen not one but
> many of their camps and seldom or never have they failed to be artistic
> in their setting, and this one was no exception. Knowing they must be
> Silas Abraham's and Sampson Beaver's families, acquaintances of a year's
> standing, I could not resist a hurried call. The children spied us first, and
> tumbling head over heels, ran to cover like rabbits . . . above the din and
> excitement I called, 'Frances Louise!' She had been my little favorite when
> last we were among the Indians, accepting my advances with a sweet baby
> womanliness quite unlike the other children, for which I had rewarded her
> by presenting her with a doll I had constructed . . . love blinded the little

mother's eyes to any imperfections, and the gift gave me a spot of my own in the memory of the forest baby. . . . In an instant her little face appeared at the tepee-flap, just as solemn, just as sweet, and just as dirty as ever.[9]

It was this group of Stoneys, members of the Wesley Band, who the previous year had given Schäffer her Indian name – Yahe-Weha, Mountain Woman. Banned from hunting in the National Parks, they were still able to hunt, trap, and live beyond their boundaries. In 1907 she remained with them for four days. 'When I hear those "who know" speak of the sullen, stupid Indian,' she wrote,

> I wish they could have been on hand the afternoon the white squaws visited the red ones with their cameras. There were no men to disturb the peace, the women quickly caught our ideas, entered the spirit of the game, and with musical laughter and little giggles, allowed themselves to be hauled about and pushed and posed in a fashion to turn an artist green with envy. . . . Yahe-Weha might photograph to her heart's content. She had promised pictures the year before, she had kept the promise, and she might have as many photographs now as she wanted.[10]

Sampson Beaver's wife, Leah, was no doubt among the women that afternoon. He was thirty years old at the time, and she looks around the same age. In the language of the tourist, Schäffer described him crouching to light his pipe at a campfire:

> his swarthy face lighted up by the bright glow, his brass earrings and nail-studded belt catching the glare, with long black plaits of glossy hair and his blanket breeches . . .[11]

It was Sampson Beaver who then gave Schäffer one of the great gifts of her life – a map of how to reach the legendary Maligne Lake, which she had hitherto sought unsuccessfully – thereby repaying his daughter's friend many times over. He drew it from memory of a trip sixteen years before – in symbols, 'mountains, streams, and passes all included.' The next year Schäffer, her friend Mollie Adams, 'Chief' Warren, her young guide whom she later married, and 'K' Unwin followed the accurate map and became the first white people to document the shores of Chaba Imne (Beaver Lake), ungratefully renamed Maligne for the dangerous river it feeds. In 1911 she returned to survey the lake and its environs, which lie in what is now Jasper National Park.

Mary Sharples Schäffer Warren (1861–1939) was not a Canadian but a Philadelphian, from a wealthy Quaker family. Her father was a businessman and gentleman farmer as well as an avid mineralogist. She became an amateur naturalist as a child and studied botany as a painter. In 1894 she married Dr. Charles Schäffer, a respected, and much older, doctor whose passion was botany and with whom she worked as an illustrator and photographer until his death in 1903. After completing and publishing his *Alpine Flora of the Canadian Rocky Mountains*, she conquered her fear of horses, bears, and the wilderness, and began her lengthy exploring expeditions, going on horseback with pack train deep into the then-mostly uncharted wilderness for months at a time.

Schäffer's interest in Indians and the West had been awakened when as a small child she overheard her Cousin Jim, an army officer, telling her parents about the destruction of an Indian village in which women and children were massacred; afterwards, he had found a live baby sheltered by the mother's dead body. This story made a profound impression on Mary, and she became obsessed with Indians. In her mid-teens she took her first trip west, met Native people for the first time, and became an inveterate traveler. The Canadian Rockies were her husband's botanical turf, and for the rest of her life Schäffer spent summers on the trails there, photographing, writing, and exploring. She finally moved to Banff and died there.

When Schäffer and Mollie Adams decided to take their plunge into the wilderness, it was unprecedented, and improper, for women to encroach on this steadfastly male territory. However, as Schäffer recalled,

> there are times when the horizon seems restricted, and we seemed to have reached that horizon, and the limit of all endurance – to sit with folded hands and listen calmly to the stories of the hills we so longed to see, the hills which had lured and beckoned us for years before this long list of men had ever set foot in the country. Our cups splashed over. We looked into each other's eyes and said: 'Why not? We can starve as well as they; the muskeg will be no softer for us than for them . . . the waters no deeper to swim, nor the bath colder if we fall in,' – so – we planned a trip.[12]

These and many other hardships and exhilarations they did endure, loving almost every minute of it, and documenting their experiences with their (often ineptly hand-colored) photographs of giant peaks, vast rivers, glaciers, and fields of wildflowers. When they were returning from the 1907 expedition, they passed a stranger on the trail near Lake Louise who later wrote:

> As we drove along the narrow hill road a piebald pack-pony with a china-blue eye came round a bend, followed by two women, blackhaired, bare-headed, wearing beadwork squaw jackets and riding straddle. A string of pack-ponies trotted through the pines behind them.
> 'Indians on the move?' said I. 'How characteristic!'
> As the women jolted by, one of them very slightly turned her eyes and they were, past any doubt, the comprehending equal eyes of the civilized white woman which moved in that berry-brown face. . . .
> The same evening, in a hotel of all the luxuries, a slight woman in a very pretty evening frock was turning over photographs, and the eyes beneath the strictly arranged hair were the eyes of the woman in the beadwork who had quirted the piebald pack-pony past our buggy.[13]

The author of this photographic colonial encounter was, ironically, Rudyard Kipling.

As Claude Lévi-Strauss has pointed out, the notion of travel is thoroughly corrupted by power. Mary Schäffer, for all her love of the wilderness, which she constantly called her 'playground,' was not free from the sense of power that came with being a prosperous modern person at play in the fields of the conquered. At the same

time, she also expressed a very modern sense of melancholy and loss as she watched the railroad, which she called a 'python,' and ensuing civilization inching its way into her beloved landscape. More than her photographs, her journals betray a colonial lens. She is condescendingly fond but not very respectful of the 'savages,' bemoaning their unpleasantly crude and hard traditional life. In 1911 for instance, her party passed 'a Cree village where, when we tried to photograph the untidy spot, the inhabitants scuttled like rabbits to their holes.' In 1907 on the same golden Kootenai Plains where she took the Beavers' portrait, their camp was visited by 'old Paul Beaver' (presumably a relative of her darling Frances Louise). He eyed their simmering supper 'greedily,' but

> our provisions were reaching that point where it was dangerous to invite any guests, especially Indians, to a meal, so we downed all hospitable inclinations and without a qualm watched him ride away on his handsome buckskin just as darkness was falling.[14]

Despite years of critical analysis, seeing is still believing to some extent – as those who control the dominant culture (and those who ban it from Native contexts) know all too well. In works like this one, some of the barriers are down, or invisible, and we have the illusion of seeing for ourselves, the way we never *would* see for ourselves, which is what communication is about.

For all its socially enforced static quality, and for all I've read into it, Mary Schäffer's photograph of Sampson, Leah, and Frances Louise Beaver is merely the image of an ephemeral moment. I am first and foremost touched by its peace and freshness. I can feel the ground and grass warm and damp beneath the people sitting here in an Indian Summer, after disaster had struck but before almost all was lost. As viewers of this image eighty-four years later, on the verge of the quincentennial of Columbus's accidental invasion of the Americas, we can only relate our responses in terms of what we know. And as a nation we don't know enough.

Original publication

'Doubletake: The Diary of a Relationship with an Image', *Poetics of Space: A Critical Photographic Anthology* (1996) [Originally published 1992]

Notes

1 Johannes Fabian, *Time and the Other: How Anthropology Makes Its Object* (New York: Columbia University Press, 1983), 35.
2 Frank Isham – teacher, businessman, dairy farmer, mining engineer, ranch foreman, and my great grandfather – built a little wooden schoolhouse in Dakota Territory. I have a photograph of it – bleak, unpeopled, rising from the plains as a rude reminder of all the unholy teaching to come. Frank and Mary Rowland Isham had their sod house burned out from under them by a 'half breed' who didn't like the way they treated him.
3 Jaune Quick-To-See Smith, (Introduction), *Contemporary Native American Photography*, traveling exhibition by the U.S. Department of the Interior and Indian Arts and Crafts

Board, 1984. Originated at the Southern Plains Indian Museum and Crafts Center, January 29 to March 23, 1984.

4 Russell Means, 'The Same Old Song,' in Ward Churchill, ed., *Marxism and Native Americans* (Boston: South End Press, 1983), 19.

5 Dennis Grady, 'The Devolutionary Image: Toward a Photography of Liberation,' *San Francisco Camerawork*, 16 (Summer and Fall 1989), 28.

6 In 1989, Lilly and Grant Benally, members of the Navajo Nation, won a suit against the Amon Carter Museum in Texas for the frequent public (and publicity) use of a Laura Gilpin photograph called *Navaho Madonna*, taken in 1932. The court recognized that public use of a personal photograph could be offensive and the Navajos believe that 'bad effects' could result from being photographed. *The New Mexican*, June 10, 1989.

7 Fabian, *Time and the Other*, 6.

8 Dean MacCannell, *The Tourist: A New Theory of the Leisure Class* (New York: Schocken Books, 1989), 13.

9 E.J. Hart, ed., *Hunter of Peace: Mary T.S. Schäffer's Old Indian Trials of the Canadian Rockies* (Banff: Whyte Museum, 1980), 70.

10 Ibid., 71.

11 Ibid., 72.

12 Ibid., 17.

13 Ibid., 2.

14 Ibid., 69.

Catherine Lutz and Jane Collins

THE PHOTOGRAPH AS AN INTERSECTION OF GAZES

The example of *National Geographic*

ALL PHOTOGRAPHS TELL STORIES about looking. As part of a larger project to examine the *National Geographic* magazine's photographs as cultural artifacts from a changing twentieth century American scene, we have been struck by the variety of looks and looking relations that swirl in and around them.[1] These looks – whether from the photographer, the reader, or the person photographed – are ambiguous, charged with feeling and power, and are central to the stories (sometimes several and conflicting) that the photo can be said to tell. By examining the 'lines of sight' evident in the *Geographic* photograph of the 'non-Westerner,' we can see that it is not simply a captured view of the other, but rather a dynamic site at which many gazes or viewpoints intersect. This intersection creates a complex and multi-dimensional object; it allows viewers of the photo to negotiate a number of different identities both for themselves and for those pictured; and it is one route by which the photograph threatens to break frame and reveal its social context. Some of the issues raised in this chapter are particular to this specific genre of photograph while many others illuminate photographic interpretation more generally.

We aim here to explore the significance of 'gaze' for intercultural relations in the photograph and to present a typology of seven kinds of gaze that can be found in the photograph and its social context. These include (1) the photographer's gaze (the actual look through the viewfinder), (2) the institutional, magazine gaze (evident in cropping picture choice, captioning, etc.), (3) the readers' gaze, (4) the non-Western subjects' gaze, (5) the explicit looking done by Westerners who are often framed together with locals in the picture, (6) the gaze returned or refracted by the mirrors or cameras that are shown, in a surprising number of photographs, in local hands, and (7) our own, academic gaze.

 [. . .]

A multitude of gazes

Many gazes can be found in any photograph in the *National Geographic*. This is true whether the picture shows a landscape devoid of people; a single person looking straight at the camera; a large group of people, each looking in a different direction but none at the camera; or a person in the distance whose eyes are tiny or out of focus. In other words, the gaze is not simply the look given by or to a photographed subject. It includes seven types of gaze.[2]

The photographer's gaze

This gaze, represented by the camera's eye, leaves its clear mark on the structure and content of the photograph. Independently or constrained by others, the photographer takes a position on a rooftop overlooking Khartoum or inside a Ulithian menstrual hut or in front of a funeral parade in Vietnam. Photo subject matter, composition, vantage point (angle or point of view), sharpness and depth of focus, color balance, framing, and other elements of style are the result of the viewing choices made by the photographer or by the invitations or exclusions of those being photographed (Geary 1988).

Sontag argues that photographers are usually profoundly alienated from the people they photograph and may 'feel compelled to put the camera between themselves and whatever is remarkable that they encounter' (1977: 10). *Geographic* photographers, despite an often expressed and fundamental sympathy with the third-world people they meet, confront them across the distances of class, race, and sometimes gender. Whether from a fear of these differences or the more primordial (per Lacan) insecurity of the gaze itself, the photographer can often make the choice to insert technique between self and his or her subjects, as can the social scientist (Devereux 1967).

Under most circumstances, the photographer's gaze and the viewer's gaze overlap. The photographer may treat the camera as simply a conduit for the reader's look, the 'searchlight' (Metz 1985) of his/her vision. Though these two looks can be disentangled, the technology and conventions of photography force the reader to follow that eye and see the world from its position.[3] The implications of this fact can be illustrated with a photo that shows a Venezuelan miner selling the diamonds he has just prospected to a middleman (August 1976; see Figure 5.1). To take his picture, the photographer has stood inside the broker's place of business, shooting out over his back and shoulder to capture the face and hands of the miner as he exchanges his diamonds for cash. The viewer is strongly encouraged to share the photographer's interest in the miner, rather than the broker (whose absent gaze may be more available for substitution with the viewer's than is the miner's), and to in fact identify with the broker from whose relative position the shot has been taken and received. The broker, like the North American reader, stands outside the frontier mining world. Alternative readings of this photograph are, of course, possible; the visibility of the miner's gaze may make identification with him and his precarious position more likely. Ultimately what is important here is the question of how a diverse set of readers respond to such points-of-view in a photograph.

Figure 5.1 Robert Madden [Original in colour]. Robert Madden/National Geographic Stock.

The magazine's gaze

This is the whole institutional process by which some portion of the photographer's gaze is chosen for use and emphasis (Lutz and Collins 1993: Chapters 2 and 3). It includes (1) the editor's decision to commission articles on particular locations or issues; (2) the editor's choice of a small number of pictures from the voluminous number (11,000 on an average assignment) the photographer has taken; and, (3) the editor's and layout designer's decisions about cropping the picture, arranging it with other photos on the page to bring out the desired meanings, reproducing it in a certain size format to emphasize or downplay its importance, or even altering the picture. The reader, of course, cannot determine whether decisions relating to the last two choices are made by editor or photographer. The magazine's gaze is more evident and accessible in (4) the caption writer's verbal fixing of a vantage on the picture's meaning. This gaze is also multiple and sometimes controversial, given the diverse perspectives and politics of those who work for the *Geographic*.

The magazine reader's gazes

As Barthes has pointed out, the 'photograph is not only perceived, received, it is *read*, connected more or less consciously by the public that consumes it to a traditional stock of signs' (1977: 19). Independently of what the photographer or the caption writer may intend as the message(s) of the photo, the reader can imagine something else or in addition. The reader, in other words, is 'invited to dream in the ideological space of the photograph' (Tagg 1988: 183). Certain elements of composition or content may make it more likely that the reader will resist the photographic gaze and its ideological messages or potentials. These include whatever indicates that a camera (rather than the reader's eye alone) has been at work – jarring, unnatural colors, off center angles, and obvious photo retouching.

What *National Geographic* subscribers see is not simply what they each get (the physical object, the photograph), but what they imagine the world is about before the magazine arrives, what imagining the picture provokes, and what they remember afterwards of the story they make the picture tell or allow it to tell. The reader's gaze, then, has a history and a future, and it is structured by the mental work of inference and imagination, provoked by the picture's inherent ambiguity (Is that woman smiling or smirking? What are those people in the background doing?) and its tunnel vision (What is going on outside the picture frame? What is it, outside the picture, that she looks at?). Beyond that, the photo permits fantasy ('Those two are in love, in love like I am with Stuart, but they're bored there on that bench, bored like I have been in love.' or 'That child. How beautiful. She should be mine to hold and feed.'). Such differences between the reader's gaze and that of the magazine led us to investigate the former directly by asking a number of people to interpret the pictures (Lutz and Collins 1993).

The reader's gaze is structured by a large number of cultural elements or models, many more than those used to reason about racial or cultural difference. Cultural models that we have learned help us interpret gestures such as the thrown back shoulders of an Argentinean cowboy as indicative of confidence, strength, and bravery. Models

of gender lead to a reading of a picture of a mother with a child as a natural scenario, and of the pictured relationship as one of loving, relaxed nurturance; alternatively, the scene might have been read as underlaid with tensions and emotional distance, an interpretation that might be more common in societies with high infant mortality. There is, however, not one reader's gaze; each individual looks with his or her own personal, cultural, and political background or set of interests. It has been possible for people to speak of 'the (singular) reader' only so long as 'the text' is treated as an entity with a single determinate meaning that is simply consumed (Radway 1984) and only so long as the agency, enculturated nature, and diversity of experience of readers are denied.

The gaze of the *National Geographic* reader is also structured by photography's technological form, including a central paradox. On the one hand, photographs allow participation in the non-Western scene through vicarious viewing. On the other, they may also alienate the reader by way of the fact that they create or require a passive viewer and that they frame out much of what an actual viewer of the scene would see, smell, and hear, thereby atomizing and impoverishing experience (Sontag 1977). From another perspective, the photograph has been said (Metz 1985) to necessarily distance the viewer by changing the person photographed into an object – we know our gaze falls on a two-dimensional object – and promoting fantasy. Still, the presumed consent of the person to be photographed can give the viewer the illusion of having some relationship with him or her.

Finally, this gaze is also structured by the context of reading. Where and how does the reader go through the magazine – quickly or carefully, alone or with a child? In a less literal sense, the context of reading includes cultural notions about the magazine itself – as high middlebrow, scientific, and pleasurable. The *National Geographic* sits near the top of a socially constructed hierarchy of popular magazine types (e.g., highbrow, lowbrow) that runs parallel to a hierarchy of taste in cultural products more generally (Levine 1988). Readers' views of what the photograph says about the subject must have something to do with the elevated class position they can assume their reading of *National Geographic* indicates. If I the reader am educated and highbrow in contrast to the reader of *People* magazine or the local newspaper, my gaze may take the seriousness and appreciative stance a high-class cultural product requires.

The non-Western subject's gaze

There is perhaps no more significant gaze in the photograph than that of its subject. How and where the photographed subject looks shapes the differences in the message a photograph can give about intercultural relations. The gaze of the non-Westerner found in *National Geographic* can be classified into at least four types; she or he can confront the camera, look at something or someone within the picture frame, look off into the distance, or not look at anything at all.

The gaze confronting the camera and reader comprises nearly a quarter of the photos that have at least some non-Western locals in them.[4] What does the look into the camera's eye suggest to readers about the photographic subject? A number of possibilities suggest themselves.

The look into the camera must at least suggest acknowledgement of photographer and reader. Film theorists have disagreed about what this look does, some arguing that it short circuits the voyeurism identified as an important component of most photography: there can be no peeping if the subject meets our gaze. The gaze can be confrontational: 'I see you looking at me, so you cannot steal that look.' Others, however, have argued that this look, while acknowledging the viewer, simply implies more open voyeurism: the return gaze does not contest the right of the viewer to look and may in fact be read as the subject's assent to being watched (Metz 1985: 800–801).

This disagreement hinges on ignoring how the look is returned and on discounting the effects of context inside the frame and in the reader's historically and culturally variable interpretive work. Facial expression is obviously crucial. The local person looks back with a number of different faces, including friendly smiling, hostile glaring, a vacant or indifferent glance, curiosity, or an ambiguous look. Some of these looks, from various ethnic others, are unsettling, disorganizing, and perhaps avoided. In *National Geographic*'s photos, the return look is, however, usually not a confrontational or challenging one. The smile plays an important role in muting the potentially disruptive, confrontational role of this return gaze. If the Other looks back at the camera and smiles, the combination can be read by viewers as the subject's assent to being surveyed. In 38 per cent of the pictures of locals where facial expressions are visible (N = 436) someone is smiling (although not all who smile are looking into the camera), while a higher 55 per cent of all pictures in which someone looks back at the camera include one or more smiling figures.

The camera gaze can also establish at least the illusion of intimacy and communication. To the extent that *National Geographic* presents itself as bringing together the corners of the world, the portrait and camera gaze are important routes to those ends. The non-Westerner is not distanced, but characterized as approachable; the reader can imagine someone is about to speak to him or her. The photographers commonly view the frontal shot as a device for cutting across language barriers and allowing for intercultural communication. The portrait is, in the words of one early *Geographic* photographer 'a collaboration between subject and photographer' (National Geographic Society 1981: 22). In published form, of course, the photographed person is still 'subjected to an unreturnable gaze' (Tagg 1988: 64), in no position to speak.

The magazine's goal of creating intimacy between subject and reader contradicts to some extent its official goal of presenting an unmanipulated truthful slice of life from another country. Virtually all the photographers and picture editors we spoke with at the *National Geographic* saw the return gaze as problematic and believed that such pictures ought to be used sparingly because they are clearly not candid, and potentially influenced by the photographer. They might also be 'almost faking intimacy' one editor said. Another mentioned that the use of direct gaze is also a question of styles suggesting more commercial and less 'gritty' values. The photographer can achieve both the goals of intimacy and invisibility by taking portraits which are not directly frontal, but in which the gaze angles off to the side of the camera.

To face the camera is to permit close examination of the photographed subject, including scrutiny of the face and eyes which are in common sense parlance the seat of soul, personality or character. Frontality is a central technique of a 'documentary

rhetoric' in photography (Tagg 1988: 189); it sets the stage for either critique or celebration, but in either case evaluation of the other as a person or type. Editors at the magazine talked about their search for the 'compelling face' in selecting photos for the magazine.

Racial, age, and gender differences appear in how often and how exactly the gaze is returned and lend substance to each of these perspectives on the camera gaze. To a statistically significant degree, women look into the camera more than men, children, and older people look into the camera more often than other adults, those who appear poor more than those who appear wealthy, those whose skin is very dark more than those who are bronze, those who are bronze more than those whose skin is white, those in native dress more than those in Western garb, those without any tools more than those using machinery.[5] Those who are culturally defined by the West as weak – women, children, people of color, the poor, the tribal rather than the modern, those without technology – are more likely to face the camera, the more powerful to be represented looking elsewhere. There is also an intriguing (but not statistically significant) trend toward higher rates of looking at the camera to occur in pictures taken in countries that were perceived as friendly toward the United States.[6]

To look out at the viewer, then, would appear to represent not a confrontation between the West and the rest, but the accessibility of the latter. This interpretation is supported by the fact that historically the frontal portrait has been associated with the 'rougher' classes, [. . .] Tagg (1988), in a social history of photography, argues that this earlier class-based styling was passed on from portraiture to the emerging use of photography for the documentation and surveillance of the criminal and the insane. Camera gaze is often associated with full-frontal posture in the *National Geographic;* as such, it is also part of frontality's work as a 'code of social inferiority' (Tagg 1988: 37). The 'civilized' classes, at least since the nineteenth century, have traditionally been depicted in Western art turning away from the camera and so making themselves less available.[7] The higher status person may thus be characterized as too absorbed in weighty matters to attend to the photographer's agenda. Facing the camera, in Tagg's terms, 'signified the bluntness and "naturalness" of a culturally unsophisticated class [and had a history which predated photography]' (1988: 36).

These class coded styles of approach and gaze before the camera in gestures have continued to have force and utility in renderings of the ethnic other. The twist here is that the more civilized quality imparted to the lighter skinned male in Western dress and to adult exotics who turn away from the camera is only a relative quality. Full civilization still belongs, ideologically, to the Euro-American.

Whether these categories of people have actually looked at the camera more readily and openly is another matter. If the gaze toward the camera reflected only a lack of familiarity with it, then one would expect rural people to look at the camera more than urban people. This is not the case. One might also expect some change over time, as cameras became more common everywhere, but there is no difference in rate of gaze when the period from 1950 to 1970 is compared with the later period. The heavy editorial hand at the *Geographic* argues that what is at work is a set of unarticulated perceptions about the kinds of non-Westerners who make comfortable and interesting subjects for the magazine. *National Geographic* editors select from a vast array of

possible pictures on the basis of some notion about what the social/power relations are between the reader and the particular ethnic subject being photographed. These aesthetic choices are outside explicit politics but encode politics nonetheless. A 'good picture' is a picture which makes sense in terms of prevailing ideas about the Other, including ideas about both accessibility and difference.

In a second form of gaze by the photographed subject, the non-Westerner looks at someone or something evident within the frame. The ideas readers get about who the Other is are often read off from this gaze which is taken as an index of interest, attention, or goals. The Venezuelan prospector who looks at the diamonds as they are being weighed by the buyer is interested in selling, in making money, rather than in the Western viewer or other compatriots. The caption supplies details: 'the hard-won money usually flies fast in gambling and merry-making at primitive diamond camps where riches-to-rags tales abound.' And in a 1966 picture showing Ferdinand and Imelda Marcos happily staring at their children, the audience is thereby assured of their family-oriented character.

A potential point of interest in many photographs is a Western traveler. In 10 per cent of these latter pictures at least one local looks into the camera. Yet in 22 per cent of the pictures in which only locals appear, someone looks into the camera. To a statistically significant degree, then, the Westerner in the frame draws a look away from those Westerners beyond the camera, suggesting both that these two kinds of Westerners might stand in for each other, as well as indexing the interest they are believed to have for locals.

Third, the Other's gaze can run off into the distance beyond the frame. This behavior can suggest radically different things about the character of the subject. It might portray either a dreamy, vacant, absent-minded person or a forward-looking, future-oriented, and determined one. Compare the October 1980 photo of three Argentinean gauchos as they dress for a rodeo with the November 1980 shot of a group of six Australian Aborigines as they stand and sit in a road to block a government mining survey team. Two of the gauchos, looking out the window at a point in the far distance, come across as thoughtful, pensive, and sharply focused on the heroic tasks in front of them. The Aboriginal group includes seven gazes, each heading off in a different direction and only one clearly focused on something within the frame, thus giving the group a disconnected and unfocused look. It becomes harder to imagine this group of seven engaged in coordinated or successful action; that coordination would require mutual planning and, as a corollary, at least some mutual gaze during planning discussions. Character connotations aside, the out-of-frame look may also have implications for viewer identification with the subject, in some sense connecting with the reader outside the frame (Metz 1985: 795).

Finally, in many pictures, no gaze at all is visible, either because the individuals in them are tiny figures lost in a landscape or in a sea of others, or because the scene is dark or the person's face is covered by a mask or veil. We might read this kind of picture (14 per cent of the whole sample) as being about the landscape or activity rather than the people or as communicating a sense of nameless others or group members rather than individuals. While these pictures do not increase in number over the period, there has been a spate of recent covers in which the face or eyes of a non-Western person photographed are partly hidden (November 1979, February 1983, October 1985, August 1987, October 1987, November 1987, July 1988, February 1991, December

1991). Stylistically, *National Geographic* photographers may now have license to experiment with elements of the classical portrait with its full-face view, but the absence of any such shots before 1979 can also be read as a sign of a changing attitude about the possibilities of cross-cultural communication. The covered face can tell a story of a boundary erected, contact broken.

A direct Western gaze

In its articles on the non-Western world, the *National Geographic* has frequently included photographs that show a Western traveler in the local setting covered in the piece. During the post-war period, these Western travelers have included adventurers, mountain climbers, and explorers; anthropologists, geographers, botanists, and archaeologists; U.S. military personnel; tourists; and government officials or functionaries from the U.S. and Europe from Prince Philip and Dwight Eisenhower to members of the Peace Corps. These photographs show the Westerners viewing the local landscape from atop a hill, studying an artifact, showing a local tribal person some wonder of Western technology (a photograph, mirror or the camera itself), or interacting with a native in conversation, work, or play. The Westerner may stand alone or with associates, but more often is framed together with one or more locals.

These pictures can have complex effects on viewers for they represent more explicitly than most the intercultural relations it is thought or hoped obtain between the West and its global neighbors. They may allow identification with the Westerner in the photo and, through that, more interaction with, or imaginary participation in, the photo. Before exploring these possibilities, however, we will speculate on some of the functions these photographs serve in the magazine.

Most obviously, the pictures of Westerners can serve a validating function by proving that the author was there, that the account is a first-hand one, brought from the field rather than from the library or photographic archives. In this respect, the photography sequences in *National Geographic* articles resemble traditional ethnographic accounts, which are written predominantly in the third person but often include at least one story in the first person that portrays the anthropologist in the field (Marcus and Cushman 1982). For this purpose, it does not matter whether the Westerner stands alone with locals.

To serve the function of dramatizing intercultural relations, however, it is helpful to have a local person in the frame. When the Westerner and the other are positioned face-to-face, we can read their relationship and natures from such features as Goffman (1979) has identified in his study of advertising photography's representation of women and men – their relative height, the leading and guying behaviors found more often in pictured males, the greater emotional expressiveness of the women and the like.[8] What the Westerners and non-Westerners are doing, the relative vantage points from which they are photographed, and their facial expressions give other cues to their moral and social characters.

The mutuality or non-mutuality of the gaze of the two parties can also tell us who has the right and/or need to look at whom. When the reader looks out at the world through this proxy Westerner, does the other look back? Here we can look

Figure 5.2 Lowell Thomas, Jr. National Geographic Stock.

at the February 1960 issue showing two female travelers looking at an Ituri For-
est man in central Africa (see Figure 5.2). Standing in the upper left hand corner,
the two women smile down at the native figure in the lower right foreground.
He looks toward the ground in front of them, an ambiguous expression on his
face. The lines of their gaze have crossed but do not meet; because of this lack of
reciprocity, the women's smiles appear bemused and patronizing. Their smiles are
neither returned friendly greetings nor can we discern any reason for their smiles
in the man's behavior. In its lack of reciprocity, the gaze is *distinctly colonial*. The
Westerners do not seek a relationship but are content, even pleased, to view the
other as an ethnic object. The composition of the picture, structured by an oblique
line running from the women down to the man, shows the Westerners standing
over the African; the slope itself can suggest, as Maquet (1986) has pointed out for
other visual forms, the idea of *descent* or decline from one (the Western women)
to the other.

A related function of this type of photo lies in the way it prompts the viewer
to become self-aware, not just in relation to others, but as a viewer, as one who
looks or surveys. Mulvey (1975) argues that the gaze in cinema takes three forms –
in the camera, the audience, and the characters as they look at each other or out
at the audience. She says that the first two forms have to be invisible or obscured
if the film is to follow realist conventions and bestow on itself the qualities of
'reality, obviousness, and truth.' The viewer who becomes aware of his or her
own eye or that of the camera will develop a 'distancing awareness' rather than
an immediate unconscious involvement. Transferring this insight to the *National
Geographic* photograph, Mulvey might say that bringing the Western eye into the

frame promotes distancing rather than immersion. Alvarado (1979/80) has also argued that such intrusion can reveal contradictions in the social relations of the West and the rest that are otherwise less visible, undermining the authority of the photographer by showing the photo being produced, showing it to be an artifact rather than an unmediated fact.[9] Whether or not Westerners appear in the picture we *are* there, but in pictures that include a Westerner, we may see ourselves being viewed by the Other, and we become aware of ourselves as actors in the world. The act of seeing the self being seen is antithetical to the voyeurism which many art critics have identified as intrinsic to most photography and film (Alloula 1986; Burgin 1982; Metz 1985).

This factor might best account for the finding that Westerners retreat from the photographs after 1969. Staffers in the photography department said that pictures including the article's author came to be seen as outdated and so they were eliminated. Photographer and writer were no longer to be the stars of the story, we were told, although text continued to be written in the first person. As more and more readers had traveled to the exotic locales of their articles, the *Geographic* staff saw that the picture of the intrepid traveler no longer looked so intrepid. While the rise in international tourism may have had this effect, other social changes of the late 1960s contributed as well. In 1968, popular American protest against participation in the Vietnam War reached a critical point. Massive anti-war demonstrations, the police riot at the Democratic Convention, and especially the Viet Cong's success in the Tet Offensive convinced many that the American role in Vietnam and, by extension, the Third World, would have to be radically reconceptualized. The withdrawal or retreat of American forces came to be seen as inevitable, even though there were many more years of conflict over how, when, and why. American power had come into question for the first time since the end of World War II. Moreover, the assassinations of Malcolm X and Martin Luther King, Jr., and the fire of revolt in urban ghettos, gave many white people a sense of changing and more threatening relations with people of color within the boundaries of the United States.

Most of the non-*Geographic* photos now considered iconic representations of the Vietnam War do not include American soldiers or civilians. The girl who, napalmed, runs down a road toward the camera; the Saigon police chief executing a Viet Cong soldier; the Buddhist monk in process of self-immolation – each of these photographs, frequently reproduced, erases American involvement.

The withdrawal of Americans and other Westerners from photographs of *National Geographic* may involve a historically similar process. The decolonization process accelerated in 1968 and led Americans (including, one must assume, the editors of *National Geographic*) to see the Third World as a more dangerous place, a place where they were no longer welcome to walk and survey as they pleased. The decreasing visibility of Westerners signaled a retreat from a Third World seen as a less valuable site for Western achievement and as a place of more difficult access and control. The decolonization process was and is received as a threat to an American view of itself. In Lacan's terms, the Other's look could threaten an American sense of self-coherence and so in this historical moment the Westerner – whose presence in the picture makes it possible for us to see ourselves being seen by that Other – withdraws to look from a safer distance, behind the camera.

The refracted gaze of the other: to see themselves as others see them

In a small but nonetheless striking number of *National Geographic* photographs, a native is shown with a camera, a mirror or mirror equivalent in his or her hands. Take the photograph in which two Aivilik men in northern Canada sit on a rock in animal skin parkas, one smiling and the other pointing a camera out at the landscape (November, 1956). Or the picture that shows two Indian women dancing, as they watch their image in a large wall mirror. Or the picture from March of 1968 that shows Governor Brown of California on Tonga showing a group of children Polaroid snapshots he has just taken of them (March, 1968).

Mirror and camera are tools of self-reflection and surveillance. Each creates a double of the self, a second figure who can be examined more closely than the original – a double that can also be alienated from the self, taken away, as a photograph can be, to another place. Psychoanalytic theory notes that the infant's look into the mirror is a significant step in ego formation because it permits the child to see itself for the first time as an other. The central role of these two tools in American society (for example, its millions of bathrooms have mirrors as fixtures nearly as important as their toilet) stems at least in part from their self-reflective capacities. For many Americans, self-knowledge is a central life goal; the injunction to 'know thyself' is taken seriously.

The mirror most directly suggests the possibility of self-awareness, and Western folktales and literature provide many examples of characters (often animals like Bambi or wild children like Kipling's Mowgli) who come upon the mirrored surface of a lake or stream and see themselves for the first time in a kind of epiphany of newly acquired self-knowledge. Placing the mirror in non-Western hands makes an interesting picture for Western viewers because this theme can interact with the common perception that the non-Western native remains at least somewhat child-like and cognitively immature. Lack of self-awareness implies a lack of history (Wolf 1982); he or she is not without consciousness but is relatively without self-consciousness. The myth is that history and change are primarily characteristic of the West and that historical self-awareness was brought to the rest of the world with 'discovery' and colonization.[10]

In the article 'Into the Heart of Africa' (August 1956), a magazine staff member on expedition is shown sitting in his Land-Rover holding open a *National Geographic* magazine to show a native woman a photograph of a woman of her tribe. Here the magazine serves the role of reflecting glass, as the caption tells us: 'Platter-lipped woman peers at her look-alike in the mirror of *National Geographic*.' The *Geographic* artist smiles as he watches the woman's face closely for signs of self-recognition; the fascination evident in his gaze is in the response of the woman, perhaps the question of how she 'likes' her image, her own self. An early version of this type of photo a quarter of a century earlier shows an explorer in pith helmet who, with a triumphant smile, holds up a mirror to a taller, native man. He dips his head down to peer into it and we, the viewers, see not his expression but a redundant caption: 'His first mirror: Porter's boy seeing himself as others see him.' By contrast with the later photo, the explorer's gaze is not at the African but out towards the camera, indicating more interest in the camera's reception of this amusing scene than in searching the man's face for clues to his thinking. It also demonstrates the importance of manipulating relative height between races to communicate dominance. In the same genre, a

Westerner in safari clothes holds a mirror up to a baboon (May 1955). Here as well, the *Geographic* plays with the boundary between nature and culture. The baboon, like Third-World peoples, occupies that boundary in the popular culture of white Westerners (see Haraway 1989); its response to the mirror can only seem humorously inadequate when engaged in the ultimately human and most adult of activities, self-reflection.

The mirror sometimes serves as a device to tell a story about the process of forming national identity. National self-reflection is presumed to accompany development, with the latter term suggesting a process that is both technological and psychosocial. The caption to a 1980 picture of a Tunisian woman looking into a mirror plays with this confusion between the individual and the nation, between the developing self-awareness of mature adults and historically emergent national identity:

> A moment for reflection: Mahbouba Sassi glances in the mirror to tie her headband. A wife and mother in the village of Takrouna, she wears garb still typical of rural women in the region. Step by step. Tunisia has, by any standards, quietly but steadily brought herself into the front rank of developing nations.
>
> (National Geographic 1980)

Cameras break into the frame of many *National Geographic* photographs. In some, a Westerner is holding the camera and showing a local group the photograph he has just taken of them. Here the camera, like the mirror, shows the native to himself. Frequently the picture is shown to children crowding happily around the Western cameraman, Historically it was first the mirror and then the camera that were thought to prove the superiority of the Westerner who invented and controls them (Adas 1989). In many pictures of natives holding a mirror or camera, the magazine plays with what McGrane (1989) identifies with the nineteenth-century European mind that is, the notion 'of a low threshold of the miraculous [in the non-Western native], of a seemingly childish lack of restraint' (1989: 50).

In other pictures, the native holds the camera. In one sense, this violates the prerogative of the Western surveyor to control the camera as well as other means of knowledge. From an early point in the history of photography: its users recognized that the camera was a form of power. In an analysis of photographs of Middle-Eastern women, Graham-Brown (1988) provides evidence that colonial photographers were motivated to keep local subjects 'at the lens-end of the camera' (61), and quotes one who, in 1890, complained. 'It was a mistake for the first photographer in the Pathan [Afghanistan] country to allow the natives to look at the ground glass screen of the camera. He forgot that a little learning is a dangerous thing' (1988: 61). The camera could be given to native subjects only at risk of giving away that power.

Suggesting little peril, however, the pictures in *National Geographic* which place the camera in other hands create an amusing or quaint scene. A broad smile graces the face of the Aivilik man above who uses the camera lens to view the landscape with a companion November 1956). At least one caption suggests that, although the subject goes behind the camera – in 1952 a young African boy looking through the viewfinder – what he looks out at is the imagined self at whom the Western photographer has been looking moments before: 'Young Lemba sees others as the photographer sees him.'

Such pictures were more common in the 1950s. We can detect a change, as decolonization proceeded, in the simple terms with which the problem is depicted in an amazing photograph August 1982 (see Figure 5.3). It sits on the right hand side of the page in an article entitled 'Paraguay Paradox of South America.' The frame is nearly filled with three foreground figures – white female tourist standing between an Amerindian woman and man, both in indigenous dress, both bare-chested. The three stand close together in a line, the tourist smiling with her arm on the shoulder of the sober-faced native woman. The tourist and the man, also unsmiling, face off slightly towards the left where a second camera (in addition to the one snapping the photo that appears in the magazine) takes their picture. The poses and the caption ask us to look at the natives as photographic subjects: 'Portraits for pay: A tourist poses with members of the Maca Indian tribe on Colonia Juan Belaieff Island in the Paraguay River near Asunción. The Indians charge 80 cents a person each time they pose in a photograph . . .'

This rare photograph invites us into a contradictory, ambiguous, but in any case, highly charged scene. It is not a pleasant picture, in contrast with more typical *Geographic* style, because it depicts the act of looking at unwilling subjects, suggesting two things in the process. The first is the voyeurism of the photograph of the exotic. The camera gaze is *doubled* in this picture, not the native subject as in the photos above where the camera enters the frame in some explicit sense, and this doubling underlines that Western gaze. The picture's ambiguity lies in its suggestion that we are seeing a candid shot of a posed shot, and that we are looking at the subject look at us though in fact the Indian gaze is diverted 20 degrees from ours. This unusual structure of gaze draws attention to the commodified nature of the relationship between

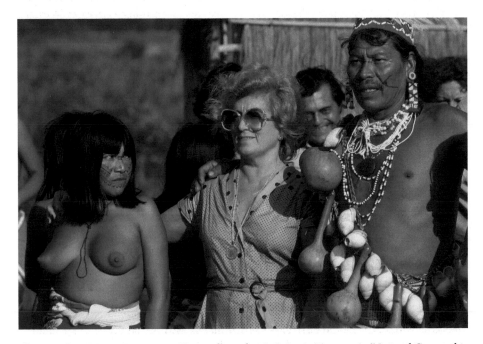

Figure 5.3 O. Louis Mazzatenta [Original in colour]. O. Louis Mazzatenta/National Geographic Stock.

looker and looked-at. The Indians appear unhappy, even coerced; the tourist satisfied, presumably with her catch. Here too an apparent contradiction – the diverted gaze and its candid appearance suggest that the *National Geographic* photographer took this picture without paying, unlike the tourists; the caption suggests otherwise.

The photograph's potentially disturbing message for *National Geographic* readers is muted when one considers that the camera has not succeeded so much in represent-ing the returned gaze of indigenous people as it has in taking the distance between Western viewer and non-Western subject one step farther, and in drawing attention to the photographer (and the artifice) between them. A symptom of alienation from the act of looking even while attention is drawn to it, this photo may exemplify a principle which Sontag says operates in all photography:

> The photographer is supertourist, an extension of the anthropologist, vis-iting natives and bringing back news of their exotic doings and strange gear. The photographer is always trying to colonize new experiences, to find new ways to look at familiar subjects – to fight against boredom. For boredom is just the reverse side of fascination: both depend on being out-side rather than inside a situation, and one leads to the other.
>
> (Sontag 1977: 42)

Avoiding boredom is crucial to retaining readers' interest and membership as well.

One could also look at the photograph from a 1990 issue on Botswana showing a French television crew – in full camera and sound gear and from a distance of a few feet – filming two Dzu men in hunting gear and 'authentic' dress. The French-men enthusiastically instruct the hunters in stalking posture, and the caption critiques them, noting that they have dressed up the natives (who otherwise wear Western clothing) for the benefit of European consumers. While this photograph is valuable in letting the reader see how images are constructed rather than found, its postmodern peek behind the scenes may also do what Gitlin notes contemporary journalism has done: engaged in a demystifying look at how image-makers control the face political candidates put forward, they encourage viewers to be 'cognoscenti of their own bam-boozlement' (1990).

Ultimately the magazine itself is a mirror for the historical, cultural, and political economic contexts of its production and use. That context is reflected in the maga-zine's images themselves, but not in a simple reflective way, as either the objectivist myth of the nature of cameras and mirrors or as the Althusserian notion of a 'specular,' or mirror-like ideology (in which the subject simply recognizes him or herself) would have it. It is perhaps more in the form of a rippled lake whose many intersecting lines present a constantly changing and emergent image.

The academic spectator

In one sense, this gaze is simply a sub-type of the reader's gaze. It emerges out of the same American middle class experiential matrix with its family of other cultural representations, its formal and informal schooling in techniques for interpreting both photograph and cultural difference, and its social relations. We read the *National*

Geographic with a sense of astonishment, absorption, and wonder, both as children and, in a way that is different only some of the time, as adults. All of the looks embedded in the pictures are ultimately being filtered for you the reader through this, our own gaze. At times during this project, we have looked at an American magazine reader who is looking at a photographer's looking at a Western explorer who is looking at a Polynesian child who is looking at the explorer's photographed snapshot of herself moments earlier. While this framing of the seventh look might suggest that it is simply a more convoluted and distanced voyeurism, it can be distinguished from other kinds of readers' gazes including the voyeuristic and the hierarchic by both its distinctive intent and the sociological position (white, middle class, female, academic) from which it comes. Its intent is not aesthetic appreciation or formal description, but critique of the images in spite of, because of, and in terms of their pleasures. We aim to make the pictures tell a different story than they were originally meant to tell, one about their makers and readers rather than their subjects.[11] The critique arises out of a desire 'to anthropologize the West,' as Rabinow (1986) suggests we might, and to denaturalize the images of difference in the magazine in part because those images and the institution which has produced them have historically articulated too easily with the shifting interests and positions of the state. The strong impact of the magazine on popular attitudes suggests that anthropological teaching or writing purveys images which, even if intended as oppositional (certainly not always the case), may simply be subsumed or bypassed by the *National Geographic* view of the world.

In addition, a suspicion of the power of images is here, as they exist in a field more populated with advertising photography than anything else. The image is experienced daily as a sales technique or as a trace of the commodity. That experience is, at least for us, and perhaps for other readers, transferred to some degree to the experience of seeing *National Geographic* images. Even if we are simply 'invited to dream' in the photograph, we are also invited to forget and to be lost in it.

Our reading of theory has also tutored our gaze at the photographs in distinctive ways, told us how to understand the techniques by which they work, how to find our way to something other than an aesthetic or literal reading, suggesting that we view them as cultural artifacts. It also suggested that we avoid immersion in the many pleasures of the richly colored and exotically peopled photographs, as in Alloula's reading of Algerian colonial period postcards. He notes his analytic need to resist the 'aestheticizing temptation' (1986: 116) to see beauty in those cards, a position predicated in part on a highly deterministic view of their hegemonic effect.[12] Alternatively, more positive views of the political implications of visual pleasure exist, a view which Jameson (1983) and others argue is achieved in part by unlinking a prevalent disdain for popular culture products from the issue of pleasure. Validating both seemingly contradictory views, however, would seem to be the fact that the seductiveness of the pictures both captures and instructs us. We are captured by the temptation to view the photographs as more real than the world or at least as a comfortable substitute for it – to imagine at some level a world of basically happy, classless, even noble, people in conflict neither with themselves nor with 'us.' These and other illusions of the images we have found in part through our own vulnerability to them. The pleasures are also instructive, however. They come from being given views, without having to make our own efforts to get them, of a world different, however slightly, from the American middle class norm. The considerable beauty with which those lives are portrayed can potentially challenge the latter, as well.

Concluding remarks

The many relations of looking represented in all photographs are at the very foun-
dation of the kinds of meaning that can be found or made in them. The multiplic-
ity of looks is at the root of a photo's ambiguity, each gaze potentially suggesting a
different way of viewing the scene. Moreover, a visual 'illiteracy' leaves most of us
with few resources for understanding or integrating the diverse messages these looks
can produce. Multiple gaze is the source of many of the photograph's contradictions,
highlighting the gaps (as when some gazes are literally interrupted) and multiple per-
spectives of each person involved in the complex scene. It is the root of much of
the photograph's dynamism as a cultural object, and the place where the analyst can
perhaps most productively begin to trace its connections to the wider social world
of which it is a part. Through attention to the dynamic nature of these intersecting
gazes, the photograph becomes less vulnerable to the charge or illusion that it masks
or stuffs and mounts the world, freezes the life out of a scene, or violently slices into
time. While the gaze of the subject of the photograph may be difficult to find in the
heavy crisscrossing traffic of the more privileged gazes of producers and consumers,
contemporary stories of contestable power are told there nonetheless.

Original publication

'The Photograph as an Intersection of Gazes: The Example of National Geographic',
Visualizing Theory: Selected Essays from V. A. R. 1990-1994 (1994) [Originally published
1991]

Notes

1 This essay. which appeared originally in *V.A.R.*, is drawn substantially from a book (Lutz
 and Collins 1993) that examines the production and consumption of *National Geo-
 graphic* photographs of the 'non-Western' world in the post World War II period. That
 book and this essay is in part based on an analysis of 600 photographs from that period;
 on several visits to the Washington headquarters where the magazine is produced and
 interviews conducted there with a number of photographers, picture editors, caption
 writers, layout and design people, and others; and on interviews with 55 individuals
 from upstate New York and Hawaii who 'read' a set of *Geographic* photographs for us.
 The present essay benefits extensively from the coding and analytic help of Tammy
 Bennington, and from the stimulating comments on earlier drafts by Lila Abu-Lughod,
 Tamara Bray, Phoebe Ellsworth, John Kirkpatrick, Daniel Rosenberg, Lucien Taylor
 and anonymous reviewers for *V.A.R.*
 The term 'non-Western' which bounds the project is awkward but represents our
 focus on the world outside the boundaries of the United States and Europe and our
 interest in how these powerful world areas (which include almost all of the magazine's
 readers) have constructed and construed other peoples. Our analysis here and else-
 where suggests that, despite some important distinctions which these readers can and
 do make within the category of the 'non-Western,' there is a fundamental process of
 identity formation at work in which all 'exotics' play the primary role of being not
 Western, not a white, middle class reader.

2 An early typology of the gaze from a colonial and racist perspective is found in Sir Richard Burton's accounts of his African expeditions, during which he felt himself to be the victim of 'an ecstasy of curiosity'. Wrote Burton:

> At last my experience in staring enabled me to categorize the infliction as follows. Firstly is the stare furtive, when the starer would peep and peer under the tent, and its reverse, the open stare. Thirdly, is the stare curious or intelligent, which generally was accompanied with irreverent laughter regarding our appearance. Fourthly is the stare stupid, which denoted the hebete incurious savage. The stare discreet is that of Sultans and great men; the stare indiscreet at unusual seasons is affected by women and children . . . Sixthly is the stare flattering – it was exceedingly rare, and equally so was the stare contemptuous. Eighthly is the stare greedy; it was denoted by the eyes restlessly bounding from one object to another, never tired, never satisfied. Ninthly is the stare peremptory and pertinacious, peculiar to crabbed age. The dozen concludes with the stare drunken, the stare fierce or pugnacious, and finally the stare cannibal, which apparently considered us as articles of diet.
>
> (Burton in Moorehead 1960: 33)

One can imagine a similarly hostile categorization of white Westerners staring at 'exotics' over the past centuries.

3 Some contemporary photographers are experimenting with these conventions (in point of view or framing) in an effort to undermine this equation. Victor Burgin, for example, intentionally attempts to break this down by making photographs that are "'occasions for interpretation" rather than . . . "the objects of consumption"' and that thereby require a gaze which more actively produces itself rather than simply accepting the photographer's gaze as its own. While one can question whether any *National Geographic* photograph is ever purely an object of consumption the distinction is an important one and alerts us to the possibility that the photographer can encourage or discourage, through technique, the relative independence of the viewer's gaze.

4 This figure is based on 438 photographs coded in this way 24 per cent of which had a subject looking at the camera.

5 These analyses were based on those photos where gaze was visible, and excluded pictures with a Westerner in the photo. The results were, for gender (N = 360) x^2 = 3.835, df = 1, p <. 05; for age (N = 501) x^2 = 13.745, df = 4, p < .01; for wealth (N = 507) x^2 = 12.950, df = 2, p < .01; for skin color (N = 417) x^2 = 8.704, df = 3, p <. 05; for dress style (N = 452) x^2 = 12.702, df = 1, p < .001; and for technology (N = 287) x^2 = 4.172, df = 1, p < .05. Discussing these findings in the Photography Department, we were given the pragmatic explanation that children generally are more fearless in approaching photographers, while men often seem more wary of the camera than women, especially when it is wielded by a male photographer.

6 In the sample of pictures from Asia in which gaze is ascertainable (N = 179), 'friendly' countries (including the PRC after 1975, Taiwan, Hong Kong, South Korea, Japan, and the Philippines) had higher rates of smiling than 'unfriendly' or neutral countries (x^2 = 2.101, df = 1, p =.147). Excluding Japan, which may have had a more ambiguous status in American eyes, the relationship between gaze and 'friendliness' reaches significance (x^2 = 4.14, df = 1, p < .05).

7 Tagg notes that the pose was initially the pragmatic outcome of the technique of the Physionotrace, a popular mechanism used to trace a person's profile from shadow onto a copper plate. When photography took the place of the Physionotrace, no longer requiring profiles, the conventions of associating class with non-frontality continued to have force.

8 For example, Goffman (1979) draws on ethological insights into height and dominance relations when he explains why women are almost always represented as shorter than men in print advertisements. He notes that 'so thoroughly is it assumed that differences in size will correlate with differences in social weight that relative size can he routinely used as a means of ensuring that the picture's story will be understandable at a glance' (*ibid.*: 28).

9 The documentary filmmaker Dennis O'Rourke, whose films *Cannibal Tours* and *Half Life: A Parable for the Nuclear Age* explore Third World settings, develops a related argument for the role of reflexivity for the imagemaker (Lutkehaus 1989). He consistently includes himself in the scene, but distinguishes between simple self-revelation on the part of the filmmaker and rendering the social relations between him and his subjects, including capturing the subject's gaze in such a way as to show his or her 'complicity' with the filmmaker, O'Rourke appears to view the reader's gaze more deterministically (for example, as 'naturally' seeing the complicity in a subject's gaze) than do the theorists considered above.

10 Compare the pictures of natives looking into a mirror with that of an American woman looking into the shiny surface of the airplane she is riveting in the August 1944 issue, It is captioned. 'No time to prink [primp] in the mirror-like tail assembly of a Liberator.' The issue raised by this caption is not self-knowledge (Western women have this), but female vanity, or rather its transcendence by a woman who, man-like, works in heavy industry during the male labor shortage period of World War II. Many of these mirror pictures evoke a tradition of painting in Western art in which Venus or some other female figure gazes into a mirror in a moment of self-absorption. Like those paintings, this photo operates 'within the convention that justifies male voyeuristic desire by aligning it with female narcissistic self-involvement' (Snow 1989: 38).

11 Our interviews with readers show that they do not always ignore the frame, but also sometimes see the photograph as an object produced by someone in a concrete social context.

12 Alloula seems not to broach the possibility of alternative kinds of pleasure (or, more broadly, positive effects or readings) in the viewing because the photos are seen to have more singular ends and because of his fear of what he terms an 'intoxication, a loss of oneself in the other through sight' (1986: 49).

References

Adas, Michael. 1989. *Machines as the Measure of Men*. Ithaca: Cornell University Press.

Alloula, Malek. 1986. *The Colonial Harem*. Minneapolis: University of Minnesota Press.

Alvarado, Manuel. 1979/1980. 'Photographs and Narrativity.' *Screen Education* (Autumn/Winter): 5–17.

Barthes, Roland. 1977. 'The Photographic Message.' In *Image-Music-Text*, trans. Stephen Heath. Glasgow: Fontana/Collins.

Burgin, Victor, ed. 1982. *Thinking Photography*. London: Macmillan.

Devereux, George. 1967. *From Anxiety to Method in the Behavioral Sciences*. The Hague: Mouton.

Ellsworth, Phoebe. 1975. 'Direct Gaze as Social Stimulus: The Example of Aggression.' In *Nonverbal Communication of Aggression*, ed. P. Pliner, L. Krames, and T. Alloway. New York: Plenum.

Geary, Christraud M. 1988. *Images from Bamum: German Colonial Photography at the Court of King Njoya, Cameroon, West Africa 1902–1915*. Washington, DC: Smithsonian Institution Press.

Gitlin, Todd. 1990. 'Blips, Bites and Savvy Talk.' *Dissent* 37: 18–26.

Goffman, Erving. 1979. *Gender Advertisements*. New York: Harper and Row.

Graham-Brown, Sarah. 1988. *Images of Women: The Portrayal of Women in Photography of the Middle East, 1860–1950*. London: Quartet Books.

Haraway, Donna J. 1989. *Primate Visions: Gender, Race, and Nature in the World of Modern Science*. London: Routledge.

Jameson, F. 1983. 'Pleasure: A Political Issue.' In *Formations of Pleasure*, ed. F. Jameson, 1–14. London: Routledge and Kegan Paul.

Lacan, Jacques. 1981. *The Four Fundamental Concepts of Psychoanalysis*. New York: Norton.

Levine, Lawrence W. 1988. *Highbrow/Lowbrow: The Emergence of Cultural Hierarchy in America*. Cambridge: Harvard University Press.

Lutkehaus, Nancy C. 1989. "Excuse Me, Everything Is Not Alright": On Ethnography, Film, and Representation: An Interview with Filmmaker Dennis O'Rourke.' *Cultural Anthropology* 4: 422–437.

Lutz, Catherine and Jane Collins. 1993. *Reading National Geographic*. Chicago: University of Chicago Press.

Maquet, Jacques. 1986. *The Aesthetic Experience*. New Haven: Yale University Press.

Marcus, George E. and Dick Cushman. 1982. 'Ethnographies as Text.' *Annual Review of Anthropology* 11: 25–69.

McGrane, Bernard. 1989. *Beyond Anthropology: Society and the Other*. New York: Columbia University Press.

Metz, Christian. 1985. 'From the Imaginary Signifier.' In *Film Theory and Criticism: Introductory Readings*, 3rd ed., ed. Gerald Mast and Marshall Cohen, 782–802. New York: Oxford University Press.

Moorehead, Alan. 1960. *The White Nile*. New York: Harper & Brothers.

Mulvey, L. 1975. 'Visual Pleasure and Narrative Cinema.' *Screen* 16(3): 6–18.

National Geographic Society. 1981. *Images of the World: Photography at the National Geographic*. Washington, DC: National Geographic Society.

Rabinow, Paul. 1986. 'Representations Are Social Facts: Modernity and Post-Modernity in Anthropology.' In *Writing Culture*, ed. J. Clifford and G. Marcus, 234–261. Berkeley: University of North Carolina Press.

Radway, Janice. 1984. *Reading the Romance*. Chapel Hill: University of North Carolina Press.

Sider, Gerald. 1987. 'When Parrots Learn to Talk, and Why They Can't: Domination, Deception, and Self-Deception in Indian-White Relations.' *Comparative Studies in Society and History* 29: 3–23.

Snow, Edward. 1989. 'Theorizing the Male Gaze: Some Problems.' *Representations* 25: 30–41.

Sontag, Susan. 1977. *On Photography*. New York: Dell/Delta.

Tagg, John. 1988. *The Burden of Representation*. Amherst: The University of Massachusetts Press.

Wolf, Eric. 1982. *Europe and the People without History*. Berkeley: University of California Press.

Ariadne van de Ven

THE EYES OF THE STREET
LOOK BACK
In Kolkata with a camera around my neck

Introduction

AS A SPECIES, the tourist has an unenviable reputation, with the sub-species of the camera-carrying tourist coming in for particularly harsh criticism. In photographic theory, even as amateur photography has become an exciting new field of research, tourist photography has remained at best unexamined, at worst condemned as inevitably commodifying and exploitative. Meanwhile, millions of us go on holiday every year – with and without cameras – and encounter realities very different from the one in which we feel at home. I have been going to Kolkata – formerly known as Calcutta – once a year since 2002; I travel with a camera and plenty of film. In the early days, I tried to pretend I was a researcher or a documentary photographer, but this was pretentious nonsense: I am a tourist wandering through a foreign city and making photographs. I hope to be a fairly sensitive tourist, but we come in all shapes and sizes. Not only did my self-image frequently collide with reality on these walks, but so did my mental picture of the city. This had been shaped, I came to realize, by the long tradition of photographic stereotyping of a city such as Kolkata by "the West"; from official colonial records in the mid-nineteenth century to today's tourist brochures and newspaper reports, the western photographic practices in India have tended to spawn stereotypes.[1] Walking through Kolkata proved to be a much more complex and unsettling experience than all those clichés had so confidently predicted and I had so blithely expected.[2]

Over the years, the mismatch became more and more baffling and, in between holidays, I went in search of an intellectual framework for my photographic encounters. For issues to do with being a tourist, I turned to anthropology and sociology. Social scientists, however, never appeared to be wrong-footed by a reality that did not fit their mental anticipations, nor did they ever admit to being tourists themselves. Their academic disdain only intensified when the tourist wrapped a camera around her neck. For the photographic aspects, I turned to photography theory. Here

I discovered that tourist photography was still the black sheep of the family, either unmentionable or deeply objectionable. In any of these disciplines, the only acceptable theoretical approach appeared to be to condemn "the" tourist as selfish and neo-imperialist. The entire debate was still couched in the concept of The Gaze as an inevitably objectifying and immoral force. And the "gazer" is beyond the pale. The flip-side of this coin, however, seemed to me the tacit assumption that the world that the tourist enters neither acts nor reacts with any kind of autonomy. Yet whenever I turned a corner in a Kolkata street, the people in that street simply would not submit to being objectified by anybody's gaze, least of all that of a passing foreign tourist.

This paper will take a fresh look at tourist photography and its practitioners. First I shall give a whistle-stop tour of the academic debate, then an account of my own interactions in the streets of Kolkata before ending with an initial attempt to rethink both the practice and the politics of the camera-carrying tourist. While the complex phenomenon of tourism varies widely depending on its setting – rural Europe is different from urban Africa, a beach different from a city, Kolkata different from Mumbai – what follows has, I hope, implications beyond my wanderings with my camera. This exploration is intended to open up a debate: it will raise more questions than it provides answers. My main concern is that for as long as the whole of tourist photography remains in the domain of the unspeakable, its ethics, aesthetics, and politics remain unexamined.

1. "No serious knowledge": the views from the ivory tower

As long ago as 1976, Dean MacCannell claimed, "the modern critique of tourists is not an analytical reflection on the problem of tourism – it is part of the problem" (10). His theory may have dated in parts, but this particular point has lost none of its relevance. In the corridors of academia as well as in the watering holes of the chattering classes, we distance ourselves as far and as fast as we can from tourists. Yet there is something peculiarly dishonest, both intellectually and emotionally, about the outright condemnation of the tourist – even if not all tourists are sweet, sensitive souls. Most Westerners, intellectuals included, are foreigners *and* tourists at least for a few weeks every year. The damning consensus effortlessly crosses disciplinary borders between anthropology, sociology, photography history and criticism, and travel writing. Although I was barely aware of it, this chorus of disdain was a persistent background noise that shaped my view of myself as a tourist making photographs. More insidiously, the chorus also insinuated itself into my encounters with the people I met. I wish to start, therefore, by picking out a few of the most influential voices from different disciplines.

Among academics, anthropologists were probably the first to stumble across tourists, in out-of-the-way places that they might have hoped to have kept to themselves. In *Tristes Tropiques*, Claude Lévi-Strauss agonizes: "I wished I had lived in the days of *real* journeys, when it was still possible to see the full splendour of a spectacle that had not yet been blighted, polluted and spoilt" (43). He is characteristically alert to the irony that his own journey is implicated. Anthropologists, who after all travel for a living, are still reluctant to confront the touristic aspects of their own behavior and of the ways in which their "subjects" react to them. In *Routes*, James Clifford

reflects on his own kind: "the people who leave and write" (65). He highlights how blurred the boundary is between anthropologists and travel writers, but keeps tourists resolutely at arm's length:

> Travel and travel discourse should not be reduced to the relatively recent tradition of literary travel, a narrowed conception which emerged in the late nineteenth and early twentieth centuries. This notion of "travel" was articulated against an emerging ethnography (and other forms of "scientific" field research) on the one hand, and against tourism (a practice defined as incapable of producing serious knowledge) on the other.
>
> (65)

Although it is not clear whether Clifford agrees with this negative definition of tourism – note the distribution of the quotation marks in these two sentences – his ambivalence is obvious. In the chapter "Palenque Log," his travel journal, the single endnote tells us that "Everything is written from the location of a meta-'independent traveler' within the tourist circuit" (237). Irony is a wonderfully useful tool.

For sociologists, the tourist presents not an annoying presence but a fascinating subject. Yet in this field, too, there is a common instinct to distance oneself from the tourist, with fleet-footed dissociation and sweeping generalization. Zygmunt Bauman even employs the tourist as a key metaphor in his analysis of the postmodern condition: "Ideally, one should be a tourist everywhere and everyday. . . . Ideally, with the moral conscience having been fed a sure-fire dose of sleeping pills" (243). Some of the harshest denunciations are to be found in research conducted under the heading "tourism studies." As recently as 2003, Crouch and Lübbren pointed out that "there remains a tendency to disparage tourism even among those scholars who have devoted a great deal of attention to the phenomenon" (5).

When a tourist starts "snapping," the scholarly contempt grows even more vociferous. Because there is a direct, albeit by no means straight, line back from tourist to early travel and colonial photography, it is perhaps natural that the critical apparatus used for the nineteenth-century practice is also applied to its modern offspring. The unholy alliance between colonialism and the camera has been carefully unpicked by, among others, Vidya Dehejia, John Falconer, Judith Mara Gutman, Christopher Pinney, and James R. Ryan.[3] In India, moreover, the ideological connection was particularly explicit: in the wake of the 1857 Uprising, the colonial administration commissioned the photographic encyclopedia, *The People of India*, as a political instrument. (It was edited by J. Forbes Watson and John William Kaye and originally published in eight folio volumes in 1868). This history casts a long and dark shadow. It was not until much later that I discovered that even in the bad old colonial days, the visual hierarchies were less clear-cut than received postcolonial opinion has it, as scholars from South Asia have been the first to argue; a point to which I shall return.

It is neither surprising nor entirely unreasonable that tourism and photography are frequently framed as extensions, joined at the hip, of the racist imperialist attitude. Peter D. Osborne declares, "The work of imperialism metamorphoses into the dreamwork of tourism and, at least in the poorer countries," it is still a form of possessing "other people's appearances – their visibility" (112–3). Anandi Ramamurthy echoes this verdict: tourists "commodify and consume yet another aspect of a place through

the photographic image – the people" (229). And, as so often, Susan Sontag is still awarded the last moral word on the subject, with her much-quoted "Most tourists feel compelled to put the camera between themselves and whatever is remarkable that they encounter" (10).[4] The blanket condemnation of the camera-carrying tourist finds its most elaborate expression in John Urry's ground-breaking *The Tourist Gaze*, which has been regarded as *the* book on the subject for two decades. In his analytical framework, there is no room for the gaze to be sensitive, intelligent, insecure, or even for the gaze to be returned: Urry essentializes "the tourist" and his "gaze." (It is worth noting that "the" tourist is still generally assumed to be male; there is little gender differentiation).

One of the voices that whispered most insistently into my ear in Kolkata was John Hutnyk's. In his book on "Western" visitors to Calcutta, he is comprehensively outraged: "tourism and charity in the 'Third World' represent the soft edge of an otherwise brutal system of exploitation. It deserves no alibi" (ix). He equates tourism and photography with voyeurism and qualifies his absolute disapproval of visitors to the city only when they recognize photography's "voyeuristic nature" – and stop photographing (149, 166). While these allegations deserve to be debated – for of course photographers past and present have frequently been inexcusably exploitative – this theoretical approach has an essentializing force that is usually frowned upon in academic analysis. Moreover, by branding the camera the devil's instrument, these critics forget that seeing itself is a political activity with its own political and ethical problems. Laying down the camera will not protect our postcolonial purity – if such a thing ever existed.

The disapproval of tourists extends beyond academia; it is so universal that many tourists have internalized it and habitually pour scorn on (other) tourists. Paul Fussell observes that to distinguish oneself from mere tourists, one becomes an anti-tourist:

> A useful trick is ostentatiously not carrying a camera. If asked about this deficiency by a camera-carrying tourist, one scores a point by saying. "I never carry a camera. If I photograph things I find I don't really see them."
>
> (47)

And thus the tourist remains the superficial, materialistic, ignorant, insensitive, rude, and noisy hate-figure of polite society and academic discourse. Anthropologists, sociologists, photography critics, and travel writers zealously police the boundaries between themselves and this despicable species. The camera is the final, firm nail in the coffin.

2. The eyes of the street look back: the views on the ground

Those were the voices in my head when I walked, year after year, through the streets of Kolkata with my camera. I first arrived in the city in 2002 as a card-carrying left-twing feminist, with a brain full of prejudices against tourists, a conscience full of postcolonial guilt, an optical unconscious full of the West's images of India – and an auditory unconscious full of those warnings against the gaze.[5] It was the city itself that started to demolish this edifice of preconceptions. People spotted me – not hard to do, at 5'9" I am a giantess by Bengali standards – caught my eye, and some of them

said, gestured or shouted from the other side of the street that they wanted me to take their portraits. Nothing had prepared me for this, but it was obviously not an option to explain that I could not possibly agree to their requests because I would be gazing. I did as I was asked, and one portrait frequently led to half a roll filled on one street corner. After a few trips, I began to fight my self-consciousness and approach people on the margins of all this activity, those who were watching but seemed too shy to ask. These interactions turned into impromptu, chaotic street theater; a good time was had by all. I realized that the camera does not gaze; instead, it creates a stage around itself: a stage that includes the person holding the camera. Kolkatans have no truck with the Western shibboleth of the invisible photographer.

It also became obvious that human beings do not react (only) to the lens: it is a dumb instrument (and we tend to forget – or not even be aware – that India has had a highly sophisticated visual culture for millennia). So what do the Kolkatans see when they look back? Which part do the other actors assign to me on that stage? Why do they want to play, or play with me in particular? On my own – without guide, translator, assistant, big lenses, camera bag, tape recorder, or Indian languages – I have nothing that puts me in a position of authority or control. They watch me and decide that if it walks like a tourist and talks like a tourist, it's a tourist (even in the early days, when I still fancied myself a cut above the tourist). My obvious ignorance may offer them a degree of freedom to be who they want to be. They take the opportunity to pull my leg and play pranks with a neighbor, take it seriously and proudly show off the kids, or present themselves to the camera as for an official portrait. They want to be photographed together or alone, full-length or face only. It is entirely up to them – and some just let me get on with it. Eye contact and consent create a framework of respect and trust. Those who do not want to be photographed wave me away; I always respect this, although I sometimes regret a lost photograph. If there is no spontaneous eye contact, I walk on: in those circumstances, my eyes would be no less voyeuristic than my camera. People who work and often even live in what we in the West regard as "public space" have private moments just like the rest of us, and these are to be respected.

As the person who operates the shutter, I retain the advantage of "deciding the moment" but the balance of power has shifted: I do not *take* the portraits, we *make* them together.[6] The gaze, both as a theoretical concept and as a frowned-upon activity, pales into irrelevance. Sparked by eye contact, the creation of a photograph is a dynamic, collaborative process in which people are looking back at the photographer. Traveler, ethnographer, documentary photographer, it does not matter what identity I ascribe to myself: the fact that Kolkatans see me as a tourist is crucial to the resulting image; the traces remain indelible. I am therefore unable to control "my" photograph; even at the moment of its making, the meaning is out of my hands.[7] And this moment, though ephemeral, is as valid as the physical end result.

The Kolkatans do not only look back at a white, Western tourist; they also look back at a woman – and, with a few more gray hairs every year, a woman who is addressed more no longer as "sister" but as "auntie." Once again, it took me some time to begin to recognize that this makes a difference, especially in my encounters with women. Some women are too shy or too modest to ask for a portrait, but enjoy being asked; others take the initiative and give me a wave to come closer. They choose a pose, in jest or in earnest. Women appear to feel at ease with me, a foreign female,

in a way that they might not with a male photographer, perhaps especially a "local" male.[8] As for me, I began to relish the slightly conspiratorial atmosphere of the shared moments with women.

These portraits made in the street are all about the eye contact: the looking goes both ways. The people who look at me could not care less about my precious self-image or my intellectual convolutions, so it was time for an overhaul of my ideas. On the ground, there is an uncontrollable crisscrossing of glances rather than a gaze, and there is much more fluidity and complexity in the encounters than the notion can contain. The Kolkatans in the streets made me realize how deeply patronizing the concept of the gaze is. Moreover, it is blatantly untrue. The recipients of the gaze turn out *not* to be powerless, *not* helplessly "captured."[9] They look back and the entire photographic scenario unravels. I am too conspicuous to be invisible, and invisibility is a precondition for the gaze as it has most often been conceptualized.[10] The recognition that the camera creates a stage around itself also exposes the illusion, still widespread, that the photographer has to be invisible for the photograph to be "real." In the instant and on the spot that I expose the negative and we make the image, before the photograph becomes the object that so many theorists have analyzed, it is above all a social occasion. This will always be visible in the resulting image.

From the theory to the practice, from words to images: a few of those resulting photographs may help make my argument. An inadvertent series of three that I made in Elliot Road epitomizes the title of this paper (Figures 6.1, 6.2, and 6.3). I was crouching on the sidewalk to focus on the early morning sunlight stroking the wall and the washing on the other side of the street, when the man with the baseball cap walked in, stopped, turned to look at me. And stayed. A man walked past him heading east. A

Figure 6.1 *Elliot Road*, 2008 A. The Estate of Ariadne van de Ven.

Figure 6.2 *Elliot Road*, 2008 B. The Estate of Ariadne van de Ven.

Figure 6.3 *Elliot Road*, 2008 C. The Estate of Ariadne van de Ven.

woman walked past him heading west. He out-stared me; I was the first to blink and move on. The street is his, not mine, and he reclaimed the photograph.[11] It was only when I passed the spot again fifteen minutes later that I managed to make the photograph I had had in mind. It is, of course, a much less interesting image.

It was the morning of Shiv Puja, not a hugely important festival in Kolkata but still a day to celebrate (Figure 6.4). The city was dotted with shrines and brightly painted clay idols of Shiva and his consort Parvati. The final touches were being laid to the lighting, the chairs and the sound systems at the shrines. In one of the streets that lead towards the river Hooghli, an elderly woman and young man were sitting outside a locked-up shop, watching the world go by. I stepped into that world, and nodded at them in passing. The woman smiled back; I liked her "and who are you?" expression and asked her if I could make a photo. She nodded. I then asked the young man, who also nodded, so my next question was if they wanted to be in the photo together. She tilted her head back and smiled proudly down at me; while her son smiled benignly, indulging her – and indulging me (I can't be sure they were mother and son – but I am).

It was a Sunday afternoon and the city was having its siesta, with people playing cards or sleeping in patches of shade (Figure 6.5). Street life had slowed down: not the Kolkata of popular Western imagination. In Durgacharan Banerjee Street, half a dozen children were playing around a wooden cart, on which a woman was relaxing, possibly asleep. The children's excited reactions to my presence alerted her and she waved me to come nearer. With gestures, I asked if it was all right for me to photograph the children. Leaning on one elbow, her hair standing on end, as unruly as mine, she watched the kids pose for me one by one. I then turned to her and gestured my question to her, too. Again she nodded – and did not move a muscle.

It was the first morning of that year's holiday; the early sun beamed horizontally into the street behind the New Market (Figure 6.6). A chapati cook, sitting outside a restaurant, insisted that I join him on his platform and accept his gift of fresh,

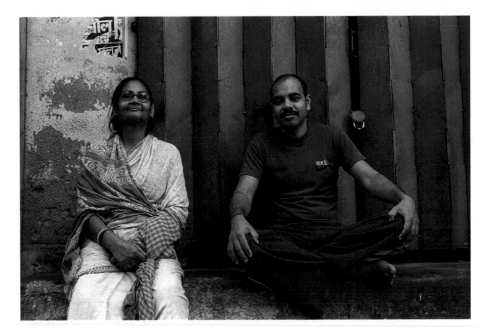

Figure 6.4 *Sovabazar Street*, 2010. The Estate of Ariadne van de Ven.

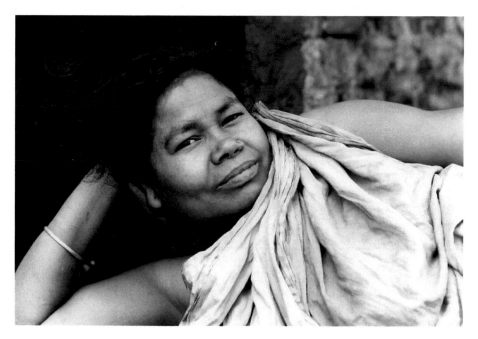

Figure 6.5 *Durgacharan Banerjee Street*, 2007. The Estate of Ariadne van de Ven.

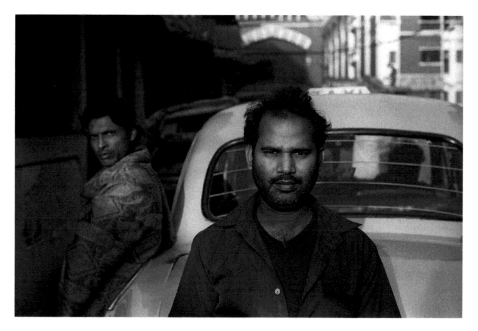

Figure 6.6 *Outside New Market*, 2010. The Estate of Ariadne van de Ven.

hot bread. Taxi drivers and rickshaw wallahs were having their breakfasts inside and hanging around getting used to the day: it was too early to tout for business. I was commandeered to make photographs of several men, all of them impatient; I gestured that I would make each portrait in turn. Only one man, wrapped in a woolen shawl, made it clear that he did not want a portrait – but he hovered around watching and even seemed to make sure he was on the fringes of the frame. When I came to the earnest, round-faced taxi-driver leaning against the boot, the sun lit up his face, while in the shade the man in the shawl leant against the side of the taxi with a frown.

There are also, every day, photographs I decide not to make. On the riverside one morning in 2008, a young man started dancing around me, chatting away in Bengali, with a stainless steel bowl in his hand. I had no means of interpreting his behavior – angry? disturbed? just larking about? – and on that occasion decided to give him a grin and walk on. He danced off and I then found out what he had been saying. "He was offering to play the fake beggar for the tourist, with his bowl." I should have played along. Even this tourist cannot bear very much reality. And yet the photograph that was not made has its own story to tell: every city, including one's own, throws up moments and encounters that are illegible. This is disconcerting, but it is part of being a tourist, and of being human.

Back in London, some of the images in which my so-called subjects had taken control jumped off the contact sheets, much more vibrant than many in which I had had the traditional photographer's control: the images of houses, graffiti, dogs, washing lines. The unpredictability of the encounters with people and the ambiguity of the resulting images reflect the social reality of visiting Kolkata much more closely than any invisible camera could. The photographs do not document "them," they do not explain anything about this city, they do not pretend to impart facts: they record only the moment. Almost by accident I found myself with a growing "chorus" of eyes looking back, defying me and defying "the West" to pin them down in the old stereotypes of extreme poverty or pretty exoticism.

3. "Looking obliquely": the wide-angled view

Where do these events in the streets leave the concept of the gaze? How does the theory frame my behavior and that of other tourists and, most important, how does it deal with the agency of the people who want to be photographed? I am not demanding absolute freedom for myself (or for tourists in general) to do as I please; far from it. Tourists do not exist in a politics-free zone, least of all in a city where colonial photography casts a very long shadow and in a nation that is still condescendingly described as "developing." Willy-nilly, my own behavior with the camera in Kolkata can only be either a continuation of that tradition or an attempt to subvert it. Yet, at the same time, many countries in the majority world and many families within those countries depend on tourists for their livelihoods – which does *not* mean that they have to subject themselves to a tourist's every whim and every photograph. By stigmatizing the phenomenon of the camera-carrying tourist for so long, however, we have neglected to develop a critical language that can discuss the quality of tourist photographs, both in the moment of their making and in their subsequent life as

objects, virtual or printed. The concept of the gaze is far too blunt an instrument to analyze the ethical and aesthetic aspects of tourist photography.[12]

What remains unspoken in all the theorizing is that even if we were to stop photographing, we all still walk around judging what we see. This issue is much larger than tourism: we all build our world views and political convictions on the basis of what we think we know. Sitting in our armchairs we judge the ways of the world by, among other "facts," images – on the screen, the newspaper page, the charity's fundraising leaflet. Even in the twenty-first century, these images continue to be produced predominantly by the Western lens; voices and views from the majority world still struggle to make themselves heard and seen.[13] From South Asia comes the critique that the images of India circulating in the West have "an exhausting predictability of themes relating to Third World economies and disaster" (Sinha and Sternberger 12) and perpetuate "images of helplessness, a colonial view of saving the natives" (Alam 1994).[14] In her critique of the so-called global village, Doreen Massey warns that "Maybe all the travelogues, and the travel, and the media coverage, can give us the illusion that we already know other peoples and other places." She goes on to argue that this "illusion of knowledge can be both dangerous . . . and potentially imperial."

Basking in this illusion of knowledge, first-time visitors to Kolkata, myself included, expect to find the images in our heads confirmed by what we see: irredeemable poverty, widespread dirt, chaotic overpopulation, and general heartlessness (symbolized in Mother Teresa's lonely status as a heroine if not a saint). It comes as a shock when the city presents us with a more complex reality. Without a camera, we can look away and walk away from any challenges to our preconceptions, but the camera stops us in our tracks. This is not about replacing one illusion with a different certainty: it is about starting to recognize that the reality of other human beings' lives goes far beyond the one-dimensional stereotypes that we have been fed about India. In a city such as Kolkata, which has no ancient picturesque temples, no elephants and precious few holy cows, the stereotypes tend to spiral around poverty. Of course one sees many people who are poor – those who are not poor, the world over, remove themselves from public space in taxis or air-conditioned cars. There is a complex set of historical, social, cultural, and economic factors underlying the poverty, but asymmetrical ignorance keeps us Westerners unaware of this multi-layered and contradictory reality.[15] We run the risk of behaving like bundles of shocked sensibility that only see "POVERTY" and thereby reduce individuals to nothing more than their economic status. Human beings are much more than just poor: they work hard or are good parents, they are witty or generous or sophisticated or beautiful, or all of those things. As complex as "we" are, in fact.

When I stepped from the street into the library to re-examine the notion of the gaze, I realized that there is no room for any of these complexities in its essentializing grip. When The Gaze first entered critical debate in the 1970s, it was important to identify the power imbalances in issues of representation. Over time, however, the concept solidified into an inflexible corset for issues much more complex than it could handle. It is surely significant that the critique of the gaze has been most forcefully articulated by the people who are supposedly being gazed *at*. Malavika Karlekar takes as her starting point that the history of photography in India is more nuanced than has generally been recognized and that "issues of agency and victimhood, choice

and denial come into play in a fast-changing and far from complicit and acquiescent environment" (20). In *Women Travelers in Colonial India*, Indira Ghose points out the frequently overlooked

> barrage of critical gazes directed at the British. No inarticulate subaltern here, the gazes at issue are those of a highly sophisticated and articulate other. They hint at an entire world of subversive discourse with the colonizing subject as object of their critical and mocking gazes.
>
> (155)[16]

The scholarly deconstruction of the colonial agenda has been an essential aspect of the historical analysis, but it has also tended to blind us to the actual portraits that the colonial photographers produced. The focus has been so insistently on the ideology of the gaze that, ironically, those being gazed at remain an unexamined, undifferentiated, passive group of humanity. An important implication of the points of view adopted by Karlekar and Ghose, among others, is that it is high time that the analytical Western eye stopped being obsessed with the colonial photographers.[17] If we set aside this collective obsession for a minute or two and look closely at the portraits these disreputable photographers made, what will hit us is how uncontrollable the gaze back often is, how it soars free from whatever ideology drives the photographers or their paymasters.

The colonial gaze was never as straightforward an instrument of appropriation and power as its past advocates and its present detractors maintain; the same applies to its offspring, the tourist gaze (or indeed any gaze through the viewfinder). In the words of Edward Said, at the end of *After the Last Sky*:

> I would like to think that we [Palestinian people] are not just the people seen or looked at in these photographs: We are also looking at our observers. . . . We are more than someone's object. We do more than stand passively in front of whoever, for whatever reason, has wanted to look at us.
>
> (166)

Despite this warning from the critic renowned for his finely tuned antenna for the essentialization of the "exotic" other, the tourist gaze still dominates the debate. And yet the eyes looking *back* sabotage the objectification that the social scientists tell us is inevitable.[18] The political irony is that by denying recipients of the gaze any form of agency or autonomy, the concept overlooks those whom it seeks to protect. It is the theory rather than the camera that disempowers the people, societies, and cultures that the critics think they are defending.

In the arena of the male gaze, by contrast, feminists have had more luck in arguing successfully against its supposed all-powerfulness (Wilson 104, G. Rose 122). In "Sexuality in the Field of Vision," Jacqueline Rose finds an opening for radical subversion:

> If the visual image in its aesthetically acclaimed form serves to maintain a particular and oppressive mode of sexual recognition, it does so only partially and at a cost. Our previous history is not the petrified block of a singular visual space since, looked at obliquely, it can always be seen to contain its moments of unease. We can surely relinquish the monolithic

view of that history, if doing so allows us a form of resistance which can be articulated *on this side of* (rather than beyond) the world against which it protests.

(233, emphasis original)

I would argue that we can apply this to the representation of other "othernesses." There is the possibility, indeed the political imperative to "look obliquely" and disrupt the illusion of knowledge. This is where the tourist may come into her own. Whether we use the opportunity or not, as tourists we are perfectly placed to look obliquely: we are free from daily routines and responsibilities, we are not in the pay of anyone, we do not try to sell a "story," we do not serve anyone's agenda, we do not have a pet theory to prove. We are at liberty to wander, to look, to wonder, to interact. If photography does anything, it celebrates the particular – in a face, in a doorway, in a street scene, in a moment. And if tourists are confronted with anything, it is the particular. The tourist encounter in a distant land can be the actual, physical spot where the complexity and the mystery of other people's lives – political, social, cultural, economic – become unavoidably real. If this makes us insecure about what we think we know and at a loss for answers, all the better. The camera can force us to rethink our certainties and preconceptions: it roots us in a real spot surrounded by real human beings, who respond to our presence and who expect a response from us in return.

The condemnation of the tourist and of the tourist gaze has also been overtaken by time itself, which I can only hint at here. On a global level, the currently "correct" term "developing nations" has become even more patronizing now that the "developed" nations have managed to develop both global recession and global warming. On a pedestrian level, mobile phones are everywhere in urban India, cheap enough not to be the exclusive property and status symbol of the middle classes. In recent years, almost every day, I have been asked to pose for or been surreptitiously snapped by mobile phones, often in the hands of children (and it doubtless happens far more often than I notice). This changes the dynamics of the photographic encounter as well as the meanings attached to portraits. In India, it is no longer the foreign tourists who hold the monopoly of photographic representation – if we ever did.

Conclusion

The fatal flaw in the discourse of the gaze is that it objectifies those who are supposedly being gazed at much more thoroughly than the gaze itself manages to do. Tourism is not going to disappear, or at least not for ethical reasons (economic meltdown and rising fuel costs are a different matter). While it is dangerous to make generalizations about roughly 900 million people crossing borders on holiday every year (UNWTO 3), those millions have been tarred with the same brush for so long that it is time to start developing a critical language that is agile enough to discuss the possibilities as well as the problems, the successes as well as the failures of the camera. We should be working towards an ethics of tourist photography along the lines that we are articulating, at last, an ethics of consumption in both green and fair trade and an ethics of tourism in eco and responsible tourism.

In a city such as Kolkata, old certainties crumble even faster than old façades: notions of surveillance, intrusion, appropriation, and exploitation all turn out to be rather more complex than theorists from the more dogmatic end of the scale would have us believe. It is in individual encounters that the poetic particularity of places and the indelible distinctiveness of human beings come to life and can be explored. It is in the same encounters that we start to wonder what it is that we think we know, which in turn may prove the beginning of a new, urgent political inquiry into the world and the judgments with which the West has traditionally, arrogantly, divided it up. The camera is one of the tools that can trigger this curiosity and for this reason alone it should not be dismissed.[19]

Acknowledgements

Without ongoing conversations in Kolkata I would not have been able to examine my own position in the way that I do. I am grateful to writer and biographer Krishna Dutta, Suvendu Chatterjee of photo agency *Drik India* (www.drik.net/india), documentary maker Joshy Joseph and Kusum Jain, founder of the feminist organization *Women's Sahayog*. I also thank Christien Franken for her stylistic advice and Christopher Tribble for his scanning skills.

Original publication

'The Eyes of The Street Look Back: In Kolkata with a Camera Around my Neck', *photographies*, (2011)

Notes

1 "The West" is so crude a term as to be almost unusable – but not quite. Politically, it still refers to an economic and political power bloc as well as to a shared vantage point from which the "rest of the world" is being looked at. I shall use "we" in the same way: not because the people living in "the West" constitute a homogenous group, but because we share enough, in relation to India, to make these valid terms. I include myself in both groups.

2 In the Western media, "Calcutta" is still a by-word for hell on earth. There are few tourists and hardly any tourist industry.

3 There is also small revisionist camp in the West, which to my mind swings to the other extreme by denying the insidious ideology of colonial photography. See for instance Ken Jacobson (2007).

4 Sontag's qualifier "most" is frequently lost in quotation.

5 To be completely accurate: I first visited Calcutta briefly in 1997, on the fourth of my annual holidays to different parts of India. I got hooked on my second visit in 2002 and have been returning every year since.

6 The portrait is apparently a very different representation of a human being in India (Pinney 1997: 198–201), therefore the Western photographer in the streets of Kolkata and the people in front of her lens may well be engaged in very different kinds of

portraiture even as we interact. At this stage, an investigation of the significance of this would take me far beyond the limits of this paper and of my knowledge.

7 Of course *the* meaning is famously, wondrously slippery at the various points of the photograph's reception – although tourist photographs are seldom awarded the ambiguity for which other photographic genres are analyzed.

8 I have checked this with Indian friends, professional photographers among them, to make sure it is not just my imagination.

9 The dynamics are totally different, of course, when people are the victims of humanitarian disasters – but that is an issue for documentary and press photographers to grapple with.

10 As has been stressed by Pinney (2004), among others, the whole concept of "seeing" is different in India; in Hinduism, when you see, you are seen. I suppose that in that sense visual perception is conceived to be like touch, and surely rightly so.

11 I am grateful to Dr Karsten Giese, who corrected me at the First International Visual Methods conference in 2009, where I said that the eyes looking back reclaim the street. The street is already his, he does not need to reclaim it. Instead he reclaims the photograph, which I imagined to be mine.

12 Or indeed any photography of "the other," in any photographic genre, distributed in any medium, by amateurs or professionals.

13 In his scathing review of Channel 4's much-trumpeted *Indian Winter* season, Aditya Chakrabortty points out that "there were no Indian or Indian-origin commissioners across the entire season." (*The Guardian* 13 January 2010). The West's ignorance of Indian photography was also striking in the pleasantly surprised reactions of many reviewers to the Whitechapel's 2010 exhibition *Where Three Dreams Cross: 150 Years of Photography from India, Pakistan and Bangladesh* (see O'Hagan in *The Guardian*, Pitman in *The Times*).

14 He is also the founder of the DRIK photo agency on the subcontinent, and co-founder of Majority World, the global initiative that champions and sells work by indigenous photographers. See www.majorityworld.com.

15 "This problem of asymmetric ignorance is not simply a matter of 'cultural cringe' . . . on our part or of cultural arrogance on the part of the European historian" (Chakrabarty 2000: 28).

16 Ghose uses the word figuratively in her literary study of British women's written accounts of India.

17 Christopher Pinney has produced a great deal of fascinating work on the complexities of the practices of photography in India (e.g. 1997, 2004, 2008).

18 Alex Gillespie has recently introduced a welcome complexity to the gaze by examining the reverse gaze of the "photographees" (Ladakhi people, in his case); but in his account, too, all tourists are alike, as are all Ladakhis. Moreover, he assumes that their "reverse gaze" is only triggered by the tourist gaze through the camera.

19 If we all were to stop photographing strangers in the streets, at home and abroad – and being photographed by them – we would end up in the situation before photography democratized portraiture: only the wealthy could afford to have portraits made. The wealthy and the famous . . .

Works cited

Alam, Shahidul. "The Visual Representation of Developing Countries by Developmental Agencies and the Western Media." *ZoneZero* 1994. <http://zonezero.com/magazine/articles/shahidul/shahidul.html>.

Bauman, Zygmunt. *Postmodern Ethics*. Oxford: Blackwell, 1993.

Chakrabarty, Dipesh. *Provincializing Europe: Postcolonial Thought and Historical Difference*. Princeton, NJ: Princeton University Press, 2000.

Chakrabortty, Aditya. "Channel 4's View of India Is a Cliché." *The Guardian* 13 Jan. 2010. <www.guardian.co.uk/commentisfree/2010/jan/13/channel-4-indian-winter-season>.

Clifford, James. *Routes: Travel and Translation in the Late Twentieth Century*. Cambridge, MA: Harvard University Press, 1997.

Crouch, David and Nina Lübbren, eds. *Visual Culture and Tourism*. Oxford: Berg, 2003.

Dehejia, Vidya, ed. *India through the Lens: Photography 1840–1911*. Washington: Freer Gallery of Art/Mapin/Prestel [exhibition catalog], 2000.

Falconer, John. "A Passion for Documentation, Architecture and Ethnography." In *India through the Lens: Photography 1840–1911*. Ed. V. Dehejia. Washington: Freer Gallery of Art/Mapin/Prestel, 2000.

Forbes Watson, J. and J. W. Kaye. *The People of India*. Bath: Pagoda Tree Press [reprint of the original, 8-volume, 1868 edition], 2007.

Fussell, Paul. *Abroad: British Literary Traveling between the Wars*. New York and Oxford: Oxford University Press, 1980.

Ghose, Indira. *Women Travelers in Colonial India: The Power of the Female Gaze*. New Delhi: Oxford University Press, 1998.

Gillespie, Alex. "Tourist Photography and the Reverse Gaze." *Ethos* 34.3 (2006): 343–366.

Gupta, Sunil, curator. *Where Three Dreams Cross: 150 Years of Photography from India, Pakistan and Bangladesh*. Göttingen: Steidl [Whitechapel, London, exhibition catalog], 2010.

Gutman, Judith Mara. *Through Indian Eyes: 19th and Early 20th Century Photography from India*. New York: Oxford University Press/International Center of Photography, 1982.

Hutnyk, John. *The Rumour of Calcutta: Tourism, Charity and the Poverty of Representation*. London: Zed, 1996.

Jacobson, Ken. *Odalisques and Arabesques: Orientalist Photography 1839–1925*. London: Quaritch, 2007.

Karlekar, Malavika. *Re-Visioning the Past: Early Photography in Bengal 1875–1915*. New Delhi: Oxford University Press, 2005.

Lévi-Strauss, Claude. *Tristes Tropiques*. London: Jonathan Cape [French original 1955], 1973.

MacCannell, Dean. *The Tourist: A New Theory of the Leisure Class*. New York: Schocken Books [originally published 1976], 1989.

Massey, Doreen. "Is the World Really Shrinking?" OU Lecture. *Free Thinking* Festival 5 Nov. 2006. <www.open2.net/freethinking/oulecture_2006.html>.

O'Hagan, Sean. "Home . . . Through Eastern Eyes at Last" [review of *Where Three Dreams Cross*]. *The Observer* 24 Jan. 2010. <www.guardian.co.uk/artanddesign/2010/jan/24/where-three-dreams-cross-photography>.

Osborne, Peter D. *Travelling Light: Photography, Travel and Visual Culture*. Manchester: Manchester University Press, 2000.

Pinney, Christopher. *Camera Indica: The Social Life of Indian Photographs*. London: Reaktion Books, 1997.

———. *The Coming of Photography in India (The Panizzi Lectures 2006)*. London: The British Library, 2008.

———. *Photos of the Gods: The Printed Image and Political Struggle in India*. New Delhi: Oxford University Press, 2004.

Pitman, Joanna. "Where Three Dreams Cross." *The Times* 22 Jan. 2010. <http://entertainment.timesonline.co.uk/tol/arts_and_entertainment/visual_arts/article6997290.ece>.

Ramamurthy, Anandi. "Spectacles and Illusions: Photography and Commodity Culture." In *Photography: A Critical Introduction*. Ed. Liz Wells. London: Routledge, 2004.

Rose, Gillian. *Visual Methodologies: An Introduction to the Interpretation of Visual Materials*. London: Sage, 2007.

stage, in which different roles, scripts, choreographies, group formations, instructions, and cues are followed" (p. 326). Furthermore, Shields believes that stereotypes and clichés associated with specific locations create a conglomeration of place-image which he calls "place-myths" (in Crouch & Lübbren, 2003). We will see that the "place-myths" associated with the case study location indeed invites specific choreographies due to Aphrodite's association with love, beauty, and sex.

To sum up, in order to (re)discover the richness of what lays behind a still image, researchers have shifted their attention: a. from the encounters between host and tourist to those found within groups of tourists (such as families, couples, etc.); b. from whether or not photographs reproduce existing landscape representations to the personal meaning of photographs; c. from the connection between photography and power to the connection between photography, meaning, and memory; and finally, d. from the social structures that shape actions to the personal performances associated with identity and self-expression. These changes in emphasis have benefited research in tourist photography immensely. However, as Haldrup and Larsen (2010) argue, because of its metaphorical appeal, "the notion of performance has been incorporated a bit too automatically and sketchily into tourist studies" (p. 6). For this reason, there is still the need for theoretical and methodological refinement (Haldrup & Larsen, 2010).

Interestingly, most researchers arguing for an active tourist emphasize vernacular tourist photography that features family and friends within a destination since social interactions and issues of self-identity are central to their arguments. Methodologies such as film, photo-elicitation, and observation are mainly used in order to expose these interactions. Even visual auto-ethnography has been successfully used to access sensual and emotional experiences (see, e.g., Scarles, 2009, 2010). In contrast, researchers arguing for a passive tourist make strong claims by highlighting landscape/cityscape representations. Most often content analysis is used to examine a large number of images. Taking into consideration these diverse approaches and study methods, this research uses mixed methods to examine both photographic processes and representations. The results of this study point towards an intermediate, more balanced tourist conceptualization which recognizes and accounts for both tourists' activity as well as the influence of social, structural, and visual constraints.

Study methods

Legend has it that the Rock of Aphrodite (or "Petra tou Romiou" in Greek) is the birthplace of the ancient Greek goddess of beauty. Located on the southwest coast of the Paphos region in Cyprus, it attracts thousands of tourists yearly who subsequently return home with postcards, souvenirs, and their own photographic representations of the location. The location of the Rock of Aphrodite was chosen as a case study because of its popularity and close identification with Cyprus. The two main research questions which evolved from the existing literature are: a. Do tourists complete a hermeneutic circle of reproduction with their landscape photographs? b. How do tourists engaged in a photographic act behave? What poses and roles do they assume? Does the specific site invite specific performances?

Since much of tourism is about images, photographs can play an important role in helping researchers access knowledge, learn about the social world (Rakić & Chambers,

2012; Stanczak, 2007) and read "the 'lives' and practices of tourists" (Haldrup & Larsen, 2012, p. 153). However, photographs are without a doubt polysemic in nature and thus can be interpreted differently depending on who views them, where, when, and how (Rakić, 2012). Furthermore, photographs are invested with personal, emotional and experiential loads which are not usually visible on their photographic surfaces. As a result, this polysemic and complex personal nature of tourist photography presents researchers with a difficulty in understanding tourists' photographic representations and processes. As Pink (2006) pointed out, the best one can hope for is to study the visible aspects of experience and not reality itself.

With this philosophical approach in mind, a variety of visual data were analyzed using a mix of quantitative and qualitative research methods in order to help answer the research questions. Specifically, three different methods were used: a. content analysis of postcards of the location and of images found on online photo-sharing applications; b. onsite observation using photo and video documentation as well as a researcher's diary; and c. semiotic and sociological analysis of representative examples. This methodological mix was chosen because it can cover both visual representations as well as photographic processes.

In order to determine whether or not a circle of reproduction exists I used content analysis of postcard representations of the Rock of Aphrodite and tourists' photographs posted on online photo-sharing applications. Content analysis can successfully identify variations and uniformities in large, diverse visual sets of data (Albers & James, 1988; Rose, 2007) and help researchers avoid searching through the photographs in order to confirm what they might think they already know (Rose, 2007). Furthermore, it can help researchers identify representative visual examples as well as exceptions.

Researchers who examined postcard imagery have argued that postcards influence the construction and representation of destinations to a large degree (Albers & James, 1988; Garrod, 2009; Mellinger, 1994). Fifty four postcards were collected from various kiosks and souvenir shops in the four largest cities of Cyprus (Nicosia, Limassol, Paphos, and Paralimni) during the summer months of 2010, which mark the height of the tourist season. The sample reached saturation, and thus was considered representative, when additional stores did not add any new images to the sample (Jokela & Raento, 2012).

These postcards were then compared with 400 images and accompanied comments extracted (in June 2010) from the two most popular online photo-sharing applications, Flickr and Picasa. Lo, Mckercher, Lo, Cheung, and Law (2011) showed that online photo albums are more popular with people older than 35 who are more experienced and enthusiastic tourists and are interested in engaging with a location at a deeper level. Even though online photo-sharing programs present researchers with the opportunity to examine photographs posted by this ideal audience, not much research has investigated the online posting of travel photographs.

Since the Rock of Aphrodite is also known as "Petra tou Romiou", both key phrases were used when searching through Flickr and Picasa. Due to the fact that Flickr hosts four times more related images than Picasa, the 300 most recent photographs were selected from Flickr and the 100 most recent photographs from Picasa. 200 photographs were landscapes (150 from Flickr and 50 from Picasa) and 200 portraits (150 from Flickr and 50 from Picasa). No differences in representation were observed in the two databases.

The data were separated into two categories: photographs of *landscapes* and photographs of *people*. The category "landscapes" includes images of the location with no apparent effort to include people in them, while the category "people" includes photographs where people are the main focus. To ensure replicability and validity of coding, the variables were clearly defined and special effort was given to create exhaustive and mutually exclusive categories (Bell, 2008; Rose, 2007). In a pilot study, two coders used the same categories to code 20 images. The agreement between coders (inter-coder reliability) was initially 91%. After discussing the elements of disagreement, two variables were adjusted and further clarified. When the pilot was repeated, the inter-coder reliability rose to 97.2%.

No matter how detailed and carefully done a content analysis is, it tells us nothing about the process of the photographic production or the photograph's symbolic meaning and significance (Albers & James, 1988; Haldrup & Larsen, 2012; Rose, 2007). In reality, content analysis usually has a "deadening effect" on images (Rose, 2007, p. 21) since it reduces them to surface representations. In order to allow images to "become alive" again, content analysis was combined with participant observation as well as semiotic analysis.

Participant observation can reveal the process of creating a photograph within a real setting as well as identify what is omitted in postcards or tourists' representations. I spent four continuous days (about five hours a day in July 2010) at the location of the Rock of Aphrodite observing and recording the photographic activity of tourists. Initially I planned to use photography as a visual record but very soon I realized that video was essential to recording photographic performances from the beginning to the end. During the analysis stage, video recordings were repeatedly viewed in order to allow me to pay attention to people's gestures and social relations. A researcher's diary was also kept which included observations, ideas, comments, descriptions, and analysis of visual records. The content analysis and observational research revealed some representative, key visual examples, which were subsequently analyzed in order to determine their symbolic meaning (Bell, 2008).

It is usually considered ethical to include in publications visual documentation that was recorded in a public space where no legal or other restrictions for photography or videomaking are imposed (Rakić, 2010; Tresidder, 2012). Actually, at the Rock of Aphrodite, photography is encouraged and widely practiced. To avoid influencing tourists' performances permission to record was not asked. Since many tourists were using their cameras, I appeared to be just another tourist with a camera, and thus the observation was unobtrusive. I never hid my camera (DSLR camera which can also produce video) and avoided recording any still or moving images that might have infringed upon the ethical or legal rights of any of my subjects. Finally, I have contacted the legal copyright holders of all the postcards and Flickr photographs presented in this article and received permission to use them.

Landscape photography and hermeneutic circle of reproduction

In the context of tourism, landscape and host representations are often homogenized and exoticized all over the world. Postcolonial theories have shown how spaces and people in non-Western countries are romanticized and exoticized through

photography by omitting any indicators of development and industry or contemporary dress and actions (Albers & James, 1983; Price, 2009). In the case of Cyprus, the Cyprus Tourism Organization promotes Cyprus as an authentic, rural, and traditional destination by eliminating any symbols of modernity, current political events, or cosmopolitanism (Eftychiou & Philippou, 2010).

Referring to the Rock of Aphrodite, the Cyprus Tourism Organization website (n.d.) states:

> According to legend, this strikingly beautiful spot is where Aphrodite rose from the waves and the foaming sea and was then escorted on a shell at the rocks known as "Rock of Aphrodite" or "Petra tou Romiou" in Greek. The Greek name, Petra tou Romiou, "the Rock of the Greek", is associated with the legendary Byzantine hero, Digenis Akritas, who kept the marauding Saracens at bay with his amazing strength. It is said that he heaved a huge rock into the sea, destroying the enemy's ships.

This basic description of the two legends immediately associates Cyprus with its Greek and Byzantine past and thus avoids any political discussions that involve "unsanctioned" Turkish Cypriot perspectives which revolve around the location's name as well as the figure of Aphrodite. Interestingly, Turkish Cypriots prefer to use the Latin name of the goddess (Venus) and named the location the "Rock of the Infidel" (Papadakis, 2006).

The narratives that accompany the landscape photographs and images found on Flickr and Picasa are similar to the ones offered by the Cyprus Tourism Organization. However, the myth of Aphrodite seems to be the most prominent one since it is repeatedly used in promotional material associating Cyprus with Aphrodite. Surprisingly, one more "legend" emerged from the comments on these online albums, a legend that involves tourists themselves. According to one user: "Legend has it that should one swim around the prominent rock three times, naked and under a full moon they will find true love". Another user mentions that if one swims naked around the rock three times, he/she will find "eternal youth" or, yet another mentions, "eternal beauty". In any case, this last "unofficial" legend, a most probably recent construction, steers away from grand mythological narratives or extraordinary male heroes and places the tourist under the spotlight – the tourist and his/her performances.

Dominant views

In the case of the Rock of Aphrodite, postcards usually present the location as unspoiled, primitive, and remote, despite the fact that a modern road is located a few meters from the location. Furthermore, a tunnel connects the site with a snack bar and souvenir shop, shower facilities, and a large parking lot. Nevertheless, a content analysis of 54 postcards present the Rock of Aphrodite as an idyllic location, with clear blue skies and blue waters (76%), or alternatively, saturated with the orange-red colors of a romantic sunset (24%). The photographs are most often taken from a cliff's edge (61%) and do not include any people in them (78%) (see Figures 7.1 and 7.2).

Figure 7.1 Postcard of Rock of Aphrodite. [Original in colour]. Courtesy of Theodorou Galleries.

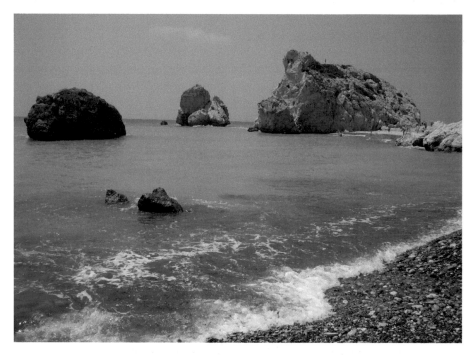

Figure 7.2 *Photo of Beach*. [Original in colour]. Courtesy of John Thurm/EyeEm.

Eleven postcards (22%) include humans in the image but most of them appear to be tiny, ant-sized, and therefore ignored. Only three postcards intentionally include a person in the image and all three feature a single female in profile, in her swimming suit, staring calmly at the blue sea. With or without the contemporary "Aphrodites", the location is presented as exotic, romantic, discovered for the first time.

The 54 postcards were compared with 200 landscapes found on Flickr and Picasa. It seems that the orientation and point of view of these two sets of photographs are surprisingly similar. From the landscape photographs found on Flickr and Picasa, 85.5% of them are framed horizontally (postcards: 81%), 90% where taken during the day (postcards: 76%) and all of them appear in color (postcards: 100%). Furthermore, they are mostly taken from above (59.5%), and more particularly, from a cliff's edge (postcards: 61%). As a result the sea and sky are the dominant elements with the Rock of Aphrodite occupying less than 10% of the photograph (55%, postcards: 52%). This confirms the hypothesis that tourists consciously or unconsciously reproduce postcard images with their own photographs.

The only significant difference is the tendency of postcards to depict the landscape at sunset (24%) more often than photographs taken by tourists (9.5%). It seems that tourists will reproduce what they see in postcards but will not go out of their way to do so. For example, if they visit the location during the day, they will not wait until sunset in order to photograph it. This is consistent with Garrod's (2009) findings, which show that tourists copy popular images of the town of Aberystwyth, though they would rarely walk all the way to the top of the town in order to get a panoramic view as most postcard photographers do.

View from a cliff and avoiding other tourists

Postcards and landscape photographs of the Rock of Aphrodite taken by tourists converge in two significant aspects: most of them were taken from a cliff's edge and most avoid including other people in the photographic frame. The first similarity is probably due to structural factors. A high viewpoint off the road leading to the Rock of Aphrodite offers tourists a parking place where they can admire the view from a steep cliff and of course take photographs. Many tour buses stop at the location to offer tourists this photo opportunity. Furthermore, a view from a cliff exaggerates the remoteness and idyllic qualities of the landscape and easily avoids the inclusion of other tourists (Suonpää, 2008).

The second similarity is especially interesting. Even though the location is a popular one with many tourists present at any time of the day, only 16.5% of the landscape photographs include other people in the photographic frame. Even in the cases were people appear in the photograph, it seems that this is only because it could not be avoided. Tourists would patiently wait for other tourists to finish photographing the Rock and move away from the edge of the cliff so they could occupy the same position in order to take a similar picture – one that avoids other tourists. Culler (1981) might be right when he mentions that " . . . part of what is involved in being a tourist is disliking tourists (both other tourists and the fact that one is oneself a tourist)" (p. 130). Of course the absence of any other tourists reinforces the idea of remote, pure, and romantic scenery.

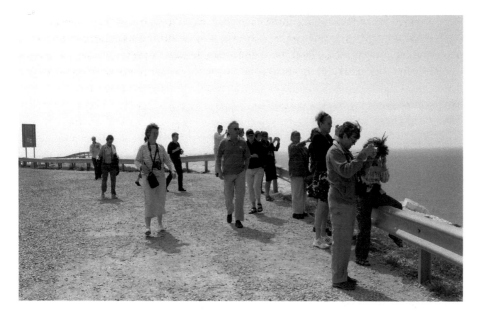

Figure 7.3 *Photo of Tourists on Rock of Aphrodite* from Flickr [Original in colour]. Theo Groen.

Only one exception was found in the sample. From the designated viewpoint, one tourist turned his back to the Rock of Aphrodite and photographed his fellow tourists who were busy photographing the scenery (see Figure 7.3). After examining the photographer's whole online album it became obvious that this was the only picture that did not feature a landscape or people posing for the camera and thus was an exception not only in the research sample but also in the specific photographic album. When the photographer was contacted in order to get permission to use his image he responded: "I never thought that a picture of the group that I posted to share with the members of the group *but omitted to cleanup*, would have scientific significance" (emphasis added, e-mail correspondence). This correspondence indicates that including other tourists in the photographic frame is usually considered a "mistake", something to avoid, or delete if it accidentally happens.

This striking similarity between postcards and the tourists' landscape snapshots of the location undoubtedly confirms the claim of a circle of hermeneutic reproduction. However, this only applies to landscape photography and not to portrait photography, where representations of the self and social relations are more crucial and therefore other conventions come into play.

Portrait photography, photographic conventions, and tourists' performances

Representing friends and family is not the same as representing a newly encountered landscape at a foreign destination. As mentioned, only three postcards of the Rock of Aphrodite include a person and in all cases that person is a young, sexy woman in her swimming suit staring romantically at the blue sea. Only two similar representations

were found in the online photo albums examined. Even though tourist portrait photography does not copy images found in postcards, it does seem to follow a different set of photographic conventions. The following sections use key examples that emerged from this study in order to explore photographic conventions and tourists' performances.

"I've been there"

A content analysis of the 200 portraits found on the online photo albums examined indicate that the majority have a horizontal orientation (76.5%), are shot during the day (97%) in color (95.5%), and the photographer is at eye level with his/her subject(s) (81%). The subjects usually appear in full portrait (66.5%), face the camera (69%), seem to be posing for the camera (73.5%) and only a small percentage do not smile (18%). In the background one of the three main rock formations that can be identified as the Rock of Aphrodite is prominent (81%), while other tourists are usually excluded from the photographic frame (76.5%).

The act of posing in front of a landmark seems to follow specific conventions: frontality, eye-level shooting, smiling, posing, and letting the landmark show. This seems to be the ultimate proof of "being there". It exemplifies a photographic convention, a part of a universal visual language, that is used and understood by people regardless of ethnicity, class, education, economic or cultural capital. As Milgram (1977) commented, photography has created a new choreography of gestures and movements that did not exist before the creation of photography.

Playfulness and possession

Because of the two-dimensionality of photography, something interesting happens when a person is standing in the foreground with an object of interest in the background. He/she can play with the dimensions of the landmark (Suonpää, 2008). With the help of photography, a tourist can create an image where he/she is kissing the Sphinx, picking up the Eiffel Tower in Paris or trying to straighten the leaning Pisa tower in Pisa. In our case, the Rock of Aphrodite becomes a small stone that can be stepped on, kicked into the sea, picked up, or held in one's palm (Stylianou-Lambert, 2010). All these actions indicate a playful attitude and a sense of ownership.

Place specific performances: love, beauty, and sex

The birthplace of the goddess of love seems to invite choreographies and performances associated with love, beauty, and sex. The following examples, which emerged through onsite observation, will demonstrate that indeed different sites become stages for different performances.

Many couples choose the location to perform their feelings of love, affection, and dedication. In one occasion, a small group of tourists arrived at the sunny beach. Before they even put their bags down they asked another tourist which of the three prominent rocks is Aphrodite's rock. A woman pointed towards a rock formation a few meters

into the sea which is actually not the "official" Rock of Aphrodite. Immediately, a man and a woman undressed and jumped with their swimsuits into the sea. A third person remained on the shore with a camera. The couple positioned themselves midway between the photographer and the alleged Rock of Aphrodite and started performing for the camera. They assumed different poses, initially just standing, then hugging, then opening their arms to the side, and then kissing. The photographer patiently recorded all their actions in a series of photographs. When the couple finished posing, they exited the water and hurried to see the photographs on the digital screen of the camera.

Aphrodite, as the goddess of beauty and love, is also associated with sex. The following performance has as its protagonists a female photographer and her female friend. The desired image seemed to be an image of "Aphrodite" emerging from the sea, or at least a sexy version of the goddess. In this case, the photographer and her subject were engaged in an active and collaborative process to produce the ideal photograph. The subject, aware of her body and self-image, was trying to find body positions to correspond to the beautiful and sexy image she wanted to project. The photographer, aware of the desired result, was constantly moving around, changing positions and points of view as well as giving instructions (see Figure 7.4). Ironically, the poses taken and the movements of the photographer correspond to another set of conventions – those of the erotic photograph. This is how the choreography of a "Playboy" magazine shooting could have looked like without the expensive equipment, lights, and assistants. Therefore, different sets of conventions might also merge with tourism-related photographic conventions.

More often than not, tourists would focus on their own photographic processes and ignore others. Occasionally, however, they do notice other tourists and comment on their behavior. A comment on a landscape photograph on Flickr reads: "When I

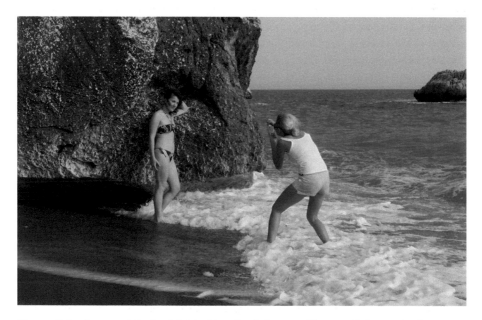

Figure 7.4 *Posing as Aphrodite*. [Original in colour]. Courtesy Theopisti Stylianou-Lambert.

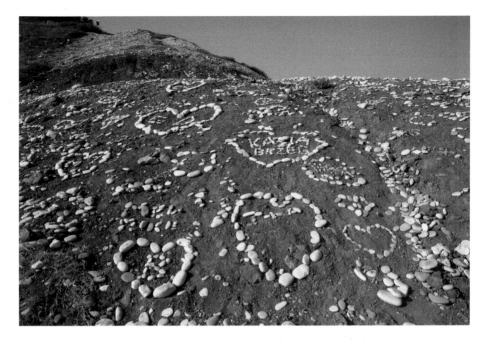

Figure 7.5 *Love Stones*. [Original in colour]. Courtesy Theopisti Stylianou-Lambert.

arrived here there was a woman of advanced years posing topless in front of the rock while her husband took photos!". Another comment on a photograph of a woman taking a picture of a man posing on a rock reads: "An unusual choice for a man to be having taken at Aphrodite's Rock, the birthplace of Aphrodite, the God of Love [sic] . . . ". Both comments indicate that people have specific ideas about how someone, in this case an elderly person and a male, should be photographed in a space associated with beauty, youth, and femininity. The same way some performances are considered appropriate, others are simply *not* appropriate for specific locations.

Another example of a tourist performance associated with love is the arrangement of "love stones". A hill opposite the Rock of Aphrodite is filled with white stones which are arranged in heart shapes. The tourists' initials are carefully placed in the interior of the shape again with white stones (see Figure 7.5). After arranging the stones, tourists usually photograph the result. Through the love stones, tourists seem to express their desire to alter in a small way the landscape, to leave a mark behind of their presence, the same way tourists leave a love note on the walls of Juliet's house in Verona, Italy. This performance was observed and copied by several tourists who visited the location. Since tourist sites are also social sites, tourists will take their cues not only from promotional material but also from other tourists.

Negotiations and identity construction

Photography is a tool for identity construction for both the photographer and the subject. The photographic image must register a desirable image, an image that corresponds

to one's sense of identity, or otherwise it is dismissed. Especially now with the use of digital photography, images can be taken, reviewed, and if necessary deleted on the spot. The following incident describes this process of negotiating images of self-identity.

A group of three teenage girls in their swimsuits are engaged in the photographic act for several minutes. The first girl takes a picture, reviews the image, consults with her friends, receives suggestions, steps backwards and takes another set of photographs. The camera changes hands. The second girl seems to be a more active photographer. She kneels on the ground for a more dramatic point of view, she directs the other two girls, and then reveals the result. The girls seem to be happy with the result so the third girl finally takes the camera. The other two girls pose and then play with the water for a more active picture.

This process of trial and error, of interaction between photographer and subjects, of negotiating, and directing is all part of constructing desired images which (re)create, and reinforce a sense of self. Similar events were described by Haldrup and Larsen (2003) when observing families. These kinds of actions reveal that social interactions constitute an important part of the photographic act and have the potential to be extremely creative and meaningful.

Photographic etiquette: the "privileged" space, and the "reciprocity rule"

A young woman was knee-high in the water photographing the Rock of Aphrodite. Then she tried to create a self-portrait with the Rock of Aphrodite in the background by stretching her arm as far as possible, turning the camera towards her and pressing the button. After looking at the resulting image she decided to move a few steps away from the Rock for a more successful picture. She carefully reframed her photographic frame, stretched her arm and took another picture. She repeated this process once more. When she was preparing to give it another try she suddenly noticed my presence. She appeared to be surprised, immediately stepped back, and, almost apologetically, waved at me to indicate that I can go ahead and take a picture now. Most probably, the woman thought she was crossing my photographic frame while I was trying to get a photograph of the location, and therefore felt the need to apologize.

This example shows that tourists might be concentrating deeply on their own photographic acts but they also seem to have an implicit understanding among themselves. They are respectful of the space between a photographer and his/her subject even in a crowded location. If this "sacred" or "privileged" (Milgram, 1977) space is crossed, it is considered rude and, at best, annoying. According to Milgram (1977), "The reluctance of bystanders to violate the line of sight measures the strength and legitimacy that they ascribe to the photographic act" (p. 54). Vernacular tourist photography is associated with crucial aspects of one's life, such as memories, family, adventure, and self-development, and thus occupies a strong position on the list of things to do when abroad. So strong, that it deserves respect.

What followed was also interesting. After noticing my presence, I asked the woman if she wanted me to take a picture of her with the Rock of Aphrodite. She seemed to be relieved and very happy with the idea. She smilingly handed me her

camera and went back into the water for a final pose. Interestingly, an individual will gladly give a stranger his/her expensive camera equipment in order to own a photographic proof of being there. Ironically, most tourists spend the rest of their time protecting their camera from strangers from fear of being robbed.

After I assumed the role of a tourist-photographer, I directed the woman and took a couple of photographs of her with her camera. The woman thanked me and asked me if I also wanted a picture with the Rock of Aphrodite. This seems to be another element of the tourist photographic etiquette, a kind of reciprocity rule: "I will help you take your picture if you help me take mine". The event described here was observed a number of times with individuals, couples, as well as with groups who wanted a group photo.

Conclusions

The first section of this paper attempts to capture the two ends of the spectrum of how tourists with cameras are conceptualized. Tourists are either seen as primarily fulfilling a limited role in a largely predetermined system or, alternatively, as active, performing agents in constantly reinvented spaces. This study assumes an intermediate conceptual approach which acknowledges both tourists' activity and the social, structural, and visual constraints that might influence this activity. For this reason, both photographic representations (what is created) and processes (how it is created) were examined using mixed research methods.

When it comes to landscape representations, it was found that tourists indeed reproduce images they have seen in postcards. A more careful examination reveals that structural factors (such as designated viewpoints) as well as conventions of how a landscape should look influence tourists' representations of the site. A different set of conventions seems to also apply when it comes to portraits of friends and family. The conventional pose, where one faces the camera and smiles while standing in a way that reveals the landmark but not other tourists, was the most usual among the photographs examined.

At the same time, a kind of photographic etiquette seems to exist among tourists. For example, the "privileged" space between the photographer and subject is respected while tourists will happily give their cameras to other unknown tourists in order to be photographed with a landmark or all the members in their traveling group. Tourists seem to see other tourists with cameras as less threatening, as sharing a common photographic "language", as one of "them". This social interaction among tourists who happen to be at the same destination at the same time and yet are mutual strangers deserves more attention.

Apart from sharing a photographic etiquette, tourists appear to feel that some performances are more appropriate than others at Aphrodite's birthplace. Since the goddess is associated with love, beauty, and sex, performances that echo these themes appear over and over again. This indicates that tourists' performances are not always stable. They are influenced by the location/stage they find themselves in, as well as what that location symbolizes.

Interestingly, a small number of photographs with individuals in front of the landmark appear to be less traditional since they play with the landmark. In certain cases, the Rock of Aphrodite became a small stone to be thrown into the sea, held in one's palm, stepped onto, or raised above one's shoulder. Play is considered a form

of empowerment that breaks from traditional photographic conventions and helps celebrate "amateurism and the instantaneous" (Robinson & Picard, 2009, p. 6). Photographic reality becomes personalized, fragmented, playful, and light. However, we need to be careful before suggesting that these playful performances liberate tourists from conventions. Other tourists, noticing this game, copy it. As a result, the constant repetition of specific acts of playing with a landmark, such as holding the Eiffel tower or the pyramids of Giza in one's fingertips, slowly turns them into another photographic convention. Furthermore, whether or not and to what degree playing with a location is empowering for tourists can be debated.

Overall, the results of this study indicate that the cultural construction of places evident in popular images and myths, structural factors, sets of social and visual conventions as well as photographic etiquette heavily influence tourists' photographic processes and representations. This can explain to a large degree the visual uniformity that becomes apparent when analyzing tourists' photographs. However, photographic representations tell us nothing about how tourists' images are "rewritten through experiential encounter" (Scarles, 2009, p. 480). This research also highlighted some of the ways in which photographic processes involve complex social and personal negotiations that unavoidably add additional layers of meaning and inform the "rewriting" and reading of the photographs. However, even though tourists are active participants in the photographic process and produce images that have highly personal meanings, the images are still shaped by larger conventions. As Haldrup and Larsen (2010) mention, "we can conceptualize performance as a form of playful ritualized behaviour: partly constrained, partly innovative" (p. 12). To borrow the theatrically inspired terminology of the performative turn, one can envision tourists' performances as *improvisations* on changing stages with loose *social and visual scripts* that typically guide their activity.

In conclusion, this study argues for a more balanced and nuanced tourist conceptualization. Tourists with cameras can simultaneously be seen as reproducers of popular images *and* producers of images that are unique in the eyes of their creators. It is important to note that there is no conflict in the different roles tourists assume, as some literature might suggest. As in the case of everyday life, some structural factors and social conventions apply, but within these constraints people actively construct their own narratives, meaning, and sense of self-identity. Nevertheless, the question remains whether or not this activity influences the existing power balances and social structures, and if yes, in what ways.

Original publication

'Tourists with Cameras', *Annals of Tourism Research* (2012)

References

Abercrombie, N., & Longhurst, B. (1998). *Audiences: A sociological theory of performance and imagination.* London, Thousand Oaks, New Delhi: SAGE.

Albers, C. P., & James, R. W. (1983). Tourism and the changing photographic image of the great lakes Indians. *Annals of Tourism Research, 10*(1), 123–148.

Albers, C. P., & James, R. W. (1988). Travel photography: A methodological approach. *Annals of Tourism Research, 15*(1), 134–158.

Bærenholdt, O. J., Haldrup, M., Larsen, J., & Urry, J. (2007). *Performing tourist places.* Hants, Burlington: Ashgate.

Belk, R., & Yeh, H. (2011). Tourist photographs: Signs of self. *International Journal of Culture, Tourism and Hospitality Research, 5*(4), 345–353.

Bell, P. (2008). Content analysis of visual images. In T. van Leeuwen & C. Jewitt (Eds.), *Handbook of Visual Analysis* (pp. 10–34). Los Angeles, London, New Delhi, Singapore, Washington, DC: SAGE.

Boorstin, D. (1961). *The Image: A Guide to Pseudo-events in America.* New York: Harper Colophon Books.

Botterill, T. D., & Crompton, L. J. (1987). Personal constructions of holiday snapshots. *Annals of Tourism Research, 14*(1), 152–156.

Bourdieu, P. (2003). *Photography: A Middle-brow Art.* Oxfordshire: Polity Press.

Bourdieu, P., & Bourdieu, M. (2004). The peasant and photography. *Ethnography, 5*(4), 601–616.

Caton, K., & Santos, C. A. (2008). Closing the hermeneutic circle? Photographic encounters with the other. *Annals of Tourism Research, 35*(1), 7–26.

Chalfen, R. (1979). Photography's role in tourism: Some unexplored relationships. *Annals of Tourism Research, 6*(4), 435–447.

Chalfen, R. (1987). *Snapshot: Versions of Life.* Ohio: Bowling Green State University Popular Press.

Cohen, E. (1989). Primitive and remote. *Annals of Tourism Research, 16*(1), 30–61.

Crang, M. (1997). Picturing practices: Research through the tourist gaze. *Progress in Human Geography, 21*(3), 359–373.

Crouch, D., & Lübbren, N. (2003). Introduction. In D. Crouch & N. Lübbren (Eds.), *Visual Culture and Tourism* (pp. 1–20). Oxford, New York: Berg.

Culler, J. (1981). Semiotics of tourism. *The American Journal of Semiotics, 1*(1), 127–140.

Cyprus Tourism Organization. (n.d.). *Petra tou Romiou – Rock of aphrodite.* Retrieved July 1, 2010 from <www.visitcyprus.com>.

Edensor, T. (2000). Staging tourist: Tourists as performers. *Annals of Tourism Research, 27*(2), 322–344.

Eftychiou, E., & Philippou, N. (2010). Coffee-house culture and tourism in Cyprus: A traditionalized experience. In J. Lee (Ed.), *Coffee Culture, Destinations and Tourism* (pp. 66–86). Bristol, Buffalo, Toronto: Channel View Publications.

Garrod, B. (2009). Understanding the relationship between tourism destination imagery and tourist photography. *Journal of Travel Research, 47*(3), 346–358.

Graburn, N. H. (1989). Tourism: The sacred journey. In V. L. Smith (Ed.), *Hosts and Guests: The Anthropology of Tourism* (pp. 21–36). Philadelphia: University of Pennsylvania Press.

Haldrup, M., & Larsen, J. (2003). The family gaze. *Tourist Studies, 3*(1), 23–45.

Haldrup, M., & Larsen, J. (2006). Material cultures of tourism. *Leisure Studies, 25*(3), 275–289.

Haldrup, M., & Larsen, J. (2010). Performing tourist, performing the Orient. In M. Haldrup & J. Larsen (Eds.), *Tourism: Performance and the Everyday: Consuming the Orient* (pp. 1–19). London, New York: Routledge.

Haldrup, M., & Larsen, J. (2012). Readings of tourist photographs. In T. Rakić & D. Chambers (Eds.), *An Introduction to Visual Research Methods in Tourism* (pp. 153–168). Oxon, New York: Routledge.

Harrison, B. (2004). Snap happy: Towards a sociology of "everyday" photography. *Studies of Qualitative Methodology, 7*, 23–39.

Hunter, W. C. (2008). A typology of photographic representations for tourism: Depictions of groomed spaces. *Tourism Management, 29*(2), 354–365.

Jokela, S., & Raento, P. (2012). Collecting visual material from secondary sources. In T. Rakić & D. Chambers (Eds.), *An Introduction to Visual Research Methods in Tourism* (pp. 53–69). Oxon, New York: Routledge.

Larsen, J. (2005). Families seen sightseeing: Performativity of tourist photography. *Space and Culture, 8*(4), 416–434.

Lo, S. I., Mckercher, B., Lo, A., Cheung, C., & Law, R. (2011). Tourism and online photography. *Tourism Management, 32*(4), 725–731.

MacCannell, D. (1999). *The tourist: A new theory of the leisure class.* Berkley, Los Angeles, London: University of California Press.

Markwell, K. W. (1997). Dimensions of photography in a nature-based tour. *Annals of Tourism Research, 24*(1), 131–155.

Markwick, M. (2001). Postcards from Malta: Image, consumption, context. *Annals of Tourism Research, 28*(2), 417–438.

Mellinger, W. M. (1994). Towards a critical analysis of tourism representations. *Annals of Tourism Research, 21*(4), 756–779.

Milgram, S. (1977). The image-freezing machine. *Psychology Today, 10*, 50–54.

Papadakis, Y. (2006). Aphrodite delights. *Postcolonial Studies, 9*(3), 237–250.

Pink, S. (2006). *The Future of Visual Anthropology: Engaging the Senses.* London, New York: Routledge.

Price, D. (2009). Surveyors and surveyed: Photography out and about. In L. Wells (Ed.), *Photography: A Critical Introduction* (pp. 65–112). Oxon: Routledge.

Rakić, T. (2010). Tales from the field: Video and its potential for creating cultural tourism knowledge. In G. Richards & W. Munsters (Eds.), *Cultural Tourism Research Methods* (pp. 129–140). Oxfordshire, Cambridge: CABI.

Rakić, T. (2012). Philosophies of the visual [method] in tourism research. In T. Rakić & D. Chambers (Eds.), *An Introduction to Visual Research Methods in Tourism* (pp. 17–32). Oxon, New York: Routledge.

Rakić, T., & Chambers, D. (2012). Introducing visual methods to tourism studies. In T. Rakić & D. Chambers (Eds.), *An Introduction to Visual Research Methods in Tourism* (pp. 3–14). Oxon, New York: Routledge.

Robinson, M., & Picard, D. (2009). Moments, magic and memories: Photographing tourists, tourist photographs and making worlds. In M. Robinson & D. Picard (Eds.), *The Framed World: Tourism, Tourists and Photography* (pp. 1–37). Surrey, Burlington: Ashgate.

Rose, G. (2007). *Visual Methodologies: An Introduction to the Interpretation of Visual Materials.* Los Angeles, London, New Delhi, Singapore, Washington, DC: SAGE.

Scarles, C. (2009). Becoming tourist: Renegotiating the visual in the tourist experience. *Environment and Planning D: Society and Space, 27*(3), 465–488.

Scarles, C. (2010). Where words fail, visuals ignite: Opportunities for visual autoethnography in tourism research. *Annals of Tourism Research, 37*(4), 905–926.

Sontag, S. (2002). *On Photography.* London: Penguin Books.

Stanczak, C. G. (2007). Introduction: Images, methodologies, and generating social knowledge. In C. G. Stanczak (Ed.), *Visual Research Methods: Image, Society, and Representation* (pp. 1–22). Los Angeles, London, New Delhi, Singapore, Washington, DC: SAGE.

Stylianou-Lambert, T. (2010). Rock of Aphrodite: In 5 Photographic Acts. In P. Loizos, N. Philippou & T. Stylianou-Lambert (Eds.), *Re-envisioning Cyprus* (pp. 73–87). Nicosia: University of Nicosia Press.

Suonpää, J. (2008). Blessed by the photograph: Tourism choreographies. *Photographies, 1*(1), 67–86.

Tresidder, R. (2012). Representing visual data in tourism studies publications. In T. Rakić & D. Chambers (Eds.), *An Introduction to Visual Research Methods in Tourism* (pp. 187–200). Oxon, New York: Routledge.

Urry, J. (2002). *The Tourist Gaze.* Los Angeles, London, New Delhi, Singapore: SAGE.

Louise Wolthers

SURVEILLING BODIES
Photography as control, critique and concern

ALLA ÄR FOTOGRAFER ('We Are All Photographers') was the title of a recent TV series in Sweden. And even though the ubiquity of (amateur) photography calls on us to consider the use and potential of the medium, it would seem more pressing to discuss what could be summed up in another possible TV series title: 'We Are All Pictures.' Because in contemporary surveillance culture, this is a statement that holds true even for those who rarely take photographs and do not own a smartphone. The prevalent imaging of people today raises complex questions about behaviour, empathy, control, interaction and agency that we all need to address. Various forms of contemporary surveillance do, of course, have greater consequences for some individuals and sections of the population than others, namely the most socially vulnerable, as well as those who are already the object of voyeurism, exposure and visual control: women and ethnic and sexual minorities.

Current examples of registration and racial profiling in Scandinavia include the case of the personally sensitive digital register of over 4,000 Roma in Sweden (including public figures, well-known politicians and children as young as two years old) that regional police departments had established as a 'crime prevention measure', despite the fact that the vast majority of people in the register had no criminal record.[1] In December 2014 it was revealed that for a decade police in Stockholm had registered women who had reported violent attacks, in an internal register with offensive and pathologising comments, insinuating that the testimony of the victims might not be reliable.[2] Finally, there is the example of the young man of Turkish origin who was 'framed' as a terrorist by a fellow passenger on a Copenhagen train, triggering a police search and massive manhunt. It emerged that he was a university student on his way to an exam on the war on terror. In the hours before he became aware that he was wanted by the police – and immediately called the authorities himself – private and surveillance images of him were circulated on Twitter and other social and news media. The conclusion by the police was that their anti-terror alert system functioned satisfactorily.[3]

Images and gazes pervade our lives, and each and every one of us is in a constant state of potential 'framing' in public space: framing by others in the same area, by CCTV cameras, by mobile visual registration, as well as by all the digital traces we leave behind every time we use a mobile phone, credit card, etc. Even though most forms of contemporary surveillance are conducted via data registration, surveillance mechanisms can still be described using visual concepts and privileging sight.[4] Similarly, the photographic medium's traditional role in the framing, division, classification and registration of the social body and everyone marginalised from it remains relevant to the discussion of surveillance society. The history of photography and photography-based contemporary art can not only contribute to considerations of visibility, division, profiling and regulation, but can also point to the potential of surveillance and registration for empathy, protection and political empowerment.

Gender frames

It is hardly a coincidence that the first people to be subject to camera surveillance in England were women political activists – members of the Women's Political and Social Union (WPSU), better known as the suffragettes.[5] The police used both confiscated private portraits of the women and photographs taken without their knowledge to identify them. When the authorities tried to force the women to be photographed, they resisted by turning their heads away, pulling faces and closing their eyes. Scotland Yard therefore decided to take covert photographs of the women who were imprisoned, and could therefore be observed and photographed surreptitiously. A professional photographer, equipped with a new, expensive telephoto lens, sat hidden in a van in the prison yard, spying on and photographing the women.

The history of photography is full of examples of people being photographed under duress, as well as the direct and indirect surveillance of outcasts, outsiders and others: people who have either violated social gender norms and expectations, or represented the ethnic 'other', the colonised subject, or the exotic. There is a direct line from Scotland Yard's photographs of the members of the WPSU, to the scientific photography of anthropology and medicine in the 1800s; from Charcot's collection of photographs of 'hysterical' women at the Salpêtrière Hospital in Paris around 1880, to later colonial representations like French Marc Garangar's notorious identity photographs of Algerian women ordered to remove their veils for the photographer in 1960. Historically, a woman standing behind the camera and using it to create empowering counter-images by breaking the norms of the medium and gender was rare. A notable exception from the 1890s were the portrait photographers Marie Høeg and Bolette Berg, who had a studio first in Finland and then in Norway, and who also campaigned for women's right to vote. Their clientele was the better bourgeoisie, who had carte-de-visite portraits taken entirely within the strict templates dictated by the fashion of the day, reinforcing contemporary gender and class divisions. But behind the scenes Høeg and Berg photographed in a personal – and what we today would call queer – play on those very same codes. The resulting photographs, which include Høeg with a moustache wearing men's

clothes, were hidden away and not rediscovered until the 1980s. By that time, of course, a whole range of feminist artists had emerged using photography and appropriating its historical frameworks in political artworks that criticised patriarchal and sexist conventions of the image and gaze. A more recent example of a feminist insertion of the 'undisciplined' female body in art and photography history is Ann-Sofi Sidén's work *Untitled Studies (Sketches for Fideicommissum)*, which refers to patriarchal traditions of hereditary power and public statues as a way of paying tribute to and immortalising male figures. The main work is a public fountain sculpture of the artist herself, squatting and urinating with a bare behind, as a comment on the fact that historically men have been the ones to engage in territorial pissing, and the fact that boys urinating in public – also in sculptural form – is a more normal and acceptable sight. But the work also exists as a series of photographic studies of the artist squatting with her trousers around her ankles wearing a serious expression in an ironic pastiche on the photographic studies of the human body from the previous century, at the same time as insisting on making the female body that refuses adhere to aesthetic ideals visible.

Women have traditionally been among society's most looked at and surveilled subjects, something also true – often to a higher degree – of sexual minorities. The norm-breaking body, men who assume a heightened femininity and women who perform masculinely, transvestites, the transgendered, intersex people and other gender non-conformists, are generally more visible and attract the eyes of more photographers – not always intentionally or voluntarily. Surveillance and registration have functioned as disclosure, exposure to public contempt, and the shaming of behaviour that society considers reprehensible or perverted. However, activist and artistic appropriations of surveillance strategies and material have also been able to function as subversive and empowering.[6] This duality is expressed in Annica Karlsson Rixon's photographs from a Russian camp for lesbians on an island off the radar of the homophobic authorities. *At the time of the third reading / Vid tiden för den tredje läsningen / Во время третего чтения* is based on a bill that would increase the criminalisation of non-heterosexual ways of life in Russia, making it even more dangerous for most of the women on the island to be recognised and identified in this context. The artist refers to the authorities' harassment of the LGBTQ community, appropriating surveillance and spy technology by using a telephoto lens. But she refrains from any involuntary exposure, choosing instead to bring the forest to the fore in a series of images where dense rows of tree trunks could signal imprisonment, but also function as a safeguard.

In contemporary, digitalised visual culture, voyeurism and the surveillance of subjects that do not fit within Western, phallocentric legislation is simultaneously more intensive and more naturalised, i.e. more explicit. Which is perhaps why, despite the fact that women and sexual minorities have always been among the most watched and surveilled communities, until recently the issue of gender and sexuality has played a minor role in the field of surveillance studies.[7] This is something a number of transdisciplinary surveillance studies researchers have started to challenge recently, also by applying a contextualising gender perspective to Michel Foucault's theories of discipline and power – an obvious foundation stone of surveillance studies, in which biopower and governmentality are recurring pivotal points. The need for a feminist perspective is underlined by a series of actual cases of visual scrutiny

and exposure in public and semi-public spaces, including news, social and digital media, as well as the relationship between newer, digital surveillance technologies and violence against women.[8]

Machine-readable bodies

The regulation of the political and legal sphere itself is closely linked to the way the surveillance mechanisms of society currently read and register bodies. Today this regulation – with inspiration from the science theorist Donna Haraway – can be described as abstract and disembodied, like the allegedly neutral, omnipresent and authoritarian gaze of established Western science. The consequence of abstract, digitalised monitoring practices, as the surveillance theorist Toril Monahan points out, is that embodied lived experience, social equality, and alternative ways of life are devalued, and that these normative systems "draw on and reproduce traditionally masculine logics of rational, active, and disembodied control."[9] When these decontextualised and thereby discriminatory techniques are then also used to govern people, this both conceals and reinforces social inequality. When social control is exercised at a distance (or as an automated effect of the system), inequalities are more likely to be perceived as individual problems rather than structural or social issues. Developing a queer-feminist, class-conscious and anti-racist perspective on counter-surveillance has to include finding a basis for a more equal distribution of power by recontextualising these technologies in specific social contexts, places and bodies. With inspiration from Haraway's ideal of 'situated knowledge,' one strategy would therefore be to insist on intersectional, contextual experience and the body's resistance to abstract governmentality and classification.

The media theorist Irma van der Ploeg uses the term 'machine-readable bodies' to describe how biometrics function as a central and allegedly neutral tool in the authorities' sorting of people into gender, sexuality, race and class categories.[10] Today, when we are surrounded by biometric registration and everyone is expected to be prepared for 'stripping for the state,'[11] critical analyses of the normative body ideal (white, heterosexual, male) behind these technologies are crucial.[12] As Shoshana Magnet points out, biometric science is based on the assumption that the body is a stable, immutable container of personal information, and that biometric registration renders the unruly material body replicable, transmittable and segmentable. "Rising to prominence at a time when the state is determined to make citizens newly visible for the purposes of governance, biometric technologies are deployed to produce new understandings of security, the border and the nation-state." In doing so, biometrics "produce some bodies as belonging to the nation state while excluding others."[13] These new biopolitical technologies are self-perpetuating as a form of 'persuasive' protection, which simultaneously generates increased anxiety and suspicion in relationship to very specific bodies. The technologies ratify, for example, templates for 'the face of terror,' which racialise the terrorist threat.[14] In her book *Terrorist Assemblages: Homonationalism in Queer Times*, Jasbir Puar provides numerous examples of current complex, disciplinary and biopolitical mechanisms that privilege and create affiliations for certain (white, Western) subjects on the basis of the affective marginalisation of others, and describes how "terrorist bodies as a 'statistic population'

coagulate through an imagined worldwide collectivity – the Muslim world."[15] A constant virtual and actual profiling of the Middle Eastern body in particular that confirms the idea of unity in the first world.

Framing to kill

In his theories on the biopolitical regulation of the social body, which as we know supplements the disciplining of the individual body as a normalising exercise of power, Foucault describes racism as an alarmingly effective, 'scientific' way to fragment and sort the population into categories. "In a normalizing society, race or racism is the precondition that makes killing acceptable," as he writes.[16] 'Killing' here does not necessarily mean physical murder or war, but also indirect annihilation, like political death, expulsion and dispossession. In recent history, Nazism is of course a horrifying example of such 'improvement' of the species or race intended to function at every level of society to achieve *Endlösung*. The official, visual propaganda of Hitler's Germany illustrates this hyper-efficient, disciplining and regulating social machine as early as Leni Riefenstahl's *Olympia* (1936). Officially the film was to signal unity and 'Kraft durch Freude' ('Strength through Joy'), rather than any direct incitement to anti-Semitic violence, but the extreme surveillance aesthetics of the film are obvious, and the biopolitical purging had, of course, already begun.

Segregation is called apartheid ('aparthood') in Afrikaans, and the rigid, racist separation of apartheid was only possible due to an extensive apparatus of surveillance and control mechanisms. In the early 1960s, the South African photographer Ernest Cole documented the institutional, class and architectural segregation of the nation: separate banks, schools and toilets for blacks and whites, black nannies and white housewives, and the surveillance of boundaries between the races, like the counter where black miners had their fingerprints taken for documents granting them access to 'white' areas. Cole's photographs are not only important as vital, critical documentation of apartheid in South Africa, but also as a tribute to the capacity of oppressed groups to find temporary spaces and situations that were not dominated by apartheid. The photographs reveal non-surveilled 'cracks' in the system – and the hope of something different. They illustrate the paradoxical negotiations of visibility in a racist society, where blacks were categorised and rendered extremely visible as part of a strategy to make them *invisible* in relationship to rights, influence and empathy. At the same time, it was this same 'invisibility' in terms of the lack of influence and significance that made it possible for Cole to gain access to areas like the mine and photograph there. In the end, however, the photographs made Cole himself the subject of police attention, and he had to flee to the US to publish them in the book *House of Bondage*. Cole escaped South African apartheid, but the America he came to was also rife with racial tensions. This is something highlighted by Darren Newbury, among others, who implies that the text in *House of Bondage*, which Cole later distanced himself from, located the images all too specifically in a South African context, whereas alone the images could also have been seen as a critique of racism in 1960s America.[17] The political potential of the photographs is thus not limited to their specific, original context. Cole's images reveal the mechanisms of apartheid and the extreme

surveillance the system was based on, but they also function as a more general framing of the visual control mechanisms of racism.

Biopower is also exerted through war as a way to manage populations, and the medium of photography is a key meaning-generating framing of war. In her study of the epistemological frameworks that determine the valuing of life, Judith Butler analyses war photography's performative framing of people and events. She focuses on precarious lives, and explores how perceiving a precarious life as potentially grievable and therefore valuable, can generate ethical empathy. Referring to Susan Sontag's work on regarding the suffering of others, Butler argues that photography actually has the potential to influence the viewer's political opinions, i.e. certain photographs have a transitive potential that can urge us to acknowledge a life that has been and thereby also grieve its loss.[18] The photograph is hereby granted agency: it becomes a call and appeal to reject the idea that some lives are not worth grieving – the very idea that wars, terrorism and killing are based on.

This can be seen directly in Kent Klich's photographs of a funeral in Gaza, where he has photographed regularly for over a decade. His work represents a series of declarations about the massive impact of the war on daily life, like the endless homes destroyed by Israel's bombardment in 2009, when 1,400 Palestinians were killed. These images, from the series *Gaza Photo Album*, are included in the book *Killing Time*, in which Judith Butler writes: "Can these photos be said to mourn, or to give us the visual condition for mourning?"[19] Photography thus not only has the potential for empathy, but might in some cases be the only possibility that exists for grieving lost lives. *Killing Time*, the title of which refers to both the medium of photography and the consequences of war, also consists of a different kind of imagery: photographs and film fragments recorded on the mobile phones of now dead Palestinians, whose relatives have entrusted them to Klich. Here their daily visual registrations – or 'self-surveillance' – are granted the dual function of being mementoes of a precarious life lived and political testimony for posterity.

New visibilities

We are all many different kinds of image. Images in the form of data, abstractions and as the objects of voyeurism, desire, stereotyping, profiling, copying, sexism, racism, admiration, concern and respect. The biggest challenge facing us in our contemporary culture of hyper-visibility, is perhaps not that everyone is a photographer, but rather that the viewing machines that categorise, regulate, discipline and patrol the individual body operate through discriminatory abstractions that are simultaneously hidden by a semblance of neutrality and thus invisibility. Photography can contribute to making the various mechanisms in operation in the surveillance complex visible, alongside their very real effects. Which is why state powers and authorities often see the camera as a threat.[20] Photography can, in other words, function as a tool in counter-surveillance, including playing a role in critical, protective 'sousveillance.'[21] In a world of constantly new and complex zones of visibility, there is also the potential to create political, legal and social visibility – i.e. rights – for communities who have been so effectively screened out. A consensus based, limited and visible surveillance can generate inclusion, empowerment and protection. Everybody should have the right step out of the public eye now and then.

Original publication

'Surveilling Bodies: Photography as Control, Critique and Concern in Framing Bodies', *Art and Theory Publishing* (2015)

Notes

1 The case was first reported by Niklas Orrenius in the article Över tusen barn med i olaglig kartläggning. *Dagens Nyheter*. 23/10/2013.

2 First reported on the Swedish public radio programme *Ekot*. Sveriges Radio. 16/12/2014.

3 See for example Andersen, Pia Buhl. Politidirektør efter menneskejagt: Vi har ikke noget at undskylde. *Politiken*. 28/08/2014.

4 See for example Monahan, Torin. Dreams of Control at a Distance: Gender, Surveillance, and Social Control. *Cultural Studies: Critical Methodologies* Vol. 9, No. 2 (2009).

5 See for example Travis, Alan. Big Brother and the Sisters. *The Guardian*. 10/10/2003.

6 See for example McGrath, John E. *Loving Big Brother: Performance, Privacy and Surveillance Space*. London: Routledge, 2004.

7 Conrad, Kathryn. Surveillance, Gender, and the Virtual Body in the Information Age. *Surveillance & Society* Vol. 6, No. 4 (2009). Abu-Laban, Yasmeen. Gendering Surveillance Studies: The Empirical and Normative Promise of Feminist Methodology. *Surveillance & Society* Vol. 13, No. 1 (2015).

8 Mason, Corinne, & Magnet, Shoshana. Surveillance Studies and Violence against Women. *Surveillance & Society* Vol. 10, No. 2 (2012).

9 Monahan, p. 291.

10 van der Ploeg, Irma, & Sprenkels, Isolde. Migration and the Machine-Readable Body. In *Migration and the New Technological Borders of Europe*, Huub Dijstelbloem & Albert Meijer (eds.). Basingstoke: Palgrave MacMillan, 2011.

11 Magnet, Shoshana, & Rodgers, Toara. Stripping for the State: Whole Body Imaging Technologies and the Surveillance of Other Bodies. *Feminist Media Studies* Vol. 12, No. 1 (2012).

12 Kember, Sarah. Gender Estimation in Face Recognition Technology. *Media Fields Journal* No. 7 (2013).

13 Magnet, Shoshana Amiell. *When Biometrics Fail: Gender, Race and the Technology of Identity*. Durham: Duke University Press, 2011, p. 12.

14 Gates, Kelly A. *Our Biometric Future: Facial Recognition Technology and the Culture of Surveillance*. New York: New York University Press, 2011, p. 102 ff.

15 Puar, Jasbir. *Terrorist Assemblages: Homonationalism in Queer Times*. Durham: Duke University Press, 2007, p. 160.

16 Foucault, Michel. *Society Must Be Defended*. Lectures at the Collège de France 1975–1976. New York: Picador, 2003, p. 256.

17 Newbury, Darren. *Defiant Images: Photography and Apartheid South Africa*. Pretoria: Unisa Press, 2009, p. 207.

18 Butler, Judith. *Frames of War: When Is Life Grievable?* London & New York: Verso, 2009, pp. 77, 97.

19 Butler, Judith. Fragments of Lost Life. Klich, Kent and Butler, Judith. In *Killing Time*. Stockholm: Journal, 2013, p. 23.

20 Palmer, Daniel, & Whyte, Jessica. No Credible Photographic Interest: Photographic Restrictions and Surveillance in a Time of Terror. *Philosophy of Photography* Vol. 1, No. 2 (2010).

21 Mann, Steve, & Ferenbok, Joseph. New Media and the Power Politics of Sousveillance in a Surveillance-Dominated World. *Surveillance & Society* Vol. 11, No. 1/2 (2013).

Reportage: Image as agent

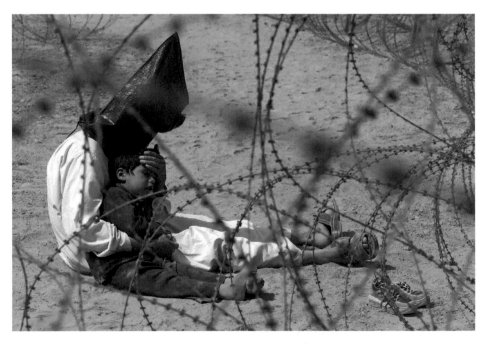

Jean-Marc Bouju, *US Army POW Center, near Najaf, Iraq*, 31 March 2003. [Original in colour]. Courtesy of AP Photo/Jean-Marc Bouju.

Introduction

THE PHOTOGRAPH BY TIVADOR DOMANICSKY, selected as frontispiece for this section, speaks of more than it shows: barbed wire, the metal uprights that once secured it, an upturned deckchair, a pitted wall with graffiti, a street with what might be a banner where a washing line might have been expected, two soldiers, and three boys wearing Middle Eastern clothing. 'Helmand Province, Afghanistan' (2010) is the stated location, but even without this caption the image connotes disruption, war, Islam, public space as male territory, and potential for confrontation. Although their stance seems quite casual, we cannot tell from the picture whether the troops are welcome or merely a now familiar fact of everyday life. In Fred Ritchin's chapter, as first published, this image was directly across the page from a picture of an execution in Syria (2013), a theme that has attracted much critical attention relating to the ethics of documenting such moments.

Since the second half of the nineteenth century there has been debate about the status and impact of photographs as evidence, especially relating to news and photojournalism, a genre that emerged in the early twentieth century when innovations in printing facilitated mass circulation of imagery (see Benjamin, 1936; Campany, 2014). In the 1970s there was concern that 'image fatigue', the idea that the public becomes inured to images of distress (war, famine, . . .), was leading to increasingly explicit pictures. Photographs alert us to specific circumstances, but for a photograph to arrest attention it needs to stand out from other visual information. The moral implications of the manner and circumstances of the making of an image also provoked discussion. For example, 'Saigon Execution' (1968) by Eddie Adams, in which we witness a Vietcong prisoner being executed, won a Pulitzer Prize for news photography and a World Press award; the 'achievement' generated a focus for arguments relating to news values, practices and ethics.

Then, the debates focused on photojournalism, the press and broadcast media. Now, since the advent of news media online and imagery as a primary means of social media communications, the traffic in photographs has increased exponentially, to an extent whereby it is extraordinarily difficult to make absolute distinctions between documentary evidence, 'fake' news and media manipulations, even for the purposes of scholarship. The massive accumulation of photographic information and the speed and flow of image circulation are daunting when we seek to reflect on the import, impact and ethics of news values and photojournalistic representation.

In *Regarding the Pain of Others* (2004), through reference to Virginia Woolf's discussion in *Three Guineas*, Susan Sontag reminded us that looking at images reinforces a distinction between 'us' the viewers and 'them', those whose lives have become the subject of horror images. As she noted, 'Being a spectator of calamities taking place in another country is a quintessential modern experience, the cumulative offering by more than a century and a half's worth of those professional, specialized tourists known as journalists' (Sontag,

2004: 16). She qualified this through reminding us that reading and significance are context-specific:

> [T]o an Israeli Jew, a photograph of a child torn apart in the attack on the Sbarro pizzeria in downtown Jerusalem is first of all a photograph of a Jewish child killed by a Palestinian suicide-bomber. To a Palestinian, a photograph of a child torn apart by a tank round in Gaza is first of all a photograph of a Palestinian child killed by Israeli ordnance. To the militant Identity is everything.
>
> (op cit: 9)

She also referenced conflict in the Balkans (1990s); her comments apply regionally, and globally.

In the first essay in this section, John Berger argues that violent imagery, abstracted from particular contexts, universalizes the idea of suffering rather than inviting analysis of specific events, thereby provoking a sense of moral inadequacy rather than political proactivity. Taken together the pictures juxtaposed by Fred Ritchin testify to troubles in the Middle East (Western Asia). Following Sontag, Ritchin agrees that a prevalent and generalized view of circumstances has previously contributed to reaffirming a distinction between 'them' and 'us'. However, he remarks that, through the agency of social media and the enhanced flow of visual imagery, photographs of that which might horrify may also be deployed as propaganda to condone – rather than condemn – brutality.

Likewise considering pictures from conflict zones, Francis Frascina analyzes images from Vietnam, 1968, and 'kill team' photographs from Afghanistan, 2010, that demonstrate disconnection between official representations of military activity and the actuality of abuse, torture and murder on the ground by American forces, presented as resulting from insurgent activities. Referencing work by British artist Steve McQueen and Chilean artist Alfredo Jaar, Frascina then reflects on artists' responses to atrocities as a means of bringing us face to face with the implications of conflict, particularly noting their blurring of faces to disguise the identity of victims as a – now increasingly familiar – response to the ethics of representation.

Exploring the ethics of representation in relation to images as a means of alerting us to a need for compassion and action, Liam Kennedy contrasts the conditions of work by Larry Burrows in Vietnam and of Jean-Marc Bouju in Iraq to explore changes in ways in which new media technologies extend the sphere of image and influence, and ways in which the influence of photojournalism on western perceptions reflects global power relations. He particularly notes common narrative scenarios, modes of framing and motifs that, he argues, continue to complexly re-inflect and reinforce ideologies that shape ways of seeing, knowing and responding to pictures of suffering as well as broader geopolitical apprehensions.

Photographs may operate as palimpsests for social relations, including ethnic tensions. Taking an example of a found photograph from Sarajevo, Bosnia, Sharon Sliwinski addresses questions of conflict through reflection on 'pictorial violence' – that is, the defacing of photographic images. Arguably this viciousness in itself

testifies to the indexical force of photographs. If an image is a means of asserting presence, or a perspective on historical moments, then its erasure signifies a denial of voice, a refusal to allow a right to communicate.

For Ariella Azoulay, the ethics of photo-reportage start with photography's role as a key mediator within the social relations of citizenship. She suggests that the reality values attributed to pictures are core to photography since accuracy of representation and communication is the prime purpose. Arguing that photographs as still images uniquely allow for a prolonged viewing engagement, thereby fostering a reflective, or action-oriented, response to circumstances depicted, she suggests that the (unwritten) civil contract between photographer and people or situations depicted is one of trust in images. Photographs may also testify to absence or loss. Considering legacies of conflict, and taking examples from Cyprus and Argentina, Elizabeth Hoak-Doering reflects on scenarios of mothers, contemporary Pietà figures, holding photographs of sons or other missing male relatives whose fate is unknown.

The fluidity of image circulation may have unintended consequences. In considering the infamous 'Abu Ghraib' pictures of American soldiers humiliating prisoners in Iraq, André Gunthert argues that were it not for digital photography and the Internet as an open arena of communication, these photographs would not have been widely seen. In terms of image as agent, that the behavior of the soldiers attracted public attention was an unintended consequence, one that ultimately led to prosecution of soldiers immediately involved.

As Ethan Zuckerman points out, with the remarkable rise in ownership of camera phones, statistically speaking events are more likely to be documented by amateurs rather than professional photographers. Citizen reportage not only responds to developments but also can mobilize them – for instance, political protests. In addition, the flow of imagery online allows for confusion between eyewitness accounts of events otherwise not documented and propaganda. Given the uncertain provenance of some imagery and the challenge of verification, how then to curate balanced representation of occurrences and circumstances, whether within mainstream news contexts or elsewhere – for instance, online galleries?

Likewise focusing on the rise of citizen photojournalism, Mette Mortensen considers the implications for image ethics in relation to what she terms non-professional, user-generated content that not only circulates online but also may be used more formally by professional news networks keen to capture the immediacy of insights from places where events are transpiring. It is argued that, especially given that eyewitness sources and authorship may not be clear, even though the graphic rawness of imagery may assure authenticity, there is a need for explicit editorial procedures to sustain professional news processing standards, whether dealing with major events or more everyday reportage. She also comments on the generation of 'instantaneous icons', noting the speed with which images now acquire recognition – for instance, camera-phone footage of a young Iranian woman bleeding to death, having been shot by a sniper when attending a political demonstration in Tehran in 2009, that was posted on Facebook and YouTube, with a still from the video widely published. Why this picture and whether its import

has more long-lasting influence are questions that beg reflection given that the speed of circulation is replicated in the speed with which each set of images and concerns becomes superseded by others. Given the pace of image flow and the global reaches of photojournalism now, whether citizen or professional reportage, questioning the status and influence, the potential and limitations of the agency of imagery within social and political relations seems ever urgent.

Bibliography of essays in Part 2

Azoulay, A. (2005) 'The Ethic of the Spectator: The Citizenry of Photography', *Afterimage*, 33:2, September/October, pp. 38–44.

Benjamin, W. (1936) 'The Work of Art in an Age of Mechanical Reproduction' in Hannah Arendt (ed.) (1973) *Illuminations*. London: Fontana.

Berger, J. (1980) 'Photographs of Agony', in *About Looking*. London: Writers and Readers.

Campany, D. (2014) 'Walker Evans: The Magazine Work'. Göttingen: Steidl.

Frascina, F. (2011) '"Face to Face": Resistance, Melancholy, and Representations of Atrocities', *Afterimage*, 39:1/2, July, pp. 49–53.

Gunthert, A. (2008) 'Digital Imaging Goes to War: The Abu Ghraib Photographs', *Photographies*, 1:1.

Hoak-Doering, E. (2015) 'A Photo in a Photo: The Optics, Politics and Powers of Hand-Held Portraits in Claims for Justice and Solidarity', *Cyprus Review*, 27:2, Autumn, pp. 15–42.

Kennedy, L. (2012) 'Framing Compassion', *History of Photography*, 36:3, pp. 306–314.

Mortensen, M. (2011) 'When Citizen Photojournalism Sets the News Agenda: Neda Agha Soltan as a Web 2.0 Icon of Post-Election Unrest in Iran', *Global Media and Communications*, 7:1, pp. 4–16.

Ritchin, F. (2014) 'Of Them, and Us'. *Aperture*, 214, Spring, pp. 42–47.

Sliwinski, S. (2009) 'On Photographic Violence', *Photography and Culture*, 2:3, pp. 303–315.

Sontag, S. (2004) 'Regarding the Pain of Others'. London: Penguin Books.

Zuckerman, E. (2014) 'Curating Participation', *Aperture*, 214, Spring.

John Berger

PHOTOGRAPHS OF AGONY

T HE NEWS FROM VIETNAM did not make big headlines in the papers this morning. It was simply reported that the American air force is systematically pursuing its policy of bombing the north. Yesterday there were 270 raids.

Behind this report there is an accumulation of other information. The day before yesterday the American air force launched the heaviest raids of this month. So far more bombs have been dropped this month than during any other comparable period. Among the bombs being dropped are the seven-ton superbombs, each of which flattens an area of approximately 8,000 square metres. Along with the large bombs, various kinds of small antipersonnel bombs are being dropped. One kind is full of plastic barbs which, having ripped through the flesh and embedded themselves in the body, cannot be located by x-ray. Another is called the Spider: a small bomb like a grenade with almost invisible 30-centimetre-long antennae, which, if touched, act as detonators. These bombs, distributed over the ground where larger explosions have taken place, are designed to blow up survivors who run to put out the fires already burning, or go to help those already wounded.

There are no pictures from Vietnam in the papers today. But there is a photograph taken by Donald McCullin in Hue in 1968 which could have been printed with the reports this morning. (See *The Destruction Business* by Donald McCullin, London, 1972.) It shows an old man squatting with a child in his arms, both of them are bleeding profusely with the black blood of black-and-white photographs.

In the last year or so, it has become normal for certain mass circulation newspapers to publish war photographs which earlier would have been suppressed as being too shocking. One might explain this development by arguing that these newspapers have come to realise that a large section of their readers are now aware of the horrors of war and want to be shown the truth. Alternatively, one might argue that these newspapers believe that their readers have become inured to violent images and so now compete in terms of ever more violent sensationalism.

The first argument is too idealistic and the second too transparently cynical. Newspapers now carry violent war photographs because their effect, except in rare cases, is not what it was once presumed to be. A paper like the *Sunday Times* continues to publish shocking photographs about Vietnam or about Northern Ireland whilst politically supporting the policies responsible for the violence. This is why we have to ask: What effect do such photographs have?

Many people would argue that such photographs remind us shockingly of the reality, the lived reality, behind the abstractions of political theory, casualty statistics or news bulletins. Such photographs, they might go on to say, are printed on the black curtain which is drawn across what we choose to forget or refuse to know. According to them, McCullin serves as an eye we cannot shut. Yet what is it that they make us see?

They bring us up short. The most literal adjective that could be applied to them is *arresting*. We are seized by them. (I am aware that there are people who pass them over, but about them there is nothing to say.) As we look at them, the moment of the other's suffering engulfs us. We are filled with either despair or indignation. Despair takes on some of the other's suffering to no purpose. Indignation demands action. We try to emerge from the moment of the photograph back into our lives. As we do so, the contrast is such that the resumption of our lives appears to be a hopelessly inadequate response to what we have just seen.

McCullin's most typical photographs record sudden moments of agony – a terror, a wounding, a death, a cry of grief. These moments are in reality utterly discontinuous with normal time. It is the knowledge that such moments are probable and the anticipation of them that makes 'time' in the front line unlike all other experiences of time. The camera which isolates a moment of agony isolates no more violently than the experience of that moment isolates itself. The word *trigger*, applied to rifle and camera, reflects a correspondence which does not stop at the purely mechanical. The image seized by the camera is doubly violent and both violences reinforce the same contrast: the contrast between the photographed moment and all others.

As we emerge from the photographed moment back into our lives, we do not realise this; we assume that the discontinuity is our responsibility. The truth is that any response to that photographed moment is bound to be felt as inadequate. Those who are there in the situation being photographed, those who hold the hand of the dying or staunch a wound, are not seeing the moment as we have and their responses are of an altogether different order. It is not possible for anyone to look pensively at such a moment and to emerge stronger. McCullin, whose 'contemplation' is both dangerous and active, writes bitterly underneath a photograph: 'I only use the camera like I use a toothbrush. It does the job.'

The possible contradictions of the war photograph now become apparent. It is generally assumed that its purpose is to awaken concern. The most extreme examples – as in most of McCullin's work – show moments of agony in order to extort the maximum concern. Such moments, whether photographed or not, are discontinuous with all other moments. They exist by themselves. But the reader who has been arrested by the photograph may tend to feel this discontinuity as his own personal moral inadequacy. *And as soon as this happens even his sense of shock is dispersed*: his own moral inadequacy may now shock him as much as the crimes being committed in the war. Either he shrugs off this sense of inadequacy as being only too familiar, or

[margin, handwritten: enraged but move on easily]

else he thinks of performing a kind of penance – of which the purest example would be to make a contribution to OXFAM or to UNICEF.

In both cases, the issue of the war which has caused that moment is effectively depoliticised. The picture becomes evidence of the general human condition. It accuses nobody and everybody.

Confrontation with a photographed moment of agony can mask a far more extensive and urgent confrontation. Usually the wars which we are shown are being fought directly or indirectly in 'our' name. What we are shown horrifies us. The next step should be for us to confront our own lack of political freedom. In the political systems as they exist, we have no legal opportunity of effectively influencing the conduct of wars waged in our name. To realise this and to act accordingly is the only effective way of responding to what the photograph shows. Yet the double violence of the photographed moment actually works against this realisation. That is why they can be published with impunity.

Original publication

'Photographs of Agony', *About Looking* (1980)

Fred Ritchin

OF THEM, AND US

WAR PHOTOGRAPHY, at least the imagery that has been made for public consumption, has long distinguished itself, as has much of journalism, by focusing on "them" instead of a more familial "us." The photojournalist's role traditionally has been that of a third-person reporter attempting to achieve a semblance of neutrality while advancing toward the battlefront. In practice, though, the photojournalist usually sides with his or her own country's forces — although there are important exceptions, like much of the critical, even sardonic photography that emerged from the Vietnam War.

But digital media has made it easier to sidestep the usual means of production and distribution, disrupting the long-standing practice in which photographers provided images to media outlets that are then filtered by editors who decide on their use. Digital technology allows anyone, including both professionals and nonprofessionals, to make images cheaply and distribute them efficiently. Photographers may experiment with different roles, including that of publisher and editor, as well as alternative perspectives from which to view the conflict. And the rapid rise of social media makes photographs that are conceived from the perspective of "us" — the combatants or those caught in the conflict — at least as common as those made of "them."

Several decades ago British critic John Berger wondered why "a paper like the *Sunday Times* continues to publish shocking photographs about Vietnam or about Northern Ireland whilst politically supporting the policies responsible for the violence," citing a highly distressing black-and-white photograph by Don McCullin of a bloodied Vietnamese man squatting in the street and holding his child on his lap. Berger was critical of such public, iconic photographs as representing events that were disconnected from the experience of many readers. He later came up with a different idea: "The task of an alternative photography is to incorporate photography into social and political memory, instead of using it as a substitute which encourages the atrophy of any such memory. . . . For the photographer this means thinking of her or himself not so much as a reporter to the rest of the world but, rather, as a recorder for those involved in the events photographed. The distinction is crucial."

In effect, Berger was arguing in 1978 for a family album, but one without the "sentimental and complacent" stance of MoMA's 1955 iconic exhibition *The Family of Man* which, among other simplifications, treated "the existing class-divided world as if it were a family." Those photographed would not be rendered as exotic or "other" but made integral to the reader's experience. There would be, in effect, a shared web of relationships that would resonate today with the intimacies of social media and the hypertextual qualities of the Web. Rather than represented as distant, the victims of war, those who instigate it, and those watching from afar could be made more proximate and, potentially, more mutually engaged.

Recently, some have taken up the challenge. Basetrack (see page 118), for example, was an experimental social media project, tracking about one thousand United

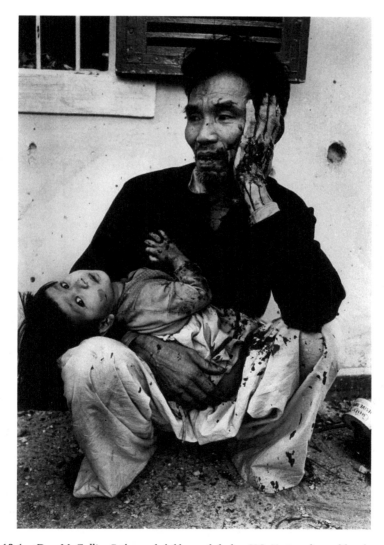

Figure 10.1 Don McCullin, *Father and child wounded when U.S. Marines dropped hand grenades into their bunker, Tet Offensive, Hue, Vietnam*, 1968. © Don McCullin/CONTACT Press Images.

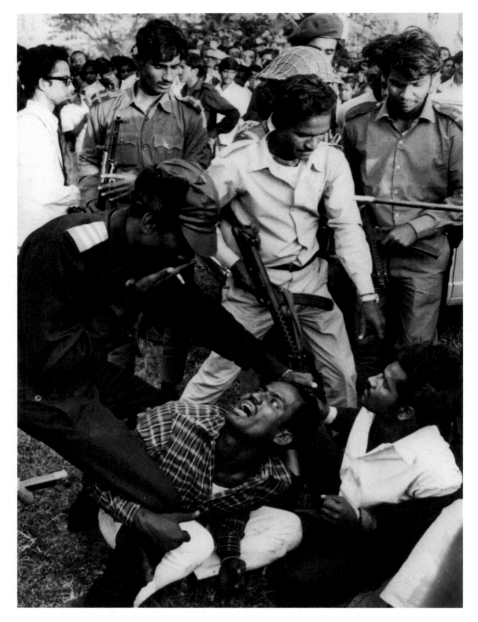

Figure 10.2 *Guerrillas in Dacca, Bangladesh* beat victims during the torture and execution of four men suspected of collaborating with Pakistani militiamen accused of murder, rape, and looting during months of civil war, December 18, 1971. Photograph by Horst Faas and Michel Laurent. © Horst Faas, Michel Laurent/Shutterstock/AP Photo.

States Marines who were part of the first Battalion, Eighth Marine Regiment, during their deployment to southern Afghanistan in 2010–11. A small team of embedded photographers, including project founders Teru Kuwayama and Balazs Gardi, primarily used smartphones along with a Facebook page to connect Marines to their families

and a larger public. A newsfeed was also provided, as well as written posts, and a tool for the military both to redact images and to explain why they would black out certain segments.

In large part the project was created out of frustration with mainstream media: "It wasn't just the military that was discouraging us from making meaningful pictures," stated Kuwayama. "The magazines we worked for – or gave our pictures to – clearly didn't want them either. We would come back from an embed, where we'd been in the fight of our lives, and we would get these absurd reasons about how that wasn't interesting enough to publish or wasn't right for that week." Family members, not surprisingly, responded to Basetrack quite differently; for example, one mother's comment on Facebook: "It has truly saved me from a devastating depression and uncontrollable anxiety after my son deployed. Having this common ground with other moms helped me so much and gives me encouragement each day."

But in 2011 it was the Facebook discussions, primarily among family members, and not the photographs or Basetrack's geotagged map interface that became problematic for the military. According to Gardi, a good deal of the comments that military officials found difficult to handle were about relatively minor matters, such as parents asking why their sons and daughters had to wear brown rather than white socks on patrol. The photographers were then "uninvited" a month before the troops' deployment was to end; now only the Facebook page is still active, with curated news and continuing audience discussions.

Not surprisingly, the photographs from Basetrack did not attempt to emulate the iconic images of war that often win photojournalistic prizes. The images they produced are, for the most part, more familiar and everyday, lacking the obsessive interest in explosions, injuries, and death that have long constituted much of the war photographer's palette. Considering Basetrack's audience, such a perspective makes sense – why make a spectacle out of that which is already such an intensely lived experience?

And it is this shift in perspective, photographing "us" rather than looking at "them," that often produces the most compelling and at times revealing images of recent conflicts – the party pictures of torture at Abu Ghraib prison, Neda Agha-Soltan bleeding to death on the street during Iran's Green Revolution, or the bombing of the London Underground. Unlike professionals who often tend to emulate previous iconic imagery of war, those whose lives are affected by the violence, either as soldiers or civilians, make images that can be more personally felt, diverse, and at times more perversely horrific.

The most assertive, and confusing, use of "us" in conflict imagery must be in Syria, where some one hundred thousand people have died. An extremely dangerous battleground for foreign journalists (twenty-eight were killed in 2012), much of the imagery that has emerged from the conflict has been made by the various parties involved and is therefore difficult to either contextualize or authenticate. (The *New York Times* web project, "Watching Syria's War," is one attempt to crowdsource this work.)

Sometimes what is revealed, as was the case with the pictures of torture in Abu Ghraib prison, is ghastly. And, given the competing claims by adversaries intent on using the media for their own aims, it is difficult for an outsider to know what to believe or with whom to sympathize. A problematic response by one rebel group to this uncertainty was to have an outside professional photographer witness and

authenticate their own barbarity, thereby replacing the more partisan perspective of "us" with more journalistically acceptable, and credible, third-person imagery.

On September 12, 2013, *Time* magazine's Lightbox blog published photographs and a written account by an anonymous foreign photojournalist (he planned on going back to Syria and did not want to reveal his identity) who had unexpectedly been given access to witness the beheading of a young man near Aleppo, one of four decapitations he photographed in a single day as he traveled with a rebel group. "What follows is a harrowing series of photographs of Islamic militants publicly executing, by decapitation, a young Syrian in the town of Keferghan, near Aleppo, on August 31, 2013," the blog reported.

The photographer's account is chilling:

> *I was feeling awful; several times I had been on the verge of throwing up. But I kept it under control because as a journalist I knew I had to document this, as I had the three previous beheadings I had photographed that day, in three other locations outside Aleppo.*
>
> *The crowd began cheering. Everyone was happy. I knew that if I tried to intervene I would be taken away, and that the executions would go ahead. I knew that I wouldn't be able to change what was happening and I might put myself in danger.*
>
> *I saw a scene of utter cruelty: a human being treated in a way that no human being should ever be treated. But it seems to me that in two and a half years, the war has degraded people's humanity. On this day the people at the execution had no control over their feelings, their desires, their anger. It was impossible to stop them.*

And he ends his account:

> *As a human being I would never have wished to see what I saw. But as a journalist I have a camera and a responsibility. I have a responsibility to share what I saw that day. That's why I am making this statement and that's why I took the photographs. I will close this chapter soon and try never to remember it.*

To contextualize the images, *Time* provides a video showing these photographs and others of various atrocities in which an editor, Bobby Ghosh, asserts that both sides are guilty of horrific behavior. The editor also points out that, unlike much of the imagery that emerges from Syria made by partisans, these photographs are made by a professional photojournalist and therefore have a greater credibility – although the photographs that were published in the slide show do not show the faces of the executioners (one executioner is shown masked) and barely anyone in the crowd, while the victim's face is mostly visible. "Because of the danger in reporting inside Syria, it was not possible to confirm the identity or political affiliation of the victim," wrote Patrick Witty of *Time*. "Nor are we certain about the motivation of his killers. One eyewitness who lives in the area and was contacted by *Time* a week after the beheadings said that the executioners were from ISIS, an al-Qaeda franchise operating in Syria and Iraq."

Obviously, witnessing such barbarity by invitation is fraught with ethical dilemmas. In 1971 when four Bangladeshi men were to be executed publicly in Dacca, several photographers refused to attend, arguing that they would not be party to a photo

op. Two photographers who went shared the Pulitzer Prize for their photographic series, *Death in Dacca*, of the prisoners being bayoneted and killed.

Did the professional photographer in Syria, and by extension *Time*, in exposing the horrific event also provide the rebel group with a propaganda coup by certifying their barbarity (or, perhaps in their own terms, their righteousness)? Publishing the images on Lightbox, a forum for discussion of photography, should have provoked a larger public debate. If the individuals or the group participating in this extreme violation of human rights are not identified with any certainty, what redress will be possible? Does the contextualizing video lessen the horror of this one execution by pointing out that the other side also commits barbarous acts? (Should, for example, the photographs of the My Lai massacre committed by U.S. troops during the Vietnam War have been contextualized with images of barbarities committed by the North Vietnamese or Vietcong?) And what does this mean for the coverage of other conflicts in which social media plays a prominent role, and in which professional journalists cannot adequately provide either context or a counterbalance?

Photography is becoming more and more of a weapon of war. Usually, governments and other entities engaged in a violent conflict try to have photographers show them in the best light – not as cold-blooded killers but as fighters for a better way. Now, as the photographs of the beheading show, evidently there is value in being depicted as brutes, whether to terrorize one's enemies or to demonstrate one's fervor for a cause. Working, as Berger suggested, "as a recorder for those involved in the events photographed" can be enormously disturbing as well as revelatory.

The family album, meanwhile, is enlarged yet also diminished, the horrors made palpable, if not always palatable: witness the recent flip-flops in Facebook's rationales for publishing videos of decapitations, including one said to have been documented in Mexico. The company's reasoning ranged from trying to protect children who might view the videos to condeming such activities as human rights violations to wondering if the videos should be published at all. Confronting various forms of human behavior, not all of them defensible, may be one of social media's most enduring legacies – helping us to define who we are, and maybe even pushing us to become more responsible, and responsive, human beings (on a local level this seems to be happening more frequently in cases of bullying, although certainly not everywhere). And, in the ongoing debate in this digital era about what a professional photojournalist can do that an amateur cannot, the ability to authenticate decapitations as they are happening must be one of the most frightening arguments that can be made.

Original publication

'Of Them and Us,' *Aperture* (2014)

Francis Frascina

"FACE TO FACE"
Resistance, melancholy, and representations of atrocities

... the ruthlessness of our attempts to be rid of [unconscious impulses] ... might be one reason why illegally occupying armies, who can neither settle nor face their own conscience, become so brutalized — it is their own discomfort they are trying to erase.

Jacqueline Rose[1]

To be in relation with the other face to face is to be unable to kill.

Emmanuel Levinas[2]

DURING 1970, hundreds of thousands of United States citizens marched in protest against atrocities committed in Vietnam by U.S. soldiers brutalized by a situation that rendered them victims of their government's projections of fear and terror. In that year, the U.S. bombing of Cambodia and the shooting of protestors on college campuses by the National Guard were further rungs on the ladder of escalation. An earlier rung had been reached with the publication in *Ramparts* magazine of horrific photographs of Vietnamese burn victims, including children, caused by the U.S. use of napalm, which provoked new forms of artists' dissent in 1967. Then, in late 1969, color images of the My Lai Massacre reproduced in *Life* magazine re-galvanized artists and intellectuals to utilize photographs of atrocities and their perpetrators to force members of the government and the military to face their own consciences and to mobilize support for the anti-war movement. Consider, for example, the face of Lieutenant William Calley, leader of the platoon responsible for the killings at My Lai, reprinted as masks to be worn on the back of protestors' heads in 1970 and 1971. His eyes' blank circles metaphorically represented him as unable to look at, to see, to be face-to-face with the Other in Vietnam. Judith Butler writes that for Emmanuel Levinas, the face "is that vocalization of agony that is not yet language or no longer language, the one by which we are wakened to the precariousness of the Other's life, the one that rouses at once the temptation to murder and the interdiction against it."[3] There is a constant

tension between the fear of undergoing violence and the fear of inflicting violence. The fear of one's own death could be overcome by obliterating the Other, but this might require a need "to keep obliterating, especially if there are four hundred men behind him, and they all have families and friends, if not a nation or two behind them."[4]

The "Kill Team" photographs

In early 2011, photographs of U.S. atrocities in Afghanistan, leaked by investigative journalists and freedom of information organizations, dominated public debates about the "war on terror"[5] and the nature of effective dissent. Inevitably, these revelations evoked those during the Vietnam War and raised questions about responses by artists, writers, and intellectuals – then and now. In May 1971, the *New York Review of Books* published a letter from Robert Lowell, poet and dissenter, after President Nixon had effectively pardoned Calley. The relevance of Lowell's letter for 2011 could be grounds for melancholy:

> His atrocity is cleared by the President, public, polls, rank and file of the right and left. . . . Our nation looks up to heaven, and puts her armies above the law. No stumbling on the downward plunge from Hiroshima. Retribution is someone somewhere else and we are young. In a century perhaps no one will widen an eye at massacre, and only scattered corpses express a last histrionic concern for death.[6]

At the end of March 2011, Naomi Wolf considered the "recent scandal" surrounding atrocity photographs taken in early 2010 by U.S. soldiers in Afghanistan, which were first published in the German newsmagazine *Der Spiegel* on March 21, 2011. The magazine reported that it had obtained four thousand photographs and videos taken by a self-styled "Kill Team," and reproduced three images, digitally blurring the faces of Afghan victims.[7] Between January and May 2010, members of the 5th Stryker Brigade, 2nd Infantry Division, conspired to target civilians, kill them, and make their deaths appear to be those of insurgents.[8] Writing in the *New Yorker* blog, investigative journalist Seymour Hersh drew immediate parallels with the content and slow disclosure of photographs of U.S. abuse and torture at Abu Ghraib prison in 2003 (reported in March 2004), and those of the My Lai Massacre in March 1968 (reported in November 1969).[9] Hersh was instrumental in revealing details and images of the latter, and again with Abu Ghraib in the *New Yorker* soon after the *60 Minutes* television news program graphically broke the story on April 28, 2004.[10]

Apart from the ethics and morality of the acts depicted, these images of atrocity constitute representational practices in which value is accorded to particular lives. For Susan Sontag, this raises fundamental questions about how viewers of photographs, numbed by media saturation, regard "the pain of others."[11] For Judith Butler, it highlights discrepancies in mourning, grief, and loss in representations of violence inflicted on lives deemed less worthy than those of sanctioned perpetrators.[12] Furthermore, Butler suggests the Abu Ghraib photographs could be considered as a form of embedded reporting in so far as they conform to – and articulate – widely shared social norms of the war.[13] Rather than constituting evidence of rogue behavior or shock

revelations, these images are consistent with the process of disavowal represented by officially sanctioned embedded reporting. Although in practice during the Vietnam War, it was Secretary of Defense Donald Rumsfeld's Embedded Media Program, approved in February 2003, which saw a systematic attachment of war reporters to frontline military units in Iraq. Before joining their battalions, embedded journalists signed a contract specifically defining when and what they could report. Embedded journalism is consistent with a process of image control, military attacks, and denial of alternative evidence – such as cell phone images of atrocities taken by civilians – as "unverifiable" by journalists attached to military units. Domestic media and legal agencies ferociously attack revelations from outside this officially sanctioned wall of control. One example is the *Collateral Murder* video released by WikiLeaks on April 5, 2010 – a classified U.S. military video depicting the indiscriminate killing of over a dozen people, including two Reuters news staff, in the Iraq suburb of New Baghdad.[14] The retaliatory attempts to punish or silence WikiLeaks indicates that such classified imagery is evidence, in Jacqueline Rose's terms, of occupying armies' inability to face their own consciences and of the discomfort they are trying to erase.[15]

Although the kill team photographs became widely available on global news outlets, Wolf observed that "the images themselves – even redacted to shield the identities of the victims – have not penetrated the U.S. media stream." Early U.S. newspaper reports relied on descriptions of the atrocity photographs, illustrating their texts with military headshots of participating uniformed soldiers, photographed in front of the U.S. flag.[16] In contrast to the facial expressions of these official portraits of valued lives, one of the atrocity photographs in *Der Spiegel* depicts a U.S. soldier with a wide grin staring back at the camera and his hand, as Hersh puts it, "on the body of an Afghan whom he and his fellow soldiers appear to have just killed, allegedly for sport."[17] Significantly, Hersh identified a new photographic aesthetic of "that smile," seen before "on the faces of the American men and women who piled naked Iraqi prisoners on top of each other, eight years ago, and posed for photographs and videos at the Abu Ghraib prison outside of Baghdad."[18] "That smile" to the camera, to the photographer, to the envisaged viewer, shocked audiences in 2004 because it seemed to signify a pleased confirmation of another person's pain, humiliation, degradation, and death imposed by agents of power. Seen again in the kill team photographs, the smile invites acceptance of, and assumes a visual collusion in, acts disavowed by the official military portrait: the beret with insignia badge of honor and camouflage fatigues with proper names, and "U.S. Army" labels that, together with the national flag, frame the photographed soldiers. The framing is designed to signify collective identification – heroic, moral, and ethical – that may be at odds with the identities, subjectivities, and desires of the photographed soldiers.

Wolf implies there is a domestic media agenda, a process of managing imagery, and an implicit censorship that results in an ideological infantilism of U.S. nationals deprived of the knowledge required for active citizenship. She observes:

> the images are so extraordinarily shocking that failing to show them – along with graphic images of the bombardment of children in Gaza, say, or exit interviews with survivors of Guantánamo – keeps Americans from understanding events that may be as traumatic to others as the trauma of the terrorist attacks of September 11, 2001.[19]

The latter becomes an exceptional commodity – as Dana Heller's anthology details[20] – to be preserved and safeguarded from dilution as a unique trauma with its survivors and victims kept apart from other traumas perpetrated by government sanctioned agents under the "war on terror."

Visual culture is often regarded as secondary to the impact of social and political interaction. Wolf, following in the traditions of theorists from Butler to Stuart Hall, reasserts the materiality of the cultural – here photographic representations and their dissemination – as maker of events. Specifically, these images of atrocity, perpetrated by U.S. soldiers far away, are a conjuncture within contested social and political norms of extended domestic culture wars. They constitute a fusion of aspects of social life that might have different origins but are convened in the same place. For example, Wolf notes that "the leading U.S. media outlets, including the *New York Times*, have not seen fit to mention that one of the photos shows a U.S. soldier holding the head of a dead Afghan civilian as though it were a hunting trophy."[21]

Wolf, Hersh, and *Der Spiegel* make reference to the way that the U.S. soldiers in the kill team photographs were posed as though hunting trophies or killing for sport, and *Der Spiegel* reported that fingers and bones were retained as gruesome mementos. A soldier with a human corpse in Afghanistan rather than a game hunter with a dead animal in the U.S. produces a disconnection in representations of, on the one hand, the ethics of a foreign war and, on the other hand, domestic expectations about guns, hunting, and sport. In 2008 and 2010, as debates about the "global war on terror" or "overseas contingency operations" continued to rage in the light of photographs and reports of U.S. atrocities, the Supreme Court issued two decisions on the Second Amendment. It ruled that the Second Amendment protects the individual's right to possess and carry a firearm unconnected to service in a militia – for example, a gun used for hunting – and the right to use that firearm for lawful purposes such as self-defense in the home. The disconnect of the kill team photographs relates to conventions and legacies of early pioneer hunting activities and the history of American colonial partisan militia, such as the young, highly mobile Minutemen who fought during the American Revolutionary War in defense of domestic freedoms. Militias eventually became professionalized as the National Guard at home and as the U.S. Armed Forces, occupying countries regarded as the source of threats to "homeland security." Government projections of fear and terror threatening hearth and home have led to military activities abroad, many of which replicate domestic norms and assumptions – about violent self-defense, hunting, and the power of individualism – that dehumanize the Other: "At the very moment when my power to kill realizes itself, the other has escaped me."[22]

Disconnect

A pressing issue for artists and intellectuals is how to respond to the disconnect between the controlled release of official representations of military activity, and the unpredictable emergence of images of abuse, torture, and murder by soldiers on missions described as defending freedom and governed by the Geneva Conventions.

This issue so preoccupied the editors of the influential journal *October* that it devoted its winter 2008 issue to responses to a questionnaire with the overriding

question "In what ways have artists, academics, and cultural institutions responded to the U.S.-led invasion and occupation of Iraq?" *October* 123 included forty-two responses to its questionnaire "urged upon us," the editors say, by "the increasing sense of horror and shame at our being an involuntary part of the ever-expanding war economy – which is to say, our participating in everyday life in the United States in 2007."[23] They were also keen to understand "why the role of academics, intellectuals, and artists in the cultural public sphere has been reduced to anesthesia and amnesia" after "the events of 9/11."[24] For some intellectuals, such as Rosalyn Deutsche, *October*'s question was symptomatic of left melancholy, an outdated attachment to a particular political analysis, ideal, or set of questions, rather than a necessary recognition of the need to develop radical ways of responding to contemporary events.[25] These intellectuals are wary, or weary, of old leftist responses that are cynical about the hypocrisy of capitalist war machines, or stress the inevitable blowback from actions kept secret from citizens, or regard the aesthetics of atrocity photographs as allegories of base ritualistic behavior in colonial wars.

Perhaps both *October*'s question and accusations of left melancholy are symptomatic of a numbing condition described by Rose. The disclosures of atrocity photographs taken at Abu Ghraib, to which can be added the kill team photos in Afghanistan, reveal how the state rushes to return such misdeeds "to the citizen precisely as 'individual disgrace.'" However, this is a diversion: the "state uses secrecy and censorship to rob its citizens of the critical defenses with which they might be able to deal with the reality of war."[26] For Rose, this is not merely the use of censorship of information: "Numbing its own citizens' capacity for judgment is one of the chief war aims of the modern state."[27]

October's editors cite two "notable exceptions to the general indifference": works by Emily Prince on U.S. military deaths in pursuit of President George W. Bush's "war on terror," and by Steve McQueen on British military deaths in Iraq. Both record "the fact that the vast majority of the soldiers are in their twenties" and are mostly recruited "from the working classes" of the U.S. and U.K.[28] Prince's project, shown at the 2007 Venice Biennale, is necessarily ongoing. In 2004, she began drawing four-by-three inch portraits of "American Servicemen and Women Who Have Died in Iraq and Afghanistan (But Not Including the Wounded, Nor the Iraqis Nor the Afghanis)." Her portraits include a soldier's name, hometown, age at death, date of death, and sometimes a short personal tribute. Inevitably, they evoke the "Portraits of Grief," the series of passport-size photographs, together with short personal tributes, of those who died in the attacks on September 11, 2001, that appeared daily in the *New York Times*.[29] Prince displays her portraits in two ways: as an enormous map of the U.S., with each portrait placed on a wall to mark the person's hometown; and contained in archive boxes and bound books as a memorial vitrine.[30]

McQueen's project "Queen and Country" began after the artist visited Iraq in 2003, following his appointment as an official war artist by the British Imperial War Museum. He was commissioned by the museum and the Manchester International Festival to respond to the conflict in Iraq, with "Queen and Country" first exhibited in the Great Hall of Manchester Central Library at the 2007 Festival. McQueen asked families of British service personnel who had died during the invasion and occupation of Iraq to select a photograph of their lost child, spouse, or partner. At the start of the project, 115 families were asked to participate; ninety-eight agreed. Since then, more soldiers have died and more families have been asked to partake in the project.

The photos were reproduced as facsimile sheets of multiple postage stamps together with the profile of the Queen of the U.K. and Commonwealth in a top corner, as is the Royal Mail convention. The Queen is the "Head of State" in whose name military personnel are required to fight by the British government for "their country." While discussions were underway with the Royal Mail to issue these as real stamps, McQueen exhibited the work. Each sheet of "stamps" was dedicated to one individual with his or her name, regiment, age, and date of death printed in the margin. They were installed in double-sided panels in a cabinet evoking the conventions of museum and gallery print and document collections. Visitors could pull out the panels and be face to face with the multiple images of one victim of the Iraq invasion.[31] The work was dedicated to all victims, including the then estimated 600,000 Iraqi men, women, and children. These victims must be imagined, a possibility constrained or enabled by the context in which the portable "Queen and Country" is displayed.[32] Both McQueen and Prince make the deaths of service personnel visible as individual faces; the faces of Iraqi victims are not there to encounter.

"The Geometry of Conscience"

Perhaps it is necessary to look elsewhere for examples of effective responses to atrocity that are more sensitive to the incisive analyses offered by Butler, Rose, and Sontag. Consider, for instance, how Alfredo Jaar responds to another "September 11" and its legacy in his "La Geometria de la Concienca" ("The Geometry of Conscience," 2010), which is part of the Museum of Memory and Human Rights in Santiago, Chile. The museum, which opened in January 2010, is dedicated to the thousands of Chileans who were tortured, murdered, or "disappeared" during General Augusto Pinochet's seventeen-year dictatorship. Pinochet came to power in a military coup sponsored by the U.S. government on September 11, 1973, overthrowing elected President Salvador Allende.[33] Within the main building, photographs of the disappeared and dead arranged in a three-story-high panel are re-framed in a human context by the museum display. Under Pinochet, whose face in Chilean media represented power and authority, the "disappeared" were dehumanized, their faces disregarded. As Butler points out in her discussion of Levinas, within the media the face is always "framed," invariably with tendentious results. Media portraits, particularly in the service of war, often effect dehumanization – as if, for example, the face of Osama bin Laden was the face of terror itself. The question then is: "How do we come to know the difference between the inhuman but humanizing face, for Levinas, and the dehumanization that can also take place through the face?"[34]

Jaar's commissioned memorial enters this debate through practice. In a large plaza beneath the main museum, the entrance to "The Geometry of Conscience" begins with thirty-three steps taking visitors six meters below ground. In going down, Jaar evokes parallels with other memorials and museums that are the antithesis of conventional vertical monuments.[35] For example, in different ways, the Vietnam Veterans Memorial in Washington D.C., the Berlin Holocaust Memorial, and the Jewish Museum Berlin take visitors below ground level. Jaar also incorporates an alienating effect through physical means: the shadowed five-meter square plateau in front of the minimal entrance is followed beyond the portal by another five-meter square concrete

space lit indirectly by two side doors. A museum guide explains the next stage: a maximum of ten people are to enter a third space for three minutes and remain silent. After the door closes automatically, visitors encounter a minute of total darkness. With eyes adjusting to the lack of light, it becomes apparent that there are silhouettes of heads on the back wall. All are different and of two kinds mixed randomly: half are the silhouetted heads of the victims of Pinochet's regime, and half the silhouetted heads of anonymous Chileans photographed by Jaar on the streets of Santiago. Family and friends can humanize the silhouettes of victims of Pinochet's inhuman acts. For others, the silhouettes prompt a process of recognition and responsibility. Everyone is placed in an ethical and visual position well characterized by Butler's question: "How do we come to know the difference between the inhuman but humanizing face . . . and the dehumanization that can also take place through the face?"

After another minute, the lights switch on, taking ninety seconds to reach full intensity. With the full blinding light evoking Jaar's "Lament of the Images" (2002), it becomes clear that both sidewalls are mirrored, creating a sense of infinity. According to Jaar, "You are illuminated historically, conceptually, physically and emotionally by the faces of the living and the dead."[36] Full darkness returns for thirty seconds with the afterimage of the silhouettes imprinted on retinas. The doors open.

The recent media convention of blurring the faces of victims of military atrocities renders the Other anonymous and dehumanized. Does this convention express respect for personal identities, or does it represent legal precautions to avoid being sued, or to minimize compensation claims by families and relatives? "That smile," observed by Hersh in Abu Ghraib and kill team photographs, is in tension not only with the blurred Other, but also with the soldiers' formal military portraits — a tension embodied in protestors' use of the Calley mask in 1970 and 1971. These factors create questions of difference: identities vs. identification, identifiable vs. unidentifiable, inhuman vs. humanizing, blurring vs. seeing. Artists' responses to atrocities that engage with these questions, such as those by Prince, McQueen, and Jaar, represent the difficult task of resisting state numbing of citizens' capacity for judgment. In doing so, they are concerned with placing viewers "in relation with the other face to face" that locates them at the ethical center of representational practices.

Original publication

'"Face to Face": Resistance, Melancholy, and Representations of Atrocities', *Afterimage: The Journal of Media Arts and Cultural Criticism* (2011)

Notes

1 Jacqueline Rose, "Freud and the People. Or Freud Goes to Abu Ghraib," in *The Last Resistance* (London and New York: Verso, 2007), 167.

2 Emmanuel Levinas, *Ethics and Infinity* (1985), quoted by Judith Butler in *Precarious Life: The Powers of Mourning and Violence* (London and New York: Verso, 2004), 138.

3 Butler, 139.

4 Ibid., 137.

5 President Bush announced a post-September 11th "war on terror" (in his "Address to a Joint Session of Congress and the American People" on 20 September 2001) declaring that it "will not end until every terrorist group of global reach has been found, stopped, and defeated." In March 2009, President Obama's administration requested that the Pentagon and speechwriters replace "Long War" or "Global War on Terror" with "overseas contingency operations." See Oliver Burkeman, "Obama administration says goodbye to 'war on terror'", the *Guardian*, 25 March 2009 (www.guardian.co.uk/world/2009/mar/25/obama-war-terror-overseas-contingency-operations).

6 Robert Lowell, "Judgment Deferred on Lieutenant Calley," letter to the *New York Review of Books* 16, no. 8 (6 May 1971): 37.

7 See www.spiegel.de/international/world/0,1518,752310,00.html

8 One of the twelve soldiers facing court marshal, Jeremy Morlock, who appeared in the photos, pleaded guilty to the murder of three Afghan civilians in a plea bargain: "US 'kill team' soldier who murdered unarmed Afghans escapes life sentence," the *Guardian* (March 24, 2011): 25.

9 Seymour Hersh, "The 'Kill Team' Photographs," the *New Yorker*, posted March 22, 2011, www.newyorker.com/online/blogs/newsdesk/2011/03/the-kill-team-photographs. html#ixzz1KNPvmZYH

10 On My Lai, see Chapter 4 of my *Art, Politics and Dissent: Aspects of the Art Left in Sixties America* (Manchester and New York: Manchester University Press, 1999); Hersh's "Torture at Abu Ghraib" appeared online on April 30 and in the print edition of the magazine on May 10, 2004.

11 Susan Sontag, *Regarding the Pain of Others* (New York: Farrar, Strauss and Giroux, 2003).

12 Judith Butler, *Precarious Life* op.cit., and Butler, *Frames of War: When Is Life Grievable?* (London and New York: Verso, 2009).

13 Butler, *Frames of War*, 82–83.

14 As of May 4, 2011, this can be found at www.collateralmurder.com/ and on YouTube.

15 Rose, 167.

16 For example, see Alissa J. Rubin, "Photos Stoke Tension Over Afghan Civilian Deaths," the *New York Times* (March 22, 2011): A4, www.nytimes.com/2011/03/22/world/asia/22afghanistan.html?scp=3&sq=%22Kill%20Team%22&st=cse).

17 Hersh, "The 'Kill Team' Photographs," unpaginated.

18 Ibid.

19 Naomi Wolf, "I Want My Al Jazeera," *Project Syndicate* (March 31, 2011), www.project-syndicate.org/commentary/wolf34/English

20 Dana Heller, ed., *The Selling of 9/11: How a National Tragedy Became a Commodity* (New York and Houndsmills: Palgrave Macmillan, 2005).

21 Wolf, "I Want My Al Jazeera," unpaginated.

22 Levinas, quoted by Butler, *Precarious Life*, 138.

23 *October* 123 (Winter 2008): 6.

24 Ibid.

25 Rosalyn Deutsche, *Hiroshima After Iraq: Three Studies in Art and War* (New York: Columbia University Press, 2010). See my review in *Art Monthly* 341 (November 2010): 35.

26 Rose, 163.

27 Ibid.

28 *October* 123: 5.

29 All of them available at the *New York Times* on the web (www.nytimes.com/portrait) and in 2002 in book form.

30 See www.saatchi-gallery.co.uk/artists/emily_prince.htm

31 See www.artfund.org/queenandcountry/index.php

32 Up to May 2011, it has appeared at ten venues since first shown at Manchester Central Library in 2007; see www.artfund.org/queenandcountry/The_Tour.html

33 See Christopher Hitchens, *The Trial of Henry Kissinger* (New York and London: Verso, 2001), especially chapters 5 and 6, and Ariel Dorfman, *Other Septembers, Many Americas: Selected Provocations*, 1980–2004 (London: Pluto Press, 2004).

34 Butler, *Precarious Life*, 141.

35 On this important distinction between memorials and monuments see Marita Sturken, *Tangled Memories: The Vietnam War, the AIDS Epidemic, and the Politics of Remembering* (Berkeley, Los Angeles, and London: University of California Press, 1997).

36 "Alfredo Jaar Interviewed by Kathy Battista," *Art Monthly* 342 (December 2010 – January 2011): 4.

Liam Kennedy

FRAMING COMPASSION

PHOTOJOURNALISM HAS LONG ASSUMED an ethical function to bear witness to the suffering or degradation of others, and photographers have often directed this function to arouse concern and provoke action.[1] This ethical function, however, is embedded in complex ways within ideas of the human and of humanitarianism that have shadowed the ideologies of imperial governance and expansion by European and American powers since the mid-nineteenth century. There is an argument to be made that photojournalism is principally – that is, historically and culturally – a 'western' invention. Indeed, photojournalism may be considered a significant medium that has shaped western perceptions of domestic and foreign environments, due to its key roles in delineating and cataloguing the social and political contours of modernity, in functioning as an evidential analogue of the legal and diplomatic imperatives of the nation-state, and as a visual record of imperial expansion and geopolitical conflicts concerning the interests of the nation-state. Western photojournalism has been significantly shaped by the idealisation of a culture of humanity, and in particular the promotion of compassion as a commensurate response to the suffering of distant others.[2] This is evident in the ways in which it defines categories of human need and harm, and constitutes caring and suffering subjects through conventions of visual representation.

As photojournalism developed as a distinctive genre of documentary imaging in the twentieth century, it adopted and adapted the ethics of compassion and the figuration of embodied suffering via visual frames, repertoires and motifs that are still familiar to us today. This is not to say that compassion has been a stable, conventionalised structure of feeling in photojournalistic imaging across this period – although there are certainly recurrent, clichéd examples we would all recognise – but rather it is contingent on the ideological conditions of visuality that more broadly shape ways of seeing, including the looking relations (of recognition and identification) that configure our affective responses to images of suffering.[3] And so, our consideration of the role of compassion within the frames of photojournalism needs also to consider how geopolitical frames influence the conditions of visuality, which are also conditions of

human relationality. In this paper, I will consider some of the ways in which compassion is framed in photojournalism that is focused on the U.S. at war – specifically, the Vietnam War and the War in Iraq – and how these framings intersect with particular geopolitical configurations to designate the conditions of possibility of an ethical response to the distant other.

While photojournalism has performed a significant role in promoting and sustaining a humanistic perspective on the violence of war and human rights abuses – most particularly by positing compassion as a framing device for the representation of the suffering or subjugated bodies of distant others – it has more often than not operated within a political economy of media production skewed to represent the values and interests of dominant western powers. Often, under these conditions of representation, compassion becomes the default frame that simultaneously invites viewers to engage terror and suffering via affective responses to agony, yet disengages them by eliding the geopolitical realities of power and violence that underlie the horrors. As such it registers the multiple professional and ideological demands on the photographer and the multiple tensions the framing of the photograph signifies even as it works to create a stable image. The work of two photographers, Larry Burrows and Jean-Marc Bouju, offers an opportunity to illustrate and develop this argument.

'A Compassionate Vision'

Larry Burrows covered the Vietnam War for *Life* magazine from 1962 until his death in 1971, when the helicopter carrying him and three other photographers crashed over Laos. Burrows's work constitutes a remarkable documentary chronicle of the conflict, from the presence of military advisors in the early 1960s, through the quagmire of key battles in the late 1960s, to the extended war in Cambodia and Laos in the early 1970s. Across this period Burrows's perspective on the war shifted, from that of a 'hawk' to one of disillusionment with American involvement in Vietnam. In his photography, we can see Burrows working to strike a balance – between document and aesthetics, between objectivity and subjectivity – that will make the war meaningful to western viewers, and to himself.

Quite when Burrows's sense of disillusion settled in is unclear, but it seems in line with the more general disenchantment of the American public from 1968 onwards, in the wake of the Tet Offensive. Between 1968 and 1970 Burrows's major stories were focused less on U.S. operations or even on the U.S. soldier than on South Vietnamese civilians and their sufferings. In 1968 he photographed Ngwyen Thi Tron, a twelve-year-old South Vietnamese girl who had lost a leg following an attack by a U.S. helicopter in a free-fire zone (Figure 12.1). Burrows recalled:

> Walking the streets of Saigon in 1968, I saw two Vietnamese children rocking back and forth on a swing in a Red Cross compound. They were not the same as any other two youngsters, for they had only one leg between them and it was Tron who propelled the swing.[4]

Burrows befriended Tron and documented her recovery as she learned to use an artificial leg and readjust to home and village life. A photo-essay focused on Tron was

Figure 12.1 Larry Burrows, *Nguyen Thi Tron at the National Rehabilitation Institute, Saigon. Life,* 65:19 (8 November 1968), cover. The cover of *Life* magazine features a photograph of Vietnamese 12-year-old Nguyen Thi Tron as she watches a craftsman put the finishing touches on her new prosthetic leg, Vietnam, November 8, 1968. Her leg was amputated after she was shot by a U.S. helicoptor during the Vietnam War. Photo by Larry Burrows/The LIFE Premium Collection/Getty Images.

published in *Life* on 8 November 1968, with text by Don Moser that focused on the move towards peace in Vietnam. Tron was not the first poster-child of injured innocence during wartime, but she was one of the most famous instances in the Vietnam War, not least because of the profile Burrows's piece in *Life* could provide. The *Life* story used her images and story to both conjure compassion among readers – the images prompted some readers to send donations of aid for Tron and her family – but also to suggest the war was taking a new direction, moving towards peaceful resolution. As

such, Tron's painful rehabilitation stands in for the national rebuilding now required of the country.[5]

For Burrows, Tron was a more personally troubling symbol of his responses to the war and to the Vietnamese people. His growing sense of disillusion was partially displaced onto the suffering-yet-stoical figure of Tron. At the same time, Burrows was concerned about his own relationship to Tron as a photographer and benevolent other. *Life*'s Dan Moser recalled:

> Larry became quite attached to Tron and she to him, and this worried him constantly. He realized that if she became too dependent on him, her life would be even more difficult when he left her. So he tried to maintain a certain emotional distance from her, acting like a cheerful uncle and trying — not always successfully — to mask the depth of his own feelings.[6]

This complexity of relations and feelings would affect Burrows again in 1970 when he photographed the homecoming of Nguyen Lau, a ten-year-old Vietnamese boy who had been paralysed by a mortar fragment and received medical treatment for two years in the U.S. Lau was unable to integrate back into family and village life, and Burrows documented the estrangement. For Burrows, Lau's difficulties were emblematic of the war: 'Lau's is not the greatest tragedy in Vietnam. But as one looks at the picture of this courageous little chap, one has to wonder whether the ultimate agony of this war is not to be seen in his eyes'.[7] Burrows's close attention to these stories of injured children both announced and deflected his growing unease about the meaning and impact of the war. Unwilling or unable to decry U.S. involvement in Vietnam, he picked out and underlined the human suffering of the South Vietnamese.[8]

Burrows's efforts to provide a more considered statement on his evolving perspective culminated in his *Life* essay entitled 'Vietnam: A Degree of Disillusion', published on 19 September 1969. The photo-spread consisted of four separate stories that offered different perspectives on South Vietnamese soldiers and civilians. Burrows introduced the article with a statement:

> All over Vietnam you see the faces — more inscrutable and more tired now than I have ever known them to be. Their eyes do not meet yours, because they are aware that the enemy is still, even today, all around them, watching. They are in the middle. The pressure on them is terrible and has existed for some thirty years.
>
> I have been rather a hawk. As a British subject I could perhaps be more objective than the Americans, but I generally accepted the aims of the US and Saigon, and the official version of how things were going. This spring, impressed by government statistics showing that conditions were improving, I set out to do a story on a turn for the better. In the following three months I indeed found some cause for optimism — better training and equipment in the South Vietnamese Army, more roads open and safe — but I also found a degree of disillusion and demoralization in the army and the population that surprised and shocked me.[9]

This announcement of his own position – 'I have been rather a hawk' – was the most direct comment Burrows made about his ideological views of the war. Even here, he did not directly address his own sense of disillusion nor did he question the U.S. mission in Vietnam but focused on what he perceived to be the disillusion of the South Vietnamese people. His son Russell Burrows has commented on this, asserting that Burrows's 'change' in perspective:

> [h]ad nothing to do with the fact that the war was wrong; he was opposed to its stupidity [. . .] to how the war was being waged [. . .]. Many people, journalists and others, radically changed their minds around 1968. Where my father was different was in his beliefs that the South Vietnamese people wanted and supported the American effort, and that they would be willing and able to shoulder that burden as the United States withdrew. It was in photographing an essay on those people that his beliefs were confronted, and the result was 'A Degree of Disillusion'.[10]

This interpretation underlines Burrows's continued support for the U.S. mission. The scales falling from his eyes revealed not a failure of U.S. values but of Vietnamese will.

As Burrows photographed South Vietnamese people throughout 1968 and 1969 (partly in an effort to move beyond conventional imagery of the war), a growing sense of the destruction of the fabric of their lives disturbed him:

> The story is hard to tell in pictures. The people are simple and hard-working and bear pain in silence. You look into their placid faces and think of the torment going through their minds. I remember one woman in a village we went into – a mother sewing, with a dead VC at her feet. A Vietnamese officer asked her if she knew him. She said no, and went on sewing. He searched the hut and found a family picture. The VC was her son.[11]

It was the loss of humanity that most affected Burrows and this was the message he strived to transmit through his photography. Yet Burrows never really managed to produce a coherent story of Vietnamese life that illuminated the causes and consequences of this loss of humanity. The unifying element in the photo-story on disillusion is the imagery of injured or suffering women and children, which were framed as stories of compassion – the very quality the Vietnamese appeared to lack, according to Burrows's anecdote.

The South Vietnamese remained 'inscrutable', beyond Burrows's reach visually and ideologically; their unknowability a register of the formlessness of the war and a mirror of the damage done to an idea of humanity that was also revalidated as the compassionate ethos of the photographer-as-witness. There was a tension in much of this imagery that registered Burrows's perturbation about how to visually express what he saw and about his role as witness. One photograph depicted a U.S. soldier watching a young South Vietnamese mother suckle a child in the village of Rach Kien in 1967. The caption informs us that the soldier is acting as a guard, as the woman proved to be an assistant to her father who was 'a Vietcong "tax collector"'.[12] The strong composition accentuates the borders and relations between war and domesticity. The woman is seated in profile in the doorway to what appears to be a domestic dwelling, with the

photographer shooting from inside the building; beyond the woman and dominating the centre of the frame is a soldier languidly holding a rifle by his side while he stares at the nursing woman. The ambiguities of the photograph are not contained by the caption – it remains compelling because of the shifting connotations of care and domination that attend the echoing gazes of soldier, photographer and viewer. As such, it potently represents the complexity of the moral economy that informs Burrows's 'compassionate' point of view.

Notably, Burrows's *Life* editors picked on the idea of compassion in their memorial issue and the book published in 1972, *Larry Burrows: Compassionate Photographer*. The memorial article, 'Vietnam: A Compassionate Vision', presented a portfolio of his work. According to the text, Burrows's compassion and focus on the human distinguished him: 'Larry Burrows looked at war; what he saw was people',[13] In the 1972 book, John Saar, who was *Life*'s bureau chief in Hong Kong in this period, remarked:

> The more Larry Burrows saw, the more he cared. His continued involvement with the calamity of others did not harden or deaden him. In the last few months of his life, a new sense of concern for a universal humanity took a strong grip of him.[14]

Since his death Burrows has been mythologised as the prototype of the fearless professional and the compassionate photographer, witnessing on behalf of others. It is a compelling myth and one that has influenced many young photographers. However, it glosses over what were the real – creative and professional – qualities of his work, just as it ignores the limitations of his 'compassionate vision'.

Fred Ritchin has suggested that the nature of the Vietnam War challenged many photographers to reconceive their role:

> The photographers had to try to comprehend scenes that elided the more familiar mythology of good and evil. It was the territory of actual war, the microcosm of bullet piercing skin, the universe of crumbling souls. In an attempt to parse landscapes of horror, intellectually confusing and morally ambiguous, photojournalism became a medium that interrogated layers of reality rather than providing simple answers. The photographers had transcended – some might have said 'abdicated' – their traditional role as recorders of a monumental conflict who worked in the service of one side.[15]

Burrows never quite abdicated the traditional role – he was 'rather a hawk' and remained broadly sympathetic to the U.S. mission in Vietnam. He was very much an 'embedded' journalist, reliant on and aided by the U.S. military for access and other support to produce his work. However, his work nonetheless registered the mutation in the role of the photojournalist to which Richtin refers. While Burrows never formulated a coherent narrative of the war, the uneven responses to it reflected in his work remain an important documentary chronicle both of the war's shifting contours and of his sensitivities to this. That his efforts to make sense of the war and of his own relation to it drew him to 'a new sense of concern for a universal humanity' underlined his myopia about the geopolitical realities of the conflict and his own position, but also

suggests the peculiar tensions he experienced in attempting 'to parse landscapes of horror' and create a point of view that reflected the moral ambiguities of his own role.

A good case in point is the image depicting the U.S. soldier gazing at the nursing Vietnamese woman. With whom is the viewer being asked to empathise and identify in this image? What are we witnessing in this scene? Is this a scene of care or a scene of domination? The dialectics of care and domination emblematise the contradictions of the American mission in Vietnam and render this a suggestive, primal scene of that corrupted mission. In the ambiguities of this image we sense that the limit of Burrows's 'compassionate vision' is also the essence of its documentary truth.

Performing compassion

The moral economy that structured western visualisations of international conflict and suffering in the Cold War period, including the Vietnam War, was focused on narratives and images of liberation, containment and freedom – key tropes in Burrows's work – that reflected the conditions of visuality shaped by geopolitical realities. This economy was ruptured by the endings of the Cold War. As the dominant geopolitical narratives fractured, so did the visual narratives of photojournalists – to be replaced by fragmented and confusing imagery that visualised a chaotic globalisation. Photographers at work in the former Yugoslavia in the 1990s were particularly cognisant of this. The Russian photojournalist Oleg Klimov, discussing the Kosovo crisis, observed:

> With this war something crashed in the very core of the planet, the East and the West got all mixed up. What we saw in print and on TV was the hi-tech information war with man lost in it. And that is probably how wars will look from now on.[16]

The result of the end of history in this telling was the loss of man; that is, of the verifiable human subject as the focus and locus of the moral imperatives of documenting conflict and suffering and of the role of the photographer as witness. Klimov was right, something had crashed; the sense of moral mission that accompanied western photojournalism's visualising of distant suffering was thrown into confusion – firstly, by the breakdown of the bipolar structures and narratives that had shaped the telling of Cold War stories and, secondly, by the failure of western powers to intervene in the Balkans despite the visual evidence produced by many photographers.

There emerged from this confusion new conditions of visuality that were significantly shaped by the effects of new media technologies on global communications and by the geopolitics of liberal capitalist expansionism, and, in particular, by the imperatives of humanitarianism that have become so complexly entwined with issues of global governance since the endings of the Cold War. In this context, photographers began to find their subjects once again – imagery of refugees and aid camps became prominent – as they gravitated to the theatres of so-called 'ethnic wars' and their human fallout in the former Yugoslavia and in sub-Saharan Africa. Throughout the 1990s the idea of the photographer as witness took on fresh significance as human rights issues came to the fore in global conflicts with the emerging ability to

prosecute gross violations transnationally and the explosive growth of international nongovernmental organisations (NGOs). The role of visual evidence took on a heightened significance – representation and documentation are key to the pursuit of human rights issues – and the NGOs promoted this. Photojournalists refigured their conventions in relation to these contexts and now began to work more directly and self-consciously within human rights frameworks, in many instances commissioned by the NGOs. They expanded their documentation of suffering, injustice and crimes against humanity; the ethical imperatives to bear witness and evoke compassion became more assertively grounded and framed in photojournalistic practice.[17]

 This 'new humanitarianism' has been entangled with the imperatives and goals of U.S. foreign policy, particularly in the wars in Afghanistan and Iraq. One result of this and a measure of the effects of a 'perpetual war' on western sensibilities is the shifting sense of human relationalities encoded in compassionate photojournalism. A good illustration is provided by a photograph by Jean-Marc Bouju, a French photographer working for Associated Press, who was embedded with the 101st Airborne Division in Iraq. It depicts a man and child in a prisoner-of-war camp in Najaf (Figure 12.2). This photograph won the World Press Photo of the Year Award in 2003. Bouju has said the boy was crying when his father was arrested and so the American soldiers allowed the two to stay together, then cut off the father's plastic handcuffs so he could hold his child.[18] We can read the photograph as a symbol of compassion (of the soldiers towards the prisoner, of the father toward the son), but we could also read it as evidence of a lack of compassion. The admixture of cruelty and kindness signified by

Figure 12.2 Jean-Marc Bouju, *US Army POW Centre, near Najaf, Iraq*, 31 March 2003. [Original in colour]. Courtesy of AP Photo/Jean-Marc Bouju.

the image is disconcerting. The dissonance is indicative of the ambiguities inherent in using photography as a documentary witness. We traffic back and forward between the particular and the universal, between the humanistic and the imperial, between care and domination, between sentiment and critique – where does our gaze rest?

It is possible to argue that this image depicts the dialectics of freedom and oppression in the activity of empire, but that begs further questions, particularly about the location of freedom. Does freedom reside in the motivations of the captors, in the transcendent humanism of the embrace of the parent and child, or does it inhere in the very act of looking? Looking relations surrounding the imagery of subjugated bodies and bodies in pain, particularly those framed by colonial or postcolonial conditions of power and conflict, have a complex and fraught history.[19] The looking relations of empathy and identification presuppose a connection between body, space and violence that authenticates the evidentiary power of the image – the logic of this connection is that 'a buried truth' is located in the alien body sited in the postcolonial peripheries and 'must be brought up to the surface in modes of exposure and display'.[20]

Photojournalism is one such mode of creating this display, and this photograph references a long history of photojournalistic imagery of violent conflict, using a frame and conventions common to the genre – the *pietà* composition, for example, is commonplace in such imagery.[21] An even more common element in this visual history is the spectacular and perfomative role of the subjugated body. This image also offers a performance, but here it is not the mute testimony of the body typical of earlier work, but rather a performance of compassion itself, which both foregrounds and destabilises the looking relations of empathy and identification. It is a performance that involves the compassion of the father in relation to his son, the compassion of the American soldiers in relation to the father and son, and the compassion of the viewer in relation to the scene.

The performance is excessive, a performance of an unlimited (imperial) power, which includes the power to humanise and dehumanise. Commenting on the unlimited nature of U.S. power, the French philosopher Alain Badiou argues that:

> it is different from the dialectic of the master and slave [. . .]. A power governed by a representation of its unlimited character relates to the other under a predicate of non-existence [. . .]. The USA invented the violence of the relation to the one whose non-existence it posits [. . .]. The USA is the One that has no other. And the mode of being of that One is the destruction of the other, which is not destruction but liberation, since the other does not exist. Liberate the Iraqis from their claim to exist; bring them back down to the comforts of their non-existence: this is the spiritual essence of American war.[22]

In these terms, we might say that what we see in this image is the *mise-en-scène* of the war on terror as a perpetual war, wherein war is universalised on behalf of human emancipation. What we see, to use Badiou's terms, is a performance of an unlimited power that promises to liberate the other from his non-existence – connoting war as 'an abstract form of the theatrical capture of an adversary'.[23] As such, this scene is a performance of liberation that mimics the military performance of liberation as a (rhetorical) political aim of the US invasion of Iraq.

This excessive visual performance of compassion foregrounds the ethical knot in viewing relations conditioned by US imperialism. I ask the same question of this image as I asked of the Burrows image of the US soldier standing over the Vietnamese woman and child. Is this a scene of care or a scene of domination? Part of the difficulty in making a judgement is that the postures of care and domination draw on the same foundation, our inescapable human vulnerability.[24] This nexus of care and domination has become a prominent and disturbing feature of the image world of globalisation and of the geopolitical world of war, conflict and human rights abuses that this image world often, if unevenly, represents. In mass media, images of domination and vulnerability meld into one another. Think, for example, of the image banks of famine, sustainable development and ethnic warfare that overflow one another. In international relations the discourse of humanitarianism inflates the demand for care as an issue of liberal governance of failing states and a legitimate rationale for intervention. In this discourse, the meanings of care and domination are carefully parsed to meet dominant politico-economic interests. Wherever we look, we find political structures of domination and ethical structures of care collapsing into each other.

This is what the photograph represents, the performance of that chiasmic relation. As such, it depicts a primal scene of American empire, for the disturbance of the relation between care and domination is now generalised in the global image world as a response to the conditions of perpetual war. This perpetual war has dislocated the ethical registers of temporal and spatial distance that structured and promulgated an ethics of compassion in the representation of the suffering of others. Today, we in the West live in the perpetual present of a war that exists in real time and for which we as have yet no adequate ethical gauge of our human affiliations. Just as it withholds explanation, the photograph mimics that lack. Its very failure to provide answers makes it valuable as an indicator of the limits of our knowledge formations and ethical imaginations.[25]

Conflict photography foregrounds issues of affective relationality that are due to the nature of the medium but also shaped by geopolitical conditions of visuality. It raises pressing moral and political questions about the scope of ethical concern in international relations. Such questions are not new. Over 200 years ago, pondering an earlier age of globalisation, Immanuel Kant asked whether a 'community of nations' was made more or less possible by enhanced global communications.[26] For Kant, as Andrew Linkalter notes:

> the issue was whether human beings can expand their moral horizons in line with the geographical extension of social and political relations, whether they can reduce the moral importance of distinctions between insiders and outsiders in response to the changing significance of territory and space.[27]

This Enlightenment problem remains one of the central questions of our own age of globalisation, especially as the scope of ethical concern in international relations today is re-territorialised by new media technologies and shaped by the USA's preponderance of power.

Notably, some theorists of globalisation now argue that the spaces of our emotional imagination have been expanded in a transnational sense as we are connected

(virtually) to new spaces of empathy and aggression.[28] This has become a key point of discussion in debates on cosmopolitanism and human rights, particularly as these bear upon issues of global governance and civil society. Certainly, the image world that is the surface of globalisation is also our shared world of affective attachments, of social and imaginary imbrications of humanity, and of new relations of interdependence.[29] As this image world becomes more and more saturated by images of corporeal violence and vulnerability, it becomes imperative to consider the aesthetics, the ethics, and the politics of the claims the suffering bodies of others make upon us.

Original publication

'Framing Compassion', *History of Photography* (2012)

Notes

1 The literature on this ethical function is diverse. The most prominent critical commentators include: Susan Sontag, *Regarding the Pain of Others*, New York: Penguin 2004; Lilie Chouliaraki, *The Spectatorship of Suffering*, London: Sage Publications 2006; Judith Butler, *Frames of War: When Is Life Grievable?*, London: Verso 2010. The photographer's perspective is most fully captured in the interviews that make up a large part of Denise Leith, *Bearing Witness: The Lives of War Correspondents and Photojournalists*, Sydney: Random House 2004.

2 The sight of the other's suffering body is at the heart of the modern humanistic tradition. See Thomas Laquer, 'Bodies, Details and the Humanitarian Narrative', in *The New Cultural History*, ed. Lynn Hunt, Berkeley: University of California Press 1989, 176–204. With the advent of photography, documentary imagery of suffering bodies became instrumental in supporting reform movements, in shaping perceptions of poverty, and in reporting on violent conflicts elsewhere in the world.

3 On the ideological construction of visuality as 'a way of seeing', see Gillian Rose, *Visual Methodologies: An Introduction to the Interpretation of Visual Materials*, London: Sage 2007, 1–27.

4 Larry Burrows, 'Vietnam: A Degree of Disillusion', *Life* (19 September 1969), 67.

5 Images of Tron were published over a year later in *Life* (12 December 1969), showing her surrounded by dolls and stuffed animals sent by American readers. These images were published one week after *Life* published images of the My Lai massacre and in this context they function to sentimentalise the violence done to Vietnamese civilians by U.S. forces, reassuring American readers that the U.S. acts responsibly, with humanitarian intent. See Kendrick Oliver, *The My Lai Massacre in American History and Memory*, Manchester: Manchester University Press 2006, 69.

6 Larry Burrows, *Larry Burrows: Compassionate Photographer*, New York: Time Inc. 1972, n.p.

7 Larry Burrows, 'Vietnam: A Compassionate Vision', *Life* (26 February 1971), 34–45.

8 The American artist Martha Rosler placed one of Burrows's photographs of Tron in a photomontage that became part of her 'House Beautiful: Bringing the War Home' series (1967–72). In the photomontage, the image of Tron is placed within an image of a suburban American sitting room, taken from *House Beautiful* magazine. The juxtaposition is intended to challenge comfortable associations with the imagery of war and domesticity in the U.S. in this period.

9 Burrows, 'Vietnam: A Degree of Disillusion', 69.
10 Susan Moeller, *Shooting War: Photography and the American Experience of Combat*, New York: Basic Books 1989, 354.
11 Burrows, *Larry Burrows*, n.p.
12 Larry Burrows, 'The Delta: New US Front in a Widening War', *Life* (13 January 1967), 27.
13 Burrows, 'Vietnam', 34.
14 Burrows, *Larry Burrows*, n.p.
15 Fred Ritchin, 'Parsing the Wound', in *Under Fire: Great Photographers and Writers in Vietnam*, ed. Catherine Leroy, New York: Random House 2005, 160.
16 Dirck Halstead, 'The End of History and Photojournalism', *The Digital Journalist*, www.digitaljournalist.org/issue9910/editorial.htm.
17 See Susie Linfield, *The Cruel Radiance: Photography and Political Violence*, Chicago: University of Chicago Press 2010, 205–258.
18 'AP Photographer Wins World Press Photo 2003', *Associated Press* (13 February 2004), www.ap.org/pages/about/pressreleases/pr_021304.html.
19 See Frantz Fanon, *White Skin, Black Masks*, New York: Grove 1994; Catherine A. Lutz and Jane L. Collins, *Reading National Geographic*, Chicago: University of Chicago Press 1993; and Deborah Poole, *Vision, Race, and Modernity: A Visual Economy of the Andean Image World*, Princeton, NJ: Princeton University Press 1997.
20 Allen Feldman, 'Memory Theatres, Virtual Winessing and the Trauma-Aesthetic', *Biography*, 27:1 (Winter 2004), 187.
21 See Susan Moeller, *Shooting War: Photography and the American Experience of Combat*, New York: Basic Books 1989, 20 and 401.
22 Alain Badiou, *Polemics*, London: Verso 2006, 24.
23 Ibid., 26.
24 See Judith Butler, *Precarious Life: The Power of Mourning and Violence*, London: Verso 2004; and Rochelle M. Green, Bonnie Mann and Amy E. Story, 'Care, Domination and Representation', *Journal of Mass Media Ethics*, 21:2&3 (August 2006), 177–195.
25 This ability of images to stir compassion across cultural and linguistic boundaries suggests that photography should not be too readily reduced to its cultural mediations. Transcultural mechanisms of figuration entangle us in complicated relations of identification and recognition with the cultures on view, involving psychological and somatic forms of inter-subjectivity between viewers and actants.
26 Immanuel Kant, 'To Perpetual Peace: A Philosophical Sketch' (1795), in *Perpetual Peace and Other Essays*, Indianapolis: Hackett 1983, 107–144.
27 Andrew Linklater, 'Distant Suffering and Cosmopolitan Obligations', *International Politics*, 44 (January 2007), 19–36.
28 See Ulrich Beck, *Cosmopolitan Vision*, London: Polity Press 2006.
29 See Susan Buck-Morss, 'Visual Studies and Global Imagination', www.surrealismcentre.ac.uk/papersofsurrealism/journal2/acrobat_files/buck_morss_article.pdf.

Sharon Sliwinski

ON PHOTOGRAPHIC VIOLENCE

even scratched to death
a simple rectangle
of thirty-five
millimeters
saves the honor
of all the real
J-L Godard,
Histoire(s) du cinéma

ONE OF THE MOST POTENT IMAGES collected during the Bosnian War was a found photograph (Figure 13.1). According to its finder, the photojournalist Ron Haviv, when the daughter of the Muslim family pictured in the image returned to Sarajevo after the war, she found her family home had been looted. Serbs who had occupied the house during the war finally left once the city was reunited under the Muslim-led Bosnian government. But upon their departure, the occupiers stole almost everything – the furniture, appliances, cabinets, sinks, and even the windowpanes. The defaced photograph was the sole item left behind (Haviv 2000: 175).

On the one hand, the sheer endurance of this image is remarkable. Unlike all the other household items, the photograph managed to survive as a melancholy relic of war. In this respect, photographs – and family photographs in particular – appear to hold little exchange value. Their worth is usually non-transferable. On the other hand, the narrative illustrates the way photography lends itself to a variety of uses in times of war. Specifically, the example shows how photographs can be pressed into service to actually *wage* war. The violence done to the surface of the image appears, on first glance, to echo the violence occurring throughout the region. The family members' identities have been scratched out, "cleansed" of the customary markers of ethnicity. In the hands of the occupiers, the photograph became an emissary of destructive affect, a canvas for the expression of sadistic desires.

Figure 13.1 *Blood and Honey* – defaced photograph found by a Bosnian family on their return home. March 17th 1996. [Original in colour]. © Ron Haviv/VII/Eyevine.

This solitary example of pictorial violence opens a larger set of questions about the nature of human aggression. What is the status of violence carried out in effigy? Should the defacement be read as a fantasy that forestalls more direct forms of violence? Or is this a kind of "acting out" that inevitably leads to more profound forms of destruction, namely the annihilation of human beings? (Freud 2006 [1914]).[1] Can the particular violence done to the image be read for its "psychology of style"? That is, does the particular defacement open understanding into the other forms of violence that took place during the dissolution of the former Yugoslavia? And apart from these hermeneutical questions, why does photography – as opposed to the myriad of other material artifacts of a home – lend itself so easily to the expression of aggression? In other words, perhaps this example calls for a broader investigation into the ways photography is not only a unique medium of visual reproduction, but also as a unique medium for the expression of violence. Hannah Arendt (1970) reminds us that violence – as distinct from power, force, or strength – requires implements.[2] The history of warfare is inextricably bound up with the history of technology. The frightening example from the Bosnian War suggests that by the close of the twentieth century, photography became one of the exemplary implements of genocide.

The violent effacement is, however, only one of the affective registers bound up in this example. The photograph's history of uses include: the family's initial circulation and preservation of the snapshot, the occupier's acquisition and sadistic defacement, and finally the spectator's melancholy contemplation of the relic in the time of afterwards, when one meets its reproduction in Ron Haviv's own collection of photographs of the war, *Blood and Honey: A Balkan War Journal*. This is to say, the contemporary spectator enters into, and indeed, becomes a participant in this narrative only at its conclusion. But this last site is itself unstable because the spectator is actually obliged to perform a dual task: to identify the subject *of* the image and to identify *with* it (Olin 2002). In order to comprehend this sequence of historical events, in order to know, one has to imagine for oneself the terrifying significance of this lonely relic. The spectator, in other words, becomes both the receiver of the object's enigmatic message *and* the carrier of its affective resonances. The wager of this paper is that attending these registers – thinking through this "acting out" of genocide in pictures – can shed new light on the nature of human violence writ large.

Community building

The old Yugoslavia boasted one of the world's richest tapestries of language, religion, and culture before its people turned to violence in the 1990s. The chief architect of this breakdown was Slobodan Milošević, a member of the Yugoslav Communist Party, who rose to power in the country in the late 1980s. During his rise through the ranks, journalists sympathetic to the politician began spreading a fantasy about a grand conspiracy against the Serbian nation: the KGB together with the CIA, the Albanians, the separatists in Slovenia, and Islamic fundamentalists in Bosnia were purportedly working together to weaken Serbia. As a result of this inflammatory rhetoric, café life began to breakdown along "ethnic" lines (during this conflict the term "ethnicity" was often used as a euphemism for religious affiliation). Serbs began refusing to send their children to school with Muslims. Croats complained of being laid off

by Serb managers, and vice versa. In June 1991, Croatia and Slovenia declared inde-
pendence from Yugoslavia, which was quickly followed by an announcement from
Macedonia. The next spring the Federation of Bosnia and Herzegovina announced
its own secession. What began as local skirmishes in Croatia escalated until the fall
of 1991, when the Yugoslav army launched an invasion into Croatia to "protect" the
Serb minority who lived there. Within a few months, Serbs had seized a quarter of
Croatia's territory and convinced the UN to send a force to guard the region. The
Yugoslav army then redeployed their forces to Bosnia and war broke out there in
1992 when Serb paramilitary forces attacked Bijeljina and other towns, driving out
the Muslim populations. After three and a half years of bloodshed, including the night-
mare of Srebrenica – Europe's worst massacre in more than five decades – NATO
intervened with air strikes. The Dayton Peace Agreement, signed on December 14,
1995, bought a brief and tense ceasefire to the region. The peace only lasted a few
months, whereupon Albanians, living in a virtual apartheid system in Kosovo, began
attacking Serbian police units in 1996. Milošević used these attacks by the Kosovo
Liberation Army to relaunch his plans for an "ethnically cleansed" Serbian nation. By
the fall of 1998 the Serb police had driven tens of thousands of Albanians from their
homes. NATO again demanded that Milošević withdraw his police units after Serb
troops massacred a group of civilians in the village of Račak. The president's negotia-
tors refused and NATO launched a limited air campaign. This only incited the Yugo-
slav army to expand their ethnic-cleansing operations. Thousands of Albanians were
killed and some one million people were driven from their homes. Milošević finally
withdrew his forces only once NATO threatened a ground campaign (Gutman 1993;
Maas 1997; Sudetic 2000; Power 2002). The tragedies in this region offer one of the
most potent examples in recent decades of just how difficult it is to love thy neighbor.

When the Bosnian War began in 1992, Western political leaders and even United
Nations negotiators proposed that the fighting was the result of "ancient ethnic
hatreds," animosities that had been smoldering for centuries in the blood of a people
prone to violence. Such portrayals lean on a strange – one might say infantile – theorizing
in which violence is believed to break out because chance events inflame millennia-old
blood tensions. Such a narrative appears to be easier to entertain than one in which a
group of humans deliberately choose to reconstruct their world through mass exter-
mination. Genocide, after all, is an exercise in community building (Gourevitch 1998:
95). In *Civilization and its Discontents*, Sigmund Freud (Freud 2002 [1930]) offers a ver-
sion of this thesis with what he calls the "narcissism of minor differences." The term
describes how peoples who share the same space of nation find means to distinguish
themselves as members of a particular social group. In Freud's words: "One should not
belittle the advantage that is enjoyed by a fairly small cultural circle, which is that it
allows the aggressive drive an outlet in the form of hostility to outsiders. It is always
possible to bind quite large numbers of people together in love, provided that others
are left out as targets for aggression" (Freud 2002 [1930]: 50). The thesis is counter-
intuitive: rather than posit a biological or "ethnic" source for social violence, Freud
proposes that community dynamics are structured by the vicissitudes of love and hate.
The omnipotent desire for purity compels the members of a social group to expel
their impurities onto nearby others. The group remakes their neighbors into strangers
in order to cement their own attachments. Genocide, in other words, is a story about
the treacheries of love.

Can the photograph tell us anything more about this drama of social violence? The defaced image from Bosnia is reproduced in Ron Haviv's book, *Blood and Honey*, which provides an expansive visual documentation of the conflict. The album is a fitting home for the lonely relic. Haviv's book offers a pictorial catalogue of the violence that gripped the region: a crowd of Bosnians dodging sniper fire at a peace rally in the Spring of 1992; a Muslim captive pleading for his life from a paramilitary unit called the Tigers; the remains of a Kosovar Albanian reduced to ashes by Serbian forces in 1999; emaciated prisoners awaiting deportation at the Serb-run Trnopolje camp; Sarajevo's new "warchitecture";[3] and most famously, one of Arkan's Tigers kicking a murdered Muslim woman in the head in Bijeljina.[4] Thousands of photographs emerged from the wars in the Balkans, but *Blood and Honey* bears witness to the primary target of the violence: civilians. Uncannily akin to the defaced photograph, this war's ravages are visibly inscribed onto the very bodies of the people whose likeness Haviv captured with his camera.

The found photograph is one of the very last images reproduced in *Blood and Honey*. And while Haviv's photographs ask us to dwell on photographic events, on the images' pained and painful referents, the found photograph refuses this look. The damage done to the surface of the image makes it difficult for the spectator to drift into the photographic scene and so changes the functioning of the image. The destruction draws attention to the photograph as an artifact, as a two-dimensional picture that fails to represent that which is absent. The damage is specific in this regard: a combination of fine horizontal scratches which bite into the paper and four long vertical cuts that pierce the image.[5] In his study of defacement, Valentin Groebner (Groebner 2004) calls upon a medieval German word to characterize the quality of such disfigurements: *Ungestalt*. Both a noun and an adjective, *Ungestalt* could be translated into English as "hideous" or "hideousness," but taken more literally, the term points to a particular quality of formlessness. That is, unlike "hideousness" which implies a gruesome disfigurement that may be all-too-visible, *Ungestalt* can signify that which has no appearance (Groebner 2004: 12). The distinction is important in the Bosnian example. The damage done to this photograph does not merely mar the family's faces.[6] This is not simple vandalism. Where there were once identifiable people in this photograph, only terrifying voids remain. The family has been rendered into faceless exemplars of horror.

The mad image

The grounds for assessing the significance of this violence are contested. The status of the photographic image – and especially the nature of the evidence the document can proffer – has been under debate virtually since the inception of the camera. On one side stands Roland Barthes's famous dictum that all photographs proclaim "that-has-been," that is, what one sees in the image once really existed (Barthes 1981: 77). This position argues that the photograph, as a material registration of light, provides unique phenomenological evidence of the prior existence of a thing. Yet Barthes cautions: there is madness in the medium's proximity to reality. The image refers to something that is both *not* there and indeed *has been* and this particular quality renders the photograph "a mad image, chafed by reality" (Barthes 1981: 115).

On the other side of the debate, contemporary theorists argue that what photography shows is mere illusion. John Tagg claims that the "photograph is not a magical 'emanation,' but a material product of a material apparatus set to work in specific contexts, by force, for more or less defined purposes" (Tagg 1988: 3). This alternative position contends the significance of whatever "has-been" is not bound by the photographic frame, but shaped by who and how and why viewers look. Rather than reside in a unique proximity to the real, here photographic meaning is thought to depend upon the circulation and context in which the image is viewed (Burgin 1982; Tagg 1988; Apel and Smith 2007; Phu and Brower 2008).

The debate about photographic meaning is particularly resonant when it comes to images of violence. Susan Sontag underscored the problematic in *Regarding the Pain of Others*, her second and last book on photography, when she wrote: "all photographs wait to be explained or falsified by their captions. During fighting between Serbs and Croats at the beginning of the recent Balkan wars, the same photographs of children killed in the shelling of a village were passed around at both Serb and Croat propaganda briefings. Alter the caption, and the children's deaths could be used and reused" (Sontag 2003: 10). Ron Haviv's found photograph – and specifically the violence enacted upon its surface – seems to offer further evidence for the radical malleability of photographic meaning. Not only can meaning be shifted simply by changing the context of viewing, but by altering (or in this case, by defacing) the graphic properties of the image. The meaning of a photographic image is never fixed, never guaranteed, and never to be trusted. Like all implements of violence, this medium will lend its signifying powers to the highest bidder:

But this proven malleability of photographic meaning should not lead us to lose sight of the force of a photograph, or of the problematic point where, as Barthes puts it, the image is "chafed" by reality. It is significant, in other words, that the defacement of the family photograph in the hands of the Serb occupiers does not fully destroy the prior meaning of the photograph as a family keepsake. Indeed, the defacement actually *relies* on this prior meaning to lend the violence its force. The destructive gesture needs the significance of the family's image to remain at least partially legible. The set of questions this example quickens, therefore, centers less on the source of photographic meaning than on the significance of its treatment, on the extraordinary vicissitudes of affect: How can the photograph act as both a source and emissary of the occupiers' aggression? How does the image come to be marked by affect but also serve as the medium of its transmission?

In psychoanalytic terms, affect is the qualitative expression of the quantity of drive energy as well as its fluctuations (Laplanche and Pontalis 1973: 13). Freud uses the term "quota of affect" as a way to point to the particular amount of a drive's charge. The affective representation of this charge can take a variety of forms, from bodily signs (physical sensations and parapraxis) to conscious, nameable feelings. Affect is, then, simply a medium for drive energy. The distinct fate of affect's character – the extraordinary vicissitudes of emotional life – is not only subject to internal pressures but also to pressures from the outside world. Affect is the register through which we are susceptible to the world as well as the means by which we affect it.

Barthes offers us an opening for thinking through how the photograph serves as both a container and agent of affect: "The Photograph," he insists, is "a bizarre *medium*, a new form of hallucination" (Barthes 1981: 115, original emphasis). In contrast to

an illusion (which is a strictly visual perception), a hallucination can include an array of sensory and somatic sensations: smells, feelings, tastes, and sounds. What Barthes proposes is that photography's peculiar effects – its madness – far exceed the realm of vision. Photography is a medium that can encompass a broad affective terrain. In the dense last chapter of *Camera Lucida*, Barthes dwells on the various ways society has attempted to tame this madness which keeps threatening to explode in the face of whoever looks at a photograph. There he calls photography "ecmnesic," which is to say this medium produces something more than just a vision of the past. Looking upon an image can induce a state of delirium in which the past actually *feels* present. Photography is a form of hallucination in which one can feel oneself *to be* in a prior time.

This sounds like madness to be sure. Given Barthes's admission that he is writing while deep in grief over his mother's death, one might wonder if his evaluation of photography's functioning is distorted by melancholia. Even Freud admitted he had difficulty evaluating whether mourning is ever successful (Freud 2005 [1917]). As a means to measure its success, Freud contrasted mourning with melancholia, the latter being a distinct position a subject takes in relation to the loss of the beloved object. Normally, a respect for the reality of the loss carries the day, which is to say one's attachments and investments in the beloved are slowly withdrawn in a painful, piecemeal fashion. But the melancholic turns away from the reality of the loss and holds onto the beloved in a hallucinatory manner – in effigy, in the truest sense of the word. In normal mourning, there is a painful recognition that the lost other is no longer, nothing but a memory, an image in the mind of the viewer (Derrida 1996). The melancholic functions as if the other still exists. Listen to Barthes on the photograph: "it bears the effigy to that crazy point where affect (love, compassion, grief, enthusiasm, desire) is the guarantee of Being. It then approaches, to all intents, madness; it joins what Kristeva calls '*la vérité folle*'" (Barthes 1981: 113). For Barthes, photography can open a hallucinatory passageway to the other's being. Through the photograph one can actually *enter* the crazy spectacle, take into one's arms what is dead, what is going to die.

One may be tempted to dismiss Barthes's thesis about photography as the madness of a man deep in grief, a man gripped by a hallucinatory wish-psychosis. But this mode of mental functioning finds a curious parallel in the delusions of war. Like mourning, war can provoke a psychological distress that is expressed most clearly in an altered relation to the other. In fact, in much of the psychoanalytic writing on the subject, the problem of war is placed in the context of mourning. For Franco Fornari, war is a "paranoid elaboration of mourning" (Fornari 1975: xviii). For Jacqueline Rose (1993), war parallels the ambivalence of love relationships evident in melancholia. In times of war, aggression is projected onto the enemy-other. In melancholia, the human tendency toward hatred is satisfied by turning the aggression back against the self. In *On War*, one of the most famous texts ever written on the subject, Carl von Clausewitz defines war in the following quasi-psychoanalytic way: as "an act of violence [that] is intended to compel the enemy to fulfill our will" (Clausewitz 1982: 101). In grief and in war, it is difficult to let the other go.

The parallel between these two psychological positions is underscored by the treatment of the found photograph. This example from war-torn Sarajevo cements Barthes's theory. According to Ron Haviv's account, the occupiers successfully took up residence in the house of their enemy, making a home for themselves in the place

of the (hated) other. Even when forced to abandon the house, they took the enemy-other's possessions with them. In psychoanalytic terms, the Serbs identified with the Muslim family so thoroughly they managed to incorporate their most intimate household objects. Identification is a way to modify self-representation, a complex process where the subject assimilates some aspect or property of the other and is thereby transformed. Put simply, the occupiers were able to take the family's objects as their own. Only the photograph stubbornly refused this inscription. Where the occupier's own image ought to have appeared, the Muslim family's faces looked back. Put differently, the photograph registered as a refusal, as a lack, as *negative ocular proof* of the occupiers' existence in the place of the other. Akin to Barthes's vision of the photograph as ecmnesic, for the Serbs, the Muslim family snapshot appeared to function like a negative hallucination.[7] In the face of the photograph, the fact of the family's *existence* could not be denied. The photograph registers the stakes of this struggle with plastic clarity. The cruel, deliberate scratches testify to a violent surge of affect. The image became a medium, a site of the transference through which the occupiers could express their hatred: an embodied location where unconscious wishes could be actualized. In short, the photograph provided a hallucinatory venue for the Serbs to realize the annihilation of their neighbors.

Intractable reality

The example from Bosnia is certainly not the most extreme incident of photographic violence in the history of war. The destruction of the European Jewry during World War II was designed not only to eradicate an entire people, but also to consume all memory itself. During the course of their methodical extermination project, the Nazis went to great lengths to expunge all traces of their victims. It is well known, for instance, that prisoners arriving at Auschwitz-Birkenau had their personal belongings confiscated upon arrival. These items were sent to the Kanada storehouse to be meticulously sorted and catalogued: clothing, toys, shoes, eyeglasses, prosthetic devices, gold teeth, wristwatches, jewelry, suitcases, books, hair – *anything* that could be reappropriated by the German people. Contemporary visitors to the museum at Auschwitz can still ruefully gaze upon huge bins of these artifacts. Less well remembered is what happened to the personal effects that were deemed unusable, those things that resisted German reappropriation and were therefore deliberately destroyed: letters, drawings, family photographs. According to one Auschwitz survivor, Yehuda Bacom, there was a separate crematorium in the gas chamber complex where such items were incinerated (cited in Young 2001: 16).

The full significance of this deliberate destruction – and in particular its transferential relationship to the burning of people – has perhaps yet to be realized. Throughout his oeuvre, Freud never tired of emphasizing the strangeness of encountering signs of the transference. He came to regard it as both necessary and dangerous to the project of analysis. Transference is both the condition for analysis *and* the most powerful obstacle to its success. In his own way, Roland Barthes proposes that the photograph functions similarly. These peculiar images are the site of our most ambivalent attachments, locations through which we pass "beyond the unreality of the thing represented" (Barthes 1981: 117). The photograph opens a paradoxical relationship

in which one encounters the very letter of time, a backward movement in which the past dominates our view of the present.

Focusing on the affective treatment of the image – attending photographic violence rather than depictions *of* violence – opens a "sideways" view of the functioning of social violence (Žižek 2008). What the Nazis and the Serbs find intolerable and rage-provoking about the ferociously normal family photographs is not the immediate reality of Jews or Muslims. It is the figure, the image of the "Jew" and the "Muslim," that is the true target of violence. Instances of photographic violence underscore the primacy of this fantasmatic dimension. Such instances of "acting out" should not, in the end, be regarded as a mere secondary effect, as a distortion of "real" social violence. Indeed, the symbolic realm is the ultimate resort of all human violence (Žižek 2008: 66). And this is the "mad" point of all photography, the place where the image is "chafed by reality." To rephrase Barthes's enigmatic thesis, the photograph offers an uncomfortable proximity, a kind of suture between the social and psychical realms. When the identity of this family was attacked through the ravaging of the photograph, it was not merely a statement about what the family represents. Rather, the attack determined their social existence, the very *being* of these subjects. In a mad, hallucinatory way, one only has to look at the photograph to *feel* the force of this vicious inscription.

Is there something to be gained from attending this violence? Judith Butler (2004) proposes that thinking through our exposure to violence and the task of mourning that follows constitutes an important dimension of political life. The work of mourning is set in contradistinction to the violence of war. Grief, Butler contends, provides as an alternative ground for imagining community. One can gather a sense this perilous task by looking through *The Last Album*, a rare collection of the personal photographs that survived Auschwitz's crematoria (Weiss 2001). The pictures in this album are quotidian scenes from the first decades of the last century: a group of teenagers playfully thumbing their noses at the camera, a proud family posing in front of a store, a smartly dressed couple on a promenade through town, children modeling their costumes for a school play, a wedding, a picnic. Similar to the family snapshot from Sarajevo, the pictures in *The Last Album* do not represent the violence of the genocide in any direct fashion.[8] Yet the history of their violent treatment still manages to convey the qualitative force of war's affects. The fact the Nazis took such pains to destroy these objects in the same manner as they did their owners underscores Barthes' thesis about the ecmnesic quality of photography. Yet the images in *The Last Album*, like the Sarajevo snapshot, nevertheless offer a uniquely moving testimony of the catastrophe's reach. For here spectators meet the painful, piecemeal work of mourning head-on. This is what I think Barthes meant with his last words on the photograph: in each of these images one confronts "the wakening of intractable reality" (Barthes 1981: 119). Everything pictured in these photographs is lost and yet everything must be let go. Negotiating such losses reconfigures the very ties that bind.

Original publication

'On Photographic Violence', *Photography and Culture* (2009)

Notes

1 One thinks of Heinrich Heine's oft-cited line from Almansor: "That was only play. Where they have burned books, they will end in burning human beings."

2 Hannah Arendt, who wrote *On Violence* in the wake of the 1968 student uprisings and in the context of the rising violence in the US Civil Rights movement, argued that violence is related to power and strength, but distinct in its instrumentality: "Phenomenologically, it is close to strength, since the implements of violence, like all other tools, are designed and used for the purposes of multiplying natural strength until, in the last stage of their development, they can substitute for it" (Arendt 1970: 46). Can one imagine the Bosnian example as a signal of this transformation, as a quotidian example of this "last stage of development" when the implement of violence substitutes for the violence itself?

3 The term "warchitecture" emerged in Sarajevo as a name for the catastrophic destruction of architecture during the 1992–1996 siege of the city (cf. Herscher 2008).

4 These and many more of Haviv's photographs can be viewed in an online photo essay: http://photoarts.com/haviv/BloodandHoney/, accessed February 13, 2009.

5 Ron Haviv confirms: "the scratches actually pierce the image. It appears the vertical lines were done using some sort of implement and the horizontal possibly with a razor blade" (personal correspondence, January 14, 2009).

6 Attacks upon the face carry a special symbolic significance. Groebner's study (Groebner 2004) draws attention to the link between facial disfigurement, racism, and policing of the sexual order. In 1938, for instance, he reports that the Swiss physician and racial anthropologist George Montandon published an article in France calling for the creation of a Jewish state in Palestine as the solution to the "Jewish Question." The article called upon Jews to divest themselves of their other citizenships and further proposed a "protective policy" that prevented mixing with other races. Sexual relations between Jews and non-Jews were outlawed. Montandon proposed that men violating this law should be castrated and women under the age of forty should have their noses cut off (Groebner 2004: 67). Groebner finds precedent for this particular punishment in fifteenth-century Nuremburg where the cut-off nose appeared as the symbol *par excellence* of losing face, that is, of lost honor (Groebner 2004: 80). The face thus disfigured – rendered *Ungestalt* – was a visible mark of an invisible sexual disgrace that could range from adultery to (passive) homosexual activity. Montandon's propsal from 1938 features an additional phantasm in its tacit reference to the allegedly "Jewish" nose that so fascinated nineteenth- and twentieth-century racial anthropologists (Groebner 2004: 86). A symbolic link is implied between the (Jewish) nose and circumcised penis, between the policing of illicit sexual activity and its punishment in facial disfigurement.
 Groebner's study bears a surprising significance to the found photograph from Bosnia. In the Balkans, the most common way to identify "ethnicity" was by family name. Most family names are easily identifiable as Orthodox Christian Serbian, Bosnian Muslim, or Catholic Croatian. But in Bosnia in particular, some names are common among all three groups and many families have long genealogies of mixed marriages. There are no immediately apparent physical differences between the three peoples. Throughout the region, however, only Muslims practice circumcision. During the war it became common practice for Bosnian Serb (or Bosnian Croat) soldiers to order men to drop their pants for identification. The widespread rape of Muslim women during the conflict was often "justified" through a reference to circumcision (Olujic 1998). In light of Groebner's study, the fine scratches and long, vicious cuts done to the Muslim family photograph perhaps can be seen to bear a deeper symbolic significance about the sexualization of aggression. The damage perhaps points to the Serbian occupiers' fantasies about circumcision and the invisible sexual act. But such expressions of aggression are not easy to interpret. Freud

famously remarked that Thanatos – the destructive drive – purposely eludes perception (Freud 2002 [1930]: 57). It works silently, so to speak, discerned only as a residue left behind by Eros. The found photograph bears the marks of this struggle. The artifact provides a kind of mute testimony about the work of sadism – Eros yoked out of shape, perverted by the destructive force of Thanatos.

7 My discussion draws heavily here from André Green's notion of "negative hallucination" (Green 1999 [1973]).

8 There is a large and growing body of literature that questions photography's capacity to represent the events of the Holocaust (or indeed any traumatic event) faithfully. Engaging the complexities of this debate is far beyond, and indeed aside from, the scope of the present paper. I would, however, point the reader to Georges Didi-Huberman's recent book *Images in Spite of All* as one of the most lucid sites of the debate. Speaking of four photographs made by the *Sonderkommando* in Auschwitz in 1944, Didi-Huberman contends that the photographic image appears in the fold between two impossibilities: the imminent obliteration of the witness and a certain unrepresentability of testimony. Moreover, because the *Sonderkommando* felt the perilous need "to snatch an image from the real," we are perhaps obliged to contemplate, to *imagine* the hell that was Auschwitz in the summer of 1944 (Didi-Huberman 2008: 7).

References

Apel, D. and Smith, S. M. 2007. *Lynching Photographs*. Berkeley: University of California Press.

Arendt, Hannah. 1970. *On Violence*. San Diego, CA: Harcourt Brace.

Barthes, Roland. 1981. *Camera Lucida: Reflections on Photography*. New York: Hill & Wang.

Burgin, Victor. 1982. *Thinking Photography*. London: Macmillan.

Butler, Judith. 2004. *Precarious Life: The Powers of Mourning and Violence*. New York: Verso.

Clausewitz, Carl von. 1982 [1832]. *On War*. Harmondsworth: Penguin.

Derrida, Jacques. 1996. By Force of Mourning, trans. P.-A. Brault and M. Naas. *Critical Inquiry* 22(2): 171–192.

Didi-Huberman, Georges. 2008. *Images in Spite of All: Four Photographs from Auschwitz*. Trans. S. B. Lillis. Chicago: University of Chicago Press.

Fornari, Franco. 1975. *The Psychoanalysis of War*. Bloomington, IN: Indiana University Press.

Freud, Sigmund. 2002 [1930]. In Adam Philliips (ed.), *Civilization and Its Discontents*. Trans. D. McLintock. London: Penguin.

Freud, Sigmund. 2005 [1917]. Mourning and Melancholia. In Adam Phillips (ed.), *The Penguin Freud Reader*. Trans. S. Whiteside. London: Penguin.

Freud, Sigmund. 2006 [1914]. Remembering, Repeating, and Working through. In Adam Philips (ed.), *The Penguin Freud Reader*. London: Penguin.

Gourevitch, Philip. 1998. *We Wish to Inform You That Tomorrow We Will Be Killed with Our Families*. New York: Picador.

Green, André. 1999 [1973]. *The Fabric of Affect*. Trans. A. Sheridan. London and New York: Routledge.

Groebner, Valentin. 2004. *Defaced: The Visual Culture of Violence in the Late Middle Ages*. Trans. P. Selwyn. New York: Zone Books.

Gutman, Roy. 1993. *A Witness to Genocide*. New York: Macmillan.

Haviv, Ron. 2000. *Blood and Honey: A Balkan War Journal*. New York: TV Books.

Herscher, Andrew. 2008. Warchitectural Theory. *Journal of Architectural Education* 61(3): 35–43.

Laplanche, Jean and Pontalis, Jean-Bertrand. 1973. *The Language of Psycho-Analysis*. Trans. D. Nicholson-Smith. New York: Norton.

Maas, Peter. 1997. *Love Thy Neighbor: A Story of War*. New York: Vintage.

Olin, Margaret. 2002. Touching Photographs: Roland Barthes's 'Mistaken' Identification. *Representations* 80: 99–118.

Olujic, Maria B. 1998. Embodiment of Terror: Gendered Violence in Peacetime and Wartime in Croatia and Bosnia-Herzegovina. *Medical Anthropology Quarterly* 12(1): 42–43.

Phu, Thy and Brower, Matthew. 2008. Editorial. *History of Photography* 32(2): 105–109.

Power, Samantha. 2002. *'A Problem from Hell': America and the Age of Genocide*. New York: Harper.

Rose, Jacqueline. 1993. *Why War? Psychoanalysis, Politics and the Return to Melanie Klein*. Oxford: Blackwell.

Sontag, Susan. 2003. *Regarding the Pain of Others*. New York: Farrar, Straus, and Giroux.

Sudetic, Chuck. 2000. The Crime and the Witness. In Ron Haviv, *Blood and Honey: A Balkan War Journal*. New York: TV Books.

Tagg, John. 1988. *The Burden of Representation: Essays on Photographies and Histories*. Minneapolis: University of Minnesota Press.

Weiss, Ann, ed. 2001. *The Last Album: Eyes from the Ashes of Auschwitz-Birkenau*. New York: W.W. Norton.

Young, James E. 2001. Introduction. In Ann Weiss (ed.), *The Last Album: Eyes from the Ashes of Auschwitz-Birkenau*. New York: W.W. Norton.

Žižek, Slavoj. 2008. *Violence: Six Sideways Reflections*. New York: Picador.

Ariella Azoulay

THE ETHIC OF THE SPECTATOR
The citizenry of photography

The conquest of the world as a picture

SHORTLY AFTER PHOTOGRAPHY'S APPEARANCE, the process of "conquering the world as a picture"[1] commenced. In this era, photography became a prime mediator in the social and political relations among citizens, as well as the relations between citizens and the powers that be.[2] We thus live in an era in which it is difficult to conceive of even a single human activity that does not use photography, or at least provide an opportunity for it to be deployed in the past, present or future.[3] Newspaper reportage, jurisprudence, medicine, education, politics, family, entertainment and recreation – everything is mediated by photography.[4] There are virtually no restrictions on the use of photography in public space.[5] Everyone and everything is liable to become a photograph. However, there are exceptions – military zones, for instance, and other enclosed spaces where rules concerning the use of photography are enforced.[6] In certain domains, the use of photography is a duty (identity photos for official documents) or normative (class photographs). Most often, the encounter with photography does not require explicit consent from its users, whether they are photographers or spectators. That which has yet to be conquered is always susceptible to becoming a goal of conquest: "the conquest of the world as picture" was not hastily undertaken, nor did it emerge out of oppression. Conquering the world as a picture means that every citizen could see – through photographs, and thus through the eyes of others – more than they could see by herself. This process was not directed from "on high" by means of a central body that administered the use of photography, or regulated the infinite output that it produced. Photography functions on a horizontal plane, it is present everywhere – actually or potentially.[7] The conquest of the world as picture is enacted simultaneously by everyone who holds a camera, serves as the object of a photograph or looks at photographs.

The conquest of the world as picture was photography's vision from its very beginning, and is performed anew each and every moment. The dynamic partnership of "everyone" in the fulfillment of this vision makes them citizens in the citizenry of photography. Their participation simultaneously in the conquered world (as picture) and in the powers that conquer (photographer and spectators), actually prevents the completion of the process of turning the world into a mere picture. This partnership makes the conquest of the world through more and more pictures an ongoing and unfinished enterprise. Within a social context, the logic of photography exceeds the singular act of photography and is woven into the net of a plurality of people, where all are photographing at the same time, thus lending their human gaze and their mechanized gaze to others in a way that essentially escapes their control. This is the origin of the ontological difference that marks the status of the image in an era that began with the invention of photography. The civil contract of photography is the agreement that allows the logic of photography to overpower social relations, while at the same time provide a point of resistance against photography's total control, initiating a responsibility to prevent the completion of this very control.[8]

Here is a photograph that exemplifies the civil contract of photography. In 1988, the Israeli newspaper Hadashot sent reporter Zvi Gilat, translator Amira Hassan and photographer Miki Kratzman on assignment to report on a soldier's post built on the roof of the house of the Abu-Zohir family. Mrs. Abu-Zohir demanded that the photographer take a picture of her legs, where she had been shot with rubber bullets by Israeli Defense Forces (IDF) soldiers. The photographer – who regularly took pictures of the Israeli-Palestinian conflict, had seen rubber bullet injuries before and who was familiar with the habits of his editors and their expectations in regard to photography – dismissed her request, claiming that rubber bullet wounds don't make good pictures. He had not seen her wound but his knowledge was based on past experience, which was abundant. But the woman was insistent – after all, she was a signatory of the civil contract of photography. She knew that her wound was singular, and that her right to be photographed did not oblige anyone to see the photo (nor any editor to publish it). But she acted, nonetheless, as if it was her right to demand her photo be taken, and everyone else's duty to see it. The editor and the spectator are civilly obliged to address her demands. The right or duty does not stem from the law, but from the civil contract of photography. She was seeking to become a citizen by means of, through and with photography. By becoming a citizen she enables others to become citizens. She came face-to-face with one citizen: the photographer. He asked to see the wound before he granted her request. She refused. She would not expose her legs in public, her body was her own. Her participation in the civil contract of photography was an agreement to be photographed – not to be seen – by a photographer.

PHOTOGRAPHER: Show me your legs.

MRS. ABI-ZOHIR: I won't show you my legs. You're not going to see my legs.

PHOTOGRAPHER VIA TRANSLATOR: Explain to her that this photo is going to appear in the newspapers and the entire world is going to see her legs.

MRS. ABU-ZOHIR: A photo's a photo. I don't care if the photo is seen, but you're not going to be in the room with me when I expose my legs.

An agreement on photography? "Yes," Abu-Zohir would say, but there would be no wholesale agreement on photographer-photographed relations as the press dictates. Abu-Zohir demanded the picture of her wound. The photographer prepared the camera, directed its' gaze, determined the exposure length, focused the lens, deposited the camera in the journalist's hands and left the room. The journalist shot an entire roll of film in order to obtain a single image, the one in which I am now standing as a spectator. Abu-Zohir's bare feet were planted on the ground, pressed to the floor, supporting the entire weight of her body as she stood staunch and upright. She leveled her gaze at the camera – not the photographer, he was clearly of no concern to her – she rolled up her pant legs, pulled up her skirt, and framed the injury. It's as if she were saying: "I, Mrs. Abu-Zohir, am showing you, the spectator, my wound. I am holding my skirt like a screen so that you will see my wound." Alongside her stood a little girl, perhaps her daughter, who felt comfortable enough to walk barefoot. She was allowed to look. Perhaps she was even required to look, unlike myself, the spectator of the photo. The girl signifies the distance between whoever looks at her and whoever looks at the photo. Abu-Zohir placed the girl beside her as a reminder – so that no one can mistake the photo for that which is photographed in it, but also to insure that no one will forget the continuity between the photo and what has been photographed in it.

Abu-Zohir, when she let her skirt fall back down, sought to put an end to the photographic act. But the photo will not allow photography to end, nor will Abu-Zohir alone dictate its course. This photo, from which her silent gaze looks out at me, will not let go. Nothing has concluded, though the hour of photography has passed.

Trust in photography

Abu Zohir's request for a photograph of her injury is based on the assumption that the camera makes it possible to obtain as sharp, clear and lifelike an image as possible of what appears in front of the lens. This is more than an assumption, it is an agreement among the citizens of the citizenry of photography over the status of the photographed, and the possibility of a transition from the photograph to the photographed – that is, access to what is imprinted on the photograph. This agreement is the convention of photography, which can be exemplified by two well-known anecdotes. The first concerns responses Russian filmmaker Dziga Vertov received after he presented his films in the 1920s to peasants who had never seen a movie: surprised and embarrassed by the close-ups, they adamantly objected to the cynicism of decapitating people for the sake of cinema. The second anecdote concerns an anthropologist who showed a Bush woman a snapshot of her own son: the woman could not recognize her son's face until those around her pointed to each detail in the photograph and called it by name. These two anecdotes describe peoples' first encounter with the media. In the first anecdote, identification is extreme – to the point of total identification – between the filmed image and its reference, to such an extent that what appears on the screen seems to the peasants to be actual persons who have just been decapitated. For the woman in the second anecdote, the identification is so unfeasible that she does not recognize her son in the reference. The gesture of identification, expressed in pointing out "this is x," characterizes the viewing of a photograph. The absence of this gesture, which reaches the extreme among inexperienced spectators like those described in

the anecdotes, indicates that the experience of the narrators of the anecdotes were gathered through practice and socialization.

When various teachers and writers use these anecdotes they wish to critically expose the fact that photography and cinema are practices of representation that are culturally dependent and that their particular mode of representation is not to be taken for granted. Such anecdotes, which are told again and again, enable the narrators to distinguish themselves from other spectators. The narrators' viewing skills in these media have caused them to already forget the inauguration that was demanded of them, which is exemplified through the protagonists of the two anecdotes. The ritualistic dimension of narrating the anecdotes transforms the very act of storytelling into an instrument of socialization, enabling the storytellers to express a seemingly critical position. Although restricted to a general claim about the cultural conditioning of photographic representation, such narrations allow the one who relays them to believe that a deep truth has been exposed, all the while ignoring the obligation she has toward the social agreement in relation to the photographed image, which lies at the heart of the civil contract of photography.

Instead of serving as a point for critical reflection, the narrator regards photography's cultural dependence simply as a negative feature, overlooking that this fact is what characterizes the political conditions of the visible in the photographic era. In other words, transmitting such anecdotes often absolves the transmitter from actually grappling with their content. As soon as they are told, everyone knows that the storyteller knows that photography is a convention. Through the anecdote, the fact that photography is a convention becomes a secret of photography that must be exposed, thus the narrator becomes the critical agent who conveys this secret. The fact that these anecdotes can be told again and again (and by a vast number of people), and that the narrator or his listeners can reveal the secret every time without ever exhausting the secret, should necessitate a new inquiry into the convention of photography and its status as a secret. The secret that unveils photography as a convention is usually related to the level of representation – what is seen in the picture is identified by members of the same culture because they have been trained to see photographs and identify similarities between such photographs and the photographed object. This convention is the rule of photography, but only rarely is it encountered face to face, with its rough seams so apparent. Even in a society accustomed to photography, in which disputes are made over what is represented by various experts who linger over an image in order to make it speak, the fact that photography is a convention is simultaneously visible and concealed. The image appears as a group of marks with an obscure meaning, accompanied by graphics (arrows indicating who or what is shown in the picture) or lingual signs (words or concepts that organize the scene so that it will not escape the eye of the spectator) in order to assist in the creation of meaning from the group of marks. These signs facilitate the gesture of identification – "this is X." The signs themselves, as well as the disputes over their referent, attest to the fact that the photograph does not speak for itself, that what is seen in the photograph is not immediately given, and that its meaning must be constructed and agreed upon.[9] As demonstrated by the above anecdotes, the inquiry into the convention of photography focuses on the plane of the visible, while leaving in shadow, and maybe even in secret, the convention of photography as it exists on the plane of political relations. Speaking of the convention as "the thing agreed upon" – that is, the object of

agreement – undermines the fact that a convention is first and foremost a gathering, as indicated by the Latin root of convening, con-venir, meaning coming together, to an agreement.

Most histories of photography[10] ignore this element of agreement that is involved in photography, along with the social relations shaped by this agreement. These histories are written from a hegemonic viewpoint that accepts the institutionalization of photography as a movement toward progress. In addition, they fail to consider the primary, constitutive link between the State or sovereign power and photography, nor the contentions made by those opposed to photography at its inception. Accepting the motif of progress as the self-evident, central axis for the unfolding of events,[11] these histories overlook the fact that from its very beginning photography has been a mass medium that rudely and violently fixes anyone and anything as an image. Despite this, for almost two centuries, photography has still attempted the realization of the moment of convening that has existed within it from the very beginning.

In order to understand this agreement, it is necessary to interrogate the conditions that brought about its achievement among people who were unfamiliar to one other. The origin of this agreement can be located at the point when a certain type of photography was established, and acquired a monopoly within a very short span of time. The famous, enthusiastic speech of the French physicist François Arago, delivered before the French Chamber of Deputies in 1839, allows us to isolate a constituent moment in this establishment. In his speech, Arago hoped to convince his colleagues of the importance of the invention and the necessity of the State to take steps to protect and promote it. Arago pointed to the great potential of photography to assist in various fields of human endeavor, as well in many different fields of knowledge (including philology, astronomy, archeology and art). However, the benefit of photography seems of secondary importance when compared to the truly great project that he implies in his remarks – the conquest of the entire world as a picture.

On one hand, he counted everything that could be turned into an object of photography – which is more or less the entire world; on the other hand, he emphasized the fact that anyone could participate in realizing the capabilities of the invention. According to Arago, the invention does not simply yield "experimental results among the curiosities of physics."[12] If this was the only benefit of the invention, as he clearly states in his speech, "[it] would never have become a subject for the consideration of this chamber." Instead, it is under discussion not only because a much larger community of non-scientists could handle it, but also because it has created a shift in the possibilities of conquering the world as a picture. Much more than single visual representations resulting from a large investment of practice, time and resources, photography is an endless multiplicity of images of which anyone can become the producer and the agent, by simply following a short set of instructions. "When, step by step, a few simple prescribed rules are followed, there is no one who cannot succeed as certainly and as well as can Mr. Daguerre himself."[13] When reading Arago's vision it is difficult to miss the prophetic announcement of the imperialistic power of photography. Arago's enthusiastic arguments were intended to weaken, or perhaps even silence, the voices of those opposed to photography and its institutionalization.

Traces of those voices have barely survived in the discourse on photography, and when they do receive a mention here or there, they are generally presented as reactionary and primitive for having ascribed magical properties to photography. Even

when Walter Benjamin, who dreamed of writing an alternative general history, and an alternative history of photography in particular, presented such voices through the dichotomy of conservatism and progress, he scornfully described such voices as opponents of the "Black Art from France."[14] Ever since photography's appearance on the stage of history, any possibility of repudiating what has turned into the self-evidence of photography, or photography as being self-evident, has thus been drastically curtailed. If there was, in photography, any measure of otherness – as its opponents at the outset insisted – it has been effectively denied and domesticated, whereby photography has rapidly spread into every corner of life, and assimilated into the modern landscape.[15]

Arago concluded his speech to the Chamber on a patriotic note, depicting France as the bearer of glad tidings: "France has adopted this invention and from the first has been proud to be able to generously present it to the entire world."[16] The State responded to Arago's panegyric to photography and his demand that its inventors be rewarded by purchasing the patent rights and transforming the invention into common property.[17] The object of these glad tidings was no longer a mere technological invention, but a political revolution – a second French Revolution. Like the first, which formulated the rights of man and citizen, this revolution reshaped the status of both man and citizen.[18] The French State purchased the patent rights of the camera as fabricator of images, but it couldn't make the action of photography its own.

Photography, as such, cannot be appropriated.[19] Selecting the daguerreotype, Daguerre's invention, over the competing inventions of William Henry Fox Talbot or Hippolyte Bayard, whose photos appeared less accurate and more pictorial, was a decision in favor of photography as a scientific tool, to be used as an instrument of truth, and to transmit information on what "had been there" – information that could be used for legal, historical or cultural purposes. Distinguishing photography from painting (which does not hold an indexical relation with its object) separated photography from the logic of collections and exhibitions that were presented to the curious eyes of individuals. In the type of photography that was thus established, epistemological criteria set the standard for the relation between the photographic result and its object, so that photography is supposed to enable the identification and recognition of the photographed.

In addition to a few specific operating instructions for each chosen model, the instruction manuals supplied with every camera have given expression to these epistemological criteria: "the instrument you have in your hands is intended to help you obtain an image of reality that is as clear, sharp, exact and reliable as can be, under all visibility conditions, from any distance or angle." These criteria guide any use of photography – including the purchasing of photographic equipment, the ordering of a photo, looking at a photo in the newspaper, learning of an event by means of a photo, photographing a certain person or situation or being photographed in order to provide identity for an official document. Photos have a contractual standing that is presumed to ensure a clear, sharp, legible, decipherable and true image, such that what "was there" in front of the camera lens, was also "there."[20] The subject engaged in photography expects it to serve as a means toward the end for which it was intended. The purpose of photography reproduced in most instruction manuals echoes an "original" purpose, which results, each time, in the renewal of its sanction. The technical language and the phrasing of the instructions refer directly to

the instrument and its operation, but the principles of agreement among the users are presupposed, which can be derived from both the technical language and the various uses of photography they attempt to support: generality, accessibility, publicity, transparency, neutrality and impartiality. Although these principles are often violated under varying circumstances, and are typically subject to constraints and restrictions of different kinds, they nevertheless serve as the rules of the game that has been agreed upon by all. But the camera itself does not fulfill these principals – a photographer is required to apply them.

The public trusts the photographer – who incarnates the public right to know – to faithfully perform his work and consistently negotiate with the institutions responsible for regulating the access routes to potential photographic objects. At times this contract is updated to conform to the demands of a newspaper, or the consequences of a particular event, but its essence is stable. Even if a critical study were undertaken of a set of photographs taken by a certain photojournalist, and the pattern of their appearance in a newspaper scrutinized, it might reveal particular interests, but this fact would not weaken the photographer's belief in universal principles that guide his work. Without this belief, he and the society that, in principal, defends his freedom of action would have difficulty granting him the professional title of "press photographer."[21] He acts in accordance with the political motto of "the public's right to know" and the moral "duty to report" as it has been conducted in the international arena. Astonishingly, even visual matters are at stake, demands for the transparency of information do not use verbs from the visual field, such as "the right to see" or "the right to take photos." The conversion of the visual into the verbal exposes the instrumental approach to photography that characterizes various fields of legal, political or moral discourse that constantly make use of photography. Photography is thus perceived as a transparent means of achieving the same general, universal goals.

The public assumes that photography is an instrument that can be controlled, one that is capable of supplying its demand. But the public cannot trust the photographer unconditionally, since he may be biased by some particular interests. The civil contract of photography is not a specific contract made with a specific photographer, but the expression of an agreement over certain rules among users of photography, and the relation of those users and the camera. If and when the photographer betrays his mission and wishes to divert the visible, the camera – as the impartial emissary of the public – will ensure the immortalization of reality as it Stands, so that this reality will one day reveal itself. If the camera betrays, or goes out of control, the photographer (as the public's emissary) will know how to regain control over the instrument and continue to produce what is demanded. Similar to the Lacanian subject one is supposed to know, the contract at hand allows the public to see the camera as that which is supposed to show. The camera, however, is not a subject, and is usually dependent on whoever operates it. But from the moment this operator takes hold of it, he too is no longer sovereign.[22]

Among the users of photography there is a silent agreement over the duality of photography, which is concerned with the way in which the medium of photography links the photographer and his object. The photographer and his object (the photographed) each work on the medium and intentionally and/or unintentionally undermine the other's exclusive control over it. This agreement concerning the act

of photography established the convention of the photographic product (the photo-graph), and assumes this object testifies to what "had been there," while nonetheless claiming that it is culturally dependent. Indeed, someone might sign the agreement over what "was there" – the photographer, for instance – but this signed agreement is only ever a partial version of what appears to the eye of the spectator. There-fore, what was indeed existed, but not necessarily this way, and it has not necessar-ily ended. The spectator is required to reconstruct what has been there from out of the visible, as well as to reconstruct what is not immediately manifest, but which can – in principle – become visible in the exact same photograph. One's responsibility toward the historical agreement on the status of the visible in photography requires this reconstruction, and to do this she should become a spectator.

Becoming spectator, becoming citizen

Becoming a citizen of the citizenry of photography means rehabilitating the relation between photograph and photography, between the printed image and the photo-graphic event – that is, the event that took place in front of the camera, constituted by the meeting of photographer and photographed object that leaves traces on a roll of film. There is a gap between the photo and the photographic event that both those who take an aesthetic position, as well as those who take an entertaining position, seek to eliminate. Becoming a citizen means replacing these impartial positions with a position that is partial to the civil contract on photography, a contract without which modern citizenship is invalid, as it is the contract that made the conquest of the world as picture possible. Citizens have been bound together in an agreement on photog-raphy, through the convention of photography, according to which, what appears in the photo "was there." But the conquest of the world as picture means that what appears in the photo is not all that was there – this has been agreed upon by the civil contract of photography – but was, however, photographed from out of what "was there" – and this, as well, has been agreed upon through the same civil contract. In an era that witnesses the conquest of the world as picture, in which social relations are mediated through photography, to be satisfied with citizenship as merely a legal status means agreeing to close the gap between the photograph and photography, agreeing to the absolute conquest of the world as picture while eliminating the social relations that hold the power – merely by existing – to prevent this absolute conquest. Becom-ing a citizen in the citizenry of photography means giving renewed sanction to the gap between the photograph and photography, between the world and the picture. Becoming a citizen means opposing the absolute conquest of the world as picture, on account of the same civil contract in which the conquest of the world as picture was agreed upon, when political relations had been the guarantee against its absolute conquest as picture.

Beginning in the 1990s, the conditions of visibility for photography have been altered within museum space. Subsequently, the massive introduction of horror images into that space transformed the museum into an alternative site vis-à-vis the media and its particular logic. Within the museum space, which began to host images of horror from various zones of war and conflicts, a new spectator posi-tion emerged from which responsibility for the sense of the image coalesces with

the responsibility toward the photographed. Not only have present images of horror been gazed upon in this space, but also a widespread review of photographs from the past, in which early moments of the civil contract of photography can be restored. The contemplative act, which previously characterized the museum subject, has thus been replaced by the subject as civil spectator, who watches the image in order to see within it the conditions of its fabrication and eventual possibilities for intervention in what it frames.

The term "spectator," much like the verbs "to observe" or "to watch," is not typically employed in regard to still pictures. It is customary to use such terms with reference to phenomena and, within the sphere of art, in reference to movie screenings or other modes of entertainment. With the photograph, the tendency is to "look at" or "contemplate," and that which is photographed is customarily "seen." The distinction refers to the object – the stationary object is accessible to immediate and exhaustive viewing (that is, seen in its entirety), which gives rise to such clichés as "a picture is worth a thousand words." A moving image, however, eludes the stable gaze, but only through its constant replacement by successive images: "It" has to be watched continuously, as long as there is something to see before one's eyes. A photograph, being a fragment taken from a flow or a sequence, is supposedly a stationary object. What's seen in the photograph is not given, and the gaze upon it can never immediately exhaust it. The gesture of identification – "this is x" – frequently used in reference to photographs, homogenizes the plurality out of which a photograph is made and unifies it into a stable image, giving the illusion that we are facing a closed unit of visual information. This gesture, frequent in so many domains, is part of an ongoing effort to suspend the civil power of being a spectator and neutralize the power of the civil contract of photography.

The dictionary defines "spectator" as a person who watches an event, which takes place before their eyes, without them taking any part. But this language refers not only to the placement of the spectator in regard to the event, but also to the way in which the action unfolds in time. The spectator's work is one of prolonged observation, performed at the margins of a particular activity or event. The spectator observes a certain space and has the capacity to report on what their eyes see. From their position, the spectator can occasionally foresee, or predict the future. The secrets of the future could be revealed to them, but so too could the atrocities of the present, thus they are able, through skilled observation, to identify and forewarn others of the dangers that lie ahead. The act of prolonged observation has the power to turn a still photograph into a theater stage, upon which what has been frozen in the photograph comes to life. The spectator is called to take part, to move from the addressee position into the addresser's position and to demonstrate responsibility toward the sense of the photograph by addressing it even further, turning it into the beacon of an emergency, a signal of danger or warning – transforming it into an emergency énoncé.[23]

Original publication

'The Ethic of the Spectator: The Citizenry of Photography', *Afterimage: The Journal of Media Arts and Cultural Criticism* (2005)

Notes

1 On this Heideggerian expression, see Ariella Azoulay, *Death's Showcase* (Cambridge, MA: MIT Press, 2001).

2 The omnipresence of photography differs from Chat of merchandise which is part of the world of labor and production and its contractual form is mainly defined by employer-worker relation.

3 Heidegger described the modern era as the "conquest of the world as picture" (Martin Heidegger, "The Age of the World Picture," in *Electronic Culture*, ed. Timothy Druckrey (New York: Aperture, 1996). Guy Debord described this era as "the society of spectacle." See Guy Debord, *The Society of Spectacle* (New York: Zone Books, 1995). These two discussions, which speak of the omnipresence of the image in the modern era, do not explicitly address photography and the particular ramifications of the conquest of the world by means of it, although they both undoubtedly relate to the photographed image.

4 Even law which once avoided the use of photography in actual court hearings, introduced it into the evidentiary hearing, see Tal Golan, "Learning to See: The Beginning of Visual Technologies in Medicine and Law," in *Law, Society and Culture* (Tel Aviv: The Buchman Faculty of Law Series, Tel Aviv University, 2003).

5 The ban on photography is still exceptional in the western world. Hiroshima and Nagasaki are famous examples—where, during the first years of the American occupation, films were confiscated

6 Since the middle of the 1990s, following the terrorist attacks in Israel and 9/11 in the United States, newspapers occasionally report on photographers or citizens who have been asked to stop taking photos in different public areas. The fact that prior to these attacks terrorist gathered photographic information in the open public space has led to attempts by a few policemen to limit photographic activity, but as of yet, no law has been legislated.

7 This is similar to power as described by Michel Foucault; see Foucault, *Histoire de la sexualité* (Paris: Gallimard, 1976).

8 On photography as omnipresent, and in the use of "everyone" see Pierre Bourdieu, *Un Art Moyen* (Paris: Minuit, 1965).

9 See Stefano Boeri, "Eclectic Atlases," Documenta X Documents, No. 3 (Ostfildern-Ruit, Germany: Cantz, 1996). A distinct example is the controversy among various institutions over the number of participants in demonstrations seen from air photos, spawning various methods to interpret the visible. See Farouk El Baz, "Crowd Space: Bodies Count," *Wired* (June 2003).

10 Including the critical ones, which attempt to depict the invention as the product of a period, rather than of a unique inventor.

11 Starting in the 1980s many studies that address the institutional uses of photography have appeared. However, these studies do not linger over the State's relation to photography. See Allan Sekula, "The Body and the Archive," in *The Contest of Meaning* (Cambridge, MA: MIT Press, 1989); Vincent Lavoie, *L'Instant-Monument* (Montréal: Dazibao, 2001); Carol Squiers, *Overexposed* (New York: The New Press, 1999); André Gunthert, "Daguerre ou la promptitude," *Etudes Photographiques*, No. 5 (1998).

12 The enthusiastic speech of the French physicist François Arago, delivered before the French Chamber of Deputies in 1839, allows us to isolate a constituent moment in this establishment. In his speech, Arago hoped to convince his colleagues of the importance of the invention and the necessity of the State to take steps to protect and promote it. See Dominique François Arago, "Report," in *Classic Essays on Photography*, ed. Alan Trachtenberg (New Haven, CT: Leete's Island Books, 1980).

13 Ibid.

14 Walter Benjamin briefly discusses this in his essay "A Small History of Photography," in *Selected Writings Volume 1: 1913–1926* (Cambridge, MA: The Belknap Press of Harvard University Press, 1996).

15 For a discussion of the denial of the logic of photography, see my discussion of Aim deüelle Lüski's cameras, The Civil Contract of Photography (forthcoming).

16 Arago, p. 24.

17 The invention is usually attributed to Daguerre, thus forgetting the contribution of Nicéphore Niépce and his son Isidore, who contributed to its invention. To purchase the invention, the State paid both Daguerre and the younger Niépce.

18 The State paid for the invention but did not take possession of it, thus renouncing both the monopoly it might have had by virtue of its purchase, as well as the possibility of having the government play an explicit role in the processes of institutionalizing the invention. Although the State relinquished its rights to the invention, one must not underestimate its role in regard to photography and its functions. The purchase of the invention and the concurrent renouncement of any rights obtaining to this purchase entailed that both a national (French) and universal stamp were at once imprinted upon the invention. Thus France sought to retain the spiritual monopoly, but also hoped to turn photography itself into a symbol of democratization. From its very beginning photography had been presented us a gift to the nation, a blessing bestowed upon it, and a right granted it; to this day it has been conceived us an instrument with positive attributes of assistance and support.

19 Despite the decision to confer the invention on the entire world, a patent was taken in England on the invention of the daguerreotype, and for several years it was not accessible to everyone. See Elizabeth Eastlike, "Photograph," *Classic Essays on Photography*.

20 On the "it was there" of photography see Roland Barthes, *La Chambre Claire* (Paris: Seuil, 1980).

21 I base my argument here on an ongoing analysis of press photos as well us many conversations I have held with journalistic photographers, some of which are published. See Azoulay, *Death's Showcase*.

22 For more on this subject see my discussion of Roni Kempler, who shot the video footage of Yitzhak Rabin's assassination. See Azoulay, *Death's Showcase*.

23 Relying on Deleuze's notion of the sense, I would contend that the sense of a photo should always be enunciated in another énoncé, be it a photograph or a text. See Gilles Deleuze, *Logique du sense* (Paris: Minuit, 1969).

Elizabeth Hoak-Doering

A PHOTO IN A PHOTO
The optics, politics and powers of hand-held portraits in claims for justice and solidarity

A T T H E M O T O R C Y C L E R A L L Y O F 1 9 9 7 ,[1] one year after the killing of Tassos Isaac within the barbed wire no-mans' land of the Nicosia Buffer Zone, I witnessed a traditionally dressed widow drive a tractor into the same barbed wire. Mrs Panayiota Pavlou Solomi sat high up on the blue agricultural tractor that was decorated with a banner, which read, 'ΠΑΜΕ ΝΑ ΣΠΙΡΟΥΜΕ ΤΑ ΧΟΡΑΦΙΑ ΜΑΣ' (Let's go plant our fields). In addition to this banner, the tractor was pinned with flapping black-and-white photographs of the scores of missing persons from the village of Komi Kepir, many of whom are her relatives (see Fragko, 2002). In Mrs Pavlou Solomi's lap, she cradled the largest of her portrait photographs: her husband and her son who both are still, as of February 2016, officially missing. She was acting alone, and handling the jolting tractor with the skill of a lady who had farmed her entire life. Behind, and on both sides of her there was a crowd of people with cameras. This isolated act, within the context of a charged political demonstration, projected symbolic meanings that related to Mrs Pavlou Solomi personally, as a Cypriot civilian, and as a Greek Cypriot woman. Her attention-getting performance was about Cypriot Missing Persons and the ongoing military occupation of the north part of Cyprus, but it also figuratively pushed at the heavily protected boundaries of Cypriot norms for women's self-expression.

The media-driven image of a bereaved or worried person holding the photograph of a missing relative has recently become fairly common, even though the disappearance of individuals is certainly not limited to modern warfare, or to warfare itself. Similarly, people have been posing for photographs holding older photos in their hands since the popularisation of photography as a medium. However, it was not until well into the twentieth century – and specifically in Cyprus and Argentina – when relatives of missing persons began to hold personal photographs up to the photojournalist's lens: a phenomenon that came about after the invention of the portable camera, the spread of global media and common understanding of individual human rights. For Ariella Azoulay (2012) this kind of photograph is a gesture that illustrates 'the event of photography par excellence'. But the gesture in this particular composition is only one

Figure 15.1 Image 1: *Berlin-Nicosia Motorcycle Rally* 1997, Mrs Panayiota Pavlou Solomi at Buffer Zone. © photograph: Elizabeth Hoak-Doering.

aspect of the present analysis and, departing from Azoulay's work, the paper will look at events outside of the Israel-Palestine binary, and also outside of Cyprus, presenting different paths for analysing embedded imagery in photographic theory.

This kind of photo within a photo is presented here as the 'photographic Pietà', and I work on several levels to describe, contextualise and explore it. To do so, I begin with a discussion of photography, showing how repetition modifies a prototype, both perceptually and actually. I distinguish the effect of this repetition from any perceptual and theoretical modifications to an original that take place during mass printing. I build these optical effects onto social science observations that Paul Sant Cassia makes in his work, *Bodies of Evidence* (2005), where he discusses the modalities and strategies of pictorial enunciation among displaced Cypriots in the context of Cypriot intercommunal strife and the war of 1974. Then, working through Azoulay and also Jalal Toufic (particularly 2004), this study broadens into an examination of how different modalities of photography can construct, or define a discourse between disempowered parts of society and the mainstream, and how it seems to amplify the cause of

missing persons. This paper takes substance from, updates and revises the theoretical approach of a work previously published (Hoak-Doering, 2014).

Temporal dislocation and historical distance

Temporal dislocation is part of a photograph's charm: it says something about the past, while physically existing in the present. The current popularity of the 'selfie' demonstrates that even the passing of a few seconds describes an interesting gap in time. Temporal dislocation can awaken a momentary existential crisis about memory and human experience that reaches back to the origins of recording media in the late nineteenth century. With the invention of the Phonograph, for example, people questioned how real or experienced time could be 'kept', and 'used' later. Some wondered what, then, is the role of human memory? (see Daniels, 2011). Similar questions give photography, as a recording medium, its aura '. . . a strange tissue of space and time: the unique apparition of a distance, however near it may be . . .' (Benjamin, 2003 [1935], p. 23). In addition to the historical distance created in the gap between the exposure of the photograph and the viewer's gaze, old photographs also bear their age through physical decay. The dissipation of the chemical processes or substrates – of glass paper, board or metal plate – also demonstrate the existence of historical distance. Of course historical distance also appears in the contents of the photographic image, and these can also create bridges between past and present.[2]

Figure 15.2 exemplifies historical distance. It is a street photograph of bakers carrying sticks of bread in a jubilee, marking the end of the Spanish American War. The original is a glass slide, and so historical distance is clear from the material, texture and format of the image. The content also shows historical distance; the bakers' uniforms, the style of the parade, and other cues assert that this was a long time ago (it was 1898). Still, the setting is recognisable to someone who knows the city. Often, the allure of historical distance hinges on a viewer's ability to make intellectual connections, and to engage with its content in a diachronic way. Historical distance may illustrate the viewer's distance from the past, while also making connections with it.[3]

Embedded distance in photography

Embedded distance in photography occurs when photos appear in, or as the subject of photographs. A photograph is usually the subject of other photographs because it has historical content that relates to the person holding the original. The urge to do this is typical enough to have been featured on the cover of Anchor Books' paperback edition of Susan Sontag's *On Photography* (1989). These pictures usually show generations of a family; for example a younger person demonstrating her lineage by displaying the old photograph of relatives. As a result of this stylistic understanding, embedded distance does not readily attract attention – and so it could be interpreted or deployed in a political fashion, both intentionally and unintentionally.

Historical distance, as we have noted, is partly determined by the materiality of the image: the way the image looks faded, brown, or softened; and partly determined by the contents of the image. What, then, are the optical results of embedded

Figure 15.2 Image 2: *Baker's Jubilee Philadelphia PA, USA* (1898). © photograph: William Harvey Doering. Courtesy of the Library Company of Philadelphia.

distance? What happens to an image when it is re-photographed? And how does this relate to any meanings that could be conveyed in the newer image?

The photographic Pietà

The Pietà is an icon of suffering; a motif where a mother holds the dead body of her son or husband. The classic use of this motif is religious, in paintings, and particularly sculptures of the Passion, where Mary holds the body of Jesus. Michelangelo's (1499) *Pietà* is the quintessential example of the motif, but the motif is not always religious. After the World Wars artists also used the mother-bearing-son composition in a secular (although referential) way to symbolise sacrifice and a nation in mourning, particularly in European monumental sculpture. In another form an angel, usually the Archangel Michael, can replace the mother figure.

The *photographic Pietà* is a contemporary and secular version of that religious motif. In this case a woman is photographed holding a photograph of her son, fiancé, husband, father or another male relative. Over time, the usual chronological realities do not always confer and so, as Sant Cassia notes (2005), sometimes a woman has aged in relation to the photograph she holds: a photo of her fiancé could look like her son. The present discussion is limited to the majority of such pictures in which women hold images of men, which Sant Cassia (2005) typifies as 'Penelopes and Vigils'. It leaves for further exploration the many variations that include children holding images of adults and vice-versa, men holding images, and women holding pictures of women (Sant Cassia, 1998–1999, 2005; and the photo archive of Andreas Manolis).

The photographic Pietà functions in visual culture differently from the classic Pietà. In addition to its Christian modalities, the Pietà mobilises notions of national sacrifice. As such, the classic Pietà is usually mounted on behalf of a place or organisation, and any individual commemoration is often found on a cenotaph that accompanies the work. By contrast, the photographic Pietà is individually specific: a particular woman holds a portrait (or portraits) of a particular person (or people), usually but not always men. Occasionally the women are named and their stories are known, but their faces are always recognisable and intentionally exposed. Such iconic images of mothers holding pictures of relatives appear in media coverage of disappearances related to war and other catastrophic events, where there seems to be a common strategy (intentional or unintentional) for discourse with media, politicians and the public. The political circumstances of vigils and protests where this photographic form appears vary from dissent to patriotism, and also in the ways that images substitute for, or recognise the existence of missing individuals.

In the 1970s three main groups emerged that began using photographs of their missing relatives to communicate through the media: Greek Cypriot relatives of missing persons, the Mothers of the Plaza del Mayo (Argentina) and the National League of POW/MIA Families (USA). Since then, the use of a personal photograph within a media-publicised vigil can now be found in many other parts of the world: Mexico, Thailand, Sri Lanka, Pakistan, Nepal, East Timor, Indonesia and Kashmir to name but a few (Thornhill, 2014; Mugiyanto et al., 2008). The common factor among all these groups is the use of the personal photograph to create political awareness of missing persons, and to communicate this injustice to a larger public. The photographic Pietà can be seen where it reinforces official government narratives as in Cyprus and the United States of America, but it can also be seen where official government narratives are denounced – as in Argentina (Sant Cassia, 2005) and Asia (Mugiyanto et al., 2008). In each of these groups the function of the embedded image in vigils and demonstrations is slightly different, possibly revealing perceptual differences among these cultures with regard to photography.

Vigils in Argentina by the Mothers of the Plaza del Mayo explicitly aim to expose the government's complicity in, and to end official silence about the *disparecidos* – civilians who disappeared by force during the Dirty War of 1976 through 1983. There is no agreed-upon number of *disparecidos* from the Dirty War; estimates of missing range between 9,000 and 30,000. Mothers of the *disparecidos* gather on Thursday afternoons at the political hub of Buenos Aires, the Plaza del Mayo, in front of the presidential palace, wearing white scarves and carrying or wearing photographs of their missing relatives. Their scarves are embroidered with the names of missing

persons, symbolising baby's blankets, and these notorious headscarves have become an emblem of the group. The Mothers of the Plaza del Mayo have received international accolades for their human rights activities and they have been the subjects of academic research (there are many: see Guzman Bouvard, 1994; Fisher, 1989). They have also inspired pop artists, Sting and U2 among others. Their activism and the causes they stand for can only be summarised here, but Sant Cassia generously develops this topic in relation to Cypriot vigils in *Bodies of Evidence* (2005, pp. 267, 273). Here, these large-scale actions are acknowledged and referenced as vital points of comparison with Cypriot women's demonstrations on behalf of missing persons.

In the USA, the National League of POW/MIA (Prisoners of War/Missing in Action) Families are among many well-organised American support groups for relatives of American missing servicemen. More than 83,000 military personnel are currently listed as POW/MIA from modern American wars; this number excludes current and recent military engagements in Iraq, Afghanistan, Pakistan and elsewhere (United States Department of Defence Prisoner of War/Missing Personnel Office). Unlike the Mothers of the Plaza del Mayo, mothers from this group maintain personal vigilance that demonstrates their patriotism. They do not protest or stage vigils, instead they perform in a way that reminds civilians about the sacrifices that military families make and this performance includes using the POW/MIA emblem in different ways on a daily basis. The emblem is a silhouette of a serviceman and a watchtower, framed in a barbed wire motif, and the portrait profile is based on a particular serviceman, graphically transformed. The emblem of the POW/MIA is most often seen as a black flag (Leepson, 2015; see also Sturken, 1997). Like the symbolic headscarves of the Mothers of the Plaza del Mayo, this distinctive black flag is also a logo; that is, the flag most often hangs below the American flag, but it also is transformed into automobile stickers, charms for bracelets and other paraphernalia (for the controversy about this flag see Perlstein, 2015). When the National League of POW/MIA Families participate in public acts of commemoration they tend to use this black and white symbol rather than photographs of their individual missing relative(s), so the photographic Pietà here is transformed in an interesting way where a symbol, not a portrait, is held up to the camera.[4] As a result, these women seem more like the classical Pietà: a patriotic mother and a symbolic model of sacrifice for the nation. Nevertheless these are not idealised mothers, but rather named individuals who pose with a symbol of the cause more often than a personal photo. The National League of POW/MIA Families present themselves in compliance with the sacrifices and honours of military life, trusting their government and the aims of the military, which pledges to 'Keep the promise', 'Fulfill their Trust' and 'No one left behind' (US Department of Defence Prisoner of War/Missing Personnel Office). The difference in the way these people use symbols rather than photographs of their missing may be tied to cultural and perceptual differences about photography, as will be shown later. Importantly, however, the American missing are servicemen and women: They were lost while on military duty, and this is different from the Argentine missing who are civilians.

In contrast to the other examples, the Cypriot missing are both civilian and military. With few exceptions, the images used in researching this paper come from Andreas Manolis who has worked as a press photographer in Cyprus since 1975. He captured multiple types of embedded images from demonstrations, vigils and funerals on both sides of the UN Buffer Zone, among Greek Cypriots and Turkish Cypriots.

The phenomenon is more common in post-war Greek Cypriot media than in Turkish Cypriot media, and the subjects of the photographs here discussed are all Greek Cypriot. This is emphatically not to imply that there are no Turkish Cypriot missing from events before and during the war in 1974 and the intercommunal fighting that intensified around 1963 (see Sant Cassia, 2005, p. 149 and the archives of Andreas Manolis). Officially, 493 Turkish Cypriots disappeared during the period 1963–1974 (CMP, 2015). Nor is it to imply that there is a cultural difference in the Turkish Cypriot affective response to missing family members. Instead, the media coverage of Turkish Cypriot missing reflects an official narrative about the Turkish army invasion of 1974, and it demonstrates that Turkish Cypriots were expected to remember – and in a different way from Greek Cypriots – to forget aspects of their recent history (see Papadakis, 1993). The official Turkish Cypriot stance on their missing persons is that they are martyrs who died for the sake of establishing a separate, new Turkish Cypriot state (Sant Cassia, 2005). Greek Cypriots now claim 1,508 military and civilians who disappeared during intercommunal unrest around 1963, and during the invasion in 1974 (CMP, 2016). Since July of 2007, mortal remains are being recovered and returned through the efforts of the bicommunal Committee for Missing Persons (CMP). The 2016 CMP report states that 1,064 individuals have been exhumed, and through DNA testing the remains of 480 Greek Cypriots and 149 Turkish Cypriots have been identified (CMP, 2016). In contrast with the official Turkish Cypriot narrative of martyrdom, the official Greek Cypriot narrative is that the remaining persons missing are possibly alive. As will be discussed later, aspirations for the return of Greek Cypriot missing persons is sometimes officially conflated with aspirations for the return of the north part of the island and a future as a reunified Cyprus (Sant Cassia, 1998–1999, 2005).

The photographic Pietà is linked with a group of Greek Cypriots who self-identify as Cypriot relatives of missing persons. While not all of these people take part in public demonstrations and vigils, there are roughly two bodies of people who do; and they differ in the intensity and in the ways that they stage their vigils. The general body is known as the Pancyprian Committee for the Return of Missing Relatives and Undeclared/Missing Prisoners of War [Pankypria Epitropi Syngenon Adiliton kai Adhiloton Aichmaloton], and it is a mixed group of families and relatives – both men and women – of the Greek Cypriot missing, who are usually from working and middle class families (Sant Cassia, 1998–1999, p. 274). Of these, a contingent known colloquially as the Mothers of Cyprus – Oi Manadhes tis Kyprou – will be discussed later.

The Pancyprian Committee for the Return of Missing Relatives and Undeclared/Missing Prisoners of War uses as its emblem a stylized image of a woman holding a photograph – a direct link between the photographic Pietà and the motivation behind the cause. This graphic image functions as the group's symbol, but it is not manifest in an overarching way like the headscarf of the Argentinian mothers, or the POW/MIA flag. The Cyprus government, though, did use iconic examples of the photographic Pietà to support its own agenda and ideological aims. Sant Cassia (1998–1999) relates how the post-invasion government symbolically conflated the loss of territory in the north of the island with the cause of Greek Cypriot missing persons. Thus, people participating in vigils also – perhaps unintentionally – also participated in an official narrative of waiting for return of property, even though they were not necessarily internally displaced. While Sant Cassia rightly points out that public demonstration

was one of only a few means to communication between marginalised people and the political elite, I will emphasise that the Cyprus government co-opted photographic Pietà images for its own agenda. Cypriot relatives of the missing may or may not trust that the government is acting in their interests, and they may or may not be concerned with the reunification of the island and return of land under Turkish military control. The motive behind demonstrations for the Missing was most often personal: individual pleas for justice and human rights.

In July of 2007 the bicommunal Committee on Missing People in Cyprus began exhumations, DNA identification, and return of mortal remains, and at that point the official discourse that symbolically linked missing property with missing people had to change. As with the return of mortal remains, so the government introduced public discourse about compromises in the return of territory. This was during the time of the direct talks between the leaders of the two communities (beginning in 2002) and the Annan Plan referendum (2004). Along with this change in political climate vigils became less frequent, mortal remains are gradually being returned to families and absolute faith in the government's official narrative about the so-called Cyprus Problem (unresolved land and human rights disputes from 1974 and before, and the continued presence of United Nations Peacekeepers) seems to be softening. Demonstrations by the families of Cypriot Missing never reached the point of large-scale protests that crossed social and economic strata, nor were they able to directly confront the government's opacity on the plight of the missing as directly as the mothers of the Argentinian missing do. Instead, these vigils balanced patriotism with criticism by posing existential, subjective questions about human rights to institutions: to the Cyprus government, foreign powers, and the United Nations. Although strident, their demands were posed within frameworks of government and civil society that were acceptable at that time.

The photographic Pietà reflects a shift in focus from group to individual iconography, possibly related to a modern, popular understanding of individual rights. Crafted in the aftermath of World War II, the Universal Declaration of Human Rights (1948) came about as a result of the Holocaust, but popular understanding of these rights apparently did not happen immediately. Azoulay counts only three instances where Palestinian 'plaintiffs' demonstrated their loss to Jewish photographers during the violent displacement of Palestinians and the establishment of the state of Israel (the *Nakba*, 1948; Azoulay, 2012 p. 229). Thus, the emergence of the photographic Pietà shows that there may have been a gradual change in the ways individuals learned to relate injustice through mass media via photography. Azoulay's narrow focus may not be a fair gauge on the latter observation, however; it begs further exploration especially into the profound archives of Jewish peoples as photographic subjects during and after the Holocaust. On another level, the photographic Pietà's emergence may also reflect changes in the camera itself. Sontag (2003) writes that before about 1940 cameras were not portable enough to take pictures of individuals in varied environments, and so the photographic Pietà would have evolved along with photojournalism, too: not only in terms of what can be photographed, but also in terms of a new critical relationship between subjects, their agency and role in picture-making. The photographic Pietà is a performative motif – that is most effective when the object of a demonstration – whether large or small. And it is in direct discourse with the media, whose coverage broadcasts both the cause and individual experiences.

Figure 15.3 Image 7: *Ledra Palace Roadblock*, observation post by police barracks late 1970s. © photograph: Andreas Manolis.

The distant subject

A woman in the photographic Pietà is not holding the embedded photo as a *memento mori*, an image of the dead. In a departure from the classic Pietà, she is holding the portrait of a missing person whose fate is unknown, and whose partial-presence is emphasised by the optical effects of both embedded and historical distance. Sant Cassia describes the state of her unknowing as 'having an existential ambiguity' which is different from the classic 'liminality' that anthropologists use to describe the transitory state between life and death (Sant Cassia, 1998–1999).

Embedded photos of missing men are often but not always black and white, formal like an official military or passport photo or wedding picture, or a school photo. Collars and close shaves, a modest smile – these are usual characteristics of the held

pictures and, although not quite sombre, these portraits often conform to general practical and professional standards. Why are such photos chosen? Sometimes they are not chosen: sometimes they are the only photos that remain after the upheaval of a war (conversation with Andreas Manolis, 10 September 2010). Given a choice, a formal picture is often more desirable even though less indicative of the man as a particular character. Such formalities add to the effects of embedding that begin to erase the individual. These icons of men are provocative in the way that they stand in for a particular person; the way they seem to emanate, or encapsulate his ghost. The viewer gleans little about the individual, and is probably not expected to. By implication though, the viewer is expected to respond to the idea of losing someone whose portrait we would so tenderly hold ourselves.

Three examples of the photographic Pietà that will be discussed here – in Cyprus, Argentina and the USA – are all Christian societies, although respectively Greek Orthodox, Catholic and predominantly Protestant (The Pew Forum report, 2007). It is interesting to look at the faiths of these societies and reflect on the deployment of the photographic Pietà in relation to variations in Christian beliefs about iconography. Greek Orthodox people, for example, often compare the practice of kissing icons (veneration) to kissing a picture of a loved person.

> In using an icon in devotion, one could legitimately accord it honor, because of the one portrayed in it . . . All such honor was directed to the one portrayed in the icon, and not to the painted materials themselves. In making this distinction . . . they were recognizing a common human phenomenon. Whether . . . in the way one responds to the picture of the emperor, or in the way a young man might treat the picture of his girl-friend back home, people distinguish between the picture itself and the one portrayed, and yet they do not hesitate to treat those pictures with special honor, as having a unique connection to the ones pictured in them.
>
> (Payton, pp. 189–190)

The Catholic practice of veneration changed slightly with regard to religious art and objects after Vatican II (1962–1965):

> The net result of . . . evolutionary developments was that the church build-ing housed a whole series of foci for people who visited the church outside the time of the liturgy or even during the liturgy. It was not uncommon in the past to see people at side altars or burning candles before an image even during mass. It is precisely because churches lost a certain sense of focus that the 2nd Vatican Council foresaw a return to the fundamental needs of the church
>
> (Cunningham, 2009, p. 97)

Nevertheless, accepted understandings about the Incarnation make Catholic and Orthodox churches more similar than different in the ways believers interact with religious art and material, including the sacramental bread and wine. This is particu-larly so when they stand in comparison to Protestants. For Orthodox and Catholics, the bread and wine are believed to become, through consecration, actual elements

of the body of Christ. Among Orthodox Christians, veneration of icons and religious artefacts reflects the idea that God can be manifest in human flesh (Jesus):

> ... since Christ became true man, it is legitimate to *depict his face* (sic) upon the holy ikons; and, since Christ is one person and not two, these ikons do not just show us his humanity in separation from his divinity, but they show us one person of the eternal Logos incarnate.
>
> (Ware, 1979, p. 72)

This departs from the positions of the iconoclasts (and thus all Protestants) who believe that the sacrament and religious imagery are only symbolic.

Differences in the way the photographic Pietà appears in Orthodox/Catholic populations compared to predominantly Protestant populations may speak to minor differences in the accepted understanding of a photographic portrait. That is, that Orthodox and Catholic people may read into a photograph something closer to Barthes' proposition that photographs hold the light from the eyes of the deceased (Barthes, 2000). By contrast, Americans (and even post-Vatican II Catholics) are much more likely to show restraint toward religious imagery, and caution in expressing such an embodied understanding of a photograph; suggesting, perhaps, another reason for the POW/MIA mothers to be photographed with the symbol of the cause rather than a photograph of their relative(s).

The media and the Pietà

As opposed to the photographs that are held in hand, which are cherished personal possessions, the photographic Pietà is not personal. It is public and demonstrative, because photojournalists capture and format the image, and the media amplifies it, along with the cause. This, according to the photographer Andreas Manolis, is perhaps not intentional. He remarks that ' . . . [the women] are not looking at me. They are looking through me' (personal conversation, 30 September 2010). However, as is clear from the example above (image 9), the photojournalist can choose how to frame the embedded image, shaping meaning around the public act of showing a personal photograph. This embedded picture of the missing person describes the temporal, physical and metaphysical distance from a demonstration. A woman who is demonstrating may hope that her face will tell her story with human appeal; that the embedded image may add authenticity to the story, and she may also seek purpose in a more general search for justice.

The photographic Pietà suggests a truncated grieving process for missing persons that is highlighted by, even created by the media. As the embedded image of the missing person becomes optically distanced, the woman holding the portrait in a demonstration in a way enacts her relative's disappearance. This optical and performative repositioning of the person in the photograph (its content) mobilises new layers of meaning, new viewpoints: the effect of which is to 'meaningfully reorder everyday life' (Sturken and Cartwright, p. 89). The demonstrating woman also acts out the im/possibility of taking on the traditional feminine gender role of mourning over a body (Sant Cassia, 1998–1999, p. 272), and exhumations that have taken

place since 2007 result in a transformation of the photographic Pietà. Burials re-pri-oritise the portrait photograph as ambiguity lessens along with the return of mortal remains (image 10).

A citizenry of photography?

Ariella Azoulay's notion of a 'civil contract of photography' provides the basis for a discussion of ownership and civic participation in the photographic Pietà. Her work is entertained with caution however, because while she deals precisely with the rela-tionship between viewer, photographic moment and content, her writing style dis-tances the reader in a way analogous to the photographic one with which she finds fault. Readers of *The Civil Contract of Photography* will find, for example, her obser-vation that '[t]here has always been a regard for the visible. The world has a visible dimension; human beings are equipped with eyes and conduct themselves, to a large extent, in and through the world in keeping with the ways they observe it' (2008, p. 94). This kind of padding, or patronising, functions as the literary equivalent of a weak state photographer's distance from the distasteful content of the picture he must record (this distance is illuminated in her 2012 work, especially pp. 227–228). Furthermore, her theoretical 'citizenship of photography' is difficult to grasp because its ' . . . members are . . . anyone and everyone who bears any relationship whatsoever to photographs – as a photographer, a viewer of photographs, or a photographed person . . . the citizenry of photography is borderless and open' (2008, p. 97). Is the citizenry of photography really all-inclusive? How can it have meaning if it is indis-tinguishable? Foundational questions aside, looking at the photographic Pietà in the context of Azoulay's perspectives on ownership and civic duty exposes a space where photographic actors, agents and subjects do not fit in with her so-called citizenry. This space is outside of the Israel-Palestine binary, which is the stage for her work. Perhaps through these departures, her 'citizenship of photography' may find a comprehend-ible, even if less comprehensive constituency.

Azoulay's work functions in this discussion where she talks about framing the 'event of photography' (2012) and individuals using photography as part of anti-state petitioning (2008). She says, '[a]s long as photographs exist, I will contend, we can see in them and through them the way in which . . . a contract . . . enables the injured parties to present their grievances, in person or through others, now or in the future' (2008, p. 86), and while this makes sense in terms of exposing injustice, this is the context in which Azoulay declares that all photographs are public property by nature. She attempts to revise the traditional notion that the photograph ' . . . was recognized as belonging to whomever possessed the instrument that created the photographic image and the support on which the original image was printed, rather than to the one who stood in front of the camera . . . ' (2008, p. 99). The photographic Pietà con-trasts with the notion of photographs as public property. In the environment where a woman holds a picture at a demonstration, and where the subject of that picture is missing, for an academic to say that woman's photograph could be public property is a misunderstanding of the situation. Speaking almost directly to this scenario she writes, 'At the same time that a photograph lies in someone's hands, someone else can always claim the deposited image for themselves, or at least demand to participate in

its safekeeping . . . [which] stems from a duty toward the deposit as such . . . ' (2008, p. 103). Safekeeping of photos is, for Azoulay, a civic duty and this extends even to institutional or journalistic control and deployment of images where the identity of a person in the content is unknown. That said, the people in the photographic Pietà have other things at stake, especially if the embedded portrait is the only one left after the upheaval of war and internal displacement (as previously suggested here, p. 29), and especially where it could be locally understood as a physical, and spiritual link to the missing person. Although Azoulay proclaims, 'the concepts of property and ownership are ontologically foreign to photography' (2008, p. 103), ownership of these particular hand-held portraits cannot be massaged into the property of an intellectualised citizenry. The essence of demonstrating a portrait to a camera is that a woman is showing physical, kin-ownership; and loss of kin, after all, is the message of the photographic Pietà. Portraits of the missing are definitely not something that 'someone else can always claim', even in the name of civic duty, without losing meaning. Until the image becomes the sub-content of a 'photographic event', these photographic portraits clearly belong to families. Civic duty comes into play depending on how the portraits are mobilised, and this discussion follows.

What does participation in the 'citizenry of photography' look like? Azoulay's civic duty is best shown in photographs where a person gestures at the circumstances of a catastrophe (2012, p. 229). This would naturally include the photographic Pietà, except that the latter begs for a deeper reading. In the scenario of the photographic Pietà, the catastrophe and victim are convoluted by the state of unknowing, and the gesture is part of a performance that may only be personal interest, or it may come from a sense of civic or national duty. For sure, these pictures are deliberately made along with the media. The women 'give the photographer the right to turn them into a photographic image' but Azoulay's issue with them 'receiv[ing] no material reward' (2008, p. 106; see also p. 116) seems irrelevant compared with the other power transactions that are taking place. In fact, where she elaborates to say that 'the photographer . . . may even become wealthy . . . ' her argument loses traction in the environment of these photographs. This is not to say that the people who become 'the content' (2008, p. 100) of photographs do not deserve better, or more recognition – rather it is to say that in the present case what is sought out is exactly this high-profile portrait photo. The subject of the photographic Pietà is not 'abandoned . . . unable to determine [the photograph's] composition and the modes of distribution'. Quite the opposite: this kind of photograph, which Azoulay dismisses, (quoted later, p. 229) embodies the subject's empowerment, not her victimhood. Azoulay's fixation on the specific controversy with Florence Owens Thompson and Dorothy Lange, eclipses other possible discourses in which the photographic subject is not a victim but rather a participant and an agent. In the photographic Pietà a woman is taking control of the 'deposit' (2008, p. 103) of her private image by deliberately exposing it and re-framing it in yet a larger body of like-minded political activity. Although it could be seen as a concrete example of Azoulay's 'civic duty' it is also – importantly – a gendered civic duty accomplished in spite of paternalistic cultural norms, and while maintaining the privilege of image ownership on all levels. In the personal, performative context of the photographic Pietà, Azoulay's presumptive citizenry of photography has a subgroup of women non-conformists who participate in collective, often anti-state efforts as discreet individuals with private claims, and personal photographs.

Jalal Toufic's *Vampires* (2003) presents a welcome contrast to Azoulay's choreography of camera, photographer, image, victim and viewer. Toufic gets around such framing by pursuing multiple understandings of human presence. No more imaginary than Azoulay's 'citizenry', Toufic's references centre on film, where '[the] definite embodiment in cinema is undone' (2014, p. 41), and on liminal states that are enacted by such figures as vampires and the undead (2014, p. 20). Elsewhere, Toufic outlines a 'disconnection of the sensory functions' that is both the result and the cause of experiencing extraordinary injustice (see Toufic, 2005, pp. 64–66). Being part of such threshold events presents challenges to perceptual certainties that are taken for granted in most everyday life, but for Toufic, to witness violence, or to commit it, opens up parallel realities such as described in Quantum physics (Schroedinger's cat). Following this, images may only be likenesses, and states of altered consciousness – madness, hypnosis, yoga trance or psychological experimentation – suggest alternative understandings of human presence. Threshold experiences of violence trigger multiple possibilities for existence that include liminal zones, vampires, and bodies-double and through these dynamics Toufic presents the reader with a way out of Azoulay's camera-victim-viewer circumstance. By talking about disembodiment, he unhitches a picture's human subject from individual presence (Toufic, 2003, pp. 36–37). That is, where Azoulay calls a person in a photograph the 'content', Toufic sees a spectrum of possibilities: it may be a likeness but not an actual individual; the individual may exist in this, or another universe. Moreover, the image may be a cinematic matte (*ibid.*, pp. 46–47), created strategically over time: a likeness meaningfully installed in a semantic environment with other objects. Where Azoulay's voice corrals a fictional 'citizenry' in response to [official Israeli] photographers framing [Palestinian] victims, Toufic takes a Houdini-like position that comes from inside that frame – that escapes the frame – that might even declare the frames never existed. The tools he uses to stage the disembodiment necessary for escape appear in physics, writing, fiction and cinema. This is most notable in his reference to the 1956 speech by Egyptian president Gamal Abdel Nasser, where Nasser's voice was 'broadcast on radio and reaching the Israeli-occupied territories in Palestine – not so much the body, its source, as a land, a country, without which even when incarnated in a body it remains a voice-over [an exiled voice]' (Toufic, 2003, pp. 49–50). Toufic's writing comes from within the frame and escapes it, presenting endless ways to understand the energy behind the photographic Pietà and its dissemination.

Framing and dissemination: external and internal reproduction

Distribution of images from demonstrations about the missing is a central feature of the photographic Pietà, yet this functional complicity with the media may come at a cost.

Does reprinting a photo in the media diminish the sense that the missing person represented is a unique individual? In the context of ephemeral and popular consumption, Benjamin (1935) describes a scenario in which a reproduction passes as a satisfactory copy of an original, and multiplying this ersatz causes certain losses in the original's authenticity. Benjamin's concerns about mass production of images – and Sontag (2003) shares these – do apply to the photographic Pietà (see

also Hoak-Doering, 2014, pp. 184–185). That is to say, the photographic Pietà may now be considered a hackneyed trope in the international news about missing people and even Azoulay's condescension is evident where she dismisses it as a 'tactic familiar from the 1980s (sic) onward where the photographed person shows his or her catastrophe to the camera' (2012, p. 229). The uniqueness that is arguably compromised is not in the image of the missing person, but rather in the uniqueness of the context; the demonstration, the sheer numbers of which, appearing in the press diminishes the originality of each demonstration, whether in Cyprus, Argentina or elsewhere in the world. Manufacture of many copies of an original is different from the mechanism of embedded distance. Embedded distance comes from multiple generations of an image, not multiple copies, and in the media, the embedded picture is always only second generation, no matter how many copies are printed. Thus, on one hand the embedded distance visually articulates the loss of a person: embedded reproduction actually authenticates the photographic Pietà image as a representation of a missing person. On the other hand, Benjamin's warning about the loss of authenticity through mass production does apply where the photographic Pietà is appropriated as propaganda.

Conclusion

The Greek Cypriot photojournalistic image of a woman holding a photograph of her missing relative is a prototypical photographic Pietà, but it is not the only example of the motif. Other cultures also protest in similar ways although under very different political and ideological circumstances. Both embedded and historical distances result from this performative media interface, heightening the impact of images used in demonstrations, and projecting the existential absence of missing persons into an optical arena that is politically meaningful. This trope highlights how individuals can operate within, and defy ideological structures; not just patriarchal, economic or nationalist ideologies, but also optical, compositional structures in the media, both of which are complicit with power. Intentional self-exposure to the photojournalist's lens overturns the presumed victimhood of the photographic subject, and turns her into an activist. That is, the photographic Pietà exposes modalities that give disempowered people access to power through the media, and this is especially true for women. Although this discussion has focused on the photographic aspect of this performative trope, the symbolic ones mentioned are also operative in parallel ways that are becoming increasingly important with hashtags and other social media conventions that offer speed and widespread visibility. There is room for much more research on this, where symbols take the place of individuals. There is also scope for debate as to whether the photographic Pietà is perceived to be efficacious or over-used in the media. This paper is a beginning, a way to describe the photographic Pietà as a visual parsing of social science material already established on the subject, and an attempt to highlight one area in Cypriot politics where women have been vocal and visible. In that respect, the paper leaves much leeway for further work: into archival precedents for the photographic Pietà and in the many overlooked ways in which women have exerted power in Cyprus.

Acknowledgements

Ruth Keshishian, the Moufflon Bookstore, Nicosia Library Company of Philadelphia
Andreas Manolis, press photographer, Cyprus
Mrs Panayiota Pavlou Solomi, Limassol

Original publication

'A Photo in a Photo: The Optics, Politics and Powers of Hand-held Portraits in Claims for Justice and Solidarity', *Cyprus Review* (2015). The original article includes further images; we were unable to source permissions to reproduce them all.

Notes

1 See 'Motor Bike Rally to Kyrenia in Occupied Cyprus 1996'. Available at: [www.argyrou. eclipse.co.uk/Rally.htm].
2 Barthes finds this historical discontinuity in the Winter Garden photograph, in which his mother was a child. He says, 'no anamnesis could ever make me glimpse this time starting from myself ' (Barthes, 2000, p. 65).
3 In contemporary documentary and films in Cyprus, E.A. Davis (2014) finds historical distance as a way to identify and assess archival material, which is embedded for effects that range from the evidentiary to reification of personal recollection, and stand-ins for evidence where none is available. In film, this shows through variations such as in cinematic quality, antiquated screen ratios and editing anomalies.
4 Graphic symbols transforming into representation also happens with the girls kidnapped from their secondary school in Chibok, Nigeria (14 April 2014). In protests against government inaction and awareness campaigns for the 219 girls still missing, the logo 'Bring Back Our Girls' essentialises their disappearance. This is especially true with the hashtag, #bringbackourgirls. Both the phrase and the hashtag are held up to cameras more often than images of individuals.

References

Azoulay, A. (2008) *The Civil Contract of Photography*. New York: Zone Books.
———— (2012) *Civil Imagination: A Political Ontology of Photography*. London: Verso.
Barthes, R. (2000) *Camera Lucida*. Translated by R. Howard. New York: Farrar, Straus and Giroux (original work published in 1980).
Benjamin, W. (2003) 'The Work of Art in the Age of Its Technical Reproducibility', 2nd version, translated by E. Jephcott, R. Livingstone, H. Eiland and others, in Jennings, M.W., Doherty, B. and Levin, T.Y. (eds.), *The Work of Art in the Age of Its Technological Reproducibility, and Other Writings on Media*. Cambridge, MA: Belknap Press of Harvard University Press, pp. 19–55 (original work published in 1935).
Bouvard, M.G. (1994) *Revolutionizing Motherhood: The Mothers of the Plaza de May*. lANHAM, md: Rowman & Littlefield.
Committee on Missing Persons in Cyprus (CMP) (2016) Retrieved from: [www.cmp-cyprus. org], last accessed on 3 February 2016.

Cyprus News Agency (2014) 'Successful Protest Turns Tourists Away'. Retrieved from: [www.hri.
 org/news/cyprus/cna/1996/96-10-20.cna.html], last accessed on 2 October 2014.
———— (2015) 'Motorbike Rally to Kyrenia in Occupied Cyprus '96'. Retrieved from: [www.
 argyrou.eclipse.co.uk/Rally.htm], last accessed on 12 October 2015.
Daniels, D. (2011) 'Hybrids of Art, Science Technology, Perception, Entertainment, and Com-
 merce at the Interface of Sound and Vision', in Daniels, D. and Naumann, S. (eds.), *See
 This Sound, Audiovisuology 2*. New York: Distributed Art Publishers, pp. 9–25.
Davis, E.A. (2014) 'Archive, Evidence, Memory, Dream: Documentary Films on Cyprus', in
 Constandinides, C. and Papadakis, Y. (eds.), *Cypriot Cinemas: Memory, Conflict and Identity
 in the Margins of Europe*. London: Bloomsbury, pp. 31–60.
Fisher, Jo. (1989) *Mothers of the Disappeared*. Boston: South End Press.
Fragko, G. (2002) 'Panagiota Solomi: I Insist to Learn What Happened to My People', *Philelefthe-
 ros*, 20 January.
Hoak-Doering, E. (2014) 'The Photographic Pietà: A Model of Gender, Protest, and Spatial-
 Temporal Dislocation in Modern Cyprus', in Wells, L., Stylianou-Lambert, T. and Philip-
 pou, N. (eds.), *Photography and Cyprus: Time, Place and Identity*. London: I.B. Tauris,
 pp. 167–190.
Kirschenblatt-Gimblett, B. (1990) 'Objects of Ethnography', in Karp. I. and Levine, D. (eds.),
 Exhibiting Cultures: The Poetics and Politics of Museum Display. Washington, DC: The Smith-
 sonian Institution Press, pp. 386–443.
Leepson, M. (2015) 'The Story of the POW/MIA Flag', *HistoryNet*, 12 August 2015. Retrieved
 from: [www.historynet.com/the-story-of-the-powmia-flag.htm], last accessed on
 14 October 2015.
Mugiyanto, *et al.* (2008) *Reclaiming Stolen Lives*. Philippines: Asian Federation against Involun-
 tary Disappearances (AFAD).
Papadakis, Y. (1993) 'The Politics of Memory and Forgetting in Cyprus', *Journal of Mediterranean
 Studies*, Vol. 3, No, 1, pp. 139–154.
Payton, J.R., Jr. (2007) *Light from the Christian East: An Introduction to the Orthodox Tradition*.
 Downers Grove, IL: InterVarsity Press.
Perlstein, R. (2015) 'The Story Behind the POW/MIA Flag', *The Washington Spectator*, 10 August.
 Available from: [http://washingtonspectator.org/the-story-of-the-other-racist-flag/],
 last accessed on 14 October 2015.
Pew Research Center (2007) 'The Pew Forum on Religion and Public Life Survey'. Retrieved from:
 [http://religions.pewforum.org/reports], last accessed on 1 March 2012.
Psaltis, C., Beydola, T., Filippou, G. and Vrachimis, N. (2014) 'Contested Symbols as Social
 Representations: The Case of Cyprus', in Moeschberger, S.L. and Phillips De Zalia, R.A.
 (eds.), *Symbols That Bind, Symbols That Divide: The Semiotics of Peace and Conflict*. Switzer-
 land: Springer International Publishing, pp. 61–90.
Sant Cassia, P. (1998–1999) 'Missing Persons in Cyprus as Ethnomartyres', in *Modern Greek
 Studies Yearbook*, a publication of Mediterranean, Slavic and Eastern Orthodox Studies,
 Vol. 14/15. Minneapolis: University of Minnesota, pp. 261–284.
———— (2005) *Bodies of Evidence: Burial, Memory and the Recovery of Missing Persons in Cyprus*.
 New York and Oxford: Berghahn Books.
Sontag, S. (1989) *On Photography*. New York: Doubleday (original work published in 1977).
———— (2003) *Regarding the Pain of Others*. New York: Farrar, Straus and Giroux.
Sturken, M. (1997) *Tangled Memories*. Berkeley: University of California Press.
Sturken, M. and Cartwright, L. (2009) *Practices of Looking: An Introduction to Visual Culture*, 2nd
 edition. Oxford: Oxford University Press.
Thornhill, T. (2014) 'Did This Woman Order the Massacre of 43 Students in Mexico?' *Daily Mail*,
 30 October. Retrieved from: [www.dailymail.co.uk/news/article-2813976/Did-woman-
 order-massacre-43-students-Mexico-Mayor-s-wife-dubbed-Lady-Murder-ordered-
 police-stop-protesters-ruining-party.html], last accessed on 23 September 2015.

Toufic, J. (2003) *Vampires: An Uneasy Essay on the Undead in Film*. Sausalito, CA: Post-Apollo Press.

———— (2005) *Ashura: This Blood Spilled in My Veins*. Lebanon: Calligraph.

———— (2014) 'A Hitherto Unrecognized Apocalyptic Photographer: The Universe', *E-Flux Journal*, May, No. 55.

United States Department of Defense Prisoner of War/Missing Personnel Office. Retrieved from: [www.dtic.mil/dpmo/], last accessed on 1 March 2012.

Ward, O. (2015) Lisson Gallery. Personal email communication 30 October 2015.

Ware, K. (1979) *The Orthodox Way*, revised edition. Crestwood, NY: St. Vladimir's Seminary Press.

André Gunthert

DIGITAL IMAGING GOES TO WAR
The Abu Ghraib photographs

"**INCONVENIENT EVIDENCE:** Iraqi Prison Photographs from Abu Ghraib" opened in New York's International Centre of Photography on 17 September 2004.[1] Among the mass of Abu Ghraib prison photographs that had been published since the spring of that year, seventeen images were chosen, all from digital sources. Although displayed against the black gallery walls, captioned with white text and surrounded by large margins in the tradition of classic press prints, the Abu Ghraib images were pinned to the wall, unframed. Despite this break with the usual codes of art photography exhibition, it was clear that these were important historical documents, icons that had "taken their place in the gallery of canonic images, as immediately recognizable as Marilyn struggling with her billowing dress".[2]

How the Abu Ghraib torture photographs attained this exceptional status was not immediately self-evident. From Robert Capa to Hocine Zaourar and Nick Ut, the authors of "image monuments",[3] which marks the history of photo-journalism, were for the most part experienced professionals. In contrast, the images in the Iraqi prison were taken by amateurs for personal purposes. And while this characteristic does not exclude them radically from the photo-journalist paradigm, which does include a few famous instances of photography by non-professionals, such as the Zapruder film of the Kennedy assassination, the Abu Ghraib photographs are the first digital images to be counted among the most celebrated photographs of our time. Moreover, considering that just a few years ago the arrival of digital technology was described as a "change in the nature of photography" supposedly undermining "the medium's inherently authentic nature",[4] the reception of the Abu Ghraib images is particularly striking. Despite the contested veracity of digital imagery, these photographs were immediately accepted as reliable. Their subsequent function as proof and testimony confirmed their rightful role in the long tradition of photographic recording.

Can the Abu Ghraib icons be considered the equal of any photograph? Not according to the many commentaries made after the first images appeared; these emphasized their distinctiveness, primarily their mode of production: the vast number of the

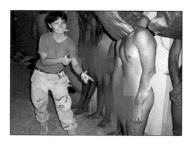

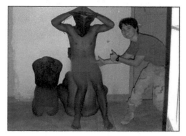

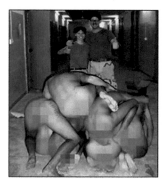
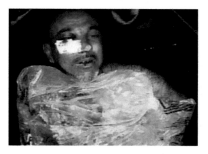

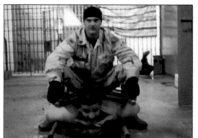
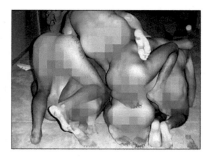

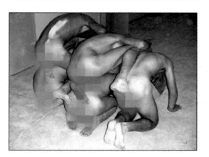
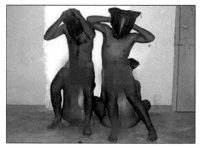

Figure 16A Courtesy Andrea Gunthert

images, supposedly attributable to the easy availability of digital cameras and above all their rapid and uncontrollable circulation via the Internet.[5] But while generally correct, these common-sense observations are inaccurate in the case of the pictures from the Iraqi prison. The number of torture images seen had been relatively small and their dissemination took place five months after they were taken.

It seems important, then, to reconstruct the history of the emergence and circulation of these images. Their first appearance was in a short "60 Minutes II" item on 28 April 2004 when Dan Rather showed six photographs that had been reproduced on an animation stand[6] (see Figure 16A). Two days later, on 30 April, Seymour Hersch published "Torture at Abu Ghraib" in the *New Yorker*, and the text was reproduced on the magazine's website with nine images[7] (see Figure 16B). Compared to those broadcast by CBS, the pictures in the *New Yorker* stressed the sexual dimension of the iconography. Faced with the subsequent media frenzy, CBS decided to put its pictures online on 5 May — fourteen images in total (see Figures 16A and 16B), including one borrowed from the *New Yorker*. The CBS and the *New Yorker* groups of images were similar: seven were identical and two were variations of the same image — but the slight differences in framing, colour and overall look of the images indicated that the two groups were distinct and had come from different copies. Yet over the following days the world press systematically mixed these two closely linked sets into one corpus.

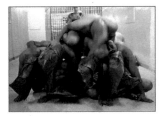

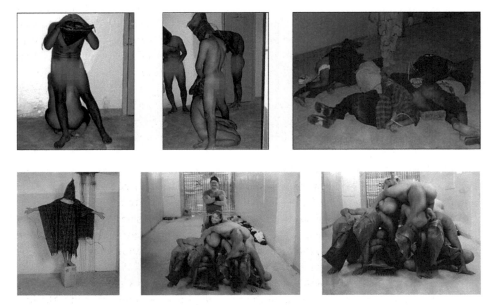

Figure 16B Courtesy Andrea Gunthert

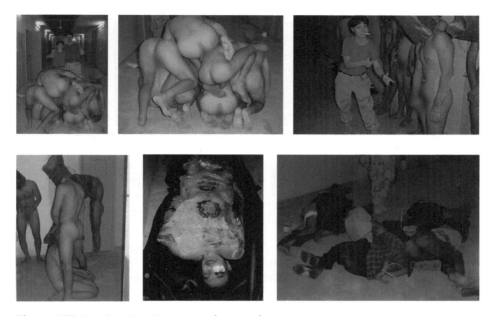

Figure 16B *(continued)* Courtesy Andrea Gunthert

The original appearance of these groups of images, one on television, one in print, were not as independent as it seemed. At the end of the original CBS transmission a text indicated that although the network had been in possession of the documents for several weeks, it had delayed their broadcast following Department of Defence directives and had made the decision to show them only under the threat of being scooped. Although essentially selected from same range of subjects that CBS had access to, it was really the *New Yorker* that set the tone for the media's treatment of the events: Dan Rather's presentation included an interview with General Mark Kimmitt, who tried to rationalize the "abuse" by describing it as a series of isolated acts, whereas Seymour Hersch's *New Yorker* article seconded the conclusion of the Taguba report denouncing a system-wide practice. With the quasi-simultaneous diffusion of a coherent group of images and the convergence of television, press and Internet information, all supported by the credibility of well-known journalists and press institutions, a wide media system was in place within a few days. No discussion of the photographs' veracity was ever formulated.

On 1 May, the United Kingdom's *Daily Mirror* dedicated its front page to pictures revealing British troops torturing Iraqi prisoners. The small group of images (obviously different from the American) were in black and white classic documentary style and clearly taken by professional photographers.[8] Experts and journalists immediately raised doubts as to their authenticity. After intense controversy reported on by the BBC (see Figure 16C), the newspaper printed a public apology on 13 May and announced the dismissal of its editor-in-chief, Piers Morgan.[9] A comparison of the different receptions of the digital and silver-based photographs shows a remarkable inversion of our usual understanding of the relation of photographs and truth: the former were judged more authentic. The reasons for this reversal are complex. As with

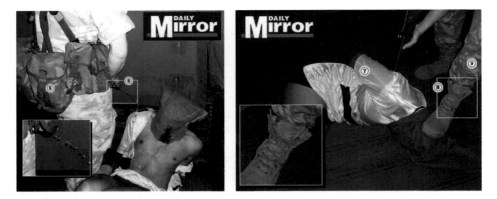

Figure 16C Courtesy Andrea Gunthert

any document, an image cannot constitute sufficient evidence by itself; it can only be an element, a link in a chain whose structural integrity depends on the relation of its parts. The credibility of the Abu Ghraib photographs does not come from any value intrinsic to their production process but rather from the process that resulted in their publication: the criminal case handed on 31 January 2004 to General Antonio Taguba whose report, presented to military authorities at the end of February, had begun to circulate in the press and was rendered public on 5 May.[10]

Under what conditions can an investigation that would seriously undermine the army's line of command be made public in a country at war? At the beginning of 2004, the manifest dysfunction of the Abu Ghraib prison made evident in the eviction of General Janis Karpinski was still being treated moderately by the press.[11] The situation was not favourable to any criticism of military action: Saddam Hussein had been captured the night of 14 December 2003 and the first anniversary of the conflict was nearing. Despite ongoing terrorist attacks, both the government and public opinion wanted to believe the conflict would soon come to an end. It was in April 2004, when the guerrilla acts in the Sunni region intensified, that the perception of the situation changed. A series of brutal images, from the lynching of civilians in Fallujah on 31 March to the hitherto unseen coffins of American soldiers featured on the front page of the *Seattle Times* on 27 April, paved the way for a shift in public opinion.[12] For the first time, according to a poll organized by CBS and the *New York Times* between 23 and 27 April 2004, a majority of Americans (52 per cent) disapproved of the way their government was handling the conflict. The time seemed right for questioning the goals and methods of the war. Originating from within the army itself, the Taguba report constituted a precious tool for the press. Precise and rigorous, detailing the results of an investigation and its overpowering conclusions in a mere fifty pages, the report became the main source of journalistic analysis. If the authenticity of the photographs was never questioned, it was not only because the torture they depicted was effectively documented by the report but also because the photographs were themselves elements of the investigation. Correlated with testimony enabling the identification of the photographers, the date and the conditions in which they were taken, the images had the status of evidence, explicitly referred to by the prosecution as proof of the charges.

The cornerstone of the photographs' credibility, the criminal case also provided the conditions of their transmission to the press. Charged with maltreating prisoners, one of the accused soldiers, Ivan Frederick, appealed to his family to organize his defence. Among his attempts to mobilize politicians or army leaders, his uncle, retired Sergeant William Lawson, contacted a consultant from the "60 Minutes II" show through the website "Soldiers for the Truth".[13] Such an exchange was made possible by the troubled debates that had involved the military since the war in Afghanistan, when opposition to the methods imposed by the Pentagon were translated into a "politics of leaking"[14] of information to the media.

These various contextual elements explain the relative tardiness with which the images began to circulate – the majority of which, among the first to be published, notably the "Hooded Man",[15] were taken on 8 November 2003. Moreover, given that the characteristics of a digital file guarantee that the same image will look identical under the same viewing conditions, one can demonstrate that the series of photographs broadcast by CBS and the *New Yorker* are not identical documents but two distinct sets of prints on paper. The differences in colour dominance, the alterations in framing of the CBS set and the visible traces of printing lines in the *New Yorker* set all suggest that the pictures used by the editorial teams were inkjet prints or reproductions via a colour photocopier. Far from representing the model of instantaneous communication of digital files by electronic media, the publication of the first images of the Abu Ghraib tortures are the product of mechanisms that can in no way be distinguished from those that have long produced the most traditional photographs.

While such facts undermine our usual assumptions about the circulation of digital imagery, there are also other effects that denote a new economy of images. One is the ease with which these photographs have become canonical. The iconographic repetitions and exchanges between the press and television channels had already organized the multiple occurrences of these visual documents as news: with the evolution of the electronic network, the Internet became a third actor in this redundancy, which contributed to the production and repetition of such icons. This aspect is particularly true of the photographs of the Iraqi prison from their first diffusion through three concurrent media and, constituted as evidence, inevitably helped the images to become monuments.

Furthermore, the corpus of Abu Ghraib photographs provides an ideal case study with which to analyse the mechanisms of such processes. After the diffusion of the first two series of images, news organizations engaged in a race for more torture photographs. Despite announcements anticipating several hundred or even thousand more images being revealed, the results of this ruthless quest were scarce. Only the biggest media agencies gained access to new images, parsimoniously dealt out by the sources: the *Washington Post* published five photographs on 9 May 2004, including the famous "Leashed Man"[16] as well as photographs from the initial corpus (see Figure 16D). That same day, the *New Yorker* unveiled an exclusive shot that also become notorious (see Figure 16D). It was only on 19 and 21 May that two new images were broadcast by ABC television (see Figure 16E), followed by a further group of six by the *Washington Post* (see Figure 16E). Given the number of repetitions throughout, the total number of photographs published that month barely reached thirty. There was still a clear difference between the memorial impact of the first wave of images, from 28 April to 9 May, and that of the second, from 19 May 2004 onwards. Not only had the media frenzy faded, the stories also lost some of their interest. While the first wave of images

was characterized by a large proportion of sexual or pornographic photographs as well as images of strange and shocking situations, the second wave was witness to a redundancy of motifs, and even a certain confusion. It is clear that the best candidates for canonization were the simpler images (the hooded man, the leashed man, the prisoner threatened by dogs), those whose subject matter is easily identifiable and could best act as emblems (the martyr, the torturer and the victim, helplessness in the face of violence). In contrast, photographs of too many subjects, with too much going on in the background or of situations needing interpretation were more difficult to remember.

We are left with the least recognized and yet most specific characteristic of recent digital photographic practice to help us understand how these images were realized. One of the most surprising aspects of the iconography has been to confront us with the smiling faces of torturers in the act of torturing. Several writers have questioned the specific situation that enabled the taking of those photographs, without regard for moral censorship or legal prudence. Meticulous answers have been formulated that look at the conditions that make possible barbaric behaviour in times of war.[17] Some people have linked these strange photo-souvenirs to early twentieth-century American postcards of lynching scenes in which the torturers pose smiling for the camera.[18] The parallel seems the most obvious: but how to explain the disappearance of this ignominious genre for nearly a century? This is where the new characteristics of photography must be taken into consideration.

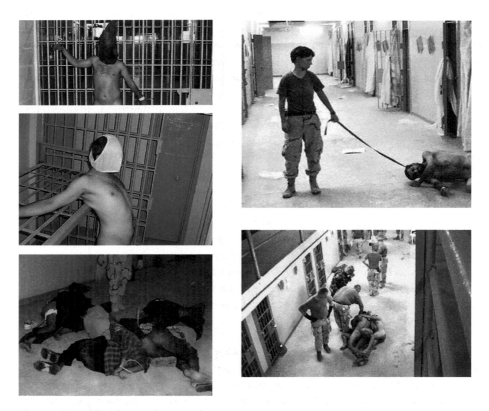

Figure 16D Courtesy Andrea Gunthert

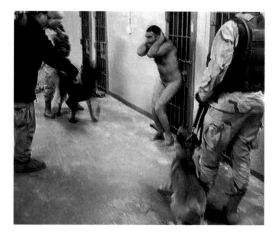

Figure 16D *(continued)* Courtesy Andrea Gunthert

The most striking feature of the shift from a traditional photographic prac-
tice to a digital one lies in the disappearance of the photograph's value. A digital
image can be recorded or not, kept or deleted, with no effect other than on the
space in the memory card. The understanding that an image has virtually no cost is
without doubt one of the most satisfying discoveries about this new medium, one
that incites users to take more shots. This aspect definitively modifies the way we
take pictures. There is a change in the way taking photographs is perceived: the
privileged moment associated with silver-based photography is stripped of its aura.
Digital photography makes taking photographs free and without cost, as if it was
without significance.

At least at first. For this is a transitory characteristic that belongs to the his-
tory of photography and marks a threshold: that separating one technology from
another. Considering the roll-film camera in 1888, Albert Londe warned his read-
ers that:

> This camera is definitely very practical [. . .]. We will nevertheless have to
> make the general criticism of roll film and multiple plate holders that they
> may lead users to neglect the quality of the image. The amateur who only
> takes six glass plates with him on a trip will use them wisely and will cer-
> tainly bring back six well-studied and ultimately interesting photographs.
> If this amateur has a stock of 24 or even 48 plates, one fears that he will
> waste them by shooting randomly and upon his return, he will be forced
> to admit that most of the photographs are mediocre because they were
> taken too hastily.[19]

This perception will soon fade. The seeming insignificance of taking digital pho-
tographs comes from the fact that the new practice is measured against the old. This
threshold effect is typical of the contemporary state of digital photography whose
access to mass practice greatly increased in 2003. Without ignoring the devastat-
ing consequences of a conflict without justification, one must argue that the recent

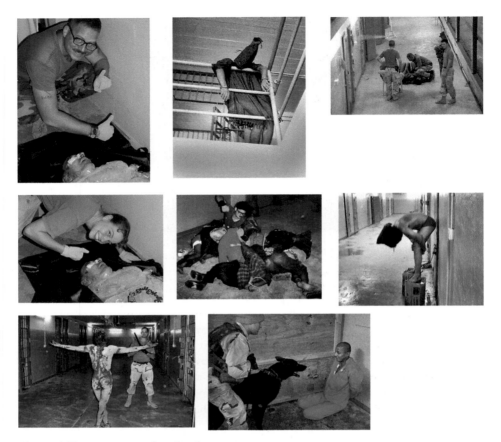

Figure 16E Courtesy Andrea Gunthert

equipping of the American population with digital cameras played a key role in the making of the Abu Ghraib photographs.

The sequence of events from autumn 2003 to spring 2004 around the images of Abu Ghraib was exceptional. There are few chances that this process will happen again in a similar fashion. Its political consequences still need to be evaluated. On the iconographic level, it provides a number of important conclusions. First, it contradicts all the Cassandra predictions of a decline in our sensibility to the language of images, the end of their ability to move us and to engender pity. It negates the forecasts according to which entry to the digital photography era would render the recording process unreliable. It also goes to prove, in an exemplary way, that the digital image belongs to the history of photography, a witness to its mechanisms and principles. Abu Ghraib will be remembered as the first event that made a place in history for digital photography.

Acknowledgements

This paper was first published in *Etudes photographiques* 15 (2004): 124–34, under the title "L'Image numérique s'en va-t'en guerre. Les Photographies d'Abou Ghraib". The author would like to thank Marta Braun for her valuable help.

Original publication

'Digital Imaging Goes to War: The Abu Ghraib Photographs', *photographies* (2008)
[Originally published 2004]

Notes

1 See <www.icp.org/exhibitions/abu_ghraib/index.html>. 10 October 2004.
2 Danner, "Abu Ghraib".
3 See Lavoie, *L'instant-monument*.
4 Morice, "Keith Cottingham ou le sujet artificiel" 20. During the same period, Régis Durand says that: "indeed photography seems to have come to a threshold in its short existence: technological evolution has reached the point where photography is about to become something very different from what defined it at its inception (particularly with the predictable disappearance of the use of light-sensitive film to the profit of a totally digital treatment of images)" (7).
5 See Guerrin and Lesnes, "Le Numérique et internet bousculent le Pentagone"; Sontag, "Regarding the Torture of Others".
6 See <www.cbsnews.com/stories/2004/05/05/60II/main615781.shtml> (reworked on 5 May 2004).
7 Hersch, "Torture at Abu Ghraib".
8 Byrne, "Rogue British Troops Batter Iraqis in Mockery of Bid to Win Over People". (The article was removed from the website www.mirror.co.uk after 13 May 2004).
9 See especially Anon., "Army Photos".
10 Taguba, "Executive Summary of Article 15–6 Investigation of the 800th Military Police Brigade".
11 See Starr, "Details of Army's Abuse Investigation Surfaces".
12 Rousellot, "La Presse s'arme de critiques" 7.
13 McMahon, "SFTT Role in Uncovering Abu Ghraib Abuses".
14 Mason, "George Bush et l'occupation de l'Irak".
15 Danner, "Abu Ghraib".
16 Ibid.
17 See Wieviorka, "Irak" 39.
18 See especially Sante, "Tourist and Torturers"; Brison, "Torture, or 'Good Old American Pornography'?".
19 Londe, *La Photographie moderne* 25–26.

Works cited

Anon. "Army Photos: Claims and Rebuttals." *BBC News*. 14 May 2004 <http://news.bbc.co.uk/1/hi/uk/3680327.stm>.
Brison, Susan J. "Torture, or 'Good Old American Pornography'?" *Chronicle of Higher Education*. 4 June 2004 <http://chronicle.com/free/v50/i39/39b01001.htm>.
Byrne, Paul. "Rogue British Troops Batter Iraqis in Mockery of Bid to Win Over People." *Daily Mirror*. 1 May 2004.
Danner, Mark. "Abu Ghraib: The Hidden Story." *New York Review of Books* 51.15. 7 October 2004 <www.nybooks.com/articles/article-preview?article_id=17430>.
Durand, Régis. *Le Temps de l'image*. Paris: la Différence, 1995.

Guerrin, Michel, and Corinne Lesnes. "Le Numérique et internet bousculent le Pentagone." *Le Monde*. 14 May 2004.

Hersch, Seymour. "Torture at Abu Ghraib." *New Yorker*. 30 Apr. 2004 <www.newyorker.com/fact/content/?040510fa_fact>.

Lavoie, Vincent. *L'Instant-monument: du fait-divers à l'humanitaire*. Montréal: Dazibao, 2001.

Londe, Albert. *La Photographie moderne: pratique et applications*. Paris: Masson, 1888.

Mason, John. "George Bush et l'occupation de l'Irak. L'effondrement de la droite américaine?" Talk given during the CIRPES seminar, EHESS. 4 June 2004.

McMahon, Robert L. "SFTT Role in Uncovering Abu Ghraib Abuses." *Website "Soldier for the Truth"*. 12 May 2004 <www.sftt.org/cgi-bin/csNews/csNews.cgi?database=Unlisted%2edb&command=viewone&id=12>.

Morice, Anne-Marie. "Keith Cottingham ou le sujet artificiel." *La Recherche photographique*. 20 (Spring 1997): 20.

Rousellot, Fabrice. "La Presse s'arme de critiques." *Libération*. 5 May 2004: 7.

Sante, Luc. "Tourist and Torturers." *New York Times*. 11 May 2004 <http://query.nytimes.com/gst/abstract.html?res=F20C11F639580C728DDDAC0894DC404482>.

Sontag, Susan. "Regarding the Torture of Others." *New York Times Magazine*. 23 May 2004 <www.nytimes.com/2004/05/23/magazine/23PRISONS.html?ex=1097726400&en=679fb1b15ae29b34&ei=5070>.

Starr, Barbara. "Details of Army's Abuse Investigation Surfaces." *CNN*. 21 January 2004 <www.cnn.com/2004/US/01/20/sprj.nirq.abuse>.

Taguba, Antonio M. "Executive Summary of Article 15–6 Investigation of the 800th Military Police Brigade." Report (5 May 2004 version). <www.msnbc.msn.com/id/4894001>.

Wieviorka, Michel. "Irak: hygiène du bourreau." *Libération*. 13 May 2004: 39.

Ethan Zuckerman

CURATING PARTICIPATION

W HEN TERRORISTS DETONATED THREE BOMBS in the London Underground on July 7, 2005, the first images of the tragedy came not from professional photographers but from the cellphones of those trapped in stations underground. As survivors climbed to the surface, they sent photos to family and friends, who forwarded them to the press. Desperate to capture the unfolding crisis, the press circulated these eyewitness photographs as reporters and photojournalists struggled to understand what had happened and how best to illustrate it.

As a result, a blurry, grainy image of Londoner Adam Stacy, shot by Elliot Ward on his Sony Ericsson V800 mobile phone, became one of the iconic images of the 7/7 bombings. Ward posted the photo to MoblogUK, a UK photo-sharing site, and BBC News and SkyTV began featuring the image to report on the explosion on Stacy's train, which killed twenty-one passengers. Wikipedia's entry for the 7/7 bombings features the image of Stacy, handkerchief to his face to protect from smoke inhalation, lit by the packed train's dim yellow emergency light.

In 2005, when Ward captured the image of Stacy, there were about one hundred million camera phones sold annually. By 2011, more than a billion camera phones were sold per year, joining the more than four billion already in circulation. The phenomenal success of the camera phone is part of a participatory shift that has transformed the photojournalistic equation. If an event or occurrence is documented, statistically speaking, it is far more likely to be documented by an amateur than by a professional. This has obvious implications for photojournalism: with bystanders as amateur documentarians, the professional photojournalist no longer is the designated witness to tragedy or triumph. We may hope she is freed up to document the unsurprising, the aftermath, and to help understand slower, ongoing processes. But this may mean that the work of the image maker as witness is now an unaffordable luxury to cash-strapped, shrinking professional newsrooms.

These movements toward citizen reportage resonate beyond eyewitnessing. The production of visual media has become a way to demand attention for situations and events

that professional media overlooks. When a small group of protesters occupying Gezi Park in Istanbul, opposed to its proposed transformation into a shopping mall, were teargassed by the police, Turks were outraged both by the disproportionate use of force and by CNN Türk's failure to report on the protests. Referencing CNN Türk's decision to air a documentary about Antarctic penguins instead of the protests, a gas-mask-wearing penguin became an unofficial protest mascot, and Turkish activists adopted a disciplined process of self-documentation, producing photos and videos that demonstrated the peaceful nature of the protests and the disproportionate responses of the police and the military.

In placing media-making central to their movement, Gezi protesters followed in the footsteps of the global Occupy resistance, which embraced media production as a central pillar, and equipped each encampment with a media tent. Occupiers saw the production of media as serving two key functions. By livestreaming events in each camp, they could ensure that police abuses were captured and broadcast. (Consider Lieutenant John Pike, whose aggressive tactics toward students protesting at University of California – Davis led him to be immortalized as "pepper spray cop" in countless Internet memes after Bryan Nguyen captured Pike's act and posted his shots on Flickr.) By creating and disseminating media, Occupiers protected themselves and countered what they saw as a mainstream media bias against the movement, creating an alternative narrative that would find its audience online.

The media war that has paralleled Syria's civil war may be the apotheosis of this method of self-documentation. On all sides of Syria's conflict, video producers create and air videos that (claim to) document atrocities and celebrate victories. The videos are uploaded via satellite Internet connections and posted on YouTube channels. Some

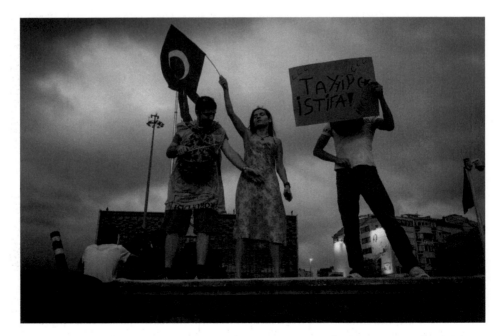

Figure 17.1 Mehmet Kacmaz, *Protesters holding a sign calling for the resignation of Turkish Prime Minister Recep Tayyip Erdoğan during protests in Gezi Park, Istanbul*, June 2, 2013. [Original in colour]. © Mehmet Kacmaz/NARphotos/Eyevine.

Figure 17.2 *Man with Bow and Arrow*. [Original in colour]. Courtesy of Boniface Mwangi.

Figure 17.3 Installation view of *Picha Mtaani*. [Original in colour]. Courtesy of David Mutua/ Boniface Mwangi.

are accompanied by VJs, who act as network anchors for these amateur networks. A subset of these videos offers key insights into an ongoing and insufficiently covered conflict. Others are propaganda, with piles of burning tires used to provide a smoky backdrop to dramatize the effects of war on a particular neighborhood or ethnic group.

The resulting documentation represents a massive challenge to journalists, who need imagery to tell the stories unfolding in Syria but are understandably concerned about propagating false reports. (The remarkable saga of Tom MacMaster, an American graduate student who persuaded the *Guardian* that he was a Syrian-American lesbian blogging from Damascus, is ample reason to give editors pause.)

It is reasonable for mainstream journalists to be suspicious of the provenance of these images. The same technologies that have made it possible for eyewitnesses to share what they see make it equally easy to manipulate images and present them out of context. But this is more of a problem for journalists and curators than consumers. The documentation practiced by Syrian rebels and Occupiers is explicitly a form of activist speech. As such, we are advised to be on guard to read it as persuasive, not reportorial.

Where these images present a more serious problem is for the curator who wants to create a portrait of events that is representative and fair. We faced this problem at Ushahidi, a Kenyan nonprofit technology company founded in the wake of Kenya's violently disputed 2007 election, where I have been an adviser and now chair the board of directors. Kenyan bloggers and software developers built a crowdsourced reporting tool to document post-election violence when local media decided to black out coverage of violence for fear of further inflaming tensions. Ushahidi collected and mapped more than a thousand reports of violence, using SMS and MMS to collect text and picture messages from Kenyans throughout the country.

Problems arose when local and international commentators began referring to the Ushahidi map as a "collective portrait" of the crisis. Human rights experts like Dr. Patrick Ball correctly pointed out that the Ushahidi portrait was likely to be incomplete and skewed, favoring the reports of those technologically savvy enough to document and post images. Further, they observed that Ushahidi was vulnerable to manipulation if misattributed imagery was posted, overemphasizing one group's losses or scapegoating another. We responded to this problem by launching a massive research effort to build tools that could verify text and images shared via social media, overcoming problems of provenance by creating tools that allowed us to make educated guesses about the reliability of online information. This research was frustrating and ultimately unsuccessful, and we recently abandoned the effort, concluding that we could not verify social media quickly and at scale. Ushahidi remains an important platform for community documentation, collective reporting, and crisis response, but we've come to accept that the documentation that comes from dozens or thousands of citizen reports is categorically different from documentation produced by a single, verifiable actor.

The challenge of verification offers one sustained role for the professional documentarian: the transparent witness. Documentary inevitably features a point of view, and professional documentarians often clearly communicate their agendas, allowing us to read their imagery as one of multiple possible framings of a complex event. That we recognize documentary as art as well as reportage helps in this matter too. We expect a documentarian to have a perspective but also to be fair, to show us what she thinks is most important but via what is caught on camera rather than creating images ex nihilo, as propagandists do.

We may also see documentarians emerging as a new type of curator, using their experience documenting a complex situation to filter imagery created and shared by

citizens and activists. Sorting through the welter of images created by citizen documentarians is overwhelming for someone distant from the events depicted but tractable for someone familiar with the hard work of capturing a complex reality in a set of images. New documentaries that combine citizen-created imagery with the work of a professional documentarian are already emerging. Jigar Mehta's 2011 *18 Days in Egypt*, crowdsourced documentary of the Egyptian revolution assembled from footage contributed by protesters, is one laudable example.

Both citizen documentarians and seasoned photojournalists struggle to present slow news – stories that unfold over years and decades. The subtleties of climate change create occasional dramatic images, but capturing the most profound changes, like desertification, requires patience and time. Here, citizen documentary offers a powerful new aid for the professional: the ability to use images collected from a range of places and wide span of time to tell a complicated story. When documentarians Kara Oehler and Jesse Shapins wanted to portray the changing shape of the American downtown, they invited any interested participants to take part by photographing streets named "Main Street" and tagging those photographs as part of the Mapping Main Street project. Their work has led to the creation of a new platform, Zeega, that allows the collection and curation of digital media. By combining broad participation with careful curation, they suggest a method that professional and amateur documentarians may use to help us grasp slow-news stories in a powerful new way.

Questions about authenticity, provenance, and agenda are inevitable as we consider the ramifications of the rising tide of citizen journalists. But a more pressing concern, affecting the documentary field as a whole, may be the scarcity of attention. Multidisciplinary scholar Herbert Simon articulated the problems stemming from too much information. "In an information-rich world," he wrote, "the wealth of information means a dearth of something else: a scarcity of whatever it is that information consumes. What information consumes is rather obvious: it consumes the attention of its recipients."

Simon wrote those words in 1971, panicked by the abundance of information that could be created and disseminated by the new technology of photocopying; one can only imagine his reaction to warring Syrian factions with their own online news networks. As we consider the implications of citizen documentary, we need to consider how (and whether) these images come to be viewed.

For many years, it has been a challenge for professional documentarians to reach broad, politically influential audiences. Now we face a competitive media ecosystem in which documentation of the quotidian competes for attention with documentation of global injustice and outrage. The ordinary and the extraordinary are delivered via the same media, in the same channels, to the same audience. There is a natural tendency to gravitate to the everyday events in the lives of those near and dear to us over extraordinary events in the lives of people who are culturally or geographically distant. The ultimate challenge presented by citizen documentation may be in ensuring that images find the audiences they need and deserve.

Original publication

'Curating Participation'. *Aperture* (2014)

Mette Mortensen

WHEN CITIZEN PHOTOJOURNALISM SETS THE NEWS AGENDA

Neda Agha Soltan as a Web 2.0 icon of post-election unrest in Iran

Introduction

HISTORY OFFERS NUMEROUS EXAMPLES of how the global media circulation of images from conflict zones may aggravate violent confrontations, as well as exert a decisive influence on policy-making and public opinion. With the rise of citizen photojournalism, we have witnessed a re-arming of visual warfare in the 21st century. In response to the production and distribution of images becoming inexpensive and accessible enough for any participant in a conflict to assume the role of photojournalist with a worldwide audience, video clips and stills by non-professionals frequently turn into 'breaking news' in the international media (Andén-Papadopoulos, 2009a, 2009b; Christensen, 2008; Kennedy, 2008; Mortensen, 2009). The general public became aware of amateur productions as a factor of power in 2004, when the pictures of the atrocities occurring in the Abu Ghraib prison led to violent reactions and spurred international debate about the legitimacy of the war in Iraq. With regard to the Abu Ghraib scandal and other high profile cases, such as Saddam Hussein's hanging (2006), the anti-government demonstrations in Myanmar (Burma) (2007), the post-election unrest in Iran (2009) and the terrorist attacks in New York City (2001), London (2005) and Mumbai (2008), amateur productions reach an audience counted in the millions. This immense appeal may be explained by the manner in which citizen photojournalism provides an alternative to the mainstream media's coverage of conflict, terror and war, or less idealistically, by voyeurism or appetite for sensation sparked by dramatic, violent content.

Drawing on a case study of the mobile telephone footage of the Iranian woman Neda Agha Soltan, who was killed during a demonstration in Tehran in June 2009, this article investigates the ethical dilemmas involved with the Western news media's eager dissemination of citizen photojournalism as a unique and headline-grabbing source. The article consists of three sections. After introducing the research field and the case, the first section defines citizen photojournalism historically and theoretically

as the joint offspring of today's participatory practices and the tradition for bearing witness. The second section analyses citizen photojournalism as a news source. On the one hand, the new visuals may grant us insights into areas of tension, to which the media has no other access for reasons of censorship or other limitations whether logistical or self-inflicted. On the other hand, amateur footage challenges the ethical standards of conventional journalism with its fragmentary and subjective format, not to mention the difficulties involved with tracking a clip's author and origin. In the third section, I argue that the coverage of the post-election unrest in Iran highlights the general lack of editorial procedures for accommodating citizen photojournalism. Even though Western media applauded the availability of manifold amateur productions in the decentred and heterogeneous fashion of Web 2.0, they took familiar paths when seeking out the footage of Neda as a centralized, symbolic icon to illustrate the complex political situation.

Review of the research field

Within participatory journalism, non-professional visuals are the only user-generated content to occasionally achieve a status similar to professionally produced content, that is, amateur footage as breaking news (Pantti and Bakker, 2009: 485). The news media monitor social websites and encourage their audience to submit eyewitness dispatches of unfolding events. As any media user is well aware, the deployment of citizen photojournalism is not restricted to the coverage of war and conflict. Amateur recordings are included in reporting on natural catastrophes, for example the tsunami in the Indian Ocean (2004) or hurricane Katrina in the US (2005), just as they are utilized in event-driven news, of which the video footage of police violence against Rodney King is an early example (1991). In addition, viewers or readers send in pictures for day-to-day journalistic features, such as the weather forecast. This development changes the role and self-perception of the audience (Allan and Thorsen, 2009: 4), and, further, challenges the news media's traditional monopoly on determining which stories and point of views are worthy of attention. As mainstream media rely increasingly upon the appropriation of first-person amateur recordings, the boundaries between formal and informal crisis reporting are contested (Liu et al., 2009: 45). Everyday recording devices have enabled a worldwide complex of relations between ordinary people, and between ordinary people and media organizations (Frosh and Pinchevski, 2009: 10).

Considering the extent to which visual testimonies by amateurs have saturated the news media in recent years, they have received minimal scholarly scrutiny. The notable exception is the comprehensive work on Abu Ghraib: however, academia has paid little attention to how the case anticipates a radical shift in the news coverage of war and conflict. Instead focus has been on exploring the political consequences (e.g. Danner, 2004; Hersh, 2005) or the pictures' embeddedness in visual culture (e.g. Brison, 2004; Solomon-Godeau, 2004; Sontag, 2004). Several recent articles engage critically with 'soldier photography' beyond the Abu Ghraib scandal and reflect on the new speed and scope of distribution (Andén-Papadopoulos, 2009a, 2009b; Christensen, 2008; Mortensen, 2009). Albeit closely related to citizen photojournalism, other questions are raised when military personnel are behind the camera: the possible documentation

of war crimes (Heer and Naumann, 1995; Heer et al. 2007; Hesford, 2004); picture making as a way for soldiers to deal with the traumas of war and honour fallen comrades; and the inherent security threats if the adversary takes offence at the images, or they reveal classified information. In all, the current tendency for citizen photojournalism to seize the front pages passes virtually unnoticed in media studies. To the best of my knowledge, the only exception at present is the article: 'Misfortunes, memories and sunsets: Non-professional images in Dutch news media' (2009) by Mervi Pantti and Piet Bakker, which takes the more general approach of outlining the different genres of non-professional imagery submitted by the public to mainstream Dutch news organizations.

The YouTube martyr

As is often the case with citizen photojournalism, the news media adopted a strategy of publish first, validate later when airing the footage of Neda Agha Soltan, who was fatally wounded by a gunshot on 20 June 2009.[1] Nonetheless, after a few days of confusion, the Western media agreed on the following version of the story. Neda, a 26-year-old graduate from the Islamic Azad University in Tehran, was shot, suddenly and seemingly unprovoked, while attending a demonstration against the suspected rigging of the 12 June election that secured another term in office for the president in power, Mahmoud Ahmadinejad. No one has been legally charged with the killing, yet it is widely believed that the sniper belonged to the Basij – a volunteer militia. Two grainy and disturbingly graphic camera-phone films document the event.[2] The longest lasts 48 seconds and begins with Neda collapsing in front of a white car. A large pool of blood is on the ground at her feet. Two men, later identified as Neda's singing instructor and a doctor, are frantically trying to save her, but evidently it is in vain; her eyes then close and blood flows out of her nose and mouth. Originally, the video was posted on Facebook and YouTube by an Iranian asylum seeker in Holland after a friend in Tehran called on 20 June at 5 pm to ask this asylum seeker to publish the film he had just recorded of the killing of a young woman (Tait and Weaver, 2009). The second video, which was recorded by an anonymous filmmaker contains a 15-second close-up of Neda Agha Soltan, unconscious and bleeding heavily. A frame from this sequence is the most widely reproduced picture, along with a still from the first video of Neda lying on the ground, while the two men perform first aid. The intense dissemination of the stills is most likely due to their iconic appeal and reproducibility in the printed media.

Within minutes rather than hours, CNN launched the first video of Neda as a major news story. Soon after, both clips were featured everywhere in print, broadcast and online news. At least for a while, most of the world became familiar with Neda's face; young, beautiful and covered with blood. The footage was ascribed instant authority as the principle icon of the protest movement in Iran and became the object of intense public emotionality. Tribute was paid to Neda as a 'YouTube Martyr', and the Western media told the same story over and over again of how the murdered woman gave the Iranian demonstrators a name, a face, a 'unifying symbol' (Parker, 2009). On Google Earth, the site of her death was renamed 'Martyr Square'. Her face was reproduced on T-shirts and posters – one of them designed to look like Barack

Obama's iconic 2008 campaign image calling for change. In demonstrations in Tehran and elsewhere people carried placards with her face to the rallying cry of 'We are Neda'. People wrote 'is Neda' on their Facebook status updates and uploaded a photo of Neda as their profile pictures. Furthermore, in line with the emergence of a memorial culture online, the internet flooded with pictures, poems and songs praising Neda as an 'Angel of Freedom' or 'the Iranian Joan of Arc'.

Digital activism: the case of post-election unrest in Iran

In this era, recently labelled 'The Cult of the Amateur', participatory practices continue to gain ground (Keen, 2007). The role of the audience shifts, from the act of consuming to taking active part in partially or fully producing the media content. One significant outcome of this development, termed 'convergence culture' by Henry Jenkins (2006) and others, is that collective meaning making within popular culture changes the way politics operates. By means of active user participation, information travels across 'old' and 'new' media systems and sets the political agenda, often in an unpredictable manner. Digital activism is a clear case in point.

The Persian Gulf War is popularly dubbed 'the CNN war' due to this network's pioneering live broadcast from the front line, amounting to the vanguard media experience of war in 1991. By comparison, and quite telling of today's conditions for news production, CNN's live news on the uprising in Iran repeatedly took the form of transmitting and discussing photos and videos submitted to CNN.com's site iReport by people attending rallies. Similarly, the websites of the *Huffington Post*, *The New York Times*, the *Guardian* and other leading media posted a mix of unverified videos, minute-by-minute blogs and anonymous twitter messages (Stelter, 2009). On-site political activists turned into essential sources as a result of the Iranian government's ban on independent and foreign media reporting on non-official events.

The uprising over the assumed electoral fraud was soon named 'The Twitter Revolution'. Iranian protesters circumvented the strict governmental control on digital communication and shared their experience of the regime's brutal handling of opponents in recordings on social networking sites like Facebook and YouTube or news network sites like iReport, as well as in 'tweets', that is, micro-blogs on the social network site Twitter (Web Ecology Project, 2009). iReport alone received a total of 5200 Iran-related submissions in June 2009 (Stelter, 2009).

For obvious reasons, the frequently asked question of whether citizen journalism and citizen photojournalism should be regarded as a democratization of the media bears a special resonance within the Iranian context of a theocracy, which holds one of the most sophisticated centralized technical filtering systems in the world (OpenNet Initiative, 2009). Internet censorship in Iran completely blocks sites such as Flickr and MySpace. Likewise, access to YouTube, Facebook and other platforms was shut down during the 2009 presidential election. In addition to internet censorship, satellite television signals were jammed and protesters' mobile phones confiscated to prevent many-to-many exchanges of textual and visual information.

Reflecting on digital activism in Iran, former US Deputy National Security Advisor Mark Pfeile argued in favour of Twitter as a candidate for the Nobel Peace Prize (Pfeile, 2009). Digital media have no doubt empowered people to share information

and rendered it more difficult to keep brutal acts out of sight, because 'the world is watching', to quote a popular expression in the coverage of the unrest in Iran. Nevertheless, it is essential to keep in mind that only 35 per cent of Iranians have internet access (OpenNet Initiative, 2009: 2). If the outside world relies primarily on electronically transmitted videos and text messages as news sources, it runs the risk of underestimating the support for President Ahmadinejad among the poorer, rural population, who are less likely to use online social media than the well-educated and English speaking (Flitton, 2009). Moreover, the technology is two-edged, given that, for example, Twitter threatens to become a powerful tool for the Iranian regime to track dissidents.

The eyewitness

In addition to today's participatory practices, citizen photojournalism should also be regarded in continuation of the tradition for witnessing. While always an important concept in conventional journalism, 'eyewitness' has become an inescapable keyword in the contemporary media landscape (Zelizer, 2007). This is due to the radical transformation which the long-established figure of the witness is currently undergoing. Eyewitnesses no longer just settle for making an appearance in the media as sources of information and experience, they are themselves producing and distributing media contents.

With mobile cameras always at hand, everybody is a potential eyewitness today. In a culture marked by compulsive picture taking and sharing, bearing visual testimony is invariably an option, whether we find ourselves situated as bystanders to history in the making, at a scene of crime or merely in the humdrum of everyday life.

In order to conceptualize the omnipresent contemporary eyewitness, it is beneficial to look into this figure's weighty historical baggage. Historically, witnessing originates from law and theology. On the one hand, most known legal systems have depended on the witness as an indispensable source of information. On the other hand, the witness – especially in the form of the martyr – is featured in various religious traditions. Etymologically, this is indicated by the term 'martyr' deriving from the Greek word 'μάρτυρ', meaning 'witness', that is, one who attests to the truth by suffering (Thomas, 2009: 95). Particularly since World War II, the media have constituted another essential framework for witnessing. While 'the act of witness is never itself unmediated', as John Ellis observes (2000: 11), issues relating to the representation of traumatic events and the media in question gained more urgency after the war, when visual and eventually also audiovisual media turned into the favoured platforms for delivering testimony.

Obviously, the act of witnessing changes dramatically when the witness moves behind the camera. This may be deduced by a quote from the seminal essay 'Witnessing' (2001) by John Durham Peters, in which he writes about witnessing traditionally falling into the separate realms of passively 'seeing' and actively 'saying':

> To witness thus has two faces: the passive one of *seeing* and the active one of *saying*. . . . What one has seen authorizes what one says: an active witness first must have been a passive one. Herein lies the fragility of

witnessing: the difficult juncture between experience and discourse. The witness is authorized to speak by having been present at an occurrence. A private experience enables a public statement. But the journey from experience (the seen) into words (the said) is precarious.

(Peters, 2001: 709–710)

When witnesses create and disseminate pictures themselves, witnessing no longer appears to be two-sided. There hardly appears to be a passive act of observing prior to the active, mediated act of bearing witness. The event is already experienced in a mediated form as it plays out, both figuratively and literally speaking, since the scene is taken in with attention split between the mobile phone screen's reproduction of the event and the event in real life.

Whereas the juncture between 'seeing' and 'saying' or between 'experience' and 'discourse' used to be 'precarious' and 'difficult', as Peters puts it, the distance is now easily covered with technological devices leaving the witness to invest less of his or her own self in the transition. In turn, the testimonies themselves have become 'precarious' and 'difficult' with their unedited and subjective form as a demonstration of how the modes of production and distribution largely set the conditions for reception.

Citizen photojournalism as a news source

Moving on to the second section on citizen photojournalism as a news source, the footage on the one hand comes across as authentic on account of its speed, intimacy and strong reality effect, along with the fact that it is not usually infiltrated by commercial interests or legislative politics at the outset. On the other hand, the basic who, why, when and where of the imagery often hangs in the balance. Recurrently, the producers remain anonymous and withhold information, for reasons of safety in the case of Iranian citizen photojournalists, but also as something of a genre convention. Now more than ever, eyewitness testimonies appear 'notoriously contradictory and inarticulate' (Peters, 2001: 710). The immediacy and proximity to events characteristic of the eyewitness have intensified to a degree that the accounts often balance on the edge of the intelligible.

How do we position ourselves as spectators of citizen photojournalism? With the jumpy, grainy pictures distinctive of the handheld camera, the footage points back to the time of origin and to the eyewitness' bodily presence and recording of the event. Citizen photojournalism holds a strong appeal for identification with the author, even if we do not know with whom we are supposed to identify. This raises the question of what kind of responsibility is entailed in watching, for example, the clips of the killing of Neda, if we subscribe to the often-cited stance proposed by Ellis (2000): 'You cannot say you did not know'?

The ethical issues deriving from citizen photojournalism's troublesome status as a source of information become particularly evident when the news media propagate the footage to the general public. By and large, the established media have not presently standardized procedures for using eyewitness testimonies parallel to, for example, the set of rules in the court of law. This may pose problems with regard to three topics: source criticism; violence; and security politics.

First, the 'old' media tend not to reflect on the consequences of the 'new' media's blurring of boundaries between those documenting a conflict and those participating in it, even though this is a decisive step away from the ideals of the photojournalist as an objective observer. The lack of a stable figure or institution responsible for the images prevents the media from the practice of naming and testing the reliability of the source, which is a cornerstone in the code of ethics for journalism. Although the media are developing methods for dealing with this, for example iReport indicates whether the clip is 'vetted', the user still has to make a more or less informed decision on how to extract knowledge from the material. Navigating through the mass of citizen photojournalism indeed comprises a difficult task, especially since the moral claim associated with the eyewitness is up for discussion. Traditionally, the moral constitution of the person presenting her or himself as an eyewitness has been of great importance, because it was conceived as a civil courageous achievement when a private individual took responsibility for an event by putting forward a public statement that may contribute to the news coverage and in the course of time to the writing of collective history (Peters, 2001; Zelizer, 2002). When every onlooker, every participant, may join the ranks of eyewitnesses, it is questionable whether the moral claim still holds. While some citizen photojournalists appear to be motivated by political activism, others seem to simply follow the everyday habit of visually documenting our lives and experiences, for example, when passers-by photograph a fire or a traffic accident.

Second, citizen photojournalism tends to be more graphic than other visual and audiovisual journalism, and pushes the limits of what is deemed acceptable to show. Albeit that no editor, organization or administration has resolved whether to release particular pictures in the first place, the news media seem more inclined to show explicitly violent amateur recordings, perhaps because they are already available in the public domain (Pantti and Bakker, 2009: 472). For instance, the first video of Neda was broadcast on all the major television networks on primetime news and breakfast television (Jardine, 2009). This calls forth the familiar issue of how we are constituted and constitute ourselves as spectators to mediated human suffering (Boltanski, 1999; Chouliaraki, 2006, 2008; Hesford, 2004; Seaton, 2005; Sontag, 2003). With a 'deterritorialization' of experience, the media show the pain of distant others every day, in the main without giving us the option of acting on their situation, apart from 'paying and speaking' (Boltanski, 1999: 17). At stake is also the related issue of the impact of violence, given that no proportionality exists between the force of violence and onlookers' propensity to an empathic, reflective or active response. Even if violence is exhibited pedagogically to prevent future violence, engage the viewer or realistically display the brutality of armed conflicts, the spectator is enrolled in the logics of violence and needs to position him or herself in a difficult process of identification and distancing.

Third, owing to citizen photojournalism's precariousness as a source and the violent content, the material lends itself to radical readings and reactions. Amateur productions frequently become matters concerning security politics, when they are mobilized in a propagandistic image-war where the contending parties fight through the media about which truth the pictures substantiate. While the consensus among European and US news media was to interpret the Neda-clips as the appalling killing of an innocent bystander, the Iranian state media ventured other explanations. The newspaper *Javan* wrote that a woman by the name of Neda Agha Soltan had presented

herself at the Iranian embassy in Greece, maintaining she was the person depicted in the pictures that falsely documented her death (e.g. BBC Monitoring Middle East, 2009). Another story published in the pro-government paper *Vatan Emrouz* claimed that the newly expelled BBC correspondent Jon Leyne had hired a contract killer in order to film the shooting (e.g. Fletcher, 2009; *The Times*, 2009). Other media agreed with the version put forward by the Iranian security forces that the videos in themselves proved the killing had been staged, because the filmmakers must have been forewarned in order to record the event (e.g. Dehghan, 2009). These and other theories illustrate that even though citizen photojournalism is praised for its authenticity, the pictures seldom convey a fixed message apprehended by spectators across time and place. Rather, they give way to situated interpretations that are used to legitimize different political beliefs and calls for action.

To sum up, while citizen photojournalism has the capacity to disclose otherwise unobtainable intelligence for the benefit of the level of information and the democratic debate, it nonetheless poses challenges to the ethical standards of journalism and to security politics which remain largely unacknowledged.

The instantaneous icon

The third and final section of this article analyses the specific case of how the Western news media deployed citizen photojournalism as a source during the Iranian uprising in June 2009. In a culture where everybody is an eyewitness in the making, the amount of visual material online follows an ascending curve. Is this reflected in the established news media? Yes and no. Mimicking social platforms, the websites of news networks often feature a broad selection of pictures. Yet, this does not appear to be of decisive importance for the pictures generating the lead stories or for the media's overall approach to armed conflicts. Accordingly, the footage of Neda Agha Soltan was instantly assigned authority as an icon, regardless of its origin and the unsteady production of meaning and knowledge at present indicative of Web 2.0. The 'new' media logics of Web 2.0 converged with the 'old' media logics of using photographic icons as a condensed symbolically charged way of representing and remembering war and conflict. Examples abound, suffice it for now to list *Flag-raising of Iwo Jima* by Joe Rosenthal (1945), Nick Út's photograph of the Napalm-burnt Vietnamese girl (1972) along with the hooded man and other Abu Ghraib images (Brink 2000; Goldberg, 1991; Hariman and Lucaites, 2007).

The reception of the imagery of Neda is a paradigmatic example of the way in which an icon is established. At the same time as the picture cleared the front pages, the news media engaged in a collective, performative speech act of repeatedly attaching the word 'icon' to it, or by other rhetorical means consolidating its significance as a unifying symbol. To quote a few of the many catchphrases from international print and broadcast news from 22–24 June 2009, that is within four days of the killing, Neda was referred to as an: 'instantaneous icon'; 'internet icon'; 'icon of revolt'; 'icon of unrest'; and a 'protest icon' (e.g. Collins, 2009; Fleishman, 2009; Jafarzadeh, 2009; Kelly, 2009; Kruse, 2009; William, 2009). In other words, the news media enthusiastically took part in the self-fulfilling prophecy of declaring the material's iconic status.

A similar unity of reception was asserted in the consistent address of onlookers in the form of a 'we'. The slogan 'We are Neda', which was soon appropriated by print and broadcast news, is the most self-evident example. In the slogan's symbolic assumption of the dead woman's identity, the personal pronoun 'we' establishes a consensual, joint ownership for the canonization of the imagery. This includes the members of the audience in assumed agreement on the morally and politically charged understanding of the image. In all, the canonization of Neda's image demonstrates how an emotional and political unity is often articulated in the reception of icons or icons to be, as if it can be taken for granted, when in fact the reception is in itself instrumental for constructing and mobilizing this unity.

Why this picture?

Which visuals travel from digital subcultures to the centre stage of mainstream media? And specifically, why did the visuals of Neda so capture our attention? The recordings (and especially the stills) of the young woman bleeding to death on the street in Tehran, triggered an emotional response in confirming predominant conceptions; not only about the conflict in Iran but also about a larger framework of politics and popular culture. Icons tell people what they already know, or what they would like to be told. Facilitating this approach, the footage of Neda shares with other icons an inciting combination of affective appeal, semantic openness and rich intertextuality (Brink 2000; Goldberg, 1991; Hariman and Lucaites, 2007). The interpretation of the material by US and European news media, attests to how it may be perceived as an intersection of central Western visual discourses. In particular, three discourses prevailed: the Middle Eastern woman in the Western imagination; student protests; and martyrdom.

The first discourse concerns the deceased Neda Agha Soltan's gender, ethnicity and religion. In the West, the young, beautiful Middle Eastern woman represents a site of intense erotic and political investment. Going back to the colonial period, women's bodies have constituted a fierce symbolic battleground. To name one prominent example, the liberation of the veiled woman has served as a strong argument for Western intervention in the Middle East and Northern Africa on several historical and recent occasions. In addition, Neda Agha Soltan symbolizes a democratic vision for a new Iran, with the hope attached to a class of young, educated women emerging despite the limitations on women's rights implemented by President Ahmadinejad (e.g. Kelly, 2009).

Second, Neda's picture also refers to famous photographs of student protesters, risking their lives during anti-government demonstrations. This iconographical figure, established with the revolts across Europe in the late 1960s, has become a powerful visual frame of reference for student rebellion, regardless of regional and political contexts. In their coverage of Neda Agha Soltan, the printed media drew parallels to the images of German student leader Benno Ohnesorg, who was shot during a rebellion in West Berlin in 1967, the Czech student Jan Palach setting himself on fire in 1969 in the struggle against Soviet repression, and the lone man standing in front of a column of tanks during the revolt at Tiananmen Square in 1989 (e.g. Alexander and Böhmer, 2009; Jardine, 2009; Joseph, 2009; Kennedy, 2009).

Third, the fact that Neda's death is captured on tape evokes the tradition of martyrdom, that is, sacrificing one's life for a higher goal. As is well known, martyrdom has given rise to several iconographies, both in Christianity and in historical and modern Islam. Arguably, in contemporary Western media discourse, martyrdom is mostly negatively associated with suicide bombers. Yet several articles also remark upon the significance of martyrdom in Iran, most famously with the so-called 'Martyrs of the Revolution', the Iranian dissidents killed in the 1979 revolution (e.g. Fathi and Mac-Farquhar, 2009).

The three discourses needless to say represent a diverse field of historical, geographical, political and cultural contexts. Still, they comprise the interpretive framework behind the icon of Neda and foster a sense of political and cultural continuity. Icons create 'an illusion of consensus' when a 'referential slippage' takes place, from the original context of the footage to projected values (Hariman and Lucaites, 2007; Sontag, 2003: 3). Only in part representing the novelty of the situation, icons are readily embraced by the general public as universal messages, due to their allusions to widely held ideas and historical precedents. When the news media drew attention to the discourses reflected in the imagery of Neda, they helped found the icon on factual and pictorial likenesses with previous icons. However, as noticed by German historian Cornelia Brink, familiarity with photographic icons, achieved by visual quotation and wide circulation, may hinder the audience from engaging in the complex reality from which they originate (Brink, 2000: 143–144). Always self-referential, an icon not only prompts the audience to relate to the content and specific context of the represented subject matter, but also to what might be termed the 'icon's iconicity', that is, its own history of contexts and intertexts. In short, rather than providing a visual entrance to reality, icons may block that very same entrance.

Conclusion

The rise of citizen photojournalism has created a landslide of visual information on current world affairs that would have been impossible few years ago. In the present era of digital transformation, still larger sections of the world's population are able to share their visual documentation of events. The news media currently face the challenge of developing editorial procedures and formats to accommodate the new sources. Indeed, the news media indisputably play an essential role as a platform for editorial selection and communication of citizen photojournalism when considering the vast quantity of pictures in circulation and their lack of professional consistency and ethical standards. Otherwise, this emerging genre may be of limited value for the common media user.

The 2009 post-election uprising in Iran is a paradigmatic example of how Web 2.0 opens new opportunities for reporting on unfolding events. It is also an example of how the news media, regardless of their acclamation of the democratic hope conceived by 'the twitter revolution', resort to conventional framings of war and conflict. By simultaneously creating and celebrating icons, they leave the methodological and theoretical questions unanswered concerning how to handle citizen photojournalism's quantity and archival logics, its subjectivity and insecurity. Likewise, they refrain from

contemplating how to use the material as a source and dealing with issues of ethics, ownership, legitimacy, verification and newsworthiness.

Another central point concerns the future of icons. Digital technologies have made canonization less controllable and predictable given that citizens, soldiers, activists and others embedded in war and conflict may spark it. While the public seems to be increasingly sceptical of pictures designed to become icons and obviously serving governmental propaganda, amateur footage appeals to spectators with its raw and authentic glimpses into combat zones. Canonization confers the otherwise fleeting and transitory visual representations of Web 2.0 with the weight of history; they gain momentum from their exemplary expression of the public's anxieties and aspirations in a particular setting and create a bond between spectators. Still, the political mobilization of one icon may be at the expense of the diversity of viewpoints; the audience misses out on the experience of Web 2.0's bulk of visuals that may, optimistically speaking, be closer to the complexity of armed conflicts.

The footage of Neda Agha Soltan and the story of Neda Agha Soltan gave rise to strong emotions. Outrage, grief and fear turned into 'a resource for politics' (Butler, 2004: 30), and yet the imagery also inspired hope and a sense of unanimity. This article by no means intends to call the validity of this response in question; rather the reverse. Nevertheless, a simple fact needs to be considered: when one picture is singled out, countless others are left out.

Original publication

'When citizen photojournalism sets the news agenda: Neda Agha Soltan as a Web 2.0 icon of post- election unrest in Iran', *Global Media and Communications* (2011)

Notes

1 My account and analysis of the case are based on a thorough examination of all articles in major US and world publications, along with transcripts of TV broadcasts relating to the killing of Neda Agha Soltan, in the period from 20 June to 20 September 2009. As no independent investigation of Neda's death has been conducted, facts are not conclusively verified.

2 www.youtube.com/watch?v=MvPHxmXYILA&feature=related and www.youtube. com/watch?v=4DH9USpc9pM&skipcontrinter=1 (URLs accessed on 16 September 2010).

References

Alexander, D. and Böhmer, D.D. (2009) Die wütende Stimme der Bilder. *Frankfurter Rundschau* 22 June.

Allan, S. and Thorsen, E. (eds.) (2009) *Citizen Journalism: Global Perspectives.* New York: Peter Lang.

Andén-Papadopoulos, K. (2009a) US soldiers imagining the Iraq war on YouTube. *Popular Communication* 7(1): 17–27.

Andén-Papadopoulos, K. (2009b) Body horror on the internet. *Media, Culture & Society* 31(6): 921–938.

BBC Monitoring Middle East (2009) Iran paper says Neda's death during post-poll protest 'suspicious'. 1 July.

Boltanski, L. (1999) *Distant Suffering: Morality, Media and Politics*. Cambridge: Cambridge University Press.

Brink, C. (2000) Secular icons: Looking at photographs from Nazi concentration camps. *History & Memory* 12(1): 135–150.

Brison, S.J. (2004) Torture, or 'good old American pornography'? *Chronicle of Higher Education* 4 June: 11–14.

Butler, J. (2004) *Precarious Life: The Powers of Mourning and Violence*. London: Verso.

Chouliaraki, L. (2006) *The Spectatorship of Suffering*. London: Sage.

Chouliaraki, L. (2008) The symbolic power of transnational media: Managing the visibility of suffering. *Global Media and Communication* 4(3): 329–351.

Christensen, C. (2008) Uploading dissonance: YouTube and the US occupation of Iraq. *Media, War & Conflict* 1(2): 155–175.

Collins, D. (2009) Neda the martyr. *The Mirror* 23 June.

Danner, M. (2004) *Torture and Truth: America, Abu Ghraib and the War on Terror*. New York: New York Review of Books.

Dehghan, S.K. (2009) Thousands defy ban to take to Tehran streets on day of remembrance for fallen protesters. *Guardian International* 31 July.

Ellis, J. (2000) *Seeing Things: Television in the Age of Uncertainty*. London: IB Tauris.

Fathi, N. and MacFarquhar, N. (2009) In a death seen around the world, a symbol of Iranian protests. *The New York Times* 23 June.

Fleishman, J. (2009) Unrest in Iran: Slain protester becomes a symbol. *Los Angeles Times* 23 June.

Fletcher, M. (2009) Neda died in my hands. *The Times* 26 June.

Flitton, D. (2009) A very public death. *The Age* 23 June.

Frosh, P. and Pinchevski, A. (eds.) (2009) *Media Witnessing: Testimony in the Age of Mass Communication*. Hampshire: Palgrave Macmillan.

Goldberg, V. (1991) *The Power of Photography: How Photographs Changed Our Lives*. New York: Abbeville Press.

Hariman, R. and Lucaites, J.L. (2007) *No Caption Needed: Iconic Photographs, Public Culture, and Liberal Democracy*. Chicago: The University of Chicago Press.

Heer, H., Manoschek, W., Pollak, A. and Wodak, R. (eds.) (2007) *The Discursive Construction of History: Remembering the Wehrmacht's War of Annihilation*. Basingstoke: Palgrave Macmillan.

Heer, H. and Naumann, K. (eds.) (1995) *Vernichtungskrieg: Verbrechen der Wehrmacht 1941–1944*. Hamburg: Hamburger Edition HIS Verlagsges.mbH.

Hersh, S. (2005) *Chain of Command: The Road from 9/11 to Abu Ghraib*. New York: Allen Lane.

Hesford, W.S. (2004) Documenting violations: Rhetorical witnessing and the spectacle of distant suffering. *Biography* 27(1): 104–144.

Jafarzadeh, S. (2009) Neda's death in street creates an internet icon. *The Washington Times* 24 June.

Jardine, C. (2009) Dying seconds that last for ever. *The Daily Telegraph* 24 June.

Jenkins, H. (2006) *Convergence Culture: Where Old and New Media Collide*. New York: New York University Press.

Joseph, J. (2009) Like the student in Tiananmen Square, Neda is image that becomes an icon. *The Times* 23 June.

Keen, A. (2007) *The Cult of the Amateur*. New York: Doubleday.

Kelly, C. (2009) 'Courageous' women front Iran's resistance movement. *The Toronto Star* 24 June.

Kennedy, H. (2009) Internet turns ordinary woman into Angel of Iran. *Daily News* 25 June.

Kennedy, L. (2008) Securing vision: Photography and the US foreign policy. *Media, Culture & Society* 30(3): 279–294.

Kruse, M. (2009) At moment of death, an Icon of Iran revolt. *St Petersburg Times (Florida)* 23 June.

Liu, S., Palen, L., Sutton, J., Hughes, A.L. and Vieweg, S. (2009) Citizen photojournalism during crisis events. In: Allan, S. and Thorsen, E. (eds.) *Citizen Journalism: Global Perspectives.* New York: Peter Lang, 43–63.

Mortensen, M. (2009) The camera at war: When soldiers become war photographers. In: Schubart, R., Virchow, F., White-Stanley, D. and Thomas, T. (eds.) *War Isn't Hell, It's Entertainment: War in Modern Culture and Visual Media.* Jefferson, NC: McFarland, 44–61.

OpenNet Initiative (2009) Internet filtering in Iran. URL (consulted April 2010): http://opennet.net/sites/opennet.net/files/ONI_Iran_2009.pdf

Pantti, M. and Bakker, P. (2009) Misfortunes, memories and sunsets: Non-professional images in Dutch news media. *International Journal of Cultural Studies* 12(5): 471–489.

Parker, K. (2009) The voices of Neda: A sniper's bullet gives a movement its symbol. *The Washington Post* 24 June.

Peters, J.D. (2001) Witnessing. *Media, Culture & Society* 23(6): 707–723.

Pfeile, M. (2009) A Nobel prize for Twitter. *Christian Science Monitor* 6 July.

Seaton, J. (2005) *Carnage and the Media: The Making and Breaking of News about Violence.* London: Penguin.

Solomon-Godeau, A. (2004) Remote control: Dispatches from the image wars. *Artforum* 62(10): 61–64.

Sontag, S. (2003) *Regarding the Pain of Others.* London: Penguin.

Sontag, S. (2004) Regarding the torture of others. *New York Times Magazine* 23 May.

Stelter, B. (2009) Journalism rules are bent in news coverage from Iran. *The New York Times* 29 June.

Tait, R. and Weaver, M. (2009) The accidental martyr. *The Guardian* 23 June.

Thomas, G. (2009) Witness as a cultural form of communication: Historical roots, structural dynamics and current appearances. In: Frosh, P. and Pinchevski, A. (eds.) *Media Witnessing: Testimony in the Age of Mass Communication.* Hampshire: Palgrave Macmillan, 88–111.

The Times (2009) Death in the afternoon, editorial. *The Times* 27 June.

Web Ecology Project (2009) The Iranian election on Twitter: The first eighteen days. URL (consulted April 2010): www.webecologyproject.org/wp-content/uploads/2009/08/WEP-twitterFINAL.pdf

William, B. (anchor) (2009) NBC News 6:30 PM EST, 22 June.

Zelizer, B. (2002) Finding aids to the past: Bearing personal witness to traumatic public events. *Media, Culture & Society* 24(5): 697–714.

Zelizer, B. (2007) On 'having been there': 'Witnessing' as a journalistic key word. *Critical Studies in Media Communication* 24(5): 408–428.

PART THREE

Image and identity

Joy Gregory, *Eiffel Tower, Paris*, 2001 [Original in colour]. Courtesy of Joy Gregory.

Introduction

THE RELATION BETWEEN IMAGE AND IDENTITY has been debated in relation to photography in general, and also, more specifically, domestic photography. Historically, the initial critical focus was on photographs and the politics of representation. Representation simultaneously depicts and symbolises. Stuart Hall, in his extensive writings on the subject, defined systems of representation as referring both to ways of organising and categorising concepts and to understanding relations between them. In this formulation, concepts are material as they relate to objects or experiences. They are also intrinsically ideological in that systems of ideas are brought into play in order to place and comprehend the significance of material experience. Language performs a mediating role; it does not simply reference objects, events, experiences; rather, language operates as a link between experiences and what they mean to us. The politics of representation was concerned with stereotyping (e.g., of women) and with marginalisation (e.g., of ethnic minorities). In analysing the play of ideological discourses, the still image is interrelated with other media forms (advertising on- and off-line, radio soaps, newspaper features, social media, . . .) as sites within which particular ideas may be reinforced.

One result of interrogating representation was a burgeoning of photographic projects whereby people were encouraged to envisage aspects of their own experience, thereby challenging marginalisation or stereotypes. Class, gender, sexual orientation and ethnicity were explored and people were empowered through taking control of the means of picturing their own lives. The family, viewed as a complex and potentially repressive institution, came into focus. Simultaneously, the family album, as a site of personal histories, attracted analysis. Representational processes became understood as oscillating complexly between visible stereotyping and more invisible subjective processes of accommodation within social and domestic hierarchies. As the 1970s feminist slogan proclaimed, 'the personal is political' – that is, a question of power relations – a slogan that now might be reframed as a distant precursor to recent American #metoo developments.

Psychoanalysis, developed in the early years of the twentieth century, is premised on the formative influence of childhood experience. We are not born into the world as fully formed or patterned potential adults; rather we *become* who we are. Subjectivity develops and changes as a consequence of myriad encounters within the world of experience, including response to ways in which ideas, people and places are represented to us. We are thus subjectified within ideological processes which operate complexly at both conscious and unconscious levels of psychic patterning. For Freud, the sexual, which is biologically rooted, and the symbolic are key forces, experienced individually, but consequent upon cultural formations. Psychoanalysis as a therapeutic model is premised on the centrality of memory and on dreams as spaces wherein difficult (traumatic) experiences, or unconscious fantasies, are handled through displacement or through condensation. In effect, experience or fantasy is put aside or masked through a substitute image, memory or reference; or diluted through being condensed into something less complexly disagreeable and therefore more manageable. Freud himself does not discuss

photography. But clearly photographs, especially personal photography, relate to individual experience and may operate, like dreams, to condense or to displace, in effect offering a stand-in for actual experience. Photography, more generally, in selective reproduction of images of people, places and events, operates forcefully, in ideological and material terms, within specific cultural formations.

Personal memory and photography are thus inextricably intertwined. It may be difficult to distinguish between that which is remembered 'directly' and that which is remembered due to the continuing existence of a photograph which acts as an aide-memoire whilst perhaps veiling more complex relationships or narratives. Furthermore, an event, or set of circumstances, may have been experienced differently by various family participants (or groups of friends), so the photograph as token may provoke diverse recollections. Indeed, a particular image may belie actual social relations.

Investigating uses of photography in the 1960s, French sociologist Pierre Bourdieu found that more than two-thirds of photographers are 'seasonal conformists', taking photos at family and social events or in the summer holidays. Whether taken by a professional photographer or by a participant, the photograph symbolised significant moments within a family or community context, becoming 'an object of regulated exchange' within group history (Bourdieu 1965: 19–20). Historically, men may have been the principal picture takers, but in general women have been the keepers of the family album, in charge of creating a wall of images, or of choosing pictures for framing and display. Domestic histories were inflected through the selection and centring (on the page or on the mantelpiece) of certain relatives or events – to the exclusion of others. Photographic coding was also significant: who was most clearly in focus, central within the social group? Who was relegated to the edge of the frame?

As a result of the development of online, digital and mobile communications, the scenario is now very different; online sites have extended or substituted for the traditional family album as a physical domestic archive. The use of Facebook and other social media mechanisms for the updating and circulation of images of family and friends and for business and political networks has introduced a fluidity whereby spheres of activity can seem extensively inter-connected and non-hierarchical in the sense that everything seems to have acquired similar priority. There has been a flattening of social relations across a range of spheres, especially given the brevity of communications such as image captions or comments posted via Twitter. The use of images as a primary means of communication – for instance, the Instagram portrait that, with no words, in effect states 'here we are' – defines place (here), group (we: family; friends; colleagues) and time (now). One consequence of the new fluidity of communications has been a dissolution of boundaries between differing spheres of activities, public and private. It can seem that life is increasingly led in public and that identities are multi-layered, complex and fluid in ways that may not previously have been acknowledged. Given the intensity and ubiquity of image-flow, analysis of photographic coding and issues in representation within the broader and increasingly complex context of visual discourses remains crucial.

The first essay included here raises broad questions pertaining to cultural processes and shifting senses of identity. Bailey and Hall trace developments in black cultural theory and practices, arguing that changing times and circumstances should provoke shifts in analytical approaches and in tactics for counteracting stereotyping in representation. Although anchored through reference to then contemporary photography by black British photographers, and first published in an issue of *Ten.8* devoted to black British photography in the 1980s, the essay offers something of a hallmark in theorising identity-producing processes and the operations of the image. In the following essay, George Dimock offers an exemplary case study from the early illustrated press (1901) in which he problematises the interaction of photographs and writing in an article on African-Americans in rural Georgia ('the heart of the Black Belt' in the South). He suggests that the photo captions countermand the principles expressed in W. E. B. Du Bois' elegant narrative (later rewritten as part of his book *The Souls of Black Folk*). He identifies some captions as explicitly white supremacist in attitude, thereby contributing to undermining the political views espoused in the written article. Through his analysis Dimock demonstrates ways in which photographic representation, captioning and lay-out contribute to re-enforcing or re-inflecting themes addressed – in this instance, questions of race and identity.

Viewing the photograph as indicative and as a token operating to enhance particular memories led to the proposal developed by Jo Spence, in particular with Rosy Martin, that photographs could contribute to 're-modelling' history. Their first joint essay, 'New Portraits for Old: The Use of the Camera in Therapy', was published in 1985. Photo-therapy is a process, which draws upon co-counselling techniques, and involves time, trust, confidentiality and therapeutic objectives. Individuals review their personal histories analytically, bringing forward particular feelings and memories for exploration through performance in which key personal moments are re-enacted and photographed by the collaborator. Their later essay, included in abridged form here, indicates a breadth of possibilities, including permission to explore feelings through 'play'. The process opens up a theatre of memory, and the resulting photographs may become bearers of new meanings which contribute to pointing to further subjective issues for examination. Here the interaction of (photographic) image and subjective sense of identity is utilised proactively, as a way of unlocking previous self-limitations.

French linguist and psychoanalyst Jacques Lacan has indicated ways in which experience – especially, but not exclusively, within the family – contributes to structuring unconscious subjective patterns of feelings. Interrogation of personal photography, the snapshot and the family album, drew upon such psychoanalytic models in order to read beyond the image. The photograph masks family relations which obtain 'behind the image', as it were. It has long been noted that family albums record particular highlights of family history: births, weddings, parties, festival celebrations, holidays – but not death, divorce, arguments when travelling or, indeed, the everyday banal. Social conventions dictate that people group together, pose and smile when photographed. Often it is a detail – of posture or refusal to look at the camera – which indicates that all is not quite as it at first appears. Hence

it was argued that personal photographs can be read symptomatically, through observation of detail, perhaps in conjunction with reading diaries and notebooks, or with interviews. The photograph thus becomes viewed as an indicator of malaise.

The following two essays interrogate questions of memory and identity, but from starting points that position the personal in relation to ethnicity, or to cultural displacement. Taking an image of her father as starting point, bell hooks considers the operations of the family snapshot and of the 'gallery' wall within the home. She notes fluidities of meaning and interpretation as each family member positions him- or herself with the patriarchal family network of relationships. She argues that the picture histories formed on the domestic wall of images functioned as a site of empowerment within the struggle over representation. Likewise, taking one photograph as a starting point, Annette Kuhn interrogates the family photo as 'memory work' within the construction of narratives that operate between personal and social spheres. Taking what at first sight appears as a typical mother and baby snapshot, and collaborating with the owner of the image (the baby in the image), she proposes an analytic model that takes cues and clues within the image as a starting point for determining ways in which individual memories link with collective forms of memory, thereby contributing to shaping social perceptions,

Identity is not simply a matter of the 'work' of individuals coming to terms with specific personal stories and experiences. Lily Cho reminds us that passport photographs function to secure nationality. She argues that, additionally, they foreground a tension between legal nationhood and the emotional affiliations that operate within discourses of modern citizenship, especially in instances of migration. Her critical exploration of passport images highlights ways in which the emotional figures within our sense of citizenship.

Questions of image, identity and representation resonate between public and private, commercial and domestic, with, as has been suggested, extensive slippages between what were in the twentieth century generally viewed as relatively discrete boundaries, at any rate in western culture. Furthermore, methods of visual communication shift – for instance, snapshots may be emailed to distant relatives; the 'family album', in the form of digi-video, may be played back on the TV screen; Instagram and Snapchat substitute for phone calls or letters. In this respect, the spaces of the photo album, television, phone and computer are increasingly convergent and interactive. The 'confusion' of messages, whereby personal experiences may be in effect inter-cut with, for instance, 'reality TV' – which aesthetically may not look very different – emphasises the interplay of personal imagery and the general circulation of images.

Bibliography of essays in Part 3

Bailey, David A. and Hall, Stuart (1990) 'The Vertigo of Displacement', in David A. Bailey, and Stuart Hall (eds.) *Critical Decade, Ten.8* Vol. 2/3. Birmingham: Ten.8.

Bourdieu, P. (1965) 'Photographic Practice as an Index and an Instrument of Integration', in (1990) *Photography: A Middle-brow Art*. London: Polity Press. Original French publication, 1965.

Cho, Lily (2009) 'Citizenship, Diaspora and the Bonds of Affect: The Passport Photograph', *Photography and Culture* 2(3): pp. 275–288.

Dimock, George (2013) '"The Negro as He Really Is": W. E. B. Du Bois and Arthur Radclyffe Dugmore', *Exposure* 46(1): pp. 36–50.

hooks, bell (1994) 'In Our Glory: Photography and Black Life', in Deborah Willis (ed.) *Picturing Us, African American Identity in Photography*. New York: The New Press.

Kuhn, Annette (2007) 'Photography and Cultural Memory: A Methodological Exploration', *Visual Studies* 22(3): pp. 283–292.

Martin, Rosy and Spence, Jo (1988) 'Photo Therapy: Psychic Realism as a Healing Art?', in *Spellbound, Ten.8* 30, Autumn.

David A. Bailey and Stuart Hall

THE VERTIGO OF DISPLACEMENT

[. . .]

A MAJOR SHIFT TOOK PLACE in the 1980s when a significant body of work from black photographers challenged, explored and pushed back the parameters of photographic practices. A range of influences, many derived from film, performing and visual arts, came into play. But perhaps the most crucial shifts occurred within documentary genres. The development of theories which called into question documentary photography's claims to some form of objective truth, the growing critique of the classic realist text, and the reappropriation of the avant-garde and surrealism were important. At the same time, the development of post-structuralist theory introduced new concepts of identification, plural identities, and encouraged the move away from the essential subject towards the development of the decentered subject. There were also campaigns orchestrated by a range of constituencies within the black communities to create and circulate positive images. All of these had a significant influence on the content and form of black photographic practices in the 1980s. This article explores these shifts and influences in order to map out how a particular moment in black photography developed.

Documentary truth and guaranteed knowledge

The history of black photographic image-making has been obsessed with opening up the apparently fixed meanings of images. One of the key sites for this struggle is documentary. Documentary photography carries a claim to truth, with the meta message of *this is how it really was*. This stems from its close relationship with classical realism and the classic realist text – exemplified most powerfully by the nineteenth century novel – which places the spectator in a position of absolute knowledge and truth. In

a similar way, documentary claims to reveal the truth, because realism as a narrative form places the spectator in the position of guaranteed knowledge.

The use of the documentary form by many black photographers in the 1970s and early 1980s has, therefore, to be seen within a wider political framework – as part of the attempt to reposition the guaranteed centres of knowledge of realism and the classic realist text, and the struggle to contest negative images with positive ones. For example, both Armet Francis in *The Black Triangle* and Vanley Burke in his portraits of Handsworth used the documentary form to articulate a political statement about making visible black images and black image-makers. Linked to this was the issue of access for black people to the discourse of photography so that they could represent and reflect on their own experience – which has been a major theme throughout the 1980s. There was a general campaign to give black photographers the opportunity to do work that would be seen, gain some kind of credibility, and work against the negative or eurocentric representations of the dominant regime.

This contestation by black photographers was not done in isolation, but was linked to a larger campaign which had support from institutions, academic bodies and a wide range of black individuals and organisations. Within the GLC (Greater London Council), for example, there was a campaign against negative imagery and the way in which certain communities were disenfranchised, discriminated against and marginalised. A key element in the campaign was to give access to these groups by way of finance, infrastructure, lobbying and distribution. At the same time, the GLC created a platform for debate through conferences, seminars, workshops and publications.

Cultural studies and the shift to avant-gardism

A further key element in the development of this debate came from the body of writing and teaching known as cultural studies, which developed ideas from Gramsci as well as from black and feminist movements, and addressed the notion of hegemony. It was argued that the question of power has important cultural and ideological aspects. In *The Empire Strikes Back* and *Policing The Crisis* – both published in the early 1980s – the notion of popular cultural resistance is explored as a form of political resistance. Cultural studies work on race opened up what was going on at the base of English society around race and authoritarian populism, locating new forms of racism articulated around forms of national identification, a sense of Englishness, and the crisis facing a society going through post-imperial trauma.

Against this background, a number of black photographers began to explore questions of identification, the issue of how best to contest dominant regimes of representation and their institutionalisation, and the question of opening up fixed positions of spectatorship. This was a move away from documentary, away from the image as something which referred beyond itself to an objective truth, to a concern with representation as such. This mode of contestation goes against the grain of realism: indeed, it opens up realism and exposes it as a particular genre and privileges instead, non-realist modes such as formalism, modernism and surrealism, which can be grouped together under the rubric of avant-gardism.

This anti-realism was developed at a theoretical level in *Screen* magazine which argued that the way in which the realist text places the reader/spectator in the

position of guaranteed knowledge serves to conceal and naturalise ideology. In order to disrupt this naturalistic ideology of truth it becomes necessary to disrupt the very thing which positions the spectator so securely – the form of realism. Hence, the importance of avant-gardism which breaks up the realist relationship between work and spectator, thereby preventing the spectator from settling back into an empiricist and secure relationship to knowledge.

It would be misleading, however, to view the shift from documentary to avant-gardism in black photographic practice as simply one visual discourse replacing another. The shift needs to be contextualised within a wider field where a variety of questions – both new and old – were being addressed around black imagery. We need to look again at the earlier documentary forms which were supposedly being super-seded in the mid-1980s and recognise that they continue to offer something of value. It would be as absurd to consider documentary a reactionary form *per se* as it would be to assume that a deconstructive avant-garde practice must be progressive. Clearly, there is a need for a more refined critical apparatus for seeing what someone who is practising in the documentary genre can and can't do, how the genre limits them and how the genre allows them to refer to certain things which those who are working in the avant-garde genres cannot, as well as how avant-garde genres open up connections which realism blocks out.

Exploring the kaleidoscopic conditions of blackness

By the mid-1980s, the campaign to contest negative images with positive ones had moved on to an enquiry into the politics of the image itself. It was here that the black photography movement produced its most innovative and exciting work in a range of work that explores complex debates on fine art practices, gender, sexuality and being black and British.

It was at this stage also that many black practitioners began to articulate the view that black is something which is only partly represented by skin colour – a conceptual shift which owed much to post-structuralist discourses on identity and decentering the subject. Post-structuralist thinking opposes the notion that a person is born with a fixed identity – that all black people, for example, have an essential, underlying black identity which is the same and unchanging. It suggests instead that identities are float-ing, that meaning is not fixed and universally true at all times for all people, and that the subject is constructed through the unconscious in desire, fantasy and memory. This theory helps explain why for example an individual might shift from feeling black in one way when they are young, to black in another way when they are older – and not only black but male/female, and not only black but gay/heterosexual, and so on.

The notion that there is no essential blackness – that black is a cultural term, a political term, that it is a choice of identity – also forced the recognition that the fact of a photographer being black did not guarantee an anti-racist image, any more than the fact of being black guarantees right-on politics.

Black photography therefore moved towards the need to represent plural identi-ties which are never fixed and never settle into a fixed pattern – which, in a nutshell, is what decentering the subject means. Instead of concentrating on representing an essential black (as opposed to white) identity, the emphasis shifted to the process

of identification. A black male, for example, might in some situations identify with being black and in other situations identify with being male – and sometimes these two forces do not pull in the same way. Identities can, therefore, be contradictory and are always situational. Being black does not override the fact that along another axis such as class, gender or sexuality a person may come out in a different position. Identities are then permanently decentered, and there is no master identity such as class or nationality that can gather all these strands into a single weave. In short, we are all involved in a series of political games around fractured or decentered identities.

This means that there is no one thing that is black – black is connected to all these different categories – some blacks are sexist, some blacks are not, some blacks are heterosexuals, some blacks are gay and some blacks are middle class. Identities are positional in relation to the discourses around us. That is why the notion of representation is so important – identity can only be articulated as a set of representations. And, perhaps more importantly, since black signifies a range of experiences, the act of representation becomes not just about decentering the subject but actually exploring the kaleidoscopic conditions of blackness.

In such a situation, it became clear that the individual black artist could not represent the whole of the black experience. How could all of those experiences be spoken of through one photograph, one voice? An aspect of the black experience can be represented, but this representation has to be seen as more tentative and partial.

The 1980s therefore signalled the end of the essential black subject and the kind of essentialism which assumes that the progressive, creative character of black representation is guaranteed by the fact that it is made by a black subject.

This in turn demanded a climate where it was possible to say: 'Black this may be, black you may be, well-intentioned the work may be, but it doesn't come off.' And, by implication, it also required the acknowledgement that it is equally possible that a white photographer, with only limited understanding of the black experience, might be able to say something of significance to a black audience. Unquestionably, this is a much harder form of political practice to take on because the sides are not neatly drawn up: the goodies and baddies aren't given for you neatly nor are they any longer inscribed as to who they are and what their position is. So, the struggle ceased to be simply a binary opposition, replacing one bad photographic practice with an oppositional good photographic practice. It shifted into the arenas of criticism: the politics and the ethics of criticism.

This was highlighted in critical responses to the work of Robert Mapplethorpe and Rotimi Fani-Kayode.

Black and white: towards a new critical response

The essentialist position was effectively saying that as a white photographer photographing a black body, Mapplethorpe could by definition only appropriate and fetishise it. This body of criticism is underpinned by the belief that a white photographer photographing a black subject is photographing across the line of domination and subordination and that this determines the nature of the image.

Against this, the 1980s produced a fresh body of criticism which said: Yes. Mapplethorpe does fetishise, abstract, formalise and appropriate the black body. But, on

the other hand, we can see that Mapplethorpe is contesting the dominant representation of black masculinity in a lot of black photography – he lets loose his desire for the black male form which many black male photographers suppress. So, on the one hand Mapplethorpe is contesting a one-dimensional representation of black masculinity, while on the other expropriating the black male form in a fetishistic way. Both things are true.

If you say only the first thing, you feel comfortable: but you haven't yet given yourself up to that extraordinary play of desire which is why black photographers can't leave Mapplethorpe's work alone.

In Rotimi Fani-Kayode's work we can see many of the same forms of desire and contestation about black masculinity that we find in Mapplethorpe's work.

Rotimi Fani-Kayode's work operates alongside Mapplethorpe's critique of dominant representational regimes of black masculinity, and it does not really contest Mapplethorpe's fetishism of the body. So, you have to say both things about Mapplethorpe and both things about Rotimi Fani-Kayode.

Figure 19.1 Rotimi Fani-Kayode, *Bronze Head*, 1987. Courtesy Autograph. Copyright Kayode/ Hirst.

Figure 19.2 Rotimi Fani-Kayode, *Sonpponnoi*, 1987. Courtesy Autograph. Copyright Kayode/ Hirst.

However, one of the ways in which Rotimi's work does differ is in the way that Mapplethorpe artificially constructs the forms of the body – black and white, male and female – in an iconographic way, turning them into icons but suppressing the real forms of ritualism in which the construction of iconography forms part of a social practice. Mapplethorpe's ritualisation is tied only to an aesthetic, whereas Rotimi Fani Kayode's ritualisation seems to reach back to a longer tradition. When he uses a mask it connotes generations of masks used in different spiritual, social, figurative traditions. We don't feel that kind of tradition in Mapplethorpe. The only thing behind Mapplethorpe's work is fashion, the ritualisation of fashion, the iconography of fashion.

It is also important to recognise that there are many things in Rotimi's work which are not in Mapplethorpe's — in other words, we have to get to the stage of refusing to talk about Mapplethorpe as only a fetishtistic, gay, white, male photographer, and Rotimi's work as either limited and restricted because it is influenced by Mapplethorpe or entirely encapsulated and appropriated by Mapplethorpe. Rotimi has both learned from him, fought him off and brought another tradition of representation into his own work.

To get some kind of genuine comparative assessment you have to get inside the contradictory modes and forms and practices of representation operating across both these photographers' work.

Black photography in the 1990s: a struggle on two fronts

The blurring of the old oppositions of black/white, good/bad, documentary/avant-garde does not remove us from earlier struggles to open up more space for black photographers. Simply because the game has got more complicated it does not mean that you lose sight of the struggle. Although a second front has been opened the first front must not be neglected. Questions of access to the means of representation, the relationship of black photographers to the institutions, visibility and exclusion — these are still as important.

If you don't have the means of representation at your disposal then you do not have the access to the places where photographic work can be exhibited, discussed and criticised. You are not even in the game, and you are not part of the photographic discourse. The struggle for entry is a struggle for all black photographers, but once the door has been opened then the name of the game changes. It is then necessary to ask what these photographers are doing with the space that has opened, and what are they doing in relation to discursive practices to which they now have access. Both have to go on. It is very dangerous to talk about the second and not talk about the first because that would be a way of closing the door after a small elite has gone through.

Ultimately, there has to be a wide, active dialogic community which is interrogating, evaluating, reconstructing histories, putting back in place the invisible discursive conditions which make new texts possible. All that scholarship, criticism and political and cultural interrogation is part and parcel of the development of a well-articulated theory and practice of black representation — doing it, writing about it, arguing about it, theorising it, writing its history and so on — it is all crucial work.

Original publication

'The Vertigo of Displacement', *Ten.8* (1992)

Rosy Martin and Jo Spence

PHOTO-THERAPY
Psychic realism as a healing art?

> The victim who is able to articulate the situation of the victim has ceased
> to be a victim; he, or she, has become a threat.
>
> <div align="right">James Baldwin</div>

SINCE THE 1950S THERE HAS BEEN a massive development in private sec-
tor counselling and therapy in this country. This is a response to the overwhelming
unmet needs of people, and is often in opposition to the official agencies of medicine,
psychiatry and social welfare work which, however benevolent they may appear, still
aim to confine and control. Institutionally, and particularly if we are women, (espe-
cially working class and/or Black women) we are encouraged to accept situations
which we should resist. Women's working and domestic situations are often awful, but
the resultant depression or anger is often so well contained, that eventually many of
us become silenced or ill. Rather, we need forms of assertiveness training to assess our
needs better and to try to get them met, individually and collectively. Our work is an
intervention into the field of (and redefinition of) 'health education', since it engages
with the institutionalised mind and body split of western culture.

[. . .]

An imag(in)ed identity?

It has been argued by such differing theoreticians as Winnicott and Foucault that there
are various 'gazes' which help to control, objectify, define and mirror identities to us.
Sometimes these gazes are loving or benevolent, but often they are more intrusive
and surveilling. Out of the myriad fragments thus mirrored to us, first unconsciously
as babies, then as we are growing into language and culture, aspects of our identities
are constructed. Through the internalisation and synthesis of these powerful gazes we
learn to see and differentiate ourselves from others, in terms of our class, gender, race

and sexuality, thence into other sub-groups. We learn the complexity of the shifting hierarchies within which we are positioned.

The mother represents the primary gaze, which is then transformed into the gaze of mother/father, within their conflicting power relationship. Yet the 'family' is itself positioned within the various discourses of society, which each set up their own gaze of definition, power and control. (For example when the powerful-to-the-child mother takes the child to the doctors she introduces the child to, and mediates between, the child and the discourses of medicine, in which situation she herself is relatively powerless.)

We discovered that we can re-enact these discursive gazes, which are not separate but overlap and reinforce each other. In particular we have reconstructed the gazes of mother and father (family); aspects of the communications industry; and various institutional discourses – for example medicine, fashion, education, law. Revisiting each of these has made it clear that they could be described as 'mirrors' in which we as individual children or adults saw, experienced, internalised (often in a self-oppressive way) what those who were/are doing the mirroring or surveillancing were offering, constructing or defining from within their belief systems.

Our work has centred on family relationships, memory and history, so of particular interest has been the writings of the Austrian psychoanalyst Alice Miller.[1] Crucially, she has argued that within the family it is often the unmet narcissistic needs of parents, interlinked with the wider discourses of a given culture, that are basic to how a child is mirrored and 'sees' herself. We have found this of particular interest because in our photo-therapy work we have been criticised for being 'narcissistic' (always used as a pejorative term). Given that most of our work relates to the multifaceted concept of 'resistance', and that we are trying to unearth, make safe, and analyse the working through of such resistances, we would argue that, what we have unmasked through the re-enactment and mapping out of these gazes is a validation of our anger and discontent at our inability to come to terms with these fragmented selves constructed out of the needs, views, attributions of others and our powerlessness in relation to them.

What photo-therapy engages with is primarily the 'needy child' within us all which still needs to be seen and heard. The therapist has to become the advocate of this 'child' and to encourage her to recreate and witness her own history, to feel safe enough to protest, and then learn to become her own inner nurturer. Such work is not about 'parent blaming' but enables us to move beyond that dead end. Instead we re-invent and assert ourselves by becoming the subject rather than the object of our own histories.

[. . .]

A cultural context?

The images in circulation in a particular culture act to mould and set limits upon how each of us will 'see ourselves' and 'others'. Although we are never totally fixed by these images, they do shape our sense of reality. They are a major constituent of the dominant culture as well as being used continually to construct official histories.

Figure 20.1 Working on absences in the family album I take as a starting point my feelings of abandonment when as an evacuee I was sent away from my family. Later I find a snapshot in a box of old pictures which shows my mother with the much loved new baby of the same period, circa 1940. Sitter/director: Jo Spence. Photographer/therapist: Rosy Martin. Courtesy of the Jo Spence Memorial Archive.

For some people, who are positioned by and identify with such all-pervasive imagery unproblematically, photo-therapy would seem to be a superfluous activity. If however, you are not acquiescent with the positions assigned to you, if you are constructed or labelled as one of the various 'Others' vis-à-vis your sexuality, disability, age, gender, race and class in this society, and in receipt of the negative projections of those with power, then you might wish to engage in work on identity to redefine yourself. You then become the active subject of your own dissonant history. Photography

seems to be an ideal tool since in contradistinction to the rest of the communications industry – most of us already have personal practices with our own cameras in the form of snapshotting and the *family album*. All we need to do is to re-define and re-invent such practices.

Our earliest photographs in family 'archives' have invariably been taken by adults who are themselves caught up within a set of aesthetic expectations, culled (whether they know it or not) from the discourses of popular photography. As examples, we cite the world-wide advertising of Kodak with its universalising regime of images. Then there are the popular and amateur photographic magazines which fetishise technology, offering a voyeuristic gaze of the personally owned camera as a way of experiencing pseudo control in the world. Within the uneven power dynamics of the family, adults also have a vested interest in what is represented and what is not. It is hardly surprising therefore that the stories about ourselves which we can common-sensically construct from family albums probably say more about the histories of amateur and popular photography and their conventions than they do about the history of any given family or its individual members.

We can now understand, with hindsight, that the privately owned (though industrially produced) images of the family (pleasurable as they undoubtedly are) should not be seen as sources of information. Better perhaps that they be viewed as visual indices of the unconscious desires of parents (and those with institutional power, for example schooling) to provide evidence of their own 'good parenting'. 'It was in your own interests' said over a bland school photograph, or 'We did the best we could' and 'Look what a happy family we were', are phrases we recollect from looking at the album with our parents.

Family snaps hardly give any indication of the contradictions, power struggles or desires inherent at all levels of family life, or in the intersection of that life with the structures which make up a patriarchal society with sexual, racial and class divisions. On the other hand, taken as a genre, they give us infinite pleasure. Family albums if taken outside the family and viewed collectively can also contain valuable resource materials for social historians who are compiling dissenting histories of oppressed or minority groups. When the various histories of childhood come to be rewritten, perhaps family albums will prove to be useful tools there.

Reinventing the family album?

We can conceive of three overlapping spheres of activity with which individuals and families can engage in order to become more aware of the contradictory workings of their own subjectivity and of their histories. These can best be described as follows:

1 By using existing family album photographs as a basis for telling stories, and beginning to unmask memories with a sympathetic listener or in a workshop or collective situation. The agenda for this is always set by the context, the degree of trust and the underlying goal of the process. Whilst the oral historian may be attempting to retrieve, record and give back a dissenting history to the speaker/s and their subject positions vis-à-vis class, race, gender or a range of institutions, the therapist is more concerned with the psychic interpretations of individuals.

2 Taking things further by creating a *new family album* through snapshotting and documenting that which is absent or customarily ignored. If we train ourselves to 'see' differently, visual markers of various rites of passage which are socially tabooed within the family album can be made. For example, divorce, illness and death; undervalued everyday events such as signing on for the dole, child care, schooling, housework, visiting the doctor. (The experience of those who have tried to take snapshots within institutional contexts immediately foregrounds the problem of the institutional gaze, as permission is often hard to obtain, or limited access only is offered. This in itself offers a useful learning process in relation to forms of external censorship and self censorship).

Events which could not be photographed at the time can be remembered through the photography of objects or places which 'stand in' for the person/s or objects involved. In this way it is possible to break down ideas of universalised experience and to provide a spectrum of markers of race, class and gender through the photography of work, conflict and 'less-than-ideal' aspects of self and family. These areas of life are often photographed by 'professionals' who make a living out of the misery of others, while they help to label and position people as 'victims'. By recording such events ourselves, particularly by those people who are powerless and marginalised by the dominant stories in circulation (e.g. in contradiction to the 'happy family') a new form of social autobiographical documentation can be put together.

3 By the creation and use of images of the theatre of the self as practised within phototherapy. This practice can be especially useful for exploring the contradictory visual markers of sexuality, of power relationships, and expressing *our own* desires.

Photo-therapy – 'theatre of the self'

Fundamental to our approach is that of ideally being non-judgmental, active, viewers and listeners. As Patrick Casement has noted, 'The therapist's presence therefore has to remain a transitional or potential presence (like that of a mother who is non-intrusively present with her playing child). The therapist can then be evoked by the patient as a presence, or can be used by the patient as representing an absence. This is the world of potential space which is part real and part illusory. . . . The patient needs to be allowed opportunities for optimal experience without interference from the therapist. . . . The therapist has to discover how to be psychologically intimate with a patient and yet separate, separate and yet still intimate'.[2]

Section 28 of the Local Government Act of 1988 in Britain states that: A Local Authority shall not:

a) Promote homosexuality or produce material for the promotion of homosexuality.
b) Promote the teaching in any maintained school of the acceptability of homosexuality as a pretended family relationship by the publication of such material or otherwise.
c) Give financial or other assistance to any person for either of the purposes referred to in paragraphs (a) or (b). Nothing of the above shall be taken to prohibit the doing of anything for the purpose of treating or preventing disease.

Figure 20.2 *Unwind the Lies that Bind.* Internalised oppressions. Circa 1988. Sitter/director: Rosy Martin. Photographer/therapist: Jo Spence. Courtesy of Rosy Martin.

How does it feel to have the negative projections of others stuck upon me? To internalise their oppressive stereotypes? To be bound, contained and silenced by their hatred and their fear? What do they hate so forcibly? What do they fear so passionately? Why do they choose to scapegoat lesbians and gays? Easy targets?

There are a series of pejorative myths as to what a lesbian could and should be: myths arising from fear, ridicule and contempt, and perpetrated as a means of social control of all women.

Our susceptibility to absorbing oppressive ideas and theories has one major root cause, which is institutionalised in society, but not always recognised as such – the oppression of children and young people and the resultant sense of powerlessness instilled at an early age. Alice Miller has uncovered the 'poison' in universally accepted adult behaviour. Children are silenced. But the more suppressed the expression of any outrage, the more split off the hurt becomes. Hatred for the perpetrator is not allowed, so it is repressed, stored and internalised until it has some outlet in a socially sanctioned form such as racism, classism, misogyny and homophobia.

Our own practice has always been client-centred and client-directed, and unlike most other therapies, has been done mostly on a reciprocal basis, exchanging the power positions of therapist and client. We have also drawn on a range of therapies; for example in psychodrama the sitter/client can act out with others past scenarios or patterns; in gestalt the sitter/client can role play or take up different positions within a family scenario or any other power dynamic, try them out, be heard and seen; in Neuro Linguistic Programming the sitter/client can 'reframe' past experience and examine the present limiting factors arising from it; and as in psychosynthesis, the sitter/client can work on various sub-personalities, personal or archetypal symbols, or visualisations. What photo-therapy enables is visual markers of such work, and is a form of self-documentation unlike anything possible via snapshotting or naturalistic documentary modes of photography.

[...]

Why are photographs of value in therapy?

Apart from the inter-active process of photo-therapy itself, we have found that the photographs which result from sessions greatly enrich the ongoing therapeutic dynamic for the following reasons.

a) Whilst we know, intellectually, that photographs are not 'real', do not 'tell the truth', but are specific choices, constructions, frozen moments, edited out of time – yet we invest them with meaning. Still, most people believe that photographs have the power to signify 'truth'. It is this contradiction and tension that is so productive in the therapeutic process. As we view the images and witness their mutability it becomes apparent that 'truth' is a construct, and that identity is fragmented across many 'truths'. An understanding of this frees up the individual from the constant search for the fixity of an 'ideal self' and allows an enjoyment of self as process and becoming.

b) They act as a record, a mapping out, of the process gone through in a session, and the making visible of psychic reality. They act as a tangible marker of something which could otherwise go back into the unconscious and remain dormant for a long time.

c) They offer us the possibility to objectify and see a separate part of oneself which can then be integrated back into the overall subjectivity, or core self, as and when we are ready for it, as in psychosynthesis. Although photography objectifies, because photo-therapy is process-based, photographs can act as 'transitional objects' (as theorised by Winnicott) towards another reality. In this sense they can be seen as stepping stones.

d) Photographs can potentially provide unfiltered contact with the unconscious, transcending talking and making possible the direct use of images and symbols. For example, as Assagioli has said of psychosynthesis, symbols are seen as 'accumulators', in the electrical sense, as containers and preservers of a dynamic

psychological charge.[3] This 'charge' or psychological energy can be transformed by the use of the symbol, channelled by it, or integrated by it. Symbols are especially powerful for transforming the unconscious which does not operate with the language of logic but with images.

e) They can prompt a cathartic release in that they are able to work directly on gut feelings without the interception of the intellect.

f) Transcending the single image, it is possible to order and re-order the photographs into a variety of mini-narratives, which in themselves can be moved around, providing an infinity of matrixes or montages. There is never a fixed story being told, no narrative closure. Transformation of fixed or screen memories thus become possible through such forms of visual montaging. By adding actual objects, or aspects of other media to photographs, we can make collages. These are effective methods of taking things to pieces and putting them together again differently.

g) Photo-therapy can make visible different 'parts' or 'sub personalities' of our subjectivity, as well as enabling us to explore different positions within a dynamic. Thus we can play cyclically with positions of authority and victimisation, power and powerlessness and so on.

h) They can be used as a tool within other therapeutic practices – for example, as a starting point for further sessions.

i) Photographs can help us to 'unfreeze', acknowledge what has previously been resisted and repressed, then let go and move on from the material being worked through.

j) As well as enabling a coming to terms with 'negativity', photographs can be markers of triumph, a celebration of integration, and the successful exploration of an issue or pattern.

[. . .]

Psychotherapy takes place in the overlap of two areas of playing, that of the patient and that of the therapist. Psychotherapy has to do with two people playing together The corollary of this is that where playing is not possible then the work done by the therapist is directed towards bringing the patient from a state of not being able to play into a state of being able to play Playing implies trust, and belongs to the potential space between (what was at first) baby and mother figure. . . . It is in playing and only in playing that the individual child or adult is able to be creative and to use the whole personality, and it is only in being creative that the individual discovers the self.[4]

Original publication

'Photo-Therapy: Psychic Realism as a Healing Art?' [excerpted], *Ten.8* (1988)

Notes

1 See in particular *Thou Shalt Not be Aware: Society's Betrayal of the Child*, by Alice Miller, Pluto Press, 1985, and *The Drama of Being a Child*, by Alice Miller Virago, 1981 (see also *Prisoners of Childhood, for Your Own Good*).
2 *On Learning from the Patient*, by Patrick Casement, Tavistock Publications, 1985.
3 From *Playing and Reality*, D.W. Winnicott, Tavistock Publications, 1471.
4 *Psychosynthesis*, by R. Assagioli, Turnstone Books, London, 1975. See also: *Putting Myself in the Picture*, by Jo Spence, Camden Press, 1986.

George Dimock

"THE NEGRO AS HE REALLY IS"
W.E.B. Du Bois and Arthur Radclyffe Dugmore

Photography implies that we know about the world if we accept it as the camera records it. But this is the opposite of understanding, which starts from not accepting the world as it looks.

— *Susan Sontag*, On Photography[1]

If worse come to worst, can the moral fibre of this country survive the slow throttling and murder of nine millions of men?

— *W. E. B. Du Bois*, The Souls of Black Folk[2]

Summary

NINETEEN PHOTOGRAPHS BY THE EARLY photojournalist and nature photographer Arthur Radclyffe Dugmore (Figure 21.2) — purporting to illustrate an important text by W. E. B. Du Bois (Figure 21.1) published in *The World's Work* (June 1901) — serve, upon closer examination, to undermine and confound the author's intentions. The images themselves are profoundly indifferent and without redeeming cultural value insofar as that phrase implies a modernist investment in self-conscious and intentional picture making. To dissect at some length the ways in which they compromised Du Bois's arguments on behalf of the fundamental integrity and resiliency of African Americans living in the Black Belt is to watch dominant ideology at work in the age of Jim Crow. But these images need not be utterly abandoned to the interests and delusions of white supremacy. To read them, along with their captions — either counter-intuitively as oblique confirmations of Du Bois's argument or symptomatically as white defenses against the anxieties aroused by his lyrical advocacy for the inherent dignity and promise of African Americans — is to provide the modern reader with a more flexible and resilient model for the ways in which photographs can be interrogated against the grain of their original context and ostensible meanings.[3]

Figure 21.1 Photographer unknown, *W.E. Burghardt Du Bois*, The World's Work 2, no. 2 (June 1901). Public domain.

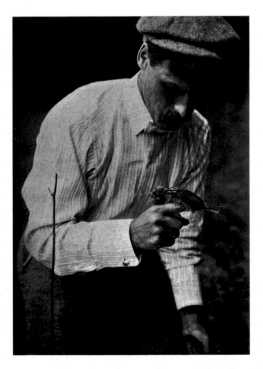

Figure 21.2 A.R. Dugmore, *The Author Photographing a Wild Bird on His Hand*, The World's Work 1, no. 1 (November 1900). Courtesy of the artist.

Introduction

An article by W. E. B. Du Bois entitled "The Negro As He Really Is" appeared in the June 1901 issue of *The World's Work*, a newly minted, monthly, middle-brow American magazine devoted to national and international affairs. It was accompanied by nineteen photo-illustrations by Arthur Radclyffe Dugmore, an Anglo-Irish, early photojournalist and pioneering wildlife photographer commissioned by the magazine's editor, Walter Hines Page.[4] *World's Work* was one in a burgeoning network of publications that took advantage of the new print technologies that allowed for the mass circulation of photographs in a type-compatible format. (Photographic illustrations appeared on roughly half its pages.) Du Bois's text described and analyzed the lives of African Americans in Dougherty County, Georgia – the heart of the Black Belt – and subsequently became, in revised and lengthened form, two chapters in Du Bois's revolutionary book *The Souls of Black Folk*. Dugmore's photographs now constitute a footnote in the scholarship on that founding work of African-American Studies.[5]

Modern commentators have taken a range of attitudes towards Dugmore's illustrations. While Lee W. Formwalt (2001) commended them for the richer understanding they provide concerning "life in the Black Belt at the turn of the century," the 1999 Norton Critical Edition of *Souls* reproduced them with a cautionary note: "Because of the racist nature of the captions, it is safe to assume that Du Bois was not their author."[6] Robert B. Stepto (1991) took strong exception to them as "Du Bois's unintended contribution to turn-of-the-century photojournalism."[7] He singled out three whose racist captions wrest control of the text away from Du Bois.[8] Stepto interpreted Du Bois's substantial reworking and expansion of his *World's Work* article for *Souls* as a "contextual purgation" and "purification" made necessary in order for the text to become "once again [Du Bois's] own expression."[9] These are three very different readings of Dugmore's photographs: 1) as benign, indexical traces elucidating their historical referents; 2) as problematic image-text formations whose captions can or should be disavowed; 3) and as antithetical constructs of white supremacy undermining the author's meaning and intent. Such disparities would suggest the need for a more nuanced account of these images in relation to the text they supposedly serve, if only to extend and clarify rather than resolve the contradictions involved.

As the original core text that gave rise to chapters seven and eight of *Souls*, "The Negro As He Really Is" carries the seeds of literary greatness, for it is hard to overestimate the importance of Du Bois's best-known work. What began as an invitation from *The Atlantic Monthly* to compile a collection of previously published essays became a foundational narrative of African-American consciousness and identity woven together from the many strands of Du Bois's life experience, academic training, and literary sensibility. In his biography, David Levering Lewis articulates the transformative effects of this text on American race relations: "For the first time in the brutal, mocked, patronized, and embattled history of Negro life on the North American continent, there was now a revelation of the race's social, economic, and psychological realities and prospects of such lyricism, lucidity, and humanity as to leave its mark on a white America guilty of evasion, obfuscation, and hypocrisy."[10]

In this context, Dugmore's photographs must be judged as something more than superficial, inadequate, or negligently uncomprehending. At their worst, they constitute visual embodiments of that white "evasion, obfuscation, and hypocrisy" against

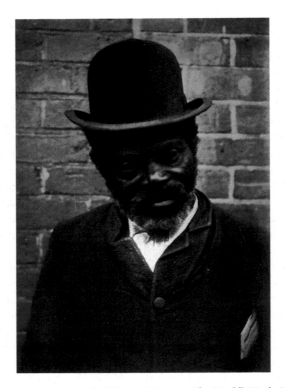

Figure 21.3 A.R. Dugmore, *A Friend of George Washington*, The World's Work 2, no. 2 (June 1901). Courtesy of the artist.

which *Souls* raised its extraordinarily generous and forgiving voice. The most egregious instance of Dugmore's betrayal of Du Bois's text concerns an image and a caption that would seem to be as far removed from the article's argument as it is inimical to the dignity of its African-American subject (Figure 21.3). A portrait of an old black man in bowler hat and buttoned coat bearing a gentle, introspective, quizzical expression is accompanied by the following identification: "A FRIEND OF GEORGE WASHING- TON. He believes that he was with Washington when the cherry tree was cut down and allowed his photograph to be taken only on condition that a copy would be sent to his old friend."[11] At the literal level, the deforming racism of this photo-caption, with its insinuating tone of amused contempt, is completely at odds with the letter and spirit of Du Bois's narrative of the ongoing, heroic struggle on the part of rural African Americans to overcome the harsh legacies of the plantation system. (Later, an argument will be made for how this image might be construed to illustrate Du Bois's implicit condemnation of the injustices and inefficiencies of Southern tenant farming that result in "migration to town [as] the Negro's remedy.")[12] To contemplate the logic and explore the circumstances by which Du Bois and Dugmore came to exist on the same page is to begin to unravel the workings of dominant ideology at the dawn of the media age.

Walter Hines Page, the founding editor of *World's Work*, is a key figure here. Born and raised a southerner, he had been the first white editor, while at *The Atlantic*, to

accept Du Bois's groundbreaking essays for publication in the mainstream popular press. Yet as the controlling intelligence behind *World's Work*, he was also committed to preserving stable race relations in the New South and to promoting the business interests of a new national corporate order.[13] As will be argued later in this essay, within this conflicted matrix of liberal reform and status quo, a space existed for the construction of "A friend of George Washington" as the white negation and disavowal of the black testimony Du Bois brought to bear on the national conscience regarding the past and present of the Black Belt.

My project here is to examine in some detail the contentious and contradictory workings of Dugmore's photographs in this early moment of photojournalism: to read them in their original context for the ways in which they compromised the radical challenges to white supremacy posed by Du Bois's text. To explicate their complicity with the dominant ideology of their era is a necessary precursor to any consideration of how these images might be critically reclaimed as part of the pictorial heritage of African Americans.

In his magisterial *The Art and Imagination of W. E. B. Du Bois*, Arnold Rampersad describes "The Negro As He Really Is" as "a journalistic adaption of social science enlivened by deft descriptions of the sharecropper's life in Dougherty County, Georgia." Written at a pivotal moment in Du Bois's career, the text does not overtly contest Booker T. Washington's politics of accepting segregation and disfranchisement in exchange for economic advancement and a gradual improvement in race relations. Yet its uncompromising indictments of tenant farming and the rack-rent system anticipate, if only indirectly, Du Bois's subsequent call for full civil rights and access to university education as crucial elements in the struggle to realize the "limitless potential" of African Americans.[14]

Du Bois's text is a hybrid of his dual early career as academic sociologist teaching at Atlanta University and as pioneering race man, cultural interpreter, and brilliant literary stylist.[15] As such it serves as a partial draft of the fully orchestrated, complexly composite masterpiece, *The Souls of Black Folk*, published two years later in 1903.[16] The article is based on empirical research not unlike the study undertaken some five years earlier for his groundbreaking *The Philadelphia Negro*.[17] Dougherty County, located 180 miles south of Atlanta, was chosen for its high density of blacks living within a region "small enough to cover in the two or three months of summer vacation." Du Bois and his two or three graduate assistants "visited nearly every colored family in the county."[18] The text mixes sociological observation – "Among this people there is no leisure class; ninety-six per cent of them are toiling" – with the impressionistic sketches of a cosmopolitan observer: "They are uncouth country folk, good-natured and simple, talkative to a degree, yet far more silent and brooding than the crowds of the Rhine-Pfalz, Naples, or Cracow."[19] At times, Du Bois's writing is charged with radical empathy: "It is hard for an individual mind to grasp and comprehend the real social condition of a mass of human beings without losing itself in details and forgetting that after all each unit studied is a throbbing soul. Ignorant it may be, and poverty-stricken, black, and curious in limb and ways and thought; and yet it loves and hates, it toils and tires, it laughs and weeps its bitter tears, and looks in vague and awful longing at the grim horizon of its life – all this, even as you and I."[20]

The title, "The Negro As He Really Is," cuts two ways. Read against Du Bois's text, it points to an informed, polemical rebuttal to a collective white consciousness

marked by ignorance and prejudice: "We seldom study the condition of the Negro to-day honestly and carefully. It is so much easier to assume that we know it all."[21] In relation to Dugmore's photographs, however, the title strongly connotes indexical immediacy and realist transparency. Here, visible before you on the page, is "the Negro" taken from life "as he really is." A time-honored habit of magazine consumption is to scan the pictures and peruse the captions rather than to read the text with sustained critical attention. To do so in this instance is to come away with a version of African-American life in the Black Belt that usurps and deforms Du Bois's project. In purporting to show "the Negro as he really is," the photographs, together with their captions, supplant Du Bois's sophisticated sociological analysis and his sympathetic portrayal of struggle and resiliency against the legacies of slavery with easily read white stereotypes: the kerchief-wearing peasant woman behind the plow as romantic symbol of timeless and mindless agrarian labor; the dignified cobbler and broom maker as proud artisans representing the best that can be expected or permitted by way of social standing and professional achievement; young children playing as little Topsies strutting their stuff upon the minstrel stage. Far from supporting and adumbrating Du Bois's text, these images convey the coruscating contagion of the white racism typical of the mainstream media in the age of Jim Crow.[22]

Du Bois, Dugmore, and *the World's Work*

Documentation for the Du Bois-Dugmore collaboration is hard to come by. Du Bois makes no reference to the photographs or their maker in the *World's Work* article or elsewhere. The one substantive account occurs some thirty years after the fact in Dugmore's relentlessly genial and superficially informative memoir, *Autobiography of a Wanderer:*

> My next work was to do an article with illustrations for the *World's Work* on the negro [sic] question in Georgia; so I went first to Atlanta to see Du Bois, one of the most interesting and delightful men I have ever met, and a great educator and believer in the future of the coloured race. He joined us at Albany, where my wife and I stayed at an hotel which was so dirty that it was a disgrace to the white race, and yet Du Bois was not allowed even to come on the verandah to talk to me because he was "coloured." It did not take long to collect the material required for the article, and by the beginning of April [1901] we were back at South Orange [New Jersey].[23]

While Dugmore makes plain his personal admiration for Du Bois and his cosmopolitan disdain for the Jim Crow South, he gives no evidence here or elsewhere that he shared his collaborator's faith in "the future of the coloured race." He narrates his time spent in Georgia as just one among many commissioned assignments squeezed into a crowded schedule between a honeymoon canoe trip in Kissimmee, Florida, and a trout fishing excursion at the Spruce Cabin Inn in Canadensis, Pennsylvania. His recollections may have at least as much to do with Du Bois's celebrity at the time of the memoir's publication in 1930 as with their work together in 1901.

"The Negro As He Really Is" was one of at least fifty reform writings Du Bois published between 1897 and 1910 in the mainstream American press in order to "inform white Americans about those historical and contemporary social problems in the African-American community that made reform ideas necessary."[24] With his degrees from Harvard and the University of Berlin and in his position as professor of economics and history at Atlanta University, the thirty-three-year-old Du Bois was the most authoritative African-American voice to comment on American race relations from an academic standpoint and one of the very few qualified sociologists wholly devoted to investigating the lives of blacks for reform purposes.

Dugmore was best known for his pioneering photographs of birds and other wild animals in their natural habitat. His first important article on that subject, which had won him wide public recognition, had appeared some eight months earlier (November 1900) in the inaugural issue of *World's Work*.[25] He would go on to have a close working relationship and friendship with the magazine's founder, part owner, and managing editor, Walter Hines Page.[26]

The partnership of Dugmore and Du Bois is gravely mismatched in *World's Work* with regards to time, commitment, and cultural achievement. On the one hand, Du Bois's profoundly radical and innovative text was soon to become, in its revised form, a landmark of American literature, by an author wholly devoted to the affirmation of black identity and the struggle for black civil rights. On the other, Dugmore produced, on paid assignment, a series of technically competent, utterly conventional photographs made in about a week's time.[27] The result of a one-time foray by a privileged, foreign-born, adventurer, and nature enthusiast into the troubled waters of American race relations, the photos offer no formal or conceptual resistance to the racism of their captions.

The photo-captions are best understood not as the anomalous or idiosyncratic products of individual editors, or even, perhaps, of Dugmore himself, but rather as aspects of a seamless and integrated worldview that it was the business of *World's Work* to articulate and promote. In this instance, the magazine's part owner and managing editor, Walter Hines Page, serves as a representative figure and spokesman for his age. An extraordinarily successful editor at *Forum* and *The Atlantic*, he had, nonetheless, partnered with Frank N. Doubleday in 1900 in the founding of Doubleday, Page & Company, principally in order to exert full editorial control over his own, newly founded, quality magazine, *The World's Work*. His first editorial served as a "clarion manifesto of optimistic America entering upon the twentieth century": "It is with the newly organized world, its problems and even its romance, that this magazine will eagerly concern itself, trying to convey the cheerful spirit of men who do things."[28]

In leaving *The Atlantic*, Page was also renouncing the genteel literary tradition of its founders, including Harriet Beecher Stowe, Ralph Waldo Emerson, and Henry Wadsworth Longfellow, now castigated in the pages of the new magazine as authors "who write well yet [are] writing about subjects of no earthly concern to anybody but their own craft." Writing as an art form was to be replaced by "the literature of action" and of "achievement," by which Page meant that his magazine would give voice to those men who "cannot write well" but who "feel the thrill of our expanding life" characterized as "a thing of extraordinary accomplishment, full of the healthful joy of growth." *The World's Work*'s reliance on photographic illustration was a significant feature of such worldly, anti-literary topicality. Taking advantage of the latest

development in print technology, photographic images signaled the triumph of expediency and immediacy in an age of corporate industry over what American author and editor William Roscoe Thayer defended, in a letter to Page, as the *"best* work — which is, after all, deliberate, sober, mellow, imaginative."[29] In other words, everything that Dugmore's photographs were not.

While Page was interested in reform movements and could be critical of specific social abuses and injustices, in the main *World's Work* was an apologist for the trusts and for current trends in big business.[30] Arguably, "The Negro As He Really Is" was, at the time of its publication, one of the most authoritative and critical examinations of race relations in the American South to appear in the mainstream white press. Yet Page created a powerful ideological counterweight by filling the introductory "March of Events" section of this same issue with glowing accounts of "The Increasing Co-Operation of the Races," "Practical Examples of Self-Help," "The Ogden Party," and "The Southern Educational Conference."[31] In his authoritative biography of Du Bois, David Levering Lewis lists Page among the "arbiters of the Industrial North and the New South" responsible for advancing "the new educational creed" embodied in Booker T. Washington's Tuskegee Institute through the work of the Southern Education Board and the General Education Board.[32]

Page embodied both the possibilities and limitations of progressive white thought in the era of Jim Crow. His personal history with Du Bois mirrored that contradictory mixture of advocacy for race reform and privileged complicity with the established order that characterized his magazine. In a 1925 letter to Page's biographer, Du Bois paid due respect to "the first magazine editor who ever accepted an article of mine." That first article was "The Strivings of the Negro People," a groundbreaking articulation of the African-American experience for a national audience. Published in *The Atlantic* in August 1897, it later became, in revised form, the crucial first chapter of *The Souls of Black Folk*. Du Bois later met Page in his Boston office: "We had a simple talk together but that talk meant a great deal to me. He intimated that he would be glad to see more of my work and expressed a great deal of sympathy with my point of view which was unexpected to me at that time because I knew him to be a Southerner." The letter goes on to recount Page's visit to Du Bois in Atlanta when planning *World's Work*: "I remember particularly, he impressed it upon me for the first time that there was a great difference of opinion among Southern whites as to their attitude towards Negroes." As ambassador to Great Britain at the outbreak of World War I, Page was able to be of significant service to Du Bois's wife and daughter who had sailed to England without passports. Du Bois's letter concludes, "I did not know Mr. Page intimately, but my few contacts with him have left me a peculiarly fine impression of his personality and of his great breadth of sympathy."[33] However, an exchange of letters in November 1905 suggests that the relationship was not without its conflicts. When Page solicited him for further manuscripts, Du Bois took the co-founder of Doubleday, Page & Company to task for publishing the best-selling and viciously racist novels of Thomas Dixon, an action Page defended on the grounds of freedom of the press. Page later declined Du Bois's proposal for a collection of essays titled "Sociology of the Negro American."[34]

In 1899 Du Bois was "startled to his feet" by the lynching of Sam Hose a few miles outside of Atlanta. He was on his way to meet with Joel Chandler Harris, editor of *The Atlanta Constitution*, with a "restrained letter on the lynching, intended for the editorial

page." When he learned that the victim had been burned as well as lynched and that his blackened knuckles were on display in a white storeowner's window further down the street where he was walking, he turned back in numbed horror. As Lewis comments, "Fourteen years of preparation, research, and writing suddenly seemed mockingly irrelevant."[35] The gap is wide between the real-world historical violence of a lynching and the ideological hijacking of Du Bois's text by Dugmore's photo-illustrations within the pages of *World's Work*. Yet they are not unrelated. The signs and meanings circulating within the mass media promulgated the scientific racism and white supremacy that constituted the conditions of possibility for such extremes of spectacular, extra-legal white violence no matter how assiduously deplored or disavowed in the editorial pages of that same middle-brow press.

In its concerns for agrarian reform, economic self-help, and family cohesion, "The Negro As He Really Is" conforms, at least in part, to the formulation of the African-American as a "problem" whose solution Booker T. Washington sketched out in his Atlanta Exposition speech of 1895. Two years later, Du Bois's revised and expanded text was published as "Of the Black Belt" and "Of the Quest of the Golden Fleece" in *The Souls of Black Folk*. With the addition of some 6,000 words, along with key emendations – and in the absence of Dugmore's photographs – Du Bois's analysis of the Black Belt carried a far more radical and challenging message. In the pages of *World's Work*, the Negro had been a "problem" to be solved and a "question" to be answered using the managerial skills and economic resources of white corporate interests operating in the best of all industrialized worlds. In the context of *Souls*, however, the Negro becomes an autonomous being bearing the savage scars of slavery and struggling against the tide of American racism: "To the real question, How does it feel to be a problem? I answer seldom a word."[36]

The photographs

In keeping with *The World's Work*'s anti-literary utilitarianism, Dugmore's photographs, like nearly all the early photo-illustrations included in the magazine, operated metonymically as the closest, most transparent and self-evident approximation of the thing itself rendered with all the point-and-shoot immediacy of literal transcription.[37] No matter how intrepidly procured, each image of person, place, or thing served within the essay as an unexamined and unproblematic stand-in for its referent. A thoroughgoing semiotic innocence attaches to this early moment of magazine photography long before the coining of the term "social documentary" in the mid-1920s or the golden age of photojournalism (1930s through 1960s). Neither Dugmore's memoirs nor Page's magazine treated photo-illustration as anything but the most straightforward and empirically trustworthy of genres. No critical framework yet existed within which to contest the cultural work of Dugmore's images and their accompanying captions.[38]

Born in Wales, Dugmore's father was a British colonial officer, his mother the niece of a Lord Chancellor of Great Britain.[39] By upbringing and inclination he was a peripatetic outdoorsman: a mariner, huntsman, fisherman, naturalist, and photographer. He was among the first commercial photographers to invent a career for himself as a specialist in wildlife and nature photography.[40] His first important article,

"A Revolution in Nature Pictures," published in the inaugural issue of *World's Work* (November 1900), constitutes one of the earliest accounts of wildlife photography and includes his pioneering images of small birds in their native habitats (Figure 21.4). In this piece, Dugmore extolled the camera as a "recorder of facts" to be embraced as an instrument of "great scientific value for it cannot lie." The camera, he claimed, eliminated "the personal equation" and supplanted "the human eye itself" in rendering the rapid movements of birds and other animals. Wildlife photography, in other words, was photography at its most literal, empirical, and prosaic.[41]

Dugmore brought these same skills and outlook to his work with Du Bois in Dougherty County. The assignment "did not take long" nor was it memorable in any way except that it allowed him to claim association with his eminent collaborator some thirty years later. His process concentrated on securing the image as surrogate reality: correct exposure, adequate shutter speed, centered subjects. (The edges of the frame mattered little since they could always be cropped later.) Formal analysis and interpretation – the photograph as picture and metaphor – remained beyond the horizon of interest or expectation. These type-compatible, low-grade photoengravings served as pedestrian, economical, mass-reproduced talismans of the real. Displayed within the confines of the text, they were intended for hasty perusal in the midst of reading to see what an exotic and low-rent part of the world looked like in all its superficial immediacy.

Figure 21.4 A.R. Dugmore, *Negro Woman Ploughing in a Cotton Field*, The World's Work 2, no. 2 (June 1901). Courtesy of the artist.

Dugmore's passing reference to his collaboration with Du Bois tells us almost nothing about the technical practicalities or social dynamics attending the making of these pictures except that they were made quickly at a particularly hectic moment in his budding career as a magazine photographer. Based on the evidence of the pictures themselves, the photographing occurred in public spaces, from a discrete middle distance: "in the cotton field" or "on the street," outside "the log cabin home" or inside the "Negro store."[42] They give no indication in visual terms – framing, composition, gesture, or facial expression – that Du Bois's presence facilitated any more intimate or trusting contact across the color line. Nor do they reflect the text's imaginative empathy or personal voice. They objectify a social condition – the Negro as "question" or "problem" – whose parameters have been defined in such a way as to obviate the need for any white person to come before the camera lens.

The photographs' relationship to Du Bois's text varies greatly from one illustration to the next – sometimes corresponding, at others contradicting, at still others pursuing agendas advanced from alien quarters.[43] Of the nineteen images, only two make direct use of Du Bois's text in the captions (presented here in italics): one shows a Negro school where children go after "*crops are laid by,*" the other is a street scene in Albany where rural folk "*meet and gossip with their friends.*"[44] Four photographs of women working in the fields respond more generally to Du Bois's descriptions of agricultural labor in the Cotton Belt, although the marked absence of their male counterparts goes without comment. Three other pictures would seem to complement Du Bois's discussion of the influx of "black peasantry" into town on Saturdays.[45] One instance stands out for the way in which Du Bois's text physically wraps around the photograph so that the image becomes the visual scene designated by the narrator's rhetorical gesture of pointing "yonder" (Figure 21.4): "This is the Cotton Kingdom, the shadow of a dream of slave empire which for a generation intoxicated a people. *Yonder* is the [a photograph, *Negro Woman Ploughing in a Cotton Field*, intervenes] heir of its ruins – a black renter, fights a failing battle with debt. A feeling of silent depression falls on one as he gazes on this scarred and stricken land, with its silent mansions, deserted cabins and fallen fences."[46] The image is subtitled "A field cultivated on the rent system" and would seem to illustrate Du Bois's core theme: the black tenant farmer dispossessed of a chance to rise and freighted with the elegiac despair of slavery's aftermath. The image is doubled on the facing page, a reverse angle shot of the same woman, plow, and mule.[47] The simultaneous coming and going of this figure can be seen to evoke the monotony and endlessness of tenant labor locked outside of historical time and the dynamics of progress. The final image shows two women fertilizing the soil with guano – a supplemental, technical aspect of cotton growing nowhere addressed in Du Bois's text.

"*Big House*" *and Negro Quarters* evokes a white presence – signified by absence – in the form of an abandoned farmhouse that is, "no longer in use although the Negro quarters are" (Figure 21.5). It is the one photograph that directly responds to Du Bois's insistence on Dougherty County as "historic ground" understood in relationship to those who have lived and suffered there at the hands of white slave owners. "The plantations of Dougherty in slavery days were not so imposing and aristocratic as those of Virginia. The Big House was smaller and usually one-storied, and set very near the slave cabins."[48] The dilapidated state of the abandoned white farmhouse

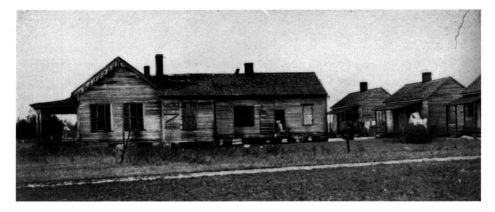

Figure 21.5 A.R. Dugmore, *Big House and Negro Quarters*, The World's Work 2, no. 2 (June 1901). Courtesy of the artist.

contrasts markedly with the well-tended "Negro cottages" depicted at the bottom of the same page.

The most problematic photographs in the series are those whose captions are saturated in the language and outlook of white supremacy, thereby putting them wholly at odds with the tone and content of Du Bois's text. For example, two horizontal images take up a full page and represent children playing and dancing on open ground some distance from the fenced cabins where they presumably live (Figure 21.6). The foreground shadows indicate that these two shots were taken from a single vantage point only moments apart. The scene is not unlike the one powerfully re-enacted in Julie Dash's 1991 film *Daughters of the Dust*, in which children's singing and dancing celebrate the continuity and sustaining pleasures of West African music and dance as carried over into the American South.[49] The *World's Work* captions however – "LEARNING TO SHUFFLE EARLY" and "A PICKINNINY CAKE WALK" – over-lay the contextual specificity of these particular children's lives with the deforming associations of the minstrel show as popular white entertainment.[50]

As mentioned at the beginning of this essay, the most overtly racist photographic illustration accompanying "The Negro As He Really Is" is Dugmore's portrait of an elderly black man wearing a bowler hat posed outdoors against a brick wall (Figure 21.3). With slightly tilted head, unkempt beard, white shirt, dark jacket, and rumpled collar, he carries a newspaper or pamphlet under his left arm and stares askance at the camera. There is something not quite right about the man's eyes. But whether their downward-turning, uncoordinated, hollow stare is produced by a defect of the image or of the human subject cannot be determined. The caption mocks him for his delusional claims of friendship with the founding father of the nation. He is a mad man and a fool presented for the edification and amusement of the white, middle-class reader.

The specificity of the George Washington anecdote gives room for speculation that the caption is a piece of noxious editorial mischief based on information supplied by Dugmore. Regardless of origin, its appearance carries the imprimatur of *World's Work* and its worldview. If one is willing to extend some measure of critical attention

Figure 21.6 A.R. Dugmore, *Learning to Shuffle Early*, The World's Work 2, no. 2 (June 1901). Courtesy of the artist.

to this image, there is at least one way in which it can be seen to illustrate Du Bois's text. Toward the end of the article, Du Bois summarizes his intent, "[To] trace the rise of the black freeholder in one county of Georgia's Black Belt, and his struggle for survival, to picture present conditions and show why migration to town is the Negro's remedy."[51] In the politics of accommodation mapped out in Booker T. Washington's

Atlanta Compromise speech, "migration to town [as] the Negro's remedy" is one defi-
nition of "the Negro problem" to which Washington's famous answer was "cast down
your bucket where you are."[52] In his closing sentence, Du Bois alludes, in prophetic
prose, to the abandonment of the cotton fields as a form of judgment against a white
power structure that refuses to do justice to the black tenant farmer: "The sin of the
country districts is visited on the town, and the social sores of city life to-day may,
here in Dougherty county and perhaps in many places, near and far, look for their
final healing without the city walls."[53] Only with the end of the rack-rent and chattel-
mortgage systems that Du Bois has discussed at length, tracing their historical origins
in slavery and describing their current workings under Jim Crow, will the inhabitants
of the Black Belt remain on the land and contribute to the general welfare of county,
state, and nation. The "friend of George Washington," with his back against a brick
wall and his mind lost in a maze of nationalist mythology, here becomes the visual
embodiment of the "social sores of city life to-day," a deranged refugee from the
country coming to town to haunt the perpetrators and material beneficiaries of an
unjust social order.

But in keeping with Stepto's objections as introduced at the beginning of this
essay, it is far more likely that, for the vast majority of readers who perused the images
and scanned the captions, this image confirmed the prevailing white stereotypes that
Du Bois was contesting. And yet, at least for the contemporary reader, there is another
way of reading this photograph: namely as a white counter-image designed to ward off
the threatening truths of the article's argument. *A FRIEND OF GEORGE WASHINGTON*
serves as a visual disavowal of (and substitution for) the dangerously sane, griot-like
figure who bears witness in Du Bois's text to the fundamental injustice of the planta-
tion system: "I see now that ragged black man sitting on a log, aimlessly whittling a
stick. He mutters to me with the murmur of many ages when he says, 'White man sit
down whole year; Nigger work day and night and make crop; Nigger hardly gits bread
and meat; white man sittin' down gits all. It's wrong.' "[54]

Dugmore's illustration is a hedge against such testimony. Its caption re-inscribes
the witness of history robbed of his capacity for truth telling, a betrayal and silencing
that Du Bois overcame with the publication of *Souls*.

When Du Bois came to expand his portrayal of the Black Belt in *Souls*, he added
two more black elders bearing witness to white perfidy. Described respectively as an
"old ragged black man, honest, simple, and improvident" and "a ragged, brown, and
grave-faced man," they carry the burden of historical memory. The first "told us the
tale" of the "Wizard of the North" whose capitalist investments in land, mills, and
machinery in the 1870s led to embezzlement and abandonment leaving a plantation
village in ruins "like some gaunt rebuke to a scarred land."[55] The second bears witness
to a level of white violence that it was *World's Work*'s business never to acknowledge:
"This land was a little Hell. . . . I've seen niggers drop dead in the furrow, but they
were kicked aside, and the plough never stopped. Down in the guard-house, there's
where the blood ran."[56]

Finally, a group of images seems motivated by an agenda originating else-
where and operating tangentially to Du Bois's empirical investigation of and
advocacy for the black tenant farmer. Two sympathetic portraits of black arti-
sans, a cobbler and a broom maker, each take up their own full page (Figures 21.7
and 21.8), yet Du Bois never addresses the role of the skilled tradesmen in

Figure 21.7 A.R. Dugmore, *In the Cobbler's Shop*, The World's Work 2, no. 2 (June 1901). Courtesy of the artist.

Figure 21.8 A.R. Dugmore, *At Work Making Brooms*, The World's Work 2, no. 2 (June 1901). Courtesy of the artist.

the Black Belt. The word "artisan" appears once, and then only to emphasize the overwhelming percentage of the population who are farmers.[57] The cobbler and broom maker figure so prominently and honorifically because they promote the ideals of industrial education and craft labor as advocated by Booker T. Washington and inculcated at Hampton and Tuskegee, with the backing, to say it again, of Walter Hines Page and the white northern business elite.

Dugmore's *A Parson and Part of his Flock*, a banal image representing three or four men standing at a distance on the sidewalk next to a telegraph pole, is one of the four images illustrating the Saturday influx of rural black folk into town[58]. Its title begs explanation. Black religious practice is nowhere mentioned in Du Bois's article, and only a somewhat longer coat and the hint of a clerical collar on the left-hand figure give credibility to "parson." How then did this nondescript scene – all we see are backsides – make it into the pages of *World's Work*? Again, as with the cobbler and broom maker, the image "illustrates" by way of allusion, another, competing and more palatable text – one that was being published in serial form in *Outlook* magazine in 1900–1901 – namely Booker T. Washington's *Up from Slavery*.

A favorite element in Washington's polemic against higher education for African Americans was the figure of the ignorant, self-serving black preacher whose pretensions to learning and labor-shirking "calls to preach" became a negative foil to Tuskegee's promotion of industrial education.[59] He also provided comic relief as a reassuring caricature skillfully deployed by Washington in currying favor with the white power elite. Du Bois's text treats these African-American men, standing in conversation on the sidewalk on a Saturday afternoon in a small southern town, for all their struggles and limitations, as fellow citizens "even as you and I."[60] Dugmore's image converts them into objects of ridicule. The pattern holds: Dugmore's nineteen photographs worked collectively within the pages of *World's Work* to support the status quo even as they purported to illustrate a text that was to become, in its revised and expanded version, a substantive part of one of the great revolutionary works of world literature.

One can only imagine the cold fury of the future author of *Souls* when affronted by the *World's Work*'s insidious interleaving of Dugmore's photographs and captions into his sociologically informed, lyrically articulated defense of African Americans living in the Black Belt. While no record remains of Du Bois's response to Dugmore, recent scholarship does provide a compelling account of his own instrumental curatorship, only a year earlier, of another, very different, set of photographs portraying blacks in Georgia as part of the Georgia Negro Exhibit presented at the 1900 Paris Exposition. In *Photography on the Color Line*, Shawn Michelle Smith interprets Du Bois as the archivist of other photographers' work who constructed for an international audience a counter-archive consisting of 363 images that "aimed to dismantle the racial hierarchies that fundamentally informed legal and scientific knowledge around 1900."[61] The Paris photographs, organized into four albums and presented without caption or attribution, contained photographs made within "the Veil." The photographs constituted, for the most part, "portraits of progress," representing "a small nation of people" – prosperous, cultured, stylish, and appealing – who had made it into the ranks of the American middle-class.[62] Taken collectively, these images are the antithesis of Dugmore's photographs in that they confound the many distinctions – including skin tone, demeanor, clothing, fashion, and class status – around which Jim Crow was organized. The African-American subjects portrayed in the Georgia albums

actively participated in the construction of their own idealized self-images according to the codes of commercial portraiture. Du Bois promoted these images in Paris as evidence of the rise of African Americans in the new century. His curatorship was premised on his faith in a collective national identity, based on democratic principles and economic opportunity, ultimately overcoming the indignities and injustices of American racism.

Original publication

'"The Negro As He Really Is": W. E. B. Du Bois and Arthur Radclyffe Dugmore', *Exposure* (2013)

Notes

1 Susan Sontag, *On Photography* (New York: Farrar, Straus and Giroux, 1973), 23.
2 W. E. B. Du Bois, *The Souls of Black Folk* (A Norton Critical Edition) (New York and London: W.W. Norton & Company, 1999), 45.
3 The formative model for this critical approach is Allan Sekula's, *Photography Against the Grain: Essays and Photo Works, 1973–1983* (Halifax, NS, Canada: Press of the Nova Scotia College of Art and Design, 1984).
4 W. E. B. Du Bois, "The Negro as He Really Is," *The World's Work* 2, no. 2 (June 1901): 848–866. The article carried a long subtitle that summarizes its content: "A definite study of one locality in Georgia showing the exact conditions of every Negro family – their economic status – their ownership of land – their morals – their family life – the houses they live in and the results of the mortgage system." It can be accessed online through Google Books at: http://books.google.com/books?id=IF6tNZnhO7wC&prin tsec=titlepage&as_brr=1&source=gbs_summary_r&cad=0#v=onepage&q&f=false (accessed October 19, 2012).
5 See Lee W. Formwalt, "W. E. B. Du Bois's View of the Southwest Georgia Black Belt," in *W. E. B. Du Bois and Race*, edited by Chester J. Fontenot, Jr., and Mary Alice Morgan (Mercer University Press, 2001), 11–25. The photographs are also reproduced in Du Bois, *Souls*, 195–213.
6 Formwalt, "W. E. B. Du Bois's View," 14; and Du Bois, *Souls*, 195.
7 Robert B. Stepto, *From Behind the Veil: A Study of Afro-American Narrative* (Urbana and Chicago: University of Illinois Press, 1991), 58.
8 Ibid., 60.
9 Ibid., 61.
10 David Levering Lewis, *W. E. B. Du Bois: Biography of a Race* (1868–1919) (New York: Henry Holt and Company, 1993), 296.
11 Du Bois, *The World's Work* 2, no. 2, 860.
12 Ibid., 864.
13 Robert J. Rusnak, *Walter Hines Page and the World's Work 1900–1913* (Washington, DC: University Press of America, 1982), 105–116.
14 Arnold Rampersad, *The Art and Imagination of W. E. B. Du Bois* (Cambridge, MA and London: Harvard University Press, 1976), 62–63.
15 Ibid., 59. "Race men" is a term used by blacks to refer to those high-achieving African-American men who proudly affirm their heritage and ethnicity in defiance of white supremacist assumptions of black inferiority. See Eugene Holly, Jr., "Amazon.

com Review" at: www.amazon.com/Race-Men-W-Bois-Lectures/dp/0674004043 (accessed November 14, 2012).
Race Men is also the title of an important feminist critique of the ways in which concepts and enactments of black masculinity from Du Bois to Danny Glover contribute to the oppression of black women. See Hazel V. Carby, *Race Men* (Cambridge, MA and London: Harvard University Press, 1998).

16 The critical commentary on *Souls* is legion. For a sophisticated analysis of the text as "generic narrative," see Robert B. Stepto, "The Quest of the Weary Traveler: W. E. B. Du Bois's, "The Souls of Black Folk," in *From Behind the Veil* (Urbana and Chicago: University of Illinois Press, 1991), 52–66. For the centrality of the sorrow songs, see Eric J. Sundquist, "Swing Low: The Souls of Black Folk," in *To Wake the Nations: Race in the Making of American Literature* (Cambridge, MA and London: Harvard University Press, 1993), 457–539. For the cultural politics of gender at work in Du Bois's construction of race and nation, see Hazel V. Carby, "The Souls of Black Men," in *Race Men* (as in note 15), 9–41. For a relatively recent selection of essays, see Dolan Hubbard, ed., *The Souls of Black Folk: One Hundred Years Later* (Columbia and London: University of Missouri Press, 2003).

17 Lewis, *W. E. B. Du Bois: Biography of a Race*, 179–210. Research for *The Philadelphia Negro* occurred between August 1896 and December 1897. Commissioned by the University of Pennsylvania, it was published in 1899 as an early instance of empirical and statistical sociology that Rampersad nevertheless describes as "a study in the art of cultural suasion through social science." Rampersad, *The Art and Imagination*, 51.

18 Formwalt, "W. E. B. Du Bois's View," 12–13. Du Bois's article contains a meticulous chart tabulating the relative growth of blacks and whites in the county from 1820 to 1890 while the text is filled with hard statistical data such as the number of marital separations (35 per 1,000) and the density of indoor living space (25 persons for every 10 rooms). Du Bois, *The World's Work* 2, no. 2, 851, 853, 857.

19 Du Bois, *The World's Work* 2, no. 2, 851, 860.

20 Ibid., 858.

21 Ibid., 851. In *Souls* Du Bois added a sentence that makes white prejudice even more explicit: "Or perhaps, having already reached conclusions in our own minds, we are loth to have them disturbed by facts." Du Bois, *Souls*, 90.

22 This is an expanded version of a point made by Stepto (see note 7), 60.

23 A. Radclyffe Dugmore, *The Autobiography of a Wanderer* (London: Hurst & Blackett, Ltd., 1930), 115. Several years later, Doubleday published a biography of Dugmore by Lowell Thomas, the journalist and broadcaster best known for his promotion of T.E. Lawrence in *With Lawrence in Arabia* (1924). Purporting to be "the story of Major Dugmore in his own words, as he told it to me," *Rolling Stone: The Life and Adventures of Arthur Radclyffe Dugmore* rehashes much of the material in Dugmore's autobiography but contains no account of his collaboration with Du Bois. Lowell Thomas, *Rolling Stone: The Life and Adventures of Arthur Radclyffe Dugmore* (Garden City, NY: Doubleday, Doran & Company, 1933), 7.

24 Brian L. Johnson, *W. E. B. Du Bois: Toward Agnosticism, 1868–1934* (Plymouth, UK: Rowman & Littlefield, 2008), 73–74.

25 A. Radclyffe Dugmore, "A Revolution in Nature Pictures," *The World's Work* 1, no. 1 (November 1900), 33–46. See http://books.google.com/books?id=688YPNQ5HN wC&printsec=frontcover&source=gbs_ge_summary_r&cad=0#v=twopage&q&f=t rue (accessed October 19, 2012).

26 Dugmore, *Autobiography*, 121–122.

27 The chronology of Dugmore's memoirs suggests that the assignment was completed within a very compressed time frame – no longer, perhaps, than a week – with much

else going on. His marriage on January 17, 1901, was followed by a honeymoon canoe trip to Kissimmee, Florida. He then took time to travel to Key West to make "fish photographs and paintings for Dr. Everman's book" before traveling to Atlanta and Dougherty County to work on the *World's Work* assignment. "By the beginning of April" he was back home in New Jersey. Dugmore, *Autobiography*, 114–115.

28 Frank Luther Mott, *A History of American Magazines 1885–1905* (Cambridge, MA: Harvard University Press, 1957), 773.

29 Ibid., 773–774. Emphasis in the original.

30 Ibid., 775–776.

31 Du Bois, *The World's Work* 2, no. 2, 800–801. The Ogden Party refers to a group of Northern educators and philanthropists, organized and funded by Robert C. Ogden (1836–1913), dedicated to promoting Booker T. Washington's accommodationist program for educational reform in the South.

32 Lewis, *W. E. B. Du Bois: Biography*, 266.

33 W. E. B. Du Bois, typed letter to Burton J. Hendrick regarding Walter Hines Page, dated January 2, 1925. Item is listed for sale by Grey Parrot Gallery. See www.greyparrotgallery.com/pages/books/213914/w-e-b-dubois/w-e-b-dubois-typed-letter-regarding-walter-hines-page (accessed October 19, 2012).

34 Herbert Aptheker, ed., *The Correspondence of W. E. B. Du Bois*, Volume 1 (Amherst, MA: University of Massachusetts Press, 1973), 113–114. See also Lewis, *W. E. B. Du Bois: Biography*, 370.

35 Lewis, *W. E. B. Du Bois: Biography*, 226.

36 Du Bois, *Souls*, 10.

37 The exception is the regular appearance of formal, full-page, honorific portraits of great men, including one of Du Bois seated at his desk, published in the same issue in which his article appeared. See Du Bois, *The World's Work* 2, no. 2, 794.

38 While Jacob Riis, as early as the 1890s, and Lewis Hine in the 1900s harnessed photo-illustration to the polemics of progressive reform, these remained isolated instances on the fringes of the emergent consumer culture valorized in *The World's Work*.

39 Henry Peter Brougham (1778–1868), was Lord Chancellor of Great Britain from 1830 to 1834.

40 For a summary of his career, see Thomas, *Rolling Stone*, 2.

41 Finis Dunaway, "Hunting with the Camera: Nature Photography, Manliness, and Modern Memory, 1890–1930," *Journal of American Studies* 34 (2000): 2, 211.

42 These are all phrases taken from the captions accompanying the photo-illustrations. *The World's Work* 2, no. 2, 848, 854, 858, 860.

43 Photo-illustrations by A.R. Dugmore in "The Negro as He Really Is," *The World's Work* 2, no. 2 (June 1901): 848–866.

 1 "WORKING BY DAY IN THE COTTON FIELD" [848]

 2 "IN THE COBBLER'S SHOP" [849] (full page)

 3 " 'BIG HOUSE' AND NEGRO QUARTERS. The house is no longer in use although the Negro quarters are." [850, top]

 4 "NEGRO COTTAGES. Owned by the Negro who keeps the store pictured on page 858." [850, bottom]

 5 "A NEGRO SCHOOL NEAR ALBANY, GEORGIA. Where children go after 'crops are laid by.' " [851, top]

 6 "NEGRO WOMAN PLOUGHING IN A COTTON FIELD. A field cultivated on the rent system." [852]

 7 "A REST IN THE FURROW" [853]

 8 "WOMEN FROM THE COUNTRY. A Saturday group in Albany, Ga." [854, top left]

9 "ON THE STREET. 'They meet and gossip with their friends.' " [854, lower left]
10 "A PARSON AND PART OF HIS FLOCK" [854, middle right]
11 "HER WEEK'S MARKETING" [855, full page]
12 "LEARNING TO SHUFFLE EARLY" [856, top]
13 "A PICKANNINY CAKE WALK" [856, bottom]
14 "HUTS NEAR ALBANY, GEORGIA. Showing old mud and wood chimney." [857]
15 "A TYPICAL NEGRO STORE" [858, top]
16 "AT WORK MAKING BROOMS" [859, full page]
17 "LOG CABIN HOME" [860, top left]
18 "A FRIEND OF GEORGE WASHINGTON. He believes that he was with Washington when the cherry tree was cut down and allowed his photograph to be taken only on condition that a copy would be sent to his old friend." [860, bottom left]
19 "WOMEN 'SOWING' GUANO" [860, middle right]

44 Du Bois's text describing a Negro school reads, "Most children get their schooling after the 'crops are laid by' and very few there are that stay in school after the spring work has commenced." *The World's Work* 2, no. 2, 860. His portrayal of Albany, Georgia on a Saturday includes the following: "They drink a good deal of whiskey, but they do not get very drunk; they talk and laugh loudly at times, but they seldom quarrel or fight. They walk up and down the streets, meet and gossip with friends, stare at the shop-windows, buy coffee, cheap candy and clothes, and at dusk drive home happy." *The World's Work* 2, no. 2, 851.

45 Ibid., 850.

46 Ibid., 852. Emphasis added.

47 Ibid., 852–853.

48 Ibid., 852.

49 Julie Dash (writer and director), *Daughters of the Dust,* (independent film distributed by Kino International), 1991. This was the first feature film by an African-American woman to be distributed theatrically in the United States.

50 For the complexities of minstrelsy, see Eric Lott, *Love and Theft: Blackface Minstrelsy and the American Working Class* (New York: Oxford University Press, 1993).

51 Du Bois, *The World's Work* 2, no. 2, 864.

52 Booker T. Washington, "The Atlanta Exposition Address" at: http://historymatters. gmu.edu/d/39/ (accessed November 3, 2012).

53 Du Bois, *The World's Work* 2, no. 2, 866.

54 Ibid., 863.

55 Du Bois, *Souls*, 80–81.

56 Ibid., 82.

57 Du Bois, *The World's Work* 2, no. 2, 858–860.

58 It is inexplicably omitted from the Norton Critical Edition of *Souls*.

59 See Booker T. Washington, "The Reconstruction Period," in *Up from Slavery*, at: www. bartleby.com/1004/5.html (accessed October 19, 2012). Du Bois's antagonistic review of *Up from Slavery* was published in *The Dial* just one month after the appearance of "The Negro as He Really Is." *The Dial* (July 16, 1901): 53–55. An expanded version, "Of Mr. Booker T. Washington and Others," became the third chapter of *Souls*.

60 Du Bois, *The World's Work* 2, no. 2, 858.

61 Shawn Michelle Smith, *Photography on the Color Line: W. E. B. Du Bois, Race, and Visual Culture* (Durham and London: Duke University Press, 2004), 8.

62 The Library of Congress (with essays by David Levering Lewis and Deborah Willis), *A Small Nation of People: W. E. B. Du Bois and African American Portraits of Progress* (New York: HarperCollins, 2003).

bell hooks

IN OUR GLORY
Photography and black life

ALWAYS A DADDY'S GIRL, I was not surprised that my sister V. became a lesbian, or that her lovers were always white women. Her worship of daddy and her passion for whiteness appeared to affirm a movement away from black womanhood, and of course, that image of the woman we did not want to become – our mother. The only family photograph V. displays in her house is a picture of our dad, looking young with a mustache. His dark skin mingling with the shadows in the photograph. All of which is highlighted by the white T-shirt he wears.

In this snapshot he is standing by a pool table. The look on his face confident, seductive, cool – a look we rarely saw growing up. I have no idea who took the picture, only that it pleases me to imagine that he cared for them – deeply. There is such boldness, such fierce openness in the way he faces the camera. This snapshot was taken before marriage, before us, his seven children, before our presence in his life forced him to leave behind the carefree masculine identity this pose conveys.

The fact that my sister V. possesses this image of our dad, one that I had never seen before, merely affirms their romance, the bond between the two of them. They had the dreamed-about closeness between father and daughter, or so it seemed. Her possession of the snapshot confirms this, is an acknowledgment that she is allowed to know – yes, even to possess – that private life he had always kept to himself. When we were children, he refused to answer our questions about who he was, how did he act, what did he do and feel before us? It was as though he did not want to remember or share that part of himself, that remembering hurt. Standing before this snapshot, I come closer to the cold, distant, dark man who is my father, closer than I can ever come in real life. Not always able to love him there, I am sure I can love this version of him, the snapshot. I give it a title: *in his glory*.

Before leaving my sister's place, I plead with her to make a copy of this picture for my birthday. It does not come, even though she says she will. For Christmas, then. It's on the way. I surmise that my passion for it surprises her, makes her hesitate. Always rivals in childhood – she winning, the possessor of Dad's affection – she

wonders whether to give that up, whether she is ready to share. She hesitates to give me the man in the snapshot. After all, had he wanted me to see him this way, 'in his glory,' he would have given me a picture.

My younger sister G. calls. For Christmas, V. has sent her a 'horrible photograph' of Dad. There is outrage in her voice as she says, 'It's disgusting. He's not even wearing a shirt, just an old white undershirt.' G. keeps repeating, 'I don't know why she has sent this picture to me.' She has no difficulty promising to give me her copy if mine does not arrive. Her lack of interest in the photograph saddens me. When she was the age our dad is in the picture she looked just like him. She had his beauty then – that same shine of glory and pride. Is this the face of herself that she has forgotten, does not want to be reminded of, because time has taken such glory away? Unable to fathom how she cannot be drawn to this picture, I ponder what this image suggests to her that she cannot tolerate: a grown black man having a good time, playing a game, having a drink maybe, enjoying himself without the company of women.

Although my sisters and I look at this snapshot and see the same man, we do not see him in the same way. Our 'reading' and experience of this image is shaped by our relationship to him, to the world of childhood and the images that make our life what it is now. I want to rescue and preserve this image of our father, not let it be forgotten. It allows me to understand him, provides a way for me to know him that makes it possible to love him again and against past all the other images, the ones that stand in the way of love.

Such is the power of the photograph, of the image, that it can give back and take away, that it can bind. This snapshot of Veodis Watkins, our father, sometimes called Ned or Leakey in his younger days, gives me a space for intimacy between the image and myself, between me and Dad. I am captivated, seduced by it, the way other images have caught and held me, embraced me like arms that would not let go.

Struggling in childhood with the image of myself as unworthy of love, I could not see myself beyond all the received images, which simply reinforced my sense of unworthiness. Those ways of seeing myself came from voices of authority. The place where I could see myself, beyond the imposed image, was in the realm of the snapshot. I am most real to myself in snapshots – there I see an image I can love.

My favorite childhood snapshot then and now shows me in costume, masquerading. And long after it had disappeared I continued to long for it and to grieve. I loved this snapshot of myself because it was the only image available to me that gave me a sense of presence, of girlhood beauty and capacity for pleasure. It was an image of myself I could genuinely like. At that stage of my life I was crazy about Westerns, about cowboys and Indians. The camera captures me in my cowgirl outfit, white ruffled blouse, vest, fringed skirt, my one gun and my boots. In this image, I became all that I wanted to be in my imagination.

For a moment suspended in this image: I am a cowgirl. There is a look of heavenly joy on my face. I grew up needing this image, cherishing it – my one reminder that there was a precious little girl inside me able to know and express joy. I took this photograph with me on a visit to the house of my father's cousin, Schuyler.

His was a home where art and the image mattered. No wonder, then, that I wanted to share my 'best' image. Making my first big journey away from home, from a small town to my first big city, I needed the security of this image. I packed it carefully. I wanted Lovie, cousin Schuyler's wife, to see me 'in my glory.' I remember

giving her the snapshot for safekeeping; only, when it was time for me to return home it could not be found. This was for me a terrible loss, an irreconcilable grief. Gone was the image of myself I could love. Losing that snapshot, I lost the proof of my worthiness – that I had ever been a bright-eyed child capable of wonder, the proof that there was a 'me of me.'

The image in this snapshot has lingered in my mind's eye for years. It has lingered there to remind of the power of snapshots, of the image. As I slowly work on a book of essays titled *Art on My Mind*, I think about the place of art in black life, connections between the social construction of black identity, the impact of race and class, and the presence in black life of an inarticulate but ever-present visual aesthetic governing our relationship to images, to the process of image making. I return to the snapshot as a starting point to consider the place of the visual in black life – the importance of photography.

Cameras gave to black folks, irrespective of our class, a means by which we could participate fully in the production of images. Hence it is essential that any theoretical discussion of the relationship of black life to the visual, to art making, make photography central. Access and mass appeal have historically made photography a powerful location for the construction of an oppositional black aesthetic. In the world before racial integration, there was a constant struggle on the part of black folks to create a counter-hegemonic world of images that would stand as visual resistance, challenging racist images. All colonized and subjugated people who, by way of resistance, create an oppositional subculture within the framework of domination, recognize that the field of representation (how we see ourselves, how others see us) is a site of ongoing struggle.

The history of black liberation movements in the United States could be characterized as a struggle over images as much as it has also been a struggle for rights, for equal access. To many reformist black civil rights activists, who believed that desegregation would offer the humanizing context that would challenge and change white supremacy, the issue of representation – control over images – was never as important as equal access. As time has progressed, and the face of white supremacy has not changed, reformist and radical blacks alike are more likely to agree that the field of representation remains a crucial realm of struggle, as important as the question of equal access, if not more so. Significantly, Roger Wilkins emphasizes this point in his recent essay 'White Out' (published in the November 1992 issue of *Mother Jones*). Wilkins comments:

> In those innocent days, before desegregation had really been tried, before the New Frontier and the Great Society, many of us blacks had lovely, naïve hopes for integration. . . . In our naïveté, we believed that the power to segregate was the greatest power that had been wielded against us. It turned out that our expectations were wrong. The greatest power turned out to be what it had always been: the power to define reality where blacks are concerned and to manage perceptions and therefore arrange politics and culture to reinforce those definitions.

Though our politics differ, Wilkins' observations mirror my insistence, in the opening essay of *Black Looks: Race and Representation*, that black people have made few, if any, revolutionary interventions in the arena of representations.

In part, racial desegregation, equal access, offered a vision of racial progress that, however limited, led many black people to be less vigilant about the question of representation. Concurrently, contemporary commodification of blackness creates a market context wherein conventional, even stereotypical, modes of representing blackness may receive the greatest reward. This leads to a cultural context in which images that would subvert the status quo are harder to produce. There is no 'perceived market' for them. Nor should it surprise us that the erosion of oppositional black subcultures (many of which have been destroyed in the desegregation process) has deprived us of those sites of radical resistance where we have had primary control over representation. Significantly, nationalist black freedom movements were often only concerned with questions of 'good' and 'bad' imagery and did not promote a more expansive cultural understanding of the *politics* of representation. Instead they promoted notions of essence and identity that ultimately restricted and confined black image production.

No wonder, then, that racial integration has created a crisis in black life, signaled by the utter loss of critical vigilance in the arena of image making – by our being stuck in endless debate over good and bad imagery. The aftermath of this crisis has been devastating in that it has led to a relinquishment of collective black interest in the production of images. Photography began to have less significance in black life as a means – private or public – by which an oppositional standpoint could be asserted, a mode of seeing different from that of the dominant culture. Everyday black folks began to see themselves as not having a major role to play in the production of images.

To reverse this trend we must begin to talk about the significance of black image production in daily life prior to racial integration. When we concentrate on photography, then, we make it possible to see the walls of photographs in black homes as a critical intervention, a disruption of white control of black images.

Most southern black folks grew up in a context where snapshots and the more stylized photographs taken by professional photographers were the easiest images to produce. Significantly, displaying those images in everyday life was as central as making them. The walls and walls of images in southern black homes were sites of resistance. They constituted private, black-owned and-operated, gallery space where images could be displayed, shown to friends and strangers. These walls were a space where, in the midst of segregation, the hardship of apartheid, dehumanization could be countered. Images could be critically considered, subjects positioned according to individual desire.

Growing up inside these walls, many of us did not, at the time, regard them as important or valuable. Increasingly, as black folks live in a world so technologically advanced that it is possible for images to be produced and reproduced instantly, it is even harder for some of us to emotionally contextualize the significance of the camera in black life during the years of racial apartheid. The sites of contestation were not *out there*, in the world of white power, they were *within* segregated black life. Since no 'white' galleries displayed images of black people created by black folks, spaces had to be made within diverse black communities. Across class, black folks struggled with the issue of representation. Significantly, issues of representation were linked with the issue of documentation, hence the importance of photography. The camera was the central instrument by which blacks could disprove representations of us created by white folks. The degrading images of blackness that emerged from

racist white imaginations and circulated widely in the dominant culture (on salt shakers, cookie jars, pancake boxes) could be countered by 'true-to-life' images. When the psychohistory of a people is marked by ongoing loss, when entire histories are denied, hidden, erased, documentation may become an obsession. The camera must have seemed a magical instrument to many of the displaced and marginalized groups trying to create new destinies in the Americas. More than any other image-making tool, it offered African Americans disempowered in white culture a way to empower ourselves through representation. For black folks, the camera provided a means to document a reality that could, if necessary, be packed, stored, moved from place to place. It was documentation that could be shared, passed around. And ultimately, these images, the worlds they recorded, could be hidden, to be discovered at another time. Had the camera been there when slavery ended, it could have provided images that would have helped folks searching for lost kin and loved ones. It would have been a powerful tool of cultural recovery. Half a century later, the generations of black folks emerging from such a history of loss became passionately obsessed with cameras. Elderly black people developed a cultural passion for the camera, for the images it produced, because it offered a way to contain memories, to overcome loss, to keep history.

Though rarely articulated as such, the camera became in black life a political instrument, a way to resist misrepresentation as well as a means by which alternative images could be produced. Photography was more fascinating to masses of black folks than other forms of image making because it offered the possibility of immediate intervention, useful in the production of counter-hegemonic representations even as it was also an instrument of pleasure. Producing images with the camera allowed black folks to combine image making in resistance struggle with a pleasurable experience. Taking pictures was fun!

Growing up in the fifties, I was somewhat awed and frightened at times by our extended family's emphasis on picture taking. Whether it was the images of the dead as they lay serene, beautiful, and still in open caskets, or the endless portraits of newborns, every wall and corner of my grandparents' (and most everybody else's) home was lined with photographs. When I was younger I never linked this obsession with images of self-representation to our history as a domestically colonized and subjugated people.

My perspective on picture taking was more informed by the way the process was tied to patriarchy in our household. Our father was definitely the 'picture takin' man.' For a long time cameras were both mysterious and off-limits for the rest of us. As the only one in the family who had access to the equipment, who could learn how to make the process work, he exerted control over our image. In charge of capturing our family history with the camera, he called and took the shots. We constantly were lined up for picture taking, and it was years before our household could experience this as an enjoyable activity, before anyone else could be behind the camera. Before then, picture taking was serious business. I hated it. I hated posing. I hated cameras. I hated the images they produced. When I stopped living at home, I refused to be captured by anyone's camera. I did not long to document my life, the changes, the presence of different places, people, and so on. I wanted to leave no trace. I wanted there to be no walls in my life that would, like gigantic maps, chart my journey. I wanted to stand outside history.

That was twenty years ago. Now that I am passionately involved with thinking critically about black people and representation, I can confess that those walls of photographs empowered me and that I feel their absence in my life. Right now, I long for those walls, those curatorial spaces in the home that express our will to make and display images.

Sarah Oldham, my mother's mother, was a keeper of walls. Throughout our childhood, visits to her house were like trips to a gallery or museum – experiences we did not have because of racial segregation. We would stand before the walls of images and learn the importance of the arrangement, why a certain photo was placed here and not there. The walls were fundamentally different from photo albums. Rather than shutting images away, where they could be seen only by request, the walls were a public announcement of the primacy of the image, the joy of image making. To enter black homes in my childhood was to enter a world that valued the visual, that asserted our collective will to participate in a noninstitutionalized curatorial process.

For black folks constructing our identities within the culture of apartheid, these walls were essential to the process of decolonization. Contrary to colonizing socialization, internalized racism, they announced our visual complexity. We saw ourselves represented in these images not as caricatures, cartoon-like figures; we were there in full diversity of body, being, and expression, multidimensional. Reflecting the way black folks looked at themselves in those private spaces, where those ways of looking were not being overseen by a white colonizing eye, a white supremacist gaze, these images created ruptures in our experience of the visual. They challenged both white perceptions of blackness and that realm of black-produced image making that reflected internalized racism. Many of these images demanded that we look at ourselves with new eyes, that we create oppositional standards of evaluation. As we looked at black skin in snapshots, the techniques for lightening skin which professional photographers often used when shooting black images were suddenly exposed as a colonizing aesthetic. Photographs taken in everyday life, snapshots in particular, rebelled against all of those photographic practices that reinscribed colonial ways of looking and capturing the images of the black 'other.' Shot spontaneously, without any notion of remaking black bodies in the image of whiteness, snapshots posed a challenge to black viewers. Unlike photographs constructed so that black images would appear as the embodiment of colonizing fantasies, these snapshots gave us a way to see ourselves, a sense of how we looked when we were not 'wearing the mask,' when we were not attempting to perfect the image for a white supremacist gaze.

Although most black folks did not articulate a desire to look at images of themselves that did not resemble or please white folks' ideas about us, or that did not frame us within an image of racial hierarchies, that need was expressed through our passionate engagement with informal photographic practices. Creating pictorial genealogies was the means by which one could ensure against the losses of the past. They were a way to sustain ties. As children, we learned who our ancestors were by endless narratives told to us as we stood in front of pictures.

In many black homes, photographs – particularly snapshots – were also central to the creation of 'altars.' These commemorative places paid homage to absent loved ones. Snapshots or professional portraits were placed in specific settings so that a

relationship with the dead could be continued. Poignantly describing this use of the image in her most recent novel, *Jazz*, Toni Morrison writes:

> ... a dead girl's face has become a necessary thing for their nights. They each take turns to throw off the bedcovers, rise up from the sagging mattress and tiptoe over cold linoleum into the parlor to gaze at what seems like the only living presence in the house: the photograph of a bold, unsmiling girl staring from the mantelpiece. If the tiptoer is Joe Trace, driven by loneliness from his wife's side, then the face stares at him without hope or regret and it is the absence of accusation that wakes him from his sleep hungry for her company. No finger points. Her lips don't turn down in judgement. Her face is calm, generous and sweet. But if the tiptoer is Violet the photograph is not that at all. The girl's face looks greedy, haughty and very lazy. The cream-at-the-top-of-the-milkpail face of someone who will never work for anything, someone who picks up things lying on other people's dressers and is not embarrassed when found out. It is the face of a sneak who glides over to your sink to rinse the fork you have laid by your place. An inward face – whatever it sees is its own self. You are there, it says, because I am looking at you.

I quote this passage at length because it describes the kind of relationship to photographic images that has not been acknowledged in critical discussions of black folks' relationship to the visual. When I first read these sentences I was reminded of the passionate way we related to photographs when I was a child. Fictively dramatizing the way a photograph can have a 'living presence,' Morrison offers a description that mirrors the way many black folks rooted in southern traditions used, and use, pictures. They were and remain a mediation between the living and the dead.

To create a palimpsest of black folks' relation to the visual in segregated black life, we need to follow each trace, not fall into the trap of thinking that if something was not openly discussed, or if talked about and not recorded, that it lacks significance and meaning. Those pictorial genealogies that Sarah Oldham, my mother's mother, constructed on her walls were essential to our sense of self and identity as a family. They provided a necessary narrative, a way for us to enter history without words. When words entered, they did so in order to make the images live. Many older black folks who cherished pictures were not literate. The images were crucial documentation, there to sustain and affirm oral memory. This was especially true for my grandmother, who did not read or write. I focus especially on her walls because I know that, as an artist (she was an excellent quiltmaker), she positioned the photos with the same care that she laid out her quilts.

The walls of pictures were indeed maps guiding us through diverse journeys. Seeking to recover strands of oppositional worldviews that were a part of black folks' historical relationship to the visual, to the process of image making, many black folks are once again looking to photography to make the connection. Contemporary African American artist Emma Amos also maps our journeys when she mixes photographs with painting to make connections between past and present. Amos uses snapshots inherited from an elder uncle who took pictures for a living. In one piece, Amos paints a map of the United States and identifies diasporic African presences as

well as particular Native American communities with black kin, using a family image to mark each spot.

Drawing from the past, from those walls of images I grew up with, I gather snapshots and lay them out, to see what narratives the images tell, what they say without words. I search these images to see if there are imprints waiting to be seen, recognized, and read. Together, a black male friend and I lay out the snapshots of his boyhood, to see when he began to lose a certain openness, to discern at what age he began to shut down, to close himself away. Through these images, he hopes to find a way back to the self he once was. We are awed by what our snapshots reveal, what they enable us to remember.

The word *remember* (*re-member*) evokes the coming together of severed parts, fragments becoming a whole. Photography has been, and is, central to that aspect of decolonization that calls us back to the past and offers a way to reclaim and renew life-affirming bonds. Using these images, we connect ourselves to a recuperative, redemptive memory that enables us to construct radical identities, images of ourselves that transcend the limits of the colonizing eye.

Original publication

'In Our Glory: Photography and Black Life', *Art on my Mind* (1995)

Annette Kuhn

PHOTOGRAPHY AND CULTURAL MEMORY
A methodological exploration

T HE PAST TEN OR FIFTEEN YEARS have seen a flowering of research and scholarship on cultural and social memory, across the humanities and the social sciences (Fentress and Wickham 1992; Bal, Crewe and Spitzer 1999; Misztal 2003; Radstone and Hodgkin 2003). Among the many facets of this work is a quest to extend and deepen understandings of how personal memory operates in the cultural sphere: to inquire into the distinguishing features of expressions of memory – how, where and when memories are produced, and how people make use of memories in their daily lives. In terms of objects – and, importantly, methods – this quest is best regarded as a cultural rather than, say, a psychological one. The aim is to seek fresh insights and new ways of conceptualising and understanding the ways in which people's personal or individual memories relate to, intersect or are continuous with shared, collective, public forms of memory – and ultimately how memory figures in, and even shapes, the social body and social worlds. To the latter extent, this is also a sociological project, an exercise in *Verstehen* sociology.[1]

Personal and family photographs figure importantly in cultural memory, and memory work with photographs offers a particularly productive route to understanding the social and cultural uses and instrumentalities of memory. Drawing on a case study of one photograph, this article sets out, develops and interrogates a set of interlocking 'memory work' methods for investigating the forms and everyday uses of 'ordinary photography' and how these may figure in the cultural and social production of memory.

In general, studies of cultural memory draw on, and often mix and match, a range of methods of inquiry – sociological, ethnographic, literary – so that a sort of unselfconscious methodological *bricolage*, pragmatic and in varying degrees inventive and productive, prevails in work in the field. My own preference is for a grounded approach that carefully builds up explanations from clues and traces extracted from readings of objects of study: the cultural historian Carlo Ginzburg calls this kind of inductive approach – a way of knowing characteristic of detective work, criminology,

psychoanalysis and diagnostics – 'conjectural knowledge' (Ginzburg 1989). In work on cultural memory, the conjectural method involves taking as a starting point instances or cases – expressions of memory of some sort – and then working outwards from them, treating what can be observed in the instances at hand as evidence pointing towards broader issues and propositions about the nature and the workings of cultural memory. This kind of inquiry can be productively conducted with singular instances (a life story, a film or a photograph, for example) and with several or numerous cases; with the researcher's personal memory material or with materials gathered by, with or from others. Methodological approaches and research designs range from textual analysis to ethnographic inquiry, and may include various combinations of the two. One central plank remains, however: the notion that memory and memories are discursive and that through memory work of various kinds it is possible to come to an understanding of how memory operates as a type of cultural text (Radstone 2000).

Memory work, a mode of inquiry embodying certain methodological assumptions, may be defined as:

> an active practice of remembering which takes an inquiring attitude towards the past and the activity of its (re)construction through memory. Memory work undercuts assumptions about the transparency or the authenticity of what is remembered, taking it not as 'truth' but as evidence of a particular sort: material for interpretation, to be interrogated, mined, for its meanings and its possibilities. Memory work is a conscious and purposeful staging of memory.
>
> (Kuhn 2000, 186)

Memory work takes all forms of remembering, memory accounts and memory texts as material for interpretation, and opens to question the taken-for-grantedness, or the transparency, of acts of memory in relation to the past. Taking expressions of memory as material for interpretation, memory work may deploy established procedures for analysing cultural texts, and these will be as productive and convincing as the practitioner's craft skills and insight allow.

As an approach to source material, evidence or 'data', this approach is, of course, qualitative rather than quantitative; and the task of the practitioner in memory work is not merely to analyse but also to understand – that is, to try to enter into the memory-world of the text, the account, the performance (though not of the informant – the task is not to psychoanalyse people but to be helpfully at hand at the birth of new insight and fresh understanding). Negotiation and intersubjectivity, then, are key features of memory work. Moreover, the interpretive procedures used in memory work will necessarily be governed by the nature and the medium of the memory text itself. 'Reading' a visual medium, for example, involves a set of procedures rather different from those of interpreting an oral reminiscence; though the researcher's attitude towards the 'object' will remain the same in either case: respectful, open, unintrusive. While there is a certain amount of craft or expertise involved here, a DIY approach to memory work (especially under the guidance of an expert) can work very well.

* * *

In most societies, family photographs have considerable cultural significance, both as repositories of memory and as occasions for performances of memory. A study of these processes can be helpful towards understanding how the personal and the social aspects of remembering interact in various cultural settings. Drawing on the methodological approach to memory work outlined above, this article sets out a corpus of methods of inquiry appropriate for conducting memory work with photographs. It explores some ways in which these may be refined and extended in future studies of the forms and everyday uses of 'ordinary photography', and how these may figure in the cultural production of memory. The substantive starting point of this inquiry is a single, diagnostic case study of one photograph. It builds on a three-pronged methodological approach: first, the interpretive approach to family and personal photographs developed for my own autoethnographic work with photographs and other visual media; second, an extension of this devised for group workshops on family photography and memory in which participants bring along photographs of their own and work on them with others; and third, an adaptation of the 'oral-photographic method' developed by the Canadian art historian and curator Martha Langford for work on family photographic albums (Langford 2001, 2006; Kuhn 2002).

For the first approach, work on a photograph starts with a few simple procedures:

1 Consider the human subject(s) of the photograph. Start with a simple description, and then move into an account in which you take up the position of the subject. In this part of the exercise, it is helpful to use the third person ('she', rather than 'I', for instance). To bring out the feelings associated with the photograph, you may visualise yourself as the subject as s/he was at that moment, in the picture: this can be done in turn with all of the photograph's human subjects, if there is more than one, and even with animals and inanimate objects in the picture.

2 Consider the picture's context of production. Where, when, how, by whom and why was the photograph taken?

3 Consider the context in which an image of this sort would have been made. What photographic technologies were used? What are the aesthetics of the image? Does it conform to certain photographic conventions?

4 Consider the photograph's currency in its context or contexts of reception. Who or what was the photograph made for? Who has it now, and where is it kept? Who saw it then, and who sees it now?

(Kuhn 2002, 8)

In the extended autoethnographic context of the photography and memory workshop, participants use these protocols as a guide to memory work with their own photographs and in turn as a means of assisting others in their own 'performances of memory'. While these workshops may offer a variety of possible objectives and outcomes – personal development, team-building, and so on – two aspects remain central to participants' experience. First, a sort of eye-opening takes place because of this unfamiliar context for, and fresh approach to, something that is very familiar and ordinary and which yet may very well also carry some emotional weight. Second, there is a shared fascination with – and a quest to understand – others' memory accounts; this has a certain 'deep'

ethnographic quality about it. This latter aspect becomes particularly apparent where a group is intercultural or multinational in composition.

The procedures outlined above, especially when combined with a *Verstehen* approach to these familiar and immediately accessible objects, personal photographs, seems to unlock meanings and insights extraordinarily readily, and participants do not feel they have to be 'experts' in order to be able to do the work and find it valuable. However, alongside personal insights, working in this way can also generate findings of considerable scholarly value and cultural significance. The workshop method, I would contend, offers potential in its own right as a qualitative research method, and there is considerable scope for extending it into larger scale, and/or intercultural, studies of 'ordinary' photography and cultural memory. At one level, it may be regarded as a group variant on the oral interview: this is similar in some respects to a method in wide use in social-psychological research, though the 'memory work' application is distinctive in the depth and the degree of interactivity involved. For in this kind of research 'subjects' or 'informants' are actively engaged, in collaboration with the researcher, in producing new knowledge: in this respect, the approach is both empirical and also close to that of 'postmodern' ethnography, whilst bringing a quality of *Verstehen* into play. In this process, those involved may themselves be changed by this knowledge; and to this degree there is also potentially an 'action research' aspect to the work.

The importance of the photographic medium in this process cannot be overstated: a combination of memory work and photography brings something entirely distinctive to the methods and findings of cultural memory research. The power of this combination stems, I would argue, from the very everydayness of photography – from the ways photography and photographs figure in most people's daily lives and in the apparently ordinary stories we tell about ourselves and those closest to us (Hirsch 1997). This, combined with the capacity of the still photographic image to 'freeze' a moment in time, lends extraordinary impact to an apparently ordinary medium (Bazin 1971; Barthes 1984). As commonplace material artefacts, family photographs and albums contain meanings, and also seem infinitely capable of generating new ones at the point at which photography and memory work meet.

Martha Langford, who works extensively with family photographic albums deposited in museum archives, argues in her book *Suspended Conversations* that people's uses of these albums are governed by the same underlying structures as those of the oral tradition – of oral memories and life stories: 'Our photographic memories are used in a performative oral tradition' (Langford 2001, viii). Not only do photographs operate as props and prompts in verbal performances of memory, but the collection of photographs that makes up a family album itself also follows an 'oral structure': 'An album is a classic example of a horizontal narrative shot through with lines of both epic and anecdotal dimension' (Langford 2001, 175). This in turn informs the interpretive performances that accompany displaying and looking at photograph albums. Developing an 'oral-photographic' method, Langford has tested this through 'performative viewings' of archived albums, conducted both with donors/compilers of the albums and also with informants who have no connection with or knowledge of the families who figure in them. Her findings suggest that even outsiders will weave stories around albums, stories which embody precisely the epic, anecdotal quality that marks the memory text.

Langford's work complements that of visual anthropologist Richard Chalfen, who is interested in how people produce and use their own photographs in domestic

Figure 23.1 Annette Kuhn, *Mother and Child*. Courtesy of the artist.

settings, or 'how ordinary people do ordinary photography' (Chalfen 1987, 12). Chalfen conducted a large-scale ethnographic study of amateur photography and pictorial communication based on around two hundred collections of 'home mode imagery' (photographs and home movies) made in the northeastern USA between 1940 and 1980. While Chalfen's interest was in the processes and activities that go on within families around their own 'ordinary photography', Langford's concern is with the family photograph album as it survives, as an artefact, beyond its originary production and reception contexts. But despite these differences of approach and objectives, both find that family photographs and family albums figure as occasions for communication, cross-cultural exchange and cultural continuity, and agree that there is something distinctive about the discursive features of these image-based communications, the kinds of talk that accompany viewings of family photographs and albums.

Work on personal and domestic photography and memory can unlock doors to understanding not only the ethnography of everyday memory talk but also the workings of cultural memory across wider social-historical spheres. It can do this most effectively by activating a range of potentially interlocking methodological approaches to a set of similar phenomena: a concern with orality and memory as a form of storytelling prompted by the ensemble and sequencing of images in family albums that belong to neither researcher nor informants; an ethnographic tracking of people's practices around their own family photographs – their content, their production, their everyday uses; and a practice of memory work that makes close attention to singular family and personal photographs the starting point for inquiry that then radiates outwards from the image, eventually to embrace ever broader cultural, social, even historical, issues.

* * *

Figure 23.2 Annette Kuhn, *Writing.* Courtesy of the artist.

The case study that follows draws upon, develops and interrogates this corpus
of methods, using a photograph that was brought to a photography and memory
workshop.[2] Among the participants was a man in his twenties who had recently
moved to Britain from his home in the People's Republic of China. Jack Yu (Yu
Zhun) was born in Deyang in the province of Chengdu, in Sichuan in south-west
China, and attended university at Chongqing in Sichuan. In 2000, on completing
his studies in International Relations, he joined the British Council in Chongqing,
moving to Britain in 2004. Jack brought to the workshop a small, square (no more
than 5cm by 5cm) monochrome snapshot with a deckle edge and some writing on
the reverse. It shows a youngish woman in medium shot, holding an infant. In the
background is a building and, behind that, some trees. Introducing his photograph
to the group at the start of the workshop session, Jack explained that it was taken
in China in 1979, almost certainly by his father, and that the woman in the picture
is his mother and he himself the child. He had no memory of the actual occasion,
he said. He had been carrying the photograph (reproduced above) in his wallet for
several years.

At first sight, and to the western eye, this photograph may well look like a fairly
ordinary mother-and-baby snapshot: the pose and the setting are entirely typical of
a very familiar genre. Of the events typically portrayed in the numerous examples of
American 'home mode imagery' that he studied, Chalfen observed a rather circum-
scribed set of subject matters. Most prominent among these are images of family

members' babyhoods and early lives, images invariably focusing on the theme of relationships:

> This photograph typically shows a parent . . . holding a baby while stand-
> ing outside near the front steps of the house or by a side wall of the
> house. Some form of colourful shrubbery or flowering bush is frequently
> included. The picture is usually a long shot, and both participants are seen
> facing the camera.
>
> (Chalfen 1987, 77)

The absence of colour and the closer framing notwithstanding, this could very well be a description of Jack Yu's picture, taken many thousands of miles away and in dramati-cally different circumstances: the pose of the subjects, the stress on the relationship, the *mise-en-scène* of house and leafy nature (though in a western context this small monochrome snapshot, with its fancy edging, looks like a photograph from the 1950s or 1960s rather than the late 1970s). And if here, too, 'kinship, material culture and aesthetic preference are wrapped up in one snapshot' (Chalfen 1987, 77), there turn out to be historical and cultural singularities, as well as similarities of form and con-tent, at work here. When doing memory work with personal photographs it is not unusual to encounter this mix of familiar and unfamiliar, recognition and surprise – and this on the part of all concerned, including and especially the picture's owner.

This photograph, and the brief account and explanation of it that emerged in the workshop setting, may at first sight seem to reference a migration experience of a relatively recent kind: the movement of large numbers of mostly young people, as students and migrant workers, from parts of mainland China to the West. But there is certainly more in this photograph to explore; and if it evokes a sense of recognition in the outsider, such a response itself calls for investigation. Further inquiry in this case involved extending the workshop method and adapting Langford's 'oral-photographic' method to conduct a 'performative viewing' of the picture with its owner and sub-ject. The procedure began with a close scrutiny of the actual photograph, conducted in a conversation between the author and the photograph's owner, according to the methodological procedure outlined above, and using the original photograph itself as a constant point of reference.[3] The two-way talk prompted by the photograph has then in turn been treated as material for interpretation.

Attention to the photograph's aesthetic and compositional attributes highlights details of the pose and setting and the framing and composition of the image. Here, the natural lighting suggests that the picture might have been taken in the afternoon, the leafy trees and the bare arms of the subjects that the season is spring or summer. The woman wears a brightly patterned shirt and supports the child on a sturdy right arm. The little boy has on a striped shirt and his hand rests on a bag that is slung across his shoulder. Jack's comments on what he is wearing (he calls the shirt 'my favourite', and says about the bag: 'lots of older children, they go to school, they have a school bag so you fancy that, you pretend to be grown up') are unmarked by actual memory of the occasion: he is looking back on his younger self from the standpoint of the present, or perhaps repeating a parent's memories of himself as a child. The house

in the background appears rather prominent, and the image is composed so that the human figures appear slightly to the left of the intersection of roofs at the corner of the building.

The writing on the back of the photograph records the date (July 1979) and the subject ('our Zhun and mummy'). Jack was born in 1977, and the photograph was taken when he was two years old. His mother, he says, would have been about thirty at the time. Jack quickly launches into a dramatic and eloquent account of the picture's backstory. He was born at the end of the Cultural Revolution, and his parents were of the generation whose youth and early adulthood had been very much shaped by the events of the previous decade. In 1979, while they are still relatively young, this part of their lives has come to an end, and mother and child stand at the still uncertain threshold of a new life. Speaking for his mother, Jack says:

> I think at that time, '79, her life, the material life in China was still quite tough. She said that there was food rationing. In order to get him bottled milk, to bring up the baby. She had to get up at 6 o'clock in the morning to run across the town to queue up to get a bottled milk, and also the milk is half water, half milk, diluted milk.

Shifting to a more distanced register, he adds:

> It was, I would imagine, after Deng Xiao-Ping's policy – the open door policy – was promulgated at that time, so people like her would see the hope, our life will improve.

As Jack tells it, the story behind this photograph, the story of the years just before his own birth, is one of almost unimaginable hardship and trauma. His mother, the privileged daughter of a leader of one of China's ethnic minority groups, was a Red Guard sent to the countryside for 're-education'. Jack's father, previously a professional dancer, was likewise sent to the country where his first wife, with whom he had a daughter, was shot dead in a riot at the hospital where his wife worked as a nurse. These were the circumstances in which his parents met and married, says Jack: the Cultural Revolution had brought them together. This photograph, then, represents a new phase in his parents' lives, one that coincides with – is made possible by – social and economic changes in China (Deng's 'open door' policy). Jack's account is supported by certain details in the photograph: considered next to the sober uniforms of the Cultural Revolution, his mother's brightly patterned, but simply cut, blouse may be read as emblematic of these still nascent stirrings of change, while her sturdy arm perhaps speaks of her recent past and physical labour as a Red Guard.

Jack's emphasis on the coincidence of his own birth with the end of the Cultural Revolution lends his own arrival a redemptive quality: the new baby would make up for the losses suffered by its parents:

> [My mother] would lie all her hope on the baby. . . . There was a big hope, my parents, especially my mum, because she thinks her life is to some extent destroyed because she couldn't get a good education, she was sent to the countryside for a few years and also the family connection, there was

no way she could be promoted or . . . so basically her life is there already. So she could foresee the time when she retires, but the difference it would make is that she has got a baby, the baby will grow up, might make a huge difference.

This is all the more so given that (notwithstanding the existence of an older half-sister, who does not live with the family) Jack is effectively 'that proudest of possessions in any Chinese family, the only child' (Buruma 2001, 227), and a boy at that. Life was still hard, says Jack, and there was still considerable uncertainty in his family, in the whole of China, about how things might turn out. But 'more direct assurance for a person like my mum is that I've got a son. . . . People place more value on boys than girls. . . . So my mum . . . I've got a son. My son will grow up and become my hope'. If every newborn child embodies renewal and hope for the future, the hope represented by the little boy in the picture is thoroughly and very distinctively overdetermined by its historical circumstances.

If the pose by the house is a typical topos for a mother/infant snapshot, this particular house carries meanings of its own. Jack explains that it was situated in the centre of Deyang, the city where he lived until he went to university; and that it is probably part of a late Qing dynasty *hutong*, or walled family compound, dating perhaps from about 1910 and originally built for a wealthy household. This one, he thinks, would have been taken over by the government after 1949, and by the late 1970s part of it formed offices for the local government, his parents' employer, and part was living quarters for employees: 'You work here and your employer allocates houses for you, so you live actually within walking distance from your office'. Jack's account of the spaces of the compound suggests that it comprises 'four houses on four sides', with an enclosed courtyard, and that there is another area at the rear with living accommodation for other families. His emphasis on the fact that several families are sharing this compound and its 'not brilliant' facilities (draughty windows, no heating or indoor plumbing, no kitchen) suggests a certain detached attitude on Jack's part towards his first home; and indeed there is no indication in his account of any direct experience-memory of the spaces of the house itself, though his recollection of the natural world surrounding it does have the ring of lived recollection: 'I know as a child, I still remember around me you'd got sparrows, occasionally you can see wild animals . . . you could get lots of big trees . . . ' The family soon moved elsewhere in Deyang, and Jack remembers the compound being demolished in the early 1990s.

Jack's limited memory of, and apparent lack of sentiment about, the house in the photograph is perhaps connected with the fact that for him it clearly represents old China – not just the China that had been swept away in 1949 by Mao, but Mao's China as well: in fact, Jack's account emphasises the house's associations with a moment of transition between Maoism and a new order. Today, all traces of the compound have been wiped away and the place remains only a memory – and for Jack a vague one at that – an unmourned victim of China's recent urban regeneration. At the same time, the building remains strikingly prominent in the photograph: the composition and framing (mother and child positioned close to the junction of two roofs in the background, a point of intersection of old and new, past and future, perhaps) suggests that this place, the compound, may carry greater meaning for the photographer, the father whose voice is largely absent from Jack's account, than it does for Jack himself.

While he has no memory of the actual occasion, Jack is certain that the photograph was taken by his father, with a borrowed camera:

> I think probably it's a brand . . . a Chinese brand called Seagull. If you talk to a Chinese person asking what's a big Chinese brand, make of a camera, must be Seagull because all the industry stayed all in one or two makes of a camera so the Seagull was quite dominant and popular, so I would imagine it was a Seagull Chinese camera.

In China in the 1970s families rarely owned cameras, and having a photograph taken was regarded as a major event. Cultural historian Nicole Huang notes that during the Cultural Revolution family photographic portraiture, though not officially encouraged, flourished at a semi-public level, in the form largely of monochrome studio-produced images, often of entire families, made (as in earlier times) to mark some important family occasion. Now, though, says Huang, it was the 'separation, distance, displacement, longing, homecoming' (Huang 2005) that went with the massive urban – rural migration of the Cultural Revolution that provided occasions for family visits to the local photography studio.

Taking one's own photographs was a far less common practice, however, since few families or individuals were in a position to own cameras. Portable cameras like the Shanghai-made Seagull twin-lens reflex could be hired on a daily or weekly basis, and Jack's father might well have rented rather than borrowed the camera that took this picture. It was not, in any event, his own. Nor would it have been an easy-to-use snapshooter's camera: such things were simply not available in China at the time. All in all, then, family photography in 1970s China was far from the casual, everyday affair that it was in the West. Maoism discouraged any activity, including domestic photography, that might be seen to promote family ties; and Huang says that the studio family portraiture she describes was conducted as a 'discreet and distinctly private' activity 'in an era when the private was inevitably politicised' (Buruma 2001; Huang 2005). Interestingly, too, she notes that these photographs were (and still are) rarely put on display in the home, and that people did not make photograph albums either. In 1979, then, the very making of a family photograph like Jack's is itself a marker of change, of a reinscription of family ties.

And yet the conditions of production of Jack's picture are in some respects out of the ordinary as well. Rather unusually in the circumstances, it is not a studio portrait, but has been made outdoors at home using a borrowed or rented camera, a camera that in fact requires a certain amount of skill to use. This, together with the composition and framing of the picture, itself suggests that Jack's father is a fairly skilled, and an exacting, photographer. The framing of the subjects, barely off-centre against the just-visible junction of the rooftops, the angle of the mother's arm in relation to the frame edge, the composition of the trees to span the top edges of the frame – all betray a 'good eye' and some expertise or natural aptitude on the part of the photographer.

Jack explains that his dance-trained father 'is artistic . . . he likes to manipulate people', and that his own memories of later picture-taking sessions make him 'pretty much sure that my dad sort of directed this'. He even imagines his mother telling his father to stop faffing about and just get on with taking the picture. Unusual in the circumstances, too, is the fact that this picture is not a one-off but part of a rather

substantial collection, filling several albums, of photographs of Jack (some of them studio-made) taken from his infancy up to the age of six or seven. Jack explains the absence of pictures of himself after that age as, paradoxically, to do with the fact that at just around this time, the early to mid-1980s, his parents bought a camera. Significantly, though, Chalfen found that photographs of children in his American collections of 'home mode imagery' also tend to tail off at this sort of age.

It is clear that for Jack this picture condenses myriad meanings about his own origins and about the – universally fascinating, it seems – period immediately preceding his own arrival in the world. These meanings are heightened and transformed here, however, because the period concerned is widely experienced as a 'caesura', a past removed from the present by an historical event (in this instance the change from Maoist revolutionary to reform politics) that acquires a mythical quality and particularly readily absorbs personal histories into greater events (Feuchtwang 2005, 180).[4] For Jack, the photograph is about the upheavals of the Cultural Revolution that came to an end just before he was born, about his parents' roles in the drama and trauma of that earlier time, about the paradox that he owes his very existence to the Cultural Revolution, and above all about himself as marker of hope and talisman of an as yet uncertain redemption. In this regard, the photograph, along with all the others taken of Jack in his early childhood, lends particular meaning to the commonplace impulse to record a child's early years, meaning that would in all probability be shared by Jack and his parents.

But for Jack alone, the photograph carries a further – and probably a more intensely experienced – set of meanings. These it acquired only after Jack had left home for university: at the age of nineteen or twenty, he recalls, he returned to Deyang and spent some time at his parents' house. He offers a recollection – perhaps the most vividly expressed memory in his entire story – of being 'captured' during that visit by this particular photograph out of all the others in the family albums. As he tells it, it is as if the picture reached out and seized him, so that 'I immediately said yes I need to get this one'; and he took it out of the album. He has carried it around with him ever since.[5]

Asked if he ever shows the photograph to anyone else, Jack says no, because (and this recalls Barthes' explanation in *Camera Lucida* for not publishing his own treasured photograph of his mother) it is far too 'personal', too 'special', and others could not possibly understand how much it means to him. In fact, he rarely even looks at it himself:

J I always carry it around. I don't sort of scrutinise it like this . . . I just feel . . . I don't really need to look at it all the time. I just feel I want this thing with me in my bag or whatever. I just feel that my mum or my parents or my whole background is with me. So I don't really need to physically look at it.

A So it's part of you in a way?

J Yeah. I don't. . . . You know, like you've got your hand is part of you, but you don't need to look at your hand, but if you want . . .

A It's part of you, you couldn't do without it.

Clearly for Jack the photograph is as much about his life now, far from where he was born and grew up, as it is about his own, his family's or his country's past; though in a

way these pasts and the present are folded together in his account. He says on behalf of his mother as she was in the photograph, as she is now perhaps, that the two-year-old boy is *her* (significantly perhaps not '*their*', i.e. both parents') 'treasure'. And speaking for himself now, Jack says that the photograph is *his* 'treasure'. At several levels, then, this photograph embodies something of unmeasurable and almost incommunicable value, and it speaks of a present as well as – perhaps more than – of a past, or pasts.

* * *

An interactive performative viewing of Jack Yu's photograph brings to light depths and details of meaning and association that had not emerged in the group workshop, as indeed it opens up readings that at least begin to unpack the intersections and continuities between the personal, the familial and the social that lie embedded in the image's many layers of meaning. But this 'oral-photographic' exercise in memory work is really only one more stage of what could, if taken further, become an even deeper and wider investigation. Memory work is rather like peeling away the layers of an onion that has no core: each level of analysis, while adding more knowledge, greater understanding, also generates further questions. Analysis, as Freud might have it, can be interminable.

In this particular case, further questions centre most pressingly around the *absences* in the photograph and in Jack's memory-story. Perhaps the most eloquent, the most insistent, of these is Jack's father's voice – silent everywhere but in the picture itself, where it hints in the most tantalising way at issues which are not, cannot be, addressed in Jack's account. A further absence is itself an absence: the empty space in the family photograph album left when Jack took away the picture that so 'captured' him. This absence surely resonates with all the different ways family albums can be used in different contexts, by different generations and at different stages in a family's lifespan. How are the albums, created by Jack's parents and still in China, used now that the child whose early years they documented is grown up and far away from home? How does the empty space in one of them speak to those who keep, and perhaps sometimes look at, that album today? And what of all three or four albums as an ensemble of meanings and stories: what stories – similar, divergent, overlapping – might these elicit from Jack's mother and Jack's father or indeed from Jack himself?

This exercise raises important issues of methodology, among them questions concerning the role and activity of the researcher in what is in effect a collaborative, intersubjective, autoethnographic inquiry. For example, how important for the depth or the productivity of the inquiry is the researcher's prior knowledge of the photograph's social, cultural, historical, even technical, contexts and antecedents? Is it necessary, or even helpful, for the researcher to be immersed in the culture from which the memory text emanates (Smith 2003)? What might a cultural anthropologist, or a cultural historian, or even a photography specialist, do with such material? Would a 'lay' cultural insider be better placed than any 'expert' outsider to interpret it? Each would certainly be sensitive to different aspects of the material at hand – the photograph, the memory-stories – so that we might expect overlapping stories or stories told from different angles to emerge.

To suggest that analysis may be interminable and that interpretations may vary is in no way to detract from the value of this kind of inductive, diagnostic inquiry. As a

demonstration of the productivity of a particular combination of methods in investigating the meanings and uses of family photography across a range of contexts, both private and public, the value of this small exercise in memory work is self-evident. A qualitative approach to memory work that combines close readings of a photograph or photographs with the ethnographic work of performative viewing can clearly be usefully deployed on a small scale, as here with a single informant and one photograph. However, it could well be equally productive when used on a larger scale, in inquiries on 'home mode imagery' and its forms and uses across a range of cultural and historical contexts, inquiries involving larger numbers of images and informants. Indeed, in a rapidly changing world of domestic image-making technologies, this mixed approach to memory work with photographs might even offer tools for predicting future forms and uses for 'home mode imagery'.

Acknowledgements

Many thanks to Nick Wadham-Smith and Lolli Aboutboul of the British Council for making this project possible; to Philip Schlesinger and his colleagues for their encouraging feedback on a version of this article presented at a seminar in the Department of Film and Media, University of Stirling, December 2006; to Jiang Jiehong for checking an earlier draft of this article; to Stephan Feuchtwang for his extremely helpful suggestions; and above all to Yu Zhun and the others who took part in the 'Eye to Eye' workshop for their generous and enthusiastic collaboration.

Original publication

'Photography and cultural memory: a methodological exploration', *Visual Studies*, (2007)

Notes

1 Developed initially by Max Weber in relation to sociological inquiry, *Verstehen* is an approach that involves understanding the object of inquiry from within, by means of empathy, intuition or imagination; as opposed to knowledge from without, by means of observation or calculation (Weber 1968).

2 The workshop was conducted by the author at a British Council Conference, 'Eye to Eye', London, November 2004. See www.counterpoint-online.org/cgi-bin/item.cgi?id=553; INTERNET (accessed 19 December 2006). Of the thirteen workshop participants, around ten nationalities, and many backgrounds and current circumstances, were represented.

3 The conversation took place in December 2005 in the British Council office in Manchester. Because it is in effect an auratic object, the importance of having the actual photograph to hand in this kind of memory work cannot be overstated. The interview was audiotaped and quotations in the text are taken from the transcript.

4 My thanks to Stephan Feuchtwang for drawing attention to the concept of the caesural event and its specific relevance to Jack's memory-story.

5 On wallet photographs, A. D. Coleman relates a telling anecdote about a group of stu-
 dents, most of whom, on being asked how many were carrying snapshots of themselves,
 family and friends, reached for their handbags or wallets. When warned not to produce
 the photographs unless they were willing to burn them, 'not a single photograph came
 forth' (Coleman 1979, 132).

References

Bal, Mieke, Jonathan Crewe, and Leo Spitzer. 1999. *Acts of Memory: Cultural Recall in the Present*.
 Hanover, NH: University Press of New England.
Barthes, Roland. 1984. *Camera Lucida*. London: Flamingo.
Bazin, Andre. 1971. The ontology of the photographic image. In *What is Cinema?*, edited by
 A. Bazin. Berkeley: University of California Press.
Buruma, Ian. 2001. Afterword. In *Bertien van Manen: East wind west wind*, edited by B. van Manen.
 Amsterdam: De Verbeelding Publishing.
Chalfen, Richard. 1987. *Snapshot Versions of Life*. Bowling Green, OH: Bowling Green State Uni-
 versity Press.
Coleman, A. D. 1979. *Light Readings: A Photography Critic's Writings*. Oxford: Oxford University
 Press.
Fentress, James, and Chris Wickham. 1992. *Social Memory*. Oxford: Blackwell.
Feuchtwang, Stephan. 2005. Mythical moments in national and other family histories. *History
 Workshop Journal* 59: 179–193.
Ginzburg, Carlo. 1989. Clues: Roots of an evidential paradigm. In *Clues, Myths and the Historical
 Method*, edited by C. Ginzburg. Baltimore, MD: Johns Hopkins University Press.
Hirsch, Marianne. 1997. *Family Frames: Photography, Narrative and Postmemory*. Cambridge, MA:
 Harvard University Press.
Huang, Nicole. 2005. Locating family portraits: Everyday images from 1970s China. Unpub-
 lished essay, University of Wisconsin-Madison.
Kuhn, Annette. 2000. A journey through memory. In *Memory and Methodology*, edited by S. Rad-
 stone. Oxford and New York: Berg.
————. 2002. *Family Secrets: Acts of Memory and Imagination*. London: Verso.
Langford, Martha. 2001. *Suspended Conversations: The Afterlife of Memory in Photographic Albums*.
 Montreal and Kingston: McGill-Queens University Press.
————. 2006. Speaking the album: An application of the oral-photographic framework.
 In *Locating Memory: Photographic Acts*, edited by A. Kuhn and K. E. McAllister. Oxford:
 Berghahn Books.
Misztal, Barbara A. 2003. *Theories of Social Remembering*. Maidenhead: Open University Press.
Radstone, Susannah. 2000. Working with memory: An introduction. In *Memory and Methodology*,
 edited by S. Radstone. Oxford: Berg.
————, and Katharine Hodgkin, eds. 2003. *Regimes of Memory*, vol. 12, *Routledge Studies in
 Memory and Narrative*. London and New York: Routledge.
Smith, Benjamin. 2003. Images, selves and the visual record: Photography and ethnographic
 complexity in Central Cape York Peninsula. *Social Analysis* 47(3): 8–26.
Weber, Max. 1968. *Economy and Society*. New York: Bedminster Press.

Lily Cho

CITIZENSHIP, DIASPORA AND THE BONDS OF AFFECT

The passport photograph

IF YOU HAVE RECENTLY had your passport photo taken in Canada, the United Kingdom or the United States, you may recall a curious injunction against emotional expression. For a photograph to be acceptable for use on a passport, it must, in addition to following many specifications for lighting, composition and background, portray its subject as an emotionally empty one. Passport Canada, the federal department overseeing the issuing of passports in Canada specifies: "Applicant must show a neutral facial expression (no smiling, mouth closed) and look straight at the camera." The United Kingdom's Identity and Passport Service asks that the subject of a passport photograph must have a "neutral facial expression" with the "mouth closed (no grinning, frowning or raised eyebrows)." Similarly, the US Department of State's guidelines for acceptable passport photos insist: "The subject's expression should be natural, with both eyes open. Please refer to the photographs found on this website for acceptable facial expressions." The "acceptable" facial expressions reveal no emotion. They are natural only insofar as they are completely emotionally neutral. That is, they are not natural at all. They expose a citizen subject caught and composed for identification purposes. This subject is neither angry, happy, sad, disgusted, nor even particularly present.

The foreclosure of emotion in a passport photograph, the identity document that ties a person to a nation, illuminates a contradiction between feeling and citizenship. On the one hand, as these instructions for the passport photographs suggest, emotion obscures the identity of the citizen. On the other, as I will discuss in further detail, emotion, or the capacity for it, is very much a part of the conception of the modern citizen. My paper will take up this contradiction in order to examine the relationship between diaspora and citizenship. Through an exploration of the passport photograph, I argue diasporic subjects lay bare the problem of emotion at the heart of contemporary citizenship.

One might argue that the instructions for the passport photo are about security and biometrics and the urgency of the task of recognition. That might be the

case even though almost everyone I know has, at one time or another, disparaged the lack of resemblance between their passport photos and the way they normally look. And it is doubtful that, in that fraught moment of the encounter with a border patrol officer, any one of us looks as neutral or as natural as our passport photos make us out to be. Whether or not these acceptably neutral and natural facial expressions allow for easier identification, they do indicate not only what a citizen is supposed to look like, but also what being a citizen should feel like. The injunction against emotion in the passport photograph projects the way in which the ideal citizen, in the eyes of the state, is an emotionally neutral one. Let me suggest that the photographs that identify us as citizens must be without emotion because they are themselves a vestigial reminder of the fraught relationship between emotion and citizenship.

The relationship between emotion and citizenship is predicated by the question of the humanity of the citizen subject. Examining the pre-history of modern citizenship, Susan Maslan argues that modern citizenship attempts to resolve a foundational divide between the "human" and the "citizen" upon which the early modern models of citizenship depend:

> If we think that "human" and "citizen" are or *should be* corresponding and harmoniously continuous categories it is because we think in the wake of the 1789 Declaration. In the early modern political imagination, to be a citizen meant to cease to be human. This is the legacy that the Declaration tries to overcome and that it conceals . . . and so the new Republic turned to, or better yet, invented – the language of universalism to repress and resolve the tensions it can neither dissipate nor acknowledge.
>
> (Maslan 2004: 372)

Maslan's argument breaks the familiar Greek to Roman to French to American narrative of citizenship's progression as a concept. Her examination of pre-modern citizenship in relation to the legacy of the French Revolution, an event closely connected to modern conceptions of citizenship, reveals a deeply uneasy relationship between the universal claims of citizenship and the exclusions of its practice. As Giorgio Agamben notes, the discontinuity of the human and the citizen

> is implicit, after all, in the ambiguity of the very title of the 1789 *Déclaration de droits de l'homme et du citoyen*, in which it is unclear whether the two terms are to name two distinct realities or whether they are to form, instead, a hendiadys in which the first term is actually always already contained in the second.
>
> (Agamben 2000: 19)

In her reading of Agamben, Ariella Azoulay observes a much more significant tension between the rights of Man set against that of the community of citizens: "When [Agamben] identifies the man of the declaration as a trace of *homo sacer*, whose invention preceded that of political man, as the basis of political sovereignty, he misses the direct threat that man poses to the citizen" (Azoulay 2008: 61). It is a threat which turns on the problem of recognition and misrecognition.

Suggesting a strong relationship between photography and citizenship, Azoulay outlines the problem of recognition and misrecognition in her argument for a civil contract of photography. She proposes that there is a "civil contract" in photography which functions analogously to the civil contract of citizenship:

> The conceptual valences between photography and citizenship are in fact two fold. Because . . . photographs are constructed like statements (*énoncés*), the photographic image gains its meaning through mutual (mis) recognition, and this meaning (even if not the object itself) cannot be possessed by its addressor and/or addressee. Citizenship likewise is gained through recognition, and like photography, is not something that can simply be possessed.
>
> (Azoulay 2008: 25)

Azoulay's argument suggests that photography and citizenship are intimately bound by the work of recognition and the perils of misrecognition. The need for the former and the dangers of the latter are a reminder of the formal demands (plain background, impassive facial expression, head framed at the center of the photograph) of identification photographs themselves. Even though Azoulay's analysis focuses largely on journalistic images of the Israeli-Palestinian conflict, the genre of identification photographs attend precisely to her argument. The necessity of recognition gives rise to the stark formalism of identification photographs for passports.

Of course, the insistence upon the passport itself suggests a certain faith in the notion that people are who their documents declare them to be. "With the widespread use of a similar passport," Mark Salter notes, "the examination at the border came to be centered on whether *documents* – rather than the traveler herself – were in order" (Salter 2003: 28). The introduction of the passport photo was one attempt at maintaining the fidelity between the traveler and her passport. According to John Torpey's *The Invention of the Passport*, a man named Richebourg claimed in an article in the July 22, 1854 edition of *La Lumière* to have introduced the idea of the passport photograph (Torpey 2000: 172, n.62). Salter's investigations into the archives of the British Passport Office reveal that passport photographs became a standard requirement for British passports as of 1916 when Form A was revised and "we see the first issuance of a passport in a recognizable form: a folded sheet of cardboard, not paper, that included the coat of arms of the country, a photography of the bearer, and an official standardized message from the secretary of state for foreign affairs" (Salter 2003: 28). Azoulay poses that "the camera modified the way in which individuals are governed and the extent of their participation in the forms of governance" (Azoulay 2008: 89). With the introduction of the photo requirement on passports, the camera modified the governance of individual movement along the lines of identification invented not for tracking the traveler, but rather the criminal.

The protocols of the passport photograph share something with those of another set of identification photos, the mugshot. Recalling her assertion of a civil contract of photography where the photograph constitutes a "statement," Azoulay's (2008) suggestion of photography's construction as an "*énoncé*" evokes the notorious *portrait parlé* (spoken portrait) developed by Alphonse Bertillon in the nineteenth century. With his development of anthropometry, where the human body could be measured

and broken down into a series of written codes, Bertillon standardized the identi-
fication photographs of criminals and denoted them to be *portraits parlés*, portraits
that spoke so that they could "be read in many cities, provinces, across jurisdictions"
(Cole 2001: 43). The passport photograph does not communicate "an electric body
of speed, transmitted telegraphically" the way that Bertillon's mugshots did (Matsuda
quoted in Cole 2001: 43). It was never broken down with such precision. Neverthe-
less, it calls to mind the burden of identification photos to speak, to announce and
respond to the question posed but not asked regarding the truth of one's identity, the
fidelity of one's appearance with that of image on the document, to declare *prima facie*
that one is who one claims to be.

As the history of the passport reveals, it is a document of suspicion rather than
recognition. The introduction of identification photos in passports only further posed
the question of the tenuousness of the connection between the person and the docu-
ment that purports to identify that person. Torpey (2000) observes that in 1791, with
the victories of the revolution still fresh, the French National Assembly voted to abol-
ish passport controls in favor of cosmopolitanism and freedom of movement. Only a
year later, passport controls were reinstated and increasingly refined, thus laying the
foundation for the contemporary passport. Torpey argues that the invention of the
passport emerged as a response by an increasingly suspicious state to control and iden-
tify the enemies that it saw everywhere but could not easily identify. After 1792, "the
revolutionary governments, beset by enemies domestic and foreign, real and imag-
ined, sought to use passport controls and other documentary means . . . to regulate the
movements of émigrés, counterrevolutionary brigands, refractory priests, itinerant
mendicants, conscripted soldiers, and the foreign-born, among others" (Torpey 2000:
55–56). Well into the twentieth century, the passport was understood to be a puni-
tive document. "The 1921 conference of the International Parliamentary Union in
Stockholm expressed its condemnation of the passport system and called for greater
freedom of movement" (Torpey 2000: 27). While the passport may seem relatively
benign, indeed desirable, in the contemporary period, the consolidation of its usage
attests to a long history of state suspicion leveled with particular acuity upon anyone
who does not want to stay put.

In a historical moment when more people move around more than ever before,
these claims in these moments have become more frequent and more fraught. As
Simon Cole notes of the crisis engendered by the urbanization movements in nine-
teenth-century Europe,

> People in modern cities might not be who they claimed to be. They could
> be anyone; they could come from anywhere. Nineteenth century society
> shifted from a closely hierarchical society of ranks and orders, in which
> everyone knew his or her place and the place of others, into what . . .
> Michael Ignatieff has called a "society of strangers."
>
> (Cole 2001: 9)

The status of the stranger, the foreigner, stands in tension with that of a com-
munity whose integrity is, as Benedict Anderson famously suggests, imaginary. The
diasporic subject's difference challenges the homogenizing stipulations of national
citizenship and illuminates the contradictions of citizenship. These are contradictions

that turn on feeling. Citizenship is both bonded by affect and, in the instance of its visual manifestation through the passport photograph, hindered by it. The injunction against emotion in passport photos projects a fantasy of a passive, transparent and readable national subject.

The figure of the foreigner poses a distinct challenge to this fantasy in that the foreigner's subjectivity cannot be easily assimilated into this discourse of citizenship. Torpey's recognition, through the work of Gérard Noiriel, of the problem of the "foreigner" suggests a strong connection between the idea of Man and the notion of the foreigner located within the founding of the 1789 Declaration itself:

> Noiriel has written that the modern conception of the "foreigner" came into being with the French Revolution as a result of the elimination of feudal privileges on 4 August 1789, which formally created a national community of French citizens. This Act was, however, in inherent and insoluble tension with the Declaration of the Rights of Man and Citizen, which proclaimed equality of all *individuals* and thus tended to promote the rights of foreigners as such.
>
> (Torpey 2000: 28)

This tension between the rights of Man and that of the community of citizens does not simply lie in that classic liberal problem of individual desire set against that of communal need. Rather, this tension can be located in the problem of the rights of the foreigner, coded as individual Man, which poses a threat to the rights of the citizen.

Arguing for a sharper understanding of the chasm between the figure of man and the figure of the citizen in contemporary understandings of citizenship, Maslan also draws attention to the foreignness of the figure of Man and suggests how this figure is indeed racialized. As she observes, the very title of the 1789 *Déclaration des droits de l'Homme et du Citoyen* indicates the continuity between the figure of the human and that of the citizen cannot be taken for granted.

> The authors of the Declaration understood that they were in the process of elaborating two distinct kinds of rights: rights proper to an individual *outside* of any constituted political body – that is, in the language of the eighteenth century, natural rights – and rights proper to a member of an organized political body or state. It would appear, then, that natural rights are those that belong to man and political and civil rights are those at the disposal of the citizen. Asian and Africans, both favorite French examples of oppressed peoples, would be recognized by the Declaration not as citizens of France, of course, but rather in their capacity as *men* – a title which confers upon them a body of rights that must be acknowledged and recognized by all other human beings.
>
> (Maslan 2004: 360)

This split in the declaration allowed for the recognition of the humanity of oppressed racial others such as Asians and Africans, but it also explicitly denied them any kind of obvious access to the rights and privileges of citizenship. Moreover, this

division of human from citizen was delineated along the lines of feeling in opposition to reason: "For, despite commonplace assumptions about the Enlightenment, the primary qualification for inclusion within the category of the human was the capacity to feel, not the capacity to reason" (Maslan 2004: 358). Thus a duality is established where humans feel but citizens must reason.

As the need to mediate that divide between man and citizen became more pressing, it was feeling and emotion that were pressed into service. As Maslan observes, the Marquis de Lafayette argued that the declaration should "*dire ce que tout le monde sait, ce que tout le monde sent*" (Maslan 2004: 358). The world should not only know but also feel these foundations of contemporary citizenship. The capacity to feel thus became just as, perhaps even more, indicative of humanity as the capacity to reason. The physical fact of being human came to matter less in the *ancien régime* than emotional aspects of human existence. "Sentimentalizing the 'human' of human rights implied a shift from bodies and their sufferings, to persons and their unhappinesses, from biology to the mental and emotional cognates of physical suffering" (Maslan 2006: 80). Emotion and affect could negotiate the chasm between the human and the citizen.

However, the reliance upon emotion and feeling to humanize the figure of the citizen depends upon the idea that emotions are an indication of human subjectivity. With reference to subjectivity in general, Rei Terada notes the fallacy of what she calls the "expressive hypothesis" where "[t]he claim that emotion requires a subject – thus we can see we're subjects, since we have emotions – creates the illusion of subjectivity rather than showing evidence of it" (Terada 2001: 11). It has become conventional, as Terada notes, to think of emotion as something "lifted from a depth to a surface" through the mechanism of expression (Terada 2001: 11). Expression "serves as the distracting white handkerchief" which naturalizes the logic of the expressive hypothesis (Terada 2001: 11). This white handkerchief also distracts from the role of representation in feeling. "We are not ourselves without representations that mediate us, and it is through these representations emotions get felt" (Terada 2001: 21). For Terada, the death of the subject ascribed to contemporary postmodern theory does not mean the death of feeling. On the contrary, the death of the subject inaugurates feeling.

The dream of a feeling citizen cannot hide the monstrous anti-human heart of the original citizen subject. Terada shows us that that feeling is not a guarantee of subjectivity. On the contrary, emotions can indicate the death of the subject and real subjectivity can be an indication of monstrosity. As she wryly observes of the monsters in George Romero's zombie films, they seem to "emblematize postmodern subjectivity" because "everyone knows that if there's one thing dead subjects don't have, it's emotion" (Terada 2001: 156). However, she points out that the opposite is the actual case: "Romero's living dead are notably undivided about their desires, or rather, because their desires are undivided" (Terada 2001: 156). As a "well-known counterillustration," she offers the case of the replicants in Philip K. Dick's *Bladerunner*:

> In the film . . . the explicitly sentimental moment for the replicant played by Sean Young – the one time she cries – is the moment when she discovers that she's a replicant, whose memories are not her own. We assume she had feelings before, but reserving the sight of her tears for this occasion

dramatizes the fact that destroying the illusion of subjectivity does not destroy emotion, that on the contrary, emotion is the sign of the absence of that illusion.

(Terada 2001: 157)

"Unlike replicants," Terada argues, "zombies don't experience themselves as though they were someone else" (Terada 2001: 157).

Terada's deeply provocative description of the feeling dead subject, the replicant who experiences herself as though she were someone, reveals the alienation of the unfeeling photographed citizen and, specifically, the problem of the diasporic citizen. Insofar as diaspora is a state of dislocation where one becomes located through a process of experiencing one's home – the site of one's identity – as though it were someone else's, there is some resonance between the replicant of Terada's example and that of the person in diaspora. In diaspora, the notion of identity as something that might be grounded in an idea of home is highly mediated through representation and narrative. As Vijay Mishra understands,

It is becoming increasingly obvious that the narrative of the damaged home . . . takes its exemplary form in what may be called diasporas, and especially in diasporas of colour, those migrant communities that do not quite fit into the nation-state's barely concealed preference for the narrative of assimilation.

(Mishra 2005: 112)

It has become something of a convention in diaspora studies to talk about the ways in which "home" does not exist except in memory, as a representation, and a problematically misremembered one at that. And part of that convention involves the tragic moment of recognizing that the diasporic person's home is not what they thought it was, that it exists as a fantasy or unreality which can be shattered and which renders the diasporic home experienced only as though it belonged to someone else.

Indeed, not only does the diasporic share something with the replicant, but the figure of man-citizen promoted by the *ancien régime* recalls the living dead in their unwavering and undivided desires. Through the work of Elisabeth G. Sledziewski, Maslan points out that "the desire to create the unified man-citizen, a subject who would *feel* his ties and obligations of citizenship as a part of his interiority just as he would understand his familial and amical bonds as part of his civic participation, was a central motive force in the creation of revolutionary legislation" (Maslan 2006: 75). The citizen is expected to feel unwaveringly bound to home and country in ways where the idea of home does not contradict the idea of national belonging. In contrast, the person in diaspora becomes a citizen knowing that they become one at the expense of distancing themselves from themselves. They must experience their home as though it was someone else's, and themselves as though they were someone else, as though there were no contradictions between being diasporic and being a citizen.

Feeling does not mediate the divide between man and citizen. It exposes it. Diasporas take up the dream of the feeling citizen not as a way of burying or resolving the divide between humanity and citizenship, but rather as a way of engaging it. What will save citizenship from the monstrosity of real subjectivity will be a recognition

of the distance between the person in diaspora and the citizen – a recognition of the mediation necessary for the diasporic person to become a citizen. The moment of the breaking of the illusion of some kind of naturalized continuity between diaspora and citizenship is not so dissimilar from the moment in which the replicant recognizes the death of her subjectivity. It is what makes her less, and not more, monstrous.

Given the explicit references to racialized others such as Asian and Africans that Maslan (2004) points to, racism constitutes at least one source of the divide between man and citizen in the French declaration. It made clear that one could be human in the eyes of the declaration, but not a citizen. The case of the Haitian revolution and Toussaint L'Ouverture's mistaken belief in his own access to citizenship makes this exclusion clear. Recognizing the divide between the person in diaspora and that of the citizen is an acknowledgment of the racism embedded within the concept of citizenship. To become a citizen, one must let go of one's particularity, suspend it, so as to become part of something more general, more universal. The moment when a diasporic subject must choose to side with the generalizing principles of citizenship and to let go of the specificity of diaspora is an uneasy one. It is also one in which he or she can see the racism attendant upon citizenship.

The work of Shelly Low, to which I now turn, helps reveal the ways that diasporic citizens deploy emotion to mediate the contradiction between the diasporic person and that of citizen. You could say that they are engaging in a version of the dream of the feeling citizen even as they highlight the contradictions of diasporic citizenship. Shelly Low's work does precisely this. Low's "Self-Serve" consists of a series of three digital prints. They are self-portraits with objects such as plastic Chinoiserie soup-spoons and bowls (see Figures 24.1–24.3).

Figure 24.1 Shelly Low, *Self Serve*, 2006 A [Original in colour] Shelly Low. Photographer: Alain Martin.

Figure 24.2 Shelly Low, *Self Serve*, 2006 B [Original in colour] Shelly Low. Photographer: Alain Martin.

Figure 24.3 Shelly Low, *Self Serve*, 2006 C [Original in colour] Shelly Low. Photographer: Alain Martin.

In each print, the objects obscure parts of her face. In their form, these portraits recall the stark impassivity of the passport photo or the mugshot. She faces the camera. Her head and shoulders are centered and fill the frame. The background is completely neutral and plain. She is lit so that there are no shadows on her face. Similarly, the background is devoid of shadows. The setting is stripped of anything that might mark the place she occupies when the photos are taken. While her face remains without emotion in these images, the parts of her face that are obscured suggest the possibility of affects and feelings embedded within these portraits. Low smuggles emotion into these images even as she captures its evacuation.

These "self-portraits" are part of a larger project called *Self-Serve at La Pagode Royale* that deals specifically with questions of cultural identity through the locus of the Chinese restaurant. Her questions about the function of the Chinese restaurant as a space of negotiation for cultural difference point directly to the contradictions of diasporic citizenship. She notes in her artist's statement:

> I am interested by the conundrum within cultural identity and ethnicity: whereby the desire of the immigrant to assimilate into the economy eventually compromises their own cultural identity . . . Chinese restaurants . . . "serve up" notions of an ethnic or exotic "other" according to what they feel their clientele wants or expects . . . what are the things that become cultural signifiers? What are the experiences we hold on to and perpetuate?
>
> (Low n.d.)

Low marks the difficulty of negotiating the specificity of diasporic difference where economic assimilation relies upon a performance of that difference which risks exaggerating and stereotyping it. Difference must be objectified in order for it to slide seamlessly into a larger cultural whole. In asking what it is that the diasporic subject holds onto, Low also implicitly asks what it is that the diasporic subject must let go of too.

Using objects that are almost excessively Chinese in their decorative plasticity, Low's portraits illustrate how diasporic difference carves emotion out of the picture and, at the same time, insists upon it through the stark fact of its absence. Emotion may seem to be lost, but it is actually palpably present in its very obscurity. In obscuring the face, and parts of it, Low's images draw a connection between emotion, self-identity and facial expression. As Silvan Tomkins notes, "the self lives in the face, and within the face the self burns brightest in the eyes" (Tomkins 1995: 136). Notably, two out of three of these portraits obscure Low's eyes. Tomkins's work drew on Charles Darwin's (1998 [1889]) studies of emotion and facial expression. As Paul Ekman reports in his afterword to Darwin's *The Expression of Emotion in Man and Animals*, "Tomkins' ideas about expression were consistent with what Darwin had written" (Ekman 1998: 374). Setting aside the longstanding debate about whether or not the facial expression of emotion is innate and universal across cultures, both Darwin (1998 [1889]) and Tomkins (1995) anchored their study on the face and the connection between facial expression and emotion. Let me bring the work of Darwin and Tomkins into dialogue with that of Terada by considering this implication: if emotion lies in its representation, then the face must be one of the most powerful mediums of

emotional expression. The passport photograph and Low's portraits suggest that there is indeed a strong possibility for the expressive potentiality of the face to expose the contradictions of citizenship.

Not only is Darwin's study (1998 [1889]) of the face so resonant for thinking about emotion and expression, the process by which he arrived at the visual evidence for his thesis also recalls the fine line between humanity and monstrosity for emotional expression. It is a process that in and of itself is richly suggestive of the contradictions of citizenship. Darwin's study relied upon a number of photographs of various facial expressions taken by Oscar Rejlander, James Crichton Browne, Guillaume-Benjamin Duchenne de Boulogne, Adolph Diedrich Kindermann and George Charles Wallich. As Philip Prodger notes in his essay, "Photography and *The Expression of Emotions*," Darwin's book "was one of the first scientific books ever published with photographic illustrations" and it thus "played a major role in bringing photographic evidence to the scientific world" (Prodger 1998: 400–401). For Darwin, photography would allow people to see emotions that were otherwise too fleeting. Prodger points out that Darwin was particularly interested in capturing "the ephemeral movements of facial muscles for analysis" (Prodger 1998: 403). Darwin partly solved this problem by using a series of plates taken by Duchenne of a patient at La Salpêtrière hospital upon whom a number of electrical experiments were being carried out. The patient "suffered from an anaesthetic condition of the face, which made it possible to stimulate individual groups of his facial muscles without causing involuntary response among others. It was as if, as Duchenne chillingly remarked, he were 'working with a still irritable cadaver' " (Prodger 1998: 405). Because photographic processes had not accelerated enough to capture the emotions Darwin wanted to reveal, Duchenne's plates froze "the activity of his subjects long enough to accommodate the lengthy exposure times necessitated by photographic technology" (Prodger 1998: 405). That is, in order to illustrate emotion, Darwin had to turn to images of a man who had completely lost the capacity to express emotion, who was a cadaver-like zombie requiring electrical stimulation to show emotion. That some of the most exemplary images of emotional expression in Darwin's work relied upon a figure whose face had lost feeling recalls that other ideally emotional void figure, the contemporary citizen. There is a perverse irony in the contemporary demand by the state for images of its citizens that are devoid of emotion. Now that photographic technology has accelerated to the point where a whole range of nuances of expression could be captured, there is no small contradiction in the demand for an image of citizenship that must hold any of those emotions at bay long enough for the citizen to adopt the expression of Duchenne's patient.

The demand for emotional neutrality in the passport photograph encapsulates the contradiction of citizenship even as Low's self-portraits illuminate them. As I have been arguing, the contradiction of citizenship lies in being both diasporic and a citizen where the diasporic subject's divided feelings for "home" challenges citizenship's demand for a subject whose feelings are undivided. This contradiction emerges from the demand for the capacity to feel despite the injunction against emotion in the very document that identifies one as a citizen.

Azoulay's civil contract of photography plays out in very literal ways in the passport photo and in Shelly Low's subversion of the conventions of the identification photograph. Stripping away anything that might obscure identity anything that might distract from the task of recognition, the passport photo announces its engagement

with the civil contract in its open claim for recognition. Low's self-portraits expose the ways in which race always already frustrates recognition. The overtly Chinese objects she uses to obscure parts of her face highlight race as something that can be *over-identified*, so overt that it can frustrate recognition. As Katherine Biber notes of her examination of race and photography in the case of crime scene photos that were used to accuse an Australian aboriginal man of a bank robbery, there is a "fantasy that permits law to imagine that decades of criminological, historical and cultural inquiries into race and representations, dispossession and deviance had not intercepted its capacity for vision" (Biber 2007: 5). The representation of the racialized subject in an identification photograph calls attention to the dangers of misrecognition and the instability of the connection between the photograph and its subject. For the viewer, any identification photograph poses the silent question: Is that you? The request for an identification photograph is a question of one's identity. It is a demand for proof even before the question has been asked.

Shelly Low's "Self-Serve" portraits are a response to the demand for unfeeling subjectivity made by the state in the name of citizenship. In echoing the visual protocols of the passport photo, albeit with a difference, they highlight the complicated relationship between feeling and citizenship. As Terada's work emphasizes, feeling alone will not make human subjects more human and thus feeling alone cannot mediate the contradictions between citizenship and humanity embedded within the origins of contemporary citizenship. Perhaps only when the distance between the human and the citizen can be recognized in that alienating moment of experiencing oneself as though one were somebody else, and one's home as though it were somebody else's, will citizenship come close to fully embracing the bonds of affect.

Original publication

Citizenship, Diaspora and the Bonds of Affect: The Passport Photograph, *Photography and Culture* (2009)

References

Agamben, Giorgio. 2000. *Means without End: Notes on Politics.* Trans. Vincenzo Binetti and Cesare Casarino. Minneapolis and London: University of Minnesota Press.

Azoulay, Ariella. 2008. *The Civil Contract of Photography.* New York: Zone Books.

Biber, Katherine. 2007. *Captive Images: Race, Crime and Photography.* London: Routledge.

Cole, Simon. 2001. *Suspect Identities: A History of Fingerprinting and Criminal Identification.* Cambridge, MA: Harvard University Press.

Darwin, Charles. 1998 [1889]. *The Expression of Emotion in Man and Animals.* Oxford: Oxford University Press.

Ekman, Paul. 1998 [1889]. Afterword. In Charles Darwin, *The Expression of Emotion in Man and Animals.* Oxford: Oxford University Press, pp. 363–393.

Low, Shelly. n.d. Self-Serve. *Self-Serve at La Pagode Royale.* Available at www.lapagoderoyale.ca/, accessed September 2, 2008.

Maslan, Susan. 2004. The Anti-Human: Man and Citizen before the Declaration of the Rights of Man and of the Citizen. *SAQ: South Atlantic Quarterly* 103 (2/3): 357–374.

Maslan, Susan. 2006. The Dream of the Feeling Citizen: Law and Emotion in Corneille and Montesqui. *SubStance # 109* 35 (1): 69–84.

Mishra, Vijay. 2005. Postcolonial Differend: Diasporic Narratives of Salman Rushdie. In *Linked Histories: Postcolonial Studies in a GlobalizedWorld*, eds. Pamela McCallum and Wendy Faith. Calgary: University of Calgary Press, pp. 111–144.

Passport Canada. 2008. *Canadians-Passport Photos: Step-by-Step Guide*. Available at www.pptc. gc.ca/cdn/photos.aspx, accessed September 2, 2008.

Prodger, Phillip. 1998 [1889]. Photography and *The Expression of Emotions*. In Charles Darwin, *The Expression of Emotion in Man and Animals*. Oxford: Oxford University Press, pp. 399–410.

Salter, Mark B. 2003. *Rights of Passage: The Passport in International Relations*. Boulder, CO: Lynne Reiner.

Terada, Rei. 2001. *Feeling in Theory: Emotion after the "Death of the Subject"*. Cambridge, MA: Harvard University Press.

Tomkins, Silvan. 1995. In *Shame and Its Sisters: A Silvan Tomkins Reader*, eds. Eve Kosofsky Sedgwick and Adam Frank. Durham, NC: Duke University Press.

Torpey, John. 2000. *The Invention of the Passport: Surveillance, Citizenship and the State*. Cambridge: Cambridge University Press.

United Kingdom Home Office, Identification and Passport Services. n.d. *Passport Photographs*. Available at www.ips.gov.uk/passport.downloads/photos.pdf, accessed February 18, 2009.

United States Department of State. n.d. *Guidelines for Producing High Quality Photos for U.S. Travel Documents*. Available at http://travel.state.gov/passport/guide/guide_2081.html, accessed September 2, 2008.

Snapshot culture and social media

Instagram 637122212 [Original in colour]. alexsl/iStock.

Introduction

S **NAPSHOTS ARE PROLIFIC YET,** perhaps paradoxically, historically on the whole they have been hidden from general view. Amateur photography is an active area of image-making, to an extent only relatively recently acknowledged since photos were destined largely for the privacy of the family album. Indeed, even now, online albums are often password protected, for sharing with friends and relatives rather than more broadly. Slippages from containment do, of course, occur when images are distributed via social media and, in some cases, go viral. There are frequent accounts of photos being circulated as a means of harassment or bullying within school and college communities, professional or political groups that raise new ethical issues relating to image usage.

The notion of 'snapshot' culture arguably dates from the 1880s, when Kodak first introduced a handheld box camera with the marketing slogan 'you press the button, we do the rest'. They promoted the idea that anyone could make a photograph. Initially the camera had to be returned to the manufacturer for film to be processed. By the middle of the twentieth century, exposed films, typically with 24 or 36 frames, were dropped off at a local chemist or sent away, to be received back some days later as strips of film and sets of prints. Kodak's everyone-can-do-it campaign was similar in spirit to contemporary camera phone marketing; the intention was to promote participation (through purchase of relevant equipment). Of course, although the shot may have been relatively instantaneous, nothing else was; the technologies (film vs digital) and the time between shooting and viewing were very different. Integral to photography then was a deferral of visual gratification that, it might be assumed, would cause great frustration nowadays given 'Instagram' culture, with its emphasis on immediacy of communication. The shift in lens culture within the amateur sphere has been extensive.

The five essays that follow variously address developments in the making, circulation, accumulation and use of vernacular images. A distinction between 'vernacular' and 'amateur' is appropriate. Amateur (from the Latin verb, *amar*, to love) basically refers to activities pursued for pleasure, rather than intended for professional purposes, recognition or financial gain. This does not exclude serious interest in photography; many now acknowledged as major artists were technically 'amateur' (e.g., British Victorian female photographers Julia Margaret Cameron and Lady Constance Hawarden, whose staged-at-home portraits of family and friends have been singled out from the family album for broader acclaim). Vernacular is less simply categorized. The term references notions of the domestic, indigenous or native in the sense of regional dialects or cultural traditions (by contrast with dominant culture). It often coincides with amateur image-making but also encompasses arenas such as wedding, cruise or holiday resort photography pursued by commercial photographers, with ensuing prints often making their way into albums alongside those shot by friends or relatives.

In 1991 Jo Spence and Patricia Holland co-edited a key collection significantly titled *Family Snaps*. Here, the emphasis is on personal collections offering versions

of family history and relations. Prints were assembled in albums, with women most commonly acting as editor or keeper of family memories that offered a relatively permanent record that tended to focus on specific events, such as births, parties, Christmas and holidays. The act of photographing itself becomes a part of the occasion, testifying to its exceptionality, in contrast to the banality of daily life. In her chapter, Holland links snapshots and their significance to the ideological centrality of the family unit within western social structures. Although albums may appear similar, individuals have particular emotional attachment and responses to their 'own' family narrative. Such visual story-telling functions in part as a means of situating ourselves in response to the cultural complexities and messy contradictions of actual experience. Martha Langford particularly focusses on ideological processes, speculating on the shifting resonances of images relocated from one context and purpose to another. Noting claims for appropriation as a radical gesture within art in the postmodern era, she reminds us that found imagery has had a regular presence within avant-garde practices historically and questions whether any aspect of the specificity and private mode of vernacular photography survive when resituated within an art context.

So what does vernacular photography look like now, globally? Defining photography as a key contemporary medium of exchange, Geoffrey Batchen reflects on the challenge of exploring and questioning the implications of the massive repository of images shared within sites such as Facebook, Flickr and Cyworld. He takes Joachim Schmidt's ethnography of the Internet as a starting point, with the caution that, given the scale of imagery accumulated and circulating online, imagery gleaned for his photobook collections is inevitably selective, anecdotal in terms of research aiming to comprehend the extent and implications of online accumulation.

Lev Manovich investigates the use of metadata to research camera usage. What can be learnt about the photographic behaviour of locals or tourists through mapping the locations where photographs uploaded to Flickr were taken? What can be learnt about form, genre and detail through digitally aggregating, for example, the 20,000 photographs that constitute the collection at MoMA in New York? Examining results, he concludes that the complexity of patterns of visual behaviour cannot be conveyed through any single visualization, whether cartography or photographic. Indeed, that this might even be attempted seems ambitious. As Daniel Rubenstein and Katrina Sluis point out, in the final essay included in this section, since the advent of digital cameras, especially camera phones, photography has become even more ubiquitous. They trace the transformation from print to screen-based imagery, reflecting on the ontological implications of a convergence of the still image with existing media forms. They suggest that the networked vernacular image is 'camouflaged' as not significant, benign and apolitical, thereby often not attracting critical attention. They also remark a shift within theoretical interrogation of the digital from concern with indexicality and evidential authenticity to questioning the power of surveillance and reflecting on the implications of image accumulation, digital lifestyles, and the transient status of imagery within mass online circulation.

Bibliography of essays in Part 4

Batchen, G. (2013) 'Observing by Watching: Joachim Schmid and the Art of Exchange', *Aperture* 210, Spring, pp. 46–49.

Holland, P. (1991) 'Introduction', in Jo Spence and Pat Holland, *Family Snaps*. London: Virago. pp. 1–14.

Langford, M. (2008) 'Strange Bedfellows: Appropriations of the Vernacular by Photographic Artists', *Photography and Culture* 1(1), pp. 73–94.

Manovich, L. (2014) 'Watching the World', *Aperture* 214, Spring, pp. 48–51 (2 b/w; 1 col).

Rubenstein, D. and Sluis, K. (2008) 'A Life More Photographic: Mapping the Networked Image', *Photographies* 1(1), pp. 9–28.

Patricia Holland

FAMILY SNAPS, INTRODUCTION
History, memory and the family album

Making and preserving a family snapshot is an act of faith in the future. Looking back at these modest records, made precious and mysterious with age, is an act of recognition of the past. But interpreting family pictures poses a series of challenges to different pasts, as memory interweaves with private fantasy and public history. Dreams of home and a need for belonging come up against the conflicts and fragmentations of family history, indeed of overlapping family histories, since each individual – as daughter or son, spouse, parent, step-parent, grandchild, second spouse, aunt, uncle and so on – moves through many family groupings.

A family album holds a profusion – a confusion – of pleasures and pains, as pictures old and new offer themselves up with deceptive innocence. Family collections are never just memories. Their disconnected points offer glimpses of many possible pasts, and yet, in our longing for narratives, for a way of telling the past that will make sense in the present we know, we strive to organise these traces, to fill in the gaps. Each viewer makes their own tracks through the album. Each new generation brings new perspectives, new understandings and new forgettings. For me that cheeky toddler may be an estranged brother; for you, the young man in football gear may be the elderly Australian relative you plan to visit. The laughing young mother may be sick or dead. No one may remember the proud old lady standing by her garden gate. Many faces are forgotten, and the fashions of earlier decades make us laugh. Yet the powerful claims made by family ties offer a structured framework to our sense of identity and community.

At a time when the family group – at least in the overdeveloped West – is fragmented and atomised, images continue to be produced which reassure us of its solidity and cohesion. The compulsive smiles in the snapshots of today insist on the exclusive claim of the family group to provide satisfying and enduring relationships, just as the calm dignity of earlier pictures emphasised the formality of family ties.[1]

Recording an event has become part of that event – and perhaps the most important part; for, however untidy or unsatisfactory the experience, we can ensure that

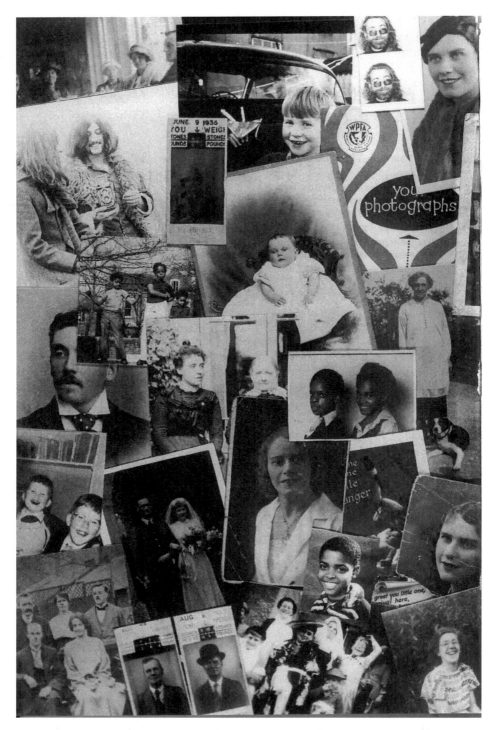

Figure 25.1 *Montage of Family Photos.* Courtesy of Pat Holland.

the picture will project the appropriate emotions into the future. The children's party may bring tantrums, but the pictures will show laughter. The holiday may be spoilt by rain, but it will be the sunny days that make it to the family album. The longed-for cohesion of the family group is secured in the imagery, each individual moment set to take its place in the measured progress of the generations.

Unlike the social historian, the owner of an album does not look for the 'truth' of the past. Instead, we give it our own recognition, just as, when we make a picture, we commit our present to be recognised by an unknown future. Small wonder that a family album is a treasured possession, nervously approached for its ambiguities, scrutinised for its secrets, poignant in its recall of loves and lovers now dead. It interweaves the trivial and the intense, the moment and the momentous, as it challenges any simple concept of memory.

Everyone's family album contains a set of pictures which, at first glance, are familiar and predictable, beginning with the careful monochromatic poses of the turn of the century, then bursting from the covers under the sheer volume of informal snaps which tumble through today's letterboxes. Yet our 'own' family pictures, however ordinary, remain endlessly fascinating as we scrutinise them for exclusive information about ourselves. The images of relatives we never knew but whose influence is felt, reminders of the optimistic youth of our parents and their parents, these things seem to throw light on our present condition. And it is here that we find, amongst these many faces, the shocking image of our earlier selves. The experience is unparalleled, for, unlike the mirror-image – which, however intensely studied, is fleeting and can be retained only in a memory which may idealise or degrade – here we can gaze at layers of our past being. We see a child, an adolescent, a young adult, unfamiliar, held in place by someone else's lens. We tell ourselves, often with incredulity, that *this* is where *we* once were. This pictured body was once the centre from which we experienced the world. And we ask ourselves how our subjective memory can be aligned with the exterior image.

The intensity of one's own family photographs can never be matched by someone else's. We invest our own album with the weight of childhood experience, searching it for information, pouring into it our unfulfillable desires. We bring an emotional involvement as well as a practical knowledge to the people and events we find between its covers. Family photography does not seek to be understood by all. It is a private medium, its simple imagery enriched by the meanings we bring to it. An 'outside' interpretation, an assessment of someone else's album, moves into a different realm: of social history, ethnology or a history of photography.

And yet, this most private of collections is also thoroughly public. Its meanings are social as well as personal – and the social influences the personal. Family photographs are shaped by the public conventions of the image and rely on a public technology which is widely available. They depend on shared understandings. Private interpretations which may subvert collective meanings are considered disruptive and discouraged. But above all, the personal histories they record belong to narratives on a wider scale, those public narratives of community, religion, ethnicity and nation which make private identity possible.

Snapshots for family albums are willingly restricted to modest public codes and rarely aspire to technical or artistic merit. They have none of the pretensions of amateur photography which strives for aesthetic control of the medium. There is

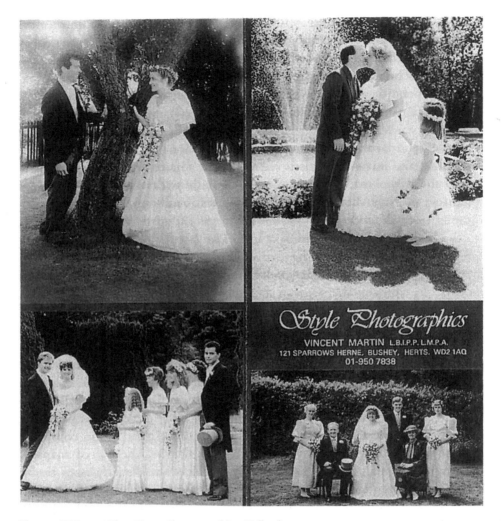

Figure 25.2 *Wedding Photos.* Courtesy of Pat Holland.

no attempt to conceal the process of picture-taking – participants present them-
selves directly to the camera in an act of celebratory co-operation. Everyone knows
what to expect from a family picture. If subject matter or visual style breaches the
conventions, the effect is less satisfactory. When high-street photographers are com-
missioned, it is because their work conforms. Experimentation or innovation are
not welcome, and intrusive 'artistic' elements, or a naturalism that attempts to 'get
behind the mask' would not keep faith with the client. Wedding pictures, perhaps
the commonest of professionally made family photographs, must show certain sym-
bolic moments and certain significant people to the best effect, or their point is lost.
The fascination of such pictures is precisely this embrace of the conventions. Pic-
tures which match up to expectations give enormous pleasure, partly because their
familiar structure is able to contain the tension between the longed-for ideal and the

ambivalence of lived experience. This is not to suggest that we should compare the image and 'reality', but that we are offered a framework within which our understandings of various realities can come into play.

The pictorial conventions of snapshot photography are dependent on widely accessible technology – cameras which are easy to use, films within the pocket of all but the poorest. The market dominance of Eastman Kodak, discussed in this book by Don Slater, has led to a situation where the sale of cameras and film is largely controlled by a single company, whose profits depend on responding to and shaping the use of snapshot photography as an important component of leisure. Their famous slogan 'You push the button, we do the rest' stressed their aim to make the process as simple and accessible as possible. Cameras and film have been developed with the family in mind.

Changes in technology have paralleled changes in the nature of both families and ideas about families in Western culture. As expectations have come to centre on the privatised security of the home, contemporary snapshots have been required to record the unguarded moments of domestic pleasure. Everyone wants pictures of their holiday – and these have been the easiest pictures to take, with bright sunlight, full-length figures and small groups. The coming of built-in flash has meant that snapshots have moved indoors and Christmas and birthday parties are added to the repertoire. Other types of picture are more difficult and need more complex equipment – hence we rarely see close-up portraits, shadowy interiors or larger groups among our snaps. Technological change influences the stories we tell ourselves about family life.

For most makers of snapshots, control stops with the moment of exposure. The developing, cropping, printing – the manual involvement with the process which is all-important for other forms of photography – are here concealed and taken for granted. These pictures plop through the letterbox, as if delivering themselves up, just like that, completed by invisible or mechanical hands. Such immediacy confirms the illusion of innocence and transparency of the snapshot, as if a mere blink of the eye could transform the mundane retinal image into a sparkling picture, always properly exposed, in sharp focus and neatly contained within a $3\frac{1}{2} \times 5$ inch border.

The 'naive' conventions of the 'private' snapshot, deeply embedded through participatory usage, are drawn on by 'public' modes – in particular advertising and publicity photography – which, unlike the snapshot, aim to be understood by as wide an audience as possible.

In many an advertisement, precious moments snatched from family life are isolated and heightened, purged of the irrelevancies and inconsistencies that go along with real snapshooting. In turn such multiplicities of perfected images, such immaculately happy families, themselves influence our domestic practice, teaching us how to stage our own pictures and perform for our own contemporary albums. The threading of public meanings through the private medium of family photography poses again and again the puzzle of the family album. Our understandings must shift from an 'inside' to an 'outside' perspective and back. Neither position has much to say to the other, but neither is enough by itself.

The family group remains a centre of fantasy – of romantic social fantasy, and of those fantasies which spring from our earliest infant lives. Family pictures are pulled into the service of these overlapping dreams – hence the ambivalence of the pleasures they give.

Michèle Barrett and Mary McIntosh have described how contemporary British society gives priority to an institution that is at best only partial and exists chiefly in

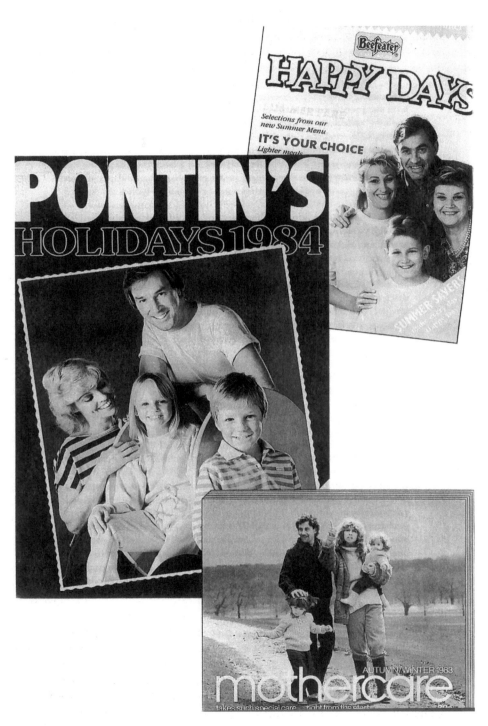

Figure 25.3 *Pontin's, Beefeater* and *Mothercare* brochures. Courtesy of Pat Holland.

what they call a 'familial' ideology which exerts pressure on public policy and social life.[2] Family albums echo that ideology as childhood and leisure times are obsessively recorded. The camera is part of a lifestyle based on house, garden and car which moulds the aspirations of the suburban nations of the prosperous West. In this vision, actual geographical location is of decreasing importance and the consumption of goods and services superficially claims to transcend class and restructure gender. For this is where the new father can build up a closer relationship with his children and take on some of the more pleasurable tasks of domesticity. This is the warm, exclusive, perfected family which today's snapshots seek to put on record – just like the ads.

But in our daily lives the bonds of family are crossed by many others, and even our familial experiences are by no means confined to the small, nuclear group. Although drawn together for the heightened moments which appear in albums, the different family members may well inhabit different 'worlds'. There are communities where women and men lead lives whose networks and social contacts hardly overlap. Members of different generations can be part of differing cultures, whether they have migrated across continents or remained a few streets from their origins. Family moments – even amongst those who come closest to the ideal – are only part of lives made up of school, work, interests, political action and institutional commitments, each bringing its own network of friends, companions and obligations. These other networks and solidarities are not made visible in the conventional family album. The worlds of production, politics, economic activity and the institutional settings of modern life – school, hospital, baby clinic – are only tangentially present. As Michèle Barrett and Mary McIntosh argue, 'the overvaluation of the family devalues other lives'.[3]

Often guarded by a self-appointed archivist, albums construct their own versions of family history, in negotiation with the ideal. Aware of the ever-present possibility of scandal, they will include significant moments and suitable family members and rigorously exclude others. Difficult individuals like divorced spouses and nonconforming siblings tend to be absent. Sickness, disease and disability are barely visible. Illegitimacy is concealed. Horrors which recent campaigns have shown to be all too frequent, like child abuse and wife beating, cannot be hinted at. Problems are suppressed, if only for the split second that the shutter is open.

We could ask: for whom is this image so carefully, so spontaneously manufactured? Family photography is not expected to be appreciated by outsiders, yet there is a need to produce the correct pictures, as if the audience were the public at large. Is each individual looking for their own ideal image? Are members of the group presenting themselves for each other, or for unknown 'others', for future generations? Is this a joint self-celebration, or is it a presentation of the imagined family group for the critical scrutiny of outsiders – even if those outsiders are never expected to see it?

Of course not all members of the family have the same relationship to the pictures in the album. The father is least visible, for it remains his role to handle the apparatus that controls the image, to point, frame and shoot. Yet from the earliest days advertisements for cameras have shown women behind the lens. This is, no doubt, a device to indicate how simple it is to take a snap; nevertheless it demonstrates a form of photography in which women are urged to participate. Even now it is difficult for a woman to become a fashion photographer, a photojournalist or an advertising photographer, but any woman can take a snapshot. Like preparing the meals and washing the clothes, this too, located in home and family, is sold as a domestic skill.

Figure 25.4 *Kodak Images.* Courtesy of Pat Holland.

As the late twentieth century asserts yet again women's domestic role, the album underlines the ways in which home remains their particular sphere and the care of children their life's task. However, it is largely they who have become the historians, the guardians of memory, selecting and preserving the family archive. The continuity

of women's stories has always been harder to reconstruct, but here, the affirmation of the everyday can itself reassert the coherence of women's memories. In her chapter, Claire Grey traces back seven generations of mothers and daughters and compares their lives.

Women have pioneered forms of writing about the past which explore areas tangential to the mainstream of political and economic change. As with other marginalised groups, forms which are themselves marginal, impure, apparently trivial have offered ways of seeing the past which insist on linking the personal with the political, the mundane with the great event, the trivial with the important. Blurring the boundaries between personal reminiscence, cultural comment and social history, paying attention to the overlap between history and fantasy, using popular entertainment, reading official histories between the lines and against the grain, these exploratory styles fit easily with the *bricolage* and loose ends of the family album. The majority of contributors to this book are working in this tradition.

The most ardent makers of family pictures are parents of young children. As adults we take some of our greatest pleasures from the next generation, but our meeting with our past selves on those earlier pages brings a very different response. As we leaf through our album, reviewing the different positions we have taken in the overlapping families pictured there, we may easily swerve from a sentimental nostalgia to an angry rejection of remembered pressures. The shifting perspectives on childhood compared across the generations become uneasy and contradictory. The album forces us to negotiate with our personal memories and offers an unpleasant jolt when memory does not correspond with image. 'We were not happy then', we cry. 'Oh, yes', others respond, 'you were. And here is a picture of you to prove it'. We may feel ourselves to have been on display, shown rather than showing, the pictures concealing our 'real' experience. Or the effectiveness of the disguise may be sufficiently disturbing to force us to question those very memories. Annette Kuhn and Simon Watney both explore these themes, showing us how family albums are about forgetting as well as remembering.

The social nature of family photography is subverted by readings which are too private, too individual, too difficult to deal with. Such readings of family snaps can rend apart their opaque and cheerful surface, as the unconscious – literally unspeakable – threatens the publicly secured privacy of the family group. The work of Jo Spence and Rosy Martin explores this space of disruptive meanings. By taking their childhood memories, as expressed in their family pictures, and working with them, they produce new images in a painful but illuminating and often witty visual commentary on family and photography.

Snapshots are part of the material with which we make sense of our wider world. They are objects which take their place amongst the other objects which are part of our personal and collective past, part of the detailed and concrete existence with which we gain some control over our surroundings and negotiate with the particularity of our circumstances. Snapshots contribute to the present-day historical consciousness in which our awareness of ourselves is embedded, part of what Zygmunt Bauman describes as the 'historical memory' of a group, 'ploughed into its collective actions, which finds expression in the group's proclivities to some rather than other behavioural responses, and is not necessarily recognised by the group as a particular concept of the past'.[4] In this collection of miniature tableaux the moments are

disjointed and displaced, like a fading memory or one that has lost its organising links. But in the act of collection and handling, a sense of historical movement is produced. The principles of selection and arrangement are exercised to tell a story of progress or decline, to construct a sense of period and to hint at major historical shifts. It is never more than a hint, for in the album, when family and politics cross it is always family which takes priority, as if the politics could be denied. Major disruptions may be lived through, but personal relations dominate the images. Political change is embedded, rarely visible on the surface.

Capitalism, in its latest triumphant phase, requires high wages and stable populations arranged in centres of consumption. For the moment, the pared-down Western family group fits the bill. Old-style patriarchal conservatism is able to ally itself with new-style, free-market ideologies. But at the same time, the global economic system wrenches families apart as the need for low-paid workers and low-priced commodities creates unemployment and forces men and women to move between towns and across continents in search of security. This is where the tragedy and violence of economic change is lived through as people become migrant workers, immigrants, refugees, enforced spouses who must all travel, often illegally, to escape poverty or oppressive regimes. Leanne Klein writes on the trade in brides from the Philippines, marketed through their photographs, their exploitation made possible through the linked ideologies of family, sexuality and racial superiority.

A discussion of ethnicity and cultural identity in relation to such upheavals is central to any consideration of the meaning of 'family' and the way families represent themselves to themselves and others through their photographs. The actuality of much family history is concerned less with continuity than with disruption, dispossession and cultural, religious and ethnic mixing. 'Critical theories are only just *beginning* to recognise and reckon with the kinds of complexity inherent in the culturally constructed nature of ethnic identities', write Isaac Julien and Kobena Mercer, arguing that 'race' will no longer do as a separate category.[5] Adeola Solanke, as a British Nigerian, discusses black people's use of family photography to reclaim links which have been broken by centuries of domination. Andrew Dewdney's 'More than Black and White' is a parallel set of family collections made by contemporary dwellers in Australia, which illustrates the interwoven complexities of shifts across continents, driven by trade, empire and war. This sort of historical exploration faces the challenges posed by comparison and juxtaposition, in contrast to the romantic obsession with 'roots' – particularly in the United States and the 'New World' – which searches back to Central Europe, Ireland and Africa for a lost authenticity.

The work of Andrew Dewdney and his collaborators shows how the groupings which make up families shift and re-form, unsettling any simple sense of continuity or locality. We continue to dream of home, but how do we place ourselves amongst our multiplying ancestors? The different 'homes' we are offered may each be as strange as the other.

Traditional family albums eschew such fluidity. There we find a series of judgements about who does and does not 'belong' to the group. In families where a lighter colour is valued, members with a darker skin may be pushed to the margins. As Benedict Anderson writes, 'Racism dreams of eternal contaminations',[6] a theme elaborated by Stuart Hall.

A modern contribution to the workings of race and ethnicity in family photographs is the increasing visibility of foreign travel. Even moderately prosperous

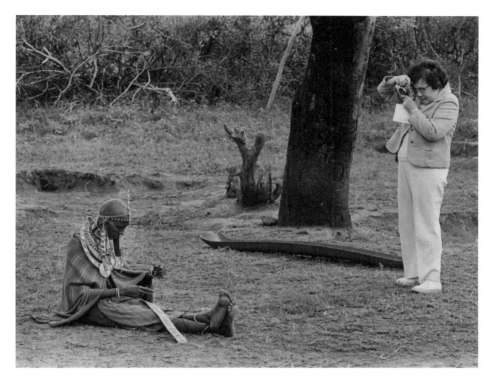

Figure 25.5 *Tourist in Africa*. Courtesy of Pat Holland.

Western families are following travel agents to more and more 'exotic' locations, and part of that experience is photographing the people they find there. The economic survival of parts of Southern Europe depends on the marketing of their landscape and their 'characters' as well as their tavernas, discos and beaches. The people of these regions must themselves be preserved, together with their culture, as quaint, colourful and entertaining. Just like the brides from the Philippines, they must sell themselves and their image, donning a mask of authenticity for the tourists' cameras.

The commodification of people made possible by photography parallels the commodification of history made possible by representations of the past, including old family pictures. In the last twenty years there has been a revival of history from below, a history of everyday life and everyday consciousness. In this context domestic pictures have gained a new currency, contributing to a different sense of the past and different ways of exploring that past. The history workshop movements which have flourished in Britain since the 1970s have aimed to bring to light the history of previously excluded groups – women, black people, ethnic minorities. Jo Stanley's account of a photo-archive project in the London Borough of Wandsworth is an example of such work, seeking to reveal struggles at the micro level against forms of political, economic, race and gender domination. These are reread as political struggles, even though their participants do not recognise them as such. What is not clear from such work is how the experience of solidarity can be used to generalise rather than exclude.

Any history of a local community must face up to intolerant, exclusive and racist behaviour. The documented memories of established white localities are very threatening to minority groups. A too-easy celebration of the concept of community can lead us to overlook such problems.

At the same time, a less political movement has been based on local history societies and family history networks. Local studies sections and archives in libraries are increasingly giving domestic photographs and family albums an important place amongst their records. Journals of local history and family history flourish. But the more commercially minded 1980s moved hastily on to a commodification of nostalgia in which old family pictures play a part. They are displayed in museums and are up for sale in the antique shops and arcades which are a feature of British towns and villages newly reconstructed, with tourism in mind, as present-day replicas of their earlier selves.

The leisure-based trek to the countryside, within nations as well as on the overseas tourist circuit, has resulted in a folklorising of people and their image as well as of buildings and landscape. Here a vision of a nostalgic national and regional past is constructed which parallels the continuous family history dreamt of by many an album. It is a vision of separate but harmonious regional cultures: the Scottishness of Scotland, the antiquity of the City of London, the ruggedness of Cornish fishing villages – each is presented with its own history, as if uncontaminated by outside influence. The search for an 'English' heritage has led to more information, more writing and publication about localities than ever before. But the evocation is of 'precious and imperilled traces'[7] against a speeding-up of time and the all-consuming power of technology. The stately homes to visit, national parks to drive through, souvenirs to purchase, combine to give an impression of an ancient nation, a harmonious totality rooted in a distant, evocative, rural past rather than formed by a recent, urban, multiethnic, conflictual one. The meaning of 'community' is becoming folklorised.

This seductive vision of the past provides an easy structure within which to place more personal accounts. Family lore itself contains what Raphael Samuel describes as 'romantic primitivism', 'a yearning for the lost solidarities of the past'.[8] Family albums can lose their dangerous ambiguities to become part of an 'infrastructure of popular memory',[9] of popular accounts of history – through novels, films, television – which reinforce a sense of national and cultural identity. It is in family rituals that 'our' ways of doing things, 'our way of life', is acted out.

In his famous commentary on history and memory, Walter Benjamin wrote: 'To articulate the past historically does not mean to recognise it "the way it really was" (Ranke). It means to seize hold of a memory as it flashes up at a moment of danger'.[10] The difference between a folkloric sense of the past and one which is dynamic in the present is at the heart of the discussions in this book. It is the difference between an antique shop past, with its smell of new wax polish accompanying fading prints in dark wooden frames, and one's own past, with its ambivalent and uneasy memories. Family photography can operate at this junction between personal memory and social history, between public myth and personal unconscious. Our memory is never fully 'ours', nor are the pictures ever unmediated representations of our past. Looking at them we both construct a fantastic past and set out on a detective trail to find other versions of a 'real' one.

Much has been made of the destabilising recognition that there can be no final, 'true' history to be discovered. However, there are other histories to be written, embedded in the old, interpreting, reconstructing, making sense of events in less dominant ways. Against a folkloric 'people's history' which leaves the power politics of official histories untouched is the recognition of politics in another form, working itself out through the detail of everyday life and reclaimed from records, like snapshots, which are outside the authority of legitimised knowledge. Homi Bhabha writes: 'Interpretation is the first condition of empowerment and it may be the last word of tyranny', even though 'the politics of interpretation are dangerous and ambivalent'.[11] Family photography may both conceal and reveal, but its investigation can never end with the closed circle it appears to represent. We are always returned to an interpretative community and faced with the recognition of difference and dissent.

Original publication

'Introduction' in Jo Spence and Pat Holland *Family Snaps* (1991)

Notes

1 Julia Hirsh, *Family photographs: Content, Meaning and Effect,* Oxford University Press, 1981.
2 Michele Barrett and Mary McIntosh, *The Anti-social Family*, Verso, 1982.
3 Barrett and McIntosh, pp. 76-80.
4 Zygmunt Bauman *Memories of Class,* London, 1982. Patrick Wright, *On Living in an Old Country,* Verso, 1985, discusses these issues.
5 Isaac Julien and Kobena Mercer, 'De margin and de centre', *Screen,* vol. 29, no. 4 : 'The last special issue on race ?', p. 3.
6 Benedict Anderson, *Imagines Communities*, Verso, 1983.
7 Wright, *On Living in an Old Country,* Verso, 1983, p. 2.
8 Raphael Samuel, 'People's History', p. xxii in Raphael Samuel (ed.), *People's History and Socialist Theory,* Routledge & Kegan Paul, 1981.
9 Graham Dawson and Bob West, 'Our finest hour', in Geoff Hurd (ed.), *National Fictions,* British Film Institute, 1984.
10 Walter Benjamin, No. VI of the Theses on the Philosophy of History in *Illuminations,* Fontana, 1970.
11 Homi Bhabha, 'Novel metropolis', *New Statesmen and Society,* 9 February 1990, p. 17.

Martha Langford

STRANGE BEDFELLOWS
Appropriations of the vernacular
by photographic artists

This quality that is not in life but in the image of life, how should we define it?

Edgar Morin 1956

THE PHENOMENON IS HARDLY NEW: artists' affiliations with the vernacular emerge on a cyclical basis throughout the history of photography. Twentieth-century bursts of activity include Dada photomontage and the Snapshot Aesthetic, the former recycling materially, the latter stylistically, images of non-artistic extraction. While these episodes make room for the vernacular in an art history of photography, entrance is limited to images that have been touched by the hand of an artist. The other's photographic object – the raw material and source of inspiration of photographic art – is transformed in the process, sometimes honored, sometimes sealed in servility. The bulk of photographic production and experience – its unwashed "vernaculars" – remains on the margins of most artistic production, its function in photographic history being, as Geoffrey Batchen has pointed out, to show us what art photography is not (Batchen 2002).[1]

This article looks at one type of work generated by the amateur-artist affiliation: the artist's bookwork as photographic album. I have focused my attention on works of European and Canadian extraction, ranging in date from 1970 to 2007, and exemplifying a variety of approaches. The UK-based American artist Christy Johnson's *Feast* (2007) is a thematic collection featuring girls at their First Communion. The artist purchased or otherwise acquired these images in European and American cities, and supplemented them with testimony from thirty-three "confessors" (Figure 26.1).

Indonesian-born, Amsterdam-based Fiona Tan's *Vox Populi* commissions are created through another process entirely, on the basis of a call for entries: ordinary people submit their albums and Tan, as artist-curator, selects and organizes the images into an installation and a book – a collective family album. At the other end of the scale are two book projects by German conceptual artist Hans-Peter Feldmann, *Porträt* and

Figure 26.1 Christy Johnson. *This is My Body. Feast: Christy Johnson and 33 Confessors* (University College for the Creative Arts, 2007). Courtesy of the artist.

Ferien (both 1994), each strictly bounded by the formation of a single female subject. And in the same vein, though dramatically different in effect, is French artist Bruno Rosier's rephotographic project, *Un état des lieux ou La mémoire des parallèles* (2005) based on the extended self-portrait of a male traveler, known only as R.T. Two different uses of the vernacular photograph are found in the oeuvre of Canadian artist Michael Snow: the artist's book and exhibition catalog, *Michael Snow/A Survey* (1970), and the album bookwork, *Scraps for the Soldiers* (2007).

In this list of artists' names and titles, we sense the vigor of intentionality: the death of the author, or replacement of the author by the author-function, is a moot point. Transferred into the hands of artists, ordinary people's pictures are being re-authored and re-signed. The vernacular is possessed and translated as a relic by these gestures; one might say that the *idea* of the vernacular is being honored. But this is of course a contradiction in terms. The vernacular is the opposite of an *idea*, being

by definition locked into place, time, and specific circumstances. Evocation of such specificity is built into these appropriative works, but in most cases, as we will see, alienated from the source to the point of abstraction. Which brings me to a fundamental question: is everyday photographic experience transferrable to art? And by this I mean not just its reification, nor even its simulacrum, but the complexity of a photographic object that has been part of a life lived. Exposure to some of these works and their critical apparatus has left me fretful that we are being sold, not "knowledge at bargain prices" as Susan Sontag once suggested about photographic content, but local photographic experience inflated to universality by a global economy (Sontag 1978: 24). There are alternatives, as my argument has been constructed to show.

This article is not a survey of the genre, but a consideration of ideas that motivate this kind of production and critically uphold it – ideas exposed in a recent article by Mark Godfrey in relation to a bookwork by Tacita Dean. I bear down on Godfrey's article, without prejudice to its subject, to unpack his faith in a trinity of values: originality, intuition, and fascination. These notions are familiar to us from the cultural discourse of primitivism, though they are rediscovered and naturalized by Godfrey as flowing from photographic objects that have had an effect on an artist, catalyzing some kind of transformative, appropriative action.

Robert S. Nelson's definition of "appropriation" helps us to understand what the motive and effect of this action might be. Nelson sees kinship between the act of appropriation and the semiotic shift that Roland Barthes enacts in relation to myth – he allows both actions to be seen as public *and* personal: "personal agency, not merely the play of signification" (Nelson 1996: 119). Intentionality rules, though significant nuances arise from the source object which is not just anything. Inside the walls of the art world, Duchampian play takes place on an even playing field: an image generally recognized as art is translated into another form that is also labeled art – in Duchamp's *L.H.O.O.Q.* (1919), a reproduction of the *Mona Lisa* is given a mustache and retitled. This action takes place within institutional norms: the aura of the object is only temporarily displaced. For these are carnivalesque shifts, by which I mean that roles and ranks are not really changed, but merely exchanged for the duration of the action, as expressed in Pierre Bourdieu's socio-economic terms: "Artists, art historians, and critics may lack the means to purchase actual works of art, but some have the power to transform ordinary objects into art and vice versa" (Nelson 1996: 123). Inserting the word "photographic" between "ordinary" and "objects" serves our purposes here – a vernacular photograph is by definition ordinary. And this leads us to Nelson's consideration of appropriative primitivism: "the cultural asymmetries involved in the discovery, redefinition, and appropriation of tribal artifacts by the modern art world" (ibid.). By substituting "vernacular photographs" for "tribal artifacts," we can consider the ramifications of this asymmetrical relationship, asking ourselves whether the use of amateur photographs risks the authority of the artist, or enhances the artist's status as a dialectician.

Artists envision these works, but their status as art depends on the approval of critics, dealers, curators, and historians – the vernacular is sometimes a conceit, strictly in the eye of the beholder. Henry Sayre's study of late-twentieth-century American avant-garde practices attends to the art-world phenomenon of photographer Nicholas Nixon's extended portrait of his wife and her three sisters, *The Brown Sisters*, an annual ritual that began in 1975. Made by a professional artist using an 8 ×

10 view camera and setting strict rules for the project (the women always lining up in the same order; one public image / year), the series strains the definition of snapshooting, but the photographs are nevertheless called "family snapshots" by the Museum of Modern Art curator Peter Galassi: "they function as snapshots, to mark time" (Galassi 1988: 25). That they do so on the walls of the Museum of Modern Art in New York[2] and in the pages of *Artforum* catches Sayre's attention as a phenomenon that he summarizes in a tautology: "a family portrait is a family portrait, and it is art because it is art (or, at least, because someone has declared it to be so)" (Sayre 1989: 39). For Sayre, the declaration functions on many levels: the Nixon project functions as a "hinge" between formalist and historical concerns (Sayre 1989: 40). The reliable staging of the Brown sisters translates their specificity – what Sayre calls their "vernacular fullness" (Sayre 1989: 37) – into a formal coherence that fastens the institution of the family and the institution of art into "the same rhetorical, aesthetic, and social structures" (Sayre 1989: 51). Galassi expresses this tight and circular relationship when he writes: "It is by now a familiar observation that no two photographs are exactly alike, that the medium is inherently plastic. Nixon's pictures recast the observation, suggesting that it is not photography but experience that is plastic, a quality made plain by photography's mechanical precision" (Galassi 1988: 25). For Sayre, *The Brown Sisters*, drained in public presentation of any personal meaning, becomes a site of speculation about modes of repetition – whether repetition of a model generates sameness, leaving the original unaffected, or difference, altering our idea of the model – in this case, the family. In *The Brown Sisters*, the Brown sisters are acting out the idea of family in a way that ask us "to contemplate whether the family is itself only a simulacrum" (Sayre 1989: 65). This is a productive line of inquiry, whether the Nixon series stands up to such intense scrutiny, or whether Sayre the critic is projecting his own dialectical desires. In what follows, conscious and unconscious collusion between the various art world players – spectators, included – is assumed and taken as another form of performance, illuminated long ago by Erving Goffman, and deeply conditioning our reception of these everyday photographic works (Goffman 1959).

Lost or found?

Mark Godfrey's analysis of Tacita Dean's fourth bookwork, *Floh* (2001) is an elaborate argument for its status as an art work (the edition of 4,000 is signed, or each book "has been touched by the artist") and its originality (Godfrey 2005: 91, n. 2). His reasoning is curiously old-fashioned: strictly on the basis of *Floh*'s formal characteristics – "its weight and size, the diversity of subject matter, the arrangement of the images, and the superb quality of their reproduction, *Floh* cannot be assimilated into existing models of artists' uses of found photographs" (Godfrey 2005: 96). *Floh* is therefore *original* and Godfrey makes it more so by contrasting Dean's work with eight established models of appropriative production. One, self-conscious deskilling à la Ed Ruscha: Dean selects both good and bad photographs, but she arranges them artistically. Two, archival arrangements of images, as practiced by Hans-Peter Feldman: Dean's themes, when they cohere at all, are purely intuitive. Three, visual expression of cultural and political systems of knowledge, as found in Gerhard Richter's monumental *Atlas*: Dean's *Floh* is comparatively humble, while

steering clear of personal or political history. Four, ironic appropriation, with political implications, as exercised by Steve McQueen: Dean is not shifting the meaning of the photographs that she uses, because they are meaningless to her where she finds them, at the flea market. Five, the reification of collective memory, as constructed by Fiona Tan: Dean's concerns are not sociological. Six, the discreditation of photographic truth claims by artists such as Christian Boltanski: Dean crafts no photographic story that might be taken as true or decried as false. Seven, the exploration of narrative structures, as in Pierre Huyghe and Douglas Coupland's collaboration *School Spirit* (2003): Dean's work is devoid of narrative devices. Eight, photographs "sourced" rather than "found" because they are the target of a directed investigation: Dean takes a random approach, methodologically comparable to the Surrealists, but yielding different effects, in part by the lack of caption or improvised text (Godfrey 2005: 96–102). According to Godfrey, *Floh* is different from everything that has come before it in all these respects.

The argument is perverse. Against the grain of a work that appears on the surface to come from the collectivity and go toward the collectivity, Godfrey frames his appreciation of Dean in terms of originality, artistry, and unbridled intuition, traits that are supposed to override her ideological and methodological formation as a subject. Her motivations are then explained in terms borrowed from Roland Barthes's *Camera Lucida*. This is ironic, to say the least, for *Camera Lucida* is universally understood as Barthes's experiment in self-conscious deskilling, the shedding of his sociology and semiological skills that left him "'scientifically' alone and disarmed" (Barthes 1981: 7). Fitting *Floh* into a reading of *Camera Lucida* actually contradicts Godfrey's point about Dean's artistic skills, because deskilling reigns in *Camera Lucida* as its primary skill set.

Throughout *Camera Lucida*, Barthes deliberately dulls the edge of connotation, the blade that had flashed so brilliantly in "The Photographic Message," an essay published in 1961. *Camera Lucida* shifts the reader's attention from the *studium*, the realm of public knowledge, to the *punctum*, the realm of private feeling. Barthes's book is about that shift and, to an appreciable degree, about the excitement that loving a photograph for all the wrong reasons – succumbing to its charms – can engender. In a very real sense, *Camera Lucida* is the unfinished business of "The Photographic Message," in which Barthes had referred in passing to Edgar Morin's notion of *photogénie*, shoehorning Morin's mysticism into a few terse comments on "informational structure" (Barthes 1983: 202). In 1961, Barthes seemed determined to keep the charm of photography in the picture without surrendering to it. Not quite twenty years later, his unabashed subjectivity seems much closer to Morin's: "the properties that seem to belong to the photo are the properties of our mind that have fixed themselves there and that it sends back to us. . . . The richness of the photograph is in fact all that is not there, but that we project or fix onto it" (Morin 2005: 22). Barthes gives himself over to that richness by hooking himself into the details of photographic images, something that most people do when they look at other people's pictures – he speculates, he empathizes, he projects. For Barthes, these activities are licensed by the indexicality of photography, its lamination to the real, which, again surprisingly, he embraces with confidence when he believes that he is seeing something that has escaped the notice of the photographer. Speculation growing into confidence in one's singular perception: out of this faith, one kind of *punctum* arises. In Barthes's analytical oeuvre, this confidence seems almost archaic, a pre-semiotic confidence in the mimetic arts, a naïve view of

photography that "The Photographic Message" had aimed to debunk. Barthes's self-conscious deskilling catapults him back in time to a state of self-recognition through realism adumbrated in Wilhelm Worringer's *Abstraction and Empathy*, a book published in 1908. There is a difference, of course. In Worringer, Western man's empathetic attachment to the mimetic arts is "a sensation of happiness . . . a gratification of that inner need for self-activation," which can be contrasted with the primitivist anxieties that produce abstraction (ibid.: 14). Barthes does not succumb to this "bipolar swing between cultures," as Margaret Iversen has called it (Iversen 1993: 14); rather he makes himself vulnerable to psychological attack by objects discerned, or half-discerned, through photographs. In the half-light of grief, this is what he needs to feel alive. But this self-activation depends utterly on the indexicality of the image – he needs to have seen for himself what was there to be seen by others, but spoke through the photograph only to him. Being thus singled out and activated by the real sets up his own bipolar framework which he develops in concluding remarks on whether the photograph is "Mad or tame?" (Barthes 1981: 119).

Godfrey takes up this question in relation to Dean's work. In *Floh*, Godfrey argues, Dean is "releasing photography from those who would tame it" (Godfrey 2005: 102). Taming is explained by Godfrey as carrying some knowledge to the photograph, and especially the time-based calculation that the pictured subject is most certainly dead. Building on Barthes and Siegfried Kracauer, Godfrey rehearses the idea that making this informed calculation is akin to re-killing the subject. *Floh* does not commit that crime, because we know nothing of the people in the pictures; with "no memory or knowledge" of the subjects, our encounter with them through the photograph is "innocent" (Godfrey 2005: 104). In other words, *Floh* is a *studium*-free zone in which deskilling avoids re-killing: this is effectively what Godfrey is saying.

Barthes is saying something else. His point about time is illustrated by flashes of *studium*, but fits into his discussion of the second kind of *punctum*, the temporal kind in which the spectator confronts the likelihood that the person who was once alive to be photographed is now dead. Like the other kind of *punctum*, this sudden realization is both objective and imaginative, sparked by a heightened awareness of three times: the spectator's present, the past of the living moment that was photographed, and the past of the unpictured death. But it is above all subjective, for as Barthes continues, "each photograph always contains this imperious sign of my future death" (Barthes 1981: 97). Each photograph contains the seeds of this realization: that the photograph could not perpetuate the life of others and will not keep death from his door. That is the source of its *punctum*, a feeling too banal to share with others, embarrassingly personal to the core.

Can we sense a *punctum* in common, say, when the single thing that *is* known about a photograph is that it has turned up nameless at a flea market, that no one was around to prevent this occurrence, either by keeping the photograph or destroying it. We can say so, but we are depriving ourselves and others of Barthes's fine distinction. A *punctum* cannot be shared without embarrassment – it is an idiosyncratic lonely *feeling*, which is why Barthes sites his most searing example in the vernacular and declines to show us the picture.

Contrary to Godfrey's reading, there is a taming taking place in *Floh*. He puts his finger on it when he discusses the "duds" in the assemblage – the incompetently made or damaged photographs that made it to the flea market and continue to circulate in this work. Godfrey muses over their miraculous survival: "they all bear witness to their

owner's one-time superstitious attachment" (Godfrey 2005: 112). This is not an inno-
cent statement; rather it suggests a baseline of photographic criteria that is known to
ordinary people and seen by ordinary people to be flaunted in Dean's work. "In some of
the most marvelous images in the book, everything has gone wrong. . . . Obviously these
were not purposefully 'abstract' photographs but errors destined for the flea market"
(ibid.: 108). Deskilled, in other words, but redeemed by Dean's artistic intervention.
Photographs are snatched from oblivion, sometimes because they remind her of other
works of art: in interview, she calls one particularly mannered found photograph "my
Jeff Wall" (ibid.: 118). Mechanism and chance may override the anonymous photogra-
pher's intentions, but the artist's talent and intentions trump both.

"Within the development of culture under an exchange economy, the search for
authentic experience and, correlatively, the search for the authentic object become
critical" (Stewart 1993: 132). So writes Susan Stewart, laying the groundwork for
her study of souvenirs as "objects of desire" and sites of memory, divided between
purchasable souvenirs of exterior sights and souvenirs of a more intimate type, often
representative of rites of passage. Both types "move history into private time" (Stew-
art 1993: 138); the life-course with its many social intersections is translated into
autobiographical compendia, such as scrapbooks and albums. Stewart stresses the
impossibility of reproducing such objects, and not just because their aura is miss-
ing, but because the experience of the object is irreproducible. This kind of souve-
nir, says Stewart, communicates sensually, "its perception by hand taking precedence
over its perception by eye" (Stewart 1993: 139). Godfrey notes that reproductions
in *Floh* include the marks on the originals as signs of temporality, but "all the found
photographs are reproduced flat and with straight borders. There is no indication of
formerly serrated edges, bumpy surfaces, or worn corners" (Godfrey 2005: 109). To
retain these things would be to "fetishize" them, according to Godfrey, but if we listen
to Stewart, or indeed to Geoffrey Batchen who has carefully studied the connections
between photography, tactility, and memory, to strip the images of their signs of use,
or even abuse, is to sever their connection to memory (Batchen 2004). The touch of
an artist may not compensate us for that loss; on the contrary, it may make our sense
of loss all the keener.

To sign is to touch, Godfrey argues, almost, but not quite, snuffing the Duch-
ampian paradox that haunts the act. For, as Peter Bürger points out, a signature car-
ries both individual and institutional freight: "Once the signed bottle drier has been
accepted as an object that deserves a place in a museum, the provocation no longer
provokes; it turns into its opposite. If an artist today signs a stove pipe and exhibits it,
that artist certainly does not denounce the art market but adapts to it" (Bürger 1996: 52).
Today, 4,000 people can refer to their signed copy of *Floh* as "my Tacita Dean."

Collecting practices

Originality is sometimes indistinguishable from the intense, almost narcissistic, fasci-
nation that an artist brings to his or her own processes of discovery. All curatorial prac-
tices, private, and institutional, participate in some way in this singularizing mode of
self-validation by removing an object from one context and placing it in another. This
act of authorship is by definition subjective and self-serving, just as autobiographical

or family history intends to cut one's self or one's familiars out of the pack, to enlarge the importance of particular life experience. A photographic album or shoebox full of snapshots may function in this way, as an expression of specificity, each photographic element nested in an idiosyncratic vernacular. Can a public work of art speak and be understood in the same way? As artists, Christy Johnson and Fiona Tan are engaged in collecting practices, constructing narratives of religious or national belonging from fragments of other lives.

Johnson's motif is Catholic girlhood, a system of reward and punishment that reaches its apex on the day of First Communion (Figure 26.2).

Like Dean, Johnson has found her images in the marketplace. As essayist Catherine Clinger explains the origins of the collection:

Figure 26.2 Christy Johnson. *Souvenir de ma Première Communion. Feast: Christy Johnson and 33 Confessors.* (University College for the Creative Arts, 2007). Courtesy of the artist.

"The original for each of the large digital prints was itself displaced. . . . Presumably, most resided at one time in a family album or on a mantlepiece, then were passed down to heirs, discarded upon death, thrown away or sold, eventually finding their way to bins and boxes in markets, junk shops, antique, and book stores in New York, London, Paris, Rome, Prague, Berlin, Vienna, Los Angeles . . . and Santa Fe, New Mexico" (Johnson 2007: 191–192). To which narrative one might add the less romantic possibility of studios going out of business, since so many of the portraits were made by professionals. The portraits range broadly in terms of place and date – racial characteristics, economic markers, photographic style, décor, and sacramental fashion codes are the handprints of the vernacular, though the signs are faint. The overall effect is truly catholic, in the sense of universal and atemporal – the depicted subjects are anonymous and voiceless, facts camouflaged by the inclusion of first-person narrations that Johnson gathered from thirty-three women who agreed to record their reminiscences about their First Communions. She then correlated the portraits and memoirs in reciprocal suggestiveness. This fictional construction creates a startling first impression of signed public confession, brimming with brutal candor, mortification, triumph, barely suppressed anger, and considerable critical distance on the little girl that was. To photographic literalists, the truth about her process will be somewhat less exhilarating and curiously reminiscent of dubious documentary projects such as Margaret Bourke-White and Erskine Caldwell's *You Have Seen Their Faces* (1937), in which Bourke-White's portraits of struggling American farmers were accompanied by Caldwell's contrived statements. Still, first impressions matter and Johnson turns this ambiguity to artistic account, benefiting from the vulnerability of the images and the vivacity of her informants' stories to emulate the ebb and flow of photographically induced memory. With considerable agility, she walks a very fine line between imagination and memory. Imagination is a friend to memory, but innovation for its own sake is not. Johnson appears to know that, and while she plays her game of correlation, her book's fidelity to the qualities of the photographic object and the grain of the conversing voices makes a space for spectatorial intervention. Do I feel this because of my own Catholic girlhood? Perhaps, but is that necessarily a weakness? After all, the vernacular begins and ends at home. Does Johnson's act of authorship thus constitute a meta-vernacular, in which my own embarrassed authoring is released, or is such a notion so contradictory as to be pure nonsense? Yet unsure of where the vernacular is, I am fairly certain where it is not.

Fiona Tan's *Vox Populi: Norway* teases the spectator with Kodak's universal promise of local knowledge and intimacy (Figure 26.3). The genesis of the work is a commission by the Norwegian parliament.

Tan toured the country, pouring over the offerings of 100 Norwegians who wanted their snapshots to be part of the national album. Tan chose 267 photographs for the mural and made a sub-selection for her artist's book, grouping the images under three headings: portraits, home, and nature. Home is the largest section: home is where the babies, the elderly, the pets, and the food are. It is also where the flash is, bouncing off the walls and mirrors, contouring the bodies in dark lines that underscore the spontaneity of this moment, that moment, and the next one, with wearing universality. In nature, the bodies seem even more robotic, functioning as staffage in vast open areas, or occupying their domain through weaponry or other forms of technology. Inside or outside, photography is the collection's common denominator,

Figure 26.3 Fiona Tan, detail from *Vox Populi, Norway* (Book Works, 2005). [Original in colour]. Courtesy of Frith Street Gallery.

catalyzing activity, demarcating both space and spatial experience. In short, Tan's divisions are more formal than scientific: *pace Godfrey*, but if this is sociology, the discipline is doomed. As Suzanne Cotter writes: "[Tan] pulls apart the assumptions implicit in documentary process to create a new and infinitely more elastic space in which the verifiable and pure conjecture are confused and scattered by the unquantifiable collection of experiences that make up individual subjectivity" (Tan 2006: 120). In other words, *Vox Populi: Norway* is Tan's selection and arrangement. From the particulars of the participants' lives, Tan has constructed a narrative of national cohesiveness in a structure of clever alternations between posed, flashed, somewhat isolated figures, deathly in their stillness, and candid, intertwining figures, alive to the camera. That they are all Norwegians is unquestionable – them's the facts – but nationality is merely the pretext for the artist's "Family of Tan," an exercise that she has since repeated within the city limits of Sydney, Australia, and Tokyo, Japan.[3] *Vox Populi* has become a trademark for Tan's artistic curatorship. There are no homes, no resting places, in such an elastic space.

Performative practices

Hans-Peter Feldmann could also be classified as a collector and user of found photographs. As Godfrey says, Feldmann is interested in archives, and especially in their copiousness and integrity which he treats with great delicacy. His prodigious practice offers two examples that are complementary to each other, while casting the

Figure 26.4 Hans-Peter Feldmann, detail from *Porträt* (Schirmer/Mosel, 1994). Courtesy of 303 Gallery/DACS.

collection bookworks examined to this point in stark relief. Spanning fifty years (1944–1994) in the life of one German woman, *Porträt* presents 324 black and white images in chronological order (Figure 26.4).

The same woman appears in every one. A comely and adventurous creature, she is photographed mostly at play, but there are also images at work, identification shots, commercial photographs, and even a few self-portraits. Reproducing everything in black and white homogenizes the group, but its real glue is the photogenic quality of the woman. She is a polymath of photographic performance, at one with the instrument, and this right from her childhood, and she is constantly expanding her repertoire of poses, grasping with astonishing acuity what is called for by different situations, different formats, different lenses. And yet she is always herself – the project is rooted in this individual, its formation by, and expression in, a photographic vernacular.

Another bookwork of Feldmann's from the same year, *Ferien*, concentrates as its title suggests on holiday snaps (Figure 26.5).

The book, as sold, is empty, save for a short text and one tipped-in color plate. It is accompanied by a packet of reproductions of color pictures taken at tourist destinations, places such as ruins, markets, natural wonders, and hotel pools. I own this book. My copy has 107 pictures, including some duplicates. I have never done what I was supposed to do: glue them into the book in my preferred order. In this, they are treated no differently than the drawerful of images earmarked for my own family album. *Ferien*'s collection appears to have come from a single source: as in *Porträt*, there is the recurrent figure of a woman, though here functioning more as a signature

Figure 26.5 Hans-Peter Feldmann, detail from *Ferien* (Weiner Secession, 1994). [Original in colour]. Courtesy of 303 Gallery/DACS.

or as staffage, than as the object of fascination described above. Her neutrality, or near neutrality as a white, middle-class tourist, licenses the spectator to do what Feldmann suggests, compile the album as one wishes, or to do what I have done, revisit it occasionally to shuffle the pictures. *Ferien*'s performative aspects are therefore much stronger than *Porträt*'s; the handling of this bookwork is the making of it, a process that can only ever be unfinished, a process whose final execution would cause the binding to explode. *Ferien* suspends time, as the best holidays do, and this is endless food for thought as I contemplate this woman – my representative – posing among the Others (snake-charmers and exotic beasts) and picking through bazaars and flea markets for the tourist trophies she will triumphantly carry home.

That I take this woman as my surrogate – trying to enter her life experience through my imagination – anchors Feldmann's project in the vernacular, though not hers, but my own. I write of her physical and human surroundings as "exotic" but of course she is the exotic element in every case. The Others are at home, just as I am at home when I pull *Ferien* from the shelf. Bruno Rosier's rephotographic project, *Un état des lieux ou La mémoire des parallèles* (2005) literalizes the identification that I am making with *Ferien*'s traveler, and with considerable éclat.

Un état des lieux ou La mémoire des parallèles is another case of flea market discovery, twenty-five prints dated from 1937 to 1953 depicting a man posing before famous prospects in Algeria, Argentina, Brazil, Canada, Egypt, Greece, Haiti, Iceland, Peru, Portugal, Uruguay, and the United States.

Most of his travels took place after World War II; Algeria, 1937, and Iceland, 1939, are the exceptions. The pretexts for these journeys are unknown; their cover story is tourism. The sites include natural wonders, such as Niagara Falls and the Mariposa Big Tree Grove, and monumental constructions, such as Hatshepsut's

temple and the New York skyline. In the source photographs, this man, known to us as R.T., stands alone against these nameable backdrops. With the support of the Musée Européenne de la Photographie, Rosier set out to recreate the found images, himself taking on the leading role. As a rephotographic project, *Un état des lieux* is reminiscent in its ambitions of Cindy Bernard's *Ask the Dust* (1991), for which she photographed the shooting locations of twenty-one mainstream American movies. Both series depend on exciting a certain level of possessive recognition in spectators who may, or may not, have visited these places, either bodily or cinematically. They are reprises of collective memory; as Emmanuel Kraft puts it, "they belong to us. They are as much a part of our common patrimony as our personal memories, real or invented" (Rosier 2005). In Rosier's project, they are also doubly autobiographical – R.T.'s and Bruno Rosier's lives and memories merge on these sites through the fruits of their labors. Tourism is work, as Morin argued long ago: "The same Parisian who ignores the Louvre, has never crossed the portal of a church, and does not go out of his way to contemplate Paris from the top of the Sacré-Coeur will not miss a chapel in Florence, will pace up and down museums, and exhaust himself climbing the Campaniles or getting to the hanging gardens of Ravello" (Morin 2005: 18–19). For Morin, the historic view is already a souvenir. The musts of any travel guide are sites already "embalmed," haunted by spirits, while the snapping tourist seeks something for the future, "enriched by the power of remembrance squared" (ibid.: 19).

Rosier presents the original and the remake of R.T.'s tourism side-by-side. The scientific aspect of his project is thus served; viewers are able to compare the two pasts on display, the histories of place and the autobiographies of two men. R.T. sets the bar of self-presentation very high; he has traveled great distances; he takes the business of *being there* very seriously. His poses are manly and resolute, and with rising intensity, so are his double's. Each photographic instant drives Rosier's stake deeper into R.T.'s ground. As R.T. ages, so does Rosier – his rephotographic project stretched out over a decade – though with a certain elasticity. In the Lisbon pictures (1949/1994), their visits are separated by forty-nine years, while the two men's trips to Algeria (1937/2003) are sixty-six years apart. But just as the present triumphs over the past, the organization of this book imposes Rosier's timeline as he works through this archive, the photographic legacy of another man's life. Each consumated pairing puts these syncretic twins one step closer to completion of their extended self-portrait, and one step deeper into a Barthesian foreshadowing of their own death. This simple fact is affectingly performed in the 2001 re-enactment of R.T.'s self-portrait of 1948 at Iguazu Falls, Argentina (Figure 26.6).

Shot from above, with a plunging guard rail and immeasurable force and space opening out below, R.T. stands in profile to the camera. He seems pensive and self-contained, and yet a blurring of his left hand – some exploratory gesture arrested – ruptures the limits of his body, extending it both spatially and temporally. His double, Rosier, also reaches forward, though not so much imitating as completing the gesture of R.T. and somehow meeting him through his outstretched fingers. The dematerialization of R.T. is purely photographic: it is something that only the camera saw and the film recorded, the doubled trace of his presence and inevitable disappearance. The *punctum* (my empathetic embarrassment) is the doubling of the wristwatch, then

Figure 26.6 Bruno Rosier, detail from *Un état des lieux ou La mémoire des parallèles*. *Argentine, Chutes d'Iguaçu*, 1948 (above) and 2001 (below). (Editions Lieux Dits, 2005). © Bruno Rosier.

blurred, later sharp. Rosier's re-enactments intensify the melancholy and mystery of images set adrift from their owner, and they do so by re-domesticating them as vehicles of armchair travel and private photographic mourning.

New works from old

Michael Snow produced his first public photographic work in 1962 but his professional interest in photography, and specifically in the photographic vernacular, had been active since the late 1950s when he produced a series of twenty-two charcoal drawings based on two photographic portraits that he had clipped from a magazine. In its final form, *Drawn Out* (1959) includes the found clipping, a reflexive Duchampian gesture that marks the beginning of Snow's incorporation of found, or otherwise acquired, photographic images into his work. This process has run parallel to his creation of photographs from scratch. Common to both modes of production is Snow's fascination with the nature of photography, specifically its indexicality, mechanism, and potential as a tool for art-making. His appropriations are undeniably licensed by twentieth-century avant-garde attitudes toward art-making, and especially its authorization by the artist, though his actions do not tilt at notions of originality or the status of the modern art museum. Photographic re-presentation is a means of heightening or altering perception of visual phenomena; this realization has led to a number of mixed-media and cinematic appropriations from the public photographic realm. In his bookworks, however, Snow's recourse to other people's pictures has drawn exclusively on his personal archive. *Michael Snow/A Survey* (1970), an artist's book published by the Art Gallery of Ontario as the catalog of Snow's first major survey exhibition, also surveyed Snow's life, beginning with his ancestors and using their family photographs, his own photographic memorabilia, as well as his engineer-father's documentary photographs, for their biographical information and formal characteristics. He accompanied these images with a family history, one that requires a very close reading as it is set in a small font. The Snow and Levesque family photographs merge with his own collection of snapshots and photographic documentation of his work. Snow provides a key to the collection by reproducing the gridded layout sheets whose last entry is his first public photographic work, *Four to Five* (1962). The placement of this work in the book marks a turn away from Snow's photographic memories toward his current artistic concerns, and personal photographs inserted after that point relate more directly to the works of art reproduced nearby. For example, images of *Snow Storm February 7 1967* (1967), photographic studies in shades of gray shot through the window of Snow's New York apartment are followed in the book by six snapshots of "Denyse and Michael Snow and Buck" (a dog) playing in deep snow before their maternal grandparents' home in Chicoutimi, Quebec. The book's penultimate image is of a snapshot taken by Denyse Snow in 1936 in which the future artist demonstrates the strange photographic effect of foreshortening by holding his feet up to the camera.

That this photographic assemblage is presented in the form of a book seems obvious, but in the work of this artist, form is never a minor consideration. *Michael Snow/A Survey* is a bookwork, in the full sense of the term – that is, a set of propositions about what a book of images and text can be. Snow improvises freely with layout and

type. He emphasizes the mechanical nature of the process and alludes to chance with instances of reversed type, variable margins, overprinting, and blank pages. He makes the beholder participate in the book's eccentric construction. There is much handling, much page-turning, required to match the captions with the pictures; their shapes and relative positions must be committed to memory in order to retrieve the names. Vernacular photographs are interleaved with documents of a conceptual art practice. Family photographs fit into this family of resemblance as black and white prints first of all, and secondly, as compressions of real-life, real-time vitality onto a photographic surface – images of life. Morin's study of *photogénie* seems to have predicted the pregnancy of Snow's home-grown dualities:

> An extraordinary anthropological coincidence: technique of a technical world, physicochemical reproduction of things, product of one particular civilization, the photograph looks like the most spontaneous and universal of mental products. It contains the genes of the image (the mental image) and of the myth (the double) – or, if we prefer, it is image and myth in a nascent state.
>
> (Morin 2005: 33)

Snow's most recent bookwork is *Scraps for the Soldiers* (Figure 26.7). The work is an almost perfectly faithful reproduction of an album compiled by Snow's aunt, Dimple F. Snow (1896–1978) in a scrapbook published during the First World War by the T. Eaton Company, to be filled by "friends at home" and sent to the soldiers overseas. Dimple Snow filled its pages with snapshots taken before, during, and possibly after the war. A variety of formats and mounting corners suggest that arrangements accrued over several years, while the inscriptions appear to have been done at one sitting. The handwriting is consistent and wet ink has sometimes bled through or blotted on facing pages and pictures. The scrapbook is signed and dated 1 February, 1921, in the same treacherous black ink. Now reproduced in its entirety, this work of art is credited to Dimple F. Snow (1921) and Michael Snow (2007).

The photographs are lively, cheerful. As Snow writes: "The book is a record of events relating to the faraway war but most importantly it is a record of some summer holidays that still resound with happy laughter echoing over a lake." Visually, war is a recurrent sub-theme, whether through portraits or candid shots of uniformed soldiers and nurses, or snapshots of radiant young women soliciting donations for the cause on tag days. When Snow looks at the album, he recognizes some of the figures as relatives and all of the figures as part of a prosperous anglophone set, taking its pleasures in the luxury hotels of the Ontario lake country or roughing it at Bear Trap Camp, Nova Scotia. If Snow sees this world from within and without, so it seems, does Dimple who never self-identifies as "me" but writes either "Dimple" or "Dimp," the latter sometimes with quotation marks around the word, as though, in novelist Margaret Atwood's words, "she were citing some written opinion to the effect that she is who she is" (Atwood 2006: 214). One effect of the work, noted by Snow, is of local happiness – this despite the tragedy of the far distant European war, which took the life of Geoffrey Snow, Dimple's brother. With these scraps of memory, Dimple creates the myth of never-ending pleasure; Snow creates its double.

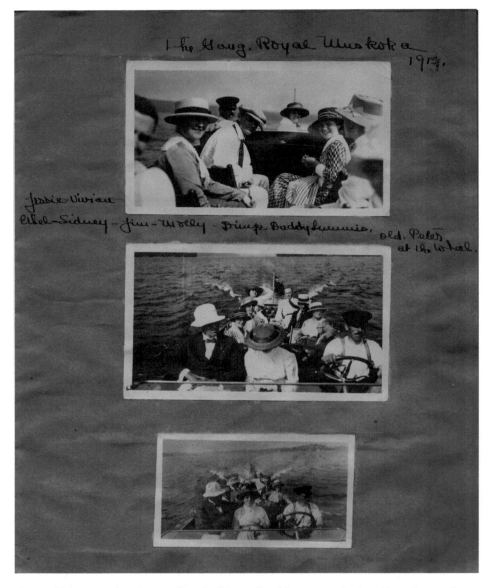

Figure 26.7 Dimple F. Snow and Michael Snow, detail from *Scraps for the Soldiers* (Zona Archives, 2007) [Original in colour]. Published by Zona Archives, Florence. Courtesy of Michael Snow. Documentation by Mani Mazinani.

To translate this work from the private to the public realm, to turn a scrapbook into an artist's book, three stages were involved. First, Snow had the idea in response to an invitation from artist-publisher Maurizio Nannucci to produce an artist's book under the imprint of Zona Archives. This brought the scrapbook he had inherited to light. Second, Snow wrote a brief introduction which has been inserted on the front and inside front cover in four languages: English, Italian, French, and German.

A thousand copies of the book were printed in Florence. At Lucca, the third act took place: Snow physically signed thirty copies of the book.

The conceptual signature was already affixed for, as a bookwork, *Scraps for the Soldiers* continues Snow's investigation of the nature of photography and photographic reproduction. Extending the performative aspects of *A Survey*, *Scraps for the Soldiers* is almost eerie in its tactility. Digital reproduction of the entire scrapbook has kept the browning and crackle of the sheet, the dog-eared corners, the marks of excision, the weight of other objects in a box or a drawer. Lying before me on a table, the object seems almost to breathe. Digitization here captures the auratic qualities of the photographic object. If Snow's were a critical practice, *Scraps for the Soldiers* could be seen as a stern critique of collecting practices that strip photographs of their meaning and materiality in the name of visual poetry, collective memory, or universal photographic experience. *Scraps for the Soldiers* translates vernacular photography into art by retaining the specificity and mystery of its origins.

Is there anybody home?

Since surrealism, the avant-garde has made a convention of haunting the margins of the culture – its flea markets – and recuperating its photographic detritus as art. Dean and Johnson show us that art is still *there* for the taking and remaking. Tan proves that ordinary people are prepared to share their photographs, are indeed proud to play a part in a collective portrait of their country or city. There is nothing new in that discovery. Falling between the cracks of originality and sentimentality, it fails the avant-garde and it fails the vernacular. Feldmann and Rosier bring us something different because they keep hold of the crucial element – this willing de-skilling that is the optimum state of reception. Making strange on the basis of the anonymous and the exotic is not something we coolly contemplate; it is something we do. Their works excite the imagination; they take us by the hand and our reception is performative. Johnson's project does that too, though an understanding of its genesis may ultimately prick the balloon. Snow, for his part, honestly locates photographic experience in the personal: he shares his family's photographic hoard, shifting it from the edges of the art world to the core of his practice. This gesture is immersive and moving, and it is also richly informative about the uses of photography in ordinary life.

Batchen writes:

> Vernaculars are photography's *parergon*, the part of its history that has been pushed to the margins (or beyond them to oblivion) precisely in order to delimit what is and what is not proper to this history's enterprise . . . vernacular photography is the absent presence that determines its medium's historical and physical identity; it is that thing that decides what proper photography is not.
>
> (Batchen 2002: 58–59)

And that identity is improperly and unapologetically rooted in personal, present-based feelings and desires, the very opposite of Modernism's disinterest and universality, and just as foreign to Postmodernism's ironic corrections.

Snow is neither a historian, nor a theorist. His works of art are the seedbeds of theory and they are inscribed in art history because they locate a medium's most vexatious and intriguing problems and inform their solutions. In this case, they encourage us to think about our feelings. *Scraps for the Soldiers* is a touching expression of singular happiness made in a time of general mourning (Figure 26.8).

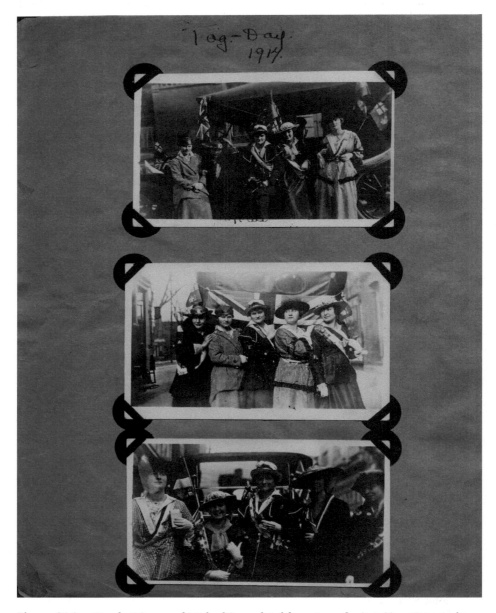

Figure 26.8 Dimple F. Snow and Michael Snow, detail from *Scraps for the Soldiers* (Zona Archives, 2007) [Original in colour]. Published by Zona Archives, Florence. Courtesy of Michael Snow. Documentation by Mani Mazinani.

This message comes from the other side – Dimple speaks from the grave – and with a pragmatism and joyfulness in the moment that is almost brutal – its madness is certainly not tamed. Earlier I spoke of primitivism's asymmetrical relationships, and their expression in acts of photographic appropriation. What we see in *Scraps for the Soldiers* is the reversal of that power dynamic: between Snow and his aunt Dimple, who knows better of what is spoken and unspoken in this piece? From the edges of an avant-garde practice comes a simple photographic lesson about the particulars of life and death; loftier ideas are also there for those who seek abstractions to assuage their grief.

Original publication

'Strange Bedfellows: Appropriations of the Vernacular by Photographic Artists'. *Photography and Culture* (2008)

Notes

1 Batchen's interrogation of photographic history and attention to the vernacular as a significant omission has been taken up by a number of critics and curators, notably by Leslie K. Brown in her exhibition for the Photographic Resource Center, Boston, *Contemporary Vernacular: Contemporary Responses to Family and Found Photographs* (2004), see *In the Loupe: The Newsletter for the Photographic Resource Center of Boston University* 28(6) (2004): 8–11.
2 Sayre refers to John Szarkowsi's presentation of the first two portraits in the Museum of Modern Art's thematic exhibition *Mirrors and Windows* (1978). Nixon's images were classed by Szarkowski as "windows," thereby asserting their transparentness and specificity.
3 The author reviewed Tan's *Vox Populi: Norway* and Johnson's *Feast* for *Source,* under the editorship of Richard West.

References

Atwood, M. 2006. The Boys at the Lab. *Moral Disorder and Other Stories*. New York: Doubleday.
Barthes, R. 1981. *Camera Lucida: Reflections on Photography*, trans. R. Howard. New York: Hill and Wang.
Barthes, R. 1983. The Photographic Message (1961). *A Barthes Reader*, ed. S. Sontag. New York: Hill and Wang.
Batchen, G. 2002. Vernacular Photographies. *Each Wild Idea: Writing, Photography, History*. Cambridge, MA and London: MIT Press.
Batchen, G. 2004. *Forget Me Not: Photography and Remembrance*. Amsterdam: Van Gogh Museum and New York: Princeton Architectural Press.
Bürger, P. 1996 [1984]. *Theory of the Avant-Garde*, trans. M. Shaw. Minneapolis: University of Minnesota Press.
Dean, T. 2001. *Floh*. Göttingen: Steidl.
Feldmann, H.-P. 1994a. *Ferien*. Düsseldorf: Wiener Secession.
Feldmann, H.-P. 1994b. *Porträt*. München: Schirmer/Mosel.

Galassi, P. 1988. Introduction. *Nicholas Nixon: Pictures of People*. New York: Museum of Modern Art.

Godfrey, M. 2005. Photography Found and Lost: On Tacita Dean's *Floh*. *October* 114 (Fall): 90–119.

Goffman, E. 1959. *The Presentation of the Self in Everyday Life*. Garden City, NY: Doubleday Anchor Books.

Iversen, M. 1993. *Alois Riegl: Art History and Theory*. Cambridge, MA and London: MIT Press.

Johnson, C. and 33 Confessors. 2007. *Feast*. Canterbury, Epsom, Farnham, Maidstone and Rochester: University College for the Creative Arts.

Morin, E. 2005 [1956]. *The Cinema, or the Imaginary Man*, trans. L. Mortimer. Minneapolis and London: University of Minnesota Press.

Nelson, R. S. 1996. Appropriation. *Critical Terms for Art History*, eds. R. S. Nelson and R. Shiff. Chicago and London: University of Chicago Press.

Rosier, B. 2005. *Un état des lieux ou La mémoire des parallèles*. Introduction by E. Kraft. Paris: Lieux dits.

Sayre, H. M. 1989. *The Object of Performance: The American Avant-Garde Since 1970*. Chicago and London: University of Chicago Press.

Snow, M. 1970. *Michael Snow / a Survey*. Toronto: Art Gallery of Ontario.

Snow, M. 2007. *Scraps for the Soldiers*. Florence: Zona Archives.

Sontag, S. 1978 [1973]. In Plato's Cave. *On Photography*. New York: Farrar, Straus, and Giroux.

Stewart, S. 1993. *On Longing: Narratives of the Miniature, the Gigantic, the Souvenir, the Collection*. Durham and London: Duke University Press.

Tan, F. 2006. *Vox Populi: Norway*. London: Book Works.

Worringer, W. 1997 [1908]. *Abstraction and Empathy*. Chicago: Ivan R. Dee.

Geoffrey Batchen

OBSERVING BY WATCHING
Joachim Schmid and the art of exchange

IT IS SURELY TELLING that in the same month – January 2012 – Eastman Kodak declared bankruptcy and Facebook, the world's largest online social-network site, moved toward becoming a publicly traded company valued at $100 billion. The following April, Facebook spent one of those billions acquiring Instagram, a startup offering mobile apps that let people add quirky effects to their smartphone snapshots and share them with friends.

The inference could not be clearer: social media has triumphed over mere media, or at least over the photographic medium as we once knew it. But what is the nature of the social in digital image-sharing sites? And what about the nature of photography itself? Has it too become bankrupt, reduced to no more than a vehicle for conveying sentimental platitudes? Or does it continue more or less as it always has, banal or fascinating according to the prejudices or interests of each viewer, avoiding its own obsolescence through yet another one of its strategic technical transformations?

Everyone concedes that photography is now a medium of exchange as much as a mode of documentation. Able to be instantly disseminated around the globe, a digital snapshot initially functions as a message in the present ("Hey, I'm here *right now*, looking at this") rather than only as a record of some past moment. This kind of photograph is meant primarily as a means of communication, and the images being sent are almost as ephemeral as speech, so rarely are they printed and made physical. As Michael Kimmelman once put it in the *New York Times*, photographing has become "the visual equivalent of cellphone chatter." That chatter demands a different kind of body language than in the past, with arm outstretched and photographer looking *at*, rather than through, the camera. Contemporary photographers gaze at a little video screen and decide when to still (or not) the moving flow of potential images seen there. In operating that camera, they enact a sort of cultural convergence, in which the distinction between production and reception, and between moving and still images, has clouded. Danish scholar Mette Sandbye has proposed we consider this convergence a "signaletic" one, such that the "that-has-been" temporality of photography once

described by Roland Barthes has been replaced with a "what-is-going-on," a sharing of an immediacy of presence.

That said, the sheer number of photographic images being loaded onto social media sites makes any analysis of the phenomenon difficult. Facebook has reported that more than three hundred million photographs are uploaded onto its site every day, meaning

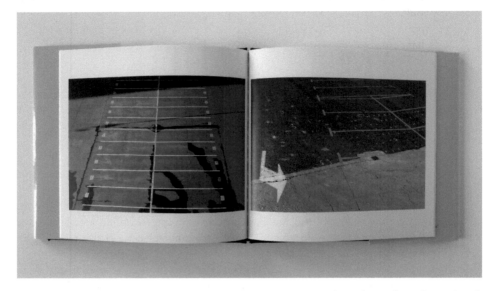

Figure 27.1 *From Other People's Photographs: Parking Lots.* [Original in colour]. © Joachim Schmid.

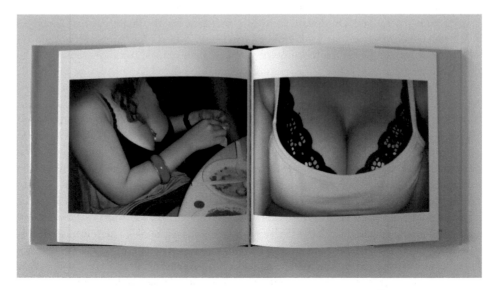

Figure 27.2 *From Other People's Photographs: Cleavage.* [Original in colour]. © Joachim Schmid.

that the site currently hosts more than 140 billion images. That makes Facebook about forty-six times more photographic than Flickr, the next largest depository. Established in February 2004 by a Vancouver-based company, Flickr reportedly gains about 4,500 new photographs every minute (so nearly 6.5 million a day), mostly gathered into the electronic equivalent of personal photo-albums. Nevertheless, even the White House releases its official photographs there. And it's just one of a number of such sites (the oldest, South Korea's Cyworld, has boasted that at one stage 37 percent of the South Korean population had an account). How can anyone examine a representative sample of contemporary photographic practice in the face of such overwhelming statistics?

As it happens, a German artist named Joachim Schmid spends six hours a day perusing and grabbing images from Flickr, using them to illustrate his own artist books under the title *Other People's Photographs*. When I asked him why, he told me: "I do it so that you don't have to." In the process of saving me the trouble, he also provides a kind of anecdotal, surrealist ethnography of global photography today. Again, it has become a truism to remark on the refashioning of privacy in our digital age, with social media stretching the word "friend" to include a vast array of relative strangers. Schmid's unauthorized publication of Flickr photographs merely extends this array to comprise discriminating denizens of the art and book-collecting world. His website discusses *Other People's Photographs*:

> Assembled between 2008 and 2011, this series of ninety-six books explores the themes presented by modern everyday, amateur photographers. Images found on photo sharing sites such as Flickr have been gathered and ordered in a way to form a library of contemporary vernacular photography in the age of digital technology and online photo hosting. Each book is comprised of images that focus on a specific photographic event or idea, the grouping of photographs revealing recurring patterns in modern popular photography. The approach is encyclopedic, and the number of volumes is virtually endless but arbitrarily limited. The selection of themes is neither systematic nor does it follow any established criteria – the project's structure mirrors the multifaceted, contradictory and chaotic practice of modern photography itself, based exclusively on the motto "You can observe a lot by watching."

For one such book, Schmid first gathered some ten thousand images of "currywurst," the local fast food of his hometown of Berlin, lovingly photographed by those unlucky souls about to consume it (he tells me that, over his many earlier years spent gathering discarded analog photos, he found only a handful of such images). People visiting Berlin apparently want to remember the food they are about to eat, or at least to share the experience of that want with others. Even within the apparent global homogeneity of Flickr we can thus find viral traces of the local asserting themselves – if, that is, we care to look for them.

In fact, it is only Schmid's looking that turns this otherwise international genre of food photography into a regional, even an autobiographical, focal point. Indeed, it might be said that a collapsing of the global into the personal is at the heart of his practice, making it true to the character of social media itself. Sitting at his computer screen, he downloads certain subjects and motifs that seem to recur in the constant stream of photographs he sees on Flickr's "Most Recent Uploads" page, which he refreshes constantly. Of course, there are now sites that set out to facilitate this same

Figure 27.3 *From Other People's Photographs: Currywurst.* [Original in colour]. © Joachim Schmid.

Figure 27.4 *From Other People's Photographs: Self.* [Original in colour]. © Joachim Schmid.

sort of distillation process, such as Pinterest, a social media website launched in 2010, on which its twelve million users compile collections of pictures they find on the Internet. But Schmid brings both a distinctively ironic eye and the play of chance to this process (he finds his images rather than searching for them), thus allowing us to take note of exhibitionist desires that might otherwise remain scattered and lost in the infinity of digital space. In short, each of the thirty-two-page samplers in *Other People's Photographs* imposes a thematic unity on an otherwise unruly universe of images. A diverse group, these samplers include the titillating flash of *Cleavage*, the deadpan documentation of *Mugshots*, the concrete poetry of *Fridge Doors*, and the more literally concrete jungle of *Parking Lots* (surely a choice of category inspired by Ed Ruscha), to name only a few of his titles.

Among other things, Schmid has recognized the sudden popularity of previously unknown genres of image, such as the proliferation on Flickr of photographs of camera boxes, apparently now the first thing everyone takes with their new camera: takes, and then shares online. In a similar vein, one of his recent books comprises nothing but photographs of the photographer's shadow. Some things, it seems, never change. Or maybe they do: what's interesting about this digital genre is that all these shadow-pictures seem to have been deliberately made, a significant shift in an amateur practice in which clumsy accident once ruled the pictorial roost.

Here on Flickr, through the mediating agency of Schmid's hunting and gathering, we get to see the art world, which once upon a time mimicked this aspect of the so-called snapshot aesthetic, now having that mimicry copied and reabsorbed back into vernacular practice. It seems the analog snapshot is indeed remembered in digital form, but only via a historic artistic mediator.

Another frequent image appearing on Flickr is the self-portrait made with camera in hand, arm outstretched, a type of photograph made possible only with the advent of lightweight digital cameras. Schmid's book on this genre implies that there are many more young photographers doing this than those over thirty, and more women than men. His selection also leaves the impression that this practice is more popular in Japan than in other countries (although, as he admits, this could be because Japanese teenagers upload their files onto Flickr as he starts work in Germany, whereas American members upload while he is asleep). In Korea, this kind of photograph has its own name: *selca* (self-camera). Korean scholar Jung Joon Lee reports that many young women who practice selca adopt specific angles and facial expressions that are designed to give them bigger eyes, a higher nose bridge, and a smaller face. But this kind of specificity, and a critical engagement with the Orientalism it internalizes, is subsumed in Schmid's book to the startling conformity of the genre, to a blithe repetition of form that appears to obey no identifiable cultural imperative beyond narcissism. Here, then, is the challenge his project lays before us – not just to make sense of contemporary photography, but to find ways to creatively intervene within it; not just to wonder at its numbing sameness, but also to exacerbate into visibility the abrasive political economy of difference.

Original publication

'Observing by Watching: Joachim Schmid and the Art of Exchange', *Aperture* (2013)

Lev Manovich

WATCHING THE WORLD

L AST SUMMER THE MUSEUM of Modern Art in New York asked the Software Studies Initiative, a program I started in 2007, to explore how visualization could be used as a research tool, for possible methods of presenting their photography collection in a novel way. We received access to approximately twenty thousand digitized photographs, which we then combined, using our software, into a single high-resolution image. This allowed us to view all the images at once, scrolling from those dating from the dawn of the medium to the present, spanning countries, genres, techniques, and photographers' diverse sensibilities. Practically every iconic photograph was included — images I had seen reproduced repeatedly. My ability to easily zoom in on each image and study its details, or zoom out to see it in its totality, was almost a religious experience.

Looking at twenty thousand photographs simultaneously might sound amazing, since even the largest museum gallery couldn't possibly include that many works. And yet, MoMA's collection, by twenty-first century standards, is meager compared with the massive reservoirs of photographs available on media-sharing sites such as Instagram, Flickr, and 500px. (Instagram alone already contains more than sixteen billion photographs, while Facebook users upload more than three hundred fifty million images every day.) The rise of "social photography," pioneered by Flickr in 2005, has opened fascinating new possibilities for cultural research. The photo-universe created by hundreds of millions of people might be considered a mega-documentary, without a script or director, but this documentary's scale requires computational tools — databases, search engines, visualization — in order to be "watched."

Mining the constituent parts of this "documentary" can teach us about vernacular photography and habits that govern digital-image making. When people photograph one another, do they privilege particular framing styles, à la a professional photographer? Do tourists visiting New York photograph the same subjects; are their choices culturally determined? And when they do photograph the same subject (for example, plants on the High Line Park on Manhattan's West Side), do they use the same techniques?

To begin answering these questions, we can use computers to analyze the visual attributes and content of millions of photographs and their accompanying descriptions, tags, geographical coordinates, and upload dates and times, and then interpret the results. While this research began only a few years ago, there are already a number of interesting projects that point toward future "computational visual sociology" and "computational photo criticism." In 2009, David Crandall and his colleagues from the Computer Science Department at Cornell University published a paper titled "Mapping the World's Photos" based on analysis of approximately thirty-five million Flickr photographs. As part of their research, they created a map consisting of the locations where images were taken. Areas with more photos appear brighter, while those with fewer photographs are dark. Not surprisingly, the United States and Western Europe are brightly illuminated while the rest of the world remains in the dark, indicating more sporadic coverage. But the map also reveals some unexpected patterns – the shorelines of most continents are very bright, while the interiors of the continents, with the notable exceptions of the States and Western Europe, remain completely dark.

Using their collected photo set, Crandall and his team also determined the most photographed locations in twenty-five metropolitan areas. This led to surprising discoveries – New York's fifth most photographed location was the Midtown Apple store; Tate Modern ranked number two in London. A photo-mapping project created in 2010 by data artist and software developer Eric Fisher addressed a question likely prompted by such information: how many of these images were captured by tourists or local residents, and how does this distinction reveal different patterns? Fisher's *Locals and Tourists* plotted the locations of large numbers of Flickr photographs by using color to indicate who took them: blue pictures by locals, red pictures by tourists; yellow pictures might have been made by either group. In total he mapped 136 cities, then shared these maps on Flickr. In his map of London we see how tourists frequent a few well-known sites, all in Central London, while locals cover the whole city but document less assiduously.

These pioneering projects use metadata to reveal telling patterns in social photography. However, they did not use actual images in their visualizations, a practice first explored, to my knowledge, by artist James Salavon. For series such as *Every Playboy Centerfold*, begun in 1997, and *Homes for Sale*, 1999, Salavon composited a number of images to reveal the photographic conventions used to represent particular subjects. His more recent work, *Good and Evil '12*, 2012, consists of two panels, each showing approximately twenty-five thousand photographs returned by a Bing image search for the one hundred most positive or negative words in English.

Media artists like Salavon demonstrate how visualization may uncover patterns in the content of large image collections. This is an idea my lab has explored further by developing open-source visualization tools that can be used by anyone working with images – art historians, film and media scholars, curators. One of our software tools can analyze visual properties (such as contrast, gray scale, texture, dominant colors, line orientations) and some dimensions of content (presence and positions of faces and bodies) of any number of images. Another tool can use the results of this analysis to position all images in a single high-resolution visualization sorted by their properties and metadata. We used these tools to visualize a variety of image collections, ranging from every cover of *Time* magazine between 1923 and 2007, a total of 4,535 covers, to one million Japanese manga pages.

Figure 28.1 Jay Chow and Lev Manovich, *Every Shot from Dziga Vertov's film 'Man with a Movie Camera'* (1929), 2012. Courtesy Jay Chow and Lev Manovich.

Figure 28.2 David Crandall, Lars Backstrom, Dan Huttenlocher, Jon Kleinberg, *Mapping the World's Photos,* 2009 (detail). A map visualization of about thirty-five million geotagged photographs collected on Flickr. The white dots on the map correspond to photographs, highlighting popular cities and landmarks. Courtesy David Crandall.

For our recent project, Phototrails, I'm working with art history Ph.D. student Nadav Hochman and designer/programmer Jay Chow to explore patterns among millions of photographs uploaded to social-media sites. We downloaded and analyzed 2.3 million Instagram images from thirteen global cities. One of our visualizations shows 53,498 photographs shared by people on Instagram in Tokyo over a few consecutive days. The progression of people's dominant activities throughout the day – working, having dinner, going out – is reflected in changing colors and relative brightness. No day is the same. Some are shorter than others, or the progression between different activities is very gradual, while in others it is sharper. Together, these photographs create an "aggregate documentary" of Tokyo – a portrait of the city's changing temporal patterns constructed from thousands of documented activities.

But are aggregated documentaries new? Dziga Vertov's 1929 experimental film *Man with a Movie Camera*, the subject of one of our projects, portrays a single day in the

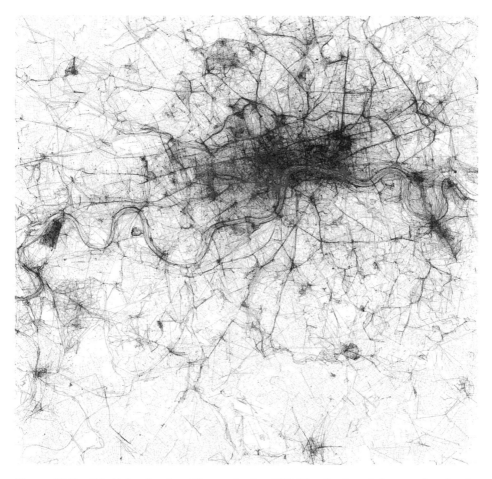

Figure 28.3 Eric Fisher, *Locals and Tourists, London,* 2010. Visualization of photographs taken by locals (shown in blue in the original), tourists (red), or either group (yellow) in London, collected via Flickr. [Original in colour]. Base map © OpenStreetMap, CC-BY-SA; visualization © and courtesy Eric Fisher.

life of a Soviet city and might be considered a precursor to the form. The film combines footage shot in three separate Ukrainian cities – Odessa, Khartiv, and Kiev – over a three-year period. Vertov wanted to communicate particular ideas about construct-ing a communist society that guided the selection and editing of his footage. Unlike Vertov, our visualizations of human habits rendered through Instagram photographs do not reflect a single directorial point of view, but this does not make them entirely objective. Just as a photographer decides on framing and perspective, we make formal decisions about how to map images, organizing them by upload dates, average color, brightness, and so on. But by rendering the same set of images in multiple ways, we remind viewers that no single visualization offers a transparent interpretation, just as no single traditional documentary image could be considered neutral. The tremendous diversity of social photography reflects the complex patterns of life unfolding in the world's cities – this can never be fully captured in a single visualization, despite our ability to harness an excess of images.

Original publication

'Watching the World', *Aperture* (2014)

Daniel Rubinstein and Katrina Sluis

A LIFE MORE PHOTOGRAPHIC
Mapping the networked image

Introduction

RECENT CHANGES IN THE PRODUCTION, distribution, consumption and storage of images caused by the merging of photography with the Internet have had a notable effect on varied and diverse social and cultural processes and institutions including medicine (Pap et al.), journalism (Colin, Gillmor), law enforcement (Cascio), tourism (Noah et al.), space exploration (Lanzagorta) and fine art.[1] In all these areas digital imaging causes shifts in the way bodies are imagined and perceived, wars are fought, people are monitored, works of art valorized and the public informed of all of the above. Photography is now ingrained in so many processes, that a scholar of photography must also be highly informed about industries and institutions that traditionally have had little to do with the study of photography. Conversely, researchers in the fields of cultural anthropology (Okabe and Ito), informatics and human computer interaction (Van House et al., Kindberg et al.) and are increasingly concerned with the importance of digital photography to their fields of study.

In this article we choose to focus on only one area of photography, which we consider to be key in understanding the shifts which are occurring in our perception of the medium. Popular photography was, for several decades, the focus of studies by cultural theorists and historians, curators and artists. But it is only with the dissemination of personal photography online that 'Kodak culture' (Chalfen 8–18), augmented by 'Nokia culture' became distributed and shared on a scale comparable with news or commercial photography.

The distribution and sharing of snapshots online highlights a paradoxical condition that characterises snapshot photography: it is both ubiquitous and hidden. Since the beginning of the 20th century the snapshot has been the archetypal readymade image: place holder for memories, trophy of sightseeing, produced in their millions by ordinary people to document the rituals of everyday life. And yet despite being the most mass-produced photographic product, the snapshot has remained highly private,

concealed from public eye, and quite often an invisible image. When snapshots do appear in public, whether in the context of fine art exhibitions and publications or in scientific journals, they are often presented as 'found images' – stripped of notions of authorship or details about the original purpose of the image, its subjects and the circumstances of its creation. Even as the anonymous snapshot is used extensively as a metaphor or a sign in works of fine art from Jeff Wall to Nan Goldin, from Christian Boltanski to Gerhard Richter, these artists seem to be filling a gap left by the absence of genuine, real-life snapshots in the public domain. Looked at as a genre, snapshot photography seems to have many imitators but no recognised originals, many admirers but no masterpieces, many iconoclasts but no icons.

Inverting this paradigm, the 2007 exhibition 'We are all Photographers Now!' at the Musée de l'Elysée, Lausanne, Switzerland,[2] responded to the way in which the photography of 'ordinary people' has achieved visibility and popularity, challenging the way in which photography is framed and consumed. Photo sharing and social networking sites now provide a platform for photographers to deliver their images to locations where millions can view them simultaneously. Being in the right place with the right phone is now enough to make you a photojournalist, or give you access to gallery wall space. Snapshots now appear not only in web-based family albums and diaries, they also literally cover the face of the earth: augmented by geographic coordinates they are superimposed onto screen-based online maps of the world.[3]

Photography is dead, long live photography

If one looks back at the brief history of digital photography it becomes very clear that the issues that bothered critics and historians twenty years ago are significantly different from the questions we may need to ask now. For many scholars, the most pressing issues were those concerning the digital image's ability to represent the Real (Mitchell 23–57, Ritchin 36, Rosler 50–56). The malleability of digital photographs was then seen by many as the central element of the digital revolution and caused some to herald the 'death of photography,' shattering the privileged status of the photograph as 'objective' truth (for accounts of this period see Robins 29–50).

Instead, we now see that the power of the photograph to document is not diminished due to digital technology. From CCTV stills, traffic control and monitoring systems, to photo-reportage, the digital image plays a major role as 'evidence.' The low resolution, pixilated appearance of early camera phone photographs and video clips is now an accepted part of the syntax of truthful and authentic reportage in the same way that the grainy black and white photograph once was. The speed with which these highly compressed JPEGs are transmitted and amalgamated into news media is an indication of the acceptance of the explicitly digital image into the structure of news reporting while emergent practices such as citizen journalism and sousveillance (Mann et al. 177) rely on the instant distribution that the networked camera facilitates.

A typical example of this shift is the camera phone image taken by Adam Stacey on his way out of the underground on the morning of the 7/7 London bombings.[4] Alongside other camera phone images, his picture rather than the photographs taken later that day by photojournalists, became iconic of the incident. Significantly, the picture that appeared on major news sites was a self-portrait of Stacey, one hand

covering his nose and mouth, with the tube carriage in the background. Here, the camera phone provides the means of reporting from the perspective of the participant in the event, the ergonomics of the telephone even allowing for easy inclusion of the photographer in the picture. Compare that to the position of the photojournalist: whose professional ethics dictate the position of the *detached observer*, assisted by the adoption of bulky photographic equipment and long range lenses which create a physical separation between subject and object.

The mass-amateurisation of photography, and its renewed visibility online signals a shift in the valorisation of photographic culture. If, in the past, the arena of public photography was dominated by professional practitioners, currently, the work of specialists is appearing side by side with images produced by persons who don't have the same professional investment in photography.[5] As a result, the roles of the professional photographic image and that of a snapshot are changing.

The early years of digital photography

During the first years of the 'digital revolution,' digital technology was largely inserted into the framework of existing traditional photographic practice. Through the 1990s the dominant shift was marked by replacing the technology of the analogue photograph (film, chemical processing, darkroom practices) with the technology of digital capture, and image manipulation. But these technological changes did not radically alter the economy of production and storage of photographic images.

The arrival of digital imaging did not revolutionise popular photography but caused gradual shifts in the habits of hobbyists and middle-class amateurs who bought computers, scanners and ink-jet printers but used them within the old paradigms of analogue photography. The photographic darkroom and the photo lab were replaced by Photoshop and a colour printer. The ability to make prints without the need for a home darkroom, and the ease with which old, faded prints could be improved or restored convinced many photographers to swap the photo lab for domestic digital set-up. But during the first stages of penetration of digital photography into the amateur market (1990s) 'going digital' was not about the acquisition of a digital camera – which was at that time an expensive tool beyond the reach of all but the richest dilettantes. Instead, the flatbed scanner or the more specialised film scanner became the central hardware of the digital 'lightroom' as it provided a way of digitising film negatives and old prints, correcting and restoring them beyond what was previously possible in the darkroom and printing them on inkjet paper which mimicked photographic emulsion. The digital print was considered a compromise: not as good as a darkroom print, but an acceptable surrogate. Here the print persisted.

Imaging software of that decade also simulated the tools and techniques of photographic craft; Photoshop was the software of choice, with its array of familiar darkroom tools for 'dodging' and 'burning,' sharpening and blurring. Image management software (Thumbs Up, ACDSee) employed the metaphor of a light box to display rows of images presented as a sheet of mounted transparencies.

Even when digital cameras became more affordable for the consumer market, the promise of immediacy that digital photography offered was frustrated by unsuitable methods for *instant* image sharing. Showing digital photographs to family and friends

relied on being physically gathered around a single computer's screen – and relied on the presence of a computer literate person to operate the software. Whilst sending photographs by email was possible and indeed practiced, there were significant barriers to the uptake of this. Internet access in the 1990s was characterised by slow and expensive modem connections, accompanied by the popular adoption of low-capacity web-based email accounts. The practice of sending large attachments was quite risky, potentially condemning the recipient to an overflowing mailbox or terminal boredom whilst waiting for images to appear onscreen. Meanwhile, the publishing of images online was either a complicated or costly process, usually requiring a website domain, a hosting subscription, and a web designer or computer-savvy friend.

From print-based to screen-based photography

The advent of affordable, consumer oriented digital cameras introduced amateur photographers to several technological innovations which contributed to dramatic changes in popular photographic practices. In 1995, the first digital consumer camera with a screen made it possible to preview an image before it was taken (Tatsuno 36). In addition to the screen, the digital camera also acquired a delete button, which provided a way of erasing unwanted shots from memory. With these two innovations, digital technology addressed the two significant barriers for engagement with photography: the delay between taking a picture and viewing it,[6] and the cost of each exposed frame (Bourdieu 78).

From now on it became possible to engage with photography in a remarkably different way. The ability to take a picture, look at the screen, re-adjust the composition and correct the camera settings until the image is perfect created an environment of accelerated learning which gave amateurs the tools to compete with professionals. In the world of still film cameras, years of training were required to mentally transform a 3D view into a 2D plane, and translate light and colour into photographic (greyscale or colour) values in order to visualise the scene the way it would look in print. Ansel Adams famously attributed great importance to this skill:

> I can not overemphasize the importance of continuous practice in visualisation, both in terms of image values [. . .] and image management [. . .]. We must learn to *see intuitively as the lens/camera sees* and to understand how the negative and printing papers will respond. It is a stimulating process and one with great creative potential.
>
> (Adams 7. Our emphasis)

The little screen at the back of a digital camera made it possible to *see intuitively as the lens/camera sees* without years of training, dramatically narrowing the gap between the professional photographer and the amateur.

The ability to delete an image immediately after it was taken has intriguing consequences for the kind of photographs that are left after the 'on-the-fly' editing. Whatever seems imperfect, unflattering, or meaningless at the time the picture was made, is now in danger of being deleted immediately in order to free some space in the camera memory for future, presumably better, photo opportunities. The delete button

promises a set of selected and more perfect images while at the same time threatening a death blow to the traditional role of the photograph as memento and a keepsake. The ability to edit in camera means that pictures that are deemed unsuccessful disappear forever, thus eliminating the possibility of returning to them after months or years to discover redeeming qualities that compensate for their apparent imperfections. The delete button reduces the chances of discovering hidden truth in photographs: a blurred face that becomes a poignant representation of absence and loss; a bad expression that turns into a cherished quality; closed eyes that reflect the proximity of death; a stranger in the background that becomes a lover or a friend.

Today, the overwhelming majority of personal photographs are destined to never appear on paper. As computer processing power has exponentially increased, and as the price of storage has dropped, the ability to accumulate tens of thousands of images has become a reality for the vernacular photographer. For the accidental archivist, the familiar trope of the dusty shoebox stuffed full of neglected prints gathering dust has been reinvented as the hard disk cluttered by files. In 2005 one internet survey stated that 11 percent of respondents had more than 10,000 digital photos, whilst the largest group (27 percent) had between 1,001 and 5,000 digital photos ("Do you have 10,000 Digital Photos?"). Traditional models of handling photography had no way of coping with such dramatic increase in volume of photographic production.[7]

As the photographic print becomes an unwieldy vehicle for sharing this image explosion the snapshot is now commonly viewed via the screen of the camera, mobile phone or computer. As Daisuke Okabe has noted, currently the most fluid and immediate sharing of images happens when images are shared directly via the camera's screen (2, 9). In recent years, the camera screen has grown in size from an electronic viewfinder into a portable viewing frame, designed not only to compose and review but to view, edit and share photographs without resorting to computers[8] or photo-labs.[9] Some consumer cameras now have screens which mimic the scale of a small photographic print, colonising the entire back side of the camera, replacing the camera controls with a responsive touch screen (e.g. The seductive, shiny screen has also become a marketing tool for the camera; product shots frequently highlight the back, rather then the front of the camera, drawing attention to a large screen with a bright picture on it. A similar development can be observed in the way in which the design of higher end camera phones and some PDAs almost eliminate the keypad, and therefore sacrifice some of the functionality, in order to maximise the screen.

The emergence of the digital lifestyle

As our viewing practices shift towards the screen, the photograph appears within the same space as other digitised information and entertainment. Christian Metz, in *Photography and Fetish* points out the difference between a (traditional) still photograph and a movie film in terms of its "socialised unit of reading" or lexis (155). He goes on to observe that ". . . the photographic lexis, a silent rectangle of paper, is much smaller than the cinematic lexis" (155). But viewed on the computer screen, the amateur/family photograph occupies the same space as the video game, the film trailer, the newspaper and the artwork in a virtual museum. It becomes part of an endless stream

of data, disassociated from the origins of the snapshot in the personal, the ostensibly real, and private life.

In 2005, Photobucket was registering 1.3 million images being uploaded to its servers each day, which were then being replicated to over 500,000 other websites ('Fun Statistics'). Flickr recorded its 100 millionth photo upload in 2006 (Champ). Here, we observe a transformation similar in magnitude to the one that John Tagg describes in *The Burden of Representation*, when the invention of half-tone plates in the 1880s "enabled the economical and limitless reproduction of photographs" (55–56). The ease with which images replicate and transmit across telecommunications networks modifies the economies of photographic images just as drastically.

Intriguingly, there are protracted similarities between the present digital photography revolution and the events that shaped amateur photography at the turn of the 19th century. As John Tagg points out, all the technological innovations of George Eastman, the founder of Kodak, would have amounted to little if he had not thought to re-brand photography in a way which made it appealing to "a whole stratum of people who had never before taken a photograph." (54) Similarly, the technological innovations that made storing limitless numbers of images possible on cheap hard disks and memory cards, and fast and economical distribution of photographs through a high speed internet connection, would not have amounted to a re-structuring of the place of photography in society, if they had not been augmented by a shift in the marketing of computers. At the axis of this second digital revolution in photography[10] was the re-branding of the home computer as the centre of 'digital lifestyle.' Championed by both Microsoft ("Microsoft Digital Lifestyle") and Apple (Redman) this concept aims to situate the computer at the heart of family life, replacing the television and the sound system, the coffee table,[11] the phone, the family album and the slide projector. Part of this re-branding exercise earmarked photography, together with music and video, as central to the 'fun' things that the computer can do.

As part of the 'digital lifestyle,' a new generation of consumer photographic tools (iPhoto, Picasa) avoids references to the darkroom and to the photographic skills and practices of old. Gone are the metaphors of the light box and the filing cabinet; replaced instead by features more common to video software. Now, one is able to 'scroll through' long sequences of photographs by navigating a timeline: as you navigate the images flicker one after another. A whole year's worth of pictures can flash in front of your eyes in a matter of seconds. When Steve Jobs, Apple's CEO unveiled the first version of iPhoto in 2001, he referred to the 'chain of pain' involved in downloading photographs from the camera to the computer (Steinberg 1). In contrast with the past, Apple's new software was offering a 'zero configuration' environment for photography in which the camera model was recognised automatically, images stored according to date and time, and photos were 'shared' as slideshows, photo books and web pages. The new breed of photographic applications did not emphasise the manipulation and the editing of images: these were activities requiring time to learn and execute; and made almost unnecessary due to the very high 'success rate' of compact digital cameras. By discretely eliminating references to craftsmanship and specialist knowledge from digital photography software, photography is incorporated into the suite of friendly multimedia applications designed to appeal to every computer user.

This re-branding of photography occurred in tandem with a revolution in mobile telecommunications. The disappearance of the camera inside the telephone bonded

photography to the most important device of personal communications that ever existed – the mobile phone. As Kristóf Nyíri observes:

> Combining the option of voice calls with text messaging, MMS, as well as e-mail, and on its way to becoming the natural interface through which to conduct shopping, banking, booking flights, and checking in, the mobile phone is obviously turning into the single unique instrument of mediated communication, mediating not just between people, but also between people and institutions, and indeed between people and the world of inanimate objects.
>
> (2)

In the light of Nyíri's observations, it is not surprising that the influence of the camera phone on contemporary culture is the subject of extensive research by scholars in the field of human computer interaction (HCI). Such studies respond to the demand of telecommunications conglomerates to know more about social uses of mobile photography with the view of developing additional services that will further deepen the bond between consumers and their phones (see for example, Van House et al., Kindberg et al). Based mostly on the analysis of focus groups, these studies look at the things people 'do' with their camera phones. Given the methodology it comes as no surprise that most findings indicate that the main uses of camera phone photography are highly social. In the now celebrated analysis by Van House et al, "The Uses of Personal Networked Digital Imaging: An Empirical Study of Camera phone Photos and Sharing," the four main uses of camera phone photography are creating and maintaining social relationships, constructing personal and group memory, self-presentation, and self-expression (1845).

What people do with photographs after they are taken is also subject of acute attention. The emerging field of personal information management (PIM) addresses the personal photographic archive as another form of data which needs to be understood, managed and retrieved more efficiently. Rodden and Wood (409), have observed the ways in which pictures are stored, annotated, sent, shared and archived. Elsewhere, algorithms are being developed in order to assist in the creation of image collections which archive themselves (Naahman et al. 180–181). Surveying this growing literature on camera phones and photo sharing it becomes quite clear that the field is dominated by research that is not troubled by questions concerning the role of representation or the power structures which surround photography. Whilst references to the canon of critical writing on photography may appear in the occasional footnote, it is still remarkable that the new wave of works on photography (see for example Van House et al., Van House and Davis, Okabe and Ito, Kindberg et al.) can do without the persistent questions about representation that fascinated writers on photography for decades.

Before we lament the indifference of these researchers to the theories of photography, it is worth remembering that the photograph that occupied the mind of Barthes is a different object to the photograph that Okabe, Van-House and Kindberg write about. Where Barthes was turning the rustling pages of his family album, Okabe observes a formation of pixels on a 2x2 inch screen of a telephone. Where Sekula interprets the significance of the strips of light and dark in Stieglitz's fine print, Van House deals with an image that becomes illegible binary data at the press of a button.

As image-data becomes a viable substitute for the printed snapshot, we see the material structures which supported the storage and display of personal photography (shoebox, album, photo frame) being sustained by range of different practices and forms. For an increasing number of consumers, the archival and sharing practices which surrounded the print are now provided via the transmission of photographs to networked locations. Through the relocation of the image collection online, consumers are able to mitigate data anxiety by outsourcing backing up responsibilities to the companies which maintain the massive server farms which host the images ("The downside of digital snaps"). Significantly, whether located online or contained on a home PC, the digital snapshot collection now takes the form of a *database*. Borrowing Manovich's definition, "they appear as collections of items on which the user can perform various operations – view, navigate, search" ("Language of New Media" 219). With the emergence of the photo sharing platform, the photographs of millions of individuals are now contained within online databases connected to each other by hyperlink, tag, or search term. Within this context, the consumption of personal photography has become intimately linked with the software interfaces which mediate their display on-screen.

The social life of the networked image

The popularity of photo sharing needs to be considered alongside the processes that shape the World Wide Web, particularly in recent years where notions of 'community,' 'social,' 'friend,' 'free' (as in free account) and 'fun' are being reshaped through the rise of social networking and Web 2.0. Whilst often put forth as a problematic and controversial term, Web 2.0 was first coined in 2004 to describe shifts in the way in which "software developers and end users use the web as a platform" (O'Reilly). Instead of providing an interface for the navigation and display of interlinked documents, commentators observed that successful websites were appearing which mimicked the functionality and interactive possibilities more commonly found in desktop software applications. In terms of photography, it suddenly became possible to modify content online without programming skills; one could upload, rotate, annotate, distribute and organise images by interacting directly with the webpage itself. Whilst in the 1990s photo sharing sites simply functioned as add-ons for online print finishing services, the new generation of sites such as Smugmug, Buzznet, Zoto, Flickr (launched in 2004) functioned as interfaces which facilitated a playful engagement with one's own snapshots and those uploaded by others.

The photo sharing platform, like the software that supports blogging, makes the process of updating one's page simple and intuitive. However, unlike a blog, photo sharing does not require the labour of writing entries on a regular basis, and it does not demand continual activity in the way a social networking site does, and yet, photo sharing offers to its members many of the benefits of blogging and social networking. As such, photo sharing provides a flexible model of participation which allows for regular updates in the form of online photo journals, but also accommodates users who only want to upload a few images as a permanent photo gallery or those who use photo sharing as a backup solution for the image collection on their PC. At the same

time, a major appeal of photo sharing is the ability to connect with others not through writing but by posting images.

Van House notes in her study of Flickr users that many have given up blogging because it is 'too much work' and now favour the photograph as a more convenient way of sharing their experiences (2720). The practices of moblogging (blogging with a mobile phone) and photoblogging (blogging with photographs rather then text) further exploit the way in which mobile phone images have become a kind of visual speech – an immediate, intimate form of communication that replaces writing.

The networking of the snapshot provides something which vernacular photographers have always lacked: a broad audience. Don Slater has noted how marginalised the practice of *looking* at as opposed to *taking* snapshots has been, quoting a 1982 survey which stated 60 percent of respondents and their families looked at their family snaps once a year or less (Slater 138). Single images, uploaded to a photo sharing site, can accumulate thousands of viewings and long strings of comments. Whilst an invitation to someone else's 'slide night' of holiday snaps has been something to be avoided at all costs, the photo sharing environment encourages a prolonged engagement with the image, where the act of viewing other people's images online becomes a form of leisure and a social activity. Writing in 1995, Slater noted the way in which "actively using domestic photographs as opposed to taking them . . . is marginal because it is not structured into a leisure event" (140). Within a photo sharing platform, the viewing of photographs is now constructed as a creative pursuit, involving remixing, captioning and commenting upon images. At the same time, traditions of collecting, archiving, scrapbooking have become rebranded as the marketing buzzword 'life caching': a consumer 'mega trend' coined by Trendwatching.com ("Life Caching: An emerging consumer trend"). Consumers, or "anyone with even a tiny amount of creative talent" are also now rebranded as members of a 'Generation C,' for whom the *production* and *manipulation* of digital media 'Content' is both 'Creative' and inseparable from the *consumption* of digital storage, media players, and camera phones ("Generation C: An emerging consumer trend").

The photo sharing interface provides a range of built-in features designed to make the viewing of photographs into a concrete, traceable activity, which is a source of anticipation each time a user logs on to their account. Within Flickr, Jean Burgess suggests that these interface features reward users for participation:

> At the most basic level, each action of uploading an image contains a potential reward – there is always the possibility that someone will view and enjoy it; the reward is delivered in material form if another user leaves a comment or marks the image as a favourite.
>
> (140)

Viewer involvement can extend from leaving a comment at the bottom of the page to attaching notes to specific areas of the image, whereby making viewing into a creative activity that has the potential to support or subvert the intentions of the photographer. The face of the photograph can become a site of struggle between interpretations by various users, while at the same time generating layers of text that can be software read and used as a resource in search algorithms.[12]

The visibility of the networked image

A quick visit to the Flickr home page reveals that over 3000 images have been uploaded in the last minute.[13] Within this avalanche of images, the practice of tagging one's photos acts as a strategy for preventing them from disappearing from view. Tagging systems are a central feature of photo sharing sites such as Flickr and SmugMug which promote the community features of their interfaces. The practice of tagging involves the addition of freely chosen words to an image – resulting in a bottom-up subjective categorisation system known as a *folksonomy*. In a photo sharing context, tagging serves a dual function of helping to classify a personal collection of images, and making the images available to search enquiries within the photo sharing site. As such, tagging is both a part of personal image management and at the centre of the social aspects of photo sharing.

Within the Flickr environment, the practice of tagging is linked to the popularity and visibility of the image. Images which are highly ranked in search results may have been tagged with up to 75 keywords (the maximum allowed) through which they have attracted hundreds of hits and numerous comments. Within photo sharing, the practice of tagging becomes part of a strategy for self promotion that allows the individual to rise above the anonymity of most users.

The reliance on tagging for organisation and retrieval of images is an indication of the importance of textuality for online photographic procedures. Photo sharing is therefore not just a portal for photographs, but an amalgamation of mutually dependant visual and textual practices. Matt Locke has observed that annotation "creates a kind of intimacy around the photograph, capturing some of the 'murmur of laughing voices' that surrounded their creation."(391) Tagging, commenting, titling and annotating of images are essential elements of participation in the social aspects of photo sharing which play a role in creating communities of users interested in specific images.

Tagging provides a substantially different way of viewing and interacting with personal photography. Batchen states ". . . when we . . . touch an album and turn its pages, we put the photograph in motion, literally in an arc through space and metaphorically in a sequential narrative" (49). As a form of new media, the hyperlinked image enables the possibility of non-linear navigation, creating an environment where images can be connected and displayed according to an array of different categories. Significantly, as a tag is actually a hyperlink created by the *user*, tagging systems resemble more closely Vannevar Bush's conception of the Memex – where user-created links form loose trails between different documents (Johnson 121). Within Flickr, the simple addition of the tag 'cat' to an image immediately connects the image to 100,000 photos of other cats, which can be called to the screen with a single click. In this respect, tagging subverts any attempt to impose narrative order on the snapshot collection, and calls into question a snapshot's specificity or individual mark of identity. As a process it acts to join images together as communal pools of tourist snaps, sunsets and babies.

Tagging is one system which rewards users by providing a tool for search and retrieval of photographs, while at the same time making large collections of photographs legible to other software. Tagging is crucial in helping computers to make meaningful selections of images that relate to its content or emotional significance.

This stands in contrast to mechanically captured metadata: information which has been added by the camera concerning the technical context of the image (e.g. camera make, exposure). By assigning tags to their images, users are in essence describing their photographs in a way that the computer can understand.

The inability of computers to interpret pixel information in a way which would allow automatic cataloguing of photographs forces computer scientists to develop systems in which humans assist computers in 'seeing' photographs. One example of such 'human-computer' collaboration is a 'Google Image Labeler'[14] – an online game in which players score points while labelling elements of photographs presented to them by the software. Despite the fact that the only reward for the human players is the score they accumulate against others, the game is so addictive that it was estimated that it will take Google only several months to catalogue all the images on its servers. (von Ahn 319).

As a means for giving machines the ability to interpret an image, metadata provides "a new paradigm to 'interface reality'" (Manovich, "Metadata"), providing a means for the image to escape its original context. Stripped of their interfaces, photo sharing sites function as vast databases of indexed photographs which can be remixed and remapped online as *mashups*. Hackers and programmers interested in new ways of navigating and visualising images now create alternative interfaces which pull together images with maps, texts, ratings, newsfeeds and other content online. In this new context, the currency of the snapshot ceases to lie in its narrative or mnemonic value, in its indexicality, or in its status as a precious object. Instead, these practices illustrate the way in which the networked image is data, that is: visual information to be analysed and remapped to new contexts via algorithms. With the mashup tools provided by 'Yahoo! Pipes,' it becomes possible to 'read' 'The Guardian' as a sequence of images pulled from Flickr. In this example, a news feed will undergo automated content analysis, a sequence of keywords will be generated, which are then used to pull out images via a tag search from Flickr ("Guardian's Newsblog thru Flickr").

I am the camera

The mass appeal of the camera phone as a platform for digital photography (Nyíri 1) could be partly explained by the promise to fulfil a desire for unmediated photography; photography that takes place without the intervention of the camera. As Erkki Huhtamo observes, photography was the first mass media that was susceptible to miniaturisation; an inventory of 19th century photographic apparatus includes bow tie cameras, bowler hat and walking stick cameras and suitcase and book cameras. In the 20th century, subminiature cameras found their way into finger rings, pocket watches, mechanical pencils and pens (1). Beyond addressing the voyeuristic urge to be able to photograph without being noticed, these devices indicate a wish for photography with everyday objects instead of a camera, and prefigure contemporary developments in the field of wearable electronics. This desire is motivated not only by the wish to make the act of photography invisible and mobile but also by the fantasy of blurring the boundaries between the act of living and the act of taking photographs. While examining photoblogging practices, Cohen identifies the yearning for photography without photography during an interview with a photo blogger called

Ed, who expresses the wish to ". . . go around recording, taking pictures by [pause] blinking . . ." (891) Cohen goes on to explain that Ed's desire is to "augment his body with the means to generate photographs as he lives; remove duration from the process of taking a photograph; remove the need to reach out and grasp a separate physical device in order to fix the image." (892).

A camera inside a telephone seems like something that might have appeared in a Victorian catalogue of detective cameras – minute, invisible and much more convenient to operate discretely then a camera concealed in a bowler hat. Eliminating the camera from the practice of photography removed a barrier to spontaneous image capture, allowing anyone with a telephone to participate in the documentation of their immediate environment. The ability to take photographs without becoming a photographer is appealing not only because it makes photography less technological, but also because with the absence of the camera, the photographer does not become an observer but remains intimately connected to the subject of photography. At the same time, the act of wearing a camera at all times opens up a different relationship to space, turning everything in one's immediate environment into a potential subject for a snapshot.

Digital image abundance

Whilst the traditional album provides a discrete framework for displaying a limited selection of images, photo sharing websites exist as spheres of image abundance. Accordingly, we see our attention shift from the singular photographic image to image *sequences*: the image 'pool,' the 'slideshow,' the 'photostream,' the image 'feed.' At the same time, images from camera phones and digital cameras are not "frozen moments in time" in the way photographs used to be understood. A recent offering from one of the leading camera manufacturers is a 6 mega pixel camera that captures sixty full resolution frames per second ("Casio developing 300 fps CMOS based camera"); one can only wonder what is the meaning of the 'decisive moment' in these circumstances and what is the difference between photography and video (beyond the fact that photography now has more frames per second). But even if the technological gadgetry does not seduce us, we are still left with endless amount of images available from photo sharing websites. This inexhaustible stream makes it hard to develop an intimate relationship with a single image. The assurance of infinite scopic pleasure online encourages a restless, continual search in which the present image, exciting as it is, is only a cover for the next, potentially more promising and thrilling. Caterina Fake, Flickr's founder argues that "the nature of photography now is it's in motion. . . . It doesn't stop time anymore, and maybe that's a loss. But there's a kind of beauty to that, too."(Harmon)

The possibility of snapshot photography not as composed of static, physical objects but as something more akin to live transmission is also seen in the emergence of screen-based electronic photo frames. The digital photo frame mimics the traditional photo frame, but replaces the print with a flat screen, displaying a constant stream of digital images within a familiar 8 x 10" proportion. Recent models are marketed for their ability to integrate wirelessly with photo sharing sites, using RSS to suck down image sequences directly to the mantelpiece. Here, personal photography is imagined

as an image 'feed': the image is presented as a shifting sequence, able to dynamically update itself within the frame as new images are posted by the user online.

Return of the anonymous snapshot

Within this flow of images the value of a single photograph is diminished and replaced by the notion of a stream of data in which both images and their significances are in a state of flux.

Within this flow of images the value of a single photograph is being diminished and replaced by the notion of a stream of data in which both images and their significances are in a state of flux. Disassociated from its origins, identified only by semantic tags and placed in a pool with other images that share similar metadata, the snapshot's resonance is dependant on the interface which mediates our encounter with it. Corby and Baily (referring to earlier work by Johnson), explain:

> While often presented as some form of untainted fact, statistical visualizations, database interfaces, etc., act as both a membrane for access, and a culturally organized surface that formulates perception of underlying data and informational structures. Simply put, there is no natural connection between the data and its representational form, other than the fact it is digital material.
>
> (113)

Stripped of its original context, the personal photograph appears to be 'authorless'; and can function as a highly versatile vessel for ideological narratives from news reports to fine-art installations to programming experiments. The lack of significance represented by the authorless snapshot now has more to do with its belonging to a class of images that share similar metadata, than it does to photography's intrinsic polysemy. Put another way, transmitted over networks, the snapshot image signifies an absence of meaning, it is the ambient visual background against which visual narratives are told, distributed and consumed.

The work of Paul Frosh, (concerned with the online image banks through which stock advertising photographs are now accessed), is significant in this context because he develops a model of analysis for images which are intentionally made to be unseen. In "Rhetorics of the overlooked" his analysis is focused on the generic images of "smiling, white middle-class families at the beach, well-groomed businessmen shaking hands, romantic young couples kissing" (175) manufactured by the stock photography industry, which he contrasts with the attention seeking, highly visible and dramatic advertising images which attract most consumer and critical attention. As Frosh puts it:

> I hope to resurrect the significance of the ordinary, the unremarkable and the overlooked in our understanding of how many (if not most) advertising images communicate, and to replace the isolated object of the consumer-critic's specular interest with an unremarkable but enveloping visual environment.
>
> (173)

The distinction Frosh makes between the 'isolated object' and the 'visual environment' when talking about stock photography, has clear implications for the way networked vernacular photography can be understood as ocular 'white noise': "Stock photography . . . emits the 'background noise' of consumer cultures: vast numbers of similar images which are repeatedly produced and preformed as ordinarily familiar and ordinarily desirable" (191).

Similarly the networked snapshot is overlooked not simply because it is bland, banal and repetitious, but also because it is a non-object. And not just in the sense in which photographs always had an insecure presence as an object, due to their role as signifiers that we tend to *look through*, rather then *look at*. Within online networks, the individual snapshot is stripped of the fragile aura of the photographic object as it becomes absorbed into a steam of visual data. By giving up the attributes of a photograph as a unique, singular and intentional presence, the networked snapshot is becoming difficult to comprehend with the conceptual tools of visual literacy and photographic theory. The comparative silence of photographic theorists in regard to vernacular photography online, could, in part, be due to this.

By taking on the appearance of a snapshot, the networked image is camouflaged as a non-political, non-significant and non-ideological site that does not merit textual analysis. This is perhaps a source of the persistence and power of the networked image. Invisibility of course is not without its benefits; not only does it help to evade analysis, criticism and deconstruction that are the fate of the louder, more visible images, but through being unnoticed, vernacular images appear normative, all-encompassing, and inherently benign. In their capacity as readymade, mass-produced and slightly silly, the snapshot perpetuates the notion of the world going about its business in a natural way. The practice of tagging, which results in millions of images identified with 'holiday,' 'party,' 'wedding,' 'family' reinforces a sense of identity and unity which overwhelms differences and distinctions. They advance a sense of uniformed, global satisfaction with the way things are without being called to account for their lyrical promotion of "universal human nature" (Barthes "Mythologies" 101). The self-image of the deprived, the cut-off, the bombed out, does not exist online because the rhetoric of personal photography is anchored in a sense of individual and social identity and the pathos of control over the means of image making. Within the context of the networked snapshot, this means access to the internet, to electricity and to mobile telephone networks.

The great talent of the online snapshot is to make specific historical conditions appear natural and universal. What Paul Frosh says about the stock image rings true about the vernacular photograph too: "it erases indexical singularity, the uniqueness of the instance, in favor of uniformity and recurrence – the systematic iconic repetition of staged image types." (189). Through the semantic mechanisms of tagging and metadata, the specificity of each online snapshot is obliterated by the way in which a single hyperlinked keyword can group together thousands of disparate images. Can 4,150,058 photographs tagged with 'party' be wrong?

Original publication

'A Life More Photographic; mapping the networked image'. *photographies* (2008)

Notes

1 Members of the public were invited to contribute to the exhibition *How we are now: Photographing Britain* at the Tate Britain, London, UK 22 May – 2 September 2007 by submitting photographs to a Flickr group. <www.tate.org.uk/britain/exhibitions/howweare/slideshow.shtm>

2 *We are all photographers now!* Musée de l'Elysée, Lausanne, Switzerland 08.02–20.05.2007

3 See examples at the Panoramio website <www.panoramio.com>; Flickr's image map <www.flickr.com/map> and Woophy < www.woophy.com>.

4 See the image in its original context, posted by Alfie Dennen to his blog at Stacey's request: <http://moblog.co.uk/view.php?id=77571>

5 In studies by Van House et al. ("The Uses of Networked Imaging" 1856), Okabe and Ito, it is suggested that the camera phone has enabled the freedom to explore new paradigms of visual storytelling and personal expression.

6 Roland Barthes sums up this sentiment in *Camera Lucida*: "I am not a photographer, not even an amateur photographer: too impatient for that: I must see right away what I have produced[.]" (9).

7 Only a generation ago the average number of photographs taken by a family during one year is estimated to be 3 to 4 rolls of film. (King 9, Chalfen 14).

8 At the same time, the marketing of recent camera phones suggests that the mobile phone is now being re-constructed as a mobile multimedia computer. The latest phones from Nokia are described in promotional literature as "multi-media devices" and elsewhere as "multi-media computers" ("Nokia Introduces the Next Story in Video with the Nokia N93").

9 For an evaluation of on-camera sharing practices, see Salwen, E. "Beyond Chimping." *AfterCapture Magazine*, June/July 2007. 4 August 2007 <www.aftercapture.com/print-archives/564/beyond-chimping>

10 In this respect 2004 perhaps marks the beginning of this shift: it was a year of massive growth for digital cameras, as was the year in which sales of camera phones outstripped sales of digital cameras (which outsold film cameras) (Raymond). In the same year, the term Web 2.0 is coined (O'Reilly), and Google revolutionises online storage with the introduction of 1GB email accounts.

11 See Microsoft's multimedia coffee table covered in Popular Mechanics: <www.popular-mechanics.com/technology/industry/4217348.html>

12 Compare Flickr's "interestingness", a ranking algorithm for seeking out the "best" images on their servers. <www.flickr.com/explore/interesting/>

13 Flickr Website <www.flickr.com>, accessed 16th Oct 2007, 5:15pm.

14 To play Google Image Labeler, visit <http://images.google.com/imagelabeler/>

Bibliography

Adams, A. *The Negative*. Boston, MA: Little, Brown & Company, 1994.

Barthes, R. *Camera Lucida: Reflections on Photography*. Trans. Richard Howard. London: Vintage, 1993.

————. *Mythologies*. London: Vintage, 1993.

Batchen, G. *Forget Me Not: Photography & Remembrance*. New York: Princeton Architectural Press, 2004.

Bourdieu, P. *Photography: A Middle-Brow Art*. Cambridge: Polity Press, 1990.

Burgess, J. "Vernacular Creativity and New Media." PhD Diss., Queensland University of Technology. 1 Oct. 2007. <http://adt.library.qut.edu.au/adt-qut/public/adt-QUT20070727.112603/>

Cascio, J. "The Rise of the Participatory Panopticon." Worldchanging.com. 4 May 2005. 2 Apr. 2007. <www.worldchanging.com/archives/002651.html>

"Casio Developing 300 fps CMOS based Camera." *Digital Photography Review*. 31 Aug. 2007. 1 Oct. 2007. <www.dpreview.com/news/0708/07083101casio300fps.asp>

Chalfen, R. *Snapshot Versions of Life*. Bowling Green, Ohio: The Popular Press, 1987.

Champ, H. "100,000,000th." Weblog Post. *Flickr Blog*. 15 Feb. 2006. 10 Aug. 2007. <http://blog.flickr.com/en/2006/02/15/100000000th/>

Cohen, K. "What Does the Photoblog Want?" *Media Culture & Society* 27 (2005): 883–901.

Colin, C. *Citizen Journalist: Cameraphones, Photoblogs, and Other Disruptive Technologies*. Indianapolis, IN: New Riders, 2005.

Corby, T. and Baily, G. "System Poetics and Software Refuseniks." In *Network Art: Practices and Positions*. Ed. Tom Corby. London: Routledge, 2006, 109–127.

Dennen, A. "London Underground Bombing, Trapped." Weblog Entry. *Alfie's Moblog*. 7 Jul. 2005. 20 Sept. 2007. <http://moblog.co.uk/view.php?id=77571>

Derene, G. "Microsoft Surface: Behind-the-Scenes First Look (with Video)." *Popular Mechanics*. Jul. 2007. 1 Oct. 2007. <www.popularmechanics.com/technology/industry/4217348.html>

"The Downside of Digital Snaps." *Sydney Morning Herald Online*. 17 Sept. 2007. 1 Oct. 2007. <www.smh.com.au/news/technology/the-downside-of-digital-snaps/2007/09/19/1189881557134.html>

"Do You Have 10,000 Digital Photos? Survey Says You're Not Alone." *BusinessWire*. 13 Dec. 2006. 12 Apr. 2007. <www.enewspf.com/index.php?option=com_content&task=view&id=136&Itemid=2&ed=9>

Frosh, P. "Rhetorics of the Overlooked: On the Communicative Modes of Stock Advertising Images." *Journal of Consumer Culture* 2 (2002): 171–196.

"Fun Statistics." *Photobucket Blog*. Weblog Entry. 3 Mar. 2005. 6 May 2007. <http://press.photobucket.com/blog/2005/03/fun_statistics.html>

"Generation C: An Emerging Trend and New Business Opportunity." *Trendwatching.com*. 2 Oct. 2007. <www.trendwatching.com/trends/GENERATION_C.htm>

Gillmor, D. *We the Media: Grassroots Journalism by the People, for the People*. Sebastopol, CA: O'Reilly, 2004.

"Guardian's Newsblog through Flickr." *Yahoo Pipes*. 19 Feb. 2007. 1 Mar. 2007. <http://pipes.yahoo.com/pipes/pipe.info?_id=rvbMVvm_2xGmo_i6IBeTaQ>

Gye, L. "Picture This: The Impact of Mobile Camera Phones on Personal Photographic Practices." *Continuum: Journal of Media & Cultural Studies* 21 (2007): 279–288.

Harmon, A. "We Simply Can't Stop Shooting." *International Herald Tribune*. 7 May 2005. 5 May 2007. <www.iht.com/articles/2005/05/06/business/ptphotos07.php?page=1>

Huhtamo, E. "An archaeology of mobile media." Keynote address, *ISEA*, 2004. 2 Aug. 2007. <www.isea2004.net/register/view_attachment.php?id-6230>

Johnson, S. *Interface Culture: How New Technology Transforms the Way We Create and Communicate*. New York: Harper Collins, 1997.

Kindberg, et al. "How and Why People Use Camera Phones: Technical Report." HP Lab and Microsoft Research, 2004.

———. "The Ubiquitous Camera: An In-Depth Study of Camera Phone Use." *IEEE Pervasive Computing* 4.2 (2005): 42–50.

King, B. "Photo-Consumerism and Mnemonic Labor: Capturing the Kodak Moment." *Afterimage* 21 (1993): 9–13.

Lanzagorta, M. "Interactive Visualization of a High-Resolution Reconstruction of the Moon." *Computing in Science and Engineering* 4.6 (2002): 78–82. 18 Oct. 2007. <http://dx.doi.org/10.1109/MCISE.2002.1046600>

Lewis, J. "View: Memory Overload." *Wired Magazine.* 11 Feb. 2003. 20 Jan. 2007. <www.wired.com/wired/archive/11.02/view.html?pg=2>

"Life Caching: An Emerging Consumer Trend and Related New Business Ideas." *Trendwatching.com.* 2 Oct. 2007. <www.trendwatching.com/trends/LIFE_CACHING.htm>

Locke, M. "Let Us Grind Them Into Dust! The New Aesthetics of Digital Archives." *Hybrid: Living in Paradox: Ars Electronica 2005.* Ed. Gerfried Stocker and Christine Schöpf. Osterfildern-Ruit, Germany: Hatje Cantz, 2005, 390–393.

Mann, S., Fung, J. and Lo, R. "Cyborglogging with Camera Phones: Steps towards Equiveillance." In *Proceedings of the 14th Annual ACM International Conference on Multimedia* (Santa Barbara, CA, USA, October 23–27, 2006). Multimedia '06. New York: ACM Press, 177–180.

Manovich, L. *The Language of New Media.* Cambridge, MA: MIT Press, 2001.

———. "Metadata, Mon Amour." Home Page. 2002. 1 Oct. 2007. <www.manovich.net/DOCS/metadata.doc>

Metz, C. "Photography and Fetish." *The Critical Image: Essays on Contemporary Photography.* Ed. Carol Squires, Seattle: Bay Press, 1990, 155–164.

"Microsoft Digital Lifestyle." *Microsoft Corporation.* 20 Sept. 2007. <www.microsoft.com/uk/lifestyle/>

Mitchell, W.J. *The Reconfigured Eye: Visual Truth in the Post-Photographic Era.* Cambridge, MA: MIT Press, 1992.

Naaman, et al. "Leveraging Context to Resolve Identity in Photo Albums." In *Proceedings of the 5th ACM/IEEE-CS Joint Conference on Digital Libraries* (Denver, CO, USA, June 07–11, 2005). JCDL '05. New York: ACM Press, 178–187. <http://doi.acm.org/10.1145/1065385.1065430>

Noah, S., Seitz, S. and Szeliski, R. "Photo Tourism: Exploring Photo Collections in 3D." *ACM Transactions on Graphics.* 25 Mar. 2006, 1–11. 1 Sept. 2007. <http://research.microsoft.com/IVM/PhotoTours/PhotoTourism.pdf>

"Nokia Introduces the Next Story in Video with the Nokia N93." *Nokia Global.* 25 Apr. 2006. 2 Oct. 2007.<http://press.nokia.com/PR/200604/1046557_5.html>

Nyíri, K. "The Mobile Phone in 2005: Where Are We Now?" *Proceedings of Seeing, Understanding, Learning in the Mobile Age.* Hungarian Academy of Sciences, Budapest, 28–30 April, 2005. 3 Sept. 2007. <www.fil.hu/mobil/2005/Nyiri_intr_tlk.pdf>

Okabe, D. "Emergent Social Practices, Situations and Relations through Everyday Camera Phone Use." *Mobile Communication and Social Change*, October 18–19, Seoul, Korea. 2 Jun. 2007. <www.itofisher.com/mito/archives/okabe_seoul.pdf>

Okabe, D. and Ito, M. "Camera Phones Changing the Definition of Picture-Worthy." *Japan Media Review.* 29 Aug. 2003. 5 Apr. 2006. <www.ojr.org/japan/wireless/1062208524.php>

O'Reilly, T. "What Is Web 2.0? Design Patterns and Business Models for the Next Generation of Software." *O'Reilly Network.* 30 Sept. 2005. 5 Oct. 2007. <www.oreillynet.com/pub/a/oreilly/tim/news/2005/09/30/what-is-web-20.html>

Pap, S., Lach, E. and Upton, J. "Telemedicine in Plastic Surgery: E-Consult the Attending Surgeon." *Plastic & Reconstructive Surgery* 110.2 (2002): 452–456.

"Personal Photography 2.0."Weblog Entry. *The Future of Possibilities.* 31 Dec. 2006. 2 Aug. 2007. <http://digitalintuition.blogspot.com>

Raymond, E. "22.8 Million Digital Cameras Sold in 2004 so far; Up 43% from 2003." *Digital Camera Info.* 7 Aug. 2007. <www.digitalcamerainfo.com/content/228-Million-Digital-Cameras-Sold-in-2004-so-far-Up-43%25-from-2003.htm>

Redman, R. "Jobs at Macworld: Apple Driving Digital Lifestyle." *ChannelWeb Network*. 17 Jul. 2002. 28 Sept. 2007. <www.crn.com/it-channel/18819736>

Robins, K. "Will the Image Move Us Still?" In *The Photographic Image in Digital Culture*. Ed. Martin Lister. London: Routledge, 1995, 29–50.

Rodden, K. and Wood, K. R. "How Do People Manage their Digital Photographs?" In *Proceedings of the SIGCHI Conference on Human Factors in Computing Systems* (Ft. Lauderdale, Florida, USA, April 05–10, 2003). CHI '03. New York: ACM Press, 2003, 409–416. 2 Feb. 2007. <http://doi.acm.org/10.1145/642611.642682>

Rosler, M. "Image Simulations, Computer Simulations: Some Considerations." *Ten.8 Digital Dialogues: Photography in the Age of Cyberspace* 2.2 (1991): 52–63.

Ritchin, F. *In Our Own Image: The Coming Revolution in Photography*. New York: Aperture, 1990.

Slater, D. "Domestic Photography and Digital Culture." *The Photographic Image in Digital Culture*. Ed. Martin Lister. London: Routledge, 1995, 129–146.

Steinberg, D. H. "At MacWorld, Jobs Shows iPhoto & New iMac." *O'Reilly Mac Developer Centre*. 1 Sept. 2002. 12 Aug. 2007. <www.macdevcenter.com/pub/a/mac/2002/01/08/keynote_report.html>

Tagg, J. *The Burden of Representation*. New York: Palgrave Macmillan, 1988.

Tatsuno, K. "Current Trends in Digital Cameras and Camera-Phones." *Science and Technology Trends* 18 (2006): 36–44. 24 Sept. 2007. <www.nistep.go.jp/achiev/ftx/eng/stfc/stt018e/qr18pdf/STTqr1803.pdf>

Van House, N. "Flickr and Public Image-Sharing: Distant Closeness and Photo Exhibition." *CHI '07 Extended Abstracts on Human Factors in Computing Systems* (CHI 2007), San Jose, CA, USA, April 28–May 03, 2007. New York: ACM Press, 2007, 2717–2722.

Van House, N. and Davis, M. "The Social Life of Cameraphone Images." *Proc of the Pervasive Image Capture and Sharing: New Social Practices and Implications for Technology Workshop (PICS 2005) at the Seventh International Conference on Ubiquitous Computing* (UbiComp 2005) in Tokyo, Japan. 2005. 2 Sept 2007. <http://people.ischool.berkeley.edu/~vanhouse>

Van House, N., et al. "The Uses of Personal Networked Digital Imaging: An Empirical Study of Cameraphone Photos and Sharing." *Extended Abstracts of the Conference on Human Actors in Computing Systems* (CHI 2005), Portland, Oregon, April 2–7, 2005. New York: ACM Press, 2005, 1853–1856. 2 Apr. 2007. <http://people.ischool.berkeley.edu/~vanhouse/van_house_chi_short.pdf>

Vaskevitch, D. "View: Your permanent record isn't." *Wired* 11.08 Aug 2003. 20 Jan 2007. <www.wired.com/wired/archive/11.08/view.html?pg=1>

von Ahn, L. and Dabbish, L. "Labeling Images with a Computer Game." *Proc. of the SIGCHI Conference on Human Factors in Computing Systems* (Vienna, Austria, April 24–29, 2004). CHI '04. New York: ACM Press, 2004, 319–326. 11 Oct. 2007 <http://doi.acm.org/10.1145/985692.985733>

Medium and mediations

I Didn't Recognise You with Your Clothes On (detail), 1998. © Phil Poynter.

Introduction

A S A MEDIUM OF REPRESENTATION AND MEDIATION, it has been argued that photography, with its long association with direct documentation, brings an aura of authority to ways in which products are presented or stories are told. Barthes' collection of short essays, *Mythologies*, in which he reflected on representation and myth through analyzing a range of imagery from food and wine to portraits of electoral candidates, indicates something of the range of themes and concerns that characterize the selection of essays on visual culture, representation and commodification. Barthes' collection was first published (in French) in 1957. That the English version (trans. 1972) has remained in print ever since points to the significance of his insistence on semiotic analysis of everyday imagery. His approach was academic in that he was concerned to devise a method for interrogating ideological processes whereby images acquire influence as signifiers of meaning. His work was particularly taken up in relation to questions of power and persuasion, socially and commercially.

Photography in advertising continues to attract interest in terms of image analysis and also modes and contexts of circulation. We encounter, or are assailed by, imagery in increasingly diverse commercial contexts online, as well as in print media. These include magazines and billboards and other physical locations as well as mediations via digital screens, such as phones, tablets or laptops. In this section, three examples of Judith Williamson's analysis of recent examples are juxtaposed with two examples from Barthes' earlier collection. Her essays particularly draw attention to the apparent seamlessness with which photographic techniques and illusory associations come together, thereby distracting from the economic interests of companies whose products are on offer. Items are promoted in terms of not only their use value but also the lifestyles that are drawn into association. We simultaneously purchase a product and an image of ourselves as a particular type of person.

Mythologies was not illustrated. This reflected a confidence that his references – for instance, to *Elle* magazine or Citroën cars – were highly familiar within French culture and therefore to his readers. They were also substitutable in that, for instance, the points he raised about the design of cars could be applied similarly to other European or American trademark profiles, as is his brief discussion of the tactile when new models are displayed. Williamson's articles each start with the advertisement under discussion, reproduced in colour. (It has not been possible to include them here, but these examples – or their equivalents – can be found online.) By contrast with Barthes' selection, national specificity is less evident as global corporations operate internationally in ways that contrast markedly with national or regional specificity – for instance, the post-war France that formed Barthes' primary point of reference.

Online is increasingly the space of consumption, whether purchasing from companies that also have a high street or shopping mall presence or from organizations whose sales interface is exclusively virtual. For those with access to computers – which is by no means global, for geographic territory, national wealth and personal

economic status variously influence availability – questions of online representation and mediation are particularly relevant. Everyday encounters normalize the presence of products and the form they take. For instance, recent years have witnessed campaigns for the reduction of single-use of plastics, now acknowledged as a major source of pollution due to non-degradability once disposed, but without campaigns to foster awareness the everyday presence of plastic in our lives came to seem utterly normal. Advertising photography has had a significant role to play within this normalization. Conversely, online campaigns have contributed significantly to raising public awareness of environmental issues relating to consumer behaviour.

In terms of patterns of consumption, historically, food has been a symbol of sharing, sociality, status and celebration, as well as, of course, necessary for subsistence. Reflecting on 'food porn' within everyday cultures of consumption, Yasmin Ibrahim suggests that messaging spectacles of food via online networks has become a new means to connect and affirm social relations. What we eat relates to our identity and our sense of belonging within particular communities; as such, she argues, in transforming food into digital commodity, social media imaging provides a means of self-presentation that contributes to reaffirming social capital and currency.

Press photography likewise selectively popularizes, reflects, re-inflects or reinforces cultural attitudes. Here the inter-relation of photographs as illustrations and 'soft' news stories is particularly significant as pictures retain the documentary authority associated with photojournalism – the camera was there so it must have happened – whilst serving to highlight aspects of a story that might have celebrity curiosity value but one that we might view as downright prurient. Karin E. Becker offers a brief historical outline of uses of photography in magazines and newspapers, as a prelude for critical discussion of photojournalism and the tabloid press. Her fundamental concern is with contexts and uses of images, including those by picture editors and art directors. It is argued that photography in the tabloid press both illustrates and serves to deconstruct news. Carol Squiers focusses on the history of the emergence of paparazzi photojournalism, fascination with celebrity, and ways in which intrusive photography contributes to reinforcing voyeuristic attitudes. Through the example of press coverage of Princess Diana (former wife of Prince Charles, heir to the British throne) she considers tabloid press as a locus of negotiating questions of femininity and domesticity as well as, in this instance, challenging the authority and privacy of monarchy as an institution.

The notion of celebrity rests on a sense of difference between public figures, icons or role models who are famous or infamous, on the one hand, and us with our everyday lives and experiences, on the other. Karen de Perthuis distinguishes between the relation between clothing and bodies in lived experience and the requirements of fashion modelling within which photo manipulation is used to create a 'synthetic ideal'. She points towards a complexity of relations between image, imagination, the aestheticized 'fashion body' and the actual human body, arguing that the authority of fashion, and by extension the economy of the fashion industry, centrally rests on its ability to stimulate shifts in the imaginary ideal body form, stimulating consumerism through regularly constructing new marketable images and ideals.

Fashion photography is a long-standing genre, certainly in European and North American culture, that arguably has not attracted extensive academic focus despite the cultural centrality of clothing, from street style to *haute couture*. Ulrich Lehmann notes that it is through photographic representation that clothing transcends its material qualities and function to become an aesthetic idea. He argues that fashion imagery now operates between marketing concerns and creative expression, becoming closer to art photography in narratively reflecting social contexts and issues whilst, in remaining anchored to body language, gesture and style, simultaneously extending the cultural concerns of contemporary art. In relation to this, Val Williams considers the relationship between fashion photography and museums since the 1970s, suggesting that for museums showing fashion photographs has become a means of reaching new audiences and this has contributed to shifts in the profile of museums as cultural centres. At the same time, exhibitions of fashion imagery have contributed to enhancing investigation and understanding of the history and influence of fashion photography and, more broadly, to reflection on this arena of contemporary photographic practices and the complexity of meaning and mediations implicated.

Bibliography of essays in Part 5

Barthes, R. (1972) 'Ornamental Cookery' and 'The New Citroën', in *Mythologies*. London: Jonathan Cape Ltd. First published in French, 1957, Paris: Editions du Seuil.

Becker, K. E. (1992) 'Photojournalism and the Tabloid Press', in Peter Dahlgren and Colin Sparks (eds.) *Journalism and Popular Culture*. London: Sage.

Ibrahim, Y. (2015) 'Food Porn and the Invitation to Gaze: Ephemeral Consumption and the Digital Spectacle', *International Journal of E-Politics*, 6:3, July–Sept., 1–12.

Lehmann, U. (2002) 'Chic Clicks: Creativity and Commerce', in *Contemporary Fashion Photography*. Boston: The Institute of Contemporary Art & Hatje Cantz.

de Perthuis, K. (2005) 'The Synthetic Ideal: The Fashion Model and Photographic Manipulation,' *Fashion Theory*, 9:4, 407–424.

Squiers, C. (1999) 'Class Struggle: The Invention of Paparazzi Photography and the Death of Diana, Princess of Wales' in Carol Squiers (ed.) *OverExposed*. New York: The New Press.

Williams, V. (2008) 'A Heady Relationship: Fashion Photography and the Museum, 1979 to the Present,' *Fashion Theory*, 12:2, 197–218.

Williamson, J. (2014) 'Tiffany', *Source*, 81, Winter 2014/15.

—— (2016) 'Microsoft Cloud', *Source*, 85, Spring 2016.

—— (2016) 'Porsche Panamera', *Source*, 87, Autumn 2016. Belfast.

Roland Barthes

ORNAMENTAL CUISINE AND THE NEW CITROËN

Ornamental cuisine

THE PERIODICAL *ELLE* (a veritable mythological treasure) gives us almost weekly a lovely color photograph of an elaborately prepared dish: gilded partridges studded with cherries, a pinkish jellied chicken, a mold of crayfish fringed with their own russet shells, a creamy trifle embellished with a frieze of candied fruit, multicolored sponge cakes, etc.

In this cuisine, the prevailing substantial category is surface sheen: visible effort has been made to produce glazed, carefully smoothed finishes, to conceal whatever aliment is underneath by a sleek deposit of sauces, icings, jellies, and creams. Such coatings derive, of course, from the very finality of superficies, vested in a primarily visual order. The magazine advocates a cuisine devoted to sight, that most distingué of the senses, for there is, in this insistence on *appearance*, a permanent craving for distinction. *Elle* is a journal of precious things, at least so legend has it, for its role is to offer its huge working-class public (described thus according to market research) the answer to everyone's dream of chic; hence a cuisine of surfaces and alibis which consistently endeavors to attenuate or even to disguise the primary nature of foodstuffs, the brutality of meats, or the abruptness of shellfish. A peasant dish is admitted only on occasion (an "authentic" family potau-feu), as the rustic whim of blasé city folk.

But above all, a shiny surface prepares and supports a major development in a cuisine of distinction: ornamentation. *Elle*'s glazes supply a fabric for frenzied minor embellishments: intricately incised mushrooms, a punctuation of cherries, sculptured lemons, truffle slivers, silver pastilles, arabesques of crystallized fruit, the underlying layer (which is why I called it a deposit, the aliment itself being no more than an uncertain stratum) intended as the page on which can be read an entire curlicued cuisine (pink being the favorite color).

Such ornamentation proceeds by two contradictory routes whose dialectical resolution can be readily discerned: on the one hand, to escape nature by a sort of delirious

baroque (to stud a lemon with shrimps, to color a chicken shocking pink, to serve grapefruit broiled), and, on the other, to attempt reconstituting that same nature by an incongruous artifice (to arrange meringued mushrooms and holly leaves on a yule log cake, to replace shrimp heads around the adulterated béchamel hiding their bodies). A similar impulse is recognizable in the elaboration of petit bourgeois trinkets (ashtrays made in imitation of tiny saddles, cigarette lighters that closely resemble cigarettes, terrines in the shape of hares).

All this is because here, as in all petit bourgeois art, the irrepressible tendency toward extreme realism is countered – or balanced – by one of the constant imperatives of household journalism: what *L'Express* proudly calls *getting ideas*. Cooking in *Elle* is quite similarly a cuisine "of ideas." But here invention, confined to a magical reality, must apply only to *garnishing*, for the magazine's "distinguished" vocation precludes it from dealing with any real problems of alimentation (the real problem is not to stud a partridge with cherries, but to find the partridge, i.e., to pay for it).

This ornamental cuisine is in fact supported by an entirely mythical economy. It is openly a dream cuisine, as we can see in *Elle*'s photographs, which never show the dishes except from above, objects at once close up and inaccessible, whose consumption can readily be accomplished in a single glance. This is, in the full sense of the word, an advertisement cuisine, totally magical, especially if we remember that this magazine is read for the most part in low-income homes. The latter, moreover, explains the former: it is because *Elle* is addressed to a working-class public that it is very careful not to postulate an economical cuisine. Have a look at *L'Express*, for example, whose exclusively bourgeois public enjoys a comfortable purchasing power: its cuisine is real, not magical; *Elle* prints the recipe for fantasy partridges, *L'Express* for salade niçoise. *Elle*'s public is entitled only to fiction, the public of *L'Express* can be offered real dishes, with every assurance that it can prepare them.

The new Citroën

I believe that the automobile is, today, the almost exact equivalent of the great Gothic cathedrals: I mean, a great creation of the period, passionately conceived by unknown artists, consumed in its image, if not in its use, by an entire populace which appropriates in it an entirely magical object.

The new Citroën manifestly falls from heaven insofar as it presents itself first of all as a superlative *object*. It must not be forgotten that the object is the supernatural's best messenger: in this object there is easily a perfection and an absence of origin, a completion and a brilliance, a transformation of life into matter (matter being much more magical than life), and all in all a *silence* which belongs to the order of the marvelous. The DS (the Déesse, or Goddess) has all the characteristics (at least the public begins by unanimously attributing them to it) of one of those objects from another world that nourished the neomania of the eighteenth century and that of our science fiction: the Déesse is *first of all* a new *Nautilus*.

This is why it rouses interest less in its substance than in the joints of that substance. We know that smoothness is always an attribute of perfection because its contrary betrays a technical and entirely human operation of adjustment: Christ's tunic was seamless, just as the spaceships of science fiction are of unbroken metal. The DS 19 makes no

claim to being totally smooth, though its general shape is nicely rounded; however, it is the encasing of its sections which most interests the public: the edges of its windows are furiously tested, people run their hands along the wide rubber grooves which connect the rear window to its nickel surrounds. The DS has the beginnings of a new phenomenology of assembly, as if we were leaving a world of welded elements for a world of juxtaposed elements held together by the sole virtue of their marvelous shape, which, of course, is intended to introduce the notion of a more readily cooperative nature.

As for the material itself, there is no question that it promotes a taste for lightness in a magical sense. There is a return to a certain aerodynamism, new insofar as it is less massive, less incisive, more relaxed than in earlier periods of this fashion. Here speed is expressed in less aggressive, less sportif signs, as if it were shifting from a heroic form to a classical one. Such spiritualization can be discerned in the importance, the quality, and the actual substance of the glazed surfaces. The Déesse is visibly an exaltation of glass, and the cast metal is only a base. Here the sheets of glass are not windows, openings pierced in the dark shell, they are large spaces of empty air, having the smooth curvature and brilliance of soap bubbles, the hard thinness of a substance more entomological than mineral (the Citroën emblem, with its arrows, has now become a wingèd emblem, as if a change had occurred from an order of propulsion to an order of independent movement, from an order of the engine to that of the organism).

We are now confronted with a humanized art, and it may be that the DS marks a change in automobile mythology. Hitherto the superlative car belonged, one might say, to the bestiary of power; here it becomes at once more spiritual and more objective, and despite certain neomaniacal concessions (the empty steering wheel, for instance), it is now more *domestic*, more in accord with that sublimation of utensility we recognize in our contemporary household arts: the dashboard looks more like the worktable of a modern kitchen than a factory control room: the slender panes of matte rippled metal, the little levers with their white ball finials, the simplified dials, the very discreteness of the chromium, everything indicates a sort of control exerted over movement, henceforth conceived as comfort rather than performance. We evidently are shifting from an alchemy of speed to an appetite for driving.

It seems that the public has admirably divined the novelty of the themes proposed: initially responsive to neologism (an entire press campaign kept people on the alert for years), it made every effort to adopt an attitude of adaptation and utensility ("You've got to get used to it"). In the exhibition halls, the sample cars are visited with an intense, affectionate care: this is the great tactile phase of discovery, the moment when the visual marvelous will submit to the reasoned assault of touching (for touch is the most demystifying of all the senses, unlike sight, which is the most magical): sheet metal stroked, upholstery punched, seats tested, doors caressed, cushions fondled; behind the steering wheel driving is mimed with the whole body. Here the object is totally prostituted, appropriated: upon leaving Metropolis heaven, the Déesse is mediatized in fifteen minutes, accomplishing in this exorcism the entire dumb show of petit bourgeois annexation.

Original publication

'Ornamental Cuisine' and 'The New Citroën', *Mythologies* (1973) [Originally published 1957]

Judith Williamson

TIFFANY, PORSCHE PANAMERA AND MICROSOFT CLOUD

Tiffany

THIS AD FOR TIFFANY ENGAGEMENT RINGS — running in glossy magazines around Valentine's Day — is a perfect example of a continuing line of advertisements, almost all for jewellery or perfume, that use black and white photography to signify romance in particular ways. These significations draw on a photographic history which, whether or not it is actually known to contemporary audiences, has been made familiar as a kind of all-purpose visual reference by advertisements themselves.

The straightforward content of this ad's image – a man holding his jacket over a woman in the rain, as they walk laughing along a wet street – provides the narrative explanation for its small-print text, which is set like a poem: 'Will you know that you're more fun on/ a bad day than most people are on good ones/ and that I wouldn't mind if it rained/ every day for the rest of my life if it meant/ I could spend it with you?' The 'Will you?' in larger print, above the close-up image of the diamond rings, leads the romantic narrative to its culmination in a proposal.

However, it is impossible to separate the content of the image from its style, which generates a key part of the ad's meaning. The use of black and white in contemporary advertising is always connected with – paradoxically – both a 'historical' and a 'timeless' quality. Perfumes with names like Eternity have long relied on monochrome (often sepia tinted) to suggest that their configurations of men, women and children are permanent and somehow outside the hurly-burly of passing time. High-end watches and jewellery are advertised in a similar way – a model photographed in black and white seems more classy, and the product less transient, than they would if colour were used. Black and white has generally come to convey something more serious, more aesthetic, and more lasting, than colour.

These essays first appeared in the photographic journal *Source*, issues 81 (Winter 2014/15), 85 (Spring 2016) and 87 (Autumn 2016). The original images can be found on the *Source* website archive at www.source.ie.

This is the wider context of the connotations that are now inseparable from the use of black and white photography. Yet there is a more specific reference made by its use in many recent ads, a reference that precisely *is* historical. The last period in which black and white was pretty much the norm in photography was the 1950s–60s, when although colour was available its use was not widespread. This is the period implicitly invoked by the use of black and white in a great many contemporary ads: a good example is the Dolce & Gabbana series for their perfume The One. The print images in this campaign appeared as romantic stills from the film version, a Scorsese-directed black and white short titled *Street of Dreams*, featuring Scarlett Johansson and Matthew McConaughey driving through the streets of New York, then viewing it from a roof top. The style not only of the imagery but the clothing, hairstyles and even the buildings, gave this an exotic and retro flavour, a suggestion of something both continental (despite being set in New York) and mid-20th century, perhaps an Italian film of the 50s or early 60s. The film's official synopsis claims it is 'a story of unbridled emotion. A story of Italy; of Hollywood; and of the world. Its classic cinematic style evokes both the grandeur of the golden years of Hollywood, and the passion and emotion of Europe's greatest cinema icons'. And yet, the publicity also insists, 'Scorsese's campaign tells a tale of timeless glamour . . . '.

So the past conjured up by this style is both a particular period, and 'timeless'. This idea of an image that is at once a moment, and yet permanent, returns us to the Tiffany ad with the couple in the wet street. Nothing signifies a moment of spontaneity quite so well as a snapshot in the rain: the weather is unsuitable for photography, but the instant is captured, even to the visible raindrops mottling the image. This advertising photo evokes the street photography pioneered by Cartier-Bresson and pursued by many others. Cartier-Bresson's famous idea of the Decisive Moment takes on a double meaning in the Tiffany ad: his intended meaning, the decisive moment of the photograph, when the photographer sees and takes the picture, becomes also the decisive moment in the courtship. (This is also the theme of the Scorsese film – there is a brief moment to establish if the relationship is The One.) Some of the best-known images in the history of street photography are indeed romantic moments: for example, Robert Doisneau's 1950 photo *The Kiss*, reproduced on countless postcards and posters.

The evocation of street photography from this golden period is not coincidental in the Tiffany ad. The street surface itself appears to be cobbled, which heightens both the continental and the historical effect. As with the Dolce & Gabbana series, the couple's clothes are subtly chosen to look, not actually old fashioned, but 'classic', as if they could be from the early 1960s. The woman's almost knee-length skirt, simple court shoes, and the cutaway style of her top, could be seen either as present-day or from the earlier period, and the man's clothing is equally ambiguous. There is nothing to say the image is not from today – the cars are modern – yet it has the distinct feeling of a still from the 1960s, which evokes a powerful set of meanings connected to that period.

The street itself is an important part of this meaning. Not for nothing is the Scorsese film titled *Street* of Dreams. The New Wave cinema of the 1960s featured city streets almost as characters. Another iconic image conjured up by the street setting of the Tiffany ad is the *Freewheelin' Bob Dylan* album cover, a photo in muted colour tones of Dylan with his girlfriend Suze Rotolo clinging to his arm as they walk towards

the camera down a snowy Manhattan street. The Tiffany characters are like a much more smartly dressed version of this (and more romantic, in that the man, unlike Dylan, is showing consideration to his companion) — but the 60s flavour of freedom, spontaneity and a more positive sense of the future remains.

To grasp the connotations of this ad it is not necessary to have encountered the photographers Cartier-Bresson and Doisneau, to have watched classic Hollywood, Italian and French New Wave cinema, or seen early Bob Dylan covers. These are all sources for the great bank of image-history which contemporary advertising draws on: but, increasingly, contemporary imagery works as its own currency, circulating meanings that seem to function independently of the historical reserves that underwrite them.

Porsche Panamera

In a weekend colour supplement, a double-page spread opens onto yet another familiar-looking car ad. The gleaming Porsche, light reflecting off its curves, is seen against an urban backdrop that says both 'smart' and 'bohemian'. The car is sleek, photographed from an angle that makes it look long and low, and has the exotic touch of a foreign number plate. It is shown parked on a single space in a narrow street which looks like somewhere in Bloomsbury — the row includes an old commercial building with modern plate glass doors, small-scale industrial premises and a period shop/café frontage. The effect is at once specific, and generic: this is a cool, fast car in a city setting that suggests fashionable intellectual life.

To grasp the full meaning of this setting, one has to imagine it swapped for a different one: a street of glossy high-end shops, for example, or a solely residential street of townhouses. These are indeed the kinds of settings frequently used in car ads to posit the car's driver with a high degree of social precision. The car simply has to be shown parked in such contexts and we understand where the hypothetical owner shops, or lives. The urban setting shown here is equally resonant but suggests neither retail, nor domicile: it suggests work, and work in a particular kind of zone. Again, the precise connotations of the ad can be brought into focus by considering alternatives — if the Porsche had been parked among the imposing institutional buildings of a financial district, or outside a modern office block, or in an entirely industrial landscape. In this ad, the particular elements of the backdrop suggest a working arena that combines intimacy (the narrowness of the street), classiness (the period brick building which, with its plate glass doors, is clearly not a home), ramshackleness (the shabby white-painted street door with multiple bells and a noticeably fat cable running through the side), small-scale industrialness (the metal shutter which suggests some kind of yard beyond the cobbled entrance) and aesthetic charm (the arched frontage to the right). This mixture suggests a neighbourhood where cultural work takes place — publishing, digital media, design? — work with an ambience of cutting-edge creativity, serious yet 'alternative'.

The car-and-backdrop is such a familiar image type that the rather unusual nature of the backdrop here doesn't immediately jump out. Equally, the ad's caption has the familiar terseness of those pointless phrases found so often on film posters, phrases that use abstract words, usually in threes, with lots of full stops. 'The new Panamera.'

(Three words, full stop.) 'Courage changes everything.' (Three words, full stop.) *Courage changes everything*: this seems to be exactly one of those poster-type phrases that sound deeply portentous but have no actual meaning. The ad here, like many in print nowadays, is part of a wider campaign where online videos provide the fuller rationale for the still image and text. The video short for the new Panamera works up an explanation for the ad's caption: '*They* called it madness. Building the car of your dreams. . . . Madness! Launching a turbo-charged super-sports car in the midst of a worldwide oil crisis. . . . Madness! Let them call it madness – *we* call it courage. The courage to build a sports car with four business class seats. The courage to upgrade not only the driving but also the driver. The courage to transfer an unmistakeable design DNA and breed a luxury saloon that was born on the racetrack and is at home on the roads. We call it courage. And courage will change everything'.

This kind of ad prattle is familiar enough. The content here confirms that the product is meant to convey a sense of daring, defying convention and expectation. Criticism can thus be turned on its head – 'launching a turbo-charged super-sports car in the midst of a world-wide oil crisis. . . . Madness!' (but aren't we *daring* to do it!). The verbal narrative of defiance in this script resonates with the off-beat city setting in the picture to suggest an aura of radical chic – as if a Porsche in this context is subversive. 'The courage to upgrade not only the driving but the driver': while it isn't clear what that enigmatically abstract phrase actually *means*, it hints at a different kind of Porsche driver, one invested less in 'the racetrack' and more in cultural capital. The 'upgrade' works both ways: if you are an urban creative, you can be bravely subversive by driving a Porsche; if you are a Porsche driver, you can be bravely subversive by becoming an urban creative.

If a connotation of subversion is produced by these elements of image and script, there is a much more blatant raiding of actual radicalism, and a more extreme up-ending of its meaning, in the ad's caption. 'Courage changes everything' has a familiar ring not just because it is written in typical poster-speak, but because it is two-thirds of the title of Naomi Klein's bestseller about capitalism and climate change, *This Changes Everything*. On the one hand, the nerve of this expensive car ad is mind-blowing, ripping off the title of a book which explains exactly what the problem is not only with cars themselves – their physical effects on the atmosphere – but with the economic system that continues to produce them despite these effects. (Madness! one might say.) But on the other hand, the endless capacity of advertising, and the capitalism it serves, to chew up and regurgitate the language of opposition is utterly familiar.

Microsoft Cloud

This is the middle ad in a sequence of three that ran on consecutive recto pages in a recent *Wired*. Each follows a similar structure: a colour photo is superimposed on a montage of what seem to be tinted black and white photos of generically similar scenes, the tints matching the positions of the red, green, yellow and blue squares of the Microsoft logo shown in the bottom right-hand corner. The first and last ads in the sequence are captioned 'This cloud redefines winning' and 'This cloud opens one stadium to 450 million fans' – referring to uses of Microsoft's cloud by the Special Olympics and Real Madrid. Further stories about specific uses of their cloud platforms

can be found on Microsoft's website, which presents short videos, under the same captions, about all the companies shown in these and similar ads.

The example shown here is especially interesting because the featured company AccuWeather allows play with the very concept of the cloud. 'This cloud stands up to any storm' suggests both that 'the cloud' really is a cloud, floating somewhere above us, and at the same time reinforces its key selling point, the idea of security. The naming of massive-capacity digital storage after one of the most ephemeral features of the natural world is an extraordinary phenomenon in itself. 'The cloud' suggests something ethereal, barely physical; it evokes the thought bubble, the cartoon representation of mental space, and also perhaps those clouds that support the figures of saints and gods in so many representations of spiritual existence. It is the magical space into which all our data and images can be whisked away, to reappear when summoned. In reality, 'the cloud' is a huge number of high-capacity servers in maximum security units known as server farms – a term itself quaintly suggesting some kind of organic husbandry, while in fact these are industrial complexes more akin to military installations.

The development offered by the cloud is a capacity for storage that is not limited by your own hardware, and the ability of multiple users to access the same data. The cloud is supposedly more secure than your own computer, which can crash, be stolen, etc. The weather-proof cloud advertised here is a contradiction in terms in nature, but is presented as a 'solution' for both companies and individuals in the digital realm. The name of Microsoft's cloud service platform, Azure, combines these two connotations, suggesting that the place where clouds live – the sky – is a clear, *trouble-free* sky. The small print in the ad describes how 'Microsoft Azure scales to enable AccuWeather to respond to 10 billion requests for crucial weather data per day. This cloud rises to the challenge when the weather is at its worst'.

The large text about 'any storm' functions in the ad as a caption to the images shown above it. The central colour image pictures a street in deep snow, with a few figures walking between cars blanketed and street signs covered by heavy snowfall. This image is presented on top of a great many overlapping images showing different kinds of storms and extreme weather – lightning, a tornado, palm trees swept by wind – so that the top image seems to be just one pulled from a huge bank. These partially seen, montaged background images are not shown in balanced colour, but appear only as tinted – red, green, yellow and blue. Placed behind the key image, they suggest the wide range of potential data from which the main image emerges – in this case, the multiplicity of global weather conditions about which the 10 billion users are inquiring.

This overlay of images – with a touch of drop shadow between them, a classic screen trope mimicking a pile of physical pages – suggests something further, not merely about this company's use of the cloud but about the way we understand the cloud's own workings. We may rationally know that images are stored in the cloud not as intact pictures but as digital data. A photo only emerges as such when it is pulled out of the cloud. Yet it is hard for us to conceive this process, and almost impossible to represent it without suggesting that the cloud is a kind of image-bank, from which photos can be retrieved. The pictures of your holiday are imagined to 'be' somewhere out there in the cloud – but in fact are only really pictures at the moment you recall them. In its presentation of a central, colour-balanced photo, drawn from a bank of

others with a shadier, 'dormant' quality, this ad suggests an image of what precisely cannot be imaged – the cloud itself.

Few of us outside the world of programming can really imagine, in our mind's eye, the translation of digital data into the pictorial world we are familiar with from a long history of photography. The structure of this ad, and of the others like it, gives us a feeling of something 'behind' the image – which is literally where the supporting, tinted images appear. What is most interesting of all is that the portrayal of these separated colours behind a full colour image conjures up the actual process of colour photography. Early colour photographs required the creation of three negatives, one for each primary colour, while Technicolor in the cinema involved negatives in red, green and blue. Similarly, an image viewed on a computer screen today is made up of red, green and blue light.

Whether deliberately or not, such processes are hinted at by the Microsoft ad's presentation of mono-tinted photos, in key colours, underlying its main image. As mentioned above, the sections of red, green, yellow and blue tints are positioned to match exactly the four coloured segments that make up the square of Microsoft's logo. However, this obvious rationale for the use of colour doesn't explain the wider range of connotations set in motion by the ad. In seeking to represent the way images are accessed and circulated through digital means, it draws on the suggestion of much older, and more familiar, forms of analogue production. The difficult-to-picture contemporary technology of the cloud is portrayed – and, perhaps, metaphorically understood – through a subliminal sense of technologies from the past.

Original publication

'Tiffany', *Source* 81 (2014) 'Microsoft Cloud', *Source* 85 (2016) 'Porsche Panamera', *Source* 87 (2016)

Yasmin Ibrahim

THE PORNOGRAPHY OF FOOD IMAGING
The aesthetics of capturing food online

Introduction

WHAT IS THIS PERVASIVE ACT of capturing our meals via our mobile and smartphones and sharing it with wider audiences through personal networks and messaging services?[1] Why are we making a moment of the ordinary? This pervasive food sharing through mobile images is part of our digital literacy today. As an inimical part of digital culture, food images dominate as a universal symbol of social sharing and social gaze, and above all, human solidarity. Food as a subject of digital capture carries social resonance and sociability. As new behavioural and social conventions convene around the production and dissemination of food images online, food as a material yet ephemeral object ingested by the body, amenable to edible iterations as well as decomposition, has become a major subject of material objectification signifying new ways to connect, frame social relations and to negotiate our private and public realms. Food once transformed into a digital image online is often offered for public consumption, transaction and dissemination inviting the gaze of family, friends and strangers. This paper explores the notion of food porn with relevance to new media technologies and contemporary digital culture. It posits the notion that the sociality around producing and sharing food in the user generated content (UGC) economy in many ways re-negotiates the unattainable quality that food porn signifies in the mainstream media. Amateur interpretations of food porn not only democratise it as a social activity but imbue new social conventions around the capture and sharing of these images.

The term 'food porn' is increasingly used to describe the act of styling and capturing food on mobile gadgets, eliciting an invitation to gaze and vicariously consume, and to tag images of food through digital platforms. The mundane and ordinary food is attributed a spectacle in this economy premising food as the message and the medium. The term 'food porn' of course predates these ubiquitous practices of capture today. Used synonymously with 'gastro porn', it alludes to the fetishisation of food and its

coalescence with desire by styling culinary offerings through the vantage point of the camera lens to be consumed by hungry publics. This food is meant to be consumed by sight and other senses (well removed from just ingesting it), evoking our hidden desires while highlighting its unattainability. Its pornographic quality removes food from the mundane and ordinary, elevating it to the level of the pornographic. This paper specifically addresses the imaging of food through new mobile technologies whilst acknowledging the wider ecology of media and marketing phenomena which have socialised us into accepting food images and the practices of imaging food as a resonant part of digital culture in our contemporary reality.

Food throughout history has been a symbol of sharing and sociality, envy and avarice, decadence and depravity, pride and repugnance and equally a resource of commonality as well as difference. Food has an elemental quality of tapping into our emotional reservoir, our nostalgic memories and inner psyche to elicit comfort, familiarity, aversion, desire, greed, degrees of pleasure and displeasure. Food has the ability to trigger forms of affect and ubiquitous food imaging through digital platforms transforms food into a digital commodity, bringing with it a plethora of social and symbolic meanings through the acts of image capture, upload, dissemination as well as archiving. But 'food is extraordinary in its ordinariness, exceptional in the extent to which we treat it as mundane, and outstanding as a focus for the study of consumption' (Marshall, 2005: 69). Food serves to confirm membership as well as to set people apart. Food is connected to rituals, symbols and belief systems. It is associated with myth; the sacred and taboos. Food functions in social relationships; in terms of ethnicity, race, nationality, class, individuality and gender.

With increasing appropriation of technologies into our daily lives we don't often stop to question new forms of behaviours, conventions and habits which emerge with mediated communication. As we adopt new rituals and integrate these into our daily lives, we often struggle to completely comprehend why these new rituals become habitual and unquestioning moments of life's patterns and rhythms in contemporary culture. Imaging food and serving these to others via images is a widely accepted phenomenon today. The home photography situated the everyday through imagery. Richard Chalfen (1987) in writing about the 'home mode' and Kodak Culture highlighted the important role of photography in domestic life, where social practices involving family norms, traditions and values can be expressed and sustained. The everyday and its material practices became a site to enact and construct culture. This Kodak culture, which domesticated the everyday through imagery and food, is part of this visual literacy. With the convergence of technologies and the incorporation of recording features on the mobile phone, food becomes a site for multiple iterations from autobiography and memory making to self representation.

In restaurants, homes and in the streets, food as a commodity is captured, shared and archived, providing a medium for human connection, communication; public and private interactions while contributing to a repository of food images on image sharing platforms online. The domestication of food images through the smartphone and the ability to consume food through screen cultures marks a shift in production values of food porn produced by expert stylists and photographers for the cultivated audience and those produced by the smartphone flaneurs, marking the division between production and consumption in the traditional media economy compared with the prosumer economy. The amateur prosumer equipped with her mobile technology

can style and capture food through her sense of aesthetics and disseminate it to a potentially global audience. This smartphone food porn democratises imaging practices around food as a cultural artefact, while domesticating food imagery through pervasive technology as form of social exchange. The distance between the amateur and the professional is not obliterated but enables a mainstreaming of food photography in our cultural practices through the smartphone and mobile gadgets. With the late twentieth century's explosion of imaging and visualising technologies, everyday life has become visual culture (Lister and Wells). In this arena of hypermedia and multimedia age of visuality, 'seeing is much more than believing. It is not just a part of everyday life, it is everyday life' (Mirzoeff, 1999: 1).

There is a vast cultural economy around food online. From food blogging, recipe sharing, gastro tourism narratives, and food reviews to cataloguing 365 days of meals. Food imagery and meals can mediate the temporal and spatial, thus occupying a primacy in our cultural imagination and interactivity. Images are a primary form of content creation today. But what does it mean to capture something for our personal repository and image archive before we consume it? What is this urge to offer these images of food for vicarious consumption? What is it about food images which offer shared moments of communion between friends and strangers? The explanations reside at many levels and the deconstruction of these offer insights into the therapeutic nature of both food images as a cultural bridge but also social media platform as a means for sharing the banal and the mundane, and how these interactions display social relations as well as one's negotiation of self and life in the private and public realms (Ibrahim, 2015). Functioning at the level of spiritual and emotional connection, ubiquitous food imaging and sharing remain an intrinsic part of digital culture today.

Food as part of our everyday construction

Food is more than just a fuel for bodies. It is a site of consumption, pleasure, morality and renewed aesthetics. As Krishnendu Ray (2007) asserts the very visibility of something that was mundane, trivial and habitual is somewhat embarrassing but the source of discomfort for some may be the dissolution of boundary between the life world and the art world. Kerry Chamberlain (2004: 468) concurs that food permeates our relationships, infiltrating our language, our images, and that metaphors of food surround us. Food is entwined with popular culture, saturating our visual and sensory modes through television, magazines, newspapers, specialist food blogs and recipe sharing cites (Chamberlain, 2004; Lupton, 1996). These provide voyeuristic escapes into food and cuisines where money or calories are of no consequence (O'Neill, 2003). The re-fashioning of food or gasto porn then refers to the ways in which TV-programs and cookbooks often portray food as perfect, using pornographic features and visual effects (Zukin & Maguire, 2004). Richard Magee (2007) contends that food pornography takes the form of glossily lush photographs of voluptuous and sinfully rich desserts, or of fantasy recipes and lifestyle images that are 'so removed from real life that they cannot be used except as vicarious experience'. The concept of food porn then describes a movement away from motifs of aesthetics and trespasses some kind of threshold towards the obscene and unattainable; rupturing a gap and breaching the lucidity in judging what is *real* and *illusion*.

The term *food porn* is thus not just about the *content* or *way* food is represented, but rather addresses a much more complex construct of human experience (Mitchell, 2014). The term gastro porn may be attributed to Alexander Cockburn's 1977 New York Review of Books when he criticised the pornographic character of the unattainable and picture perfect dishes in connection to the insatiable desires these elicited (Cockburn, 1977). McBride (2010) suggests that the term first appeared in 1979 when Michael Jacobson as the co-found for the Centre for Science in the Public Interest used food porn to refer to unhealthy foods in the Center's newsletter. According to Jacobson he coined the term to connote a food that was so sensationally out of bounds of what a food should be that it deserved to be considered 'pornographic' (cf. Mcbride, 2010). Mcbride (2010) employs the term food porn to denote 'watching others cook on television or gazing at unattainable dishes in glossy magazines without actually cooking oneself'. Signe Rousseau (2014) contends that food porn occupies a contested space between constructions of 'legitimate' and 'illegitimate' desires when it comes to eating.

Frederick Kaufman, in likening sex porn to gastro porn observes that 'like sex porn, gastro porn addresses the most basic human needs and functions, idealizing and degrading them at the same time' (cf. Ray, 2007). The sex and food corollary is reiterated in Foucault's writing. Michel Foucault (1983) observed that food in the early Christian history was an issue of primacy, just like sex has become in the modern era, where its significance is created through a complex set of restrictions and discursive practices. Food has dominated as a subject of major preoccupation throughout history. Roland Barthes (1972: 22) in discussing the relationship between food, national identity and imperialism was conscious of the centrality of food to other forms of social behaviour;

> Today we might say all of them: activity, works, sports, effort, leisure, celebration — every one of these situations is expressed through food. We might almost say that this 'polysemia' of food characterizes modernity.
>
> (Barthes, 1972: 25)

The fetishisation of food as well as the cultural practices convening around the visual consumption of food have become important in locating the everyday. Raymond Williams (1993) decried that 'culture is ordinary', in attempting to locate culture as something lived in and common place rather than a work of art removed from social and material practices. Williams (1993: 11) in defining culture as a set of expressive practices implicated not just print, cinema and television, but also employed it to cover a range of new material entities which emerged in post-war Britain including canned foods, contraceptives, aspirin and baby Austins. Culture is then reproduced in multiple sites. Michel de Certeau *et al.'s Practice of Everyday Life living and cooking* (De Certeau et al., 1998:3) assert that 'culinary virtuosities' establish 'multiple relationships between enjoyment and manipulation'. In terms of food visuality, food is not just consumed orally and ingested, but consumed through other senses and a sense of play and desire.

Food, when dislodged from the kitchen and devoid of its nutritive or taste qualities enters a realm of the performative; valorising the visual above all else and situating it within the performative (Magee, 2007). Barbara Kirshenblatt-Gimblett (1999) argues that food that is dissociated from eating bypasses the nose and mouth. Such food may

well be subjected to extreme visual, and for that matter tactile and verbal, elaboration. Our eyes let us 'taste' food at a distance by activating the sense memories of taste and smell. Television shows and cookbooks invite us to eat with our eyes without either cooking or eating oneself. Kirshenblatt-Gimblett reminds us that the wondrous confectionery presented at the conclusion of Renaissance banquets, while technically edible, might never be eaten, though it might be enthusiastically applauded. She contends that these monumental events cultivate the visuality and appearance rather than the flavour, hence situating appearance as enduring compared to the eating of food, which can be ephemeral. The dominance of visuality or appearance is deliberate, for it emphasises a legible (edible) visual language of emblems and signs. Here the visual is the performative. Similarly, Barbara Wheaton in *Savoring the Past* notes that, in the edible allegorical tableaus that were mediaeval banquets, visual effects, rarity of ingredients, opulence and sequence of events were more important than the dishes, ingredients, preparation techniques, or flavours. Richard Magee points out that both food pornography and sexual pornography are primarily focused on food or sex as a performance, and, like all performance, are designed as a voyeuristic exercise.

While considerable attention has been accorded to food as image or symbol, food studies is somewhat muted on the topic of food as a performance medium. Allen Weiss (2002) in drawing attention to a minority stance within Western aesthetics that allows for the definition of food as art contends that the Enlightenment concord has been thwarted to expand the boundaries of form and taste. The new postmodern aesthetic premises 'the disappearance of the boundaries between the arts, disrupting the border between art and craft, repositioning classic hierarchies of form and taste'. Weiss challenges with the question; 'if fashion can become a fine art today, why not cooking?'

This variant of food porn through the smartphone invariably offers a performance medium. In digital cultures the performative and visual elements of food porn enter a complex arrangement where it is conjoined with the creation of self-identity, community, invitation to gaze, memory making, and as a form of social capital to transact and exchange. In the digital economy, the unattainable quality of food porn is mediated and made mainstream for the amateur food flaneur. Amateur food images, rather than emphasising its unattainability, hinge on the individual aesthetics and exchange of image as a form of social capital to elicit validation and to seek attention and bring moment to the everyday. The imaging of food elongates the performative, making food inedible and imbuing it with non-perishable qualities. Imaging food accords performance to the everyday while transforming the mundane into commodities for sharing. Imaging food via smartphones and mobile gadgets enables the formation of ownership to an image and intimacy which food porn of the glossy magazines and television may not engender. In so doing they don't eradicate desire or the notion of the unattainable, where one man's food is offered to another for vicarious consumption but it mediates distance and closeness to this porn through a sense of ownership. With image sharing sites allowing for dissemination, display and curation of images, the processes of creation and ownership online allows for the perception of 'this porn is mine'. The flaneur gaze of the Internet means that images can be culled from the wider web and displayed in what one might consider a personalised space online, while sustaining vicarious consumption. Desire is still a manifest part of the food porn but it can reside in the personalised spaces which we curate and publish online.

Rituals of the internet

The Internet as a virtual space is not disembedded or dichotomised from the real world. It is mediated through social and cultural norms of our lived world. But it is equally a space that can produce cultures in its own right (Hine, 2000). Our ability to enact new forms of rituals online and to seek communion, validation, therapy or to commemorate and preserve memories through image sharing and uploads has been well documented (Ibrahim, 2011, 2015). The emergence of converged mobile technologies which enable publishing and social sharing while diarising the everyday has given rise to a whole host of cultural activities around image sharing and new media visualities online. Imaging the everyday by capturing our daily routines including meals has become an important part of new media rituals and validation of the self. According to a report by Pew entitled 'Photo and Video Sharing Grow Online' (Duggan, 2013), 54% of adult users post original photos and videos online that they themselves have created. Another 47% of adult Internet users take videos or photos they found online and repost them on sites designed for sharing images with many people. According to Webstagram which ranks Instagram images by popularity, food images retain popular resonance through multiple tags including 'foodporn', 'yummy', 'yumgasm' and 'dessert'. For instance #food figured as number 25 in the top 100 tags on Instagram in 2014.

Marking life's everydayness and paces of routine through images, communicating these everyday images and inviting the gaze of others authenticates everyday life experiences; capturing the ephemerality of life while archiving and displaying the banal and the unusual. Food and meal times as symbolic imagery of our everyday (or the temporality of life) provide a means of communication and social sharing of a familiarity. They also serve as spatial and temporal devices to create a sense of space and a notion of lifetime online. This image literacy and reciprocity of exchange is part of digital culture. Food has a universal quality of resonance and food images carry this aura of desire, familiarity, comfort, spirituality as well as a sense of offering and a moment of display. The glimpse into one's private moment inevitably conveys an intimacy, but with social media platforms the intimate and public moments occupy a hybrid space where the private and public can co-exist. Food imagery provides an acceptable space of social and cultural exchange where the private and public can merge, forming hybrid spaces of material consumption, exchange and co-presence. These new rituals enacted through new mobile technologies and social media provide a means for shared and collective meaning making while renewing social connections.

The rich sociological literature on rituals confirms its symbolic, functional and therapeutic elements for humanity and society. Durkheimian interpretation of ritual emphasise the creation of social order and strengthening of group solidarity. Emile Durkheim (1976) accorded rituals a seminal role in enacting and sustaining the 'sacred' and in constructing a communally shared social reality. Victor Turner (1969) conceptualised rituals as being both creative and equally subversive attributing it with 'social drama', which can challenge social hierarchies. In contrast, Irving Goffman (1967) stresses rituals' ability to capture interactions and the performative aspects of everyday life. Rituals subsumes both the institutional and formal but also the informal and personal, providing a means for collective meaning making accounting for shared experiences as well as individual identity (Helland, 2013: 26; Rook, 1985). Defying

static manifestations to embrace the movements of time and space, rituals can reflect the changing patterns of society. As 'repeated and patterned forms of communication, rituals enable us to attach ourselves to 'our surrounding media-related world' (Semulia, 2013: 9).

These new rituals online of imaging food have both symbolic and instrumental value of marking everyday moments like meal times and staples, but equally veritable feasts and culinary spectacles which celebrate the occasion, providing a means to commemorate and remember while creating a sense of shared and or individual identities. Several authors (e.g. Sahlins, 1976; Lupton, 1996) argue that gift giving is a way of validating social relations. Furthermore, gift giving might not only relate to the giving of physical objects but might also (or perhaps even more so) relate to more symbolic acts and practices and therefore, food image are part of gift giving, the purpose of which is to validate social relations. New rituals online such as imaging food before consumption (or during consumption) have instrumental and symbolic qualities where the invitation to gaze by others authenticates life's experiences while enabling the formation of everyday and special memories offered through the process of transacting the food image. These rituals have their therapeutic function in terms of social sharing and reciprocity, but they are equally intertextual with the wider world of consumerism representing material consumption as a site of desire, meaning making, performance and engagement with capital.

Food in media and consumer culture

Throughout history we have been socialised into food imagery whether in art history, food advertising editorials, magazine features, specialised cookbooks or personal photography. Food once transformed as an image or commodity signifies a permanence, defying its perishable and destructible qualities. Imaging provides an ethereality; an ability to transcend time and space and to be accorded different cultural significance by new audiences who consume it, appealing to their senses and sensitivities in different ways. With the invention of mobile photographic equipment, particularly the Kodak camera, food has remained a subject of rites of passages, of events as well as the everyday, marking the moments and routines of life within the domestic and beyond.

With print culture, broadcasting, advertising and branding, food imagery entered a realm of consumer capitalism denoting the construction of desire and its circulation through mass media platforms. The selling and packaging of food to the masses drew on our nostalgic bonds with food while recruiting consumers for advertisers. Food porn in the hands of capital sought to create a consumption community through desire for new offerings on the market. Food advertising came through our TV sets and magazines, offering the ease of assemblage to the homemakers, enticing new audiences while renewing our intrinsic ties with food in domestic settings. The increasing incorporation of leisure readings in newspapers and proliferation of lifestyle and women's magazine also socialised us into accepting stylised food imagery as part of a new consumer culture which packaged fantasy, escapism and romance into everyday fast moving consumer products. Advertising of food took it to new heights pledging desire and enticement through the lens, which could yield pleasure and yearning en masse.

The everyday staples of bread, butter, milk and coffee could be re-fashioned through the co-optation of photography which worked to lure mass audiences to mass production and into the hands of capital. The emergence of mass advertising of consumer products through mass media enabled food imagery to be accepted as part of the consumerist landscape to fashion instant desire like instant coffee. We were socialised into food porn as part of our consumer culture through mass media even before the advent of satellite television, which could assuage niche interests. The increasing tabloidisation of the public sphere and broadcasting also saw a proliferation of cookery shows, food channels and celebrity chefs, making food a ubiquitous subject of human consumption and of decadence and a symbol of high living where the concerns were about offering creativity and variety through food rather than issues of starvation, austerity or famine. With the tele-visualisation and tabloidisation of food, food imagery entered an era of the spectacle where it can be 'groomed' for consumption through the vantage point of the lens but removed from the immediate pleasure of consuming and ingesting food. Food porn online did not emerge from a vacuum – its prominence on the digital platforms today harks back to a wider media and capitalist socialisation which leveraged on our spiritual connection with food as a symbol of culture, survival, sustenance and solidarity.

With increasing globalisation of the world, food is increasingly a part of popular culture and popular imagination. Claude Fischler contends that what we have seen in fast food is not the 'menace of Americanization' or a threat to traditional French cuisine, but an essentially benign reflection of the global circulation of culinary cultures. The globalisation of coffee chains and conveyor belt sushi joints symbolises both the increasing diversification of cuisines in cosmopolitan cultures and equally the dominance of standardised offerings through the Mcdonaldization of the globe. In the process, food acquires a popular global currency and can symbolise a multitude of meanings from the McDonaldization of society, the increasing curiosity and acceptance of world cuisines to the exoticisation of the ordinary meal.

Food, UGC and prosumerism

With the incorporation of Kodak culture and home photography, food retains a primacy as a subject of photography. With the convergence of technologies in the digital age and the incorporation of the digital photographic tools into mobile telephony the mobile phone becomes an extension of the body and memory, archiving and imaging events and rituals of the everyday. The body embedded with technology such as the smartphone is a space of double articulation in terms of functioning as a repository for memory. Beyond the cognitive ability of the brain to store visual memory and images, mobile technology such as the smartphone facilitates the production of mobile repositories, including cloud computing which can produce and carry images while on the move. Food provides a means to document and memorialise the everyday and the eventful. In the social media economy cultural food production also signifies the production of the self and diarisation of everyday life. New rituals around food consumption including the uploading of the food image before consumption, integrates seamlessly into a UGC economy where content creation and human behaviour fuse together to manifest new social conventions and rituals.

UGC is integrated into many commercial platforms and with the proliferation of social networking sites, image sharing and video archives, UGC has in parts entered a monetised economy while feeding this notion of consumer sovereignty and user empowerment online. This user-centred economy of publishing online through its emphasis on interactivity and online conversations is seen as celebrating a prosumer-ism, blurring the boundaries between production and consumption. In tandem with this, mobile telephony today enables people to record and publish images while on the move. In this digital economy where people can produce and consume incessantly, the image plays an important role in communication and in enabling connection both in the everyday and in marking the unusual. Web 2.0 celebrates the coexistence of a mul-titude of forms including images both mobile and static. In expressing everyday flows of life and in establishing co-presence as well as endorsing human communion, images are seen as a vital part of this connectivity. The virtual world yields to our desire to see ourselves in it and equally to look into the lives of others. Food provides a means of intimacy into a private realm while being a symbol of collective consumption.

The prosumer economy online has appropriated food photography as a well-established cultural convention of capture and exchange. This is evident where the Internet is saturated with features to improve techniques of imaging food with a smartphone. Condé Nast Publishers in its *Traveller* magazine ran a feature in 2014 on 'Food Photography Tips for Instagram and Smartphone', dispensing technical advice on how to get the right lighting and vantage point while staying true to the protago-nist, food. Similar articles have featured in Epicurious.com (2015) and the *Guardian* which ran a feature entitled, 'How to Photograph Food with your Phone' in 2012. A huge litany of similar articles exist online providing amateurs with tips to mainstream food photography with mobile phones. The Internet craves content and food imagery is a vital part of this economy.

People face the burden as well as the freedom to construct their own identities in postmodernity (Giddens, 1991; Christensen, 2008; Baudrillard, 2002), and new media technologies and the image economy are increasingly implicated in this. Con-sumption in modern (mass) consumer society can be highly individualistic and even narcissistic. While the sensual pleasures of eating are completely individualised, eat-ing is a highly social activity and regulated by the community (Marshall, 2005: 71) and food porn becomes a site of both personal consumption and collective desire. Holt (1995, 1998), refers to the way in which consumers use consumption objects to classify themselves in relation to relevant others. Miller and Edwards (2007) sim-ilarly explore online photo-sharing practices with sites such as Flickr and Facebook in relation to how different types of people manage public and private boundaries in this space. The coalescing of the public and private realms of consumption and notions of space make food porn amenable to multiple iterations. Like the selfie, food is part of this transaction culture and memory creation. What one consumes and experiences is archived and communicated through food. The selfie and the culture of social networking sites are driven through the uploading of content. The commodification of self and food are entwined online. The construction of the self is renewed through the constant engagement in these sites. Food as an everyday object of materiality and as a part of one's personal domain of consumption offers a means to create a personal connection while providing a common theme of interest for others to gaze.

The increasing number of image sharing sites and the communities which have emerged around gazing, curating, tagging, liking and retweeting, and re-blogging images makes food porn a tool of cultural production and interaction online; equally one of technique and aesthetics. The digital economy is made for forms of public and quasi-public sharing, inviting the gaze of the strange and familiar while enabling the self to be consumed and constructed through this image economy. According to a Pew Report in 2012, photos and videos have become a key social currency online (Lee et al., 2012). The rise of social media, especially YouTube and newer services like Pinterest, Instagram and Tumblr have made curating activities easier because they are organised for easy image and video-sharing. Beyond content creation, the Internet and social networks drive on a circulation economy constantly merging content in unlikely places. Food porn can be part of disparate narratives and conversations online and equally it can convene dedicated niche communities.

Food as a subject of human connection can transcend cultural boundaries and is often considered a product of cultural diplomacy in terms of tourism and national identity. Food images become tools to personify self, communicate intimacy and to connect to a wider audience of similar and disparate interests. Our intimacy with food means it is a site for self-representation but also a means to leave narratives of social history and autobiographies in a transient mortal world. The Internet's virtuality is in many ways is inerasable and enduring while being amenable to wider circulation and search. Our connection to the image binds us to the mortal world in complex ways. Food, then, is a medium and metaphor for this representation and the preservation of the self through the image economy. Digital cultures are undeniably shaped by the culture of the physical world, which reinforces our need to imagine ourselves beyond our situated mortality; the virtual world provides a means to leave traces of your intimate portrayals where you can both avow and disavow ownership to content you produce. The image economy, particularly the intimate images of creation, tap into this need to preserve ourselves beyond our transient world. The ubiquity of new practices and conventions in many ways reassert this, and the imaging of food is no exception; representing both the need to prolong desire and life through the symbolic metaphor of food, recognising it as an ephemeral entity, but seeking to prolong and immortalise it through the image.

Conclusion

Amateur food porn online democratised by the smartphone and convergence technologies appropriates many cultural qualities from the food porn crafted by the experts. It relocates desire as something that can be generated through UGC mediating both distance to food porn and its unattainability through ownership and creation of food images. In the process, it provides a mechanism to create social capital and currency online and to produce these to document the everyday and to renew connections with a wider community. Smartphone food porn democratises the production of desire and in doing so taps into representation of self and identity while being intertextual with our consumerist world and consumption cultures. At the heart of virtual life is our quest for self-presentation beyond our mortal existence. The image economy assuages our need to seek immortality through the virtual world. Food then becomes the medium and message.

Original publication

Article originally titled: 'Food Porn and the Invitation to Gaze: Ephemeral Consumption and the Digital Spectacle', *International Journal of E-Politics* (2015)

Note

1 This article appeared as Ibrahim, Yasmin. 2015. "Food Porn and the Invitation to Gaze: Ephemeral Consumption and the Digital Spectacle". *International Journal of E-Politics* 6 (3): 1–12.

Bibliography

Barthes, R. ([1961] 1979) 'Towards a Psycosociology of Contemporary Food Consumption.' In R. Forster and O. Rarum (Eds.), *Food and Drink in History: Selections from the Annals Economics, Societies, Civilisations*. Baltimore: John Hopkins University Press.

Barthes, R. (1972) 'Ornamental Cookery,' In *Mythologies*. p. 78. New York: Hill and Wang.

Baudrillard, J. (2002) 'The Precession of Simulacra.' In G. D. Meenakshi and D. M. Kellner (Eds.), *Media and Cultural Studies: Keyworks*. pp. 521–549. Malden, MA and Oxford: Blackwell Publishers.

Chalfen, R. (1987) *Snapshot Versions of Life*. Bowling Green, OH: Popular Press.

Chamberlain, K. (2004) 'Food and Health: Expanding the Agenda for Health Psychology.' *Journal of Health Psychology*, 9(4): 467–481.

Christensen, C. L. (2008) 'Livsstil som TV-Underholdning.' *Journal of Media and Communication Research*, 45: 23–36.

Cockburn, A. (1977) 'Gastro-Porn.' *New York Review of Books*, 8 December, www.nybooks.com/articles/8309.

De Certeau, M., Giard, L., and Mayol, P. (1998) *The Practice of Everyday Life, Volume 2: Living and Cooking*. Minneapolis: University of Minnesota Press.

Duggan, M. (2013) 'Video and Photo Sharing Grow Online.' *Pew Research Centre*, www.pewinternet.org/2013/10/28/photo-and-video-sharing-grow-online/

Durkheim, E. (1976) *The Elementary Forms of Religious Life*. K. Feilds. Glencoe: Free Press.

Fischler, C. (1988) 'Food, Self and Identity.' *Social Science Information*, 27(2): 275–292.

Foucault, M. (1983) 'On the Genealogy of Ethics: An Overview of Work in Progress.' In Hubert Dreyfus and Paul Rabinow (Eds.), *Michel Foucault: Beyond Structuralism and Hermeneutics*. Chicago: University of Chicago Press.

Giddens, A. (1991) *Modernity and Self-Identity*. Stanford: Stanford University Press.

Goffman, E. (1959) *The Presentation of Self in Everyday Life*. Edinburgh: Social Sciences Research Centre.

Goffman, E. (1967) *Interaction Ritual: Essays on Face-to-Face Behaviour*. New Brunswick, NJ: Transaction Publishers.

Helland, C. (2013) 'Ritual.' In Heidi Campbell (Ed.), *Digital Religion: Understanding Religious Practice in New Media Worlds*. New York: Routledge.

Hine, C. (2000) *Virtual Ethnography*. Thousand Oaks, CA: Sage.

Holt, D. B. (1995) 'How Consumers Consume: A Typology of Consumption Practices.' *Journal of Consumer Research*, 22(1): 1–16.

Holt, D. B. (1998) 'Does Cultural Capital Structure American Consumption.' *Journal of Consumer Research*, 25(1): 1–25.

'How to Photograph Food with your Phone.' (2012, 15 July) *The Guardian*, www.theguardian. com/lifeandstyle/2012/jul/15/how-to-photograph-food-smartphone

Ibrahim, Y. (2011) 'The Non-Stop "capture": The Politics of Looking in Postmodernity.' *The Poster*, 1(2): 167–185.

Ibrahim, Y. (2015) 'Instagramming Life: Banal Imaging and the Poetics of the Everyday.' *Journal of Media Practice* ahead-of-print: 1–13.

Jensen, P. (2008) 'The International Extent and Elasticity of Lifestyle Television.' *Mediekultur*, 45: 24–45.

Kaufman, F. (2005, October) 'Debbie Does Salad: The Food Network at the Frontiers of Pornography.' *Harper's*: 55–60.

Kirshenblatt-Gimblett, B. (1999) 'Playing to the Senses, Food as Performance Medium', *Performance Research*, 4(1): 1–30.

Lee, R., Rainier, J., and Purcell, K. (2012) 'Photos and Videos as Social Currency Online.' *Pew Research Centre*, www.pewinternet.org/2012/09/13/photos-and-videos-as-social-currency-online/

Lister, M., and Wells, L. (2001) 'Seeing beyond Belief: Cultural Studies as an approach to studying the visual.' In *Handbook of Visual Analysis*. London: Sage, pp. 61–91.

Lupton, D. (1996) *Food, the Body and the Self*. Thousand Oaks, CA: Sage.

Magee, R. M. (2007, Fall) 'Food Puritanism and Food Pornography: The Gourmet Semiotics of Martha and Nigella.' *Americana: The Journal of American Popular Culture*, 6(2), www.american popularculture.com/journal/articles/fall_2007/magee.htm

Marshall, D. (2005) 'Food as Ritual, Routine or Convention.' *Consumption Markets & Culture*, 8(1): 69–85.

McBride, A. E. (2010, Winter) 'Food Porn.' *Gastronomica: The Journal of Food and Culture*, 10(1): 38–46.

Miller, A. D., & Edwards, W. K. (2007) 'Give and Take: A Study of Consumer Photo-Sharing Culture and Practice.' Proceedings of CHI'07, San Jose, CA: ACM Press.

Mirzoeff, N. (1999) *An Introduction to Visual Culture*. London and New York: Routledge.

Mitchell, R. D. (Ed.) (2014, July 2–4) *Food Design on the Edge: Proceedings of the International Food Design Conference and Studio 2014*, Dunedin, New Zealand. Otago Polytechnic, Dunedin.

O'Neill, M. (2003, September–October) 'Food Porn.' *Columbia Journalism Review*, 5: 38–45.

Ray, K. (2007, Winter) 'Domesticating Cuisine: Food and Aesthetics on American Television.' *Gastronomica: The Journal of Critical Food Studies*, 7(1): 50–63.

Raymond, W. (1985) *Keywords: A Vocabulary of Culture and Society*. Oxford: Oxford University Press.

Rook, D. (1985, December) 'The Ritual Dimension of Consumer Behaviour.' *Journal of Consumer Behaviour*, 12: 251–264.

Rousseau, S. (2014) 'Food "Porn" in Media.' In *Encyclopedia of Food and Agricultural Ethics*. pp. 1–8. Netherlands: Springer.

Sahlins M. (1976) *Culture and Practical Reason*. Chicago, IL: Univ. Chicago Press.

Semulia, J. (2013) *Media and Ritual: Death, Community and Everyday Life*. New York: Routledge.

'Snapchat: The Ultimate Guide to Mobile Food Photography, From Lighting to Editing' (2015, 9 January) *Epicurious.com*, www.epicurious.com/expert-advice/the-ultimate-guide-to-mobile-food-photography-from-lighting-to-editing-article

Sturken, M., and Cartwright, L. (2001) *Practices of Looking: An Introduction to Visual Culture*. Oxford: Oxford University Press.

Turner, V. (1969) *The Ritual Process: Structure and Anti-Structure*. Ithaca: Cornell University Press.

Weiss, A. (2002) *Feast and Folly: Cuisine, Intoxication, and the Poetics of the Sublime*. Albany: State University of New York Press.

Wheaton, B. (1983) *Savoring the Past: The French Kitchen and Table from 1300 to 1789*. New York: Simon & Schuster.

Williams, R. (1993). 'Culture is ordinary.' In A. Gray and M. McGuigan (Eds.), *Studying Culture: An Introductory Reader* (pp. 5–14).

Zukin, S., and Maguire, J. (2004) 'Consumers and Consumption.' *Annual Review of Sociology*, 30: 173–197.

Karin E. Becker

PHOTOJOURNALISM AND THE TABLOID PRESS[1]

PHOTOGRAPHY HAS A LONG AND UNCOMFORTABLE history within western journalism. Despite its very visible presence in the daily and weekly press of the past century, photography is rarely admitted to settings in which journalism is discussed, investigated and taught. Whenever the distinction is drawn between information and entertainment, or the serious substance of a journalism appealing to an intellectual reading public is defended against the light, trivial appeal of the popular, photography falls within the popular, excluded from the realm of the serious press. Nowhere are the consequences of this position more evident than in the pages and discussion of the tabloid press. There the display and presumed appeal of the photographs are used as criteria for evaluating, and ultimately dismissing, tabloid newspapers as 'merely' popular.

The history of this link between photography and the tabloid press can be traced to photography's successive adoption by three distinct types of publications: first in the elite periodical press with its established tradition of illustration; then in the tabloid press with a more popular appeal; and almost simultaneously, in weekly supplements to the respected organs of the daily press. Examining this history reveals the development of discourses about photojournalism, including beliefs about the nature of the medium, that continue to inform photography's positions in the contemporary press.

Beliefs that photographs supply unmediated pictures of actual events could have been the foundation for treating photographs as news by institutions whose credibility rests on the facticity and accuracy of their reports about the world. Yet there is a contradiction, because photography, when constructed as a purely visual medium, is also thought to bypass those intellectual processes that journalism will specifically address and cultivate. Photography's more immediate, direct appeal is seen as a threat to reason, and to the journalistic institution's Enlightenment heritage. The tension inherent in these reconstructions of photography and journalism permeates the discourse in which these practices coexist. Tracing the history of this discourse, and particularly journalism's ambivalance toward photography's popular appeal, one finds patterns of

use and journalistic structures that refer to photography and exploit its popularity, while simultaneously insulating the elite segments of the daily press in exclusively verbal forms of journalistic practice.

Analysing the role of photography in the press can thus help illuminate the simultaneous problems of the 'political' and the 'aesthetic' in contemporary communication studies, and offers insights into the relationships among representation, historical knowledge, and value at the heart of the postmodern debate. This chapter engages these issues first, by examining the historical development of the use of photographs in the western press, and secondly, by analysing the tabloid press as the contemporary context in which photography continues to be a primary means of representing the news.

The early picture press

In the early 1840s illustrated magazines were launched almost simultaneously in several European countries. The *Illustrated London News*, founded in 1842, was a well-written weekly magazine which hired illustrators to portray important current events (Hassner 1977; Taft 1938). Its success[2] was echoed by *L'Illustration* in France and *Illustrierte Zeitung* in Germany (both founded in 1843) and which were soon followed by others. *Frank Leslie's Illustrated Newspaper* (1855) and *Harper's Weekly – Journal of Civilization* (1857) were the first such publications to appear in North America.

These magazines were all using wood engravings to illustrate the news. Well-known artists were hired to 'cover' events, and competed to be the first with their reports. *Leslie's*, for example, sent an illustrator to the hanging of the anti-slavery movement leader John Brown in 1859, with instructions to take the first train back to New York where sixteen engravers worked through the night to meet the press deadline. The text published with the engraving stated that it was 'from a sketch by our own artist taken on the spot', invoking the authority of the eye-witness (Hassner 1977: 170).

At that time the publication of actual photographs was technically impossible, but wood engravings were preferred for other reasons. The camera's 'likeness' apparently was considered stiff and too dependent on the luck of the machine, in contrast with the hand-drawn image that reflected the artist's perspective and the engraver's craft. When a photograph was used (often quite loosely) as a referent for the engraver, a statement like 'from a photograph' frequently accompanied it, lending the machine's authority to the artist's work. By the 1860s, the engraving was considered 'a meticulously faithful reproduction of reality' within a 'sphere of objectivity around the medium itself' (Johannesson 1982).[3]

Thus, the periodical press had established patterns of visual reporting several decades before the half-tone process was developed to facilitate printing photographs and text side by side. The topics that were covered, the ideals of immediacy and accuracy and the competition valorizing both the journalistic process and its product (both the hunt and its trophy), were well established on publications that carried an aura of quality and distinction. The 1890s saw these conventions of illustration gradually being adapted to photography.

Histories of photojournalism trace a heritage to a limited number of prestige periodicals, locating a tradition of photographic reportage in the work of a few editors and photographers (Hassner 1977; Edom 1976; Kobre 1980). *Collier's Weekly*, a 'cultural magazine emphasizing literary material', is often named as one of the first to shift from illustration to photo-reportage. Photographer James Hare, *Collier's'* primary correspondent throughout the Spanish – American War, is seen as the chief reason for the magazine's success.[4] Hare's assignment to investigate the sinking of the battleship *Maine* is among the earliest examples used to present the photojournalist as hero:

> He snapped the wreck of the *Maine* from every point of the compass. He caught divers still busy at the somber task of bringing up the drowned. . . . With the aid of an interpreter, Jimmy prowled through reconcentrado camps. He photographed swollen bodies with bones breaking through the skin; he took pictures of the emaciated living, and of babies ravaged by disease. Every ship that passed Morrow Castle enroute to New York carried a packet of snapshots. Their influence upon public opinion can hardly be overestimated.
>
> (Carnes 1940: 15; Edom 1976: 38)

The rapid expansion of weekly magazines in the United States was due in part to the overheated atmosphere and competitive coverage of the war with Spain. Technical innovations and new legal privileges were also encouraging growth, and most important, with industrialization and the shift to a market economy, advertising began to provide significant support for the weekly press. As many magazines cut their purchase prices in half, a potentially nation-wide market suddenly opened up and the so-called 'general interest mass circulation magazine' arose. Advertising volume grew from 360 million to 542 million dollars between 1890 and 1900 (Kahan 1968; Hassner 1977: 216–217). The availability of large advertising revenues and the assumption of a mass appeal would become foundations of the picture magazines in the 1930s.

At the turn of the century, however, there are few indications that photography actually increased magazine sales (Kahan 1968: 194; Hassner 1977: 218). Nevertheless, 'the weekly photo-news magazine concept' had been established, and the heroic construction of its news photographer had begun.

The tabloid = sensationalism = photography

Daily newspapers did not have an established tradition of illustration predating photography, which helps to explain the slow introduction of half-tone reproduction in the daily press. Daily deadline requirements also meant that the early half-tone process was too cumbersome for newspaper production routines. By the late 1890s, more than a decade after the process was invented, many papers only occasionally published photographs. The exception was the United States' 'yellow press', and particularly the fierce competition between two New York papers, Joseph Pulitzer's *World* and William Randolph Hearst's *Journal*, where pictures were seen as a key to successful and sensational coverage. The *World*, for example, carried what is claimed were 'the first

actual photographs of the wreck' of the *Maine* in 1898, and which were in fact drawn simulations of photographs (Time-Life 1983: 16).

It was in the tabloid press of the 1920s that large sensational photographs first appeared, with violence, sex, accidents and society scandals as the major themes. United States press historians point to this as a low point for the press, an expression of what they consider the loose morals and loss of ethical standards that threatened public and private life. It was a time 'made to order for the extreme sensationalism of the tabloid and for a spreading of its degrading journalistic features to the rest of the press' (Emery 1962: 624). The *New York Daily News* was a primary culprit, and by 1924 had the largest circulation of any US newspaper. Its main competitors were the *Daily Mirror* and the *Daily Graphic*. England's *Daily Mirror* (founded 1904) had established 'a genre making public the grief of private individuals', and in the 1920s was, together with the *Daily Express*, among the newspapers influenced by the US tabloids' use of photographs (Baynes 1971: 46, 51).

'Sensational' journalism breaks the press, ascribed guidelines of ethical practice with the intention of attracting attention in order to sell more papers. In this process, journalism's audience – its 'public' – is reconstructed as a mass, undifferentiated and irrational. The 'sensational' occurs within journalistic discourses that are also bounded by cultural, historical and political practices that in turn position the ethical guidelines around different types of content, an important point to remember when examining the tabloid press of different countries.[5] Yet, a component common to the various constructions of the sensational is that attracting attention takes precedence over other journalistic values, including accuracy, credibility and political or social significance. In the US, the sensationalism of the tabloid press was intensified by 'photographs of events and personalities reproduced which are trite, trivial, superficial, tawdry, salacious, morbid, or silly' (Taft 1938: 448). It was not the subject matter, in other words, but the ways the photographs reproduced it which appealed to the emotions and thereby created the sensation.

Herein lies the rationale for prohibiting the photographing of news-worthy events that take place where reason and order are seen as crucial, that is, within most judicial and legislative bodies. Newspaper violations of these prohibitions have been held up as examples confirming the need for exclusion (Dyer and Hauserman 1987) or, conversely, within photojournalistic discourse to point to the need for self-regulation (Cookman 1985). One frequently cited case was a New York divorce trial in which the husband, a wealthy white manufacturer, wanted to annul his marriage on the grounds that his wife had concealed from him that she was part African-American, which she in turn claimed was obvious to him at the time of their marriage. At one point in the trial, when she was required to strip to the waist, the courtroom was cleared and no photographs were permitted. The *Evening Graphic* constructed what it proudly called a 'composograph' by recreating the scene using actors, then pasting in photographs of the faces of actual trial participants (Hassner 1977: 282; Kobre 1980: 17). No discussion of this obvious montage as a dismantling of photographic truth is offered in today's texts, nor is the outcome of the trial itself. They do note, however, that such practices led to the *Graphic*'s nickname, 'the *Porno-graphic*' (see Time-Life 1983: 17).

The *Daily News* is seen as the leader of that 'daily erotica for the masses' (Kobre 1980: 17), particularly for heating up competition, and thus increasing the excesses

of sensationalism among the tabloids. The execution of Ruth Snyder, found guilty of murdering her husband after a much publicized 'love triangle' trial in 1928, is often given as an example. Although reporters were allowed to witness the electrocution, photographers were excluded (Time-Life 1983: 17). The day before, the *Graphic* had promised its readers 'a woman's final thoughts just before she is clutched in the deadly snare that sears and burns and FRIES AND KILLS! Her very last words, exclusively in tomorrow's *Graphic*' (cited in Emery 1962: 629).

The *Daily News*, however, had a Chicago press photographer, unknown to New York prison authorities and press, in the execution chamber with a camera taped to his ankle. At the key moment he lifted his trouser leg and made an exposure using a cable release in his pocket. 'DEAD!' was the simple heading over the photograph in the *Daily News*' extra edition. The caption gave it scientific legitimation as 'the most remarkable exclusive picture in the history of criminology', and described details ('her helmeted head is stiffened in death') difficult to distinguish in the heavily retouched photograph. The edition sold a million copies, easily beating the *Graphic*'s non-visual account of the event (Emery 1962: 629).

Within this journalistic discourse, the photograph itself had come to mean sensational journalism. In his history of photography in America in 1938, William Taft claimed:

> Such prodigious and free use of photographs in picture newspapers and magazines has in a measure defeated their own object, presumably that of disseminating news. Such journals are carelessly thumbed through, the reader glances hastily at one picture – looks but does not see or think – and passes on to the next in the same manner and then throws the periodical aside – a picture album with little purpose or reason.
>
> These criticisms and abuses the pictorial press must meet and correct if it is to command the respect of intelligent people.
>
> (Taft 1938: 448–449)

Here we see, if not the origins, then a full-blown expression of the historical antagonism between the liberal and the popular press, and photography's exclusive identification with the inferior, the popular, side of that antagonism.

The daily press 'supplements' the news

With the exception of the tabloid press, photographs rarely appeared in the daily newspapers of Europe and North America until 1920. Technical and time constraints offer a partial explanation for this delay. However, by the time daily photojournalism became practical, conventions of press photography had already been established. On the one hand, the abundant illustration in the magazines of the late nineteenth century had a broader content than 'the political, legal and economic matters [that] constituted the primary news in the traditional newspaper' (Hård af Segerstad 1974: 143). On the other hand, the leading role photography was playing in the tabloids' abuses of press credibility made it increasingly difficult to see the photograph as a medium for serious news.

Photographic realism as an ideal had entered the *verbal* codes of the daily press shortly after photography's invention. Metaphors of the American newspaper as 'a faithful daguerreotype of the progress of mankind' were common from the 1850s, with the reporter employed as a 'mere machine to repeat' each event as a seamless whole, 'like a picture'. According to Dan Schiller (1977: 93) photography 'was becoming the guiding beacon of reportorial practice'. Although the conception of photographic realism had become intertwined with the roots of objectivity in the occupational ideology of American journalism, press photography itself had been enclosed in a different and conflicting discursive field.

Daily newspapers instead had begun to print weekly supplements on the new gravure presses. The first of these appeared in New York and Chicago in the 1890s and were illustrated predominantly with photographs. Many, such as the *New York Times Midweek Pictorial*, provided substantive complements to the newspaper's daily coverage of World War I. By 1920, New York's five major newspapers had rotogravure supplements to their Sunday editions (Schuneman 1966, cited in Hassner 1977: 279). Established during the period when half-tone reproduction became feasible, these magazines were a response to the popularity of photography. Material was gathered and packaged with a weekly deadline in a magazine format on smooth paper that raised the quality of reproduction. Within this format newspapers had succeeded in developing a way to use photography that complemented the structure and appearance of the daily news, while insulating and protecting the newspaper's primary product from being downgraded by the photograph. Contemporary examples of this phenomenon persist,[6] offering a showcase for 'good' photojournalism, pursued separately from the daily news product.

Photography had followed three distinct routes in its entry into the western press, establishing separate and overlapping discourses of photojournalism which, by the 1920s, were serving as three models. One may argue that this construction is based on secondary sources, the received histories of journalism and its photography, without looking at the primary material, that is, the press itself. Yet received histories undeniably serve as models for practice, indeed that is their power. It is the memory of how things were done in the past as reconstructed in contemporary discourse – not the day-to-day production process from any specific or actual period of time – which informs today's practice.

The picture magazines' legacy

Before turning to the specific case of the contemporary tabloid press, it is important to mention briefly the mass-circulation picture magazines. Although they have had little direct influence on tabloid photojournalism, their histories and the trajectories they established continue to inform photojournalistic discourse, including standards of practice and aesthetic value (Becker 1985).

Mass circulation picture magazines emerged between the wars, first in Germany, soon thereafter in other European countries, and by the late 1930s were established in England and the United States (Gidal 1973; Hall 1972; Hassner 1977; Eskildsen 1978; Ohrn and Hardt 1981). Not only did these magazines establish new genres of photoreportage – notably the photo essay and the practice of documenting both the

famous and the ordinary citizen in the same light. More important, they emerged dur-
ing a period when, in various ways in each of their respective countries, what Victor
Burgin has described as 'a dismantling of the differentiation between high and low
culture was taking place' (Burgin 1986: 5). The notion of 'mass' art – referring to both
the production and consumption of the work – had emerged to challenge the notion
of 'high' culture as the sole repository of aesthetic value. Photography, in particular
documentary photography, became accepted as popular art, and made its first major
entry into the museum world.[7]

Walter Benjamin's predictions (1936) that the mass production of photographic
images would bring about a defetishization of the art object had very nearly been
reversed by the post-war years. Instead, we find an 'aura' reconstructed to privilege
particular spheres of mass production and popular culture, including in this case, pho-
tojournalism. Within the magazines, photography was bearing the fruits of becoming
a mass medium in a form that was popular and respected. Supported by consistently
rising circulations and mass-market national advertising, and operating in a cultural
climate which could accept the products of mass production as popular art, the status
of photojournalism and of the men and women who produced it reached unprec-
edented heights. Several specific elements of this photojournalism continue to be seen
as meriting the institutionalized culture's stamp of value: the formal structural proper-
ties of the ideal photo essay; the determination of the single photograph as an ideal-
ized moment – fetishized as 'the decisive moment' either alone or at the centre of the
essay; and the reconstruction of the photojournalist as artist.[8]

The elevation of photography's status continued to exclude the tabloid press. The
ideology of cultural value which had shifted to admit photojournalistic documents into
museum collections, gallery exhibitions and finely produced books has persisted in
treating tabloid press photography as 'low' culture. This meant, with few exceptions,
not considering it at all.[9] The vacuum which has persisted around the tabloid press
would be reason enough to examine its photojournalism. This is, after all, the daily
press where photography continues to play a major role.

The contemporary domain of the tabloid

Many very different kinds of newspapers are published in a tabloid format. The pres-
ent investigation, based on examples from the United States, England, Australia, Aus-
tria, Norway, Sweden and Denmark,[10] found wide variation in the degree to which
the different papers overlapped with news agendas of the elite press and, in the cases
of overlap, distinctly different ways of angling the news.[11] The few characteristics
these papers have in common include an almost exclusive reliance on news-stand
sales, a front page that seems to work like a poster in this context – dominated by a
photograph and headlines referring to a single story – and photographs occupying a
much larger proportion of the editorial content than one finds in other segments of
the daily press.

The particular 'look' often associated with the photography of the tabloid press –
where action and expression are awkwardly and garishly caught in the flat, raw light
of bare bulb flash – is relatively uncommon. Far more frequently, one encounters
photographs of people posed in conventional ways, looking directly into the camera.

Celebrities, including entertainers and sports figures, in addition to the pose, are often portrayed performing. Occasionally famous people are also 'revealed' by the camera, drawing on a set of stylistic features that have long been thought to typify tabloid photojournalism. Coverage of political events, that category of coverage which overlaps most with news in the elite press, is constructed using photographs following each of these forms. But this is also where one is more likely to see photographs that exhibit the traditional look of the tabloid press.

These three broad and occasionally overlapping categories of coverage – of private or previously non-famous persons in circumstances that make them news-worthy, of celebrities, and of events that correspond to conventional constructions of news – provide a framework for analysing this photography in terms of its style, communicative value and its political implications.

Plain pictures of ordinary people

Most photographs in the tabloid press are in fact very plain. They present people who appear quite ordinary, usually in their everyday surroundings: a family sitting around a kitchen table or on their living room sofa, couples and friends embracing, children with their pets. Sometimes the people in the photographs are holding objects that appear slightly out of place, so that we see the objects as 'evidence': a woman hugging a child's toy, or presenting a photograph to the camera, for example. Sometimes the setting itself is the evidence behind the formal pose: a woman standing next to a grave, or a man sitting in the driver's seat of a taxi. Their faces often express strong emotion, easy to read as joy or sorrow. These are not people whom readers recognize as famous. One would not be likely to pay much attention to them in another context.

From the words we learn what has happened to them, why they are in the newspaper. 'Pals for years', the two happily embracing women never dreamed that they were sisters who had been separated at birth. The family sitting in their kitchen has just had their children's stomachs pumped for narcotics, amphetamine capsules the pre-schoolers had found on the playground. The woman with the child's toy continues to hope her kidnapped son will be returned safely. The little girl hugging her chimpanzee has donated one of her kidneys to save the pet's life. The middle-aged woman lounging on her sofa in a tight-fitting outfit is upset after losing a job-discrimination suit; despite her sex-change operation, employers have refused to accept that she is a woman.

Sometimes they are people whose lives have been directly affected by major national or international events. Rising interest rates are forcing the family to sell their 'dream house'. A man holds the framed photograph of his daughter and grandchildren who have been held hostage in Iraq for two months.

If one can temporarily disregard the impact of the text on the meanings we construct for these pictures (the impossibility of doing so in practice will be returned to at a later point), they almost resemble ordinary family photographs. Many of the settings and postures are recognizable from that familiar genre. The photographs are also characterized by their frontality, a tendency toward bi-lateral symmetry, and the fact that people are looking directly into the camera. The pictures do not mimic precisely the forms found in family photograph collections: the attention to and control over

light and framing give them a more professional look, while the private or informal settings distinguish them from formal portraits with their typical blank backgrounds.

Yet the particular ways that these press photographs resonate with other forms of photography that are private and familiar, make the people in them accessible to viewers. The straightforward frontality of the photographs and, in particular, the level eye-contact between the person pictured and the person looking at the picture establishes them as equals, or at least as comprehensible to each other. The people photographed do not appear to have been manipulated into those postures and settings. Instead the form suggests that the act of making the photograph was cooperative. They seem aware of the way they are being presented, even to have chosen it themselves. It is their story that is being told. And they are not so different from us.

There are two other patterns for presenting photographs of non-famous people in the tabloids, which although less common, are significant. The first is the use of the official identification, or 'i.d.' portrait. Although this is also a frontal photograph with the subject frequently in eye-contact with the camera, it carries none of the connotations of the family photograph. Instead, the tight facial framing and the institutional uses of this form immediately link it to a tragic and usually criminal act.

The second exception appears spontaneous, often candid, and usually portrays action, an event that is underway. Such photographs are part of the tabloids' coverage of news events and usually include ordinary people who have become actors in those events. They are, therefore, considered in the analysis of the tabloids' photographic treatment of conventional news later in this chapter.

Celebrities

Of the several ways that famous people appear in the tabloid press, the plain photograph of the person posing at home is probably the most common. Sports figures, entertainers and, occasionally, politicians are photographed 'behind the scenes' of their public lives, together with family and loved ones. These pictures, arranged in the same manner that characterizes the pictures of non-famous people, lack only the emotional extremes to be read from the celebrities' faces; these people all appear relaxed and happy. The obviously domestic environments naturalize the stars. The photographs suggest we are seeing them as they 'really' are. At the same time, through angle and eye-contact with the camera, they are brought down to the viewer's level. The photographic construction which presents the private person as someone 'just like us' accomplishes the same task when framing the public figure.

The difference between how these two kinds of domestic pictures work assumes that the viewer can recognize this person as famous. It is not necessary for the viewer to be able to identify the person, only that this recognition takes place. Once it has, however, the home photograph does more than present the person as the viewer's equal, someone 'just like us'. In addition, it has become *revealing*. Recognizing the person's celebrity status establishes the photograph as a privileged look behind the façade of public life.

Performance photographs are also quite common, often published next to the behind-the-scenes photograph of the celebrity at home. The picture of the singer or rock star performing is often a file photograph, and the particular performance is

rarely identified. The sports figure's performance, on the other hand, is presented in a recent action photograph usually from the game or competition which provides the reason for coverage.[12] These photographs present the recognizable and familiar public face of the celebrity.

File photographs of celebrities' performances occasionally accompany stories about scandals surrounding them. When a star is arrested on gambling charges or is reportedly undergoing treatment for a drug problem, for example, the performance photograph introduces a discontinuity. The photograph contrasts the controlled public view the star has previously presented with the revelations of the present scandal.

Candid photographs which penetrate the celebrity's public façade form a distinct genre of the tabloid press. However, like the posed photograph at home, many photographs that *appear* candid must be seen as extensions of the institutional edifice constructed around the star.[13] The apparently spontaneous flash photograph of the rock musician leaving a 'gala' event with a new lover at his side, for example, may be a scoop for the photographer or a revelation for fans, but it cannot be read as a penetration of the star's public façade. He has agreed (and probably hoped) to be photographed in this public setting and, as with the photograph at home, we assume he has done all he can to control the picture that is the outcome.

Candid photographs of celebrities' unguarded moments, on the other hand, do appear in the tabloids, although with far less frequency than one is led to expect by the reputation of these newspapers. The *paparazzi*, the name Fellini gave to the celebrity-chasing photographers in his film *La Dolce Vita*, find a larger market for their work in the weekly popular press than in the daily tabloids (Freund 1980: 181). However, the death of a major film star brings *paparazzi* work into the tabloid press. And the film star whose son is on trial for murder or the sports star who was withdrawn from public life following a drug scandal are examples of celebrities the tabloids pursue for photographs.

The look of these photographs is awkward, overturning the classical rules of good composition. Objects intrude into the foreground or background, light is uneven and often garish, and even focus may be displaced or imprecise. The photographs freeze movement, thus creating strange physical and facial contortions. They appear to be the result of simply pointing the camera in the direction that might 'make a picture'.[14] This style of 'candid' photography is grounded, as Sekula (1984) argues, in 'the theory of the higher truth of the stolen image'. The moment when the celebrity's guard is penetrated 'is thought to manifest more of the "inner being" of the subject than is the calculated gestalt of immobilized gesture, expression, and stance' (Sekula 1984: 29). The higher truth revealed in the candid moment is a notion that is repeated and expanded in the tabloids' photographic coverage of news events.

The news event

'News' is defined and constructed in many different ways within tabloid newspapers, yet there is a core of nationally and internationally significant events that receive coverage across the spectrum of the tabloid daily press. In addition to the posed photographs of people whose lives have been touched by news events (discussed above), photographs are sometimes published from the time the event was taking place. These

are usually action photographs and appear candid, in the sense that people are acting as if unaware of the photographer's presence. It is incorrect to think of the events themselves as unplanned, for many are scheduled and the press has mapped out strategies for covering them. These strategies include obtaining spontaneous photographs of people at the moment they are experiencing events that are seen as momentous, even historic (Becker 1984).

Many of the photographs bear a strong similarity to the candid pictures of celebrities. Like those images, these undermine the institutionally accepted precepts of 'good' photography in their awkward composition, harsh contrasts and uncertain focus. Another similarity is that candid news photographs are structured to reveal how people react when the comfortable façade of daily life is torn away. Facing experiences of great joy or tragic loss, people expose themselves, and photographs of such moments are thought to reveal truths of human nature. Examples include photographs taken at the airport as freed political hostages are reunited with their families, or those of policemen weeping at a co-worker's funeral.

These candid photographs are typically treated as belonging to a higher order of truth than the arranged pose. Yet to rank them along some absolute hierarchy of documentary truth ignores the cultural practices we use to distinguish between nature and artifice. Examples of these practices within photojournalism include specific technical effects (artifice) that are integrated into the tabloids' construction of realism (or nature).

Extreme conditions, including darkness or bad weather, can reduce the technical quality of news photographs. So can surveillance-like techniques, such as using a powerful telephoto lens to photograph from a distance, or using a still picture from a security video camera to portray a bank robbery. Technical 'flaws' like extreme graininess and underexposure have actually become conventions of the tabloids' style, visually stating the technical compromises the newspaper will accept in its commitment to presenting the 'real' story. The techniques work to enhance the appearance of candour, lending additional support to the construction of these photographs as authentic.

Many of the tabloids have a legacy of active crime reporting, and this style suggests a continuation of that tradition.[15] In contemporary tabloids, however, suspected and convicted criminals are not as common as are the faces and testimony of ordinary people caught in traumatic circumstances not of their own making. Photographs of political leaders are likely to be small portraits and file photographs, while the common people acting in the event receive the more prominent visual coverage. This is particularly marked when a photographer has been sent to cover foreign news.

Political turmoil and natural disasters are reasons for sending photographer-reporter teams on foreign assignments. Earthquakes and famine, elections threatened by violence, the redrawing of national and international borders, popular resistance movements and their repression attract major coverage. The coverage may include photographs of local officials, but the emphasis is on ordinary people, particularly children, who are affected by the events. The photographs establish their perspective, portraying their actions and reactions in the candid style typical of tabloid news photography. Yet the words often transform the style of the coverage into a first-person account, relocating the photographer as the subject of the story. Here again,

we encounter the impossibility of seeing the photographs independently from the ways they are framed by the text.

Reframing the picture in words and layout

Photographs attain meaning only in relation to the settings in which they are encountered. These settings include, as this investigation hopefully has demonstrated, the historically constructed discourses in which specific topics and styles of photography are linked to particular tasks or patterns of practice (Sekula 1984: 3–5). The photograph's setting also includes the concrete, specific place it appears in and how it is presented. In the newspaper, photographs have no meaning independent of their relationship to the words, graphic elements and other factors in the display which surround and penetrate them. It is these elements which are, to borrow Stuart Hall's phrase, 'crucial in "closing" the ideological theme and message' of the photograph (Hall 1973: 185).

In general, the text which frames photographs in the tabloid press is far more dramatic than the photographs alone. Even a cursory analysis indicates that it is the words, in particular the headlines, which carry the tone of 'sensationalism'. 'Thirteen-year-old chopped up watchman' is the headline over a photograph of the victim's widow, posing with his photograph. 'Devil's body guard' are the words next to a photograph of two masked men standing beside a coffin draped with the IRA flag. Over a dark colour photograph of an oil platform, we read 'Capsized – 49 jumped into the sea last night'. The text is large in relation to the page size, generally in unadorned typefaces. Punctuation consists of exclamation points and quotation marks, enhancing both the drama and the authenticity of the words: 'It feels like I'm dying little by little' is inserted into one of the last pictures of the aged film star [Greta Garbo]. Often headlines are short, as for example, the single word 'Convicted!' over the police photograph of the man found guilty of murdering the prime minister.

The relationship between text and the official i.d. photograph is relatively simple to unwind. The explicit purpose of this tightly framed, frontal portrait with its frozen expression is to identify its subject in the most neutral way possible. Through its instrumental service to institutional needs, it has acquired a primary association with law enforcement and police investigations. Any time a photograph in this form is linked with news, it now connotes criminal activity, tragedy and death. The words published with the photograph serve to strengthen those connotations by repeating the associations awakened by the photograph alone and adding details that anchor the photograph's meaning in a specific event.

The relationship between text and the photographs most prevalent in the tabloids – of ordinary people posed in domestic settings – is more complex. Typically the text contradicts the 'ordinary' appearance of these subjects; they are not what they seem. The words tell us that their lives have been struck by tragedy, confusion, some unexpected joy, or else that they are deviant, carrying some secret which is not evident on the surface. The disjunction between photograph and text is greatest for photographs that present no 'evidence' that something is out of place, and instead mimic the private family portrait without interrupting its connotations of familiar security.

In these cases the text seems to carry the greater authority; it tells us what we are 'really' seeing in the photographs. The text here *illustrates* the image, instead of vice

versa, as Barthes has pointed out, by 'burdening it with a culture, a moral, an imagination'. Whereas in the case of the i.d. photograph the text was 'simply amplifying a set of connotations already given in the photograph', here the text *inverts* the connotations, by retroactively projecting its meanings into the photograph (Barthes 1977: 26–27). The result is a new denotation; we actually locate evidence in the photograph of what lies behind the formal pose. From the photograph and the apparently contradictory text together, we have constructed a deeper 'truth'.

Candid photographs, whether of celebrities or of events conventionally defined as news, offer a third case, for their look of candour depends on visual conventions that connote unreconstructed reality. Their subjects and the messages of the accompanying texts are too varied to reveal one specific pattern capable of explaining how they work together in the construction of meaning. In general, the stylistic features of the candid photograph appear to confer the text with greater authority.

When portions of the text are marked as direct quotations, a technique often used in the tabloids, additional nuances of meaning are constructed. If the quoted text is offered as the words of the person in the photograph, it becomes a testimony of that individual's experience. The quotation bonds with the subject's 'inner being' that we see revealed in the candid photograph, enhancing the connotations of closeness and depth being produced individually within the photograph and text.

Occasionally the text also specifically constructs the tabloid's photographer. Accounts include how a certain subject was photographed, emphasizing the persistence and devotion the work required. The 45-year-old *paparrazo* who took the last photographs of Great Garbo, for ten years lived only for taking pictures of "the Goddess", and now plans to leave New York and find something else to do; 'My assignment is finished', he said.

The photographer becomes a major figure, the public's eye-witness, when the words establish the photographs as first-hand exclusive reports of major news events. The two journalists sent by their newspaper to Beijing in June 1989 found themselves 'in the middle of the blood bath' that took place in 'Death Square'. The tabloid's coverage included portraits of the reporter and photographer, first-person headlines often in the present tense, heightening the immediacy, and enclosed in quotation marks ('He dies as I take the picture'), several articles written in the first person and many candid photographs, taken at night, showing the violence and its young victims.

This style of coverage, while it underscores many of the news values of conventional journalism, at the same time contradicts the ideal role of the journalist as one standing apart from the events being reported. Here the photographer is constructed as a subject, an actor in the events. The valorization of the photographer, a common theme in the wider discourse of photojournalism, enters a specific news story. This further heightens the authority of the coverage as an unmediated account: we are seeing events as they happened in front of the subject's eyes, as if we were present.

These specific techniques, the first-person text together with the harsh, high contrast candid photographs, further work to establish this as a sensational story. The events were so unusual that the journalists' conventional rules of news coverage proved inadequate. Their professional role stripped from them by what they were seeing, they were forced to respond directly and immediately, as subjects. The coverage is constructed to bring us closer, through the journalists' subjective response, to the extraordinary nature of these events.

Again, one must remember that what we see in the tabloid is not the work of photographers. Despite the presence of bylines, the photographs bear little resemblance to the photographers' frames. Extreme sizes, both large and small, and shapes that deviate sharply from the originals' rectangular proportions are routine. Photographs are combined in many different ways, creating contrasts and sequences. Graphic elements are imposed over the photographs, including text, directional arrows and circles, or black bands over subjects' eyes. Montages and obvious retouching of photographs are not unusual.

Many of these techniques contradict the conventions for presenting photographs as representations of fact. According to the rules applied in other areas of photojournalism and documentary photography, the integrity of the rectangular frame is not to be violated.[16] With few exceptions (which are often discussed heatedly by photographers and editors), the frame is treated as a window looking out on an actual world. Changes in perspective should be limited to moving the borders in or out: any penetration of the frame is disallowed as a change in the way the frame 'naturally' presents reality.[17]

The tabloid press' consistent violation of these conventions confronts the persistent construction of the photograph as unmediated. Here we see the 'original' image repeatedly manipulated and altered with irreverent disregard for the standards that guide the elite press. At the same time that the text and photographs combine to support the revelation of deeper truths in the tabloid's coverage, the journalistic 'package' continually overturns the guidelines established to protect the notion of photographic truth.

Conclusions

Contemporary photojournalism has attained the status of popular art, outside the margins of the daily press. Yet those characteristics which have been used to increase photojournalism's cultural capital in other spheres we see confronted and even inverted in tabloid newspapers. Instead of cleanly edited photo essays, the tabloids are more likely to present heavily worked layouts of overlapping headlines, photographs and text. In place of the idealized grace of the 'decisive moment', the individual photograph is generally either a compositionally flat and ordinary pose or a haphazardly awkward candid shot. And instead of the photojournalist as respected artist successfully interweaving realism and self-expression, the photographers who occasionally emerge from the muddled pages of the tabloid are impulsive individuals, consumed by the events they were sent to photograph.

The dichotomies that are usually drawn to distinguish between the tabloid and elite segments of the press cannot accommodate this photography. In the tabloid press, photographs appear to both support and contradict the institutional standards of journalistic practice. The practices used to present major news events are at the same time serious and emotional. Topics that lie well outside the news agendas of the elite press are covered using strategies that conform to standard news routines. Tabloid photojournalism is framed in texts that work to establish the photograph as credible and authentic and simultaneously prevent it from being seen as a window on reality. Such apparent inconsistencies are contained within a journalistic discourse that is irreverent, antagonistic and specifically anti-elitist.

Sekula reminds us that 'the making of a human likeness on film is a political act' (Sekula 1984: 31), and publishing that likeness in a newspaper compounds the political implications. Within the journalistic discourse of the tabloid press, photography appears anti-authoritarian and populist. There are many ways in which its specific techniques construct photographers, the people in the photographs and the people who look at them all as subjects. These subjects are accessible and generally are presented as social equals. But it is difficult to locate a systemic critique in this work.

The critique that emerges from the tabloid press, and particularly its photography, is directed instead against the institutionalized standards and practices of elite journalism. In the pages of this press, we witness the deconstruction of both the seamless and transparent character of news and the ideal of an unbiased and uniform professionalism. The photographs within the discourse of tabloid journalism work simultaneously as vehicles for news and the means of its deconstruction.

Original publication

'Photojournalism and the Tabloid Press', *Journalism and Popular Culture* (1992)

Notes

1　This essay is a revised version of the paper, 'The simultaneous rise and fall of photojournalism, a case study of popular culture and the western press', presented at the seminar 'Journalism and Popular Culture', Dubrovnik, Yugoslavia, 7–11 May 1990.

2　*Illustrated London News* circulation rose from 60,000 the first year to 200,000 in 1855, the year the tax on printed matter was repealed (Hassner 1977: 157).

3　Johannesson has also identified competing syntaxes that apparently rendered reality somewhat differently. Whereas in the United States engravings began imitating the syntax of the photograph, in Europe the engraving followed the other visual arts (Johannesson 1982).

4　*Collier's* circulation doubled during 1898, the first year of Hare's employment, and by 1912 had reached one million (Hassner 1977: 224).

5　For several examples from the present investigation see note 11, below.

6　The *New York Times Sunday Magazine* is an outstanding example, frequently commissioning well-known photojournalists to cover specific topics.

7　Maren Stange offers a convincing analysis of the political and aesthetic adjustment that occurred within the Museum of Modern Art in New York as Edward Steichen launched the first major exhibitions in the documentary style, culminating in 1955 with the spectacular popularity of 'Family of Man' and its 'universalizing apolitical themes'. This major cultural institution, she argues, had 'installed documentary photography yet more firmly in the realm of popular entertainment and mass culture' (Stange 1989: 136).

8　The reader is referred to Becker (1990) for a full development of this point. For a discussion of the left-humanist art theory which provides the basis for the reconstruction of the photojournalist as artist, see Burgin (1986: 157).

9　Exceptions include the re-interpretation of a particular style of photojournalism – in which elements are 'caught' in the frame in strange relationships to each other, usually with the added effect of bare-bulb flash – as surrealist art. Photographer Arthur

('Weegee') Fellig's work is the best-known example of art institutional redefinition of this style (Sekula 1984: 30).

The Museum of Modern Art exhibition 'From the Picture Press' is another example of this tendency to 'surrealize' photojournalism. The exhibit consisted primarily of *New York Daily News* photographs selected with the help of photographer Diane Arbus (Szarkowski 1973). Henri Cartier-Bresson has long preferred to call his work 'surrealism' instead of 'photojournalism'.

10 I am grateful to Mattias Bergman and Joachim Boes, Peter Bruck, John Fiske, Jostein Gripsrud, John Langer, David Rowe, Herdis Skov and Colin Sparks for providing copies of many of the tabloids on which this analysis is based.

11 Some contrasts may be explained by national differences in newspaper consumption patterns: in England, tabloid press readership increased during the period when people began to confine their reading to one newspaper, whereas in Sweden the afternoon tabloids continue to be used as a complement to the morning broadsheet papers.

Differences in content also suggest cultural variation in the construction of the sensational. A striking ease is the conditions under which sex becomes an explicit topic, ranging from near-nude pin-ups as a regular feature in British and Danish papers, to unusual cases of sexual preference treated as news, to the virtual absence of sex in the most serious Australian tabloids. Another contrast is the extensive coverage the British and Australian papers devote to the 'private' lives of their royalty, whereas the Scandinavian papers only cover their royal families when one member is seriously ill, is presiding over some official occasion, or has become involved in a political debate. Explaining such differences, significant though they may be, remains beyond the scope of this chapter.

12 The sports action photograph in the tabloid press appears to correspond precisely to the same genre in the sports sections of elite newspapers. If true, this raises interesting issues about why sports photography in particular is found without modification in both classes of newspapers.

13 Here I have drawn on Alan Sekula's discussion of *paparazzi* photography, although my analysis and conclusions are somewhat different (Sekula 1984).

14 Weegee, one who is credited with creating the style, said of his photograph from an opening night at New York's Metropolitan Opera, that it was too dark to see, but 'I could *smell* the smugness so I aimed the camera and made the shot' (Time-Life 1983: 54).

15 The style was associated with a particular way of working by photographers who chased down tips from their police radios into places that were dark, crowded, confusing and where they were not wanted. Although the style is now considered outmoded, a guarded admiration survives for the photographers who still follow this work routine. I wish to thank Roland Gustafsson, who has conducted interviews among the staff of Stockholm's *Expressen,* for drawing this point to my attention.

16 This convention also constructs the photographer as the authority, the intermediary through which this view of reality is refracted.

17 See, for example, the textbook guidelines for creating a 'clean' picture layout in the style of the classic photo essays (Hurley and McDougall 1971; Edey 1978; Kobre 1980: 271–281).

References

Barthes, Roland (1977) 'The photographic message', in Stephen Heath (ed. and trans.) *Image, Music, Text*. New York: Farrar, Straus and Giroux. pp. 15–31.

Baynes, Kenneth (ed.) (1971) *Scoop Scandal and Strife: A Study of Photography in Newspapers*. London: Lund Humphries.

Becker, Karin E. (1984) 'Getting the moment: Newspaper photographers at work', paper presented at the American Folklore Society Annual Meeting, San Diego.

Becker, Karin E. (1985) 'Forming a profession: Ethical implications of photojournalistic practice on German picture magazines, 1926–1933', *Studies in Visual Communication* 11(2): 44–60.

Becker, Karin E. (1990) 'The simultaneous rise and fall of photojournalism: A case study of popular culture and the western press', paper presented at the seminar 'Journalism and Popular Culture', Dubrovnik.

Benjamin, Walter (1936) 'The work of art in the age of mechanical reproduction', in Hannah Arendt (ed.), *Illuminations*. New York: Schocken, 1969. pp. 217–252.

Burgin, Victor (1986) *The End of Art Theory: Criticism and Postmodernity*. London: Macmillan.

Carnes, Cecil (1940) *Jimmy Hare, News Photographer*. New York: Macmillan.

Cookman, Claude (1985) *A Voice Is Born*. Durham, NC: National Press Photographers Association.

Dyer, Carolyn Stewart and Hauserman, Nancy (1987) 'Electronic coverage of the courts: Exceptions to exposure', *The Georgetown Law Journal* 75(5): 1634–1700.

Edey, Maitland (1978) *Great Photographic Essays from Life*. New York: Little, Brown.

Edom, Clifton C. (1976) *Photojournalism: Principles and Practices*. Dubuque, IA: Wm. C. Brown.

Emery, Edwin (1962) *The Press and America: An Interpretive History of Journalism*, 2nd edn. Englewood Cliffs, NJ: Prentice-Hall.

Eskildsen, Ute (1978) 'Photography and the Neue Sachlichkeit movement', in David Mellor (ed.), *Germany: The New Photography, 1927–33*. London: Arts Council of Great Britain. pp. 101–112.

Freund, Gisèle (1980) *Photography and Society*. London: Gordon Fraser.

Gidal, Tim (1973) *Modern Photojournalism: Origin and Evolution, 1910–1933*. New York: Collier Books.

Hall, Stuart (1972) 'The social eye of the *Picture Post*', in *Working Papers in Cultural Studies 2*. Birmingham: CCCS.

Hall, Stuart (1973) 'The determinations of news photographs', in Stanley Cohen and Jock Young (eds.), *The Manufacture of News*. London: Constable. pp. 176–190.

Hård af Segerstad, Thomas (1974) 'Dagspressens bildbruk. En funktionsanalys av bildutbudet i svenska dagstidningar 1900–1970' (Photography in the daily press), Doctoral dissertation, Uppsala University.

Hassner, Rune (1977) *Bilder för miljoner* (Pictures for the millions). Stockholm: Rabén & Sjögren.

Hurley, Gerald D. and McDougall, Angus (1971) *Visual Impact in Print*. Chicago, IL: Visual Impact.

Johannesson, Lena (1982) *Xylografi och pressbild* (Wood-engraving and newspaper illustration). Stockholm: Nordiska museets Handlingar. p. 97.

Kahan, Robert Sidney (1968) 'The antecedents of American photojournalism', PhD dissertation, University of Wisconsin.

Kobre, Kenneth (1980) *Photojournalism: The Professionals' Approach*. Somerville, MA: Curtin & London.

Ohrn, Karin B. and Hardt, Hanno (1981) 'Camera reporters at work: The rise of the photo essay in Weimar Germany and the United States', paper presented at the Convention of the American Studies Association, Memphis, TN.

Schiller, Dan (1977) 'Realism, photography, and journalistic objectivity in 19th century America', *Studies in the Anthropology of Visual Communication* 4(2): 86–98.

Schuneman, R. Smith (1966) 'The photograph in print: An examination of New York daily newspapers. 1890–1937', PhD dissertation, University of Minnesota.

Sekula, Allan (1984) *Photography against the Grain*. Halifax: The Press of the Nova Scotia College of Art and Design.

Stange, Maren (1989) *Symbols of Ideal Life: Social Documentary Photography in America 1890–1950*. Cambridge: Cambridge University Press.

Szarkowski, John (ed.) (1973) *From the Picture Press*. New York: Museum of Modern Art.

Taft, Robert (1938) *Photography and the American Scene: A Social History, 1839–1889*. New York: Dover.

Time-Life (1983) *Photojournalism*, rev. edn. Alexandria, VA: Time-Life Books.

Carol Squiers

CLASS STRUGGLE
The invention of paparazzi photography and the death of Diana, Princess of Wales

It would appear that every proprietor and editor of every publication that has paid for intrusive and exploitative photographs of her, encouraging greedy and ruthless individuals to risk everything in pursuit of Diana's image, has blood on his hands today.

— Charles, Earl Spencer[1]

I

THE DEATH of Diana, Princess of Wales, in a Paris car crash in the summer of 1997 brought immediate and mostly negative attention to the publicity mechanisms and procedures of celebrity culture. Her fame had killed her, it seemed, and the process by which celebrities were elevated and then brought low would have to pay. Angry actors, journalists from the mainstream press, and ordinary citizens in the United States and abroad took turns — on television talk shows, in newspaper and magazine letters columns — demanding an end to the kind of media practices that seemingly drove Diana to her shocking end.

The overriding theme of the pandemonium was that tabloid culture was out of control and that even the quality news media had been infected and overrun by tabloid sensibility. The first to feel the heat were paparazzi photographers, the most despised members of the news photographers's profession. A posse of these motorized snap-shooters had been following Diana and her new paramour, Emad Mohamed (Dodi) Al-Fayed, the night of the crash. Based on their proximity to the crash and on their well-documented aggressiveness, the photographers were quickly convicted in the court of public opinion of responsibility for the accident, which claimed three lives.[2]

Much of what was said and written in the aftermath of the accident was based on the assumption that the concerns, methods, and subject matter of the tabloid press — and especially of its photographers — were relatively new developments. Until this

occurrence, tabloid photographers had gone relatively unexamined in any serious way.³ Certainly, in the days following Diana's accident, it became clear that there is no consensus even within the profession of journalism on the definition of paparazzi photography. It has been discussed as an illegitimate form of celebrity photography, a peripheral type of tabloid-press image-making that could easily be eliminated if only editors would stop printing it and the general public would stop buying the tabloids it is printed in. Even the paparazzi's defenders have been unable to make a convincing case for paparazzi photography's role as part of the star-making apparatus, with its dependence on both shielding and revealing secrets about stars, which has been in place since the 1920s.

The lack of clarity about paparazzi photography's position, status, and function is understandable. In the United States, until Diana's death, little attention had been devoted to it, except for isolated magazine articles and brief vignettes on individual photographers, usually produced by tabloid news shows; similarly, the French have mainly considered the activities of contemporary French paparazzi, with the British doing the same for British photographers, while the Italians have given attention to the original Italian paparazzi of the 1950s.⁴

This essay will look at the phenomenon of paparazzi photography to define what it is and how it relates to other types of photography such as photojournalism and documentary; show that a form of paparazzi photography emerged even before it began as an organized, albeit anarchic practice in Italy after World War II and then subsequently spread throughout Western news and entertainment media; examine its deployment in regard to its arguably most famous subject, Diana, Princess of Wales, and how it was thus used to reinforce the objectifying, voyeuristic position of women in representation while also staging an attack on the British monarchy as an institution.

II

Paparazzi photography occupies a seemingly unique position outside the bounds of polite photography, defined by its self-admitted characteristics of aggression and stealthiness, narrow range of subjects, and elastic formal definitions of what constitutes a "good" picture. Despite its singular reputation, it is not a singular visual discourse. Instead, it is a rough-edged hybrid that is patched together from the visual regimes and positivist assumptions that constitute four types of photography that are practiced and consumed as if they are distinct from one another: photojournalism; documentary; celebrity photography, which is itself a hybrid of editorial and promotional photography; and surveillance photography. The paparazzo brings these photographies together in a way that maximizes outrage and seems to blanket the entire medium in disgrace.

Richard Dyer observes that the construction of celebrity personas, however artificial they may be, is aimed at making fans believe that they can have access to the "truth" about the celebrities. "Stars are obviously a case of appearance – all we know of them is what we see and hear before us. Yet the entire media construction of stars encourages us to think in terms of 'really' – what is [Joan] Crawford really like."⁵ Paparazzi photography supplies that "really" better than anything else – seemingly incontrovertible visual documentation about the people it catches in compromising or embarrassing

positions. And it does it in a timely fashion such that the photographs operate as news photographs, contributing visual vignettes of the small events and appearances that the tabloid press thrives on and that mimic documentary photography.

But paparazzi is a long way from the typical notions of documentary or news photography. It is generally disowned by practitioners of documentary photography, along with photojournalism and celebrity photography, because it does not share elements usually considered essential to each of them; in the case of surveillance photography, its practitioners usually defend its instrumental function rather than its expressive capabilities. This listing of caveats and negatives gives a clue to how paparazzi photography works, which is through a series of inversions, an upending of categories, subjects, definitions, and expectations.

Most obviously, it overturns the usual context and subjects of photojournalism and documentary photography, focusing the camera away from the battlefield of war's wounded and society's rejected to the theater of celebrity, wealth, and privilege. In the typical arena of photojournalism, the most terrible aspects of political upheaval, intergroup violence, and human want are graphically portrayed on the human body, creating tableaux of profound abjection. The emaciated figures of famine victims, the dazed visages and contorted bodies of the wounded and the dead in the midst of civil war, the griefstricken postures of those who bury the casualties are familiar sights in the catalog of human misery chronicled by photojournalism. The dire circumstances of the people pictured are generally considered sufficient reason for the photojournalist to record their plight, although the images will be reproduced only in publications which deem the victims worthy of attention.[6] In picturing the absolute vulnerability of civilian populations to all types of civil disorder, photojournalism helps create disparate visions of abjection, which variously pities, condemns, and dignifies its subjects.

The paparazzo's search for the effects of illicit assignations, exhibitionism, reputation degradation, and financial plenty on well-known individuals also ends in graphic but very different images of the human body. If the recorded figures are emaciated, that is liable to be the result of the self-imposed starvation of anorexia or bulimia rather than the politically and economically induced starvation that famine usually is today. Other self-perpetuated alterations of the body's contours that are subjects for the paparazzi are the distended stomach produced by overeating or the aftereffects of a face lift or breast implant surgery. Uncontrollable bodily ravages, of illness and old age, are also typical paparazzo subjects. More likely, the observed bodies will be well fed, well exercised, and well rested. Rather than dire circumstances, these bodies will usually be found in the most luxurious of situations. While photojournalism wants to create visions of dignified abjection, paparazzi photography records the abjection of the dignified, reducing them to objects of ridicule and mocking laughter.

Indeed, the players and the context within which they are located marks a major difference between most conventional documentary and paparazzi photography. Like photojournalism does, documentary photography has largely focused on those who are vulnerable: the impoverished, the homeless, the damaged, the victimized. The documentarian, rather than looking at the immediate results of a shocking newsworthy event, instead attends to the ongoing, long-term situations of human degradation and despair in terms of conditions such as worker exploitation, brutalizing living conditions, family violence. Traditionally, these kind of photographs have had either an implicit or explicit agenda about correcting the conditions they illuminate.

In contrast, the paparazzo focuses on those who are least vulnerable, in terms of their access to money and power: film and television stars, European royalty, pop singers, politicians. Their day-to-day living situations will be difficult to photograph, as they can usually secure their privacy when they are at home or on the set of a movie or television show.[7] So the paparazzi create their own space for documenting specific, very limited aspects of stars' lives. They are easiest to photograph when they travel and their vacations are usually taken in luxurious and exotic locales which change with the seasons and the fashions. Conversely, they are also photographed on busy city streets, restaurants, stores, and markets, where the celebrity can be seen to be engaged in everyday activities. Some famous subjects are of interest when he or she is alone, although celebrity love relationships are a major topic for the tabloid press.

Edward Herman and Noam Chomsky, in their discussion of the way news reportage functions as propaganda, proposed that people who receive the most extensive news coverage, particularly after a violent political event in countries outside the United States, do so because they are considered "worthy victims," that is, people who have been harmed by those hostile to the interests of the United States. In contrast, "unworthy victims" receive little, if any, news coverage when they suffer grave injury and death because they have been injured by friends of the United States, or they themselves are defined as enemies of U.S. interests.[8]

In terms of photographic coverage, however, the opposite is often true. "Worthy victims," such as those killed and injured in a bombing in a country friendly to the United States, are often treated with greater respect by news organizations, who don't show explicit images of their injuries. The same is true of domestic stories: during the financial-industry scandals on insider trading of the 1980s, for example, none of the Wall Street financiers were photographed as they were being arrested.[9] The so-called "perp walk," the small event staged for the news media when a suspect is transferred from a courthouse or jail to a police vehicle, is a humiliating display generally reserved for young, male Hispanics or African Americans. In the case of Diana's death, it is the perception of her as a worthy victim that produced the outcry when it was claimed that some photographers had photographed her in the wreckage of the car. The theory of the worthy victim is another marker that is inverted by paparazzi photography: the worthy victim, who would usually be protected from the camera's intrusion, is instead its primary subject.

Just as an inversion of subject and context takes place between photojournalism, documentary, and paparazzi, an inversion of photographic style takes place in paparazzi photography in comparison to posed celebrity portraiture. In the posed images taken for both editorial and advertising venues, a high value is placed on the star's ability to control and manipulate every aspect of the image – lighting, makeup, costume, hairstyle, facial expression, posture, and gesture. Big stars usually demand and receive blanket control over who takes the pictures, how they will be constructed, where in a publication they will be used, and which images will be reproduced.

In paparazzi images, the star as a subject is the only point of continuity with posed imagery. Other than that, the entire constellation of control and manipulation is rendered inoperative. The lighting in paparazzi photos is haphazard, professionally executed makeup and hairstyle are usually absent, costume is casual and often ill-kempt and ill-advised. Posture and facial expression will be the unthinking result of walking down a street or laying on a beach, rather than the conscious effort of looking

relatable?

one's best while gazing into the lens of a camera. Rather than molding a celebrity as a uniquely magical creature the way posed pictures do, paparazzi images show celebrities as more mundane figures who sometimes inhabit the same space (a city sidewalk, a parking lot), perform similar tasks (shopping, jogging), and wear the same clothing (blue jeans, sloppy sweaters) that the noncelebrity does.

The difference between what is "special" and what is "ordinary" is a major factor in comparing paparazzi and surveillance photography as well. Paparazzi is a focused kind of surveillance, as opposed to the usually unmanned, ubiquitous surveillance of much camera-based surveillance. For the average person, surveillance of all types is a fact of life, whether in public or in the workplace, although the surveillance is usually covert. People are routinely photographed as they shop, bank, drive their cars, and sit at their desks.[10] A wide spectrum of government authorities and employees of private businesses have the wherewithal to conduct surveillance, including security guards, police officers, store clerks, and IRS agents.

While the celebrity may be prey to much of this surveillance, his or her workplace monitoring is of a different order than what the average person is subjected to. The celebrity's shorter, more varied, and more concentrated work schedule – the three months it may take to make a movie in Paris, say – stands in stark contrast to the monotony of a ten-year stint as a payroll clerk at a paper factory somewhere in Tennessee, and whatever surveillance is in place there.

Celebrity members of the British royal family, however, are subjected to several layers of surveillance. They are watched by the upper-class palace courtiers – "a quaint sort of private hereditary civil service" – who have a historical, social, and financial stake in maintaining the privileges and monitoring the behavior of the royals.[11] These strangely powerful "men in grey" visited continuous rebukes to the Princess of Wales for the slightest infraction of their unwritten rules. "Diana's enemies within are the courtiers who watch and judge her every move," writes Andrew Morton. "If Diana is the current star of the Windsor roadshow then senior courtiers are the producers who hover in the background waiting to criticize her every slip."[12]

Equally as devious and potentially more harmful for Diana (and other errant royals) was the monitoring done by MI5, the domestic branch of British intelligence, with both cameras and eavesdropping equipment. At Highgrove and Kensington Palace, for instance, "spy cameras" were in place to watch Diana's every move. "When she goes for a walk in the fields surrounding Highgrove the unblinking eye of a camera swivels and tracks her while the two policemen who constantly patrol the grounds discreetly alter their perambulations so that they have her constantly in their sight."[13] At all the royal residences, phone calls that pass through the switchboard are monitored and recorded around the clock. The famed Squidgygate conversation of Diana and James Gilbey, which was picked up and publicized by an amateur radio enthusiast, was actually taped several years earlier and rebroadcast, allegedly by MI5, with the aim of having it "intercepted" by an amateur.[14]

But any newsworthy celebrity is also watched by several tiers of tipsters, both paid and unpaid, who work for celebrities or in the vicinity of them. They report to gossip columnists, tabloid reporters, and paparazzi photographers, who operate on behalf of tabloid newspapers and television programs as well as more mainstream media outlets, who in turn fashion themselves as acting on behalf of the public's right to know or the public's endless fascination with celebrity. If a picture of an

inaccessible event of intense popular interest is needed, a tipster will be enlisted to take it; it was a relative of Elvis Presley's who took the picture of him in his casket at his funeral.[15]

That unwieldy and infinitely flexible entity known as "the public" is in theory the arbiter and patron of the photographic celebrity surveillance that has come under such attack in the wake of Diana's death. In recognition of that fact, individual citizens performed various symbolic acts disavowing and/or repenting their roles as consumers of tabloid media. These included publicly burning tabloids and setting up sites on the Internet calling for individuals to take vows not to purchase tabloids.[16]

But it is "the public," the great mass of generally powerless citizens, that is usually the subject of surveillance. The paparazzo stages an inversion of that relationship in that the public, by proxy, becomes the motive force behind the paparazzo's surveillance of those who are used to possessing and wielding the kind of power that usually puts surveillance in place. The celebrity takes the position that is typically occupied by powerless "victims" in photojournalism or documentary, with the paparazzi image constructing an empowered gaze for the usually powerless public. For someone like Diana, who was subjected to so much surveillance within the boundaries of her at-home life, the additional surveillance by the photographers proved intolerable.[17] It is the surveillance aspect of paparazzi activity that celebrities react against the most violently, the sensation that they are being watched, followed, and photographed without their consent, that their most private moments or insignificant but embarrassing incidents are being caught on film for general consumption as part of the escalating traffic in pictorial sensationalism.

III

Commentators have noted the intrusive, prying capacity of photography virtually since the camera's public introduction. "A man cannot make a proposal or a lady decline one . . . a gardener cannot elope with an heiress, or a reverend bishop commit an indiscretion, but straightway, an officious daguerreotype will proclaim the whole affair to the world," wrote one editor in 1846.[18] The fact that the daguerreotype was too slow and its apparatus too cumbersome to accomplish either of those things mattered little; the editor correctly foresaw the camera's eventual use as an instrument that could capture one's most intimate and fleeting moments, although that development would not occur for almost forty years. When it did, ordinary people found themselves subjected to intrusions similar to what celebrities would later experience, a point to which we will soon return.[19]

There are certain isolated images that, in their casual insolence, could be said to prefigure the development of the paparazzi style. One photographer who made such images was an Italian count named Giusseppe Napoleone Primoli, a descendent of Napoleon I. Between about 1888 and 1905, he made thousands of images of every strata of Italian life, from sleeping bums and street vendors to the king, Umberto I. His well-born or talented friends, in both France and Italy, were also his subjects. Among them was Edgar Degas, who was captured by Primoli in a classic paparazzi-worthy venue – both insignificant and embarrassing – seemingly buttoning his fly as he steps out of a Parisian pissoir in 1889.[20]

Perhaps Primoli's images inspired another Italian, Adolfo Porry-Pastorel, who was working as early as 1912, to photograph a variety of local news subjects. According to historian Italo Zannier, Pastorel "took action photographs that looked for the curious, the unusual, the unrepeatable, and even the scandalous . . . " He also owned the Veda photo agency, which trained and represented photographers who later became known as paparazzi, including Sergio Spinelli and Tazio Secchiaroli.[21]

The photos he took and the ones he sold in his agency would not have been possible without the lighter, hand-held cameras that were introduced in the 1880s. Their relative flexibility allowed photographers to catch people in unflattering or compromising positions, inspiring much overheated debate. "The layman feared and hated the amateur with his ubiquitous camera," writes Bill Jay, "and the snapshooters ignored the restraints of common decency and good manners. The problem rapidly reached such proportion that, for the first time, the act of taking – or not taking – a picture was less an aesthetic consideration and more a moral or ethical one."[22] Photographers were referred to as "fiends" and "lunatics."[23] The *New York Times*, with an 1884 story entitled "The Camera Epidemic," proclaimed that snapshooting had become a "national scourge."[24] The outrage aroused by amateur photographers among editorial writers, judges, and legislators helped inspire a legal recognition of the right of privacy in New York.[25]

The growing community of amateurs was hardly dissuaded by irate citizens, who were aroused by stories about blackmail cases involving snapshots, with curates and prominent citizens being the favored targets of such schemes.[26] Actresses were always of interest to photographers, even when seen in less than ideal circumstances. "We must especially regret that Mdme. Sarah Bernhardt was not photographed the other day as she fell down the flight of stairs at a theatre!" wrote one writer in *The Amateur Photographer* in 1885.[27] Clearly, the desire to make the types of images that came to be known as paparazzi photographs – in all their embarrassing, trivial, and indecorous detail – began long before enterprising Italian photographers colonized the genre in the postwar era.

Those photographers are the ones Federico Fellini used as the model for his famed character, Paparazzo, the annoying news photographer who raced around Rome chasing celebrities along with the jaded gossip columnist played by Marcello Mastroianni in *La Dolce Vita* (1959). Once the film came out, the photographers – who up until then had been aptly called "assault photographers" – were thereafter known as "paparazzi," a relentless bunch who stalked the many movie stars and other celebrities who poured into Italy in the postwar years. (The origin of the name Paparazzo has never been conclusively established. Zannier says that Fellini knew a Calabrian hotel owner with the name Paparazzo.[28] Hollis Alpert quotes the writer Ennio Flaiano, whom Fellini worked with for many years, to the effect that Flaiano himself found the name in "an obscure Italian libretto."[29] Fellini wrote that he had had a friend at school called Paparazzo, who spoke very quickly and did strange imitations of insects, especially mosquitos, with his mouth.[30] Fellini has also claimed that the word was onomatopoeic, taken from a Sicilian word for an oversized mosquito, *papataceo*.[31]) Photography may have been considered intrusive in the past, but these men were the ones who formalized purposeful, strategic intrusiveness – as opposed to accidental, casual, or thoughtless intrusiveness – as a primary operating methodology. The techniques of today's paparazzi have gotten more sophisticated and

combative, but there is little that is done today that was not pioneered on Rome's dark streets.

How and why that came to be is a story of war and recovery, of social and economic transformation. It includes the changing and contested place of women in traditional Italian society, the invasion of Hollywood celebrities and other members of the international jet set into the conservative, essentially provincial city of Rome, and the reaction of Italian journalism to these changes and to increased press freedoms in the wake of fascism's collapse. The story forms a necessary backdrop to understand the construction of paparazzi photography today, albeit one that must here be radically condensed.

There is no specific point at which paparazzi photography can be said to have begun. Its defining moment occurred in Rome in the late evening and the early morning of August 14 and 15, 1958, during the Ferragosto or Feast of the Assumption holidays.[32] During that time, photographers sought to catch a variety of newsworthy celebrity subjects in compromising situations. In the process, some photographers were themselves attacked and those incidents were then immortalized in images.

Among their subjects was Farouk, the exiled former king of Egypt, who confronted Tazio Secchiaroli after he took pictures of him at a café with two young female companions — one of whom was either a singer or a prostitute — and neither of whom was his wife; he tried to break Secchiaroli's camera and take his film while another paparazzo, Umberto Guidotti, snapped a hazy shot of the scene. The same evening Secchiaroli photographed the actors Ava Gardner and Tony Franciosa kissing in Bricktop's café on the Via Veneto, while Franciosa was still married to Shelley Winters. Lastly, Secchiaroli took a sequence of images of actors Anita Ekberg and Anthony Steel arguing and staggering down a street, after which Steel also attacked Tazio and other pursuing photographers.

Irate, cheating on their spouses, and in some cases knock-kneed drunk, the celebrities played out for the photographers everything the American gossip-mongering press had been saying about them since the 1920s. The privileged lovers of nightlife exhibited with abandon the bad tempers, surfeit of alcoholic consumption, and generally excessive behavior the gossip columnists had long reported.[33]

They had been saying it only in words, however. In the United States, photographers still cooperated with celebrities in constructing idealized or at least flattering images. The photographers who covered the film industry had a vested interest in having continued access to the stars who were their main subjects, as did the magazines that ran the images. Photographers like Phil Stern, Nat Dallinger, Sid Avery, and Bob Willoughby shot candid but respectfully sympathetic images for mainstream magazines such as *Life* as well as the fan and movie magazines. In the 1950s, if *Photoplay* or *Modern Screen* ran stories or images the studios objected to, the studios would withdraw advertising.[34] The paparazzi had no such investment in maintaining good relations with the ever-changing cast of transient leading men and aspiring starlets — many from the United States — who paraded before their cameras. And scandalous images sold for ten or twenty times the amount ordinary ones did. According to Secchiaroli, an image of an American actor alone would bring him the equivalent of about U.S. $3. But a picture of the actor socializing with a pretty escort — which he asked Secchiaroli not to take — was worth about $50.[35]

In addition to the antic quality of the depictions, another noteworthy aspect of the paparazzi was that the photographers began to share the stage with the celebrities; their belligerent confrontations would enhance the price of the image as well as bringing the photographers themselves a kind of celebrity. They would even work in teams, one photographer to provoke the celebrity and one to take the resulting imbroglio.[36] One of the first sets of images by the Italian paparazzi printed in *Life* magazine was Marcello Geppetti's series of Anita Ekberg threatening photographers with a bow and arrow and then physically tussling with one.[37] The worldwide publication of such images established this seemingly new and aggressively reckless type of press photography.

Some of the original paparazzi identify their reason for taking these pictures as being primarily financial. This stands to reason, as most came from very modest backgrounds. But the fact that Italian newspapers and magazines so readily printed these impolite and unflattering photographs indicates that the images illustrated something beyond their nominal subject matter: that the very form of the images – their awkwardness, their compositional and behavioral roughness, and the often explosive emotions and embarrassing situations shown in them – served as social expression as well as celebrity news.

Accordingly, most gossip theory has been developed by social anthropologists, sociologists, and psychologists looking at verbal forms of gossip within specific communities. Amongst its several uses, interpersonal gossip serves to establish and reinforce the normative standards of the community by commenting on those who depart from perceived norms. Photographs are used in the same way; in the case of those taken by the Italian paparazzi, they examine and ridicule the objectionable components of people from the privileged classes, many of them from other countries. Among other things, they are a visual form of protest against, and hostility to, the outsiders from Hollywood and elsewhere who came to make movies on the cheap in Italy – especially the modern postwar actresses in low-cut dresses who boldly paraded on Rome's provincial streets – the loose social and sexual mores they brought with them, and the continuing prominence of American culture abroad. The photographs served to negotiate – and to resist – social change during the years of reconstruction and modernization in postwar Italy.

Among the most important of the social issues being fought over was the position of women in Italian society, which had been contested since the end of World War I. The fascist philosophers and social scientists who were prominent during Benito Mussolini's rule delineated the definition of the modern Italian woman between the wars.

According to Victoria De Grazia, beginning in the 1920s, the fascist government saw the changing roles of women in modern society as a series of problems that affected social norms. Concern over the "sexual danger" for women posed by new freedoms was shared during this period by both the Roman Catholic Church and various fascist philosophers and social technicians. Modern fashion was one point that vividly illustrated those dangers in some quarters. Organizations such as the fascist National Committee for Cleaning Up Fashion, along with the church, inveighed against the "scandalous" quality of modern women's dress, and issued stern warnings to women about the consequences of violating their prescribed standards. "By the late 1920s major Italian churches had posted signs barring 'immodest' dress."[38] In 1929, the fascist ideologue Paolo Ardali denigrated the modern woman for a variety

of perceived shortcomings, among them the power of fashion to "enslave" her, which "seems almost like the diabolical power of evil itself."[39]

Italian women were subjected to other proscriptions beyond those aimed at the cut of their clothes. Among them was the use of public space, and especially the café, which was an all-male preserve. Young women who sauntered by the café in the evening might be seen as flaunting their new and still highly contested freedoms; at the same time they would be the subject of appreciative voyeurism by the male habitués. But it would be improper for a woman to actually sit down with male friends at a café.[40] For a woman to appear in public at all was problematic, according to fascist writer Ferdinando Loffredo. Thus, women had to be dissuaded from working outside the home; he proposed that women who showed themselves in public spaces, on buses, streetcars, sidewalks, on their way to work be subjected to popular reproach.[41] "Between church and state, there was a consensus that women out alone, their company unmediated by authority, were a public danger."[42]

Mass culture, too, was seen as a problem in relation to women, especially in the form of the new pastimes of shopping and going to the movies. The cinema in general was identified with femaleness, and was deprecated as a result. One contemporary intellectual, Giovanni Papini, constructed the commercial culture of the cinema as whorish and venal, with the morals and esthetics of a streetwalker who appealed to vulnerable customers.[43] The cinema was female, and like much other commercial culture, was a threat from America. Hollywood's images "devirilized Italian men" and "debilitated" young couples.[44] "Not least of all, Americanized leisure threatened to transform Italian girls, making them masculine and independent like their American counterparts."[45]

Along with the specter of independent women, another threat for the fascists was an independent press. A former journalist himself, Mussolini believed that "newspapers were the key to success."[46] Strict regimentation of the press began in the early 1930s, when editors were forbidden to print news about "crime, financial or sexual scandals," all of which were social disturbances that might prove distracting and bring the morality of the regime into question.[47] Such subjects, of course, were the major components of a popular press, well established in the United States, that the news photographers who came to be known as paparazzi would pursue with a vengeance after the war.

Under Mussolini, however, photographers were censored; those who wanted to work had to acquire government accreditation and to know the limits on what they could photograph. Their brief was to produce images with "a very solemn or cerebral character," which would include photographs of Italy's major monuments or politically palatable photographs of fascist activities.[48] Great emphasis was placed on the cult of the Duce, including the ways in which he was to be photographed: as a statesman and warrior, as well as a man of the people, "gathering in the harvest, visiting schools."[49]

The components of Mussolini's image stressed his manly physicality as a visible proof of his powers as a head of state. He was the "first contemporary head of state to vaunt his sexuality: stripped to the waist to bring in the harvest or donning black shirt before Fiat workers, decked out as a pilot, boat commander, or virtuoso violinist, Duce was as vain as a matinee idol pandering to his female publics."[50]

Few matinee idols end strung up by their heels in a public square, as Mussolini was in 1945. His bloody repudiation notwithstanding, social relations elaborated during his regime outlasted its downfall. Among those that pertain here — and that seem to have fed the impulses that drove the paparazzi — are reactionary conceptions about the role

of women, the contested and gendered definition of public space, a suspicion of the cinema's seductions, and a deeply conflicted love-hate relationship to the United States.

Many of the fascists' theories about femaleness and its proper place were temporarily nullified during the difficult years of World War II, however. Women were pushed out of the home by the war, and placed in factory and government jobs to fill in for 1.63 million men who were gone. Women played prominent roles in the Italian resistance to the Germans that began in September 1943 after the alliance between Italy and the Allies had been struck. After the war was over, of course, women were expected to return to the home. There were plenty of official pronouncements about the role that postwar women should fulfill. In 1946, Pius XII delivered a discourse on women, in which he proclaimed that every woman was destined to be a mother and to stay home, and thus avoid the "dazzle of counterfeit luxury" that women who work outside the home experience and desire.[51] Within a few years, the church continued its promulgation of increasingly traditional views: "the woman must be subordinate to man, his intelligent and affectionate companion. And this subordination of the woman in home and church must be extended into civil life."[52]

The social pressure on women to return home was successful. By 1960 the number of women in the workforce had fallen significantly and was one of the lowest in Western Europe.[53] New women's magazines and television advertising encouraged urban women to spend money instead of earning it and exalted the "new figure of the modern Italian woman." Once married, and even after the children were grown, Italian women rarely returned to the workplace.[54] As Ginsborg puts it, "the idealized confinement of women to the home in the 1960s served to enclose them in a purely private dimension, and to remove them even more than previously from the political and public life of the nation."[55] This movement of women back into the home occurred during the years of the economic miracle, from 1958 to 1963, which were also the most active years of the paparazzi.

One big challenge to the conservative sexual and social mores of the traditional Italian was the cinema, and especially foreign cinema. The guardians of Italian culture could only look on with alarm as American movies aggressively moved into the Italian marketplace after the war. Because the film industry in the United States had been hurt by the loss of its European markets during the war, it was anxious to reestablish itself. "As Allied troops liberated Europe, American motion pictures followed in their path, with exhibition arranged by the Bureau of Psychological Warfare. The Office of War Information was handling the distribution of U.S. films in France, Belgium, the Netherlands, and Italy, until American companies could reopen their offices."[56] In the immediate postwar years, Italy was flooded with American films. Between 1945 and 1950, "the Italian market was virtually dominated by imports from America, which controlled between two thirds and three fourths" of it.[57]

During those same years, American producers suffered when the courts ruled that the studios had to divest themselves of their movie theaters, a major profit center.[58] This occurred just before television became a major competitor to film. Hollywood partially combatted television by producing movies with sexual content, which was out of the question for television, by using color and other technical gimmicks that television was not equipped for, and by reducing costs by going overseas, where labor prices in a country like Italy stayed severely depressed even during the economic miracle years.[59]

Before the war some Italian intellectuals saw the influence of American films on Italy as problematic. After the war they were confronted with the additional difficulty of hosting the many American films being made in their country. On the one hand, film production gave much-needed jobs to hungry Italians. On the other, the influx of Americans, including film personnel, tourists, and American stars, must have created substantial cultural friction.[60] There in the flesh were the independent, "masculine" American women the fascists had warned of – and that the Italians were still afraid of, as we shall later see – some of them in the person of starlet-wannabes and blondes in tight clothes.

The buxom, showy actresses and their male escorts were one of the paparazzi's major targets. While Italian women were being directed to go back into the home and to wear modest clothes, especially in public, American actresses flaunted themselves in revealing dresses on the streets of Rome. Jayne Mansfield, Ava Gardner, Linda Christian, and Elizabeth Taylor were among the best-known and most often-photographed of the American bombshells, along with the Swedish Anita Ekberg. But Ekberg's actual ethnicity meant little. She was perceived as an American-style sex bomb because she had begun her movie career in Hollywood and was crafted in the same mold as Marilyn Monroe and Jayne Mansfield. When Fellini tapped Ekberg for the role of Sylvia,

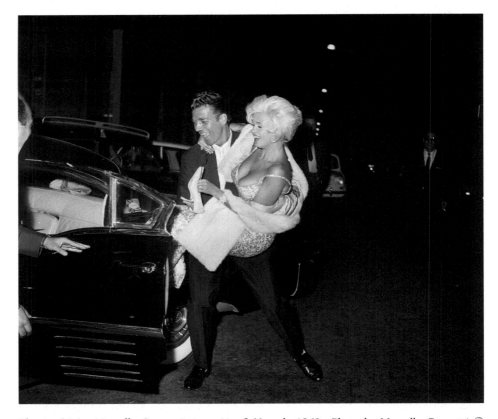

Figure 34.1 Marcello Geppetti, *Jayne Mansfield*, early 1960s. Photo by Marcello Geppetti © MGMC/dolceVita GALLERY.

Figure 34.2 Marcello Geppetti, *Anita Ekberg*, 1961. Photo by Marcello Geppetti © MGMC/dolceVita GALLERY.

the wanton film star, he predicated her on a "prototype" of this kind of woman that he had seen in an American magazine.[61] "In the film, Ekberg seems larger than life; she is the European stereotype of the hypertrophied American women, monumentalized."[62]

Ekberg was a prime target for the paparazzi: she was a prototypical sexual spectacle and she resisted them, rather than posing or staging run-ins the way Americans often did.[63] One classic series of paparazzi photos taken by Marcello Geppetti in 1960 shows Ekberg confronting paparazzi who had followed her to her Rome villa one night. Ekberg emerges from the villa in a rage, attired in her dinner dress and stocking feet and hoisting a formidable-looking bow and arrow. In the ensuing fracas, she grapples with photographer Felice Quinto, pulling his hair while kneeing him in the groin.

Although it was common for Italian men such as director Michelangelo Antonioni to fight with paparazzi, whether verbally or with his fists, few, if any, women did so. And especially not with the real weaponry and low blows proffered by this Americanized amazon. Ekberg managed to be a nightmarish vision of monstrous sexuality and masculinized behavior rolled into one, living proof of how (American) independence and wanton sex could destroy a woman's femininity.

Like many paparazzi shots, these images express criticism of Ekberg in the form of visual jokes. A number of scholars who have written about gossip – and paparazzi imagery is a visual form of gossip – draw parallels between joking and gossip. In her study on gossip as it is used in literature, Patricia Meyer Spacks uses Freud's ideas about joking to analyze the dynamics of the joke as it applies to gossip.

She notes that for Freud, aggressive content is a necessary element of the joke. She quotes him to the effect that jokes can be divided into two categories, "'innocent' and 'tendentious,' thus distinguishing those which constitute ends in themselves, serving no particular aim, from those filling a definable purpose. Two possible purposes emerge: a joke is either a *hostile* joke (serving the purpose of aggressiveness, satire, or defence) or an *obscene* joke (serving the purpose of exposure)."[64] Given that paparazzi images are taken for publication, it is apparent that they qualify more as tendentious jokes. But paparazzi images in fact collapse the categories: their purposes can be both hostile and obscene, they are variously aggressive and/or satirical, and aim particularly at the exposure of the celebrities who appear in them.

Spacks emphasizes that in order to satirize or expose effectively, the purveyor of the joke needs a hearer, just as the purveyor of a photograph needs a viewer. "This hearer plays an important part in the production of jokes," writes Spacks, who quotes Freud's contention that "no one can be content with having made a joke for himself alone."[65] Every joke demands a special "public," and "laughing at the same jokes is evidence of far-reaching psychical conformity."[66] Jokes, then, can serve as social regulation, targeting nonconformity in the interests of social cohesion.

And no one displayed greater nonconformity in the Italy of the 1950s than the outsized movie stars from other lands. When the magazine *Lo Specchio* ran the photographs of Anita Ekberg taking on the paparazzi, it paired one image of her aiming her bow with a film still of her in period Roman costume hurling a spear; the ersatz modern warrioress takes her cue from the filmic Amazon.[67] The humor in the images resulted not only from the actions being performed but from the way the bodies performing them looked: Ekberg, vacillating between physical adeptness and clumsiness, the photographers seemingly shocked into an addled passivity. In addition to the jokey absurdity of the images, they also delineate a comical physicality that would have been appreciated by an Italian audience accustomed to the physical expressionism of the traditional *commedia dell'arte*.

The *commedia* evolved as a form of popular entertainment in the Renaissance, when traveling companies of poor and usually illiterate players performed at fairs, markets, and city squares. "In the *commedia* . . . the bodies of the actors, their movements and behaviors, tell most of the story, along with verbal jokes noteworthy more for their color and rhythm than for their subtleties."[68] Some critics maintain that the entire tradition of Italian film has been influenced by the *commedia*, from the early twentieth-century dramas to the neorealist period and the more popular "comedy Italian style."[69] Angela Dalle Vacche notes that the neorealists had a particular interest in "the comedic impulse to magnify details of physiognomy and daily life."[70] Coming on the heels of neorealism, and taking some neorealist heroes as their victims/subjects, the paparazzi strove to look at the daily life of carousing celebrities, especially as it pertained to their romantic liaisons. The paparazzi hardly needed to "magnify" physiognomic details, as the celebrities did that themselves: all the photographer had to do was be watchful so as to catch the spilling cleavage, the

ungainly yawn, the drunken pratfall or ill-advised strut. But the paparazzi's provocations, which made celebrities lash out, get angry, flee from or chase the photographers, produced exaggerated reactions that created celebrities as comic visions.

Amusing in and of themselves, paparazzi images mirrored the difficult social adjustments necessitated in the postwar years, just as movies did when the tradition of the *commedia dell'arte* was transformed into the *commedia all'italiana*. "Flourishing at the height of what has been termed the 'Italian economic miracle,' the *commedia all'italiana* lays bare an undercurrent of social malaise and the painful contradictions of a culture in rapid transformation."[71]

At the same time that paparazzi were recording the physical excesses of celebrity, postwar Italian cinema was also busy creating a new ideal (body) image for the Italian woman that was untainted by frosty immobility of fascist prototypes. It was earthy, "rich with joyous sensuality, generous in its proportions, warm, and familiar."[72] The neorealists, all of whom had begun their careers in the fascist era, looked to popular theater and variety shows for their actors. "In these kinds of theatre, *total use of the body* is the instrument and form of communication, rather than interpretative, psychological, or dramatic refinements." In addition, the neorealists also looked for the ideal Italian actress, such as Sophia Loren, Gina Lollobrigida, and Silvana Mangano, at beauty contests, "where the rite of 'Italianess,' now expressed in physical forms and movements, could be celebrated to the full."[73] In a culture that was developing an indigenous expression of the body, where "new actors were trained and film actors of the 1930s were retrained, on the basis of the assumption that *face and body are language*," the bodies of American sexpots spoke a language of the gutter rather than the earth.[74]

Nowhere is that more pointedly illustrated than in Geppetti's 1962 images of Elizabeth Taylor and Richard Burton, taken while the two were filming *Cleopatra* in Italy. At the time, Taylor was married to Eddie Fisher and Burton was married to Sybil Burton.

Along with many other paparazzi, Geppetti had been stalking the two lovers, hoping to get the shot that showed what was evident to onlookers: that the two were having an affair, which became a major news story. "Looking back on that era and to that affair, one is amazed that a couple of people, mesmerized by their own egos, should have monopolized for so many months the attention of the world."[75] (Celebrity infidelity is a common story in the 1990s. But in the early 1960s, adultery was still scandalous, especially when it involved a star such as Elizabeth Taylor, who had been married three times and had already been painted as a scarlet woman.) Geppetti had photographed the couple together in a variety of situations around and outside Rome. He was able to capture them in odd, isolated situations, with each trying to move away from the other so as not to be photographed together. One series of images shows the unhappy pair after they'd run their car into a ditch on a dirt road, which Taylor claims occurred after pursuing paparazzi had "jumped in front of the car."[76]

He persisted in his quest despite the fact that on March 29, another photographer (possibly Pierluigi Praturlon) caught the two actors, attired in bathrobes, kissing openly on the set, which seemed to "prove" the affair, although the stars laughed it off.[77] The next day, the two "decided to turn the tables on the paparazzi by publicly dating on the Via Veneto, grimly impervious to the cascade of popping flashbulbs all around them."[78] Within days the formal separation and pending divorce of Taylor

Figure 34.3 Marcello Geppetti, *Elizabeth Taylor and Richard Burton*. Photo by Marcello Geppetti © MGMC/dolceVita GALLERY.

and Fisher was announced.[79] The world press reacted with an avalanche of moralizing condemnation, almost all of it aimed at Taylor. Even the Vatican newspaper chimed in, in the form of a "reader's" letter that castigated her for her divorces and their effect on her children, saying she would end in "erotic vagrancy."[80]

The sheer size of the story fueled the paparazzi, who were still looking for photographs that showed real intimacy between the two. Some paparazzi supposedly got shots of them at a seaside resort in late April, but other photographers continued the quest.[81] Geppetti got the most telling pictures that summer in Ischia, an island near Naples, of the two on a small boat sunbathing and kissing. The pictures ran in publications around the world, generating further moral indictments.[82]

One particularly stinging piece in *L'Europeo* was written by the Italian journalist Oriana Fallaci and accompanied by four of Geppetti's boat-deck pictures. The piece was based on interviews with Burton, with cameos put in by Taylor, who is repeatedly described in wholly negative terms. According to Fallaci's descriptions, Taylor looks small and exhausted; dressed in her ludicrous costume with sweat pouring from under her "raccoon" wig, she is an object of pity; when she puts on a dress, covered in "flowers and pompons" she is even more pathetic. Further, "everyone" knew that Burton, who was under terrible strain because of the affair, was going to return to his wife.

Toward the end of the piece, Fallaci unleashed her most fervent criticism. "Liz was not born in America, she was born in London . . . but I have rarely met a more American woman: ruthless, masculine. . . . Outside she is a woman, but inside she is genuinely a man."[83] In the thirty-plus years since its enunciation, the fascist assessment

of American women as "masculine" had survived as received wisdom. The postwar invasion of Italy by Hollywood had only strengthened that apprehension.[84]

It was a fear that the paparazzi capitalized on when they discovered resentment and aggression as a response to the preening perquisites of celebrity. And their pictures were embraced, as fascist press censorship was dismantled and the scandalous dirt that had been forbidden was allowed. Strict press codes for photographers were abandoned; in their place grew a range of practices, from investigative photojournalism to the celebrity scandal of the paparazzi.[85] According to historian Paolo Costentini, "This photography [paparazzi] transformed all conventions of representation."[86]

The Taylor-Burton affair was the last big story for the Italian paparazzi; the era of the Via Veneto was over by 1963, about the same time that Italy's economic boom ended. But the term "paparazzi" as well as the photography they produced had become a part of media culture.

Other European photographers began making paparazzi images, at the ski resorts, tropical getaways, and other exclusive haunts where the famous and the celebrated went to play; it took somewhat longer for the paparazzo style to catch on in the United States. During the 1960s, the definition of celebrity changed as Hollywood actors began mingling with dispossessed European royalty, American socialites, and political activists. Increasingly they were featured in the fashion press and the gossip press, and would be photographed by the paparazzi. As the rich and the privileged began to preen themselves in public, the sense of growing social dislocation and economic disparities, peripatetic celebrity culture, and profit motivation that fueled the Italian photographers was seized on by photographers around the globe.

IV

By the time Lady Diana Spencer appeared on the scene as Prince Charles's girlfriend in 1980, paparazzi photography was an established business in Western Europe. In the United States, only Ron Galella was well known as a paparazzo, mostly because of his legal entanglements with Jacqueline Kennedy Onassis, which effectively ended his ability to photograph her.[87] If "paparazzo" wasn't a dirty word before, it certainly was after Galella sued the former first lady – and lost. Even Fellini, the godfather of the paparazzi, had denounced them in print when images of Jackie O sunbathing nude on the island of Skorpios were published. "There is no such thing as a good paparazzo. A good paparazzo, that's a paparazzo who has had his camera broken. In fact, they are bandits, thieves of photography."[88] Although he meant merely to denounce the paparazzi, in pointing to the illicit, stolen quality of these images, Fellini illuminated precisely what makes them so compelling.

Diana's arrival as a subject for the paparazzi coincided with and helped establish a golden age of tabloid journalism, in both Britain and the United States. In her study of American tabloids, S. Elizabeth Bird writes that "The 1980s were the decade of the supermarket tabloids, when their characteristic formats developed and circulations peaked." Four tabloids, the *National Enquirer, Star, Globe,* and *National Examiner* had the greatest circulation growth of all magazines in the United States in 1982, reaching a combined figure of 11.4 million.[89] (In this essay, "tabloid" will refer to a weekly supermarket tabloid when the publication in question is American, but to the

tabloid-sized daily newspapers when they are British.) The expansion of the British tabloids was not comparably uniform, with one paper, Rupert Murdoch's *Sun*, accruing extraordinary gains and even more extraordinary power during the 1980s at the expense of the other tabloids. When he bought the paper in 1969, its circulation was slightly over one million. By 1988 its circulation peaked at 4,219,052.[90] Because of its popularity, the *Sun* set the editorial agenda – especially in terms of sensationalism and conservative politics – for all of the other tabloids, whose total daily sales in 1985 was 12,330,000 copies and 15,154,000 on Sundays.[91]

Perhaps because the British tabloids are marketed as daily newspapers, there is demographic information available on their readers.[92] Predictably, the readership splits along social-class lines. In 1995 the so-called "downmarket" papers – which are the *Daily Mirror, Daily Star*, and the *Sun*, and *News of the World, People*, and *Sunday Mirror* on Sundays – counted only about one-third their readers as being middle class, the rest presumably being working class. In contrast, two-thirds of the readers of the mid-market tabloids – the *Daily Express* and *Daily Mail* during the week and *Sunday Express* and *Mail on Sunday* – were counted as being middle class.

The American supermarket tabloids, however, closely guard whatever reader information they possess. One marketing study shows that in 1987 the *Globe* and *Examiner* appealed to "poorer and less-educated readers than the *Star* or *Enquirer*." According to the writer, the readers were "65 percent female, with a median age of thirty-five, and 51 percent having household incomes under $20,000. Sixty percent never graduated from high school."[93] Market research done by the *Star* shows that 75 percent of the tabloids's readers were married women in their thirties with larger-than-average families, who take the tabloid home, where it is read by the husband and children.[94]

In the case of both the American supermarket tabloids and the British daily tabloids, their social and political views generally run a gamut from merely conservative to rabidly reactionary, although the *Daily Mirror* in Britain has a more liberal readership, which is reflected in its support for the Labor Party.[95] Because the British tabs are daily newspapers, they run editorials and articles on British politics along with more human-interest stories, gossip, and/or sensational items. Like most of the other British papers, tabloids, and broadsheets alike, the *Sun* was a major supporter of Margaret Thatcher (although the paper had taken a generally pro-Labour line until she ran for office). After she was in office, her press secretary fed Thatcher's ideas to the *Sun* after helpfully translating them into "*Sun*-ese."[96]

The American supermarket tabloids mainly specialize in celebrity stories and largely ignore the workaday world of politics and politicians unless someone is caught in a sexual scandal. Indeed, it was a political sex scandal involving former Colorado senator Gary Hart and a young woman named Donna Rice, that apparently brought the supermarket tabs some measure of respectability and moved tabloid "dirt" from the margins of media respectability somewhat closer to the presumably clean, bourgeois center. The *National Enquirer* helped destroy Hart's presidential aspirations when it published a picture of the married ex-senator with Rice sitting on his lap, on board a pleasure boat aptly called the "Monkey Business." After that, editor Iain Calder said he could "detect a difference in the attitude from the national press toward the *Enquirer*."[97] That shift in attitude would then be seen in other scandals, especially in the O. J. Simpson double-murder story, when even such upscale papers as the *New York Times* would follow the lead of supermarket tabloid stories – and reap censure for doing so.[98]

The essential conservatism of the tabloids on both sides of the Atlantic is especially manifest in the way they treat stories on women – which is what we will be concerned with here – as well as gays, lesbians, and people of color, and in the celebrities they choose to feature. In the 1980s and '90s, American tabloids consistently trumpeted what the right wing liked to call "traditional American values."[99] Those values were largely constructed in opposition to feminism, homosexuality, liberalism, and identity politics of all kinds.

The coverage of women and the issue of feminism created a tricky situation for the tabloids, especially as the '90s wore on. The majority of tabloid readers are women – estimated at from 65 to 75 percent.[100] In contrast to the mainstream press, women make up almost half the subjects covered in American tabs, the great majority of them entertainers from television, movies, and the music world.[101] On the one hand the tabs openly ridicule "women's libbers" and all independent females.[102] But the women they cover are far from the norm of the traditional American housewife. The tabs negotiate this problem by stressing the aspects of star's lives that conform to conventional social notions, in terms of happy marriages, children, and even home-making prowess. As Bird puts it, "tabloid heroines are not successful career women but women who make unusual marriages and succeed as mothers. Villains, on the other hand, are women (and men) who disrupt the family ideal."[103]

In terms of the British tabs, Murdoch's papers set the tone for the coverage of women. His formula for the *Sun* was seemingly simple: at a 1969 staff meeting he announced "the three elements that were going to sell the paper: 'Sex, sport and contests.'"[104] That philosophy has been evidenced most famously and most overtly in its gleeful display and promotion of its bare-breasted "Page Three" pinups. By 1977 the *Sun* had abandoned any pretense of serious journalism. "It began not merely to report the salacious stories but to splash them on the front page: BLACK BRA BAN ON SCHOOL LOLI-TAS; VICAR QUITS FOR LOVE OF NURSE . . . "[105] And most salacious stories inevitably involve a woman whose sexual needs – or whose sexual effect on a man – lead to shame, social isolation, and destruction of the family unit.

It was within this journalistic milieu that the figure of Diana, Princess of Wales, was created and publicized. Despite the trivializing preoccupations of the tabloids, it was a grim period for Great Britain. The mid-and late 1970s had seen a huge jump in unemployment, factory closings, and inflation, and concurrent trade-union strife. At the same time, public expenditures on health, education, and art were cut. Sectarian violence between Protestants and Catholics in Northern Ireland escalated throughout the 1970s, culminating in 1979 with the bombing death of Charles's great-uncle, Earl Mountbatten of Burma, on board his yacht off the coast of Ireland. A round of strikes by public-service workers in the winter of 1978–79 led to a Conservative party victory, with Margaret Thatcher coming to power as prime minister. The worsening social problems, including bloody race riots in London in 1981 and deepening unemployment, were met with the harsh social measures of Thatcher's brand of triumphant conservatism. In June of 1981, just before the much publicized wedding of Charles and Diana, a teenager shot at the Queen as she rode on horseback in central London during the Trooping the Color parade to celebrate her birthday. With the news in England being unremittingly bleak, it has been argued more than once that the young princess was an especially attractive distraction from the domestic situation.[106]

Thus, Diana was not a figure seen in isolation. In addition to her husband and the royal family, Diana was also part of a shifting cast of characters that featured Margaret Thatcher, England's first female prime minister. In a *New Yorker* tribute, Simon Schama asserted that Diana played the antithetical role of royal "hugger" to Thatcher's Iron Lady.[107] But we must also (briefly) consider how Diana could be used by a conservative press as a weapon *against* Britain's women, working-class and professionals alike.

Much as Ronald Reagan was doing in the United States, Thatcher expended great political energy attacking women both directly and indirectly. Single mothers came in for particular abuse, especially for their supposed scheming reliance on welfare. The conservative championing of "father's rights" created a scenario in which "the single mother was easily regarded as threatening the traditional role of the father and the coherence of society in general."[108] A rhetoric of resentment and reaction against women was regularly splashed across Britain's newspapers. But women were adversely impacted by many other cutbacks, which while not overtly targeting them, nonetheless hit them the hardest, including reductions in state-sponsored health care, education, and housing.[109]

Alongside the discourse on the shortcomings of the feminized welfare state, images of Diana were counterposed. If poor, single women were the enemy, then the paragon was this responsible, traditional wife and mother, happily and uncomplainingly doing her part. Her milk-fed femininity was enhanced by the conservative pastel dresses and slacks she favored when her children were babies. There was a dual message in the way she was presented, on the one hand as a distant figure of royal privilege and on the other as a kind of timeless, classless ideal who was beloved for her display of "the common touch."

Under Thatcher, though, welfare "scroungers" weren't the only women who came in for criticism. Conservatives also blamed national ills on the professions of teaching and social work, which are heavily populated by women.[110] Diana, too, was considered a working woman, her "job" being to make public appearances for good causes and other events that, however vaguely, were purportedly contributing to civic welfare. But she was a professional women in whom cherished feminine attributes were foregrounded – kindness, good manners, impeccable grooming. And verbal restraint: for the first three years of her marriage, she is supposed to have uttered only five hundred words in public.[111]

Diana, indeed, was treated not so much as a newly minted royal wife as a godsend. As such, she was supremely useful to the tabloids, from her years as an attractive young wife and mother, her increasing glamour, and then her good works, through all the rocky patches of unhappiness, separation, confession, divorce, rebellion against the Windsors, and sudden death. In both Britain and the United States, she was used to negotiate questions about spousal loyalty, public duty, maternal responsibility, female vanity, female duplicitousness, and the structure and meaning of the royal family. As they had in the past, photographs provided graphic "evidence" about all of these issues.

That evidence was inscribed at first on the young, lush, virginal body of Diana, which in quick succession became the sexual body, the swelling, maternal body, the glamorous body, the anorexic body. Her reduction to an essential body was neatly accomplished before she was even engaged to Charles, when a much-reproduced photo of her was taken at the nursery school where she worked. In it she is holding one small child on her hip and clutching the hand of another one. Sun shines through

her sheer skirt, making it virtually transparent and revealing the strong outline of her legs; the right foot of the child she is holding hangs right over her crotch, both pointing to it and hiding it. It is an apt visual trope for the way in which the camera will be used to try to make virtual X rays that penetrate and reveal her, while children will alternately define and shield her.[112]

After her death, *Newsweek* wrote that the unwittingly revealing image showed "further proof of her naïveté," presumably for not knowing exactly how she would look when photographed.[113] In fact, its publication was only the beginning of a probing, ceaseless, and almost gynecological interest in the future princess's body. When Prince Charles was captured on tape over a decade later telling his lover Camilla Parker-Bowles that he would like to "live inside your trousers" and that he might "come back" as her Tampax, those were images the British press would have relished had they been made in reference to Diana simply because the press, along with much of the reading public, had been living – imaginatively – inside Diana's trousers for years.[114] That those words were addressed to Camilla, who has been vilified more because she is considered to be physically unattractive – with her lined and sagging middle-aged body – than because she has carried on with Prince Charles, seemed to strike dumb even seasoned commentators.

Not surprisingly, each part of Diana's anatomy was fetishized in turn. Her cleavage became an object of fantasy and a subject for the news during her first official date with Charles after their engagement. Wearing a low-cut black ball gown, she nearly spilled out of her dress as she bent over to exit her car at a Royal Opera benefit at Covent Garden in front of a mob of photographers.[115] The pictures were widely reproduced, causing consternation at the Palace and headlines in the newspapers. Diana's ungovernable bosom may have drawn the cameras, but it repelled her future royal in-laws, a dynamic that was played out on her body across the years.[116]

The fecundity symbolized by her lush breasts was coveted by the Windsors, who wanted an heir to the throne. That the press would point to her sexual desirability, however, was scandalous to the Palace, perhaps in part because it reflected so closely how the royals regarded her: as a primarily sexual being whose function was to reproduce.[117] That her sexuality could be decorative and titillating conflicted with rigid monarchical ideas about her sexual instrumentality and its proper expression, which was as mother rather than sex goddess.

These types of images are structured mainly by the imperatives of voyeurism and female spectacle. Other, later images of Diana were complicated by her increasingly more contentious relationship with Charles, his family, and the palace courtiers, the latter being an array of men who regulate and enforce the norms and perquisites of the monarchy. As photographers and reporters began to probe beneath the official news and images dispensed by Buckingham Palace, the paparazzi wanted to function more as investigative photographers, taking pictures in which Diana was still a spectacle, but of another kind. She became the vehicle by which the tabloids instigated a public discussion of the royal family's role, privileges, and income. "If the queen and her family enjoy the privileges of royal life – the chauffeurs, the red carpets, the private jets, and people bowing to them – then they must accept that photographers will try to get the unofficial side of them," said photographer Jason Fraser.[118]

More important than any photographer's agenda, though, was Rupert Murdoch's well-known antipathy to the English class system and the monarchy, which saturated

the newspapers he owned and which he reiterated in a 1989 interview. "I used to feel that this was a society that was held down by a very stratified class system and that the royal family was the pinnacle of that and that you would never really open up this society to opportunity for everybody until you tackled this class system and *it was very hard to see how you could tackle it with the royal family there*."[119] Diana's unapologetic physicality, her love affairs, and her problems with the royal family provided him the opportunity to accomplish two goals at once: to fill his newspapers with sex, while also weakening and perhaps even destroying the royal family.[120]

One thing that positioned the Windsors as a target of the press's ire was the vision of the monarchy that Elizabeth II had tried to perfect: the royal family as a domestic ideal, an exemplar for the nation. It was the image Elizabeth broadcast in the BBC's 1969 television documentary, *Royal Family*. In it are such scenes as the royal family making salad and grilling sausages at a barbecue, the Queen taking young Prince Edward into a store to buy him candy, and Prince Charles showing Edward how to tune a cello.[121] In retrospect, allowing the film to be made at all has been pronounced a tremendous blunder. As the longtime journalist A.N. Wilson put it, virtually nothing "is more humiliating for individuals than to make themselves into television 'personalities.' Television is the great leveller, and it quite indiscriminately devours those whom it attracts."[122]

Wilson's overstatement aside, much star-making publicity does indeed act to level, if not to devour. Paparazzi rely on the fact that fans want to see the images behind the image, the unofficial, the unposed, the unretouched – the "really" that Richard Dyer proposed as the aim of all celebrity coverage – and they relentlessly pursue them. Like any other celebrity institution, the royal family wants to control the image that is projected of them. Elizabeth personally inspects every frame of film taken by the official photographer on every occasion. "In consultation with several senior advisers, Elizabeth decided which photograph should be given to the media, to ensure that the correct image was being seen by the people."[123] The disturbing image of Diana and Charles at odds was in direct conflict with Elizabeth's view of the British monarchy as the über-family that set the moral tone for a nation. Such are the workings of representation that Diana would have to pay for the hypocrisy of an image that she herself felt victimized by.

It was a double victimization, for when she tried to influence and shape the image of her that was presented in the media, most particularly through the "authorized" Andrew Morton book – once she tried to assert herself as a subject by dispensing "true" revelations instead of mere tabloid rumor through the agency of a hand-picked journalist – the rest of media turned on her, calling her a "manipulator" and declaring open season on her. "At the beginning of 1992 Lady Di had few critics in the Press, and by the end of it she had few friends."[124]

The difficulty, if not impossibility of representing herself – or re-representing herself – was that by this time the figure of "Diana" was well established in representation. It was one that had been built largely with images, in print and on television, constructed from the codes that have long defined the figures of "princess," which deployed the semiotics of the fairy-tale, and "secular saint," a category established by the empathetic vigor with which she performed royalty's traditional charitable duties. This royal edifice was, additionally, imbricated with the more traditional bourgeois definitions of "woman" as wife, mother, and figure of glamour.[125]

She countered those rosy representations with others that cut through the prevailing fantasy in Andrew Morton's 1992 book *Diana: Her True Story*. Her own portrayal of herself as martyr to an unloving husband, sufferer of depression and bulimia, victim of a cold and calculating royal family, unapologetic hysteric, and would-be suicide, proposed a "really" true version of Diana's life that the public rejected at first, in part because it had already accepted what had been retailed in the tabloids as the "really" – a storybook version of Diana's life. According to Morton, "the effect of the book's appearance was even more shattering than anyone had predicted. The Palace were horrified, the media outraged and the public profoundly shocked."[126]

But Diana did have some justification for thinking she could re-represent herself, especially after years of experience with the press, during which she learned how to put across an attractive image of herself as princess. By the early '90s, she apparently decided that an alternative image of pathos was in order. In 1992 she began to stage successful photo opportunities in which she displayed herself as the lonely, neglected wife. The first occurred when she and Charles traveled to India. While Charles was giving a speech, Diana went to the Taj Mahal, where she was photographed alone against the backdrop of that ornate monument to married love. Not only did she create a lovely visual trope with which to convey her own marital solitude, but she upstaged Charles as well; her image caused a sensation, while his speech received little attention.[127] A few months later she created a similar photo with similar results while she and Charles were on an official visit to Egypt when she posed alone at the pyramids; at some point Charles had left to meet secretly with Camilla in Turkey. The same month, Lord Rothermere, the chairman of Associated Newspapers, which publishes the *Daily Mail*, informed Lord McGregor, the chairman of the Press Complaints Commission, that "the Prince and Princess had each recruited newspapers to carry their own accounts of their marital rifts," which complicates any notions of the two as mere victims of the tabloid press.[128]

At each step in this unprecedented royal battle for publicity, Diana's fortunes rose and fell with public perception. She was vilified for revealing too much – and was thought to be making some things up – after Morton's 1992 book was published. When the separation of Diana and Charles was announced in December of that year, the royal family launched a campaign against Diana through aristocratic proxies who denounced her to the press. Perceptions briefly swayed in her direction in January of 1993 when the infamous Camillagate tapes were released, in which Charles vowed his devotion to Camilla in weirdly graphic terms. Still, the palace continued to build Charles's public image while attacking Diana's. At the same time, her official duties were severely curtailed, robbing her of the consoling charitable visits at which she excelled.

Later in '93 Diana again created some masterful photo ops in response to Windsor Palace's very public slights. When the Queen failed to invite her to Royal Ascot, Diana took William and Harry on a festive spree to London's Planet Hollywood instead. When she was not invited to the Queen Mum's birthday party, she took the boys go-carting. Both forays netted her sympathetic and attractive pictures of a loving mother that featured prominently in the next day's papers, which had a good chance of being successful precisely because the pictures reinforced notions of Diana-as-good-mother.[129] But her isolation from the world stage was apparent, as was the more generally negative press she was getting as a result of the Windsor's efforts to

undermine her. The nadir of that year's media coverage of her occurred in November, when the *Sunday Mirror* published pictures of Diana, flat on her back, legs akimbo, working out on a leg-press machine at her health club. They were taken by a hidden camera rigged in the ceiling by the club's manager, Bryce Taylor, who was reported to have made anywhere from $150,000 to $1.5 million from their sale.[130] When Diana protested the pictures, Taylor claimed that she had secretly wanted to have them taken. Several influential columnists and politicians began to imply that Taylor was telling the truth, and Diana was again fashioned as "manipulating" the press.[131]

Those pictures were apparently what led to her ill-conceived withdrawal from public life in December 1993, which meant that she gave up doing many of her charitable appearances.[132] As part of her retreat, she had dismissed her personal police protection, which had shielded her not only from stalkers and other threats, but from the press as well. Certain photographers – most notoriously the freelancers Mark Saunders and Glenn Harvey – declared open season on her.

Lacking her police guard, and with the palace on the attack, Diana became a more vulnerable figure than ever before. She had tried to take a cue from Jacqueline Kennedy in renouncing her celebrity and retreating into privacy. But she lacked the crucial element that gave Jackie clout: she was not the widow of a tragic modern icon. She had no grievous mantle in which to shroud herself, no special subjectivity. Rather, she was shedding what measure of protection she had by separating from Charles and symbolically divesting herself of the royal cocoon.

What she had completely miscalculated was her ability to reject her own iconicity as Princess Diana without replacing it with some role of equal weight. Instead, she presented herself as merely another privileged woman who spent her time shopping, lunching, and exercising without the countervailing grace of her "good works" or the official glamour of her public persona. Given reports about her visits to a psychotherapist and her often tearful state, she was also going through emotional turmoil.

But the British media had come to depend on her image as a reliable seller, especially as newspaper sales declined in the latter 1980s, so there was no question of simply leaving her alone. Once that became apparent, she began to make her way back into the public eye in her most praiseworthy role, that of public patroness of worthy causes, visiting the victims of war in Sarajevo and Angola in the months before her death.

Of course, sex, not good works, was what the tabloids sold best. They thought they had found new sexual fodder with the appearance of Dodi Al-Fayed, the wealthy Egyptian with whom she died. He provided rich semiotic possibilities for tabloid exploitation, as an Arab who set off alarms at the prospect that he might marry – and procreate with – an Anglo-Saxon princess, and as a wealthy, apparently self-indulgent man whose father, Mohamed Al-Fayed, had long and unsuccessfully sought to ingratiate himself with the British establishment.[133] Some very fuzzy photos, obviously shot at some distance, of Diana and Dodi embracing on vacation just before the accident, were said to have brought anywhere between $720,000 and nearly $6 million.[134]

The pictorial bonanza that Diana provided died with her in the Paris car crash, although newspapers and magazines have continued to squeeze out revenue by headlining stories about her.[135] Despite calls to rein in the tabloid photographers in the aftermath of the accident, nothing of any substance occurred, nor – in all likelihood – will it.[136]

Figure 34.4 Marcello Geppetti, *Princess Diana*. [Original in colour]. Courtesy of John Pryke/Reuter.

Although paparazzi photography is a postwar phenomenon, the star-making apparatus that produced "Diana" is a much-enlarged version of the one that was originally put in place by the motion picture industry and the system of journalistic texts that supported it at the beginning of the twentieth century.[137] Integral to the writing of the apparatus was the discovery of secret information about the stars, although at first the secrets that were divulged were limited and banal.[138] The scope of reportable secrets was considerably expanded in the 1920s, when a string of shocking Hollywood scandals were reported, beginning with the drug overdose death of Olive Thomas, a young actress, and the arrest of popular comedian Roscoe "Fatty" Arbuckle for rape and murder, and his subsequent ruin.[139] In the 1930s, the universe of celebrity secrets most famously included those about British royalty, although they were secret only from the British public. The love affair of the Prince of Wales and an American divorcée, Wallis Simpson, was reported in newspapers around the world. He had been Edward VII, King of England for 326 days when the British public learned of the affair on December 3, 1936; he abdicated on December 11 when it became clear that he would not be allowed to marry Mrs. Simpson and retain his crown.

This historic crisis dogged the Windsors as the possibility of another ascension crisis loomed when Diana and Charles separated and new revelations surfaced about their marriage. "The abdication was a monarchical earthquake and the aftershocks continued for decades to come," writes Tunstall.[140] The Windsors's marital strife provided the basis on which the British tabloids continued to attack not only the royal family but the institution of the monarchy itself. By the fall of 1994, British polls

showed for the first time that half the respondents did not think the monarchy would survive another fifty years.[141] A largely right-wing press had managed to create the conditions under which a British republic might come into being, which would be a victory for the republican left.

Diana's death, however, muted talk of disposing of the monarchy. In part that was because her death restored a certain balance in the monarchy. If, as Marina Warner has proposed, Margaret Thatcher replaced the Queen as the "symbolic centre of power in Britain" during her tenure as prime minister, once Thatcher was out of office, we might say that Diana replaced Thatcher as the symbolic center of *feminine* power.[142] With Diana's death, the Queen could again fully occupy her own position as Britain's most visible and (symbolically) powerful woman, which had been contested by these troublesome rivals. But Diana's death seems in some sense a sacrifice for the monarchy, for the celebrity that monarchy brought her. To dispense with the royal family would be to admit that her death was a waste. And the royal family, of course, included Diana's two young princes, who were now to be protected as the bearers of their mother's memory as well as the future of the Windsors. Rather than destroying the family that she hated, she may well have extended its longevity.

For a brief time, the grief over the end of Diana drew back the curtain on the antic, unthinking, grotesque atmosphere of tabloid culture. The abject foundation of its ersatz carnivalesque was all too clearly revealed. The abjection of its subjects, its producers, and its consumers reflects the Kristevean "want" on which the desire for celebrity and its effects is predicated – no glamour without execration, no beauty without defilement. That "want" helped drive the pursuit of Diana, just as it powered the original Italian paparazzi and the gossip system that has since been created. It will not vanish with Diana's demise nor the fixing of blame for the incredible pointlessness of her death.

Original publication

'Class Struggle: the Invention of Paparazzi Photography and the Death of Diana, Princess of Wales', *OverExposed* (1999)

Notes

1 Howard Chua-Eoan, Steve Wulf, Jeffrey Kluger, Christopher Redman and David Van Biema, "Death of a Princess," *Time,* 8 September 1997, p. 33.
2 Alan Riding, "Public Likes Celebrity Photos But Hates the Photographers," *The New York Times,* 2 September 1997, sec. 1, pp. 1, 11. All the early reporting on Diana's death emphasized the putative role of the paparazzi in the car crash.
3 There are a few studies available of the tabloid press, but none of them specifically treat tabloid photography. Among them are S. Elizabeth Bird, *For Enquiring Minds: A Cultural Study of Supermarket Tabloids* (Knoxville: University of Tennessee Press, 1992); Patricia Mellencamp, *High Anxiety: Catastrophe, Scandal, Age, and Comedy* (Bloomington and Indianapolis: Indiana University Press, 1992); John D. Stevens, *Sensationalism and the New York Press* (New York: Columbia University Press, 1991). Essays that do address paparazzi photography are Karin E. Becker, "Photojournalism and the Tabloid Press," in *Journalism and Popular Culture,* eds. Peter Dahlgren and Colin Sparks (London: Sage,

1992); Alan Sekula, "Paparazzo Notes" in *Photography Against the Grain* (Halifax: The Press of the Nova Scotia College of Art and Design, 1984).

4 The only publication available in English that gives an overview of the phenomenon is *American Photo* (July/August, 1992), pp. 46–85, 92, 93. For the British photographers see Stuart Wavell, "All Out for the Prints," and William Langley, "The Grapes of Wrath," in *The Sunday Times,* style and travel magazine, Sunday, 11 September, 1994, sec. 9, and Mark Saunders and Glenn Harvey, *Dicing with Di: The Amazing Adventures of Britain's Royal Chasers* (London: Blake Publishing Ltd., 1996). Daniel Angeli and Jean-Paul Dousset, *Private Pictures,* intro. Anthony Burgess (London: Jonathan Cape Ltd., 1980), is a look at the early work of two of the most infamous French paparazzi. The original Italians are covered in Jennifer Blessing, "Paparazzi on the Prowl: Representations of Italy circa 1960" in *Italian Metamorphosis, 1943–1968,* organized by Germano Celant, preface Umberto Eco (New York: Guggenheim Museum Publications, 1994), pp. 324–33, and Massimo Di Forti, "Flash Warning: The Paparazzi Are Coming," *Aperture,* (Summer 1993).

5 Richard Dyer, *Heavenly Bodies: Film Stars and Society* (London: The Macmillan Press Ltd., 1986), p. 2.

6 As celebrity reportage has taken up more airtime and space in the American print media, however, most victims of political violence have become marginalized.

7 There was only a short period of time after World War II when stars allowed photographers to document their everyday lives with any freedom, mainly for the original *Life* magazine. Among the most unsparing of those pictures are the ones Eve Arnold took for her 1959 story on an aging Joan Crawford at work, taken at the star's request. Politicians sometimes still allow a truncated version of behind-the-scenes documentation.

8 Edward S. Herman and Noam Chomsky, *Manufacturing Consent: The Political Economy of the Mass Media* (New York: Pantheon, 1988), pp. 37–86.

9 See Carol Squiers, "Special Effects," *Artforum,* (November 1986), p. 12, for a short piece on the financiers.

10 In addition, their telephone calls may be monitored by management, along with the number of key strokes per minute they log on their computers. Their credit history is accessible to anyone who knows where to look, as is their tax history. For a general roundup of some surveillance techniques as of mid-1997, see Joshua Quittner, "Invasion of Privacy," *Time,* 25 August 1997, pp. 28–35.

11 Jeremy Tunstall, *Newspaper Power: The New National Press in Britain* (New York: Oxford University Press, 1996), p. 320. Tunstall also quotes an unnamed journalist to the effect that "many of the names [of the royal courtiers] had not changed since Queen Victoria's time; courtiers were appointed on the basis of family tradition," p. 333.

12 Andrew Morton, *Diana: Her True Story* (New York: Pocket Books, 1992), p. 196.

13 Andrew Morton, *Diana's Diary: An Intimate Portrait of the Princess of Wales* (New York: Summit Books, 1990), p. 19; also Andrew Morton, *Diana: Her True Story — In Her Own Words* (New York: Simon & Schuster, 1992; revised 1997), p. 157.

14 James Whitaker, *Diana vs. Charles: Royal Blood Feud* (New York: Signet, 1993), pp. 107–9.

15 S.J. Taylor, *Shock! Horror! The Tabloids in Action* (London: Black Swan Books, 1991), p. 87.

16 The Internet was peppered with sites calling for a variety of boycotts of supermarket tabloids, foreign publications that printed paparazzi shots, and tabloid television shows. One site in Georgia called itself PAT (People Against Tabloids) and another site adopted the name "Stoparazzi." Between August 31 and September 9, 1997, the site, "Remember Princess Diana: Stop Paparazzi," claimed to have received 23,332 hits.

17 The essay that defined and challenged certain liberal assumptions about the efficacy of documentary photography, is Martha Rosler's "In, Around and Afterthoughts (On

Documentary Photography)," in *Three Works* (Halifax: The Press of Nova Scotia College of Art and Design, 1981). Diana spelled out how difficult the press attention was for her in her statement announcing she was leaving public life in 1993. *Diana: Her New Life* (New York: Pocket Star Books, 1994), pp. 138–139. Little did she suspect that her withdrawal would fuel certain photographers even more, which is graphically demonstrated in an entire book by two paparazzi, Mark Saunders and Glenn Harvey.

18 Michael L. Carlebach, *The Origins of Photojournalism in America* (Washington, D.C.: Smithsonian Institution Press, 1992), p. 3.

19 From the time the daguerreotype was invented, operators realized the profit potential in photographing newsworthy clients. Carlebach, p. 15.

20 John Phillips, "Primoli's Due," *Connoisseur,* March 1984, p. 94. My thanks to Glen Willumson for providing me with a copy of this essay. See also Daniela Palazzoli, *Giuseppe Primoli: Instantanee e fotostorie della Belle Epoque* (Milan: Electra Editrice, 1979).

21 Italo Zannier, "Naked Italy," *Paparazzi Fotografie: 1953–1964* (Florence: Fratelli Alinari, 1988), p. 17. My thanks to Emily Miller for her translation of this text.

22 Bill Jay, "The Photographer as Aggressor," in *Observations: Essays on Documentary Photography,* ed. David Featherstone (Carmel, California: The Friends of Photography, 1984), p. 9.

23 Ibid., p. 8 and p. 11.

24 Ibid., p. 10.

25 Robert E. Mensel, "Kodakers Lying in Wait: Amateur Photography and the Right of Privacy in New York, 1885–1915," *American Quarterly* vol. 43, no. 1 (March 1991), p. 25.

26 Bill Jay, "The Photographer as Aggressor," p. 11.

27 Ibid.

28 Zannier, "Naked Italy," pp. 10–11.

29 Hollis Alpert, *Fellini: A Life* (New York: Paragon House Publishers, 1986), p. 125.

30 French Photo, March 1973, p. 63.

31 Blessing, " 'Paparazzi on the Prowl': Representations of Italy circa 1960," in *Italian Metamorphosis, 1943–1968,* p. 325.

32 Attilio Colombo, "Paparazzo Alias Secchiaroli," *Tazio Secchiaroli,* I Grandi Fotografi Serie Argento (Milan: Gruppo Editoriale Fabbri, 1983). Translation by Emily Miller. For a one-page roundup of reporage on that infamous night, see the page from the August 24, 1958, edition of *L'Espresso* reproduced in Andrea Nemiz, *Vita, Dolce Vita* (Rome: Network Edizioni, 1983), p. 20. My greatest appreciation to Andrea Nemiz for giving me a copy of his valuable book.

33 The best single source on the development of gossip as a part of the news in the United States is Neal Gabler, *Winchell: Gossip, Power and the Culture of Celebrity* (New York: Alfred A. Knopf, 1994).

34 Ronald L. Davis, *The Glamour Factory: Inside Hollywood's Big Studio System* (Dallas: Southern Methodist University Press, 1993), p. 155; also see Davis's entire chapter on publicity, especially for the role of studio photographers, pp. 137–57. In addition, see Carol Squiers, "Hollywood Glamour," *American Photo,* (May/June 1995), pp. 55–58, 106–7.

35 Tazio Secchiaroli, interview with author, Rome, Italy, 8 May 1994, translation David Secchiaroli.

36 Ibid.

37 "Swings and Arrows of Outraged Ekberg," *Life,* 31 October 1960, pp. 28–30.

38 Victoria De Grazia, *How Fascism Ruled Women: Italy, 1922–1945* (Berkeley: University of California Press, 1992), pp. 205–6.

39 Donald Meyer, *Sex and Power: The Rise of Women in America, Russia, Sweden, and Italy* (Middletown, Connecticut: Wesleyan University Press, 1987), pp. 31–2.

40 De Grazia, *How Fascism Ruled Women,* p. 202.

41 Meyer, *Sex and Power,* p. 32.

42 De Grazia, *How Fascism Ruled Women,* p. 206.

43 Ibid., p. 208.

44 Ibid., p. 209.

45 Ibid.

46 John Whittam, *Fascist Italy* (Manchester and New York: Manchester University Press, 1995), p. 89.

47 Ibid. Also see Denis Mack Smith, *Mussolini* (New York: Alfred A. Knopf, 1982), p. 143.

48 Zannier, "Naked Italy," p. 15 and Zannier, telephone interview with Emily Miller, 25 June 1997.

49 Whittam, *Fascist Italy,* p. 90.

50 De Grazia, *How Fascism Ruled Women,* p. 205. Also see Edward R. Tannenbaum, who quotes Carlo Emilio Gadda's *Eros e priapo* to the effect that Mussolini took and retained political power precisely because he was an exhibitionist, in *The Fascist Experience: Italian Society and Culture 1922–1945* (New York: Basic Books, 1972), pp. 214–15.

51 Meyer, *Sex and Power,* p. 141.

52 Ibid., p. 142. Although it is not specified, this quote was presumably from Pius XII.

53 Paul Ginsborg, *A History of Contemporary Italy: Society and Politics 1943–1988* (New York: Penguin Books, 1990), p. 244.

54 Any earnings they derived were from doing piecework at home or laboring parttime in the underground "black economy." See ibid., p. 244 and Meyer, *Sex and Power,* p. 40.

55 Ginsborg, *A History of Contemporary Italy,* p. 244.

56 Thomas H. Guback, "Hollywood's International Market," in *The American Film Industry,* ed. Tino Balio (Madison: University of Wisconsin Press, 1976), p. 395.

57 Peter Bondanella, *Italian Cinema: From Neorealism to the Present* (1983; reprint, New York: Continuum, 1990), p. 36.

58 For a good summation of this issue, see Michael Conant, "The Impact of the Paramount Decrees" in Balio, *American Film Industry,* pp. 346–70.

59 "Joseph E. Levine built himself a commercial empire on films with Steve Reeves and a cast of Italians which were produced for under $150,000 in Italy and then dubbed into English," according to Gerald Mast, during a time when the average cost of making a film in the United States was $800,000 to $1.14 million. Gerald Mast, *A Short History of the Movies* (Indianapolis & New York: The Bobbs-Merrill Co., 1971), pp. 317 & 324–5.

60 Of course, Italians had experienced American servicemen as part of the Allied occupation from 1943 on. See Ginsborg, *A History of Contemporary Italy,* pp. 39–42.

61 Alpert, *Fellini,* p. 125.

62 Blessing, "Paparazzi on the Prowl," p. 328.

63 Ibid., p. 329.

64 Patricia Meyer Spacks, *Gossip* (1985; reprint, Chicago: University of Chicago Press, 1986), p. 49.

65 Ibid., p. 50. Sigmund Freud, *Jokes and Their Relation to the Unconscious,* trans. James Strachey, (New York: Norton, 1963), p. 90.

66 Spacks, p. 50. Freud, p. 131.

67 Nemiz, *Vita, Dolce Vita,* pp. 50–51.

68 Angela Dalle Vacche, *The Body in the Mirror: Shapes of History in Italian Cinema* (Princeton, New Jersey: Princeton University Press, 1992), pp. 4–5. In addition to doing pantomimes and acrobatics, the actors wore facial masks (*maschere*) that represented well-known stereotypes.

69 Mira Liehm, *Passion and Defiance: Film in Italy from 1942 to the Present* (Berkeley and Los Angeles: University of California Press, 1984), p. 11. Also Bondanella, *Italian Cinema,* p. 145.

70 Dalle Vacche, p. 56. In *Italian Cinema,* Bondanella also notes the comic vein in neorealism – *neorealismo rosa,* p. 88.
71 Bondanella, *Italian Cinema,* p. 145.
72 Giovanna Grignaffini, "Female Identity and Italian Cinema of the 1950s" in *Off Screen: Women and Film in Italy* eds. Giuliana Bruno and Maria Nadotti, (London & New York: Routledge, 1988), p. 123.
73 Ibid., p. 123.
74 Ibid., p. 122.
75 Alexander Walker, *Elizabeth: The Life of Elizabeth Taylor* (New York: Grove Weidenfeld, 1990), p. 250.
76 David Kamp, "When Liz Met Dick," *Vanity Fair,* April 1998, p. 386.
77 Alexander Walker, *Elizabeth,* p. 251.
78 Dick Sheppard, *Elizabeth: The Life and Career of Elizabeth Taylor* (New York: Doubleday & Co., 1974), p. 304.
79 Alexander Walker, *Elizabeth,* p. 252.
80 Sheppard, *Walker,* p. 309.
81 David Kamp, "When Liz Met Dick," p. 386. The paparazzi who got the photos are not named, nor are the pictures characterized as to the intimacy they showed.
82 Photoplay magazine ran one on the cover, headlined, "Liz and Burton – Shameless Lovers" and reprinted the letter from the Vatican newspaper in its October 1962 issue.
83 Oriana Fallaci, "Gli ozi di Ischia", *L'Europeo,* June 1962, p. 26. My thanks to Amy Wanklyn for her translation and to Alexandra Rowley for her assistance.
84 In a perhaps ironic recognition of the fascist overtones of this critique, Fallaci ended the piece with an anecdote about how no one was permitted to argue with Taylor because "Miss Taylor is always right," a gloss on one of the best-known catch-phrases of Mussolini's reign, that is, that "Mussolini is always right." Fallachi, "Gli ozi di Ischia," p. 27. See Denis Mack-Smith for Mussolini's belief in his own infallibility in *Mussolini,* p. 124. My thanks to Amy Wanklyn for pointing out Fallaci's invocation of Mussolini's motto.
85 Italo Zannier, "Naked Italy," pp. 15 and 17.
86 Paolo Costantini, "Evidenze," *Paparazzi Fotografie: 1953–1964,* p. 33.
87 She had him arrested in 1969 while he was trying to photograph her and son John, prompting him to file an ultimately self-destructive lawsuit against her the following year. The upshot of his action was that he was enjoined from getting any closer than fifty yards from her or seventy-five yards from her children. Even though the distances were reduced during a 1973 appeal to twenty-five feet and thirty feet, respectively, Galella would never photograph her again. Ron Galella, *Jacqueline* (New York: Sheed and Ward, Inc., 1974), pp. 153–181.
88 *French Photo,* March 1973.
89 Bird, *For Enquiring Minds: A Cultural Study of Supermarket Tabloids,* p. 8. The statistic is from a *Business Week* study in 1983.
90 Matthew Engel, *Tickle the Public: One Hundred Years of the Popular Press* (London: Victor Gollancz, 1996), p. 332.
91 Tunstall, *Newspaper Power,* p. 41 and p. 54.
92 Although some demographic information is available in Tunstall, he breaks it down only by identifying the percentages of middle-class readers, everyone else by default being classified as "not middle class," p. 8.
93 Bird, *For Enquiring Minds,* p. 108. The information is from an advertising agency's reader profile.
94 S.J. Taylor, *Shock! Horror!,* p. 146. Although it is tremendously problematic to construct a notion of the tabloid audience on such questionable research, tabloid editors apparently do make editorial decisions based on a constellation of ideas (and biases) about what this kind of "evidence" means.

95 Tunstall, *Newspaper Power,* p. 251.

96 Ibid., p. 272. See Tunstall's chapter-long analysis of the rightward tilt of the papers, pp. 240–255. Also see Matthew Engel, *Tickle the Public,* pp. 264 and 167.

97 S.J. Taylor, *Shock! Horror!,* pp. 123–124.

98 "*Times* Is Criticized for Using Simpson Account from Tabloid," *The New York Times,* 25 Dec. 1994, sec. A. By early 1998, the source for political sexual scandal had further declined, when Matt Drudge, a right-wing gossip purveyor on the World Wide Web, broke the story that *Newsweek* was withholding a story on President Bill Clinton's alleged sexual affair with White House intern Monica Lewinsky. See James Ledbetter, "Press Clips," *Village Voice,* 3 February 1998, p. 28.

99 Bird, *For Enquiring Minds,* p. 67.

100 Ibid., p. 108.

101 Ibid., p. 77.

102 Ibid., p. 76.

103 Ibid., pp. 76–77.

104 Engel, *Tickle the Public,* p. 253.

105 Engel, *Tickle the Public,* p. 259.

106 See Simon Schama, "The Problem Princess," *The New Yorker,* 15 September 1997, pp. 64–65, on his contention that the figure of Diana cannot be understood without considering the effect of Margaret Thatcher and her harsh social policies.

107 Ibid., p. 64.

108 Maureen McNeil, "Making and Not Making the Difference: The Gender Politics of Thatcherism," in *Off-Centre: Feminism and Cultural Studies* (London: Harper Collins Academic, 1991), eds. Sarah Franklin, Celia Lury, Jackie Stacey, p. 229.

109 Sarah Franklin, Celia Lury, and Jackie Stacey, "Introduction 2: Feminism, Marxism and Thatcherism," *Off-Centre,* eds. Franklin, Lury, Stacey, pp. 26–27.

110 McNeil, "Making and Not Making the Difference . . . ," *Off-Centre,* p. 232.

111 Kitty Kelley, *The Royals,* p. 308.

112 She agreed to pose for it after crying when photographers ambushed her. See Barbara Kantrowitz, "The Woman We Loved," *Newsweek,* 8 September 1997, p. 42.

113 Jeff Giles, "A Fairy-Tale Princess," in *Newsweek Commemorative Issue. Diana: A Celebration of Her Life,* p. 31.

114 Quoted in A.N. Wilson, *The Rise and Fall of the House of Windsor,* (New York: Fawcett Columbine, 1993), p. 54.

115 Kitty Kelley, *The Royals* (New York: Warner Books, 1997), p. 272. Also see Lady Colin Campbell, *Diana in Private: The Princess Nobody Knows* (Reprint; New York: St. Martin's Press, 1992), p. 154.

116 The Queen Mother was said to be especially offended by Diana's wardrobe gaffe. A "relation" of hers was quoted as saying that although she has an ample bosom herself and enjoys wearing low-cut dresses, the Queen Mother maintains a decided sense of propriety. "In fact, when she's dining at Clarence House and one of the footmen comes to serve or clear her, she always covers the royal bosom." Lady Colin Campbell, *Diana in Private,* pp. 155–156.

117 It has been suggested that bearing children was considered, especially by Charles, to be her main function. Whitaker, *Diana vs. Charles,* pp. 166–167.

118 Stephanie Dolgoff, "The Royals!," *American Photo,* July/August 1992, pp. 60 and 62.

119 Rupert Murdoch, rebroadcast in "The Princess and the Press," *Frontline,* 16 November 1997; emphasis added.

120 Matthew Engle, *Tickle the Public,* p. 253.

121 Kitty Kelley, *The Royals,* pp. 209–11.

122 Wilson, *Rise and Fall,* p. 109. Of course, Wilson's belief that being made into a television personality is the most humiliating thing that could happen is a measure of his own

privilege as a former Oxford don and then journalist for steadfastly middle-class and upper-class newspapers such as the *Times Literary Supplement,* the *Sunday Telegraph,* and the *Daily Mail.*

123 Nicholas Davies, *Queen Elizabeth II: A Woman Who is Not Amused* (New York: Citadel Stars, 1996), p. 397.

124 Wilson, *Rise and Fall,* p. 44.

125 This discussion owes much to Abigail Solomon-Godeau's "The Legs of the Countess," *October* 39, Winter 1986.

126 Morton, *Diana: In Her Own Words,* p. 213.

127 Wilson, *Rise and Fall,* p. 101. There is at least one more version of this story. In *Diana vs. Charles,* Whitaker says that Charles pointedly rejected the February photo call because of its "gruesome superficiality," p. 226. Wilson and Whitake both get the wrong year; it was 1992.

128 Wilson, *Rise and Fall,* p. 99. The press complaints commission is a sixteen-member watchdog group that polices the British press for "excesses," particularly those having to do with the monarchy. See Tunstall, *Newspaper Power,* pp. 400–4.

129 Kelley, *Royals,* p. 443.

130 Neil Graves, "Princess Di Steel Going Strong," *New York Post,* 8 November 1993, p. 3, reported $150,000. Michael Shain and Anthony Scaduto, "Diana Wins Lawsuit Over Sexy Gym Pix," *Newsday,* 9 February 1995, sec. A, reported the $1.5 million figure when Diana settled the lawsuit she brought against Taylor.

131 Morton, *Diane: In Her Own Words,* pp. 238–39.

132 Morton, *Her New Life,* pp. 136–39.

133 Evan Thomas and Christopher Dickey, "The Last Chapter," *Newsweek,* 15 September 1997, p. 42 and Marc Fisher, "What Money Couldn't Buy," *Washington Post,* 4 September 1997, sec. D.

134 Mark Hosenball, "Taking the Tabs to Task," *Newsweek,* 15 September 1997, p. 60 and Matthew Cooper, "Was the Press to Blame?" *Newsweek,* 8 September 1997, p. 37. *Time* magazine correspondents Thomas Sancton and Scott MacLeod put the figure the two photographers made – Mario Brenna, who took the pictures, and Jason Fraser, who brokered their worldwide sale – at "well over $2 million" in *Death of a Princess: The Investigation* (New York: St. Martin's Press, 1998), p. 128. All such figures are notoriously unreliable, with the truth usually being somewhere between the extremes.

135 See Christian Berthelson, "California Law Will Allow Celebrities to Sue Paparazzi," *New York Times,* 5 October 1998, sec. C, for what California lawmakers have done to date.

136 See Todd S. Purdum, "Two Senators Propose Anti-Paparazzi Law," *New York Times,* 18 February 1998, sec. A for what U.S. lawmakers are endeavoring to do.

137 This is not to say that "fame" on a large scale is a twentieth-century phenomenon, because it is not. For a wider view of the production, maintenance, and dissemination of fame over the centuries, see Leo Braudy, *The Frenzy of Renown: Fame and Its History* (New York: Oxford University Press, 1986).

138 See Richard deCordova, *Picture Personalities: The Emergence of the Star System in America* (Urbana and Chicago: University of Illinois Press, 1990) for a definitive explication, especially pp. 82–84.

139 For one version of this often-told tale, see Kenneth Anger's *Hollywood Babylon* (New York: Dell Publishing, 1975), pp. 27–45.

140 Tunstall, *Newspaper Power,* p. 316.

141 Charles Lewington, "You've Let Us Down, Charles," *Sunday Express,* 16 October 1994, p. 1.

142 The quote about Thatcher is cited by Franklin, Lurie, and Stacey in *Off-Centre,* p. 34.

Karen de Perthuis

THE SYNTHETIC IDEAL
The fashion model and photographic manipulation

> Art itself (and with it sartorial art) is a compromise between imagination and reality; it deals with real media but implies an inability to find complete satisfaction with reality and creates a new world "nearer to the heart's desire."
>
> (Flügel 1933: 237)

AGAINST A CLEAN WHITE BACKGROUND, a beautiful naked model with glistening black skin and short spiked hair crouches awkwardly on a pile of sticks. Her arms are distorted and unbalanced in width. One preternaturally long, sinewy leg tapers down to a furred hoof. From her left collar-bone, a sharp, ridged horn seamlessly extends out towards her elbow and, from her right rib-cage, a smaller horn points menacingly upwards like a dagger. This image was created by Nick Knight in collaboration with Alexander McQueen for the designer's invitation to his Autumn/ Winter 1997–98 couture collection, "It's a Jungle Out There." On the catwalk, the collection included jackets that featured animal horns emerging from the shoulders and models who wore finger horns designed by jeweler Sarah Harmanee. So although extreme in appearance, the body of the model in the invitation could be considered as the perfect "accessory" to this collection.

McQueen is renowned for his spectacular shows and themed collections that seem to take their cue from Charles Baudelaire's description of fashion as "a sublime deformation of Nature, or rather, as a permanent and repeated attempt at her renewed reformation" (Baudelaire 1995: 33). As a designer, he has always produced collections rich in symbolic and cultural meanings and, more than most, he makes us question the relationship between the body and clothing. That this relationship can be characterized as one more appropriately carried out on the battlefield than in the rarefied atmosphere associated with Parisian haute couture has long been recognized. Georg Hegel set the scene when he maintained that "the body is one thing, the clothing another, and the latter must come into its own independently and appear in its

freedom" (Hegel 1975, 2: 747). Following this principle, he considered the drapery worn in antiquity as being far superior to modern clothing. The latter disappointed on two counts – it was subservient to the body while, paradoxically, managing simultaneously to disfigure the form of limbs. A further act of subservience, Hegel charged, was the willingness of modern clothes to bow to the caprice of fashion, which has as its rationale "the right of continual alteration" (2: 749). Hence both clothing and the body fell under fashion's domain.

A persuasive argument has also been made for fashion using its "right of continual alteration" on the unclothed body. In her book *Seeing Through Clothes*, art historian Anne Hollander showed that in art, as clothes change with the fashions so too does the body which, almost without exception, wears a "counterimage" of fashionable clothing. As a consequence, she concludes, "all nudes in art since modern fashion began are wearing the ghosts of absent clothes . . . " (Hollander 1975: 85–86). The naked body of the model in "It's a Jungle Out There" does not follow the lineaments of any actual garment – it is at best an abstraction of the clothes in the collection – and yet, even without "the ghosts of absent clothes," fashion remains as a tangible presence. This is not simply because the context is that of a Parisian couture show or because the figure in the image has the exaggerated leanness and cut-glass cheekbones of a fashion model. Rather, it is a question of ontology: how are we to categorize this beautiful but freakish creature? On the one hand, Georges Bataille in his essay "The Deviations of Nature" makes the point that what is labelled "unnatural" in the human form is, in fact, "incontestably" the responsibility of nature (Bataille 1985: 55). On the other hand, Georg Simmel has written that, "the absolutely unnatural . . . can at least exist in the form of fashion" (Simmel 1997: 205). The figure in "It's a Jungle Out There" is not, we know, a product of nature, but she is a creation of that which is *not* nature – fashion. Here fashion has ignored the corporeal realities of the model and created an utterly imaginary form, in much the same as way it would go about creating a garment.

What Hollander describes as the "integrated vision of clothes and body" (1975: 85) is thus intensified and the outcome is a synthesis of fashion and the body – a synthetic ideal.

The image for "It's a Jungle Out There" was created using digital technology. Intrinsic to this process is the idea of a radical breakdown in the correspondence between reality and the final image, and it was this that informed my initial thinking around the synthetic ideal. In the digitally manipulated image there is no original. Instead, the solid elements of the conventional photograph are dissolved into a kaleidoscope of pixels that, like the chorus line from a Busby Berkeley musical, are easily choreographed into endless permutations. In this way, explains Robin Derrick in his introduction to *The Impossible Image* (the book in which the images by Knight discussed in this article are reproduced), "pictures can be seamlessly altered, blended and mixed together," making "anything possible" (Sanders et al. 2000: 2). However, some of the most extreme instances of the synthetic ideal are created by other methods of photographic manipulation – most strikingly, for example, Alexei Hay's sequence, "Total and Fatal for You," discussed below. Nonetheless, the salient point remains that in the fashion photography produced by practitioners working at the cutting edge of what is possible with photographic manipulation – digital or otherwise – we are encouraged to think about the ontology of fashion through the body of the model. Crucially, this body contains the possibility, inherent to fashion, of reinventing itself in a constantly

changing form. By a process of transubstantiation the fleshy, organic substance of the body is transformed into the artificial, synthetic substance of the fashion garment. The separate ontological states of what is possibly "clothing" and what is possibly "body" no longer signify and in the new entity that emerges from this alchemical process, the boundary between self and non-self is dissolved. The synthetic ideal then can be seen as the embodiment of fashion's imaginary. As the avatar of fashion, it is where artifice, change and imagination coalesce on the body of the model to create a new, previously only imaginable, form.

The image body

Central to my argument is the different relationship that exists between the body and clothing in the lived world and the body and clothing in fashion representation. In the lived world, this relationship has been characterized as one of co-dependency and equivalence, to the point where "dress cannot be understood without reference to the body and . . . the body has always and everywhere to be dressed" (Entwistle 2000: 324). But in fashion representation, Roland Barthes has suggested that a hierarchy exists, with fashion at the apex. Of particular relevance to this article is his explanation of how, in fashion representation, all that is natural is dissolved into the artifice of fashion. This is a fundamentally important point as it enables the relationship between clothing and the body in the manipulated image to be viewed as an exaggeration of something that is already present in the conventional fashion image.

In *The Fashion System*, Barthes identified the distinction between the garment that is manufactured and/or worn and the garment that exists only as representation and meaning. Put simply, a picture of a dress is not a dress. What this means is that represented (or, in his terminology, "image") clothing does not have the other potential modalities contained in those garments that circulate in the lived world ("real" and "used" clothing). Represented clothing cannot serve the functions of protection, modesty or adornment. At best, it can only signify these practical considerations. Representation then allows fashion to appear in a more undiluted form, filtering out the practical functions that threaten fashion with becoming a material (as opposed to idealized) mode of being. A similar process of idealization occurs with the body of the fashion model, which is drained of any biological realities. As Elizabeth Wilson puts it, "this is the body as an idea rather than as an organism" (Wilson 1985: 58).

Contrary to what one might expect, the essential function of the body of the fashion model is not aesthetic. Barthes writes, "it is not a question of delivering a 'beautiful body', subject to the canonic rules of plastic success, but a 'deformed' body with a view to achieving a certain formal generality" (Barthes 1983: 259). Thus the ideal, incarnate body of the fashion model is "no one's body;" rather, "it is a pure form" (1983: 259). Collapsed into the sign system of fashion, it cannot signify as itself. As Barthes puts it, "by a sort of tautology" it refers only to the garment (1983: 259). The body then does not introduce anything new into the image; it is a reiteration of what is already present, that is, fashion. Once the body, the clothing, etc. have been transformed into image, no gesture, no look, no decoration is accidental; everything in the image – including all scenic elements – articulates the garment. The model appears in this framework, this setting, but does not belong to it; her reality is only in reference

to fashion. "By making its signified unreal," explains Barthes, "fashion makes all the more real its signifier, i.e., the garment." Thus, he writes, " . . . the world, *everything which is not the garment*, is exorcized, rid of all naturalism: nothing plausible remains but the garment." (1983: 303. Emphasis in original.)

An artificial humanity

At one level, the synthetic ideal is the product of an individual's (or a group of individuals') imagination – the photographer working with maybe a stylist, designer, art director, or digital technician. However, fashion – unlike art, which reveals the trace of the human hand – has been credited with a power and an aesthetic logic that operates independently of any one individual. In sartorial fashion, it is on the canvas of the human body that fashion creates and re-creates over and over its shifting image of beauty, substituting its artifice as an antidote to what Baudelaire described as the frightfulness of nature. For the French art historian, Henri Focillon, it is through subjection to this principle of metamorphosis that plastic forms are perpetually renewed and can thus be thought of as "alive." This is true of art but even more so of fashion where the stakes are higher – the intrinsic quality of metamorphosis essential not just to its continuation but to its very being. The creative impulse that drives such metamorphosis may be thought of as being coercive but, for Focillon, it is not entirely so, indeed, it may even go so far as to respect or expose "the proportions of nature." But, like Hegel, he accepts that it is more often the case that the body is required to submit to fashion's whims. He writes,

> Fashion . . . will submit form to incredible transmutations; it will create hybrids; it will impose on the human being the profile of an animal or a flower. The body becomes but the pretext, the support and sometimes only the material for utterly gratuitous combinations. Fashion thus invents an artificial humanity that is not the passive decoration of a formal environment, but that very environment itself. Such a humanity . . . obeys much less the rule of rational propriety than the poetry of ornament, and what fashion calls line or style is perhaps but a subtle compromise between a certain physiological canon . . . and a pure fantasy of shapes.
>
> (Focillon 1989 [1934]: 85–86)

Writing in 1934, Focillon's description maybe befits more the fashions of previous centuries or the couture collections of the current period than his own but, beyond that, his observations certainly seem to anticipate the relationship between the body and fashion in the synthetic ideal. Perhaps then the synthetic ideal can be understood in terms of a genealogy of fashion. By this I do not mean a genealogy that deals with fashion's contents (although, like this, it would not be linear) but rather one that deals with its ontology. Here I am suggesting that the synthetic ideal represents a progression toward the realization of the unfulfilled ambitions of fashion.

The idea of a compromise between a certain physiological canon and imaginative design echoes Flügel's observation, cited above, that art requires a compromise between imagination and reality. Both writers touch upon an aspect of fashion that

is often underplayed – the limitations imposed on *it* by the body. For despite having, over centuries, successfully altered, restricted and manipulated the natural form and surface of the human body, in lived reality fashion's authority is tempered by the raw materials of a human physiology that continues to put up a degree of resistance to its aesthetic whims. But since the earliest fashion photography, the faults of nature have been modified by retouching and airbrushing, techniques that have brought the body more into line with the fashionable ideal than that ever achieved by, for example, corsetry and cosmetics. This has produced the common charge against fashion imagery that it imposes unrealistic aesthetic standards upon women and then encourages acts of imitation. However, in the era of the "lunch-time facelift," it could be argued that, as the "real" body gets closer to the ideal of airbrushed humanity, the influence works in the opposite direction, giving fashion representation the impetus to push the limits of preservation in order to maintain an unattainable level of perfection.

Accordingly, the intensified artifice of the synthetic ideal could be seen as a determination to maintain an aesthetic that is beyond the reach of the corporeal world. It contrasts, for instance, with the way digital manipulation of the image is practiced in the mainstream fashion (and general) press where its use has become so standard that it is no longer particularly obvious. Here the hyperbolic artifice that I identify as being the hallmark of the synthetic ideal rarely appears. Instead of unsettling with its strangeness, intensifying the impression that models belong to a different species than us (sometimes literally another species, as Paul Jobling has written), the conventional perfection aimed at in these images, despite the artifice, appears normal and (possibly) attainable. However, at the cutting edge of fashion photography the appeal of computer imaging lies more in the potential it offers to create something that is beyond the reach of lived reality. For fashion, digital technology offers the artistic freedom to invent something that does not already exist.

This potential is of course already inherent to fashion. As we have seen, long before the invention of Photoshop, Focillon describes fashion as not passively decorating the formal environment but as *being* that environment; the body is not only adorned, it *is* the adornment. In Focillon's formulation of an artificial humanity, the creative control lies with fashion – but with strictures. With the synthetic ideal, any limitations imposed by the body's physiology are removed. As discussed here, this is made possible by employing techniques of photographic manipulation. However, on a metaphysical level, the genesis of the synthetic ideal can be traced to the nineteenth century where the new material conditions of industrial capitalism oversaw a shift in the relationship between the body and clothing from the eighteenth-century principle of "body as mannequin" – where dress worn in public was unrelated to the body or the character of the person wearing it – to one of an intermeshing of self and clothing (Sennett 1974).

Confronted by the phantasmagoria of commodities in capitalist modernity, Marx would write of the inversion of the social order between humans and things. He linked this to the system of commodity production that fetishized the mass-produced article, transforming it "into an idol that, although the product of human hands, disposes over the human" (Otto Rühle quoted in Benjamin 1999: 181). A contemporary of Marx, the illustrator Grandville brilliantly captured such commodity fetishism in his lithograph from 1844 titled, "Fashionable people represented in public by their accoutrements" (Figure 35.1). It shows a gathering of anthropomorphized

Figure 35.1 Grandville, *Fashionable people represented in public by their accoutrements*, 1844, *Un Autre Monde*. Courtesy of Michael Carter.

coat-stands, oversized hats, canes, high-top boots, and frock-coats engaged in polite conversation with some parasols, bonnets, feathers, blouses and shawls. They are escapees from the *magasins de nouveautés* of the Parisian shopping arcades, unmoulded by customers' bodies but still confident in their *tenue*, suggesting a world where the categories of animate and inanimate, organic and inorganic are confused. Here, cloth and leather have displaced flesh and bone, and being human is an irrelevant prereq-uisite for social intercourse.

Taking off the body

A fashion editorial by the photographer Phil Poynter, originally published in *Dazed and Confused* in 1998, revisits the theme suggested by Grandville's polite gathering of accoutrements a century and a half before. "I Didn't Recognize You With Your Clothes On" is a literal interpretation of the proposition posed by Susan Buck-Morss in her book, *The Dialectics of Seeing*. Referring to Grandville's illustration, she asks, ". . . what is it that is desired? No longer the human being: Sex appeal emanates from the clothes that one wears" (Buck-Morss 1989: 100). In the late twentieth-century version, the representation of bodiless clothing has progressed from casual conversa-tion to casual sex: fellatio on a train; sex in an anonymous bathroom; a male client in a bespoke suit, bowler hat and monocle observing a dominatrix and her female submis-sive in a hotel room; and a post-coital cigarette amid the weeds on the edge of a hous-ing estate. In each scenario, the characters are dressed according to easily identifiable

codes that place them in a social tribe or milieu. The kids in the train sport baseball caps and hooded jackets, their expensive street wear is box fresh, the couple in the bathroom is dressed in designer minimalism and the S&M/B&D participants wear upmarket versions of all the usual clichés. The "lovers" in the weeds are the only ones to have bothered undressing and lie "naked," surrounded by their hastily discarded garments. Not a single identifying accessory or item of clothing is missing or out of place. However, what *is* missing are the bodies, which have been digitally manipulated out of the frame so that only the outline created by what they are wearing remains, leaving the impression that the clothes can perform quite adequately without a human presence.

These images display an impressive technical skill of what is possible in the realm of digitally manipulated photography while simultaneously filling the conventional brief of the fashion photograph to be "new" and show the clothes. "I Didn't Recognize You With Your Clothes On" also tacitly invites a questioning of the fashion-image genre, addressing complaints regarding the use of overt erotic or pornographic references and the objectification of the (female) body in fashion photography. Even if its parodic tone means that it does this only insincerely, the mise-en-scène of the images does inevitably recall the work of photographers who have put sex and sexual perversion at the centre of the frame. To some extent then, Poynter disrobes the thinly veiled possibilities of such fashion photography. But more apparent in these images than the referencing of (or commentary on) a particular style of fashion photography is a sense of boredom surrounding the representation of the body. A fatigue perhaps brought on by the breaking down of any taboos associated with sex, or perhaps by a saturation with images of the human figure. This could particularly apply to fashion photography which, with its limited codes and repertoire, is so familiar a genre that the body is no longer needed in order to display clothes, ostensibly rendering the model obsolete. However, it is precisely because the body is so familiar that it is never really absent from the frame; if it cannot actually be seen, it exists at least as a memory. In most of the shots the clothes are moulded by an invisible human form and when this disappears, as in the last shot, the clothes lose their identity (rather than bestowing it), becoming indistinguishable from half-finished garments on a clothing factory floor. Because of this, despite its explicit sexual nature, the modern version of "Fashionable people represented in public by their accoutrements" is less radical than the original, evincing a dependence upon the body that the consumer items drawn by Grandville do not betray.

Nonetheless, Poynter's photographs are a vivid representation of the determination by the fashion object to exist independently of and dominate the human subject. Even though the familiar outline of the body remains more or less intact in these images, the absence of any actual body symbolizes a disregard for the organic body, paving the way for the possibility of a reversal of the notion that it is the body that takes off the clothes – rather, it is the clothes that have removed the body. Once this has occurred, the original frame around which fashion has been constructed for most of its history can be discarded and any organic realities of the human body ignored. The fashion object is thus left free to recreate an ideal humanity according to its own desires and tendencies, moulding the body out of a fabric more amenable to fashion than flesh. Ultimately, reconfiguring the human form itself into fashion.

Body as garment

In the preface to their book *Fashioning the Frame*, Alexander Warwick and Dani Cavallaro ask: "Should dress be regarded as part of the body, or merely as an extension of, or supplement to it?" (Cavallaro and Warwick 1998: iv). There is, they suggest, no definitive answer to this question; rather the boundaries between the "self and other, subject and object, inside and outside" are permeable and unfixed, always under a relentless process of review. Body and clothing are not separated or sealed off by some inviolable barrier but are "regions to be playfully traversed," so that each "is continually in the process of becoming otherwise" (Cavallaro and Warwick 1998: xviii). However, in the synthetic ideal, the process of playful interaction between clothing and body described by Warwick and Cavallaro is arrested and the uncertainty over the demarcation of a constantly fluctuating border is removed. In its place the (provisional) boundary, ostensibly dividing body and clothing, is permanently dissolved and the fusion of self and other, subject and object, inside and outside, animate and inanimate, organic and inorganic becomes complete.

In another collaboration with Alexander McQueen, this time for the Spring/ Summer 1997 collection, "La Poupée," Nick Knight created an image for *Visionnaire* magazine using a metal brace that manacled the arms and legs of the wearer firmly in place. (The same brace was worn in McQueen's catwalk show by the black model Debra Shaw, with a vastly different effect to the one discussed here.) Titled "Laura de Palma" (a reference perhaps to the girl whose plastic-wrapped body was found dead at the beginning of David Lynch's *Twin Peaks*), it is a picture of a naked, blonde, blue-eyed model who lies supine in a murky void, her legs held open by the metal frame and manacles, which also fix her arms in a welcoming gesture of embrace. Her eyes are open but lifeless, staring out from an expressionless face. Her skin has a yellowish tone and is plasticky with a waxy sheen. In keeping with her likeness to a combination of sex doll and shop mannequin, her pubic area is air-brushed into Barbie-doll impenetrability, effectively denying the carnal sexuality of this body. However, if her purpose as a sex object is thwarted, her purpose as a fashion object remains unquestioned. Although completely naked, she is "dressed" in a fashionably svelte frame that is strikingly accessorized by feet that taper down to form a ten-centimeter stiletto heel. The fashion object has now become an inseparable part of her body. Such a body no longer carries the characteristics or signs of the biological human; rather, its qualities have become indistinguishable from those of fashion.

Once the fashion body is transformed into the same substance as that of the fashion garment, the human body can be treated like the material of clothing and henceforth cut, shaped, pasted and stitched in any imaginable way. In "Total and Fatal for You," a 26-page, black and white editorial sequence that appeared in the September/ October 2001 issue of *Dutch* magazine, Alexei Hay explores what fashion can do with the body once it possesses the intrinsic properties of the garment. By using a mirror affixed to the lens of a black and white enlarger, Hay produces an effect that treats limbs, torso and head like scraps of fabric, patch-worked together to create kaleidoscopic forms. One image shows a model wearing a Thierry Mugler leopard-skin bodysuit and an Imitation of Christ skirt. She sits in a mountainous desert landscape, gloved hands clawing a rocky outcrop. Arms, fingers and legs are recognizably human

Figure 35.2 *Total and Fatal For You*, 2001. © Alexei Hay.

but this is not a body as we know it — there is no head and the mirroring of the image, cut down the middle, transforms the torso into a carapace and doubles the limbs to eight (Figure 35.2). This synthesis of fashion and body has produced something that could be described as a hybrid from the natural world (a leopard-skin spider?), but it is not natural. Like many of the other manipulated images in the sequence, it comes into being only as a figure from fashion's imagination.

One of the possible reference points for the mirrored images in "Total and Fatal" is the fetishistic work of the surrealist photographer, Pierre Molinier, who merged bodies together to create figures of multiple limbs and multiple entrance points. The result is a carefully orchestrated mélange of bare breasts, splayed legs and welcoming buttocks. Hay's models also are transfigured into fragmented forms, duplicated bodies contorted into positions of defenseless submissiveness, floating above the viewer as if appearing in a dream. However, the most persistent referencing of female sexuality in the series is provided by a vulva-like symbol which is either carved into the clothing of the model or, more often, formed by the configuration of the model's body in the landscape (Figure 35.3). In these images the fetishization of the body as sexual cavity is absolute; abstracted vulvas emerge out of the folds of clothing, the arrangement

Figure 35.3 *Total and Fatal For You*, 2001. © Alexei Hay.

of the body and even in the formation of the clouds. But unlike Molinier's figures, which are explicitly penetrable, Hay's are closed off. Despite their nudity – partial or suggested – and the sexually charged content of the images, they signify less as erotic or pornographic than most conventional fashion photography. This is underscored in "Total and Fatal For You" where the mirrored images are juxtaposed with "straight" fashion shots that use the conventions of porn (the come-hither look, baby-doll dress paired with high heels and stockings, legs spread open, the flash of panties or buttock cheeks, or a sultry, teenage gaze through tousled hair) to emphasize what is nearly always present in fashion images – the intimate relationship of the clothing to the naked, penetrable body that lies beneath (Figure 35.4).

The contrast between the two styles of images in "Total and Fatal For You" underscores the notion of the synthetic ideal as a body that no longer signifies as corporeal. On the one hand, we are reminded of the tantalizing suggestion, intrinsic to all clothing, that the garment can be peeled back to reveal more. As Barthes noted in

Figure 35.4 *Total and Fatal For You*, 2001. © Alexei Hay.

The Pleasure of the Text, "Is not the most erotic portion of a body where the garment gapes?" (Barthes 1976: 10). But in the synthetic ideal the erotic allure, the fascination of the fragment, the slice, the cut, the seam of the body is removed. Expectations are thwarted. The technique used in "Total and Fatal For You" of the mirror image exemplifies the self-containment of these bodies. Unlike the penetrable collage-body created by Molinier, in Hay's figures substance runs up against itself; it is a completely enclosed system. Not only is the "gape" of the garment sealed but there is also no "gape" of the body. Despite their sexual explicitness, these bodies are hermetically sealed, incapable of being penetrated. The biological reality that pornography relies upon is removed as everything organic is collapsed into the sign system of fashion.

Fashion's imaginary

"Total and Fatal for You" represents what fashion can do when its reign over the body is absolute and it is free to make of the clothing and body combination "a pure fantasy of shapes." Here we are witnessing a reversal in the "natural" order of creation, a shift in the hierarchy of human beings and things. In the synthetic ideal fashion fulfills the dream, already familiar to humanity, of "increased plasticity, an ur-state in which the world becomes totally malleable" (Carter 1997: 3). In the images described above, fashion turns this impulse back on a humanity that considered itself as *homo faber* – a maker of things. In the synthetic ideal it is "humanity" that is being made by the object. There can be no doubt as to the narcissism of fashion's project. The synthetic ideal is an image of fashion incarnate; that is, fashion presumes a "bodily" form even as it rejects the material biological substance of that body as irrelevant. By replacing the characteristics that make the body belong to the sign system of the natural order with those of fashion, the synthetic ideal then is the apotheosis of fashion and from its deified position it creates an avatar of itself. That this occurs only within the realm of the image – an admittedly reduced "world" from the point of view of humanity – is not an admission of defeat. The image could be considered as the epicentre of existence for fashion; not only does the publishing of fashion imagery rival the fashion industry itself, but the banks of photographers at each seasonal showing are the privileged audience for whom the models perform, their flashbulbs operating with a gravitational pull on the model as she proceeds in her orbit around the catwalk. Without the image as validation, fashion's launch risks being stillborn.

But given that the synthetic ideal does not exist prior to the image, rather only coming into being *inside* the realm of the image, it can be construed as not just a *product* of human imagination but as an embodiment of imagination itself. More specifically, considering the digitally manipulated image as a crucible where elements are "seamlessly altered, blended and mixed together," it mirrors the machinations of imagination as described by Coleridge. In his famous definition of the two modalities of imagination – primary and secondary – he holds primary imagination to be fundamental to human perception and a "repetition in the finite mind of the eternal act of creation in the infinite I AM" (Coleridge 1965: 167). Secondary imagination he considers as an echo of the former, differing only in degree and mode. He writes:

> It dissolves, diffuses, dissipates, in order to recreate; or where this process is rendered impossible, yet still at all events it struggles to idealise and unify. It is essentially vital, even as all objects (as objects) are essentially fixed and dead.
>
> (Coleridge 1965: 167)

Before considering the implications of this citation in full, the point can be made that the description of secondary imagination as dissolving, diffusing, dissipating in order to recreate sounds remarkably like what, in the preceding pages, I have suggested is happening in the synthetic ideal. This impression is reinforced by Coleridge's discrimination between imagination and its important but minor form, fancy. The distinction here seems to rely on the absence, in the case of fancy, of this alchemical process. In fancy, the elements come together but the traces of the joining remain visible, it is a

concatenation or what Michael Carter vividly describes as "the Frankenstein effect." Imagination, on the other hand, is a reformation that "obliterates" the differences between these elements: "its aim is fusion and seamless unity" (Carter 2000: 53). It would seem then that "fancy" describes the relationship between the body and clothing in the conventional fashion image (where the two elements maintain a degree of heterogeneity) while the equation of body and clothing in the synthetic ideal could legitimately be described as "imagination" – the originating force of which is fashion.

Imagination for human beings helps us make sense of the world, essentially by "remaking" the world. In the section on the dandy in Baudelaire's "Painter of Modern Life" essay, it is suggested that through art or, failing that, artifice one could rewrite the metaphysical world. By overcoming the state of nature, one emulates the original creator, maybe eventually replacing "the original presence of divine being" (Kearney 1988: 96). In the world of "us," of human beings, sartorial art is but one of the ways in which we achieve this goal. But if the "universe" is – like the one currently under observation – tailored by and limited by that art, then the cosmic schema will consist of that which is significant for and to fashion. Bearing this in mind, we can now approach what could be called "fashion's imaginary." The imaginary, as the French aesthetic philosopher, Mikel Dufrenne, makes clear, is not a term that is to be interchanged with imagination, nor is it created by imagination. Both these points are crucial. The distinction between the two terms – imagination and the imaginary – can be determined along a chronological axis; put crudely, imagination can be conceived of as something that takes place *after* the constitution of the mind, whereas the reformulations undertaken by Dufrenne are such that the imaginary is made into something which is anterior to the fully constituted mind. Although this suggests an *a priori* existence, it is not to be thought of as an alternative formulation of the Platonic idea, for the imaginary can be expressed, it can "exist." On the other hand, neither is there a straightforward relation between the imaginary and representation.

As construed by Carter, in Dufrenne's construction of the notion, "Art is not simply a function of representation (which would mean that at base it was a product of the mind), but it is rather an active transformation of the sensuous materiality of the world" (Carter 2000: 60). In this there is something of French philosopher Gaston Bachelard's notion of the "material imagination" – inherent to things is a potential for transformation. If we consider the synthetic ideal as an extrapolation or intensification of the conventional fashion image but with all restraints removed, the imaginary of fashion, then, might reveal the aspirations of fashion – the completion of something that was straining to be but was stopped from being realized. It is not that fashion's imaginary represents the achievement of a final, perfect form; rather, it is the realizing of a form that announces the idea of a continual becoming. In the synthetic ideal, fashion operates like imagination; the processes that create the synthetic ideal are analogous to the processes of fashion. What emerges from this is an avatar of fashion, a supreme form to which fashion has been striving – fashion's imaginary. But this is not a form that remains stable; it is a mode of being that has moulded the stuff of its world into a form that is continuously malleable. The traces of its alterations, its re-creations, are invisible, seamless; there is no "Frankenstein effect." Nonetheless, our familiarity with the body – the original, "natural" body – is such that these alterations do not go unperceived and therefore carry the idea or possibility of continual alteration.

I want at this point to return to Coleridge's definition of secondary imagination, which was earlier left hanging. In addition to the operations of dissolving, diffusing and dissipating in order to recreate, he also describes secondary imagination as being "essentially vital, even as all objects (as objects) are essentially fixed and dead." It is here that the metaphysical parallel of imagination and the synthetic ideal can be traced back to the originating force of fashion. In his essay in *Imaginary Materials*, Rex Butler observes the irony of "'plasticity' – metamorphosis itself" becoming the new ideal (Butler 2000: 43). But one could counter that for fashion, "plasticity," metamorphosis has always been the ideal; it is fashion's currency. Fashion's metamorphoses – its endless manifestations as a new source of newness – are what ensures its continuation as a system and allows us to speak of it as immortal. However, fashion's immortality, as Ulrich Lehmann has pointed out, "is of a particular kind, as it instantly dies when picked up by society and becomes resurrected at the very next moment in order to restart the cycle" (Lehmann 2000: 275–276). This interplay of mortality and immortality is fashion's metaphysical coinage, allowing it to perform an ontological sleight-of-hand – without any formal change the fashion object both "is" and "is not" fashion. In contrast to the fashion object, formal change (or, at least, the idea of formal change) is essential in the body of the model. In the synthetic ideal the body itself is moulded and transformed, drained of all that is natural or organic, its metamorphosis happening, in a sense, before our eyes. This tendency is an intensification of something that is present, but held in check in the conventional fashion image.

Conclusion

It is here, finally, that we can speculate beyond the immediate concern of this article to ask why fashion, apparently content to entertain a multitude of created forms in the body of the model, is so resistant to the multitude of actual bodily forms that exist beyond the parameters of its image world. Why does it not respond to those critics and observers who ask where are the non-slim, the non-young and those who are not able-bodied? Certainly, in part, the answer lies in fashion's industrial base, the realities of the market-place and an economy of desire. But it is also the case that fashion cannot incorporate all body shapes in a gesture of politically correct egalitarianism. If fashion were to allow the body to take over, to be just anything, any shape, any age, it would have no power. The sign of its authority – artifice – would fade. The point here is that fashion does not supplant the natural body with an ideal body but with an imagined one, one nearer to it's "heart's desire." In the synthetic ideal we witness, on the body of the fashion model, fashion's metamorphosis, "a world made malleable by imagination." If fashion were to forsake these transformations it would face the same fate as if it were to respond to those critics who ask that it arrest its interminable permutations and settle for one perfect form. By imposing its economy of perpetual alteration on the body of the model, it ensures that it will not suffer the fate of other despotic regimes that have allowed hubris to make an enemy of change; eternally changing, it will not atrophy, it will not fossilize, it will not die.

Original publication

'The Synthetic Ideal: The Fashion Model and Photographic Manipulation', *Fashion Theory* (2005)

References

Barthes, Roland. 1976. *The Pleasure of the Text*. London: Cape.

———. 1983. *The Fashion System*. Berkeley and Los Angeles: University of California Press.

Bataille, Georges. 1985. "The Deviations of Nature." In Allan Stoekl (ed.), *Visions of Excess: Selected Writings, 1927–1939*. Minneapolis: University of Minneapolis Press.

Baudelaire, Charles. 1995. *The Painter of Modern Life and Other Essays*. 2nd edn. London: Phaidon.

Benjamin, Walter. 1999. *The Arcades Project*. Cambridge, MA and London: Belknap.

Buck-Morss, Susan. 1989. *The Dialectics of Seeing: Walter Benjamin and the Arcades Project*. Cambridge, MA and London: MIT Press.

Butler, Rex. 2000. "The Interval in Carter." In John Macarthur (ed.), *Imaginary Materials: A Seminar with Michael Carter*. Brisbane: IMA Publishing.

Carter, Michael. 1997. *Putting a Face on Things: Studies in Imaginary Materials*. Sydney: Power.

———. 2000. "Notes on Imagination, Fantasy & the Imaginary." In John Macarthur (ed.), *Imaginary Materials: A Seminar with Michael Carter*. Brisbane: IMA.

Cavallaro, Dani and Alexandra Warwick. 1998. *Fashioning the Frame*. Oxford and New York: Berg.

Coleridge, Samuel Taylor. 1965. *Biographia Litteraria*. London: Dent.

Dufrenne, Mikel. 1987. "The Imaginary." In Mark S. Roberts and Dennis Gallagher (eds.), *In the Presence of the Sensuous: Essays in Aesthetics*. Atlantic Highlands, NJ: Humanities Press International.

Entwistle, Joanne. 2000. "Fashion and the Fleshy Body: Dress as Embodied Practice." *Fashion Theory*, 4(3): 323–348.

Flügel, J. C. 1933 [1934]. *The Psychology of Clothes*. London: Hogarth.

Focillon, Henri. 1989. *The Life of Forms in Art*. New York: Zone.

Hegel, Georg Wilhelm Friedrich. 1975. *Aesthetics: Lectures on Fine Art*. 2 vols. Oxford: Clarendon.

Hollander, Anne. 1975. *Seeing through Clothes*. Berkeley and London: University of California Press.

Jobling, Paul. 2000. *Fashion Spreads: Word and Image in Fashion Photography since 1980*. Oxford and New York: Berg.

———. 2002. "On the Turn–Millennial Bodies and the Meaning of Time in Andrea Giacobbe's Fashion Photography." *Fashion Theory*, 6(1): 3–24.

Kearney, Richard. 1988. *The Wake of Imagination: Toward a Postmodern Culture*. Minneapolis: University of Minnesota Press.

Lehmann, Ulrich. 2000. *Tigersprung: Fashion in Modernity*. Cambridge, MA and London: MIT Press.

Sanders, Mark, Phil Poynter and Robin Derrick (eds.). 2000. *The Impossible Image: Fashion Photography in the Digital Age*. London: Phaidon Press.

Sennett, Richard. 1974. *The Fall of Public Man*. New York and London: W. W. Norton.

Simmel, Georg. 1997. "The Philosophy of Fashion." In David Frisby and Mike Featherstone (eds.), *Simmel on Culture*. London: Sage.

Wilson, Elizabeth. 1985. *Adorned in Dreams: Fashion and Modernity*. Berkeley: University of California Press.

Ulrich Lehmann

CHIC CLICKS
Creativity and commerce

FASHION ONLY EXISTS IN REPRESENTATION. Not simply as cut and sewn pieces of fabric that are draped around the human body and transformed from static objects into a relationship with an acting, moving subject, but, more significantly, as fashion proper – as the latest stylistic trend, the most recent ideal of sartorial beauty. Fashion exists because it is represented as fashion. Clothing is elevated from its material properties to an aesthetic idea through its representation as an image in the media. It is only through this process that most clothing can become fashion in the first place. And the most common agent in this process is fashion photography, as the ubiquitous representation of garments in advertising and journalism.

Over the past decades, through a continuous proliferation of fashion photography and the growing number of magazines devoted to the representation of clothing, fashion has shifted in its historical, social, and aesthetic meaning. Developing from its original function of clothing and accessorizing the body, fashion has become an autonomous cultural object with its own structure, language, and system of signification. The original perception of haute couture as akin to a fine art has lessened and fashion has now liberated what it signifies to such an extent that its critical assessment stands apart from psychological, sociological, or art-historical modes of interpretation. One further consequence of this development over the past four decades or so has been the change in the perception of fashion photography. After quickly surpassing illustration and written descriptions of the latest clothing, fashion photography has been the dominant mode of representation within the production, distribution, and commodification of fashion for quite some time.

Recently, however, fashion photography has become all the more significant for the fact that these pictorially represented clothes have come to equal real garments in their cultural importance. The mediation of fashion now conflates with its creation and consumption. The representation of fashion is more readily accessible and easier to consume than the actual garments themselves, that is, as touched, draped, or worn. We now see clothing as images and not necessarily as made of fabric, cuts, seams, and

fastenings. Such a dominance of a garment's media image over the actual product might seem to underscore the fact that fashion photography is firmly rooted in the mirroring and promotion of clothes and accessories for the sole purpose of ever-growing public relations and sales. But contradicting this materialist reasoning, fashion photography is increasingly treated on a par with contemporary works of art; where it is consumed like autonomous art objects, largely unconnected to the manufacture and sale of clothing and accessories. The fashion photo is elevated from visual description or illustration of clothing to a significant interpretation and creative vision. Thus it increases its proximity to contemporary art as reflecting and debating social and cultural issues.

This perception of fashion images as works of art inverts the historical shift of fashion itself from exclusive haute couture to ready-to-wear clothing for the mass market. When creations in (Parisian) high fashion came to be recognized at the end of the nineteenth century as somewhat autonomous works of art (not unanimously, of course, since fashion continued to be seen essentially as a craft or industry), their representation had to follow suit in terms of sophisticated depiction and luxurious context. From the 1910s onward, colored and hand-printed magazines in limited editions featured artful drawings of the latest haute couture creations, while the straightforward photographic documentation of styles in cheap black-and-white was largely confined to magazines for the middle market, where the diffusion of creations from high fashion were mostly depicted.[1]

The character of the fashion industry as essentially split into high and low fashion did not change for some decades, but in the 1960s, with the advent of innovative ready-to-wear clothing that was independent of haute couture or alta moda, a shift occurred from the exclusive center of fashion to its contemporary and progressive margins (still designed but mass-manufactured). The claim of fashion to the status of fine art lost its currency and, accordingly, the ubiquitous photographic representation of clothing in widely distributed publication neither wanted nor could claim cultural parallels with works of art. As fashion photography has come to interpret mass-produced clothing (although in the postwar years mainly exclusive, designer wear), its relationship with fashion has finally become inverted, since it is now not the object but its representation that is seen as artistically covetable and elevated within the cultural hierarchy.

Structurally speaking, this inversion might be nothing more than another instance of the shift from real function to spectacle, from material substance to media commodification, as had been postulated by sociologists at the end of the 1960s. But the shift is not merely a structural one that propels the commodification and consumption of culture; it is also a culturally pertinent one in itself. When the mediation of fashion increases at a greater rate than the actual production and distribution of clothing, its significance for society and culture has to undergo a shift, too. As I will argue, it is the unique position of contemporary fashion photography, both in regard to its production but also in relation to contemporary art, that distinguishes its rhetoric, interpretation, and its ultimate effect on culture itself.

Production I: the photographer

Fashion photography, in presenting the essentially material expression of the human body through clothing, operates in a very ideological manner. It depicts the commodification of women and men through a system of sartorial signs that only function

within an accepted material and aesthetic system: you have to be "properly dressed" and not appear "old-fashioned." Consequently, one would imagine that such an ideological viewpoint of fashion requires its representation through editorial and advertising photography. However, the gesture of the fashion photographer is actually free to a surprising degree. With the loss of the descriptive requirements of fashion images and the ascendancy of an artistic representation of garments, perspectives on fashion ceased to be prescribed. Full-length shots to show the outfit, naturalistic lighting to heighten details, or a distinct focus to distinguish the designer's vision are no longer in demand. The representation of dress is now ambiguously left to the photographer, and the manipulation of the subject of the photo (the dress, suit, etc.) becomes, to some degree, postideological as the choice is no longer made solely according to cultural ideology but to the medium (the camera) by which the product is produced. The fashion photo is no longer required to be indicative, it does not have to present the work of the designer like an anthropological specimen. Nor does it need to declare the depicted fashion to be a social requirement as the idea that particular garments are required on certain social occasions has broken down considerably – although the general following of trends, the being "in fashion" as such, is of course still imperative.

I have argued so far that fashion photography claims an artistic high ground due to the autonomy of its images. It does not simply depict clothes objectively as coveted products of conspicuous consumption, but rather declares the very image of the garments-translated in the photo-as constituting their value. It therefore implicitly advances its own cultural status. In an ideal situation, creative fashion photography (and here we are not talking about mail order catalogs or catwalk documentation) could be said to share the same diversity of approaches as fine art, as the fashion photographer, strictly speaking, suffers the same creative anxiety or doubts as any artist over his or her perception of the object and, moreover, now shares virtually the same audience. The fact that the end product might betray a hackneyed, commonplace representation of clothes, for example the cliché of a backlit transparent evening gown revealing the model's body, does not detract from the principal liberation of the image. It indicates creative shortcomings rather than structural restrictions.

Historically, photographic images have been regarded as representations that have abstracted what was traditionally painted imagery, which in turn had abstracted the real world. In a similar process of shifts, the fashion image abstracts the designer's vision of his or her sartorial creation, which has abstracted a physical or sociocultural ideal through tailoring. The object in the fashion photo has therefore already undergone a primary transformation from idea to material before the secondary transformation (through photography) turns it back into an aesthetic or conceptual idea. This, of course, does not work with clothes that have an explicit purpose or signifier, like battle dress or a nurse's uniform, but only with clothing where fashion is implicit: garments in which the stylistic experiment outweighs, to some degree at least, its practical use.

Production II: the model

In fashion photography the object is either the model – who is reified, commodified and, at times, objectified – or his/her simulacrum, the clothing or accessories that are meant to clothe the human figure. The contrast, dependency and interaction

of the photographing subject and photographed object are constantly played out in many variations. Depending on individual perception these variations can appear for example as the sexual exploitation of the female model by the male photographer (the tradition of "men shooting women," or increasingly relevant in contemporary fashion photography depicting men's wear, as "men shooting boys") or as the abstraction of the body into a system of signifiers that is indistinguishable from the garments adorning it.

The fact that the body is the exclusive object of the photographer, yet that, unlike in photos of nudes, this body is alienated by the references of the clothes that provide the reason for the photo in the first place, renders fashion photography a dialectical body itself. It represents at the same time index and icon, it shows simultaneously the body and its disappearance behind a complex system of signification; a nonbody that only exists as a constantly updated simulacrum. Such a body, despite its outward fetishization through gender-specific (although sometimes unisex) clothing, is devoid of sex. It is ritually eroticized into an image of sexuality that bears no relation to the sensual body. On the contrary, sensuality is created through clothes and this in turn provides a visualization of the internal logic that governs fashion design: the body itself can acquire beauty (and sexuality) not through its own expression but only via its cultural signifiers.

The body in its "natural" (i.e., naked) state is asexual in fashion photography; only through the addition of commodified fashion does the body obtain sexuality within the image. This, by the way, is not equal to the old chestnut that (partially) clothed bodies are more erotic than unclothed ones, since the erotic imagination of the beholder is not necessarily required in fashion photography. Its concern lies with the construction of a sensual image through material objects. The imagination cannot undress the model, otherwise the detailed codification in the image would vanish and we would be left with the photo of a nude. If the undressing is part of the imagination, it is only because the beholder wants to wear the model's clothes him or herself.

The body's disappearance behind this system of signification brings in its wake a notion of beauty that is distinct from the original ideal of a "natural" beauty which is determinable and quantifiable (as, for example, in the Renaissance or neoclassicism). The structuralist Roland Barthes proposed in his book *The Fashion System* three ways in which the passage from abstract body to real body takes place in fashion through its consumer – be it reader, spectator or client. First we see the model whose body provides an "abstract form" which nevertheless must appear as an individual. The model's body possesses "a formal generality" without attributes. She becomes therefore literally deformed – save for the clothing that individualizes her through commodification. Yet the clothing that envelopes her is not responsible for signifying a full or slim body, but on this de-formed body the fashion signifies itself in its own generality. The model's body, however contemporary in appearance it might be, carries the sign of fashion like an albatross around her neck. Interestingly enough, this means that the link between fashion as an abstract institution and its most recent expression, its reality, is produced by the fashion photographer. Secondly, the passage from abstract body to the real body is provided through the constant updating of what constitutes the "fashionable" figure. Fashion photography, in following the suggestions of the fashion industry about the latest figure, measurements and proportions, declares a new beauty each season; a beauty that is fugitive, ephemeral and insubstantial, yet exerts

a powerful hold on corporeal ideals, often perceived by the spectator only through the mediating and distorting eye of the camera, yet nevertheless copied through the consumption of clothes, accessories, makeup and hairstyle. And this then provides the third passage from abstraction to reality: the transformation of a general "public" body through fashion itself. By deforming, actualizing and individualizing the human figure through garment and accessory, fashion manifests strange dialectics: the individualization of the body is only possible through wearing a generally accepted fashion, removed from the individual to a wider public and implicitly shared by all the readers of the magazine who regard the fashion photos.[2]

What German sociologist Georg Simmel, at the beginning of the last century, termed the "tragedy of culture," namely that the object, especially in its guise as commodity, dominated the subject and began to determine social and cultural development as a whole, finds its apotheosis in contemporary fashion photos where the subject is — literally — a mere model for its disappearance behind the fashions that adorn and conceal it.

Rhetorics I: gestures

In the fashion image a rhetoric of gestures and postures takes over, to present an empirical version of the body. Not only is the body abstracted but individual action is theatricalized, frozen into suspended movement and often barely perceptible in the folds and creases of the garment.

The rhetoric of most fashion photography is impoverished — much like the commonplace in fashion journalism and repetition in its captions and headings. The somewhat clichéd language, however, leads to an ambiguous formalism in the fashion image. We expect a distinct vocabulary of gestures to which we have become accustomed so as to present the garment, any garment, in its most favorable state. Arms crossed in front of the lap are used for low-cut décolletées, legs in the manner of the Greco-Roman contrapposto are employed in dresses that end above the knee, sucked-in cheekbones and pouting moist lips are ubiquitous, as are half-closed eyelids. Such platitudes open an easy access to reading the image. The gestures and posture do not obstruct the fashion. Their artificiality creates a limited language that at the same time projects a cultural and commercial universality through a shared interest in these very seasonal and trend-specific clothes. Barthes observed that within the fashion image everything that is not the clothes "is exorcised, rid of all naturalism: nothing plausible remains but the garment." As we have seen above in discussing the model, all traces of nature are erased through makeup, hairdo, and styling. Curiously, this also applies to the recurrent move toward very "natural," apparently unstyled fashion photography, where a seemingly unkempt model is shot in a haphazard, deliberately crude manner. Yet, again, such an effect is calculated, as it always responds to a prevailing trend that opposes glamorous "high" fashion and favors an alternative look. Here also the confines are drawn up beforehand, the apparently natural or casual look is carefully constructed and elaborately performed — often testified by the captions that credit stylists and makeup artist for what appears to be an entirely random shot of an unconventional-looking person or model.

Moreover, the traditional distinction between realism and idealism is passed over in the gestures and postures of fashion photography, as it represents neither the real

world nor an aesthetic ideal. This is partly due to the fact that the technical limitations of the camera determine the possibilities that are open to the artist. But realism – or should this read naturalism? – is eschewed in the frequent manipulating in the dark-room or digitalizing in the computer, to heighten a shifting ideal of beauty. However, as we have observed, this ideal is not overtly ideological, because the presentation exists in a deliberate vacuum, designed to appear free from social or economic reality. If we agree that the fashion photo is ideologically free in regard to its frame of refer-ence (fashion proper) and we continue to regard photos in general to be codified, then we can conclude that numerous "realities" exist independently within each image, either as artificial products of a studio environment or as fantasies to further their own commodification. The ritualized gestures and postures allow us to accommodate such unreal realities within our experience and participate in their consumption.

Rhetorics II: the narrative

One of the most distinctive features of fashion photography is the narrative. The series of images within a fashion magazine editorial or the succession of advertisements for a company or product (either following each other in one magazine or appearing in variations over the course of a season or campaign) distinguishes the fashion shoot from the single commercial pictures in food or car ads. The editorial in particular is fashion's characteristic device to invent and construct a story around clothing. This story can have a conventional, linear syntax (i.e., beginning, development, and end-ing) or it can consist of repeated variations on a theme. In order to understand fashion photography it is important to recognize the significance of the narrative.

Historically the pictoral narrative could be said to go back to the images d'Épinal – fairground popular pictures that were meant to illustrate a story or provide a moral tale. In fashion editorials for magazines such a moral is at times reduced to a mere exclamation of "buy mel" but serial fashion photos can also deal with the evolution of a character. In keeping with our observation of artificiality and anti-naturalism in fash-ion photography, this evolution often refers to the garment rather than to the actor or character of the model. The old-fashioned way of telling a straightforward story of a model's metaphorical (or actual, depending on the season) journey or erotic exploits has been replaced in recent decades by a scenario in which the clothes undergo a series of transformations to eventually reach a goal or destination – that is ultimately their consumption and their transformation from the picture plane into the realm of the commodity. Therefore a substantial shift occurs from the narrative identification with the model to the narrative identification with the object.

In its essence, the narrative in a series of fashion photos is distinct from the autono-mous image of the single work of art. The populist character of fashion photography's origins and consumption sets it apart from the greater mental effort which is required by the spectator to understand and appreciate the metaphoric qualities of a single art work. The fashion photo's metaphors or its symbolism are not independent, they often rely on a series to explain contents and character. Consequently, there is no attempt to elucidate or represent through one image alone; the relation to other images of the same series is needed. For an editorial this also implies that one garment or outfit needs its relation to other clothes within the series to justify its appearance. The individual

item therefore enters into a complex relationship with other items, and the series of fashion images essentially constructs a syntactical world of its own where the sartorial elements simultaneously derive from and lend meaning to each other.

In structural terms, the narrative develops unrelated elements into a story line. The relation between the clothes may work by virtue of a shared designer, related cultural status, or simply price range, but more often than not there is no logical connection between one garment and the next. The story line can therefore develop by virtue of having the same model wear different clothes, and the face and figure of the wearer thus serve as a link between quite different fashions. Due to such facial or corporeal connections, the individual shots of the model within each image of the editorial can become a study in kind, a microcosm of body shapes and gestures, that covers the various roles the model can assume through clothes and accessories that identify her as a member of various social and cultural groupings. The dialectical relationship between the disparity or congeniality of the garments and the facial and corporeal connections marks the editorial, and it is therefore its very structure that becomes an event.

The story within the editorial or the series of advertisements, however rudimentary it might be, is mainly told, as we have observed, through gestures, positions, bodily interaction, or through props and background, but not necessarily through coherent casting. At times we are to suspend our belief that the model is indeed the same person she or he has been in the previous photo. The syntactical breaks of the clothing also apply to its wearer, and the act of reading an editorial therefore resembles an exercise in deciphering the images via stylistic or material links (for example, a series of street-style shots or an editorial on winter wools).

The cinematic character of editorials and strings of connected advertisements is often apparent. Yet serial fashion images regularly undermine any convention of the filmic narrative, since the costumes of the hero or heroine, so to speak, have to change at an incredible rate, i.e., with each photo. Here we find another example of what Barthes meant when he remarked in regard to fashion photos that the "narrative permits simultaneously completing and eluding the structure that inspires it." The photographer takes the sequential progression of narrative film images and then pries them apart. He or she then selects a series of individual images that are regarded as representative (or visually interesting) and thereby leaves huge gaps between syntactically unconnected pictures, that require the spectator to fill in, by association or logical connection, in order to create the story line. This process appears almost inevitable, since readers always search for the narrative that will guide them as they leaf through the magazine. An idle occupation thus surreptitiously turns into a mental exercise (limited as it might appear). The idea of play in fashion, its inherent theatricality, is related to the ritualistic desire to dress up, to appear as somebody else in newly bought, borrowed, or stolen outfits. In the fashion photographer's studio as the veritable stage of fashion, such ephemeral disguises far exceed those of a theater production or film. The model wears the garments for an extremely short time and the wares are then quickly returned by the stylist to the company or shop, to be sold as sample pieces at the end of the season.

The story line determines the representation of fashion and binds it to the development of an extended communication between the photographer and the spectator. The aim is also to tell a story that is essentially insubstantial and ephemeral so as not to deflect attention from the clothes. Otherwise the reader would flick through the

magazine pages far too quickly. However, at the same time, the narrative should be powerful enough to generate an anticipation of how the clothes and accessories (the styling) will be integrated into the story line and how any character development of the depicted models, facile as it may be, will be represented. Despite all possible variations of the narratives, the identification of the spectator is integral to fashion photography in order to generate an association with the garments. At least one element of identification is required to draw the spectator into the narrative. If such elements are missing, the consumer, as the role which the spectator invariably is required to perform, is left distanced and disinterested and therefore not enticed to consume the clothing in some form. But the identification does not always function via the "image" of the fashion – the depiction of the garment in an idealized setting that caters to aspirational tendencies in the spectator. In contemporary fashion photography the narrative is often deliberately abstruse and eclectic – partly to allow for the greatest possible variation in the featured fashion – in order to create as many potential consumers as possible. Even small avant-garde fashion journals that cater to a narrowly defined focus group aspire to highly inclusive narratives in their selection of models or settings. Since contemporary fashion wants to see itself no longer as an exclusive social indicator (of status, rank, material position), but primarily as a creative force and determinant of change, its visualization, fashion photography, moves in its narratives from depicting lifestyle to more universal story lines. The dated concept of lifestyle is featured, especially in progressive magazines, only in an ironic manner. In its effort to approach the concept and cultural status of fine art, contemporary fashion photography therefore aspires, via the narrative in the editorial as one of its most potent formal characteristics, to quasi-literary contents. The syntactical breaks, which we observed above, align it with modernist efforts of the traditional artistic avant-garde.

Such conceptual aspiration might sit uneasily with the commercial rationale behind fashion photos, but it shows precisely how the transposition from representation to narrative has to function: a new context has to be constructed for the ever-same variants in clothing in order to promote the latest design. Through their visual representation, sartorial commodities are imbued with content that distinguish them not only from other (fashionable) commodities (e.g., furniture, ceramics) but from parts of their own métier or craft as well. Only selective designs are visualized by fashion photography's narrative: progressive or exclusive garments are portrayed as distinctly different from the clothes depicted in catalogs or in the descriptive photos characteristic of ordinary women's magazines, where narratives are eschewed on grounds of production costs. Meanwhile exclusive and expensive fashion attaches itself closely to story lines which in turn guides its subsequent interpretation and reception. At times the narrative deliberately moves in front of the clothes and distracts from their commercial centrality. In such advertisements or editorials the disjunct pictorial syntax aims to create a link to the exclusivity of the fashion brand.

Rhetorics III: text

Text in fashion photography is an ambiguous matter. Essentially, it appears as a caption that details the garment and provides rudimentary information about the substance and, more importantly perhaps, the value of the pictorial content. For example,

the caption: "triacetate dress with printed detail by Junya Watanabe, $4500" adds a curious dimension to our perception of the fashion photo. The image itself provides its own commentary which evaluates it in purely material terms: it gives us both its fabric and its price. We are meant to read the text as rationale for the image: the caption aligns the photo with the rest of the editorial and describes what should be clear from the photo anyway, namely that it is made of distinctive material (note the strange folds) and that it costs a lot (note that it is progressively different in its shape). The text therefore serves to reinforce our initial reading of the image and then shapes our perception of its value as a commodity. The expensive dress in the photo implicitly makes the very image of it expensive as well.

In an inverted tautology, the caption has to note semantically what is described iconically by the camera. Yet this tautology often changes into a complex question-and-answer format in which a piece of clothing is described in the text but is not immediately apparent in the photograph; on the other hand there might be a prominent feature or detail in the photo which is curiously, infuriatingly omitted from the descriptive caption and therefore determines an alternative reading to the one prescribed by the magazine.

The question of reality that we raised in relation to both the model and her gestures is raised again in regard to the semantic and iconographic representation of clothing. In the fashion photo a number of garments are present, even if we see only one in the shot itself. The first item of clothing is a photographed reality; its substances are forms, lines, surfaces, colors, light, its relationship is spatial, and there is a discernible plastic structure. Secondly, there is a written reality that exists in the caption; its substance is words, its relationship is, if not logical, at least syntactical, and there is a verbal structure. The actual garment, that is, the one that was worn by the model in the shot, in turn forms a third structure that transmits information to the first two realities, but cannot be represented fully by either: the verbal reality does not describe it adequately because language cannot function as a tracing of reality as such, and, in any case a description in lengthy detail would take up too much space within the image. The photographic reality, on the other hand, does not describe the actual garment either because of the heightened artificiality of the image and the nature of the camera. The structural link between the garment in the caption and the photographed one often seems to be absent. It appears, as Barthes radicalizes, as "a pure and simple collision of two structures." The two realities cannot be congruent and the spectator is asked to accept two distinct representations as simultaneously constituent for the fashion image.

Conclusion

Fashion photography has to maneuver between the twin poles of commercial viability and creative expression. It defines itself through the success of the commodity that it represents — notwithstanding whether this commodity is the fashion itself or the image that the designer/producer wishes to project. Unless the fashion photo succeeds in generating an interest that exceeds mere aesthetic experience and stimulates the consumer's reflex in the spectator, its meaning proper is left unexpressed. Even the most astute observers of fashion imagery — who have become more numerous as

the exposure and proliferation of images grows continually — are educated enough in regard to the media to expect a commercial relation between the photo and the fashion commodity that goes beyond the usual relationship between the photographer and his object.

Other forms of photography might be dominated by aesthetic or social consideration: "fine art" photography may abstract the image to a great degree or distort its realist aspects, while documentary photos can aspire to information and education and photoreportage may serve a political purpose. Fashion photos, although intimately bound to the sociopolitical configurations of their production, claim to serve a different purpose altogether. Their rationale functions through the visualization of another applied art, namely fashion design. Fashion photos represent, mirror, interpret, and communicate the designer's vision. The object is a given, its representation a variable. Yet this variable is determined by established visual codes. Fashion photography uses visual languages similar to those of other photographic fields — often deliberately cites them — but adapts and modifies them to the language prevalent in contemporary fashion industry. Such modes of transcription are required for both its production and distribution. It is similar to fashion design itself which, even if it aspires to cultural recognition as a fine art, requires a considerable degree of commercial success in order to be defined and accepted as fashion proper — (and not merely as esoteric costumes or individualized clothing style). Fashion photography, even in its most exclusive, coded representation, demands a certain amount of material success for its recognition.

This, of course, is not to say that fashion photography should be regarded simply as an auxiliary product that features in marketing campaigns and consequently has to eschew overt aesthetic considerations or artistic aspiration. On the contrary, with the acceptance and distribution of sophisticated, individualized fashion, contemporary fashion photography presents itself as the experimental and progressive equal to more autonomously produced works of art. And the fact that more and more "fine art" photographers now agree to work for fashion magazines, or at least deliberately operate within fashion's context, indicates that the fashion image has shifted from being a coded representation to being a site of production.

Structurally speaking, the language within fashion photography functions at a distance. Its messages are coded to a surprising degree, given its close proximity to the human body. The stifled rhetorics and gestural rituals in fashion images appear designed to preclude any emotive response or direct participation; this deliberate distancing becomes a necessary challenge for the conspicuous consumer, who aspires to connect to it through purchase of the garment. If it were not for the clothes that are the material basis for fashion photography, such distance might generate a perception of fashion photos as quasi-metaphorical works of art. The new images of fashion, in avoiding the traditional descriptive or established codes of representation of garments, now have a better chance of being raised to the cultural status of contemporary art than even the most exclusively designed couture. Both fashion and fashion photography have had their increased share of exhibitions in galleries and museums. But while the dress is still regarded as a costume, as the odd design object within a space devoted to the fine arts, fashion images, because of the medium they share with art photography, will proceed to establish themselves within exhibition spaces — whether those of art magazines or museal white cubes. In doing so the fashion photo will implicitly begin to change the nature of these spaces themselves.

Original publication

'Chic Clicks: Creativity and Commerce' in *Contemporary Fashion Photography* (2002)

Notes

1 A telling exception to the rule would be Edward Steichen's romanticized, Stieglitz-style photography of gowns by Paul Poiret for the 1914/15-edition of the magazine Art et Décoration In Paris. Yet this representation was considered inferior by contemporaries to the luxuriously drawn albums that Poiret had commissioned in 1908 and 1911, respectively, from the painters and illustrators Paul Iribe and Georges Lepape.

2 We might well say "I don't like that" or "this is passé," but we would very rarely say "this is not fashion." Therefore we all sign up to a basic agreement before purchasing or opening the magazine.

Val Williams

A HEADY RELATIONSHIP
Fashion photography and the Museum, 1979 to the present

I N 1 9 8 5 , R O Y S T R O N G, then director of the Victoria and Albert Museum wrote a preface to the catalog of the exhibition *Shots of Style: Great Fashion Photographs* chosen by David Bailey (Figure 37.1), which opened in 1985. "What is fashion photography?" Strong asked. "That is a question more easily asked than answered, even by those who practice it and wrestle with their consciences that somehow their integrity has been compromised by doing it" (Bailey 1985: 7). In an essay for the same catalog, photographic historian Martin Harrison noted the fact that "the loss of so much prime material is perhaps symptomatic of the low regard in which fashion photography was held in some quarters. It is all but omitted from even recent photographic histories: critics who have no difficulty in relating shots of trees, tin shacks or cutlery to a wide social context give fashion photography a wide berth" (Bailey 1985: 15). Six years before *Shots of Style* opened at the V&A, the International Museum of Photography at the George Eastman House in Rochester, USA, staged a groundbreaking and ambitious survey of fashion photography from the nineteenth century to the (then) present, with a large-scale catalog, written by Nancy Hall-Duncan. In the introduction to this catalog, Hall-Duncan remarked that:

> It is the two-fold stigma of commercialism and materialism that makes fashion one of the few types of photography whose very values are called into question. Fashion photographs are designed to be seducers, propaganda so potent that it can beguile us into buying the most frivolous products. Fashion photography also commits the 'sin' of being produced not only for love but for money, implying the creative manipulation and the sacrifice of photographic and artistic integrity. Fashion photographs are ostensibly as transitory as last year's style or this month's magazine issue.
>
> (Hall-Duncan 1979: 9)

Such statements, coming in the wake of what is widely recognized as the golden age of fashion photography, the decades of the 1950s, 1960s, and 1970s, during which the

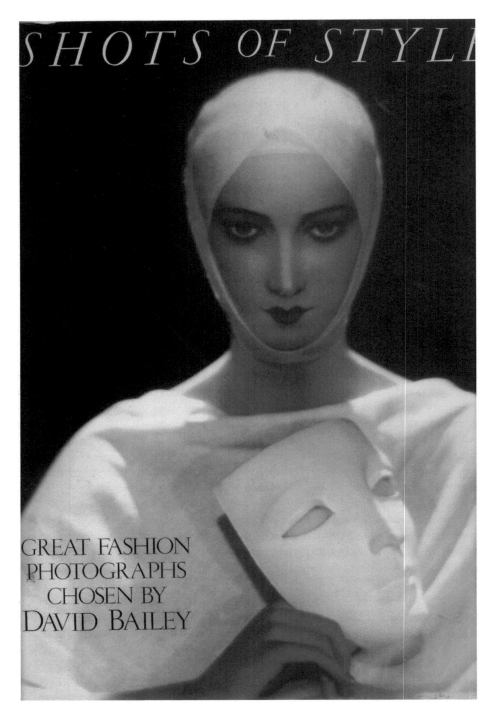

Figure 37.1 *Shots of Style: Great Fashion Photographs* chosen by David Bailey – Cover. [Original in colour]. Courtesy of Faber.

talents of photographers such as Diane Arbus, Robert Frank, David Bailey, and Helmut Newton had emerged in the cultural arena, now seem startling. Clearly, both Hall-Duncan and Roy Strong were advocates of fashion photography and its place in the museum context but their public writings show wariness towards the very genre that they are exploring and promoting. Showing fashion photography in the museum was seen as risky, and the photographs (and the people who made them) were something to be critiqued, even apologized for. For Hall-Duncan, *The History of Fashion Photography* (Figure 37.2) represented something of a crusade. Again in her introduction, she remarks that:

> it seems likely that further reassessment of fashion photography will discover new values in the medium and admit the possibility of its stylistic excellence. Our purpose is to trace the development of stylistic conventions in fashion photography and to relate fashion photography to other types of photography, the arts, society and culture. Concentrating on the three major fashion centers, London, Paris and New York, this book hopes to prove its criterion of selection: that a great fashion photograph is more than great fashion and no less than great photography.
>
> (Hall-Duncan 1979: 13)

The conundrum at the heart of this perceived unease with the fashion photograph indicates the need to look further afield to other commentators, some of whom were deeply involved with the genre, some of who looked in from the outside. One such observer was the ever-perceptive Cecil Beaton, whose sharp eye was trained not just on his numerous subjects, but also on the world around him. As a Vogue photographer, Beaton was deeply interested (and indeed beholden to) the editorial market on both sides of the Atlantic. In his 1938 book *Cecil Beaton's New York* (1938; Figure 37.3), Beaton described his encounters with the city, which represented, to this innovative, inquisitive, and perceptive observer, a quintessential modernity. He peered into nightclubs, met society hostesses and art collectors, wondered at the profusion of flowers, food, films, music, wrestling, and even basketball. Central to his interest in the city was its media, especially newspapers and magazines – indeed one of the most alluring photographs in the book is of a scattered collection of magazines, including *Time, LIFE, Daring Detective, Physical Culture,* and *PIC*. For Beaton, fashion magazines were central to professional practice. "For years," he remarked, "the best contemporary photographers have worked for vast salaries, and the result has done immeasurable good in promoting commercial photography of the highest calibre. . . . To Mr Condé Nast, the proprietor of Vogue, we owe a debt of gratitude for his particular union of art and fashion. He has made many discoveries, including De Meyer, Steichen, Huene . . . " (Beaton 1938: 65).

It was of course, Cecil Beaton's retrospective at the National Portrait Gallery in London that had brought the young Roy Strong, Director of the National Portrait Gallery in the late 1960s, the first indication of the power of the fashion photographer to attract attention and audience. Beaton's remarkable 1968 exhibition, designed by Richard Buckle (the distinguished ballet critic, who was also responsible for some spectacular exhibitions in the 1950s and 1960s, most notably his Shakespeare show at Stratford-upon-Avon in 1964) for maximum stylistic effect, was one of the first blockbuster photo shows to be held in London. And although Beaton cannot be described a

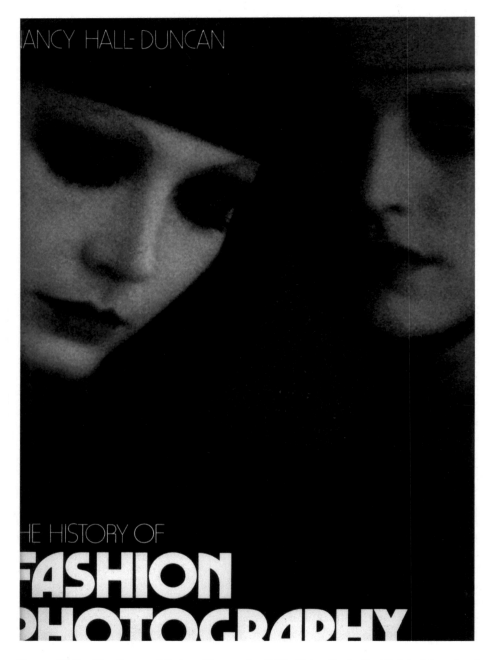

Figure 37.2 *The History of Fashion Photography* 1979, Alpine Book Co. [Original in colour]. Courtesy of Alpine Book Co.

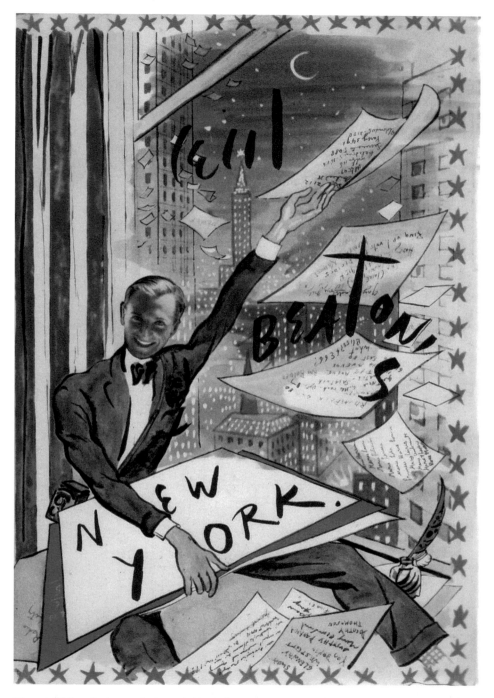

Figure 37.3 *Cecil Beaton's New York* 1938. The Literary Executors of the late Sir Cecil Beaton and of Sotheby's, UK. ©The Cecil Beaton Studio Archive at Sotheby's.

fashion photographer *per se*, as so much of his most successful work centered around portraits of high society, royalty, writers, artists, actors, and actresses, his photographs were often as much about fashion as they were about celebrity and glamour. For the National Portrait Gallery, *Beaton Portraits* (Figure 37.4) began a long and fruitful relationship between the gallery and fashion photography, with exhibitions over

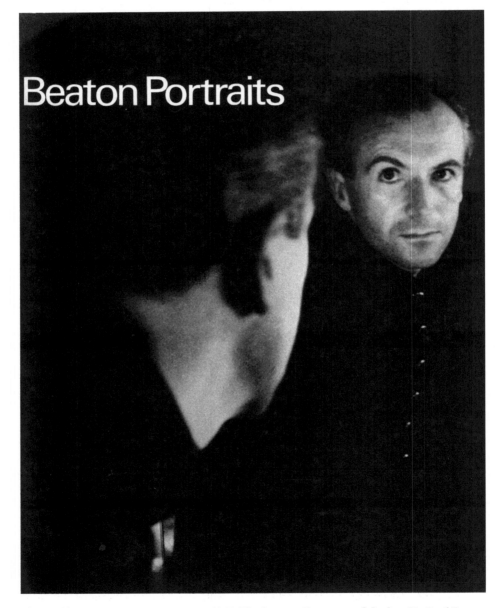

Figure 37.4 *Beaton Portraits* — cover, 1968. The Literary Executors of the late Sir Cecil Beaton and of Sotheby's, UK. ©The Cecil Beaton Studio Archive at Sotheby's.

the last decades of the work of Richard Avedon, Mario Testino, and Norman Parkinson, to name just a few. The National Portrait Gallery, with its collection of paintings (and more recently photographs) of notable Britons was not, in the 1960s, a major public draw. After the Beaton show opened, Richard Buckle telephoned Cecil Beaton to talk of the "Beaton Magic":

> he said the show was being a great success – interest mounting – 1,000 people had been through on Saturday and 1,500 today Monday. All day long there was a queue. He said it was fascinating to watch the rapt faces of the public – that he couldn't keep away – and the young looked at the pictures of the thirties as if they belonged to some long-forgotten world of Fragonard or Watteau, and at the pictures of the dressed-up beauties with an incredulous smile on their faces . . . Dicky reported that the old museum had never known such liveliness and that everyone there was going about wreathed in smiles. Roy, particularly happy, felt that they would get their expenses back in the first week. Of course I take a lot of this as exaggeration but . . . I am most surprised.
>
> (Buckle 1979: 398)

Roy Strong also confided to his diary his reaction to the somewhat unexpected sensation that the Beaton show became: "The Beaton opening came and went, 16,000 through in fourteen days. I have suddenly found myself shot into the limelight as a kind of messiah of the London museums" (Strong 1997: 32). For Strong, and more many others watching from the photographic sidelines, *Beaton Portraits* was a breakthrough in the critical and public perception of photography. Although *Beaton Portraits* was not, strictly speaking, an exhibition of fashion photography, many of the photographs had a strong fashion/pop element, and, from the beginning, the exhibition was branded by a beguiling mix of fashion, celebrity, and, of course, royalty.

In 1968, Roy Strong wrote to Jan van Dorston of his excitement about the show: "and now one is on the eve of the great Beaton show and the whole of London agog for it. . . . No one will ever be able to do a photographic exhibition again in the same way" (Strong 1997: 27). For Strong, the exhibition was a piece of theater, mirroring Beaton's own sensibilities and the design instincts of his collaborator, Richard Buckle. The photographs were hung against the walls of theatrical sets, including a prewar drawing room, a studio complete with stove, a vast revolving postcard rack containing photographs of Marilyn Monroe, plus "incense and a lot of psychedelic light" (Strong 1997: 27). On October 30, *Vogue* magazine held a launch party, and the guest list included the fashion photographer David Bailey wearing "velvet rags" (Strong 1997: 29) who arrived with the model Penelope Tree, David Hockney, Mick Jagger, and a host of Beaton contemporaries, including Lady Diana Cooper and Noel Coward (Strong 1997: 29). *Beaton Portraits* established Roy Strong as a director who changed the face of photography in the UK, and who turned around the fortunes of a dowdy and unappealing museum. "It's associated the Portrait Gallery with the land of the living instead of being an artistic morgue" (Strong 1997: 32). The exhibition was extended twice and also traveled to New York. People queued around Trafalgar Square to buy a ticket. But despite this demonstration of public interest, photography still had a long way to go, when faced with the conservatism of the museum

establishment, which was less interested in its appeal to the young and the fashionable and were, at the National Portrait Gallery at least, more exercised about the probity of allowing an engraving to be exhibited alongside a painting than they were about modernizing the gallery.

Under Strong's directorship, Colin Ford was appointed as Britain's first Curator of Photographs in 1971. Ford brought a new populism to the Portrait Gallery, and though fashion photography was not his central interest, he memorably persuaded Strong to include a photograph of British film actress Diana Dors in Strong's 1972 exhibition *The Masque of Beauty*. Having proved that exhibitions of photographs could attract substantial audiences, the National Portrait Gallery continued to show them, often including work by fashion photographers. *Snap: Instant Image '71*, which included photographs by David Bailey, was exhibited for four weeks in London, and then toured to Wales, where the Bailey photographs attracted much controversy for their alleged pornographic content. Then, as now, the work of fashion photographers was inextricably linked with sex and glamour, attracting large audiences and considerable media interest. Though gallery promotional campaigns in the late 1960s and early 1970s were inevitably less focused and dynamic than they are today, publicists were becoming increasingly aware of the potential pulling power of the fashion image.

Roy Strong's determination to keep photography (including fashion images) at the center of exhibition programming was reinforced when he took up the Directorship of the Victoria and Albert Museum in 1974. He had also become chairman of the Arts Council's influential photography committee and was impressed by Sue Davies' pioneering work at the fledgling Photographers Gallery, housed in a converted café in London's Covent Garden. Though one of Strong's early policy changes at the V&A was to close the Circulation Department, which had toured numerous photographic exhibitions to the regions, a more positive move was to consolidate and develop the museum's extensive photographs collection and to mount more ambitious temporary exhibitions at the main London venue.

For the V&A, as well as for other London galleries, David Bailey became an important figure. He exhibited there as a solo artist in 1983, in the exhibition *Black and White Memories*, and also had solo shows at the National Portrait Gallery in 1971 and the Photographers Gallery in 1973, setting a style for the new photography-only gallery that would continue throughout the directorship of Sue Davies to combine fashion, reportage, and "art" photography relatively seamlessly. For British museums, Bailey was an important figure – newsworthy, talented, and with a vivid personal life, he represented a new modern London and a new pop meritocracy in which pinstripe suits were exchanged for bell-bottoms and Afghan jackets for Burberry overcoats. Increasingly, fashion photographers and the photographs they made were seen as desirable additions to exhibition programs, modernizing the image of museums, which were perceived to be old-fashioned, elitist (and usually empty). To succeed in increasingly competitive times, museums had to embrace the new and the populist to address new and uninitiated audiences.

Bailey's selection for the exhibition *Shots of Style*, demonstrated the V&A's commitment to fashion photography as a broad genre. International in content, it included, among others, Cecil Beaton, Baron De Meyer, Man Ray, Frank Horvat, Diane Arbus, Bruce Weber, Norman Parkinson, and Irving Penn. Writing in the acknowledgments section in the catalog, Mark Haworth-Booth, then Assistant Keeper of Photographs,

declared that: "the selection sacrifices the 'merely beautiful' in favour of fashion photography as style and expression" (Bailey 1985). For Haworth-Booth, *Shots of Style* was part of a trajectory begun by the 1975 exhibition *The Land*, for which works were chosen by the photographer Bill Brandt, signaling not only that the V&A was committed to photography, but also to the curatorial judgment of photographers themselves.

By the mid-1980s, it had become clear that that the museum establishment and the fashion photography community were engaged in a close relationship that utilized each other's strengths to achieve discrete and particular aims. Over the next two decades, the V&A made a series of exhibitions, which were either specialist fashion photography shows, or which contained fashion photography as an important element. These included *John French: Fashion Photographer* (1984–5) (Figure 37.5); *Bailey's*

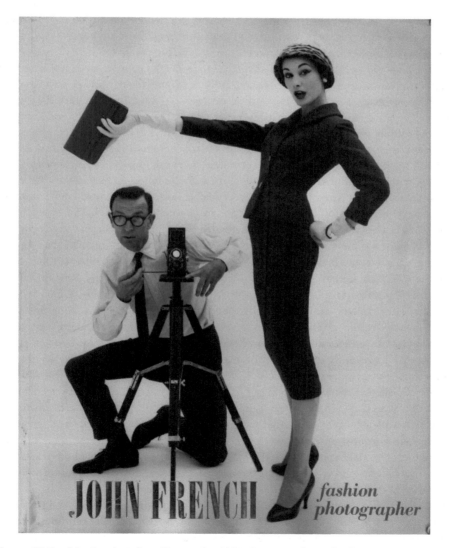

Figure 37.5 *John French: Fashion Photographer* 1984. Courtesy of V&A books.

Shots of Style (1985–6); *Irving Penn* (1987); *Appearances: Fashion Photography since 1945* (1991); *Streetstyle: From Sidewalk to Catwalk* (1994–5); *Imperfect Beauty* (2000); *Guy Bourdin* (2003), and, most recently, *The Art of Lee Miller* (2007).

Strong's determination to make the V&A the prime repository for fashion history in the UK was reinforced by his support for the decision to accept Vere French's donation of the John French Archive to the museum's Archive of Art and Design. In the foreword to the catalog he wrote: "Not only would it begin to put right the lack of a major repository for fashion photography in this country but it would lay the foundation with the work of one man who was the fount from whence flowed the practitioners of the 1960s and 1970s" (Strong 1985: unpaginated). For Strong, the French archive was not only a significant set of photographs but also a collection of "documents of archival importance" (Strong 1985: unpaginated) that would, in the future, "fully meet the needs of the many scholars and students who will undoubtedly use it" (Strong 1985: unpaginated). Strong was perhaps the first of the new wave of London museum directors who foresaw the emerging interest in the many histories of fashion photography, rather than simply in the images that it produced.

Despite the enthusiasm for fashion photography expressed by some museums, during the renaissance of serious photography in the UK from the early 1970s, most institutions fought shy of what they saw as professional (and thus commercial) photography. The Tate Gallery had for many years rejected the possibility of collecting any photographs at all, save for a small number by artists and a supporting collection in its archives. Fashion photography for this particularly conservative institution was completely outside the pale. Only in recent years, with the emergence of photographers such as Wolfgang Tillmans, who straddled the borders between "art" photography and fashion has the fashion image become acceptable at Tate. Even then, when Tillmans was shortlisted for the 2002 Turner Prize some critics were scandalized; Matthew Collings wrote in *The Observer* newspaper: "I have no idea why Tillmans is supposed to be an artist. If he wins, the message will be that the Tate . . . wants to get down and boogie in an embarrassing way with the young airheads who read *The Face*" (Collings 2002, www.tate.org.uk). Although photographs by Nick Knight and Jason Evans were included in Tate Modern's first large-scale temporary exhibition, *Century City* (2001), the inclusion of photographers known primarily for their fashion work in any Tate program is a rarity. In the recent (2007) exhibition *How We Are* (the first major photography show to be held at Tate Britain), a number of fashion photographs were included by practitioners such as Jason Evans, David Bailey, and Norman Parkinson, with a larger group of portraits by Cecil Beaton, Madame Yevonde, Dorothy Wilding, Peter Rose Pulham, and Derek Ridgers, which though not "of" fashion, were certainly closely connected.

If the Tate Gallery (and some other leading UK institutions) was trenchant in its rejection of photography, the emerging independent photography movement, made up of photographers determined to produce serious bodies of work for exhibition and publication (and supported by a growing number of specialist photography galleries, publishers, and a substantial increase in public funding), was determined to promote the medium as an exhibitable and collectible art. The struggle to establish photography as a "serious" medium, from the late 1960s onwards, meant that the innovatory work being made by many fashion and advertising photographers in the UK and Europe was regarded with much caution by photography's young turks. Photography became a contested territory in its struggle to become an independent art; it

disregarded many of those who ensured its continuing success and exposure. The line between "personal" and "commercial" work was seen to be uncrossable.

The early 1970s saw an important shift in thinking about photography in the context of culture in Britain. The opening of the Photographers Gallery in 1971, the granting of the first Arts Council of Great Britain Photographic Bursaries to independent photographers in the early Seventies, and the growing recognition of photography's importance by newcomers to the gallery and museum establishment (illustrated in exhibitions at London's Hayward Gallery, the Serpentine Gallery and Oxford's Museum of Modern Art), together with a broadening of photographic education in Britain's polytechnics and art schools, all contributed to a photographic renaissance. These initiatives were, to a greater or lesser extent, mirrored in Western Europe, and while the USA was already ahead of Europe in terms of regarding photography as a serious art form, a photographic community was also emerging which would be insistent about the need for quality publishing and exhibiting.

In Britain, photographers, gallerists, and critics had fought a tenacious battle for photography to be recognized as something other than a craft or profession, and the photography that emerged as being thought worthy of exhibiting in museums and galleries split fairly neatly between landscape poetics (for instance, the work of Thomas Joshua Cooper and Fay Godwin) and critical documentary (photographers such as Martin Parr, Chris Killip, Graham Smith, and Chris Steele-Perkins). Also acceptable were the works of photojournalists who had come to prominence through the broadsheet supplement magazines in the 1960s and early 1970s (these included Don McCullin and Ian Berry). With fewer resources, but an insistent presence, were the sociopolitical initiatives of community-based galleries, such as Camerawork in the East End of London. Within this emerging schema, fashion photography occupied a peculiar niche. As Susan's Bright's recent research into the Circulation Department at the Victoria and Albert Museum has shown, the V&A (the UK's National Museum of Art and Design) created and toured photographic exhibitions from 1968 to 1974. These included exhibitions of nineteenth-century photographs, collections of work by Jacques Henri Lartigue and Cartier Bresson, an exhibition of sports photography by Gerry Cranham, photographs of jazz musicians by Val Wilmer, Ida Kar's portraits of artists, and *The Compassionate Camera*, documentary photographs of the American dustbowl made by photographers employed by the Farm Security Administration. Though the V&A's circulating exhibitions were designed to be of appeal to a general public, distributed as they were to libraries, art colleges, and museums across the UK, fashion photography was not included in their programming (Bright, in preparation).

The presence of fashion photography within the new photographic arena of the 1970s and early 1980s was an awkward one. Fashion photographers were among the few in the photographic community who could command substantial payment for their work. Fashion photographers did not need the Arts Council's largesse, which meant that they were outside its somewhat rigid systems of control. In the 1960s, the photographers known as "the Terrible Three" – Brian Duffy, Terence Donovan, and David Bailey – became celebrities in Swinging London. In his 1965 collection *A Box of Pin Ups*, Bailey included photographs of those who represented all that was cool about London in the Sixties, from Mick Jagger to Mary Quant. The "Three" could be said to represent most of the things that the new photographic avant-garde disliked. They were seen to be frivolous, socially unconcerned, and in the service of commerce. This

was intensified in Antonioni's 1966 film *Blow-Up*, which had as its central character a modish fashion photographer (said to be inspired by David Bailey), for whom photography was a raw and exploitative exchange between photographer and subject. The new independent photographers were much more inclined towards the work of US photographers such as Lee Friedlander, Gary Winogrand, and William Eggleston and British and European practitioners such as Brassai, Bill Brandt, and Cartier Bresson, and rejected (unless to critique) photographers such as Helmut Newton, John French, and David Bailey. The independents were puritan purists, with an inclination towards socially concerned documentary and the poetic re-visioning of landscape photography. Added to this was an emerging feminist grouping (that included artists such as Hannah Wilke, Martha Rosler, and Jo Spence) – which, rather than simply dismissing fashion photography, actively critiqued work that objectified women.

Fashion photography's case was not helped by its rejection by some of its most interesting practitioners of the past. In their 1979 collection of interviews *Dialogue with Photography*, Paul Hill and Thomas Cooper (who were themselves leading members of the new British photography movement) recorded conversations with a number of distinguished practitioners, some of whom had worked as fashion photographers. The Hungarian photographer Brassai, who was a major influence on emerging photographers in the 1970s, remembered that: "When I first started working for *Harpers Bazaar, circa* 1937, I was asked to take fashion photographs. I categorically refused" (Hill and Cooper 1992: 39). Similarly, Andre Kertesz recounted that: "I had been working for [Condé Nast] in Paris as a freelancer, using my personal material and doing fashion photography outside. When I came to New York I worked for a while with Condé Nast publications, but after a while I left. It was not the kind of photography I wanted to do!" (Hill and Cooper 1992: 46). Another well-known name in the lexicon of the new British photography was French documentarist Robert Doisneau, who told Hill and Cooper that: "[In 1950–51] I was working on 'Life in Paris' and doing fashion like a pig. I didn't know anything about it and I didn't give a damn. I took the job [in the *Vogue* studio] because it offered a certain working security at last, but I regret it a little today because of all the pictures I was unable to take at the time. I have left only ten negatives from that time. The rest, little dresses – I don't give a damn!" (Hill and Cooper 1992: 82).[1]

The photographer and artist Man Ray, who was much in demand as a fashion photographer in the 1930s, working with the visionary art director Alexey Brodovitch at *Harper's Bazaar*, rejected not only fashion photography, but photography itself. As his biographer Neil Baldwin has stated: "there are precious few glass-plate negatives of Man Ray's fashion work surviving today. The more in demand he was for commercial work, the more he axiomatically progressed to hate photography, to want to do only what is absolutely necessary to keep me going, to produce something that interests me personally . . . all these one-track minded Americans, the Modern Museum and others, even after visiting my place, and seen my work, have now put me down as a photographer" (Baldwin 1988: 193–194). Man Ray's feelings about photography culminated in his 1943 article for View magazine "Photography is Not Art." Though the contents of the article were not as trenchant as the title suggests, its writing is symptomatic of the doubts even highly successful photographers experienced about the value and status of their work – for photographers who had worked in fashion, these insecurities were even more intense.

The new British photographers placed strict boundaries between their "personal" and their "commercial" work. And when particularly inspirational photographers such as

Robert Frank and Diane Arbus practiced both in fashion and as critical documentarists, histories were revised so that the work that these photographers produced would be seen to flow from personal vision rather than editorial or advertising assignments. Only relatively recently have both Arbus' and Frank's fashion photography been acknowledged and in exhibitions of Frank's work, to this day, mention of his fashion images is cursory. As far back as the 1930s, Walker Evans, whose 1938 exhibition catalog *American Photographs* became a primary visual text for postwar documentary photographers across the Western world, complained bitterly in a letter to Hans Skolle about the commercial necessities of a photographic career: "there is nothing to be done but to go after money by the nearest means to hand. For instance I have 'contacts' and leads." People in such bastard trades as advertising, publicity etc. have sometimes heard of me because I have given two exhibitions of photos. So I may get a job. I may make photo murals for Bloomingdale's store or I may make theatrical posters for Roxy's Theater. As they want them of course, not my way" (Rosenheim and Eklund 2000: 162). Determined that later photographers would not have to endure the commercial pressure that he had so disliked, Evans became a member of the Guggenheim Foundation's judging panel, helping to decide which photographers would be supported by Fellowships. Among the photographers who Evans supported for funding were Diane Arbus and Robert Frank, the *Harper's Bazaar* photographer, fighting to escape the editorial yolk (Rosenheim and Eklund 2000: 85).

Given this wide distrust of fashion and advertising photography by crucial members of the photographic establishment, it is not surprising that the exhibiting careers of fashion photographers have been noticeably uneven. The remarkable Guy Bourdin took part in only eighteen exhibitions before his death in 1991, of which six were of paintings and drawings in the early part of his career. None were in major art spaces. Only in the V&A's 2003 exhibition did a rounded picture of Bourdin emerge, with magazine work blending seamlessly with Polaroid snapshots, landscapes, and personal experiments. Bourdin had regarded his fashion photography as ephemeral; after his death, his archive was scattered and uncollected. Between 1971 and 1989, David Bailey exhibited in twelve exhibitions, only five of which centered on fashion photography. Cecil Beaton had twenty-seven solo shows between 1929 and 1985, only six of which were in major public spaces, and one of which was war photography. A useful comparison is with Beaton's near contemporary, Man Ray, who, between 1915 and 1985, had ninety-six solo shows, including exhibits at major international spaces, including the Centre Pompidou, the Metropolitan in New York, and the National Museum of American Art in Washington. Though it could be said that photographers such as Bourdin and Bailey were exhibiting freely through the medium of magazines for the greater part of their career and that fashion photography's rightful place is on the printed page rather than the gallery wall, an interesting corollary is with the work of eminent photojournalists, whose practice was also directed towards magazine publication. Gilles Peress, member of Magnum Photos since 1974, had taken part in thirty-one exhibitions between 1976 and 1993, at venues including Musée d'Art Moderne de la Ville, Paris, the Corocan Gallery, Washington, and the Art Institute of Chicago. Fellow Magnum member George Rodger exhibited prodigiously throughout his long career, taking part in forty-eight exhibitions from 1974 to 1995.

The exhibiting careers of those fashion/style photographers who did produce numerous exhibitions during the 1980s and 1990s were either those who were seen to cross the boundaries between fashion and art, or those whose work challenged notions

of public taste. Two such examples are the French partnership of Pierre et Gilles (whose wildly innovative work was seen frequently in museums and public galleries from the mid-1980s to the mid-1990s, including at venues such as the Museum of Modern Art in Oxford, UK, the Centre Georges Pompidou in Paris, and the Cartier Foundation, Paris) and the Australian-born fashion photographer Helmut Newton (whose work was much in demand by venues including the Photographers Gallery, London, the Biennale d'Lyon, and the Royal Academy of Arts, London throughout the 1970s, 1980s, and 1990s). Before fashion photography became fashionable with a new generation of museum curators and gallerists in the mid-1990s, photographers working with fashion had to be seen as either "mad" or "bad" to attract the attention of the establishment.

In the 1990s, a sea change occurred in the way in which fashion photography was regarded both by the museum and gallery establishments, but, most importantly, by an energized visual arts sector across the Western world. Photography was increasingly absorbed into the fine arts system, photographers became increasingly interesting to collectors and private dealers, works began to be editioned and acquired value. A concurrent decline in the markets for photojournalism and editorial photography obliged photographers to seek their livings elsewhere; the state and regional funding that had been made available to photographers (in the UK at least) to pursue lengthy, independent projects, had significantly dwindled.

Crucial in this interesting scenario was not so much a change in attitude of the art establishment towards fashion photography, but the increasingly interest in art shown by fashion progressives. From the early 1990s, the style magazine i-D had promoted the work of a group of photographers who would make their way into the art arena, via fashion photography, fairly effortlessly. Chief among these was the photographer Wolfgang Tillmans, whose work was published in i-D in 1991. Others included Corinne Day, Glen Lutchford, Paolo Roversi, Jason Evans (then working as Travis), and Nigel Shafran. Many of these photographers began to work at i-D during photographer Nick Knight's picture editing of the magazine; Knight provided these emerging photographers with opportunities to experiment and innovate that went far beyond any others available to them elsewhere in fashion publishing. Importantly, these photographers did not regard themselves as part of the fashion establishment and, although they saw the drawbacks in working for clients, they also glimpsed the possibilities of making exciting images for wide distribution. As interest in the visual arts accelerated, due in part to the impact of Damien Hirst's 1988 exhibition Freeze in London's Docklands, Charles Saatchi's monumental collecting, and the establishment of artist-run spaces, primarily in the East End of London, visual art had become fashionable. No longer controlled by museum mandarins, state funders or Bond Street galleries, artists seized the opportunity to show and promote their own work. Unlike the artists and photographers who had emerged in the 1970s and the culture of alternativeness, these younger practitioners had grown up in a culture of consumption, within which fashion was an important element.

In 1996, the art publishers Scalo, who had become one of Europe's most lively publishers of photographers' work, issued Camilla Nickerson and Neville Wakefield's book Fashion: Photography of the Nineties. Nickerson was then the British fashion editor of American Vogue and Neville Wakefield an art critic and curator. In Fashion, photographs by Paolo Roversi, Corrine Day, Nick Knight, Glen Lutchford, David Sims, and others were placed alongside images by art and documentary photographers such as Mary Ellen Mark, Richard Prince, Cindy Sherman, Nan Goldin, and Nobuyoshi Araki.

In London, the style magazine *Dazed and Confused*, which had emerged as a rival to the two brand leaders *The Face* and *i-D*, was enthusiastic about the melding of art and fashion from its beginnings in 1992, and, partly due to its then arts editor Mark Saunders, broke away from the established format of *i-D* and the music/style magazine *The Face* to inject real enthusiasm for what could be seen as the melding of art, fashion, and lifestyle, through reviews, interviews, and articles.

As fashion editors, curators, and artists courted each other, there were, of course, dissenting voices. Wolfgang Tillmans, who had experimented with fashion but who, by the late 1990s, was firmly established as a visual artist working with galleries and museums, remarked in 1998:

> There's a continual so-called rebellion. But fashion photography is completely conservative. Take Alexander McQueen's garments printed with war victims. His brand of shock value was rewarded with a job at Givenchy. Images of real girls who don't follow fashion became the fashion rule. Fashion photographers can be incredibly naïve and one-dimensional. They think only of cause and effect, forgetting that the market constantly changes. When a story is published in *i-D*, it's seen by the *The Face*, then *Vogue*, seen by advertisers and becomes the new dominant fashion . . . I don't like the pretence that we're all doing something radical. However grand the proclamations from photographers such as Juergen Teller or Terry Richardson that they don't want to be "in fashion," that their work is subversive, they take a look and propel it into fashionability. The substance of their work is essentially the same as David Hamilton's young girls in knickers. The work doesn't question gender roles, or why we buy into fashion, it gives you a series of feelgood factors.
>
> (Smith 1998: unpublished interview)

But despite some unease from those with first-hand experience of working in the fashion industry, the relationship between fashion photographers and the art establishment strengthened. In London, the Victoria and Albert Museum renewed its interest in fashion photography with *Imperfect Beauty* (Figure 37.6), an exhibition curated by Charlotte Cotton and opened in 2000. Like the British Council exhibition *Look at Me: Fashion and Photography in Britain 1960 to the Present*, which opened at the Rotterdam Konsthal in 1998, *Imperfect Beauty* saw fashion photographers as interpreters of contemporary society, storytellers, even documentarists. In Cotton's introduction to the catalog for Imperfect Beauty, the qualifications so evident in Roy's Strong's preface to *Shots of Style*, were noticeable for their absence. Instead, Cotton remarked:

> The most influential image-makers of the last decade have actively challenged the perceived scope of the narratives and aesthetics that could be played out in fashion photography. They have ensured the continuing capacity of fashion images to excite and seduce us through their engagement with our collective fantasies and contemporary life. In so doing, the notion of fashion photography as a document or necessary by-product of fashion has never seemed a more inadequate description of the creativity and meaning that this sphere of our visual culture embodies.
>
> (Cotton 2000: 7)

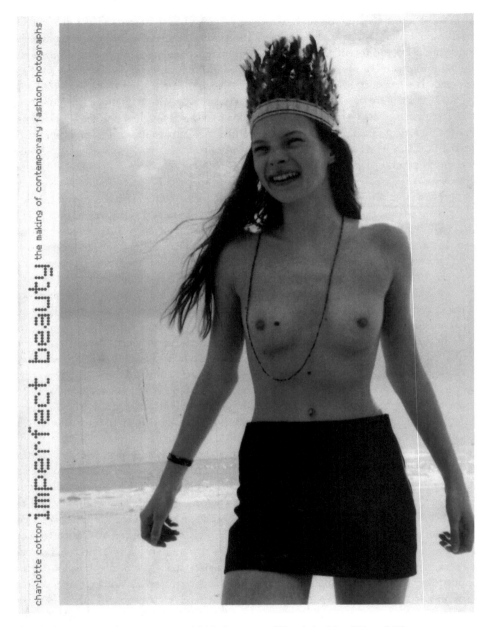

charlotte cotton · imperfect beauty the making of contemporary fashion photographs

Figure 37.6 *Imperfect Beauty* cover 2000. Courtesy of Trunk Archive/Gimpel Fils.

Back at the National Portrait Gallery, the lessons that Roy Strong had taught the museum establishment had not been forgotten. In 2002, the gallery launched an exhibition of the work of Mario Testino, which opened in the wake of an enormous pre-opening promotional campaign. Though the reviews were generally lukewarm, the public flocked to see it. Had Cecil Beaton still been alive to go to the opening party,

no doubt his diary would have contained some interesting observations about the star-studded private view, attended by models, celebrities, and the fashion cognoscenti. With his usual eye for details of the absurd, he might also have noted that prior to the opening many of the luxuriously expansive exhibition prints split in half as their stretchers expanded with the temperature change in the gallery (Fleming 2002). At the same time as the Testino show, a retrospective of the work of US photographer Nan Goldin opened at the Whitechapel Art Gallery in London. Goldin's influence on emerging fashion photographers, far greater than that of many of fashion photography's "greats," had been inestimable during the 1990s; for those who followed, or practiced fashion photography, the Goldin retrospective was far more significant than Testino's glittering array of celebrities and beautiful people. Over at the Barbican Art Gallery in London, another retrospective opened just a few weeks after Testino and Goldin. Martin Parr, the foremost of the fiercely independent photographers of the 1970s, was being honored for a three-decade career as a documentarist. By the time the exhibition opened (although none of the work was included in the show), Parr had already made a number of substantial pieces of fashion photography, his combination of sharp social observation and formidable photographic composition having been noticed by the editors of W magazine in New York by the late 1990s. By 2005, Parr had made his own semi-satiric tribute to the genre he had so often dismissed in the 1970s and 1980s as meaningless in his 2005 publication *Fashion Magazine*. In 2007, Parr's agency, Magnum Photos, opened two exhibitions of fashion photography at its London Print Room and at the Atlas Gallery. *Style: 60 Years of Fashion* photography from Magnum Photos recontextualized the work of photographers including Parr, Bruce Gilden, Alex Soth, Eve Arnold, Robert Capa, Jim Goldberg, and David Hurn, among others. On its website, Magnum explained that: "Documenting style focuses on an area of activity by no means central to the agency's purpose, but nevertheless a part of a surprising number of the photographers' experience" (www.magnumphotos.com).

Magnum Photos members are not alone among the influx of documentary and art photographers into the fashion arena. In 2004, photography's premiere exhibition venue, the Museum of Modern Art, New York, staged the exhibition *Fashioning Fiction in Photography since 1990* (Figure 37.7). Featuring groups of photographs by practitioners including Nan Goldin, Larry Sultan, Juergen Teller, Cindy Sherman, Tina Barney, Ellen von Unwerth, Mario Sorrenti, Steven Meisel, and Philip Lorca di Corcia, as well as a lengthy interview with Dennis Freedman, Creative Director of W magazine, the exhibition, though covering some familiar ground, finally established that the photographing of fashion could and should play an important part in the culture of the museum. It acknowledged that "art" photographers (Sherman, Barney, Lorca di Corcia *et al.*) had been able to use art practice in the service of fashion in ways which were not unduly compromised by the demands of the industry. Both Tina Barney and Larry Sultan, best known for their large-scale color documentary photographs from the 1980s, produced work for both corporate and editorial clients that was virtually indistinguishable from their gallery output. Larry Sultan's "Visiting Tennessee" (for the Kate Spade advertising campaign, Fall/Winter 2003), for instance, contains family tableaux that in both style and substance contain important elements of Sultan's 1980s and 1990s documentary work; Barney's 1999 story for W magazine, "New York Stories," employs the stylistic devices that so distinguished her documentary art practice. Meanwhile the work of Meisel, Teller, Lutchford, and Sorrenti, (known primarily for

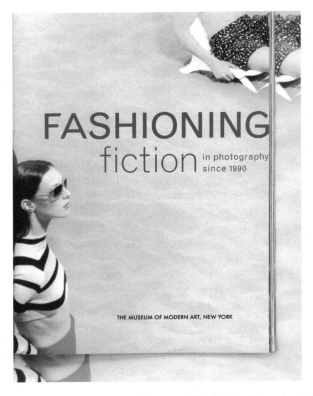

Figure 37.7 *Fashioning Fiction in Photography since 1990*. [Original in colour]. © 2017. Digital image, The Museum of Modern Art, New York/Scala, Florence.

their fashion output) fitted seamlessly into the styles and mores of contemporary art practice. The series chosen to represent Mario Sorrenti, for example, is representative of much critical color documentary photography emerging during the 1980s and 1990s from galleries and independent publications, and Meisel's 1997 fashion story for Italian *Vogue* – "The Good Life" – is indistinguishable from the staged documentary that became so central to the 1990s photographic practice of artists such as Philip Lorca di Corcia, Gregory Crewdson, Tom Hunter, and Hannah Starkey. As curators, Susan Kismaric and Eve Respini explained in the catalog to the exhibition:

> The proliferation of new [style] magazines [in the 1990s] was not only the result of increasing availability of desktop publishing, but also of a heightened interest in fashion as a conveyor of cultural ideas, as seen in the increasing number of exhibitions of and about fashion in museums such as the Victoria and Albert Museum, the Metropolitan Museum of Art, and the Solomon R. Guggenheim Museum. In the February 1999 edition of the British independent magazine *Tank*, the American photography Gregory Crewdson's photographs of staged surreal scenarios set in suburbia appear not as fashion photographs but as art that embraces the influence of film. The inclusion of art within such magazines seemed aimed at validating them as a form of art in

themselves, since many of these publications were expensive and had a very limited readership. The magazines fostered an intersection for art, music and design, and youth culture, and helped usher in a boom in fashion photography that focused even further on originality and personal expression.

(Kismaric and Respini 2004: 20)

This article has looked at some of the ways in which fashion photography and the photographing of fashion has been embraced by the museum. Though it has concentrated in particular on the ways in which British institutions have worked with fashion photography, there is evidence that, across the US and Europe, the pattern of fashion photography's journey towards the gallery and the museum has been a similar one. The relationship between fashion photography and the museum is far less uneasy in 2007 than it was in 1979, when Nancy Hall-Duncan worried about its probity, or in 1986, when Roy Strong announced his perplexity about the genre. The story is, of course, more complex than the one outlined above, and would take years in the telling. It is a story of ambition, of personality, of public relations and the press. It illustrates the necessary journey of the museum from a stern purveyor of information to a fully paid-up member of the culture of high entertainment. It is too a narrative of insecurity and desire, of photography's constant reinterpretation of itself, of the museum's need to reach out to an ever-larger audience and to compete with its peers, and is underscored by fashion's superfluity of income and the general (if relative) poverty of museums. However complicated (and sometimes compromised) the relationship between fashion photography and the museum may be and however much it may be regarded with suspicion by its critics, it is nevertheless one that has, by now, been firmly established. Seen by some as mere flirtation between art and commerce, with all the compromises that this could involve, the ever-deeper delving by curators and scholars into the history, power, and presence of the fashion photograph, is one important route to uncovering its many, and complex, meanings.

Original publication

'A Heady Relationship: Fashion Photography and the Museum, 1979 to the Present', *Fashion Theory* (2008)

Note

1 Interestingly, recent revelations that Doisneau's iconic postwar Paris photograph The Kiss, now known to be a shot posed with models rather than a work of reportage, is evidence that Doisneau's fashion experience stood him in good stead while making street photography.

References

Bailey, David. 1985. *Shots of Style: Great Fashion Photographs Chosen by David Bailey*. London: Victoria and Albert Museum.
Baldwin, Neil. 1988. *Man Ray*. London: Hamish Hamilton.
Beaton, Cecil. 1938. *Cecil Beaton's New York*. London: Batsford.

Bright, S. *Acquisition and Display of the New British Photography 1967–1981* (in preparation).

Buckle, R. 1979. *Self Portrait with Friends: The Selected Diaries of Cecil Beaton*. London: Weidenfeld and Nicolson.

Cotton, Charlotte. 2000. *Imperfect Beauty*. London: V&A Publishing.

Fleming, Amy. 2002. "You've Been Framed. My Week: Patrick Kinmonth". *The Guardian*, Friday February 1.

Hall-Duncan, Nancy. 1979. *The History of Fashion Photography*. New York: International Museum of Photography and Alpine Book Company.

Hill, Paul and Thomas Cooper. 1992. *Dialogue with Photography*. Manchester: Cornerhouse.

Kismaric, Susan and Eve Respini. 2004. *Fashioning Fiction in Photography since 1990*. New York: Museum of Modern Art.

Rosenheim, Jeff L. and Douglas Eklund. 2000. *Unclassified: A Walker Evans Anthology*. New York: Scalo.

Smith, Caroline. 1998. *Interview with Wolfgang Tillmans*. Unpublished interview.

Strong, Roy. 1985. *The Roy Strong Diaries 1967–1987*. London: Weidenfeld and Nicolson.

PART SIX

Contexts: Art, archives, education

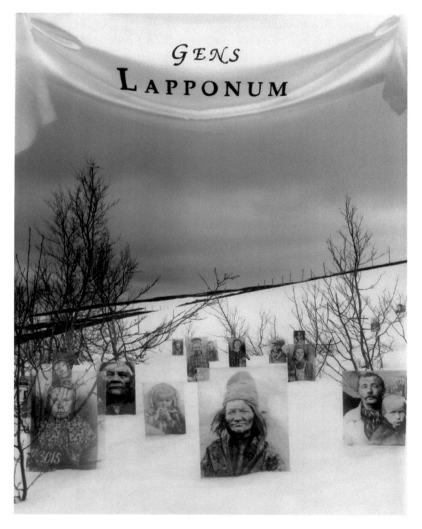

Frontispiece: Jorma Puranen, *Gens Lapponum*, 1995. Courtesy of Purdy Hicks Gallery.

Introduction

IN HIS SERIES *IMAGINARY HOMECOMING*, Finnish photographer Jorma Puranen rephotographed portraits of Sami people found in the Musée de L'Homme in Paris and printed them onto Plexiglas sheets, which he placed and photographed in Lapland, metaphorically returning a people to their homeland landscape. Central to the concept for this series was the re-locating of images; the work both operates through and encourages us to reflect upon change of context.

Within sociology, institutions are generally viewed as the point of intersection between the economic and the cultural. Thus the family, the media, the art gallery and so on can be seen to be simultaneously economic organisations and sites of sociopolitical interaction. Such institutions become contexts within which meaning is complexly negotiated, with photographic imagery contributing centrally within the ebb and flow of the knowledge economy. John Tagg has used the terms 'circulation' and 'currency', more normally associated with finance, to refer to the trajectory of the photograph as it moves with fluidity through time and space, from one context to another, used for different purposes by different groups of people (Tagg 1988).

Photographic meaning is partly determined at the moment of production, through choice of subject matter, technical and photographic codings and so on. But it is also extensively influenced by particular situations of reception. Contrast, for example, the school photograph displayed on the family mantelpiece, where it honours a particular child, with the inclusion of the same photograph within the photographer's portfolio, where the stress is on professionalism, or in the school's annual report, wherein the emphasis may be on student achievement. In effect, there is a negotiation between content and context, within which the viewer's interest in, or use of, the photograph plays a key role. A photograph may be included in a newspaper report or exhibited as part of a series on the gallery wall or within a website, but what we look for in each of these contexts, and how we see the image, differs. Shifts in ways of seeing are influenced, consciously and unconsciously, by contemporary presumptions and concerns. This may lead, for instance, to the viewer reading 'against the grain' of an image or artefact. Art theorist John A. Walker gives the example of a statue unveiled in Warsaw in 1933 commemorating fallen war heroes:

> [I]t represented a gladiator struck to death in the arena raising himself on his elbow to draw his last breath. The populace of Warsaw understood its official meaning perfectly well but they proposed an unofficial meaning by declaring that it represented the Polish people expiring under the burden of taxation!
>
> (Walker 1980: 61)

This oppositional reading reflected the particular economic context.

Simon Watney, then working in photography education, noted the interrelation of the political and the ideological, but distinguished between political

struggles relating to institutions of employment, the state, education and health-care, on the one hand, and, on the other hand, ideological struggles within the field of representation:

> Whilst photography may engage with the established practices of political struggle, through the use of the camera on demonstrations, at pickets and so on, it should be clear that this does not mean that the resulting images are in themselves 'intrinsically' political. They can only become so in relation to other institutions such as Law Courts, Industrial Tribunals, and so on, where they can 'take on' political values.
>
> (Watney 1986: 189)

Taking issue with crude Marxist notions of class determinism – over which debates were raging in Britain within the cultural studies movement and in response to feminist critiques of patriarchy – he adds that this does not mean that the cultural is somehow secondary to struggles in the economic sphere. This echoes the emphasis by French philosopher Michel Foucault on the inextricable inter-relation of knowledge, power and individual subjectivity (Foucault 1974).

The range of contexts implicated in photographic meaning and interpretation is potentially all-encompassing. Here, this section – itself a sub-section within the broader context of a collection of writings on photography – emphasises the art gallery, museum and archive as contexts. Art institutions reflect particular contemporary preoccupations and indeed may seem overly subject to shifts in aesthetic sensibilities or in social concerns (consider what sorts of themes or types of work predominate in museums and galleries local to you). Trends can be traced through exhibition themes, the fashionability of certain artists, in art market price structures or in museum acquisition policies (all of which are inter-connected). Trends may also be discerned through shifts in installation design (e.g., the exit of the modernist 'white cube'), or in types of accompanying publications and events. Specific tendencies and priorities may not always seem evident at the time; however, the archives of exhibition catalogues, press reviews and academic essays together indicate, retrospectively, characteristics of particular eras. For instance, in the mid-1990s, *Women's Art* (UK) was re-launched as *MAKE*, in effect distancing the magazine from the no longer fashionable feminist debates of the 1970s and 1980s, which had informed its original purpose and rationale.

In the first essay included in the section, written at a time of initial attempts to account for the end of modernism and to define the 'postmodern', Douglas Crimp dryly remarks on the ambiguous position of photography, newly espoused and recontextualised as art by the institutions of modern art precisely at the point of loss of confidence in the tenets of modernism. First published in *Parachute*, the critical journal of art and literature, in Ontario, Canada, this chapter is extracted from his book *On the Museum's Ruins*, in which he critically examines the role and status of art institutions in contemporary culture.

Thierry de Duve further notes the ambiguous position of photography and photographers in relation to art and art institutions. In 1997 an archive of pictures

of victims of the 1970s genocide in Cambodia was included in *Les Rencontres photographiques d'Arles*, the well-known annual international photography festival wherein there is a core focus on aesthetics. Through this he reflects on the influence of context for photo archives – in this instance, one intended to be exhibited in order that this brutal history not be forgotten. Whilst concurring with Crimp on the impact of photography for the art museum and also acknowledging that art collections as a context of viewing reinforce a hierarchy whereby the status of artist accorded to photographers and an emphasis on form (aesthetics) can distance or distract from the significance of content, Du Duve argues that, rather than rendering such institutions redundant, this invites us to consider anti-aesthetic strategies and the contemporary role of art institutions and curators.

Allan Sekula draws attention to the constitution of archives. This much reproduced essay was originally written as the introduction to a longer three-part essay for a book of mining and other photographs from the Shedden Studio, in Cape Breton, Canada, published in 1983, in which the focus was upon work, industry and everyday life. The book was intended not only to reproduce images from that archive but also as a critique of other picture books and an opportunity to encourage the reader to consider the density of meaning of pictures, and ways in which events, past and present, are represented through images. The essay was first published in Britain as a part of a collection of critical papers and photo projects on politics and photography selected to reflect then current debates around photography education and practice. In that particular context the emphasis seemed more upon interrogating archives than upon the particular Canadian example – as, indeed, remains the case given its inclusion here.

Archives are subject to change as they become rediscovered or reorganised in accordance with culturally specific interests, concerns and priorities, instrumental as well as intellectual. Elizabeth Edwards has argued for considering photo practices and archives in terms of material culture, the everyday multi-sensorial resonances of photos. She has also critically remarked on the loss of historical information through digitalisation for online image access, reminding us that notes on the inverse of paper prints may indicate provenance and stories of usage – for instance, exhibition loans – that are of archaeological interest yet risk being lost to researchers if original prints are discarded or relegated to storage. In the essay reprinted here, she argues for viewing photography archives not as passive collections but as resources offering productive potential for innovatory research.

In Britain, at the end of the 1980s, although photography workshops and a number of regional galleries were well established, as was the photography section at the V & A in London (the national collection of the 'art of photography'), photography – as opposed to fine art practices utilising photographic means – was still treated as something of a 'lesser art' by art critics. Arguably in some regions of the world, including the UK, it still is, which, given the ambiguous relation of photography to fine art (as discussed by Du Duve), is often appropriate and certainly not surprising. The field of photographic practices is broad, more extensively located in everyday practices than as projects intended for museum collection and exhibition. Liz Wells's discussion of the role and influence of the reviewer is an extended

version of a piece first commissioned for *LightReading* (then a photography news-letter for South West England).

Finally, David Bate sketches relations between art, theory and photography, indicating their fluid, overlapping, discursive presence, and muses on the situation of photography in education, the relation of photographic practice and theory to the new institutionalisation of photography as art, and implications of the rise of a domestic styled 'snapshot' aesthetic. Whilst the position of photography within educational curricula internationally has changed since, his emphasis on the necessity of interrogating the cultural role of images as a core concern for photo education remains crucially pertinent.

Bibliography of essays in Part 6

Bate, D. (1997) 'Art, Education, Photography' first published in *Hyperfoto – Magazine for Visual Culture*. Oslo, Norway: Hyperfoto.

Crimp, D. (1993) 'The Museum's Old, the Library's New Subject' in *On the Museum's Ruins*. Cambridge, MA: MIT Press.

Du Duve, T. (2007) 'Art in the Face of Radical Evil'. *October* 125, Summer 2008, pp. 3–23. © 2008 October Magazine, Ltd. and Massachusetts Institute of Technology.

Edwards, E. (2011) 'Photographs: Material Form and the Dynamic Archive' in C. Caraffa (ed.) *Photo Archives and the Photographic Memory of Art History*. Berlin: Deutscher Kunstverlag.

Sekula, A. (1983) 'Reading an Archive: Photography between Labour and Capital' in P. Holland, J. Spence and S. Watney (eds.) (1986) *Photography/Politics Two*. London: Comedia.

Tagg, J. (1988) *The Burden of Representation*. London: Macmillan.

Walker, J. A. (1980) 'Context as a Determinant of Photographic Meaning' in Evans, Jessica (ed) (1997) *The Camerawork Essays*. London: Rivers Oram Press.

Wells, L. (2002) 'Words and Pictures: On Reviewing Photography' in *The Photography Reader*. London: Routledge. [Original version published in *LightReading* 2, May 1992, Somerset: South West Independent Photographers Association.]

Douglas Crimp

THE MUSEUM'S OLD, THE LIBRARY'S NEW SUBJECT

[. . .]

SEVERAL YEARS AGO, JULIA VAN HAAFTEN, a librarian in the Art and
Architecture Division of the New York Public Library, became interested in photog-
raphy. As she studied what was then known about this vast subject, she discovered that
the library itself owned many books containing vintage photographic prints, especially
from the nineteenth century, and she hit on the idea of organizing an exhibition of this
material culled from the library's collections. She gathered books illustrated with photo-
graphs from throughout the library's many different divisions, books about archaeology
in the Holy Lands and Central America, about ruined castles in England and Islamic
ornament in Spain; illustrated newspapers of Paris and London; books of ethnography
and geology; technical and medical manuals.[1] In preparing this exhibition the library
realized for the first time that it owned an extraordinarily large and valuable collection
of photographs – for the first time, because no one had previously inventoried these
materials under the single category of photography. Until then, the photographs had
been so thoroughly dispersed throughout the library's extensive resources that it was
only through patient research that van Haaften was able to track them down. And fur-
thermore, it was only at the time she installed her exhibition that photography's prices
were beginning to skyrocket. So although books with original plates by Maxime Du
Camp or Francis Frith might now be worth a small fortune, ten or fifteen years ago they
weren't even worth enough to merit placing them in the library's Rare Books Division.

Julia van Haaften now has a new job. She is director of the New York Public Library's
Photographic Collections Documentation Project, an interim step on the way to the
creation of a new division to be called Art, Prints, and Photographs, which will con-
solidate the old Art and Architecture Division with the Prints Division, adding to them
photographic materials culled from all other library departments).[2] These materials
are thus to be reclassified according to their newly acquired value, the value that is now
attached to the 'artists' who made the photographs. Thus, what was once housed in

the Jewish Division under the classification 'Jerusalem' will eventually be found in Art, Prints, and Photographs under the classification 'Auguste Salzmann.' What was Egypt will become Beato, or Du Camp, or Frith; Pre-Columbian Middle America will be Désiré Charnay; the American Civil War, Alexander Gardner and Timothy O'Sullivan; the cathedrals of France will be Henri LeSecq; the Swiss Alps, the Bisson Frères; the horse in motion is now Muybridge; the flight of birds, Marey; and the expression of emotions forgets Darwin to become Guillaume Duchenne de Boulogne.

What Julia van Haaften is doing at the New York Public Library is just one example of what is occurring throughout our culture on a massive scale. And thus the list goes on, as urban poverty becomes Jacob Riis and Lewis Hine, portraits *of* Delacroix and Manet become portraits *by* Nadar and Carjat, Dior's New Look becomes Irving Penn, and World War II becomes Robert Capa. For if photography was invented in 1839, it was only *discovered* in the 1960s and 1970s – photography, that is, as an essence, photography *itself.* Szarkowski can again be counted on to put it simply:

> The pictures reproduced in this book [*The Photographer's Eye*] were made over almost a century and a quarter. They were made for various reasons by men of different concerns and varying talent. They have in fact little in common except their success, and a shared vocabulary: these pictures are unmistakably photographs. The vision they share belongs to no school or aesthetic theory, but to photography itself.[3]

It is in this text that Szarkowski attempts to specify the particulars of 'photographic vision,' to define those things that are specific to photography and to no other medium. In other words, Szarkowski's ontology of photography makes photography a *modernist* medium in Clement Greenberg's sense of the term – an art form that can distinguish itself in its essential qualities from all other art forms. And it is according to this view that photography is now being redefined and redistributed. Photography will hereafter be found in departments of photography or divisions of art and photography. Thus ghettoized, it will no longer primarily be *useful* within other discursive practices; it will no longer serve the purposes of information, documentation, evidence, illustration, reportage. The formerly plural field of photography will henceforth be reduced to the single, all-encompassing *aesthetic.* Just as paintings and sculptures acquired a new-found autonomy, relieved of their earlier functions, when they were wrested from the churches and palaces of Europe and consigned to museums in the late eighteenth and early nineteenth centuries, so now photography acquires *its* autonomy as it too enters the museum. But we must recognize that in order for this new aesthetic understanding to occur, other ways of understanding photography must be dismantled and destroyed. Books about Egypt will literally be torn apart in order that photographs by Francis Frith may be framed and placed on the walls of museums. Once there, photographs will never look the same. Whereas we may formerly have looked at Cartier-Bresson's photographs for the information they conveyed about the revolution in China or the Civil War in Spain, we will now look at them for what they tell us about the artist's style of expression.

* * *

This consolidation of photography's formerly multiple practices, this formation of a new epistemological construct in order that we may now *see* photography, is only

part of a much more complex redistribution of knowledge taking place throughout our culture. This redistribution is associated with the term *postmodernism*, although most people who employ the word have very little idea what, exactly, they're naming or why they even need a new descriptive category. In spite of the currency of its use, *postmodernism* has thus far acquired no agreed-upon meaning at all. For the most part, it is used in only a negative sense, to say that modernism is over. And where it is used in a positive sense, it is used as a catch-all, to characterize anything and everything that is happening in the present. So, for example, Douglas Davis, who uses the term very loosely, and relentlessly, says of it,

> 'Post-modern' is a negative term, failing to name a 'positive' replacement, but this permits pluralism to flourish (in a word, it permits *freedom*, even in the marketplace). . . . 'Post-modern' has a reactionary taint — because 'Modern' has come to be acquainted with 'now' — but the 'Tradition of the New' requires a strong counter-revolution, not one more forward move.[4]

Indeed, counterrevolution, pluralism, the fantasy of artistic freedom — all of these are, for many, synonymous with postmodernism. And they are right to the extent that in conjunction with the end of modernism all kinds of regressive symptoms are appearing. But rather than characterizing these symptoms as postmodernist, I think we should see them as the forms of a retrenched, a petrified, reductive modernism. They are, I think, the morbid symptoms of modernism's demise.

Photography's entrance into the museum on a vast scale, its reevaluation according to the epistemology of modernism, its new status as an autonomous art — this is what I mean by the symptoms of modernism's demise. For photography is not autonomous, and it is not, in the modernist sense, an art. When modernism was a fully operative paradigm of artistic practice, photography was necessarily seen as too contingent — too constrained by the world that was photographed, too dependent upon the discursive structures in which it was embedded — to achieve the self-reflexive, entirely conventionalized form of modernist art. This is not to say that no photograph could ever be a modernist artwork; the photographs in MoMA's *Art of the Twenties* show were ample proof that certain photographs could be as self-consciously about photographic language as any modernist painting was about painting's particular conventions. That is why MoMA's photography department was established in the first place. Szarkowski is the inheritor of a department that reflected the modernist aesthetic of Alfred Stieglitz and his followers. But it has taken Szarkowski and *his* followers to bestow retrospectively upon *photography itself* what Stieglitz had thought was achieved by only a very few photographs.[5] For photography to be understood and reorganized in such a way entails a drastic revision of the paradigm of modernism, and it can happen only because that paradigm has indeed become dysfunctional. Postmodernism may be said to be founded in part on this paradox: it is photography's reevaluation as a modernist medium that signals the end of modernism. Postmodernism begins when photography comes to pervert modernism.

* * *

If this entry of photography into the museum and the library's art division is one means of photography's perversion of modernism — the negative one — then there is another

form of that perversion that may be seen as positive, in that it establishes a wholly new and radicalized artistic practice that truly deserves to be called postmodernist. For at a certain moment photography enters the practice of art in such a way that it contaminates the purity of modernism's separate categories, the categories of painting and sculpture. These categories are subsequently divested of their fictive autonomy, their idealism, and thus their power. The first positive instances of this contamination occurred in the early 1960s, when Robert Rauschenberg and Andy Warhol began to silkscreen photographic images onto their canvases. From that moment forward, the guarded autonomy of modernist art was under constant threat from the incursions of the real world that photography readmitted to the purview of art. After over a century of art's imprisonment in the discourse of modernism and the institution of the museum, hermetically sealed off from the rest of culture and society, the art of postmodernism begins to make inroads back into the world. It is photography, in part, that makes this possible, while still guaranteeing against the compromising atavism of traditional realism.

Another story about the library will perhaps illustrate my point: I was once hired to do picture research for an industrial film about the history of transportation, a film that was to be made largely by shooting footage of still photographs; it was my job to find appropriate photographs. Browsing through the stacks of the New York Public Library where books on the general subject of transportation were shelved, I came across the book by Ed Ruscha entitled *Twentysix Gasoline Stations*, first published in 1963 and consisting of photographs of just that: twenty-six gasoline stations. I remember thinking how funny it was that the book had been mis-catalogued and placed alongside books about automobiles, highways, and so forth. I knew, as the librarians evidently did not, that Ruscha's book was a work of art and therefore belonged in the art division. But now, because of the reconfigurations brought about by postmodernism, I've changed my mind; I now know that Ed Ruscha's books make no sense in relation to the categories of art according to which art books are catalogued in the library, and that that is part of their achievement. The fact that there is nowhere for *Twentysix Gasoline Stations* within the present system of classification is an index of the book's radicalism with respect to established modes of thought.

The problem with the view of postmodernism that refuses to theorize it and thereby confuses it with pluralism is that this view lumps together under the same rubric the symptoms of modernism's demise with what has positively replaced modernism. Such a view has it that the paintings of Elizabeth Murray and Bruce Boice – clearly academic extensions of a petrified modernism – are as much manifestations of postmodernism as Ed Ruscha's books, which are just as clearly replacements of that modernism. For Ruscha's photographic books have escaped the categories through which modernism is understood just as they have escaped the art museum, which arose simultaneously with modernism and came to be its inevitable resting place. Such a pluralist view of postmodernism would be like saying of modernism at its founding moment that it was signalled by both Manet *and* Gérôme (and it is surely another symptom of modernism's demise that revisionist art historians are saying just that), or, better yet, that modernism is both Manet and Disdéri, that hack entrepreneur who made a fortune peddling photographic visiting cards, who is credited with the first extensive commercialization of photography, and whose utterly uninteresting

photographs hang, as I write this essay, in the Metropolitan Museum of Art in an exhibition whose title is *After Daguerre: Masterworks from the Bibliothèque Nationale*.

Original publication

'The Museum's Old, The Library's New Subject', *On the Museum's Ruins* (1993)

Notes

1 See Julia van Haaften, '"Original Sun Pictures": A Check List of the New York Public Library's Holdings of Early Works Illustrated with Photographs, 1844–1900,' *Bulletin of the New York Public Library* 80, no. 3 (Spring 1977), pp. 355–415.
2 See Anne M. McGrath, 'Photographic Treasures at the N.Y.P.L.,' *AB Bookmans Weekly*, January 25, 1982, pp. 550–560. As of 1982, the photography collection, of which Julia van Haaften is the *curator,* was integrated into what is now called the Miriam and Ira D. Wallach Division of Art, Prints, and Photographs.
3 Szarkowski, 'Introduction,' p. 206.
4 Douglas Davis, 'Post-Everything,' *Art in America* 68, no. 2 (February 1980), p. 14. Davis's notion of freedom, like that of Picasso's fans, is the thoroughly mythological one that recognizes no social differences determined by class, ethnicity, race, gender, or sexuality. It is therefore highly telling that when Davis thinks of freedom, the first thing that springs to his mind is 'the marketplace.' Indeed, his notion of freedom appears to be the Reagan-era version of it – as in 'free' enterprise.
5 For a history of MoMA's Department of Photography, see Christopher Phillips, 'The Judgment Seat of Photography,' *October* no. 22 (Fall 1982), pp. 27–63.

Thierry de Duve

ART IN THE FACE OF RADICAL EVIL*

An object that tells of loss, destruction, disappearance of objects. Does not speak of itself. Tells of others. Will it include them?

Jasper Johns[1]

FIRST, THE PHOTOS, without interpretation or commentary. Second, the facts. Every summer, the city of Arles, in the south of France, hosts an important photography festival entitled *Les Rencontres photographiques d'Arles*, with dozens of exhibitions scattered around town. In 1997, the event was placed under the artistic direction of Christian Caujolle, the co-founder and art director of the French photo agency Vu and a former chief pictures editor at *Libération*. Among several other exhibitions, Caujolle curated one entitled *S-21*, composed of one hundred portraits or identity photographs (I don't quite know what to call them) of victims of the Cambodian genocide. *S-21* is the name of a former high school in the borough of Tuol Sleng, in Phnom Penh, which Pol Pot turned into a torture center and extermination camp. Between 1975 and 1979, 14,200 people were brutally executed at S-21, either on the premises or in a field nearby. There are seven survivors. For the sake of the regime's police and bureaucracy, every man, woman, or child entering the center was photographed before being killed. To carry out this horrendous task, a fifteen-year-old member of the Khmer Rouge named Nhem Ein was sent to Shanghai to learn photography, and, a year later, was promoted to the rank of "photographer in chief" at S-21, with a staff of five under him. When the Vietnamese liberated the center in 1979, some 6,000 negatives were found. In 1994, two American photojournalists, Chris Riley and Douglas Niven, took it upon themselves to restore and print the negatives on behalf of the Photo Archive Group, a non-profit organization they founded. One hundred photos were enlarged and shown around the world, so that the Cambodian genocide – or self-genocide, as some preferred to call it – would not be forgotten. A book of the photos was published two years later, entitled *The Killing Fields*.[2] In 2002, Rithy Panh, whose family had been exterminated by the Khmer

Rouge, made a film with the aim of excavating Cambodia's traumatic past; in it two survivors are confronted with some of their jailers in order to work out the trauma. It is called *S-21: The Khmer Rouge Killing Machine*.

The school has now become the Tuol Sleng Museum of Genocide. The photos are permanently on view, most of them in small format, and frequently receive visits from the victims' families, who come to mourn their loved ones. The photographer, Nhem Ein, is alive and free, and he still makes his living as a practicing photographer in Phnom Penh. According to an interview he gave, or rather sold, to *Le Monde* on the occasion of "his" exhibition in Arles, photography was just another job for him; it had never been a passion. Working at S-21 was not a choice, he said. It was either that or be killed himself. He took up to 600 photos a day of people who he knew were innocent and had been sentenced to death, working like an automaton and blinding himself to their suffering to the point of pretending not to recognize a cousin who appeared before his camera. In 1979, he followed Pol Pot to his retreat in the northern jungle and served as the Khmer Rouge's official photographer until he defected in 1995, abandoning his wife and six children to serve the pro-Vietnamese regime of Hun Sen. He has no remorse and, upon learning of the Arles exhibition, declared himself proud to be the "star" of a photo festival in France, wearing a big grin on his face.[3]

During the *Rencontres photographiques d'Arles*, held in the middle of the tourist season, the whole city celebrates photography in all its aspects. Scores of professional and amateur photographers, photo critics, and photo buffs of all stripes run around town, cameras and telelenses hanging from their necks, rather comically clad in the multipocketed vests, à la Joseph Beuys, that have become the uniform of photojournalists around the world. Caujolle was of course aware of the festival's function in the tourism industry. He took a critical stance by assigning the 1997 festival the motto "ethics, aesthetics, politics" and organizing it into three categories: Forms of Commitment, The Duty of Memory, and The Temptations of Power. In this way, he hoped to create a context in which his decision to exhibit Riley and Niven's prints made sense. He placed the *S-21* exhibition under the rubric The Duty of Memory. In interviews, he stated very clearly that his reasons for including *S-21* in the festival were political and not aesthetic – in his own words, "to remind us that two million people, out of a population of seven million, had been massacred [in Cambodia], and that nobody moved."[4] Yet *S-21* was one exhibition among dozens, some of which had clear aesthetic motivations, and it was not alone in The Duty of Memory. The press release for the festival announced that the well-known artists Esther Shalev-Gerz and Jochen Gerz had a show under the same category, though it was subsequently moved to Forms of Commitment and listed in the catalog thereunder. The latter rubric also contained a show of the photojournalists Eugene Richards and Klavdij Sluban. And while the same press release spoke of Sluban (who had done photo-reportage on the Balkan peoples) as someone who "turns documentary images into photography," it presented Mathieu Pernot's photo-reportage on the Gypsies living around Arles as the work of a "young artist." These are interesting and touchy slippages in meaning, which will lead me to my topic.

First, we had the photos; second, the facts; third, we have the problem. Photography is *the* medium par excellence whose status as art has been problematic since its very invention. Now unanimously acknowledged as an art form, but also practiced by professionals with no interest in claiming the title of artist, photography has become

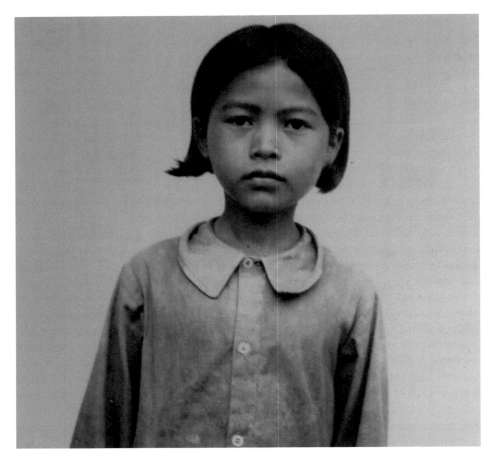

Figure 39.1 *Prisoner at Cambodia's S-21 prison*, circa 1978. Courtesy of the Photo Archive Group.

in the last forty years a vast gray zone where the boundary between art and non-art is constantly shifting and being renegotiated, on aesthetic, ideological, and institutional levels. Even more than this boundary, it is the need to distinguish between art in the generic sense and various aesthetic practices that may fall within the limits of a given medium that photography has lately come to exemplify. Think, for example, of the difference, made in the art world every day without further ado, between photographers and "artists-who-use-photography." Both groups are seen as artists, defined in the former's case as practitioners of a given art, like painters or sculptors, and in the latter's case as artists at large, who happen to express themselves in the medium of photography. True aesthetic and ideological wars are sometimes waged in the name of either of these definitions of the artist. It is quite ironic that many photojournalists argue for the documentary, prosaic specificity of their medium in order to explain why they don't care about being considered as artists, while medium-specificity is also the red thread in the modernist rationale with which critics such as John Szarkowski, the former curator of photography at New York's Museum of Modern Art, promoted photography within the museum and gave it its artistic credentials. What sort of obscure distinction among photo-reporters does the press release of the Arles festival make, when it dispatches Mathieu Pernot to the category "young artist" while presenting Klavdij Sluban as someone who "turns documentary images into photography" [sic]? Are we to suppose that Pernot is an artist-who-uses-photography, in line with the institutional definition of art that prevails in the present-day art world, whereas Sluban's press photos are elevated to being instances of "photography" (photography *itself*, photography *as such*), in line with the modernist aesthetic definition of art that prevails in institutions such as MoMA? Speaking of MoMA: while the Cambodian photos were on view in Arles, *Le Monde* published an article by its photography critic, Michel Guerrin, stating that they had "acquired an 'artistic' status by entering the collections of prestigious museums, the Museums of Modern Art in New York, San Francisco, and Los Angeles."[5] Though Guerrin's article failed to mention it, the news reached Arles that MoMA was showing the photos. This news, combined with the hype of the festival and the floating status of several of its other exhibitions, fueled speculation on the reasons for MoMA's acquisition and made contamination of the Arles *S-21* show by the photos' purported art status at MoMA inevitable. It became very difficult not to suppose that the photographs, or at least the ones MoMA had purchased, could, perhaps should, be viewed as art. Whether, by implication, Nhem Ein and his staff were to be considered artists – and whether this categorization was aesthetically, ethically, or politically defendable (to quote Caujolle's motto) – was an idea everybody in Arles that summer felt very uncomfortable with, yet it came to everybody's mind. Caujolle was of course not responsible for MoMA's acquisition and could not be blamed for the photographs' already problematic status at the festival being exacerbated by the knowledge that they would be on view in a major art museum. There and then, in Arles in 1997, MoMA's decision to collect and exhibit Nhem Ein's photos was a source of confusion. With the distance we have today, this very decision can be put to work to undo the confusion and to help us clarify the issue that is the topic of my paper: to examine the legitimacy of art and the art institution in the face of radical evil. The photos provide a particularly disturbing test case, and one that is made unbearably ambiguous by the floating status of photography within a festival whose reason to exist revolved around the motto "ethics, aesthetics, politics."

By contrast, the reason for MoMA to exist is not ambiguous at all. It is to collect and exhibit art, not to foster the duty of memory or to testify to the monstrosities engendered by political madness.

Collecting and exhibiting art are by definition the main functions of *art* museums. The standard humanist legitimation of art museums is that art is the collective property of humanity; the publicness of the museum is thus grounded on its patrimonial character. The humanist approach argues that since humanity possesses this collective treasure called art, the public has a right to access it. Accordingly, the humanist legitimation of art practice is tied up with the notion that artists are spokespeople for humanity in the aesthetic domain, and therefore it postulates the legitimacy of artists to speak on behalf of all of us. There is a circular dialectic at work in the humanist argument: the legitimacy of the museum ultimately rests on the artists, while the legitimacy of the artists rests on their contribution to the museum. And both rest on the circular assumption that respect for the human defines the human. Every work of art having found its way into the collective treasure is supposed to contain something that is of interest to humans in general, something that expresses, feeds, and rewards the humanity of humanity – I mean, the humanness of humankind. Should Nhem Ein be called an artist, he would have to be considered a legitimate representative of humankind as a whole, and that notion is obscene. Moreover, the expressions of the human condition emanating from Nhem Ein's photographs, as incredibly moving, touching, disturbing, and laden with tragic humanity as they are, would have to be attributed to his own sensitivity to the humanness of humankind, in other words, to his empathy with the models, which is even more obscene. If MoMA's raison d'être – to collect and exhibit art – ought to be justified in the humanist terms I just outlined, then in deciding to collect and exhibit Nhem Ein's photos, MoMA would have done nothing less than delegitimize its own existence.

I'm not happy with that. I cherish museums as much as I cherish art, and I don't rejoice at the prospect of dancing "on the museum's ruins," to quote Douglas Crimp's well-known critique of the art institution, which is based – not by chance and I think rightly so – on the conviction that the Trojan horse that penetrated the museum did so in the guise of photography.[6] I do share Crimp's profound mistrust of the humanist legitimation of art and the art museum. However, unlike him, I don't believe in the slightest that museums of art have lost or should lose their legitimacy. They are – and this is quite different – under threat of becoming theme parks run for profit by the private sector with the involuntary help of well-intentioned leftist scholars who see it as a victory to dissolve the singularity of "art" into the heterogeneous relativity of "cultural practices." I think art museums urgently need a legitimation other than the humanist one, one for which the S-21 photographs may provide the most adequate – because the hardest conceivable – test case. Here is, in a nutshell, how I would sketch out this alternative legitimation. Museums of *art* are institutions, I would argue, where some human artifacts are being collected and preserved *under* the name of art and shown *in* the name of art. The status of any given object included in the collection of an art museum hinges on two distinct procedures: the aesthetic judgment that has compared the object with existing art and confirmed that it deserves to be kept as art; and the public exhibition of the object on behalf of, precisely, its comparability with the collection of objects acting as standards of comparison. Thus as a rule, museums of art collect and preserve things as art and display them in the name of art. Therein

lies their legitimacy. Museums with other headings do neither: however beautiful the dioramas at New York's Museum of Natural History, the stuffed animals they contain are not preserved as works of art and are not displayed in the name of an aesthetically constituted collection of works of art either. In order to clarify the fuzzy notion of "art status," it might prove useful to clearly distinguish between the two functions of art museums and their corresponding procedures, as I have briefly described them, because room is then made for two interesting anomalies: the case where things undoubtedly collected as works of art are not shown in the name of art – for example, Rembrandt's *Anatomy Lesson* in a documentary exhibition on the history of surgery – and the case where things not necessarily acknowledged as works of art are nevertheless shown in the name of art – S-21 being an extreme such case, if not in Arles then certainly in New York.

I did not see the MoMA show. It was soberly entitled *Photographs from S-21: 1975–1979* and contained the eight photos the museum had purchased, along with fourteen others, in modest-sized, framed, and matted enlargements. It was installed in Gallery Three, located at the far end of MoMA's old photography wing and advertised as "a place where visitors may pause to sit and reflect, and where museum curators may share their enthusiasms for particular photographs, their thoughts about particular episodes in photography, and their explorations of the museum's rich collection."[7] The photography department at MoMA has a long history of admitting into its collection pictures that were obviously not made as works of art and whose vernacular condition the curators repeatedly insist should be kept in mind when viewing them.[8] Presumably, the special status of Gallery Three is meant to facilitate this attitude. Whether it succeeds is not guaranteed, however, because being a museum of art, everything MoMA presents is inevitably shown in the name of its comparability with existing art and is therefore begging the label "art" for itself. Hence the puzzlement museum visitors may feel when touring some galleries – those of industrial design and photography being prime examples: they are invited to contemplate non-art objects in reference to art. Hence also the curators' discomfort with the art/non-art dilemma, and the many disclaimers that have always accompanied MoMA's exhibitions of vernacular photography. A constant of those disclaimers is that they simultaneously deny that the photographers had *artistic* intentions when they made the photos while acknowledging that the curators have *aesthetic* concerns when they show them. The result is a clever whisking away of the embarrassing word *art* in favor of its medium-specific hypostasis, "photography." One example would be Edward Steichen's characterization of the unsigned images shown in his 1951 show *Forgotten Photographers* as "remarkably fine examples of photography" – photography, period.[9] Another would be Szarkowski's claim, in *The Photographer's Eye*, that the artist photographer's senses of reality and craft are "anonymous and untraceable gifts from photography itself."[10] And yet another is provided by MoMA's present chief curator of photography, Peter Galassi, when he states, "any kind of photograph, made for any purpose, is potentially relevant to the study of photography as a whole."[11] "Photography" (photography, period), "photography itself," and "photography as a whole" are expressions that not only suggest that some photographs are worthy of aesthetic appraisal, but also that the whole of photography – in Szarkowski's words, "the great undifferentiated whole of it" – the medium itself, withstands comparison with other artistically recognized mediums where aesthetic potential is concerned. There is no question that it does; I see no problem in admitting that

not all photographers (or all painters, for that matter) need to be called artists for their medium to be recognized as an art form. My point is that once an individual photograph conjures up its comparability with existing art works and art forms, it cannot escape begging or claiming the label "art" for itself, no matter how plain, inartistic, or vernacular it seems or is. This is true at MoMA, in Arles, or anywhere; the museum context simply makes the comparability issue explicit, because whatever the museum shows is shown in the name of art, or, when the word "art" is avoided, in the name of formal concerns that are the trademark of high art all the same. Such concerns were made very clear by Szarkowski in 1967 when, introducing *Once Invisible*, an exhibition of scientific (and thus non-artistic) photographs of things beyond the threshold of what can be seen with the naked eye, he wrote: "Such work has been independent of artistic traditions, and unconcerned with aesthetic standards," only to add a little further on that the subject matter of the exhibition was "the form – the morphology, not the function – of the pictures shown."[12]

Needless to say, the wall text for *Photographs from S-21* stays aloof from such overt formalism. Signed by curatorial assistant Adrienne Williams, who organized the show, it soberly states that when Chris Riley and Douglas Niven discovered the negatives, "they recognized that these powerful images warranted viewing by a larger audience." The reader is left to infer that the curator shares that opinion. Riley and Niven themselves are more outspoken: "When we saw the original six-by-six negatives, we knew we could make very good prints," said Niven. Riley corroborated: "We could create exceptional quality prints from these negatives. And with this quality, we could get them into publications, galleries, and museums, so as to reach a wider audience." Asked whether their project evolved out of photographic or historical concern, Riley answered, "Our initial reaction was purely photographic," and Niven added, "Even though they were of horrible subject matter, with horrible histories, we saw the possibility of making beautiful photographs."[13] It was left to Jack Woody, the publisher of *The Killing Fields*, to make the aesthetic argument dovetail with the medium-specificity-as-art argument and, in addition, to carry it beyond the formal issue of beauty or quality and to fill it with human content: "I thought they were the most amazing photos I'd seen in years. The emotional rapport the viewer has with subjects I hadn't experienced in a long time. I thought to myself, 'That's as good as photography gets'."[14] Such blunt language is miles away from the detached vocabulary of the photography curators at MoMA, but it may spell out why, in their eyes too, "these powerful images warranted viewing by a larger audience" and were "potentially relevant to the study of photography as a whole." What is relevant indeed is that Woody should speak of "the emotional rapport the viewer has with subjects" – the subjects in the photos – rather than with the photos themselves as objects of study. Suddenly, the poignancy Roland Barthes deemed essential to the medium of photography punctures MoMA's formalist discourse. Barthes's *punctum* and the way it overwhelms the viewer overrule MoMA's self-imposed restriction to the *studium* – so much so that if any specific reference to "photography itself" is summoned by the Tuol Sleng photos, it certainly is Alexander Gardner's photo of Lewis Payne/Powell on death row, whose *punctum* Barthes characterized thus: "He is going to die."[15]

Sobriety in exhibition design, noncommittal wall texts, and clever avoidance of the word "art" in press releases won't succeed in hiding the fact that our aesthetic interest in photography is shot through with feelings, emotions, and projections of

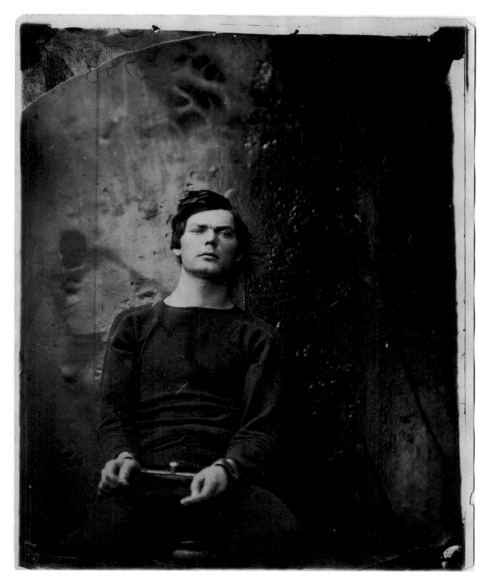

Figure 39.2 Alexander Gardner. *Lewis Payne / Powell on Death Row.* 1865. Courtesy of the Indiana Historical Society, P0409.

sympathy or antipathy that address the *people* in the photos beyond the photos themselves.[16] I am convinced that something of that emotional response to the properly *human* ordeal of the subjects in the Tuol Sleng photos had a say in MoMA's decision to acquire them. To suppose otherwise would be to lend the acquisition committee undeserved cynicism. The coolness, the aloofness – and in the case of *Photographs from S-21*, I'm tempted to add, the coyness – that are characteristic of the discourse of MoMA's photography department should not be taken at face value. They betray embarrassment much more than an affinity for lofty formalism or an aversion to the human and humanitarian content of photographs. They are preemptive moves, it seems to me, destined to silence the humanist justification for photography's place inside a museum of art. I guess inhabiting the Trojan horse when you are a defender of Troy is not the most comfortable position to be in, but it sharpens your senses. And I guess the curators of photography at MoMA must be more alert than other departments to the dangers of scavenging in "the museum's ruins," and are therefore all the keener to eschew the humanist legitimation of the art museum as a whole. With *Photographs from S-21*, the preemptive move verges on the phobic, and understandably. The slightest avowal of emotional intercourse with the photos and compassion for their subjects brings the risk of a humanist reading too close to home – and with it, the risk of proclaiming Nhem Ein an artist, that is, a legitimate representative of humanity in the aesthetic domain.

The above may be sheer speculation. As I said, I did not see MoMA's exhibition and, for reasons that will become clear, I am therefore unable to form a fair opinion on its decision to acquire and show the Tuol Sleng photographs. The idea that, with this acquisition, the humanist legitimation for art and the art institution was put to its toughest test ever, was in any case an irrepressible thought for anyone like myself who had learned of the MoMA purchase upon arriving in Arles. But what had got me thinking even before I saw the Arles exhibition was the kind of test it would represent for the alternative legitimation of the art institution I was already working on.[17] The humanist, patrimonial view argues that since humanity possesses this collective treasure called art, all are entitled to have access to it. I propose to argue in the opposite direction: provided that all have access to the treasure and are free to put its art status on trial at any given moment, its preservation in public art institutions is justified. Presentation or publicity legitimates collection or patrimony, not the other way around. The main consequence of this reversal of the humanist argument is that it shifts the freedom and the responsibility of conferring "art status" away from the museum officials and on to the viewers. In normal day-to-day conditions – that is, when the museum collects and preserves certain things as art and shows them in the name of art – this transfer is effected as an invitation handed over to the viewers to appreciate the works aesthetically, with no further consequences if they keep their verdicts to themselves. But in the two anomalous conditions I hinted at earlier – when things collected as art are not shown in the name of art (a case, incidentally, that has virtually become the rule in the world of contemporary art), or when things that are not art are nevertheless shown in the name of art (as is the case with vernacular photography at MoMA) – then real, not merely symbolic or conventional, pressure is exerted on the individual viewers to baptize the things in question as "art" or "not art" themselves. Aesthetic judgments acquire an either/or gravity they do not have in the day-to-day life of art museums – and are certainly not expected to have in the context

of a summer photo festival in a lovely Provençal town bathed in sunlight. One would have expected that the variety of shows the Arles photo festival had to offer in 1997, and their differences in status, shifting across the whole spectrum of photography's artistic and non-artistic usages, would have alleviated or even diluted the gravity the *S-21* show requested – for political, not aesthetic, reasons. The opposite was true: without *S-21* the deliberate ambiguity of the festival might have fueled passionate bistro conversations on the art status of this or that body of photographs – but conversations that would make no one lose sleep. The presence of *S-21* loaded the conversations with an exacerbated gravity that proved to be of an aesthetic much more than a political nature. Even amid an array of exhibitions containing violent images, *S-21* felt out of place, like a deliberate and solemn *faute de goût* that made straightforward aesthetic characterizations of the photos disturbing to hear and awkward to pronounce. Riley and Niven chose not to speak in Arles; it is a safe bet that hearing them talk of "beautiful photographs" and "exceptional quality prints" would have been unbearable to quite a few visitors of *S-21*.

The importance of disentangling the proposed alternative from the humanist legitimation of the art institution becomes all the more apparent when one considers that Caujolle's placement of the *S-21* show in the rubric The Duty of Memory was not free of humanist calculations. The invocation of human rights and their violation is fundamental to the prescription of the duty of memory. In relying on the concept of human rights, Caujolle may have overlooked the uniqueness of the Tuol Sleng photos. I don't think arousing compassion for the victims and their rights was the first among his motivations, but he must have seen such empathy as a precondition for political awareness and the fight against oblivion. Given that empathy with the individuals in the images is inseparable from our aesthetic response to photographs more than to other, nonindexical kinds of images (Barthes's *punctum*, again), Caujolle was bound to call on a sort of sentimental humanitarianism to sustain his decision to include *S-21* in the Arles festival. This forces me to ruthlessly examine his ethical attitude when he made that decision. It was unambiguous, politically. Caujolle adamantly refused to grant Nhem Ein and his assistants the title of artists, or the photos the status of art. Nhem Ein was an agent of Pol Pot's regime and in no way a representative of humanity. The photos were the product of a totalitarian police state and a deranged genocidal bureaucracy. Caujolle did not exhibit them in the name of art, but rather, in the name of a political imperative called the duty of memory. As far as he was concerned, art had never been at issue. His statements made sure that the photos were exhibited with a virtual yet rather visible label stating, "This is not art," and bearing his signature.

I see no reason to doubt Caujolle's sincerity, so let me try to be as clear as he. I respect and share his ethical attitude regarding the photographers. I am no more ready to call Nhem Ein an artist than he is. But my own reasons for this are quite different from his: mine are poised on the threshold where aesthetics leads into ethics and only then into politics, whereas his, as I understand them, are integrally political, and are ethical only inasmuch as justice in politics presupposes an ethical sense of justice. Whatever *aesthetic* reasons he must have had to claim that art was not at issue in Nhem Ein's photos are either subservient to the political cause he has embraced or set aside, denied, and repressed. Again, I see no reason to question his ethical and political commitment, which I endorse and respect. What worries me is the shunting

of aesthetics, which I cannot help but think is bound to give way to some return of the repressed. I cannot conceive of political clairvoyance in matters of art without trust in aesthetic experience, but this is apparently not Caujolle's philosophy. The result is that he failed to register the new aesthetic — yes, *aesthetic* — category the Khmer Rouge forced us to open, that of *genocidal images*. There is, to the best of my knowledge, no other historical instance of a political regime involved in genocide that systematically kept a photographic record of the people it exterminated. Even the Nazis did not do this systematically, and when they did, they often attempted to destroy the evidence.

> The attack against the species is the work of the species. The SS is not different from us. Personal innocence, as deep as it may be, counts for nothing in the face of this forced solidarity with the species as carrier of evil, of death, of fire. Not a trace of humanism in this.[18]

Those lines are excerpted from a text that aptly (or perhaps not aptly at all) echoes Caujolle's duty of memory, since it is titled *Autour d'un effort de mémoire: Sur une lettre de Robert Antelme* (Concerning a memory effort: on a letter by Robert Antelme). The circular dialectic at work in the humanist legitimation of art and the art institution assumes that respect for the human defines the human. Mascolo's lines, and, in their background, Antelme's book, *The Human Race*, shatter that assumption. Perhaps humanism's greatest philosophical inconsistency is to presume that inhuman behavior excludes some humans from humanity. The lesson to be drawn from the Shoah, Mascolo reminds us, is that no one can be excluded from humanity: the torturers are as human as the victims. Making Nhem Ein a legitimate representative of humanity in the aesthetic domain is obscene but consistent with both the quality of his photos and the humanist legitimation of art — *which is thereby shown to be ruined*. Though I agree with Caujolle in refusing to call Nhem Ein an artist, I believe that his reasons are insufficiently disentangled from pre-Shoah humanism. In everything he said to explain and justify his attitude (though not, interestingly enough, in his actions, as we shall see), Caujolle seems to have winced before what Mascolo called the "forced solidarity with the species as carrier of evil, of death, of fire." He did not go far enough in the direction of complicity with the murderers; he stopped short of fully assuming the obscenity of his own endeavor.

Let us recall that, upon learning of the Arles exhibition, Nhem Ein declared himself proud to be the "star" of a photo festival in France, and virtually thanked the organizers for the nearly bestowed title of artist. That is obscene enough. Now, let us momentarily grant him his title, or at least examine on what basis it could be granted to him. Surely, it never crossed Nhem Ein's mind at the time that his work was art or could be seen as such — though who knows? Unlike Marc Garanger, who was forced by the French army during his military service in the Algerian war to photograph "suspect" Algerian women, due to his civilian career as a photographer, Nhem Ein was not even a professional photographer before the Khmer Rouge sent him to Shanghai with the explicit purpose of teaching him the skills he needed to carry out his task at the side of the executioners. We cannot rule out the hypothesis that he developed a genuine taste for the medium in the course of his studies and that he took refuge in an aesthetic attitude in order to blind himself to his complicity in the atrocities committed at S-21. Though he now denies it, he may have had

conscious artistic ambitions at once prompted and perverted by his own survival strategy. There is evidence that he set up a formal photo studio fit for a more refined practice than mere mug shots – an oddity, given the circumstances. Indeed, the quality of some of the Tuol Sleng photos makes it unlikely that Nhem Ein and the photographers on his team were not conscious of their aesthetic know-how. If not unconscious artists, could it then not be said that they were "inadvertent" or "unintentional" artists?[19] The argument may be morally repulsive, yet it is aesthetically relevant: Atget didn't want to be perceived as an artist, yet the sheer quality of his work has made us brush his protests aside, and rightly so. To calm our scruples at the prospect of treating Nhem Ein like Atget, we might retort that, being morally compromised in an evil enterprise, Nhem Ein forsook every right to the title of artist. But that would be the weakest argument of all: Leni Riefenstahl was an artist, and much more compromised with the Nazi regime than Nhem Ein with the Khmer Rouge, since she was not under threat. No measure of delving into Nhem Ein's psyche, consciousness, and conscience will get us around what has long been recognized in aesthetic theory as the "intentional fallacy."[20] To try to understand the status to be given to these photographs, we should turn to Caujolle's consciousness and moral conscience instead. The latter is beyond suspicion. The former puts him in jeopardy. Though he may have underestimated the ambiguities inherent in the context of S-21's reception, Caujolle must have been aware that the label "This is art" would be attached to the photos. To suppose otherwise would be an insult to his strategic intelligence about the situation. Placing S-21 in the context of other photography exhibitions whose art status ran the gamut from press-agency photojournalism to "straight" and then "pure" photography to "art-done-in-the-photo-medium" was a calculated move, and the show's impact owed a lot to its ambiguous position on that spectrum. If the show were held at the Cambodian embassy, or in some other humanitarian context, as a ritual of political catharsis and atonement, its impact would not at all be the same. Moreover, Caujolle himself must personally have attached the label "This is art" to the photos, whether or not he knew it or acknowledged it. To suppose otherwise would this time be an insult to his aesthetic familiarity with the medium's history and to his sophisticated awareness of the medium's potential. Before he decided to show them in Arles, he had seen the photos in Phnom Penh; he had registered their emotional impact; he had acknowledged receipt of them on the aesthetic as well as on the ethical and the political levels. He simply would not allow himself to let the word "art" translate his aesthetic experience. His negation of the photos' properly *artistic* qualities is a denial in a quasi-Freudian sense and not unlike the rejection of so many masterpieces of avant-garde art by those critics who registered the works' aesthetic impact but could not deal with the emotional responses they triggered.

What makes me speak of denial is not that Caujolle acted in bad faith or unconsciously. It is that aesthetic judgments are involuntary and that the phrase "This is art" expresses an aesthetic judgment. The word "art" comes to your mind, possibly against your will, whenever a human artifact triggers an aesthetic response that calls for a comparison with existing art. In the context of an art museum, the call for such a comparison is explicit and desired – this is what "showing art in the name of art" means. At the Museum of Genocide in Phnom Penh, the photos are shown neither as art nor in the name of art. Did Caujolle's experience of them there nevertheless situate itself

in the comparative realm of aesthetic judgments about art? There is evidence of a posi-
tive answer in his own acknowledgment that "these portraits are undeniably images
presenting an aesthetic interest," and that "certain portraits could undoubtedly find
a place in an exhibition of Irving Penn or Richard Avedon."[21] To attach the sentence
"This is art" to the photos is inevitable the minute Irving Penn or Richard Avedon are
summoned, whether or not you dare admit it. Caujolle didn't deny the aesthetic nature
of his initial response to the photos. What he denied was the legitimacy of the transla-
tion of his aesthetic experience into the sentence "This is art." He must have grasped
that if he admitted that Nhem Ein's photos were art, he would also have had to admit
that Nhem Ein was an artist. But I don't believe this to be the last word on his reason-
ing; another inference can be made from the same premises. Before we broach the
subject, we need to question another aspect of Caujolle's explanation of his attitude
and uncover another denial.

This has to do with the way Caujolle installed the photos. To demonstrate that his
attitude had been ethical and political rather than aesthetic, Caujolle explained that
he had gone out of his way to de-aestheticize the installation as much as possible. His
favorite strategy to that effect was not to make decisions – or so the story goes. He had
accepted the first venue the city of Arles offered for the show, he said: a rather inhos-
pitable room, amateurishly equipped, that had once served as an exhibition room and
was in a rather derelict state. He had arranged the photos in a grid fully occupying one
and only one wall of the room. He had determined the scale of the images' enlargement
based on the number of photographs to be fit in precisely this arrangement. He had
eschewed composition and had underlined the arbitrariness of the hanging by placing
the photo of the boy wearing the number one in the top left corner of the grid. The
wall was poorly lit by a battery of spotlights that looked as if they had not been aimed
properly but left as they were. He had indeed left them as he found them. Finally, he
had printed a text explaining the reasons for the show on a transparent sheet of plastic,
neither hanging on the wall above or underneath the photographs nor on an adjacent
wall, but lying on the floor in front of the photos, as if the installation work were still
in process. The text ran the whole width of the grid, on several lines, in such a way
that you had to walk back and forth to read it, while, by the same token, you were
subjected to a lineup of gazes staring at you from the photographs, with the shattering
diversity of their appearances and the singularity of their address. All these decisions,
or nondecisions, were ethical and deliberately anti-aesthetic. I heard this explanation
from the horse's mouth prior to my visit, and I already suspected that such convenient
separation of the ethical and the aesthetic could not be upheld. The actual experience
of the installation confirmed my suspicion. It was clear to me that, his vehement deni-
als notwithstanding, Caujolle had made a number of precise aesthetic decisions, and
that these were much less conventional and thus much more artistic than the ones
usually made by a curator hanging a show. He behaved like an installation artist, a good,
politically conscious and responsible artist, who knows how the ethical legitimacy of
art hinges on aesthetic decisions, and all the more so when they take the form of a
series of calculated anti-aesthetic gestures.

At that point I began to understand why Caujolle had so stubbornly denied that
Nhem Ein's photos were art: not so much because he would have had to admit that
Nhem Ein was an artist, but because he was reluctant to admit that he himself was the
artist. Yet, what better acknowledgment could we imagine of what Mascolo called the

"forced solidarity with the species as carrier of evil, of death, of fire"? What better recognition of the fact that no one can be excluded from the humanity in whose name artists claim to speak? I think Caujolle recoiled, but he may have another explanation; he probably shares the current view that, with the exception of those grandiloquent egomaniacs practicing the worst kind of reactionary art, artists *do not* pretend to speak in the name of humanity. He thus would fall victim to the same misunderstanding that has fed all the anti-aesthetic theories of art that have come to dominate debate over the last forty years. The alternative theory that I think our times need maintains that artists legitimately claim to speak in the name of humanity, provided humanity is allowed to include the tasteless and uncultivated, the enemies of art, the barbarians, the criminals, and even – to use the three categories that emerged from the Nuremberg trials to designate the perpetrators of imprescriptible crimes – those guilty of war crimes, genocide, and crimes against humanity. "Not a trace of humanism in this," to quote Mascolo again. Caujolle's anti-aesthetic strategy as an installation artist definitely confirms that such a humanism is delegitimated as a foundation for art. But Caujolle's denials, highlighted by the fact that his acts belie his words, show that delegitimation is not enough. We don't want to be trapped in aporias such as Adorno's, when he claimed in "Cultural Criticism and Society" (1951) that writing poetry after Auschwitz was barbaric (which he then retracted in *Negative Dialectics*, 1966). It is the relegitimation we should be looking for, even if this means defending Caujolle against his own denials.

The humanist legitimation claims that art is the collective property of humanity. What if humanity is to include war criminals and people guilty of genocide? The same legitimation also entails that artists are representatives of humanity in the aesthetic domain. What if they are actually aesthetic representatives of perpetrators of crimes against humanity? On either account, Nhem Ein cannot possibly make a legitimate claim to the title of artist. The conclusion, however, is not that the title of artist has been irredeemably sullied or that practicing photography after Tuol Sleng has become as barbaric as writing poetry after Auschwitz once was for Adorno. The conclusion pays attention to the transference forced on the title of artist: it is now as if Caujolle had taken it upon himself to replace the missing artist, and with no greater claim to legitimacy. Recognizing this lack of legitimacy is the first step toward relegitimation, and Caujolle took that first step, quite paradoxically protected by his denials and the way they contradicted his acts. He assumed Nhem Ein's place, symbolically stepped into his shoes, crept into his skin, shouldered the role of the monstrously illegitimate artist, and took responsibility for the aesthetic qualities yielded by Nhem Ein's photos. This he did in his capacity as the photos' curator, protected by the knowledge that he was not their maker. And in so doing, he transferred the burden to the viewer: in spite of all his denials, he nevertheless decided that these photos deserved to be seen, for their aesthetic qualities as well as for their political relevance. He addressed them to us. He addressed them to me.

In my whole life, I have never felt that an aesthetic judgment could weigh so heavily on someone's shoulders. Nor have I ever felt so strongly that I had a moral responsibility in making that aesthetic judgment. The experience was painful, and I couldn't say why at the time. Now I think I can. It has to do with aesthetic judgments being comparative and involuntary. The fact is, it was incredibly easy – not just easy, it was automatic – to see in those photos reminiscences of Richard Avedon (I'm

not sure about Irving Penn, but then, I'm not photo-literate enough). I couldn't help Avedon's photo of a napalm victim, for example, being a screen through which I was viewing the *S-21* photos. The best among them were in any case laden with the kind of humanist poignancy you expect from a good Avedon photograph, and this made them unbearable. My experience of them was like the experience of a strongly provocative avant-garde work – the kind of work that provokes an initial response of disgust, and which you must slowly learn to appreciate – but in reverse. Here the initial response was one of cheap empathy and good conscience, while knowledge of the context in which the photos had been taken only made their potential for sentimentality worse – revolting, even. I had to fight my initial response; that's what the photos were asking. The moral responsibility I felt I had vis-à-vis these images entailed a refusal and a rejection of the aesthetic feelings they yielded. Of course this couldn't be done, because aesthetic feelings are involuntary: I couldn't deny having had them without being dishonest. Instead, the photographs actually called for a prolonged and renewed aesthetic experience of them. I spent an hour with them on my first visit and came back for another hour the next day. I found myself staring at the photos – or rather, at the people in the photos – one by one, for quite some time, until they emerged from the anonymity of mass murder and became individuals again. It's not that they were not individuals in my first experience, it's that their individuality, draped in generic humanism and conventionalized by the "Avedon aesthetics" they too easily conjured up, had to be recovered from elsewhere – most of the time from some little detail that told something specific, not about their lives or their personalities but about their present ordeal, the material conditions of detention, the fear on their faces or the disarming abandonment in their eyes at the very moment of the snapshot. I had to address each photo, each person in the photos, individually before I could acknowledge receipt of their gaze – which most of the time was indeed intensely addressed to the camera – as if it were addressed to me in person. Only then did the people in the photos rise from the dead, and only then did this unbearably controversial exhibition acquire its true legitimacy.

This is in no way the last word on the new legitimation for art and the art museum that the delegitimation of the old humanist rationale requires. *S-21* remains an extreme and fortunately rare borderline case. Why is it such a crucial test case, then? Why does Nhem Ein's complicity in the Cambodian genocide provide us with a unique example of *non-art*, one that has as much paradigmatic value for art theory as other harmless yet far more notorious examples of non-art, such as Duchamp's readymades? Is it because Nhem Ein's photos explore and transgress the limits of art? Is it because they force us to conceive of art beyond the pale of what is humanly acceptable? I don't believe in such rationales. They have been called upon too often in justification of so-called works of non-art, and in my view they never applied to really good art nor explained why negativity in art transmutes into positive qualities. Too much complacent credit is given in art criticism to the representation of trauma, the aesthetics of the abject, the celebration of disgust, the fascination with snuff movies, the aestheticization of catastrophes and terrorism, and other morbid symptoms. Karlheinz Stockhausen's claim that 9/11 was a work of art should put an end to those symptoms, for it tells their truth. To repeat: why is *S-21* such a crucial test case for art theory? 1) Because, as I hope to have shown elsewhere, the new legitimation for art and the art museum puts the humanist claim of the artist's universal representativity

Figure 39.3 Richard Avedon. *Napalm Victim, Saigon, Vietnam, April 29, 1971.* Copyright © The Richard Avedon Foundation.

to the test of the art work's universal address; 2) because I have no way of know-ing whether a work of art contains a universal address except the feeling of being addressed personally by it; 3) because, more often than not in truly innovative art, that feeling hinges on my capacity or my willingness to address the work so that it addresses me; and 4) because, in the case of images proceeding not just from murder-ous intentions but from genocidal ones, this reversal of address is made mandatory by the absolute certainty that the photographer did not address his models.[22] It belongs to the definition of genocide that the people it exterminates are annihilated in their humanity even before they are actually killed. Nhem Ein did not execute the victims; they were dead already to his eyes, inasmuch as they were reduced to things that are not spoken to and will soon be disposed of. This is why the responsibility of addressing them is imperatively transferred to the viewer of the photos, whether Caujolle or you and me. Calling the photos by the name of art, baptizing them, in the second person – "You are art" – is just one way, the clumsiest, certainly, of making sure that the people in the photos are restored to their humanity; and this, not their so-called art status, is of course what matters. To speak of shouldering the role of the *artist* that Nhem Ein could not assume is another way of saying the same. There is nothing honorific to the name artist in this sense. If anything, it testifies to the impossibility of claiming to speak on behalf of all of us without speaking for the evil part of humankind as well as for the peaceful and civilized.

Original publication

'Art in the Face of Radical Evil'. *October* (2007)

Notes

* A version of this paper was presented at the 2007 International Congress of Aesthetics, in Ankara.
1 Quoted in Susan Sontag, *On Photography* (New York: Farrar, Straus and Giroux, 1977), p. 199.
2 Chris Riley and Douglas Niven, eds., *The Killing Fields* (Santa Fe: Twin Palm Publishers, 1996).
3 Jean-Claude Pomonti, "Nhem Ein, photographe en chef des Khmers rouges," *Le Monde*, July 5, 1997. See also Craig S. Smith, "Profiting From His Shots of Pol Pot's Terror," *Wall Street Journal*, September 16, 1997.
4 Christian Caujolle's public address in Arles, July 7, 1997, in Françoise Docquiert and François Piron, eds., *Image et Politique* (Arles: Actes Sud, 1998), p. 104.
5 Michel Guerrin, "La photographie documentaire surexposée," *Le Monde*, July 6, 1997.
6 Douglas Crimp, "On the Museum's Ruins," in *On the Museum's Ruins* (Cambridge, MA: MIT Press, 1993), pp. 44–64.
7 Press release from the exhibition *Photographs from S-21: 1975–1979*, Museum of Mod-ern Art, New York, May 15–September 30, 1997.
8 For an insider's view of the history of the photography department at MoMA, see Peter Galassi, "Two Stories," in *American Photography 1890–1965* (New York: Museum of Modern Art, 1995). For an outsider's critical view of the same, see Christopher Phillips, "The Judgment Seat of Photography," *October* 22 (Fall 1982), pp. 27–65.
9 Quoted in Peter Galassi, "Two Stories," p. 11.

10 John Szarkowski, *The Photographer's Eye* (New York: Museum of Modern Art, 1966), n.p.

11 Peter Galassi, e-mail to the author, July 4, 2005. I am deeply indebted to him for having shared much of the documentary material the department had accumulated in preparation for *Photographs from S-21,* and for having meticulously responded to the many questions I had for him.

12 John Szarkowski, from the press release and wall text for the exhibition *Once Invisible,* Museum of Modern Art, New York, June 20–September 11, 1967.

13 Juan I-Jong, "An Interview with Chistopher Riley and Douglas Niven," *Photographers International* 19 (April 1995), pp. 96 and 98.

14 Quoted by Guy Trebay, "Killing Fields of Vision," *The Village Voice,* June 3, 1997.

15 Roland Barthes, *Camera Lucida,* trans. Richard Howard (New York: Hill and Wang, 1981), p. 96.

16 See my "People in the Image / People before the Image: Address and the Issue of Community in Sylvie Blocher's *L'annonce amoureuse,*" *October* 85 (Summer 1998), pp. 107–126.

17 I am still working on it, which explains why I have published very little on the subject. See my "Museumethiek na Broodthaers: een naïve theorie" (The ethic of the museum after Broodthaers: a naive theory), *De Witte Raaf* 91 (May–June 2001), a Dutch version of an otherwise unpublished talk I delivered at the "Ideals and Ideology" conference held at the Boston Museum of Fine Art in April 1998.

18 Dionys Mascolo, *Autour d'un effort de mémoire: Sur une lettre de Robert Antelme* (Paris: Maurice Nadeau, 1987), p. 63 (my translation). Dionys Mascolo (1916–1997) was a writer and committed intellectual and Marguerite Duras's second husband. He and Georges Beauchamp rescued her first husband, Robert Antelme, from Dachau in 1945. Two years later, Antelme published *L'espèce humaine* (*The Human Race*), his account of life in the concentration camp, which is also a philosophical meditation on the absolute unity of the human species. What Antelme discovered through his experience in the camp is that when the political, "positive," emancipatory concept of human *kind* is destroyed, physical survival and moral dignity have to be recovered from the "almost biological claim of belonging to the human species." (*L'espèce humaine* [Paris: Gallimard, 1957], p. 11, my translation.) With this cursory reference to Mascolo and Antelme – I could also have called on Primo Levi's *If This Is a Man* (1947) – I want to make clear that my position is not an anti-humanist one but one that acknowledges that humanism died at Dachau, Auschwitz, and Treblinka. I don't care what name will be given to the *ethical anthropology* our times need (preferably neither "neo-humanism" nor "post-humanism" – both are untruthful and ridiculous), but one thing is sure: since we are not finished with the human condition (*pace* the cyborg and other fantasies), we must think that condition anew, reckoning with the scorched earth the dreadful twentieth century has bequeathed us.

19 The issue was raised by more than one commentator on the MoMA exhibition of the *S-21* photographs. In its subtitle, Michael Kimmelman's article (*New York Times,* June 20, 1997) spoke of "unintentional art," and Jerry Adler and Ron Moreau (*Newsweek,* June 30, 1997), of "accidental art." Implied in both instances, however, was not the idea that the photographers had involuntarily produced art because they were good and well-trained photographers, but that MoMA had unduly elevated their photos to art status. Kimmelman nevertheless asks the retroactive question: "Does this imply that the killers who took them are artists? Can genocide be art?"

20 See William K. Wimsatt and Monroe Beardsley, "The Intentional Fallacy," *Sewanee Review* 54 (July–September 1946), pp. 468–488.

21 Christian Caujolle's public address in Arles, July 7, 1997, in *Image et Politique,* pp. 105–106.

22 See my essay "Do Artists Speak on Behalf of All of Us?" in Diarmuid Costello and Dominic Willsdon, eds., *The Life and Death of Images, Ethics and Aesthetics* (London: Tate Publishing, 2008), pp. 140–156.

Allan Sekula

READING AN ARCHIVE
Photography between Labour and Capital

Every image of the past that is not recognised by the present as one of its own threatens to disappear irretrievably.

Walter Benjamin[1]

The invention of photography. For whom? Against whom?

Jean-Luc Godard and Jean-Pierre Gorin[2]

HERE IS YET ANOTHER BOOK OF PHOTOGRAPHS. All were made in the industrial and coal mining regions of Cape Breton in the two decades between 1948 and 1968. All were made by one man, a commercial photographer named Leslie Shedden. At first glance, the economics of this work seem simple and common enough: proprietor of the biggest and only successful photographic studio in the town of Glace Bay, Shedden produced pictures on demand for a variety of clients. Thus in the range of his commissions we discover the limits of economic relations in a coal town. His largest single customer was the coal company. And prominent among the less official customers who walked in the door of Shedden Studio were the coal miners and their families. Somewhere in between the company and the workers were local shopkeepers who, like Shedden himself, depended on the miners' income for their own livelihood and who saw photography as a sensible means of local promotion.

Why stress these economic realities at the outset, as if to flaunt the 'crude thinking' often called for by Bertolt Brecht? Surely our understandings of these photographs cannot be reduced to a knowledge of economic conditions. This latter knowledge is necessary but insufficient; we also need to grasp the way in which photography constructs an imaginary world and passes it off as reality. The aim of this essay, then, is to try to understand something of the relationship between photographic culture and economic life. How does photography serve to legitimate and normalize existing power relationships? How does it serve as the voice of authority, while simultaneously claiming to constitute a token of exchange between equal partners? What havens and

temporary escapes from the realm of necessity are provided by photographic means? What resistances are encouraged and strengthened? How is historical and social memory preserved, transformed, restricted, and obliterated by photographs? What futures are promised; what futures are forgotten? In the broadest sense, these questions concern the ways in which photography constructs an *imaginary economy*. From a materialist perspective, these are reasonable questions, well worth pursuing. Certainly they would seem to be unavoidable for an archive such as this one, assembled in answer to commercial and industrial demands in a region persistently suffering from economic troubles.[3]

Nonetheless, such questions are easily eclipsed, or simply left unasked. To understand this denial of politics, this depoliticization of photographic meaning, we need to examine some of the underlying problems of photographic culture. Before we can answer the questions just posed, we need to briefly consider what a photographic archive is, and how it might he interpreted, sampled, or reconstructed in a book. The model of the archive, of the quantitative ensemble of images, is a powerful one in photographic discourse. This model exerts a basic influence on the character of the truths and pleasures experienced in looking at photographs, especially today, when photographic books and exhibitions are being assembled from archives at an unprecedented rate. We might even argue that archival ambitions and procedures are intrinsic to photographic practice.

There are all sorts of photographic archives: commercial archives like Shedden's, corporate archives, government archives, museum archives, historical society archives, amateur archives, family archives, artists' archives, private collectors' archives and so on. Archives are property either of individuals or institutions, and their ownership may or may not coincide with authorship. One characteristic of photography is that authorship of individual images and the control and ownership of archives do not commonly reside in the same individual. Photographers are detail workers when they are not artists or leisure-time amateurs, and thus it is not unreasonable for the legal theorist Bernard Edelman to label photographers the 'proletarians of creation.'[4] Leslie Shedden, for his part, was a combination artisan and small entrepreneur. He contributed to company and family archives while retaining his own file of negatives. As is common with commercial photographers, he included these negatives in the sale of his studio to a younger photographer upon retiring in 1977.

Archives, then, constitute a *territory of images*: the unity of an archive is first and foremost that imposed by ownership. Whether or not the photographs in a particular archive are offered for sale, the general condition of archives involves the subordination of use to the logic of exchange. Thus not only are the pictures in archives often *literally* for sale, but their meanings are up for grabs. New owners are invited, new interpretations are promised. The purchase of reproduction rights under copyright law is also the purchase of a certain semantic licence. This *semantic availability* of pictures in archives exhibits the same abstract logic as that which characterizes goods in the marketplace.

In an archive, the possibility of meaning is 'liberated' from the actual contingencies of use. But this liberation is also a loss, an *abstraction* from the complexity and richness of use, a loss of context. Thus the specificity of 'original' uses and meanings can he avoided and even made invisible, when photographs are selected from an archive and reproduced in a book. (In reverse fashion, photographs can be removed from books

and entered into archives, with a similar loss of specificity.) So new meanings come to supplant old ones, with the archive serving as a kind of 'clearing house' of meaning.

Consider this example: some of the photographs in this book were originally reproduced in the annual reports of the Dominion Steel and Coal Company, others were carried in miners' wallets or framed on the mantelpieces of working-class homes. Imagine two different gazes. Imagine the gaze of a stockholder (who may or may not have ever visited a coal mine) thumbing his way to the table of earnings and lingering for a moment on the picture of a mining machine, presumably the concrete source of the abstract wealth being accounted for in those pages. Imagine the gaze of a miner, or of a miner's spouse, child, parent, sibling, lover or friend drifting to a portrait during breaks or odd moments during the working day. Most mine workers would agree that the investments behind these looks – financial on the one hand, emotional on the other – are not compatible. But in an archive, the difference, the *radical antagonism between* these looks is eclipsed. Instead we have two carefully made negatives available for reproduction in a book in which all their similarities and differences could easily be reduced to 'purely visual' concerns. (And even visual differences can be homogenized out of existence when negatives first printed as industrial glossies and others printed on flat paper and tinted by hand are subjected to a uniform standard of printing for reproduction in a book. Thus the difference between a mode of pictorial address which is primarily 'informational' and one which is 'sentimental' is obscured.) In this sense, archives establish a relation of *abstract visual equivalence* between pictures. Within this regime of the sovereign image, the underlying currents of power are hard to detect, except through the shock of montage, when pictures from antagonistic categories are juxtaposed in a polemical and disorienting way,

Conventional wisdom would have it that photographs transmit immutable truths. But although the very notion of photographic reproduction would seem to suggest that very little is lost in translation, it is clear that photographic meaning depends largely on context. Despite the powerful impression of reality (imparted by the mechanical registration of a moment of reflected light according to the rules of normal perspective), photographs, in themselves, are fragmentary and incomplete utterances. Meaning is always directed by layout, captions, text, and site and mode of presentation. [. . .] Thus, since photographic archives tend to suspend meaning and use, within the archive meaning exists in a state that is both residual and potential. The suggestion of past uses coexists with a plenitude of possibilities. In functional terms, an active archive is like a toolshed, a dormant archive like an abandoned toolshed. (Archives are not like coal mines: meaning is not extracted from nature, but from culture.)

In terms borrowed from linguistics, the archive constitutes the paradigm or iconic system from which photographic 'statements' are constructed. Archival potentials change over time; the keys are appropriated by different disciplines, discourses, 'specialties.' For example, the pictures in photo agency files become available to history when they are no longer useful to topical journalism. Similarly, the new art history of photography at its too prevalent worst rummages through archives of every sort in search of masterpieces to celebrate and sell.

Clearly archives are not neutral: they embody the power inherent in accumulation, collection, and hoarding as well as that power inherent in the command of the lexicon and rules of a language. Within bourgeois culture, the photographic project itself has been identified from the very beginning not only with the dream of a

universal language, but also with the establishment of global archives and repositories according to models offered by libraries, encyclopaedias, zoological and botanical gardens, museums, police files, and banks. (Reciprocally, photography contributed to the modernization of information flows within most of these institutions.) Any photographic archive, no matter how small, appeals indirectly to these institutions for its authority. Not only the truths, but also the pleasures of photographic archives are linked to those enjoyed in these other sites. As for the truths, their philosophical basis lies in an aggressive empiricism, bent on achieving a universal inventory of appearance. Archival projects typically manifest a compulsive desire for completeness, a faith in an ultimate coherence imposed by the sheer quantity of acquisitions. In practice, knowledge of this sort can only be organized according to bureaucratic means. Thus the archival perspective is closer to that of the capitalist, the professional positivist, the bureaucrat and the engineer — not to mention the connoisseur — than it is to that of the working class. Generally speaking, working-class culture is not built on such high ground.

And so archives are contradictory in character. Within their confines meaning is liberated from use, and yet at a more general level an empiricist model of truth prevails. Pictures are atomized, isolated in one way and homogenized in another. (Alphabet soup comes to mind.) But any archive that is not a complete mess establishes an order of some sort among its contents. Normal orders are either taxonomic or diachronic (sequential); in most archives both methods are used, but at different, often alternating, levels of organization. Taxonomic orders might be based on sponsorship, authorship, genre, technique, iconography, subject matter, and so on, depending on the range of the archive. Diachronic orders follow a chronology of production or acquisition. Anyone who has sorted or simply sifted through a box of family snapshots understands the dilemmas (and perhaps the folly) inherent in these procedures. One is torn between narration and categorization, between chronology and inventory.

What should be recognized here is that photographic books (and exhibitions), frequently cannot help but reproduce these rudimentary ordering schemes, and in so doing implicitly claim a share in both the authority and the illusory neutrality of the archive. Herein lies the 'primitivism' of still photography in relation to the cinema. Unlike a film, a photographic book or exhibition can almost always be dissolved back into its component parts, back into the archive. The ensemble can seem to be both provisional and artless. Thus, within the dominant culture of photography, we find a chain of dodges and denials: at any stage of photographic production the apparatus of selection and interpretation is liable to render itself invisible (or conversely to celebrate its own workings as a kind of moral crusade or creative magic). Photographer, archivist, editor, and curator can all claim, when challenged about their interpretations, to be merely passing along a neutral reflection of an already established state of affairs. Underlying this process of professional denial is a commonsensical empiricism. The photograph reflects reality. The archive accurately catalogues the ensemble of reflections, and so on.

Even if one admits — as is common enough nowadays — that the photograph *interprets* reality, it might still follow that the archive accurately catalogues the ensemble of interpretations, and so on again. Songs of the innocence of discovery can be sung at any point. Thus the 'naturalization of the cultural,' seen by Roland Barthes as an

essential characteristic of photographic discourse, is repeated and reinforced at virtually every level of the cultural apparatus – unless it is interrupted by criticism.[5]

In short, photographic archives by their very structure maintain a hidden connection between knowledge and power. Any discourse that appeals without scepticism to archival standards of truth might well be viewed with suspicion. But what narratives and inventories might be constructed, were we to interpret an archive such as this one in a normal fashion?

I can imagine two different sorts of books being made from Shedden's photographs, or for that matter from any similar archive of functional photographs. On the one hand, we might regard these pictures as 'historical documents.' We might, on the other hand, treat these photographs as 'aesthetic objects.' Two more or less contradictory choices emerge. Are these photographs to be taken as a transparent means to a knowledge – intimate and detailed even if incomplete – of industrial Cape Breton in the postwar decades? Or are we to look at these pictures 'for their own sake,' as opaque ends-in-themselves? This second question has a corollary. Are these pictures products of an unexpected vernacular authorship: is Leslie Shedden a 'discovery' worthy of a minor seat in an expanding pantheon of photographic artists?

Consider the first option. From the first decade of this century, popular histories and especially schoolbook histories have increasingly relied on photographic reproductions. Mass culture and mass education lean heavily on photographic realism, mixing pedagogy and entertainment in an avalanche of images. The look of the past can be retrieved, preserved and disseminated in an unprecedented fashion. But awareness of history as an *interpretation* of the past succumbs to a faith in history as *representation*. The viewer is confronted, not by *historical-writing*, but by the appearance of *history itself*. Photography would seem to gratify the often quoted desire of that 'master of modern historical scholarship,' Leopold von Ranke, to 'show what actually happened.'[6] Historical narration becomes a matter of appealing to the silent authority of the archive, of unobtrusively linking incontestable documents in a seamless account. (The very term 'document' entails a notion of legal or official truth, as well as a notion of *proximity to* and verification of an original event.) Historical narratives that rely primarily on photography almost invariably are both positivist and historicist in character. For positivism, the camera provides mechanical and thus 'scientifically' objective evidence or 'data.' Photographs are seen as sources of factual, positive knowledge, and thus are appropriate documents for a history that claims a place among the supposedly objective sciences of human behaviour. For historicism, the archive confirms the existence of a linear progression from past to present, and offers the possibility of an easy and unproblematic retrieval of the past from the transcendent position offered by the present. At their worst, pictorial histories offer an extraordinarily reductive view of historical causality: the First World War 'begins' with a glimpse of an assassination in Sarajevo: the entry of the United States into the Second World War 'begins' with a view of wrecked battleships.

Thus, most visual and pictorial histories reproduce the established patterns of historical thought in bourgeois culture. By doing so in a 'popular' fashion, they extend the hegemony of that culture, while exhibiting a thinly veiled contempt and disregard for popular literacy. The idea that photography is a 'universal language' contains a persistent element of condescension as well as pedagogical zeal.

The widespread use of photographs as historical illustrations suggests that significant events are those which can be pictured, and thus history takes on the character

of *spectacle*.[7] But this pictorial spectacle is a kind of rerun, since it depends on prior spectacles for its supposedly 'raw' material.[8] Since the 1920s, the picture press, along with the apparatuses of corporate public relations, publicity, advertising, and government propaganda have contributed to a regularized flow of images: of disasters, wars, revolutions, new products, celebrities, political leaders, official ceremonies, public appearances, and so on. For a historian to use such pictures without remarking on these initial uses is naive at best, and cynical at worst. What would it mean to construct a pictorial history of postwar coal mining in Cape Breton by using pictures from a company public relations archive without calling attention to the bias inherent in that source? What present interests might be served by such an oversight?

The viewer of standard pictorial histories loses any ground in the present from which to make critical evaluations. In retrieving a loose succession of fragmentary glimpses of the past, the spectator is flung into a condition of imaginary temporal and geographical mobility. In this dislocated and disoriented state, the only coherence offered is that provided by the constantly shifting position of the camera, which provides the spectator with a kind of powerless omniscience. Thus the spectator comes to identify with the technical apparatus, with the authoritative institution of photography. In the face of this authority, all other forms of telling and remembering begin to fade. But the machine establishes its truth, not by logical argument, but by providing an *experience*. This experience characteristically veers between nostalgia, horror, and an overriding sense of the exoticism of the past, of its irretrievable otherness for the viewer in the present. Ultimately then, when photographs are uncritically presented as historical documents, they are transformed into aesthetic objects. Accordingly, the pretence to historical understanding remains, although that understanding has been replaced by aesthetic experience.[9]

But what of our second option? Suppose we abandoned all pretence to historical explanation, and treated these photographs as artworks of one sort or another. This book would then be an inventory of aesthetic achievement and/or an offering for disinterested aesthetic perusal. The reader may well have been prepared for these likelihoods by the simple fact that this book has been published by a press with a history of exclusive concern with the contemporary vanguard art of the United States and Western Europe (and to a lesser extent, Canada). Further, as I've already suggested, in a more fundamental way the very removal of these photographs from their initial contexts invites aestheticism.

I can imagine two ways of converting these photographs into 'works of art,' both a bit absurd, but neither without ample precedent in the current fever to assimilate photography into the discourse and market of the fine arts. The first path follows the traditional logic of romanticism, in its incessant search for aesthetic origins in a coherent and controlling authorial 'voice.' The second path might be labelled 'postromantic' and privileges the subjectivity of the collector, connoisseur, and viewer over that of any specific author. This latter mode of reception treats photographs as 'found objects.' Both strategies can be found in current photographic discourse; often they are intertwined in a single book, exhibition, magazine or journal article. The former tends to predominate, largely because of the continuing need to validate photography as a fine art, which requires an incessant appeal to the myth of authorship in order to wrest photography away from its reputation as a servile and mechanical medium. Photography needs to be won and rewon repeatedly for the ideology of romanticism to take hold.[10]

The very fact that this book reproduces photographs by a single author might seem to be an implicit concession to a neo-romantic *auteurism*, But it would be difficult to make a credible argument for Shedden's autonomy as a maker of photographs. Like all commercial photographers, his work involved a negotiation between his own craft and the demands and expectations of his clients. Further, the presentation of his work was entirely beyond his control. One might hypothetically argue that Shedden was a hidden artist, producing an original *oeuvre* under unfavourable conditions. ('Original-ity' is the essential qualifying condition of genuine art under the terms dictated by romanticism. To the extent that photography was regarded as a copyist's medium by romantic art critics in the nineteenth century, it failed to achieve the status of the fine arts.) The problem with auteurism, as with so much else in photographic discourse, lies in its frequent misunderstanding of actual photographic practice. In the wish-ful-filling isolation of the 'author,' one loses sight of the social institutions – corporation, school, family – that are speaking by means of the commercial photographer's craft. One can still respect the craft work of the photographer, the skill inherent in work within a set of formal conventions and economic constraints, while refusing to indulge in romantic hyperbole.

The possible 'post-romantic' or 'post-modern' reception of these photographs is perhaps even more disturbing and more likely. To the extent that photography still occupies an uncertain and problematic position within the fine arts, it becomes pos-sible to displace subjectivity, to find refined aesthetic sensibility not in the maker of images, but in the viewer. Photographs such as these then become the objects of a sec-ondary voyeurism, which preys upon, and claims superiority to, a more naive primary act of looking. The strategy here is akin to that initiated and established by Pop Art in the early nineteen-sixties. The aesthetically informed viewer examines the artefacts of mass or 'popular' culture with a detached, ironic, and even contemptuous air. For Pop Art and its derivatives, the look of the sophisticated viewer is always constructed in relation to the inferior look which preceded it. What disturbs me about this mode of reception is its covert elitism, its implicit claim to the status of 'superior' specta-torship. A patronizing, touristic, and mock-critical attitude toward 'kitsch' serves to authenticate a high culture that is increasingly indistinguishable from mass culture in many of its aspects, especially in its dependence on marketing and publicity and its fascination with stardom. The possibility of this kind of intellectual and aesthetic arrogance needs to be avoided, especially when a book of photographs by a small-town commercial photographer is published by a press that regularly represents the culture of an international and metropolitan avant-garde.

In general, then, the hidden imperatives of photographic culture drag us in two contradictory directions: toward 'science' and a myth of 'objective truth' on the one hand, and toward 'art' and a cult of 'subjective experience' on the other. This dual-ism haunts photography, lending a certain goofy inconsistency to most commonplace assertions about the medium. We repeatedly hear the following refrain. Photography is an art. Photography is a science (or at least constitutes a 'scientific' way of seeing). Photography is both an art and a science. In response to these claims, it becomes important to argue that photography is neither art nor science, but is suspended between both the *discourse* of science and that of art, staking its claims to cultural value on both the model of truth upheld by empirical science and the model of pleasure and expressiveness offered by romantic aesthetics. In its own erratic way, photographic

discourse has attempted to bridge the extreme philosophical and institutional separa-
tion of scientific and artistic practice that has characterized bourgeois society since
the late eighteenth century. As a mechanical medium which radically transformed and
displaced earlier artisanal and manual modes of visual representation, photography is
implicated in a sustained crisis at the very centre of bourgeois culture, a crisis rooted in
the emergence of science and technology as seemingly autonomous productive forces.
At the heart of this crisis lies the question of the survival and deformation of human
creative energies under the impact of mechanization. The institutional promotion of
photography as a fine art serves to redeem technology by suggesting that subjectivity
and the machine are easily compatible. Especially today, photography contributes to
the illusion of a humanized technology, open both to 'democratic' self expression and
to the mysterious workings of genius. In this sense, the camera seems the exemplar of
the benign machine, preserving a moment of creative autonomy that is systematically
denied in the rest of most people's lives. The one-sided lyricism of this view is appar-
ent when we consider the myriad ways in which photography has served as a tool of
industrial and bureaucratic power.[11]

If the position of photography within bourgeois culture is as problematic as I am
suggesting here, then we might want to move away from the art-historicist bias that
governs most contemporary discussions of the medium. We need to understand how
photography works within everyday life in advanced industrial societies: the problem
is one of materialist cultural history rather than art history. This is a matter of begin-
ning to figure out how to read the making and reception of ordinary pictures. Leslie
Shedden's photographs would seem to allow for an exemplary insight into the diverse
and contradictory ways in which photography affects the lives of working people.

Let's begin again by recognizing that we are confronting a curious archive – divided
and yet connected elements of an imaginary social mechanism. Pictures that depict
fixed moments in an interconnected economy of flows: of coal, money, machines,
consumer goods, men, women, children. Pictures that are themselves elements in a
unified symbolic economy – a traffic in photographs – a traffic made up of memo-
ries, commemorations, celebrations, testimonials, evidence, facts, fantasies. Here are
official pictures, matter-of-factly committed to the charting and celebration of prog-
ress. A mechanical conveyor replaces a herd of ponies. A mechanical miner replaces
ten human miners. A diesel engine replaces a locomotive. Here also are private pic-
tures, personal pictures, family pictures: weddings, graduations, family groups. One
is tempted at the outset to distinguish two distinct realisms, the *instrumental realism*
of the industrial photograph and the *sentimental realism* of the family photograph. And
yet it would seem clear that these are not mutually exclusive categories. Industrial
photographs may well be commissioned, executed, displayed, and viewed in a spirit of
calculation and rationality. Such pictures seem to offer unambiguous truths, the useful
truths of applied science. But a zone of virtually unacknowledged *affects* can also be
reached by photographs such as these, touching on an aesthetics of power, mastery,
and control. The public *optimism* that suffuses these pictures is merely a respectable,
sentimentally acceptable, and ideologically necessary substitute for deeper feelings – the
cloak for an aesthetics of exploitation. In other words, even the blandest pronounce-
ment in words and pictures from an office of corporate public relations has a subtext
marked by threats and fear. (After all, under capitalism everyone's job is on the line.)
Similarly, no family photograph succeeds in creating a haven of pure sentiment. This

is especially true for people who feel the persistent pressures of economic distress, and for whom even the making of a photograph has to be carefully counted as an expense. Granted, there are moments in which the photograph overcomes separation and loss, therein lies much of the emotional power of photography. Especially in a mining community, the life of the emotions is persistently tied to the instrumental workings underground. More than elsewhere, a photograph can become without warning a tragic memento.

One aim of this essay, then, is to provide certain conceptual tools for a unified understanding of the social workings of photography in an industrial environment. This project might take heed of some of Walter Benjamin's last advice, from his argument for a historical materialist alternative to a historicism that inevitably empathized 'with the victors':

> There is no document of civilization which is not at the same time a document of barbarism. And just as such a document is not free of barbarism, barbarism taints also the manner in which it was transmitted from one owner to another. A historical materialist therefore dissociates himself from it as far as possible. He regards it as his task to brush history against the grain.[12]

Benjamin's wording here is careful. Neither the contents, nor the forms, nor the many receptions and interpretations of the archive of human achievements can be assumed to be innocent. And further, even the concept of 'human achievements' has to be used with critical emphasis in an age of automation. The archive has to be read from below, from a position of solidarity with those displaced, deformed, silenced or made invisible by the machineries of profit and progress.

Original publication

'Reading Between Labour and Capital', *Photography / Politics Two* (1986)

Notes

1 Walter Benjamin, 'Theses on the Philosophy of History' (1940), in *Illuminations,* ed. Hannah Arendt, trans. Harry Zohn (New York, 1969), p. 255.

2 Jean-Luc Godard and Jean-Pierre Gorin, *Vent d'Est* (Rome, Paris, Berlin, 1969), film-script published in Jean-Luc Godard, *Weekend / Wind from the East* (New York, 1972), p. 179.

3 'What is represented in ideology is therefore not the system of the real relations which govern the existence of individuals, but the imaginary relation of those individuals to the real relations its which they live.' Louis Althusser, 'Ideology and Ideological State Apparatuses' (1969), in *Lenin and Philosophy and Other Essays*, trans. Ben Brewster (New York, 1971), p. 165. Althusser's model of ideology is based in part on Marx and in part on the work of the psychoanalyst Jacques Lacan. Without belabouring this lineage, or explaining it further, I would like to refer the Canadian reader especially to a work by Lacan's first English translator and critical interpreter: Anthony Wilden, *The Imaginary Canadian: An Examination for Discovery* (Vancouver, 1980).

4 Bernard Edelman, *Le Droit saisi par la photographic* (Paris, 1973), trans. Elizabeth King-dom, *Ownership of the Image: Elements for a Marxist Theory of Law* (London, 1979), p. 45.

5 Roland Barthes, 'Rhétorique de l'image,' *Communications 4* (1964). in *Image, Music, Text*, trans. Stephen Heath (New York, 1977), p. 51.

6 Leopold von Ranke, 'preface to *Histories of the Latin and Germanic Nations from 1494–1514*,' in *The Varieties of History*, ed. Fritz Stern (New York, 1972), p. 57.

7 See Guy DeBord, *La Société du spectacle* (Paris, 1967), unauthorized translation. *Society of the Spectacle* (Detroit, 1970, revised edition, 1977).

8 We might think here of the reliance by the executive branch of the United States gov-ernment on 'photo opportunities.' For a discussion of an unrelated example, see Susan Sontag's dissection of Leni Riefenstahl's alibi that *Triumph of the Will* was merely an innocent documentary of the orchestrated-for-cinema 1934 Nuremberg Rally of the National Socialists. Sontag quotes Riefenstahl: 'Everything is genuine . . . It is history—pure history.' Susan Sontag, 'Fascinating Fascism,' *New York Review of Books*, Vol. 22, No. 1 (February 1975), reprinted in *Under the Sign of Saturn* (New York, 1980). p. 82.

9 Two recent books counter this prevailing tendency in 'visual history' by directing atten-tion to the power relationships behind the making of pictures: C. Herron, S. Hoffmitz, W. Roberts, and R. Storey, *All That Our Hands Have Done: A Pictorial History of the Hamilton Workers* (Oaksille, ON, 1981): and Sarah Graham-Brown, *Palestinians and Their Society 1880–1946* (London, 1980).

10 In the first category are books which discover unsung commercial photographers: e.g., Mike Disfarmer, *Disfarmer: The Heber Springs Portraits*, text by Julia Scully (Danbury, NH, 1976). In the second category are books which testify to the aesthetic sense of the collector: e.g., Sam Wagstaff, *A Book of Photographs from the Collection of Sam Wagstaff* (New York, 1978).

11 This passage restates an argument made in my essay, 'The Traffic in Photographs,' *The Art Journal*, Vol. 41, No. 1 (Spring 1981), pp. 15–16.

12 Walter Benjamin. 'Theses on the Philosophy of History,' pp. 256–257.

Elizabeth Edwards

PHOTOGRAPHS
Material form and the dynamic archive*

THE PHOTOGRAPHIC ARCHIVE — the site of a thousand stereotypes, gathering the dust of a century, a source of fever, a site of taxonomic and self-evident meaning, an ideological performance, an embarrassing legacy of past interpretative and methodological follies.[1] An archive — of photographs — something separate from the dynamic of a discipline, something to be mined when useful, ignored at whim; a mere passive resource, tangential to the main business, a mere supporting role whose significance is defined not through its own identity but through asymmetrical relations with other objects which it serves to confirm in some way or other.[2] Even language — archive instead of collection — speaks to this. Photographs simply are a passive 'resource' activated not through their own force, but through that of the historian and their consequent juxtaposition with other classes of objects.

In this paper, which is very much in the unashamed character of a polemic on the material archive and its potentials, I want to take a broad theoretical and methodological sweep which asks what happens if, as an heuristic position, we stop thinking of photographs and their archives simply as passive 'resources' with no identity of their own, but as actively 'resourceful' — a space of creative intensity, of ingenuity, of latent energy, of rich historical force. How do photograph collections and their archival preservation elicit readings, impose themselves on the embodied experience of the user, shaping their content for the user? What, within this, is the role of the very materiality of the archive, and what are the consequences of its digital translation? Having outlined this position, I shall briefly consider three bodies of work which demonstrate the importance of 'thinking materially' within the photographic archive. The first, from the late nineteenth and early twentieth centuries, shows how material concerns were central to the building of an archive. The second is a consideration of Gillian Rose's argument on the affective space of the archive and the production of 'the researcher'. Finally, I shall discuss briefly a digital project which attempted to translate the material saliency of the archive into the digital environment.

My argument draws in particular on theories of material culture from within anthropology, which over recent years have explored the ways in which the material environment, notably things – here photographs, archives – mediate social relations. For, I shall argue, it is in the social relations between people and things, that photographs and archives, as resonant objects, become 'resourceful'. Similar concerns have also emerged in a broader cultural analysis. Notably, in refiguring a vitalist model, W.J.T. Mitchell has famously asked "what do pictures want?" as a means of accounting for "the agency, motivation, autonomy, aura, fecundity or other symptoms that make pictures into 'vital signs'".[3] How do such characteristics shape our engagement? What do they desire of us? How do they imprint themselves on our disciplinary actions? This is not a collapse into crude animism on one hand or fetishism on the other, a subjectivising of the photograph or the archive, but to recognise the dynamic relations between persons and things and the social saliency of objects, as Mitchell puts it: "to refine and complicate our estimate of their power and the way it works".[4] Mieke Bal, too, has called, in a similar way, for the reinvigoration of the object within cultural analysis, in which "objects from the cultural world are opened up to close scrutiny" and in which "an important consequence of the empowerment of objects is that it pleads for a qualified return to the practice of 'close reading' that has gone out of style".[5] That is, how might one account for the material saliency of an object – such as an archive or a photograph – is returned to analytical prominence.

These questions and positions, and the challenge they pose, are especially pertinent in the consideration of the dynamic material qualities of photographic archives. For it is perhaps significant that our awareness of the material power of the archive emerges at precisely the moment it is under threat, perhaps that flash of memory and history, of awakening consciousness in the moment of danger that Benjamin described.[6] For the move to a too-often ill-considered or unconsidered digitisation threatens to obliterate historical materialities and formative affect, and install others, because it is important to note here that digital environments are, of course, themselves socio-technical assemblages, with agency, affective and material qualities.[7] But too often these processes amount to an unconsidered re-scripting of the nature of the archive and the histories which might emerge from it, yet it is these latter, not the analogue archive, which are increasingly presented to scholars as 'the archive'.[8]

What is at stake here is vitally important to the way the tools of a discipline and its practitioners are perceived – whether in art history, history or anthropology – for the historical archive is structured through a series of highly significant material practices. These material practices have been imagined to create a resource, a body of information, without loss of that information, presented in a way to create maximum visibility, and the transmission of information. This is what a resource actually does. But at the same time, the archive, and the individual photographs in it, stand for both the social practices and the processes of a discipline, their shifting assumptions and desire are embedded in it. They constitute the archaeology of the discipline and thus constitute its 'ecosystem',[9] and, as we are all aware, ecosystems are delicate structures, the destruction or unbalancing of which can have catastrophic consequences. I would argue that the danger to the analogue archive and all that it can tell us, is its very construction as a mere 'resource'. If the photograph and the archive are reconceptualised instead as not merely passive 'resources', but 'resourceful' as I suggest, it is necessary

to ask the crucial question: what is the significance of those material forms, how is the technological assemblage rendered 'social' and therefore active?

Photographs and archives might be described, following Alfred Gell, as 'distributed objects' in that they are, at one level, bound together as objects, yet comprising "many spatially separated parts with different micro-histories", that is, material parts and their unfolding social relations which are entangled in different and significant ways.[10] Such sets of social relations are manifested archaeologically through the marks, traces, material accretions, and disturbed surfaces of the archival objects, and through multiple material configurations and multiple formats of the distributed object. They reveal traces of, for instance, systems of truth production at any given historical moment in the ways in which photographs were acquired, owned, stored, displayed, exchanged and collected. In this the archive becomes a material manifestation of social relations in which images are active. This raises further questions such as how did people assess, acquire and use photographs? What were the truth values associated with different kinds of photography and which thus shaped collecting practices? How is this traced in the material archive? In what ways were they disseminated? What were networks of exchange? What were the resonances for viewers of different material forms? How was information about photographic sources disseminated through social relationships of the discipline for instance? How do photographs shape the practices of institutions? What are the patterns of absence in collections? The material and dynamic archive is saturated with these questions, and more importantly, in part with their answers. These questions, which obviously I cannot pursue in detail, are fundamental to the work that photographs are asked to do, not only in terms of images but in terms of 'things' that people expected to behave or perform in certain ways. For material choices are affective decisions which construct and respond to the significances and consequences of 'things' and the human relations to which they are integral.

These ideas about the sociability of objects, which can only be outlined here, suggest that objects (here archives and photographs) are not merely stage settings for human actions and meanings, but integral to them. They have, as I have suggested, been developed largely in anthropology in the work of Bruno Latour and Daniel Miller, for instance, and in theoretical and phenomenological archaeology in the work of Chris Tilley and Chris Gosden. Of particular influence again has been the work of Gell, as I have already suggested, who has argued for the diverse ways in which "social agency can be invested in things or emanate from things".[11] Through this idea of the social agency of objects, Gell argues for a more "action centred" approach to things and the way in which they play a "practical mediating role [. . .] in the social processes".[12] Latour develops similar ideas in a version of "actor-network theory", the guiding principle of which is that things, here again archives and photographs, must themselves be regarded as actors in any socio-technological assemblage. Akrich adds to this theorisation, in a way which in some ways anticipates Gell's agency argument, arguing that the idea, that objects impose back onto humans through a process of 'prescription' by which objects carry a 'role expectation', predicts certain experiential and embodied responses through the qualities of its material being.[13]

Material forms are, of course, not primary agents, they have no consciousness and no direct intention, but as Dant has pointed out, systems of intentionality are themselves articulated through the material forms of objects and through the systems of

values that enmesh objects.[14] However, significantly, it is notable how often archives and documents are endowed with a metaphorical quality of personhood and action. For instance, the philosopher of history Paul Ricoeur describes documents as "sleeping" while photographs themselves are often assigned "voices" which "speak" in tones from "shouting" to "whispering".[15] Material objects are rather, however, what Gell has described as secondary agents, in that they are objective embodiments and materialisations of the power and capacity to demand or will a use in certain ways, for certain ends, permitting particular cognitive operations.[16]

Following broadly from this position, Miller has attended to the precise material qualities of objects. He has argued for a kind of banal materiality such as one might encounter in photographic archives – lantern slides, 35 mm slides, labels, boxes or filing cabinets: "[B]y dwelling upon the more mundane sensual and material qualities of the object we are able to unpick the more subtle connections with cultural lives and values that are objectified through these forms, in part, because of the particular qualities they possess".[17] Importantly here, Miller, rather than thinking only about how things signify, which he maintains privileges an intellectualised response to objects, suggests that it is necessary to think about "how things matter", as a way of allowing a space for the subjective.[18] Thus, especially relevant for any consideration of photographs' materiality, much is to be gained analytically in understanding the specific ways in which different material forms become meaningful – a point to which I shall return in my three examples.

Significantly, there are resonances of this approach in recent writing in historiographical theory, sometimes drawing on the same body of literature, notably Latour.[19] Echoing Miller's argument on 'mattering' as opposed to 'signifying', Ewa Domanska has recently pointed to the idea of historiographical 'significance' not in terms of representation or a signifying discourse, but through "the materiality and thingness" of the material trace rather than on its "textuality and content".[20] From this, Domanska argues a position of 'material hermeneutics' which, like Bal's reinvigourated object marked earlier, brings the consideration of the material back into the centre of historical understanding and interpretation. Key to my argument here is her contention that "instruments", here the photographic archive, printing papers, mounts, boxes and so forth, mediate experiences and articulate desires to the extent that they "co-constitute the reality studied by scholars".[21] Even the most mundane of material existences and practices point to both the complex producing and indeed productive practices which enable a statement to exist in certain ways.[22]

In such a reading, and this can be only a very basic summary of the debate, photographs and the archive are dynamic forces within networks of non-humans and humans which themselves constitute social processes. They exercise a form of agency as powerful and active players in that it is not the meanings of things *per se* (here what a photograph is 'of') which are important, but their social effects as they construct and influence the field of social action. Thus, the choices that constitute objects cannot be reduced to a single purposeful expression, they are latent with incidental meanings. This 'active materiality' is no better demonstrated than in the discourse of the archive as a site of resourcefulness, where the accuracy, truthfulness and authority of the socially active historical statement is technically and materially performed through the attention given to the exact nature of image-objects that comprise the archive and their 'affect' on users.[23]

Some 'resourceful' archives

In order to put some flesh on these theoretical bones, I want to look at three bodies of archival objects, and engagements with them, to consider their 'resourcefulness' – their creative direction of meaning, because all three were made to perform specific roles and intended to elicit certain forms of response.

The first example is the extensive and dispersed archive of the photographic survey movement in England, comprising amateur photographs of objects of historical interest (parish church architecture, old cottages and customs) made in the late nineteenth and early twentieth centuries.[24] Not only does this archive constitute a dispersed object – created through different micro-historical trajectories, yet discursively united as a single object. The material qualities of the archive were central to the active performance of that discourse. In the collections of photographs gathered for these archives, enormous intellectual, and indeed physical energy, was expended by their makers over the precise material forms the archive and the presentation of the photographs within it should take.[25] In this material form the dynamic materiality was seen from the inception of the archive as central to the expectations, understanding, and archival performance through which these photographs could come to have meaning.

These material debates revolved around key archival values of accuracy and longevity, materially expressed. What size of negative? Could it be retouched? Did enlargements obscure or illuminate? Should platinum, a very stable process, be the only desirable printing process? Or should silver prints be allowed if this were the only way of preserving the desired historical object? The relations of mounts and labels are especially revealing. What kind of visibility should be afforded to the photograph? Should there be cut mounts which protect the physical chemical deposits from abrasion and thus disappearance of both the photograph and the referent for whose preservation the photograph stood? Should labels be placed on the back, or apprehended in one visual act? What did this mean for the viewer? These choices were material performances of moral, scientific and subjective desires, without which this archiving project cannot be understood. For instance, as John Tagg, commenting on these archives and the way labels were deployed on mounts, has noted, there was an "extraordinary expenditure of commentary and moral fervour [. . .] [devolved] onto this little slip: how much it should say; to whom it should speak; to what code it should summon both object and viewer".[26] Labels are thus not merely a descriptive or a discursive framing, rather their spatial relations with mounts marked out the contained space of useful disciplinary knowledge, aligning and cohering disparate approaches. They also embody the potential for expanding or contested knowledge, expressed by layers of surface markings, from the laying down of photographic chemical to additions and crossings out in captions as users add comments, reattribute in a material palimpsest of disciplinary knowledge held, literally, in the hands of the user.

Then there are boxes, the building blocks of archives. Ordinary boxes in archives are arguably invisible players in historiographical analysis. However they are not neutral spaces. The form and character of boxes are part of the very nature of the institutional existence of the archive and part of its constitution and meaning. They are not merely pragmatic tools of taxonomic performances, but entangled in shifting sets of values from institutional to affective engagements with users as things are placed

in certain ways, mediated as sites of successive, layered and overlapping agencies.[27] This might be seen to question historian Steedman's contention that the archive is just 'stuff' until the historian engages with it.[28] As innumerable commentators in archival theory have noted, the archive has been mediated at every stage of its existence, constituting the process of archiving as a form of narrativising in itself. Groupings of photographs and the marking of boxes, for instance, have been selected and made to perform images in certain ways and thus mediate in social relations – the interpretations of the art historical for example. Here one can sense the potential of thinking about photographs in a Gellian sense, in that they elicit responses, stimulate affects, which would not have existed in that form if the photograph, its card, its box had not existed in that way. That is, the material forms of print, presented on mounts, contained by labels, ordered in boxes and in files, and engaged with in archival research spaces or print study rooms, rendered historical time not only an objective space, but an affective space in which objects play that "practical and mediating role in social processes" – a space of what I am terming 'resourcefulness'. What we see here is both subjective and objective registers of historical concern cohered at the surface of the mounted print in a box or file.

Not only are boxes tactile, the embodied experience of the archive is often defined in terms of heavy boxes, the sense of excavation, hands dry from the dust emitted from deteriorating wood pulp and buckram, even the smell of it. When the young French historian Jules Michelet first encountered the archive in 1833, he commented on the experience of breathing the dust of papers and parchments. As Steedman has noted "this was not simply a figure of speech" but "a literal description of a physiological process" of engagement with the archive.[29]

This position has perhaps been best articulated by my second example, Gillian Rose's critical contemplation of her experiences of using the archive of Lady Hawarden's photographs at the Victoria and Albert Museum, London.[30] In this essay, she attempts to account for the dynamic material and embodied experience of looking at the collection of Lady Hawarden's photographs, as the material takes on an agentic quality. She explores the ways in which the visual qualities of photographs and their understanding are inflected through spaces and practices of archival and photographic presentation. It is a dialogic relationship between researcher and the material archive, in which material practices both produce images in certain ways and complicate the effects of the photographs. Importantly, she argues the way in which the researcher is 'produced' by the agency of the photographs and of the archive. The material qualities and the practices of the archive mediate both the photograph and the body of the researcher which animates the space of the archive in potentially disruptive ways. This is more than simply photographs meaning different things to different people at different places and times according to the knowledge brought to them, but an engagement with the spatial and material practices of the archive as actants in human/non-human relations in the production of embodied cultural knowledge.

For instance, just as boxes set up narratives, the visual equivalence of the photographs is performed through modes of matting and mounting, setting up a suggestion of possible comparability perhaps. Further the body of the researcher is regulated in certain ways, reflecting the social values which cluster around photographs: "hold the mounts like this", "don't touch the surface of the print", "only use pencils or laptops", "leave your bag and your wet coat outside in the lockers", "No food and drink". The

regulations, and thus the way in which the photographs are apprehended, construct and materialise the body of the researcher in specific ways.[31] They become resourceful, getting the user or viewer to do certain things because the material form of the photograph is constituted in specific ways that elicit behaviours. It constructs here, as Rose argues, the researcher as a grotesquely intrusive body which must be rendered unobtrusive.[32] It heightens the effect of the archive, a consciousness of materiality and the consciousness of what transgression might mean. The prohibitive practices of the archive and the materiality of the photographs actually create in the researcher the desire to touch, to stroke, away from the rational discourses of vision and discipline. Thus, the effects were revealed as undisciplined, in both senses of the word as unregulatable and multi-valent – but instead powerfully suggest the creativity and ingenuity of resourcefulness of the material archive.

Digital materialities

Such a consideration of the haptics of the photograph in the archive must bring us to my third example which addresses the digital environment. The digital is often perceived as a site of material and haptic disruption, and thus of the archive's 'resourcefulness'. Consequently there has been considerable discussion of the nature of the digital environment and the dematerialisation of the historical object. For instance, Joanna Sassoon argues that the way in which digital projects have been approached has too often failed to engage with an understanding of photographic materiality as being active in the making of the historical rather than as being a passive object of information; that is, there has been a failure to recognise the 'resourcefulness' of photographs and archives, reducing photographs to digital shadows of their former being, both materially and intellectually.[33]

While there are many examples of digitisation – good, bad and indifferent – I want to focus briefly on a project in which I was involved, because it specifically attempted to address the tensions between the material or analogue archive and the digital archive. It aimed to maintain a sense, for the user, of the kind of thinking about the dynamic and resourceful nature of the archive and its material character, but which embraced the potential of the digital as well. Between 2003 and 2006, Pitt Rivers Museum, University of Oxford, where I was at the time Curator of Photographs, and the British Museum, London, undertook a collaborative project to make available on-line a collection of approximately 6,000 photographs of Tibet taken between 1920 and 1950 in connection with British diplomatic missions.[34] While at one level it was acknowledged that the outcome would be a straight-forward on-line picture library and archival resource, a clear objective from the outset was that it was essential to explore ways in which the material and relational qualities of the photographs – their dynamic and resourcefulness – could remain interpretatively active within a digital environment. Thus, theoretical questions on the relationship between historical apprehension and photographs became integral to the project,[35] informed by a recognition of the need to address the perceived space between what is understood theoretically and what is actually done in terms of archival practices.[36]

The photographs of Tibet existed in the archive in a variety of formats and as multiple originals, distributed objects which flowed through the social relations to which

the photographs and the archive were central. Keen attention was paid to the material and multiple forms of the images as indicative of their meanings, in that the material archive was "something that has been intrinsic to the research methodology and the continuing historical representation of these photographs".[37] The project saw the whole archive as a cultural object in its own right within which "the digital potential of the project to full effect was developed to deal with the many thousands of often very similar images, to explore their creation and relationships and thus how the visual representation of Tibet was affected and constructed by these diplomatic photographic encounters".[38] Of course, like the meaning of photographic images themselves, different material affordances and properties move in and out of significance "in conjunction with what is being done with that photography" or series of images, a flow integral to the social biography of the object.[39] For instance, photographs were circulated around the group, put into personal albums, sent to government offices, given to friends. Some were turned into lantern slides, indicating their function to disseminate ideas of Tibet, British diplomacy, and Empire for instance. Others were published in books. In the website, this information was not simply recorded in the metadata of an image but presented materially. Users can navigate through the collection following multiple originals, from raw scans of the negative through to the printed book, allowing the user to understand the material transformations of cropping, reversing and juxtapositioning, as an image moves through different spaces. For instance, lantern-slide lectures were reconstituted with their texts (which would of course have been spoken), album presences of images can be placed in their narrative sequences, relations between Tibet elites and the British mission can be traced as visual narratives within the website, through the spatial and temporal dynamics of photographic production.

In this, the aim was to address those spatially separated parts and different micro-histories of the material flow of images which were made up of multiple patterns of intention, which as I suggested earlier, are characteristic of the distributed object. The archive here is revealed not merely as a resource but as a dynamic social object that emerged from sets of cross-cultural relations in which photography itself played a dynamic part.[40] Further, the design of the website itself was geared to distributed and contested ways of constructing historical narrative. For instance, it is possible to search and order the collections according to either a Western (British) calendar or a Tibetan one. The whole structure of the web presence positions the collection of Tibetan photographs as not merely a resource, but dynamically resourceful, in that the physical act of the careful consideration and digital remediation of the photographs themselves became part of the interpretative potential of the collection. Crucially, such work can only be achieved digitally where the multiple layers of the dispersed analogue archive can be reconstituted. But it works in particular, I would argue, because the 'resourcefulness' of the analogue archive was perceived as central to the creation of digital environments.

Some closing thoughts

I have argued here that, in order to understand photograph collections, it is not simply a matter of understanding the subject matter more accurately, but understanding all material manifestations of the literal and metaphorical cross-referencing,

rewritings, citations – both visual and relational, that make up photographs. These provide the road maps of meanings and ambiguities in which collections are embedded but which evade more direct and articulated forms. The most important part of thinking materially perhaps is to use it to demonstrate the enormous potential and riches of photographs – that they are not merely picture libraries which can be simply digitised, but rich social objects which carry the material traces of people's hopes and desires, of their being in the world – the stuff of history, to return to Michelet's affective response to the archive, material "so long deserted, desired no better than to be restored to the light of day".[41] Likewise, photographs coming out of storage for encounter with the user have been described as an "energy" released.[42]

Brothman has argued, in archival theory, that records are cognitive artefacts in both their production and reception, not merely evidential artefacts.[43] The object of study is therefore not the photograph, the resource per se, but the various moments and spaces that both often lay claim to and that its materiality demands. That is, the ways in which it becomes 'resourceful' is integral to a release of energy which shapes the perception of the archive. Such an approach demands a very much more robust attention to the social and material workings of photography in the archival space. It is one which allows the looking at and the using of images as socially salient objects to be active and reciprocal, in that it does not imply merely authority, control and passive consumption. Archives may be those things too, of course, but they cannot be reduced to it. The material dynamic and restoration of material agency to the archive forestall such a reduction. Such an approach therefore places the photographic archive within multiple perspectives on the past, which cannot be contained simply in terms of its content (the resource) but the way in which their material practices demand creative interactions of humans and non-humans.

But it is also necessary to articulate this at a practical level. It remains the case that very few senior managers, who are controlling the money-making decisions about what happens and what does not, have direct knowledge of photograph collections, or any understanding of the historical riches they embrace, and their potential resourcefulness. Photographs are seen, for instance, merely as unit costs to be digitised and sold in a global image environment. It is up to photograph curators to make those who are making the decisions take notice of what is possible with photograph collections. 'Good' digitization costs relatively little more than 'bad' digitization, especially when the richness and longevity of value is factored in. And given that digitization projects on specific materials tend only to be undertaken once, it is important to maximise the resourcefulness of photographs at this point, for once ticked off the list of 'done' collections they are seldom redone.

I do not claim it is the only way, but thinking materially through the social biography of photographs as active objects in a matrix of exchanges – personal, commercial, moral, political – can generate ideas which will enable us to see photographs differently. The choice is not between analogue and digital, for one cannot substitute for the other, but rather the digital as another moment in the on-going social biography of the material archive, creating a space, as was attempted with the Tibet Album project, in which the digital becomes an exegesis on the analogue archive to the enhancement of historical understanding.

As I marked at the start, the object has become empowered within cultural analysis, and indeed as Taussig has argued, objects are never as lively as in the moment when someone threatens to kill them.[44] We are at just such a moment. Therefore, rather than occupying a fixed point of the taxonomically contained 'resource', resourcefulness constitutes part of a continuum of meaning which is an "active constituent of present being"[45] and in which the irreplaceable core remains the analogue, material archive and its tangible historiographical layers.

Original publication

'Photographs: Material Form and the Dynamic Archive', *Caraffa* (2011)

Notes

* I should like to thank Costanza Caraffa for inviting me to take part in the original symposium, and thank her and Gillian Grant, Liz Hallam, Clare Harris and Joan Schwartz for their comments and conversations on this topic. They have been immensely helpful.

1 See for example, Jacques Derrida, *Archive Fever*, transl. by Eric Prenowitz, Chicago, Il 1996; Allan Sekula, "The Body and the Archive", in: Richard Bolton (ed.), *The Contest of Meaning*, Cambridge 1992, pp. 343–389.

2 See Gaby Porter, "Economy of Truth: Photography in Museums", in: *Ten.8*, 34 (1989), pp. 20–33; Elizabeth Edwards, *Raw Histories: Anthropology, Photographs and Museums*, Oxford 2001, pp. 183–207.

3 W.J.T. Mitchell, *What Do Pictures Want? The Loves and Lives of Images*, Chicago 2005, p. 6.

4 Ibid., p. 33.

5 Mieke Bal, *Travelling Concepts in the Humanities*, Toronto 2002, pp. 8–10.

6 Walter Benjamin, "A Thesis on the Philosophy of History", in: Hannah Arendt (ed.), *Illuminations*, London 1992, p. 247.

7 For a discussion of these broader issues see, for instance, José van Dijck, *Mediated Memories in the Digital Age*, Stanford 2007.

8 See Joanna Sassoon, "Photographic Materiality in the Age of Digital Reproduction", in: Elizabeth Edwards / Janice Hart (eds.), *Photographs Objects Histories: On the Materiality of the Image*, London 2004, pp. 186–202.

9 I am grateful to Costanza Caraffa who used the word 'ecosystem' in an e-mail exchange and set me thinking in this direction.

10 Alfred Gell, *Art and Agency*, Oxford 1998, p. 221. For an example of this concept applied to collections see Frances Larson, "Anthropology as Comparative Anatomy: Reflecting on the Study of Material Culture during the late 1800s and late 1900s", in: *Journal of Material Culture*, 12/1 (2007), pp. 89–112.

11 Gell 1998 (note 11), p. 18.

12 Ibid., p. 6.

13 Madeleine Akrich, "The De-Scription of Technical Objects", in: Wiebe E. Bijker / John Law (eds.), *Shaping Technology, Building Society*, Cambridge 1992, pp. 205–224.

14 Tim Dant, *Material Culture in the Social World*, Buckingham 1999, p. 121. For a related argument of social saliency and instrumentality see Joan M. Schwartz, "'We Make Our Tools and Our Tools Make Us': Lessons from Photographs from the Practice, Politics and Poetics of Diplomatics", in: *Archivaria*, 40 (1995), pp. 40–74.

15 Paul Ricoeur, *Memory, History, Forgetting*, Chicago 2004, p. 169.

16 Ibid., pp. 20–21; Elizabeth Edwards, "Thinking Photography beyond the Visual?", in: Jonathan J. Long / Andrea Noble / Edward Welch (eds.), *Photography: Theoretical Snapshots*, London 2009, pp. 40–43.

17 Daniel Miller (ed.), *Material Cultures: Why Some Things Matter*, London 1998, p. 9.

18 Ibid., pp. 3, 11.

19 For an extended consideration of this point, see Elizabeth Edwards, "Photography and the Material Performance of the Past", in: *History and Theory*, 48/4 (2009), pp. 130–150.

20 Ewa Domanska, "Material Presence of the Past", in: *History and Theory*, 45/3 (2006), pp. 337–348, here p. 337.

21 Ibid., p. 341.

22 Bruno Latour, *Science in Action*, Milton Keynes 1987, p. 69.

23 See Elizabeth Edwards / Janice Hart, "Mixed Box", in: Elizabeth Edwards / Janice Hart (eds.), *Photographs Objects Histories: on the Materiality of the Image*, London 2004, pp. 47–61.

24 Elizabeth Edwards, *The Camera as Historian: Photography and the Historical Imagination 1885–1918*, Durham, NC, forthcoming 2011.

25 See Edwards 2009 (note 20).

26 John Tagg, "Pencil of History", in: Patrice Petro (ed.), *Fugitive Images: From Photography to Video*, Bloomington, IN 1995, p. 293.

27 Edwards / Hart 2004 (note 24).

28 Carolyn Steedman, "The Space of Memory: In an Archive", in: *History of the Human Sciences*, 11/4 (1998), p. 6.

29 Carolyn Steedman, *Dust*, Manchester 2001, pp. 26–27.

30 Gillian Rose, "Practicing Photography: An Archive, a Study, Some Photographs and a Researcher", in: *Journal of Historical Geography*, 26/4 (2000), pp. 555–571.

31 Ibid., p. 561.

32 Ibid., p. 562.

33 Sassoon 2004 (note 9), p. 199.

34 See http://tibet.prm.ox.ac.uk/. The Tibet Album Project was funded by the Arts and Humanities Research Council of the United Kingdom and led by Elizabeth Edwards and Clare Harris, with Richard Blurton from the British Museum. Mandy Sadan, as research officer, was key to the practical development of the project's theoretical perspectives within the on-line environment.

35 http://tibet.prm.ox.ac.uk/tibet_methodology_aims.html (most recent access 5 July 2010).

36 Tim Schlak, "Framing Photographs, Denying Archives: The Difficulty of Focusing on Archival Photographs", in: *Archival Science*, 8 (2008), pp. 85–101, here p. 94.

37 Mandy Sadan, http://tibet.prm.ox.ac.uk/tibet_methodology_corpus_approach.html (most recent access 5 July 2010).

38 Ibid.

39 Gillian Rose, *Doing Family Photography*, Farnham 2010, p. 19. The concept of social biography is drawn from Arjun Appadurai, *The Social Life of Things*, Cambridge 1986, which has become a standard and classic model within material culture studies. It argues that an object can only be understood through the sum of the social transactions in which it is entangled over time and space.

40 See Clare Harris / Tsering Shakya (eds.), *Seeing Lhasa: British Depictions of the Tibetan Capital 1936–1947*, Chicago 2003, and essay therein.

41 Steedman 2001 (note 30), p. 27.

42 Patricia Hayes / Jeremy Silvester / Wolfram Hartmann, "Photograph, History, and Memory", in: Wolfram Hartmann / Jeremy Silvester / Patricia Hayes (eds.), *The Colonising*

Camera: Photographs in the Making of Namibian History, Capetown 1999, pp. 2–10, quoted in Schlak 2008 (note 37), p. 97.

43 Brien Brothman, "Memory, History and the Preservation of Archival Records", in: *Archivaria*, 51 (2001), pp. 48–80, here p. 79.

44 Quoted in Asbjørn Grønstad / Øyvind Vågnes, "What Do Pictures Want: An Interview with W.J.T. Mitchell", in: *Images and Narrative*, November 2006, www.imageandnarrative. be/inarchive/iconoclasm/gronstad_vagnes.htm (most recent access 21 July 2010).

45 Brothman 2001 (note 44), p. 65.

Liz Wells

WORDS AND PICTURES
On reviewing photography

Art is an interpreter of the inexpressible, and therefore it seems a folly to
try to convey its meaning afresh by means of words.

Edward Weston, 1930[1]

THE ORIGINS OF THIS ESSAY lie in a contribution, in 1992, on reviewing
photography, commissioned by *LightReading*, a newsletter whose target reader-
ship was photo practitioners in the south-west of Britain. The newsletter was one of a
number of initiatives throughout Britain which, variously, stressed regional networks,
thereby, amongst other things, tacitly resisting the hegemony of the metropolitan. I
had spent some years writing for national photography magazines, including editing
two issues of the London-based, *Camerawork*. Living in the south-west I was often called
upon to cover events in the region; hence the invitation to write about reviewing. The
immediate context was regional, but nationally, photography exhibitions and publica-
tions seemed to attract relatively little critical coverage.[2] My concern here is to reflect
upon the role of the critic in relation to photography exhibitions, taking some account
of changing understandings both of photography and of aesthetic judgement.

Words and pictures

One of the most difficult tasks in writing about photographs, indeed, all visual arts, is
to find words which in any way adequately describe the visual object. This is an issue
whatever the context of publication. Books have limited budgets for reproduction
and exhibition catalogues may not detail all that is included in a show. For reviewers
(of photography books, or exhibitions) this difficulty is compounded if a commission-
ing magazine or journal only include one illustration. This is particularly impossible
with group shows, where work may be very varied in form and style. But no body of
work can be adequately summed up in a single picture. If it could be, why make more

than one image?! So the writer ends up using words to describe work. Photographic works have scale, tonal texture, colour intensity, and they may be framed and inter-relate within particular environments within which they are encountered. Illustrations in catalogues, reviews or essays are usually poor substitutes, as are publicity images in press releases or on event websites. Pictures do not necessarily speak louder than words, but they speak differently, with visual language sensitive to context. As Magritte remarked, a painting of a pipe is not a pipe! Likewise, words may be used to describe images and their import, but they cannot convey the affective impact of objectness – scale, physicality and presence within the space of the gallery, website or publication. It follows that words, when used to speak about pictures, seem inad-equate. Photography books are something of an exception here as they are in them-selves bookart, although reviewers may still have difficulty conveying the full import of a particular publication.

Where exhibitions are concerned, critics take responsibility for feedback to art-ists and for mediation with audiences. As Mary Kelly has noted, the catalogue outlives the exhibition itself and, as such, comes to be its key marker in history.[3] The way in which work is 'framed' by catalogue essays crucially contributes to characterising status and significance. Reviews and other published critical responses also outlive exhibitions and, along with the catalogue, contribute to marking an event. Descrip-tions and viewpoints become material for archivists and cultural archaeologists. Ulti-mately books and archives, reviews and critical essays, along with pictures and other artefacts, conglomerate as testament to the broader intellectual parameters, priorities and academic currencies of particular eras and contexts.

Contexts

Debates about the nature, place and contribution of photography reflect differing cultural understandings and priorities. For instance, British documentary is supported by and feeds into particular kinds of realist writing. But photography tended not to figure within the modernist experimental agenda in Britain which was more asso-ciated with early twentieth century literature. This contrasted with elsewhere in Europe, for instance, France, where photography, along with film, became integral to art movements of the 1920s,[4] or Germany where it played a central role in Bauhaus debates and experiments.[5] In Britain, photography remained relatively overlooked in art historical and critical terms, and had little place in the art institution until the 1980s witnessed a steadily developing network of photography galleries, several major shows, the consolidation and expansion of photography studies (at university level and elsewhere) and enhanced interest in photo-archives.

That photography has not always been viewed as an art form equal in status – albeit different to – painting and sculpture contributes to accounting for the relatively undeveloped state of photography theory and criticism in terms of photo-images, form and subject-matter, and contexts of production and consumption. Nonetheless, foundations for serious study of the medium, taking into account the inter-play of the social and the aesthetic, were laid throughout the twentieth century. The 1970s and 1980s witnessed an acceleration here as modern certainties and hierarchies came under scrutiny. Semiology engaged the visual and, after a pause, key semiological texts

were translated into English causing a flurry of excitement in Anglo-American circles.[6] Photo-historical research and analysis broadened to include more vernacular modes such as social archives and family albums; the canon of great 'masters' of photography which institutions such as MoMA had sought to foster through exhibitions and publications, came up for debate; simultaneously, historical and critical studies acquired a place within the university curriculum.

Thus, paradoxically, in Britain, as in North America, just as photography had acquired a degree of acceptance as art – and photographers as artists – the modernist critical agenda was hijacked, initially by post-modern theoretical misgivings and subsequently by the onslaught of the digital. Debates and understandings about the act of photography, about photographs as semiotic artefacts, and the everydayness of photo-aesthetics undermined any illusory sense of security about the space of photography as art, whilst, simultaneously, photo-video media became incorporated within a wide range of new postmodernist arts practices. Within the museum and the university one response was a new seriousness of academic intent in relation to photography history and culture, both as academic discipline and in terms of archiving and conservation. Fuller emphasis was laid upon proactive policies for enhancing photo-collections as well as exhibition programming. This overlaid and inter-acted with more conservative interest in specific photographers. In promoting photography as art the Museum of Modern Art in New York opened space for photographs to figure increasingly forcefully within the international art market. This all variously contributed to the everyday circulation of ideas and debates about photography which forms the critical context within which writers operate.

Reviewing photography now

Artists, galleries, agents, museums, publishers, all seek coverage of their work. In part there is genuine interest in critical feedback or debate; in part this acts as publicity for the work, the artist and the gallery. But the reviewer is not a press agent. The relationship between the critic and photographers or institutions can be an uneasy one. Typically, the gallery public relations officer is young, pleasant and helpful. At openings she – for it is often a woman – plies the reviewer with press pictures and alcohol (usually in reverse order); she will make a point of introducing the photographer(s) and exhibition curator(s). This is a part of her job. From the point of view of the gallery, the aim is to get free publicity as, regardless of what is written – to paraphrase Oscar Wilde rather freely – the most important thing from the gallery point of view is to be talked about. Some writers never go to opening nights, preferring to seek calmer moments for engagement with the work.[7] Nonetheless, as Abigail Solomon-Godeau has emphasised, criticism remains integrally caught up in the commodification of 'art' with the critic functioning 'as a kind of intermediary between the frenzied pluralism of the marketplace and the sacralised judgment seat that is the museum'.[8] Criticism contributes to celebrating the status of artists and *oeuvres*, assuring significance in terms of the gallery and museum; by extension, artworks become viewed as collectible, thus economic status within the art market is assured. Frequency of citation may come to seem as important as seriousness of critical intent!

For critics there is intellectual pleasure in reflecting upon the affect and import of particular artworks, engaging in current debates about developments within photography as a field of rather varying practices, and gearing discussion towards particular types of readership (academic, arts practitioners, daily press). But, there may be a tension between the needs of the gallery for immediate publication as publicity, and artists' aspirations for a considered response published in a serious context. Self-doubt, and desire for acclaim and support, means that photographers (also curators, editors, publishers) are sensitive to preliminary responses at exhibition openings, archive open events, or book launches. However, in my experience, photographers seek serious consideration and perceptive feedback. Likewise, most critics are driven primarily by fascination with their subject. Some are journalists with regular arts columns; a number are also practitioners. Others are based in academic institutions wherein stress is laid upon their publication profile as academic researchers engaged with contemporary ideas and debates.

But which ideas and debates? In challenging the experiments, preoccupations and hierarchies of modernism, post-modern debates also, implicitly, undermined criticism. Bill Jay has commented:

> Ideally, photographic criticism should provide one or more of the following services: introduce you to photographers of whom you were unaware; expand your appreciation of a photographer's work; place the images in the context of photography's history; place the images in the context of the artist's culture; and, while accomplishing these services, throw light upon the creative/artistic process. These services demand that the critic demonstrates superior knowledge and insight. The result will be photographic writing which is informative, elevating and, above all else, *useful*.[9]

Useful for what? This menu implies support for art and artists and suggests that the authority of the critic should rest on familiarity with ideas and artworks in a particular field. But it seems outdated. What is assumed in the reference to 'artist's culture' or to 'superior knowledge and insight'? The modernist agenda, with its search for a uniform value system and knowledge hierarchy, continues to resonate! Indeed, Jay reveals the conservatism of his position as he continues with an attack on political correctness which thinly masks an attack on feminist reappraisal: '. . . when critics tell you that all nudes are political in meaning, what they are really saying is this: in order to be accepted and liked by our peers we have decided that all nudes should be considered political. In this sense, critics are telling you more about themselves than about the photographs'.[10] Is it not useful to review photo-histories through varying lenses? The value of more recent critical theory is, precisely, that criticism has ceased to purport to be neutral, the critic is invited to acknowledge their position and preoccupations, and multiplicity of voices within debates about the import of particular bodies of work is understood to lend philosophic depth. Contemporary placing of images in the context of the 'artist's culture' has acquired a critical edge which is intended to counter *status quo* agendas.

Theory informs practice, and vice versa; the role of the serious critic may be seen as one of mediating between the two. Feminist criticism proposed a constructive role for the critic: that the critic should engage with the art object, raising new

questions and pursuing new lines of enquiry; it also, in principle, expected that the critic should be aware of her audience and develop ways of writing which do not alienate her readers. Elitist forms of writing contribute to perpetuating a hierarchical intellectual order. For critics to be constructive, they need also to be self-analytical, paying attention to the implications of what they are saying and consciously working in ways designed not simply to reproduce established assumptions and hierarchies. The reviewer's subjective response, political tendencies, assumptions about readers, and even mood on the particular day, are inevitably in some way reflected. This can be acknowledged.

Taste

A. D. Coleman reminds us that the term, connoisseurship, originally 'simply distin-guished between those who had actually laid eyes on particular works of art, thereby truly "becoming acquainted with" them (the original definition of the term's Lati-nate root, *cognoscere*) and those who knew them only second-hand, through written descriptions or etched and engraved renditions' – and later, of course, through photo-graphic reproduction (slides, book illustrations, postcards).[11] The elitist connotations which came to adhere to the term are a consequence in part of social class privi-lege associated with, for instance, the 'Grand Tour' (viewed as an essential finishing education for the sons of the British eighteenth and nineteenth-century aristocracy). Hence, for instance, Walter Benjamin's welcome for photography's wider circulation of images through which visual culture became less exclusive.[12] In addition, in taking on the tenets of High Modernism, connoisseurship became even more associated with hierarchies of critical values – connoisseurs being viewed as steeped in knowledge and therefore able to exercise discrimination within particular fields of expertise. Such notions clearly support power infrastructures within national and international economic and institutional art networks. In addition, characterisations of European Modernism, especially the various avant-garde art movements, often rested on dia-lectic notions of historical change whereby, as Poggioli suggested, 'sons' [sic] rebelled against their father figures.[13] This implies a singular historical trajectory within which younger generations of artists and critics act as a vanguard challenging the previously established.

So, what is at stake for the critic now? First, as always, criticism involves taste, judgement and a degree of independence of opinion. Good writing, by which I mean work which is well-informed, purposeful and engaging, involves critics knowing what they value and why they value it. Second, the contemporary critic operates in cir-cumstances where norms and value systems are complex and contested. Postmodern art is considerably more dispersed in issues and concerns, sources of influence and inspiration, and modes of audience address. Within this, the contemporary critic has to locate appropriate spaces of response: intellectual contexts and places of publica-tion. Informed and informative judgement is still expected, but the cultural curren-cies begging negotiation are markedly multiple. Previous knowledge assumptions and hierarchies may continue to obtain (especially in the major galleries, museums and auction houses) but are cut across by new 'post-everything' uncertainties. Audiences have been extended through new global means of communication with materials

written for email or website spaces wherein the reader, although immediate in time, may seem increasingly anonymous and far removed in location. Increasingly, it seems impossible for any single place that would like to see itself as a centre, to hold sway. Whilst any undermining of the metropolitan may be welcome, the task for the writer becomes increasingly demanding. The setting up of websites in association with exhibition and events is no substitute for direct engagement with photographic artworks, just as words cannot do justice to the affects of photographs. But websites, along with bookworks, catalogues and reviews, offer points of mediation which enable a broad audience to engage with aspects of images and ideas. All such mediations resonate discursively within the capricious complexity of contemporary imagery.

Postmodern theory insisted that things are fluid, things fall apart, there is no centre. Nonetheless, in so far as authorial hierarchies of influence persist, the fashionability of the metropolitan and the sense of superiority of the academic remain marked, as does the inter-relation between the functions of criticism and the economics of the art market. More positively, artists still seek responses, which may be more varied and interesting now, when unconstrained by the dictates of Modernist criticism. Critics' responsibilities continue to include feedback to the artist, the historical marking of particular exhibitions or events, and engagement within debates about ideas and practices, all of which also contribute to mediating work to a broader public. That critical publication is caught up in relation to the politics of the art market, and also contributes to the commodification of art, is not in itself reason to desist from comment, although it may influence choice of sites of publication and certainly lends further complexity in terms of the purpose and responsibilities of more radical writing. Fluidities heralded through the digital era should support the dismantling of legacies of hierarchical attitudes, and open space for more discursive, creative engagement with artefacts and ideas and for enjoying dissonances between words and pictures.

Original publication

LightReading 2, May 1992, amended 2002 for *The Photography Reader*.

Notes

1 Edward Weston on pictorial photography after Goethe. This quote headed up the earlier version of this essay. I have kept it as it formed my starting point – although now I cannot find its source.

2 At the time, in Britain, coverage of photography exhibitions and events in the major national papers was still relatively rare, excepting occasional high-profile retrospectives of work by particular practitioners. Professional photography magazines, such as *The British Journal of Photography,* sometimes featured gallery-based events, again largely in terms of famous names; but more usually exhibitions were covered only in brief reviews. Serious critical discussion of gallery-based work was left to small circulation magazines such as *Portfolio* (Edinburgh) and *Creative Camera* (London – now defunct). In Britain, major exhibitions may pass unremarked – except if hosted in the metropolitan centres of London and Edinburgh.

3 Mary Kelly (1981) 'Re-Viewing Modernist Criticism' *Screen* 22:3.

4 This, despite having been dismissed by influential nineteenth-century critics such as Baudelaire who viewed photography as mechanical reportage rather than artistic expression.

5 See John Willett (1978) *The New Sobriety*, London: Thames and Hudson for an introductory overview.

6 Roland Barthes, *Mythologies*, first published in French in 1957 was not translated until 1972.

7 Openings at key galleries may be good parties, but not good for looking at work! For instance, openings at The Photographers Gallery, London, are invariably sweaty experiences characterised by occasional glimpses of work on walls spotted between the heads of people networking energetically.

8 Abigail Solomon-Godeau (1991) 'Living with Contradictions: Critical Practices in the Age of Supply-Side Aesthetics' in *Photography at the Dock*, Minneapolis: University of Minnesota Press, p. 124.

9 Bill Jay (1992) *Occam's Razor*, Munich: Nazraeli Press, p. 46.

10 Loc. cit.

11 A.D. Coleman (2000) 'Connoisseurship in the Digital Era' in *Photo Americas 2000*, Portland, OR: Photo Americas, p. 2.

12 Walter Benjamin (1936) 'The Work of Art in the Age of Mechanical Reproduction' in Hannah Arendt, ed. (1970) *Illuminations*, London: Jonathan Cape.

13 Renato Poggioli (1981) *Theory of the Avant-Garde*, Cambridge, MA: Belknap Press.

David Bate

ART, EDUCATION, PHOTOGRAPHY

the age of Photography corresponds precisely to the irruption of the private into the public, or rather, to the creation of a new social value, which is the publicity of the private: the private is consumed as such, publicly.

Roland Barthes, *Camera Lucida*

WHAT IS THE MODERN FUNCTION of art and photography today? Photography as a practice is both in and out of art. Photography is a social thing encountered everywhere. It cuts across every type of discourse, every division and boundary (institutional, political, geographic, ethnic, age, sex, economic, psychic and so on). This is not to somehow say that photography is the same object or has the same purpose and meanings across each of them. Actually, what I am speaking about is not a property of photography at all, it is rather a property of the discourse upon things – like photography or art – which issue from particular institutional sites. Art is one such cultural site, education is another. They both interact with notions of the private, and photography takes place across all three. It must follow, that any discussion of photography that acknowledges these things is not necessarily going to be a simple or easy one. Nor should such debates be regarded as merely 'academic'.

Raymond Williams once remarked 'There are clear and obvious connections between the quality of a culture and the quality of its system of education.'[1] The relationship is also a complex one. In education institutions – art schools, colleges, universities – the cultural values and beliefs about art are established amongst its new recruits. Introduced to those discourses that constitute various objects and practices as 'art', students and staff alike read the same cultural magazines and catalogues that artists, curators, critics, dealers and sponsors also read. These practices, together with the exhibition system (a complex of interwoven and linked 'independent' artist-run, private and state funded institutions), are where the discourses of art are to be found. This is how it functions.

When it comes to art as a component aspect of culture, it has, since the nineteenth century, been 'regarded as one of a number of specialized kinds of production'.[2] The particular, perhaps peculiar function of art according to the dominant common-sense consensus of industrial societies is to provide new ideas rooted in the artist's autonomous creative being. (The fact that twentieth-century art has been about so many other things has not dislodged this view as common-sense belief.) That is, ideas to do with feelings, the senses, personal and apparently private 'experiences'. These have to be translated into the moulded material forms of cultural objects and images which constitute art practice. Obviously, art is not the only sector of culture engaged in this process, but the belief in art as a privileged realm remains, partly, because it *appears* to maintain an economic distance from the capitalism of 'mass culture'. But, patently, art is not impermeable to popular culture. It is saturated with it. This is not, nor should it be, a value judgement in itself. What should be judged is what relationship art has *as* culture.

How does art as an institution and set of discourses constantly renew and reinvent itself? One example is pop art in the 1950s, which like much contemporary art today, reversed the value of things: art, seen as a defence against mass culture was made to face it and in the process 'destroys' what went before, thus renewing the question 'what is art?'. This, to coin the phrase of Jean-François Lyotard's concept of 'postmodernism', is 'not modernism at its end but in the nascent state, and this state is constant'.[3] Thus, to state the obvious, the preoccupation of pop art with popular culture did not collapse the distinction between art and culture. It was just that 'popular culture' was of interest to some artists as the culture of art. It is as though one function of modern art in the twentieth century was to rummage through the junk of industrialized societies and re-value it. (The Surrealists started it.) Invariably, pop art identified, or rather, 'expressed' in its form and content, the common traits of an industrialized culture: banal repetition, series of models, stereotypes, 'Americanism', trademark icons, etc. It is the gap or distance produced by the 'reprocessing' of these representations which made pop art signify as a 'commentary' on – as critique or celebration of – popular culture. In pop art, photography was not 'art photography', it was 'popular culture' as art.[4] This was something very different from previous 'art photography'.

Art photography at the beginning of this century was treated more or less as a haven from the 'nasty' world of industrialized popular culture, war and capitalism. Today it is easy to forget, whilst looking at the pictures, how much early 'modernist' art photography was actually anti-modern. Technically and aesthetically opposed to the sort of mass production photography encouraged and made popular by the major photographic companies like Kodak, they argued – at least by their own production methods – for the photographer's control over the *process* of image making and the conditions of its consumption. A real purity of process, no enlargements of negatives, no cropping of the 'original idea'. The strain of this purity of form on the repression of content in modernist criticism and theory is well known. Also opposed to the content of image production by the dominant picture industries, (even though figures like Edward Steichen, Paul Strand and Edward Weston were involved in them) the legacy of this modernism is a technical fetishism and a craft excellence – values not necessarily to be rejected – coupled with mythologies about the act of creativity.

Peter Wollen has traced the strands of art photography that filtered down from turn-of-the-century debates.[5] Paul Strand's call for the 'integration of science and expression' (machine and human vision) is most famously consolidated in Edward Weston: 'Sharp focus and full light were to be combined with the new post-cubist principles of composition' (and paralleled in Europe by the 'new objectivity' photography of Albert Renger-Patsch, etc.). This was made popular through the work of Walker Evans, Henri Cartier-Bresson and later – but differently – Diane Arbus. Despite the modernist emphasis on the single print, it was the series or suite of pictures that showed the constancy of vision of the photographic seer as 'genius'.

In Britain, which like other European countries suffered an art, aesthetic and intellectual collapse through the impact of the Second World War, a supposed 'indigenous' tradition of documentary-reportage and fine art landscape photography (cannibalized from English landscape painting) inherited those modernist craft values. But the critique of these photographic values of modernism as the horizon of thought in art and education came through conceptual art rather than from photographers. Conceptual art, to put it somewhat simply, was concerned with the issue (politically and philosophically) of art as knowledge. It questioned the conditions and possibility of art as a practice: the production of its own enunciation and the status of the discourses and the institutions in which it took place. It also engaged with 'everyday life': sex, class, politics *and* photography. A new use of photography in art emerged (pregnant with the legacy of 1970s' reformulated notions of conceptual art) and broke with the tendencies of the older 'fine art' photography that had veered towards craft printing. Something happened again during the 1980s, with a renewed interest in popular culture and 'new' forms of colour photography, 'installation' and video. No longer interested in looking for, or 'evolving', a specific genre of fine art photography, the use of photography was opened up to 'refer to' (quote, copy, mimic, parody) those modes and codes of photography that already existed elsewhere in other institutional practices.[6] This new 'postmodern' range of concerns had a particular consequence for the theory and use of photography in some sectors of art and education.

Once upon a time, 'photography theory' used to only designate a technical theory, a study of chemistry and the structures of photographic paper, films, a theory of optics and (if you were lucky) the characteristics of light and the effects of perspective. The consequences of its value judgements were, however, mostly limited to choices of photographic materials, cameras, lenses, etc., and their use in relation to a set of given 'correct' norms. The works of Michael Langford in *Basic Photography* and the various versions of the American 'zone system' exemplify the starting points for this sort of study. These contributions to the study of photography are, needless to say, important components – the technical means of production of the photographic image is certainly relevant, not only to those making photographs, but also as part of the technological history of photography. But again to state the obvious, the notion that 'technique' is all there is to say in a theory of photography is severely limited. (Modernist art photography with its emphasis on the 'purely visual' effectively condemned itself to being dumb, despite the fact that the modernist values were established in reams of writings by Alfred Stieglitz *et al.*) The word theory, I take to mean critical theory. In the distinction of theory/practice, the activity of thinking about photography, what is called theory, is of course, itself a type of practice. It has its own agenda, just as

picture making does. Equally, the practical activity of making photographs (of whatever means or form and no matter how conscious it is or not of 'theory') implicitly or explicitly presupposes theoretical propositions. (To pick up a camera is already to start determining the meanings that a photograph will denote.) Theory involves a practice and practice involves theory. This is not some tautological slogan, masquerading as a 'deconstruction' of the binary opposition of theory/practice. Nor is it intended to point out the futility of any distinction between them. 'Theory' and 'practice' are, like it or not, the terms of one of the fundamental distinctions that anyone dealing with representations has to negotiate.

Victor Burgin pointed out in the 'Introduction' to the 1982 book, *Thinking Photography*: 'the primary feature of photography, considered as an omnipresence in everyday social life, is its contribution to the production and dissemination of *meaning*'.[7] The meanings of photographs and the issue of how, what and why meanings are derived from photographs by their audiences, is the one thing that technical theory had taken for granted and was forgotten or suppressed in modernism. Photography theory put the production of meaning of the photographic image – in any discourse – at the centre of its aim. In addition, Victor Burgin had argued: 'photography theory will either develop through attention to its own specificity or it will not develop at all'. Arguably, it has not developed, but for different reasons.

Today, a whole range of books are available on photography, with critical and methodological analyses available on advertising, art, etc. There are no excuses for the uninitiated. Semiotics, rhetoric, theories of ideology, psychoanalysis, cultural studies and sociology are all deployed now as 'text book' models for image analysis. It was – and is – a means, a set of methods to demonstrate and improve our understanding of the structures that operate in the production of meanings of pictures. But, for example, the rhetorical analysis of images was not only intended to 'decode' or 'criticize' advertising images, it was also a means to 'demystify' and displace the notions of art photography 'genius' and 'seer' that floated around art photography. The theory was also, implicitly, a critique of the 'methods' in the writings of the history of photography, which had set itself up as a master discourse in which to construct the narratives for those photographs that get held up as masterful pictures. The rise of photography as a taught subject of study in education – with more than forty new courses established in Britain during the 1990s – might be judged as a decisive social choice and cultural shift. But this would be a hasty conclusion. Even today this 'discipline' remains barely touched by, even, the 'new art history' of the 1980s.[8]

Four years on in 1986, Victor Burgin, in the concluding sentence of his essay 'The End of Art Theory' (in the book of the same name) concludes:

> In our present so-called 'postmodern' era the *end* of art theory *now is* identical with the objectives of *theories of representation* in general: a critical understanding of the modes and means of symbolic articulation of our *critical* forms of sociality and subjectivity.[9]

This shift, a response to problems of representation in the eighties, is from 'photography theory' in *Thinking Photography* to 'theories of representation in general', and their 'modes and means of symbolic articulation' in *The End of Art Theory*. In other words, a move away from the problems of specific forms of signification

towards the general cultural theory field of visual representations. Art theory, or photography theory should give way to theories of representation in general and the inter-textual reference across the domains of visual significations – even though photography theory was already interdisciplinary, like the object of its discourse: the photograph. Whereas photography theory put the photograph at the core of critical analysis, in cultural theory the photograph is one component element in a set of overlapping and interweaving 'visual cultural practices'. This shift in position coincided with the increased traffic of images between institutions and increased rapidly in the 1980s. (For example, the 'genre switching' in Benetton's use of image codes of photo-journalist pictures as their advertising; art photographers using the 'slick' lighting of advertising, etc.). In art, the 'anti-aesthetic' work of the 1970s gave over to the 'commodity pleasure' (artifice, colour,) art work of the 1980s, even though the issues of sexual difference, ethnicity, pleasure, identity politics and desire initiated in the 1970s (conceptual art, film theory, feminism, Marxism and psychoanalysis) were still the main focus. The use value of photographs had changed. This is not surprising. Not only has the photograph permeated every corner of the earth, but the experience of the photographic image has in turn transformed our sense of identity and the social. It is hard, impossible, to think about the modern world without the photographic image

At its origin, photography emerged in the context of mediums like painting and lithography and the national art academies and scientific research institutions. Industrial entrepreneurs competed to receive capital support for their inventions. Photography supplied the needs of an industrial culture, the mass reproduction of images. Needless to say, at the end of the twentieth century, the cultural and institutional frameworks in which we live are vastly different from those of the nineteenth century when photography first appeared. All the institutions that took up photography in the nineteenth century were themselves transformed in the twentieth century: art, science, medical, psychiatry, police, tourism, etc. The newer twentieth-century photo-image based institutions of advertising, fashion, news, cinema, television, (and the world wide web) have come to dominate the production and distribution of the representations of the world we live in. The consequences of this on photography are, of course, not merely technological

As computer data images also begin to aid art directors, editors and photographers to construct high resolution image fantasies, the public image world (most obviously, advertising) is increasingly populated by a kind of arbitrary 'surreal' game of impossible logic images. In art, uncanny images and 'baroque spaces' are pitched as a dissident practice against the new 'electronic modernism', where (Clement Greenberg's) 'specificity to the materials' means finding the 'essence' of a computer aesthetic (the computer produced image on the computer screen?).

As a means of apprehending visual knowledge of the world, photography is paralleled and met in the second half of the twentieth century by the dominance of the televisual screen located in most homes in the West. Since the 1950s, Paul Virilio argues, television has been like an 'introverted window' in our homes. We do not look out as we would a window onto a view that is fixed (even if the objects within it move). The images on television, however, are constantly changing (between different shots, edits and programmes, across video tapes and channel hopping) resulting in a 'deterioration of stability'.[10]

One recent tendency in British television at peak viewing hours has been to show 'replays' of amateur videos, cctv (close circuit television) camera recordings, video diaries and video tape recordings from police cars and helicopter cameras. These are played for various levels of entertainment, at main viewing hours, and range from serious documentaries to cats and babies falling over, and accidents and drunken drivers shown 'captured' on film. Networked computer users can receive information on their monitor screens from camera (video and still) images that people have installed in their homes and put out on 'the net'. These examples illustrate the problematic changing relationship towards our notions of the public and private. Public space is turned inside out, with private display in the public as public culture, while public culture is also privately displayed in homes on television and computer screens. As a teenager, I frequently heard television being condemned as an 'escape from the world'; to me it was a means of engaging with it beyond the familial setting.

As terrestrial television stations, located in particular national cultures go extra-terrestrial, with digital transmission, the opening up of new channels and satellite projections, the question of what is transmitted into our homes becomes an increasingly important question – about what 'our' paranational culture in the various 'imaginary communities' of viewers actually is. As the visual culture world expands, shedding ever more images each day which pile up around our bodies, the indexical trace value of the photograph is relativized by the digital print, video tape and computer data image. In this context, the aesthetics of a 'lived experience' takes on a new meaning.

Walter Benjamin, like Charles Baudelaire before him, noted that the photograph, despite its reproducibility, was not exempt from the cult value affect of the 'aura', the 'presence of the original':

> In photography, exhibition value begins to displace cult value all along the line. But cult value does not give way without resistance. It retires into an ultimate retrenchment: the human countenance. It is no accident that the portrait was the focal point of early photography.[11]

The idea of the authentic picture (the denotation of 'aura') has not been effaced by the reproductive qualities of the photograph. Indeed, the potential capacity for reproduction of the photograph so often quoted from Walter Benjamin is only actually fulfilled by the publicity and print industries to enable their wide distribution. There the aura is sustained, not by any uniqueness of a material object, (the photograph) but by the production values of the picture and the objects depicted. In contrast, the 'private' photograph the domestic snapshot, is the sort of image that is more likely to be unique, or at least, singular and valued *as an object*. Even where the photograph has been reprinted more than once, the single print is rarely *experienced* as merely a reproduction. It is the opposite. Private photographs are more frequently treasured as authentic objects and given a kind of naturalized function as fetish object.

In his 1978 essay 'Photography and Aesthetics' Peter Wollen argues that painting turned to a (Kantian) subjective, intuitive mode of seeing after the appearance of photography in the nineteenth century.[12] The graphic mark of the painting (the trace of the human hand) was contrasted with the mechanical tool, the camera. Photographers attempted to imitate the subjective impulse (through hand made papers, home made cameras, refusal of optics and perspective, soft 'impressionist' focus,

etc.), but these techniques (often regarded by modernists as 'gimmicks') never really became fully established in art and remained marginal. (Some of them became accepted as amateur rules for 'creative photography'.) The acceptance of photography into modern art is a recognition of an aesthetics of 'lived experience' (now characterized by its 'badness') returning to haunt a modern art that had tried to evacuate it. However, this return does not *in itself* guarantee any change, development or 'progress' in art or photography. One way that photography can emphasize the equivalent of the gesture of the human hand is by turning the camera towards 'private life', especially the private life of the artist. Here it is not the camera as instrument that is subjective (or even objective), but the intuition of the objects supposed within its field of vision.

We can begin to see here how a turn towards the private and especially the aesthetics of the snapshot look of 'immediacy', functions so readily as art. It is as though the 1970s feminist slogan 'the personal is political' has been re-interpreted, skewed and inverted. Originally intended to draw attention to the personal and private sphere as not exempt from an ethical politics of behaviour of the public sphere, 'the personal' has been construed as the expression of politics. The political is now 'the private' when it is made public. It is striking, when you think about it, how a good deal of contemporary work – some more critically aware than others – is structured by this aesthetic claim of actual 'lived experience'. One manifestation is the so-called 'amateur' coded aesthetic of the snapshot as the latest and seemingly last frontier of the photograph as 'authentic', or 'real experience'. This position in its various representational strategies appears to attempt to reveal a 'real me', recalling the strategy of early feminist art, where, as Mary Kelly argues 'the "enigma of femininity" is formulated as the problem of representation (images of women, how to change them) and then resolved by the discovery of a true identity behind the patriarchal façade'.[13] It is as though the public 'facade' of the 'individual' is now only a seething mass of privacy, whose 'true identity' is to be endlessly displayed but cannot be found. What Roland Barthes called 'the creation of a new social value, which is the *publicity* of the private' has begun to appear as more than a residual practice.[14] Indeed this practice in art relates to (I do not say 'reflects') the popular forms of televisual drama and their fascination with the lives of 'ordinary individuals'.

What does all this mean for the study of photography today? The lesson must be that the institutional divisions which were once identifiable with certain codes and styles of images have become far more slippery. The traffic between institutions, pictorial values, styles, codings and ideologies is more conventional rather than the exception, more inter-textual than institutional. To maintain the photograph as a central object in education remains a crucial objective, not so as to fetishize it, as what is now becoming the old rather than the new, but to specify its discourses, its differences (and continuities) with newer digital manifestations. After all, is not the function of education to develop an understanding and knowledge of the role of images within culture? In that respect we have still not escaped the techno-ideological project of renaissance picturing systems that has governed Western thought ever since. Perspective remains the order of Photoshop as much as it does the camera obscura, discovered so long before photography. Education then, should retain a critical distance to, and awareness of these functions and fluctuations in image culture.

Original publication

'Art, Education, Photography', *Hyperfoto* (1997)

Notes

1 Raymond Williams, *The Long Revolution*, London: Hogarth Press, 1992, p. 125.
2 'Culture' for Williams means the 'whole way of life'. See his *Culture and Society*, Penguin, 1979.
3 This is Lyotard's definition of postmodernism in *The Postmodern Condition*, Manchester University Press, 1986, p. 79.
4 See Roland Barthes, 'That Old Thing, Art . . . ' in *The Responsibility of Forms*, translated by Richard Howard, University of California Press, 1991.
5 Peter Wollen, 'Photography and Aesthetics' *Screen*, vol. 19, no. 4, winter 1978–79.
6 The internal differences within conceptual art and between artists is here less important than their collective distinction from 'art photography' and photographers. The anathema directed towards the 'fine print' of the former was only equalled by the hostility to the 'anti-aesthetic' by the latter.
7 Victor Burgin (ed.) *Thinking Photography*, Macmillan, 1982, p. 2.
8 A.L. Rees and F. Borzollo (eds.) *The New Art History*, Camden Press, 1986.
9 Victor Burgin, *The End of Art Theory*, Macmillan, 1986, p. 204. Author's emphasis.
10 Paul Virilio, *The Lost Dimension*, Semiotext(e), 1991.
11 Walter Benjamin, 'The Work of Art in the Age of Mechanical Reproduction' in *Illuminations*, Fontana, 1980, pp. 227–228.
12 Wollen, 'Photography and Aesthetics' *Screen*, vol. 19, no. 4, winter 1978–79, p. 17.
13 Mary Kelly, 'Re-Viewing Modernist Criticism' in *Art after Modernism*, ed. B. Wallis, New Museum of Contemporary Art, 1984, p. 97.
14 Roland Barthes, *La Chambre Claire*, Paris: Gallimard, 1980, p. 98. (My emphasis.)

Index

Note: Page numbers in *italics* refer to illustrations.

9/11 terrorist attacks 134, 136, 139n5, 174n6, 210, 514
60 Minutes 133, 196, 199
500px 344

ABC 199
Abu Ghraib prison 129, 133, 210–211; photographs 194–202, *195*, *196*, *197*, *198*, *200*, *201*, *202*,
Adams, Eddie 118
Afghanistan 65, 118–119, 128, 133, 135–136, 181; War in 148, 199; *see also* 9/11 terrorist attacks; Abu Ghraib prison; war on terror
Africa 62, 74, 314, *315*; Northern 218; sub-Saharan 147; West 256
African Americans 226, 245, 247–249, 260–261, 269, 414
Ahmadinejad, Mahmoud 212, 214, 218
Al-Fayed, Dodi 411, 434
Allende, Salvador 137
Allies 421, 439n60
Althusser, Louis 67, 526n3
American Indian Movement 46
American West 43, 50
Amos, Emma 271
anthropometry 289
Antonioni, Michelangelo 423, 480
apartheid 114, 156, 268, 270

Aphrodite 9, 95, 98, 100, 103, *103*, 104, 106
Apple 345, 354
appropriation 40n23, 84, 86, 211, 303, 320, 322, 332, 381; artistic 112; photographic 337; of vernacular 318–337
Arago, François 169–170, 174n12
Arbus, Diane 407–408n9, 471, 476, 481, 549
Arendt, Hannah 155, 162n2
Argentina 120, 176, 180, 185, 190, 329–330; Buenos Aires 180; *disparecidos* 180; Mothers of the Plaza del Mayo 180–181
Asia 70n6, 180; South 75, 83; Western 119
Associated Press 148
Atlantic Monthly, The 247–248, 251–252
Auschwitz concentration camp 160–161, 163n8, 513, 517n18
Australia 305, 314, 327, 399, 408n11, 482; Aborigines 60, 298
Austria 237, 399
auterism 524
avant-gardism 230–231
Avedon, Richard 475, 512–514, *515*
Azoulay, Ariella 120, 176–177, 183, 187–190, 288–289, 297

Backstrom, Lars *346*; *Mapping the World's Photos* 345, *346*
Bailey, David 4, 226, 469, *470*, 471, 475–481
Balkans 119, 147, 157, 162n6

Bangladesh 128, 130; Dacca *128*, 130–131
Barney, Tina 485
Barthes, Roland 4, 29, 35, 43, 56, 157–161, 186, 191n2, 283, 320, 322–323, 330, 340, 355, 363n6, 368, 383, 405, 445–446, 452–453, 461–462, 464, 466, 506, 509, 521–522, 547, 553; *Camera Lucida* 159, 283, 322, 363n6, 547; *The Fashion System* 445, 461; *Mythologies* 368, 546n6; "The Photographic Message" 322–323; *punctum* 322–323, 330, 506, 509; 'The Rhetoric of the Image' 29
Basetrack 127, 129
Bataille, Georges 25, 444
Baudelaire, Charles 443, 446, 455, 546n4, 552
BBC 197, 205, 217, 432
Beaton, Cecil 11, 471, *473*, *474*, 475–476, 478, 481, 484
Beaver, Sampson 42–49, *44*, 51
Belgium 421
Benjamin, Walter 170, 175n14, 189–190, 316, 399, 518, 526, 529, 544, 552
Berg, Bolette 111
Berger, John 8, 119, 126–127, 131
Berkeley, Busby 444
Bernard, Cindy 330; *Ask the Dust* 330
Bernhardt, Sarah 417
Bertillon, Alphonse 289–290
Billingham, Richard 32
bin Laden, Osama 137
biometrics 113, 287
Black Elk 48
black life 267–269, 271; camera in 265–272
Boltanski, Christian 322, 350
bookwork 318–321, 328–329, 332–333, 335, 545
Bosnia *154*, 155–157, 160, 162n2, 162n6; government 153; Sarajevo 119, 153, 157, 159, 161, 162n3, 434, 522
Bosnia and Herzegovina, Federation of 156
Bosnian War 153, 155–156
Bouju, Jean-Marc *117*, 119, 142, 148–149, *148*
Bourdieu, Pierre 34, 39n19, 91–93, 225, 320
Bourdin, Guy 481
Bourke-White, Margaret 326
Brassai 480
Brecht, Bertolt 518
Britain *see* Great Britain
British monarchy 369, 412, 431–432, 435–436, 442n128

British Museum, London 534, 538n34
Burrows, Larry 119, 142–147, *143*, 150, 151n8
Bush, George W. 136, 139n5
Butler, Judith 115, 132–133, 135, 137–138, 161
Buzznet 356

Caldwell, Erskine 326
Calley, William 132–133, 138
Cambodia 132, 142, 501, *502*, 503, 511; genocide 492, 500–501, 514; Phnom Penh 500–501, 511; Tuol Sleng 500, 506, 508–509, 511, 513; *see also* Khmer Rouge; *Photographs from S-21*; Pol Pot
camera phone 120, 205, 212, 302–303, 350–351, 353, 355, 357, 359–360, 363n5, 363n8, 363n10
Cameron, Julia Margaret 30, 34, 302
Canada 9, 64, 287, 329, 491–492, 523; Banff 44, 47–48, 50; Passport Canada 287
Capa, Robert 194, 485, 496
capitalism 314, 377, 386, 447, 525, 548
Carroll, Lewis 31, 34, 40n20
Cartier-Bresson, Henri 375–376, 407–408n9, 496, 549; Decisive Moment 360, 375, 399, 406
castration anxiety 15–16, 25
Caujolle, Christian 500–501, 503, 509–513, 516
CBS 196–199
CCTV 3, 111, 350, 552
Charcot 111
Chicago, Judy 30
childhood 2, 27, 29–31, 34, 36, 224, 239, 265–266, 270, 283, 307, 311, 313, 328; sexualization of 29, 36–38, 39n2
children, photographing of 27–38
Chile 119, 137–138; Museum of Memory and Human Rights 137; Santiago 137–138
China *see* People's Republic of China (PRC)
Chomsky, Noam 414
Chow, Jay *346*, 347
Christianity 219
citizen reportage 120, 205
citizenship 120, 134, 162n6, 172, 187, 227, 287–294, 296–298; and photography 289
Citroën 368, 372–373; Déesse 372–373
Cixous, Hélène 25
classism 241

Clausewitz, Carl von 159
CNN 206, 212–213
Cold War 147
Cole, Ernest 114
Coleridge, Samuel Taylor 454, 456
Collier's Weekly 395, 407n4
colonialism 45, 48, 75; post- 45
Columbus, Christopher 51
commedia dell'arte 424–425
commodification 368, 461, 463; of art 542,
 545; of blackness 268; of the body 33; of
 culture 459; of fashion 458; of food 388;
 of history 315; media 459; of men 459; of
 nostalgia 316; of people 315; of self 388;
 of women 459
conservatism 170, 314, 429, 475, 543
Cory, Kate 46
Coupland, Douglas 322; *School Spirit* 322
Crandall, David 345, *346*; *Mapping the
 World's Photos* 345, *346*
Crazy Horse 46
Croatia 156, 162–163n6
cultural identity 296, 314, 316
cultural memory 273–274, 276–277
curatorship 260–261, 327
Curtis, Edward 44, 46
Cyprus 9, 91, 95–96, 98, 120, 176–177,
 180–183, 185, 190, 191n3; government
 182–183; Greek Cypriot relatives of
 missing persons 180–183; Mothers of
 Cyprus 182; Pancyprian Committee
 for the Return of Missing Relatives and
 Undeclared/Missing Prisoners of War 182
Cyworld 303, 341

Dada photomontage 318
Daguerre, Louis 169–170, 175n17
daguerreotypes 17–18, 170, 175n19, 398,
 416, 438n19
Daily Express 32, 396, 428
Daily Graphic 396–397
Daily Mail 428, 433, 441–442n122
Daily Mirror 28, 197, 396, 428
Daily Star 428
Darwin, Charles 296–297, 496; *The
 Expression of Emotion in Man and Animals*
 296–297
Dean, Tacita 320–325, 335; *Floh* 321–324
decolonization 63, 66, 270, 272
Degas, Edgar 416
Deleuze 175n23

Deng Xiao-Ping 280
Denmark 399
Der Spiegel 133–135
Diana, Princess of Wales 369, 411–412,
 414–416, 427, 429–436, *435*, 436n2,
 437–438n17, 441n106, 441n116,
 442n127, 442n130; Squidgygate 415
diaspora 287, 293–294
Dick, Philip K. 292
di Corcia, Philip Lorca 485–486
digital activism 213–214
digital images/imagery 3, 194, 199, 201, 360
digital imaging 2, 349, 351; in war 194–202
digital lifestyle 303, 353–356
digital media 113, 126, 209, 213, 357, 376
documentarians 205, 208–209, 413
documentary 1–2, 33, 86, 118, 191n3,
 206, 208, 230–231, 235, 290, 326–327,
 344, 369, 412–414, 416, 432, 479–480,
 485–486, 503, 505, 517n11, 527n8, 541,
 549; aggregate 347; chronicle 142, 146;
 citizen 209; crowdsourced 209; field 209;
 filmmaker 71n9; form 230–231; genres
 229, 231; imagery/imaging 141, 151n2,
 348, 501, 503; photograph 47, 332, 467,
 479, 485; photographer 10, 73, 77, 87n9,
 481–482, 485; photography 229, 242,
 399, 406, 407n7, 413, 437–438n17,
 486; rhetoric 58–59; social 253; style
 197, 407n7; truth 147, 229–230, 403;
 witness 149
Doering, William Harvery *179*
Doisneau, Robert 375–376, 480, 487n1
Dolce & Gabbana 375
Domanicsky, Tivador 118
Du Bois, W. E. B. 226, 245, *246*, 247–258,
 260–261, *261*, 262n15, 262n16, 262n18,
 262n21, 262n23, 263n33, 263n37,
 264n44, 264n59; "The Negro As He
 Really Is" 247, 249–253, 256, 264n59;
 The Souls of Black Folk 226, 245, 247–249,
 252–253; *The World's Work* 245, *246*,
 247–254, *248*, *254*, 256, *256*, *257*, 258,
 259, 260, 262–263n27, 263n38
Duchamp 320, 324, 332, 514; *L.H.O.O.Q.* 320
Duchenne de Boulogne, Guillaume-Benjamin
 297, 496
Dugmore, Arthur Radclyffe 245, *246*,
 247–256, *248*, *254*, 256, *257*, 258, *259*,
 260, 262n23, 262–263n27; *The World's
 Work* 245, *246*, 247–254, *248*, *254*, 256,

256, *257*, 258, *259*, 260, 262–263n27, 263n38
Durkheim, Emile 385
Dylan, Bob 375–376

Eastman, George 354, 469
Eastman Kodak *see* Kodak
economy: digital economy 384, 388–389; prosumer 381, 388; social media 387; UGC 380, 387; user-centred 388
Edward VII 435
egalitarianism 47, 456
Egypt 189, 329, 418, 433–434, 496
Egyptian revolution 209
Ekberg, Anita 418–419, 422–424, *423*
Elizabeth II 137, 429, 431–433, 436
Elle magazine 368, 371–372
Elwes, Cate 30
embedded distance 178–179, 190
Embedded Media Program 134
embedded photos 184–185
Emerson, Ralph Waldo 251
England 111, 175n19, 252, 396, 398–399, 408n11, 429–430, 435, 493, 495, 532; London 27, 82, 230, 315–316, 326, 345, *347*, 426, 429, 433, 471, 475–476, 478–479, 482–483, 485, 492, 495, 533–534, 540, 545n2, 546n7
Enlightenment 150, 292, 384, 393
Erdoğan, Recep Tayyip *206*
erotica 9, 25, 396
ethnic cleansing 156
ethnicity 2, 4, 8, 102, 153, 155, 162n6, 218, 224, 227, 261–262n15, 296, 307, 314, 381, 422, 499n4, 551
Europe 8, 45, 61, 65, 67, 69, 74, 87n15, 141, 156, 160, 179, 216, 218, 290, 318, 333, 368, 370, 375, 394, 397–398, 407n3, 414, 421, 423, 427, 478, 480, 482, 487, 496, 541, 544, 549; Eastern 3; Central 314; Southern 3, 315; Western 345, 421, 427, 479, 523
Evans, Jason 478, 482
Evans, Walker 481, 549
Evening Graphic 396
eyewitness 120, 130, 205, 208, 211, 214–217

f/64 17–18
Faas, Horst *128*
Face, The 478, 483

Facebook 120, 128–129, 131, 212–213, 225, 303, 339–341, 344, 388
family album 2, 29, 31, 33, 35, 38, 40–41n31, 127, 131, 224–227, *238*, 239–240, 276–277, 283–284, 302, 305, 307, 309, 311, 313–314, 316, 318, 326, 328, 354–355, 542; web-based 350; *see also* snapshots
Family Snaps 205, 302
Fani-Kayode, Rotimi 232–235, *233*, *234*
Farouk, King 418
fashion: artists 483; body 369, 450; curators 483; definition 458–459; design 461, 467; editors 482–483; high 459, 462; industry 369, 454, 459, 461, 467, 483; low 459; magazine 463, 467, 471; model 369, 444–445, 456, 460–462; *see also* fashion imagery; fashion photographer; fashion photography; *haute couture*
fashion imagery 370, 447, 454, 466
fashion photographer 34, 311, 459–461, 464, 471, 474–483, *477*, 485
fashion photography 370, 443–456, 458–467; as art 469–487; gestures and postures 462–463; narrative 463–465; rhetoric of 462–466; text 465–466; *see also* fashion imagery
Feldmann, Hans-Peter 318, 321, 327–329, *328*, *329*, 335; *Ferien* 319, 328–329, *329*; *Porträt* 318, 328–329, *328*
Fellini, Federico 402, 417, 422, 427; *La Dolce Vita* 402, 417
feminism 11–12, 22–23, 25, 30–31, 33, 36–37, 40–41n31, 429, 551
feminist theory 22
fetishism 15–16, 18, 25, 35, 233, 447, 529, 548
Finland 111
First World War *see* World War I
Fisher, Eric 345, *347*; *Locals and Tourists, London 347*
Flickr 91, 96–98, 100, *101*, 103, 206, 213, 303, 341, 343, 344–345, *346*, *347*, 354, 356–360, 363n1, 363n3, 363n12, 388
food: advertising of 386; as art 384; channels 387; as commodity 381, 388; as cultural artefact 382; eating of 384; fast 341, 387; fetishisation of 380, 383; and human connection 389; metaphors of 382, 389; as performance medium 384; re-fashioning of 382; selling/packaging

of 386; social centrality of 383; spectacles of 369; as symbol 384, 387; tabloidisation of 387; tele-visualisation of 387; visual consumption of 383; visuality 383–384; *see also* food imagery/images; food imaging; food porn; food photography

food imagery/images 380–382, 384–389

food imaging 381–382

food photography 341, 382, 388

food porn(ography) 369, 380–384, 386–389; *see also* gastro porn

Ford, Colin 476

formalism 230, 289, 462, 506, 508

Forum 251

Foucault, Michel 10, 112, 114, 174n7, 236, 283, 383, 491

France 4, 162n6, 170, 175n18, 291, 368, 394, 416, 421, 496, 500–501, 510, 541; *Déclaration des droits de l'Homme et du Citoyen* 288, 291; French National Assembly 290; *see also* Paris

Frank, Robert 471, 481

Frank Leslie's Illustrated Newspaper 394

French, John 477–478, *477*, 480

French Revolution 288, 291

Freud 18, 15, 18, 94, 156, 158–159, 160, 162–163n6, 224, 284, 424, 511; *The Interpretation of Dreams* 18

Friedlander, Lee 480

Fussell, Paul 76

Garangar, Marc 111

Gardi, Balazs 128–129

Gardner, Alexander 496, 506, *507*

Gardner, Ava 418, 422

gastro porn 380, 383

gaze, the 4, 8–10, 19, 53–69, 70n2, 74, 76–78, 82–85, 87n18, 173, 237, 380, 385, 389, 520; academic 53, 67–68; camera 58–59, 66; colonial 9, 62, 84; direct Western 61–63, 66; discursive 237; female 9; flaneur 381, 384; frontality 58–59, 102, 400–401; magazine reader's 56–57, 67, 71n9; magazine's 56; male 39n2, 40n20, 84; mother/father 237; multiple 69; mutuality of 61; non-frontality 70n7; non-mutuality of 61; non-Western subject's 57–61; the Other's 60; the Other's refracted 64–67; photographer's 53–54, 56, 70n3; primary 237; subject's 71n9; tourist 76, 84–85, 87n18, 92; white supremacist 270

Gearon, Tierney 9, 27–38, 39–40n19, 40–41n31, 41n42

gender, politics of 2, 262n16

Generation C 357

genocide 45, 155–156, 161, 492, 500, 510, 513–514, 516, 517n19

Geppetti, Marcello 419, *422*, 423, *423*, 425–426, *426*, *435*

Gilpin, Laura 46, 52n6

globalisation 147, 150–151, 387

Globe 427–428

Godard, Jean-Luc 153, 518

Godfrey, Mark 320–324, 327

Goldin, Nan 32, 350, 482, 485

Google 359, 363n10; Google Books 261n4; Google Earth 212; Google Image Labeler 359, 363n14

gossip theory 419

Grandville 447–449, *448*

Great Britain 33, 37, 240, 252–253, 263n39, 278, 315, 383, 427, 428–430, 436, 476, 479, 491–492, 540–542, 545n2, 549–550; MI5 415; *see also* England

Gregory, Joy *223*

Groen, Theo *101*

Guardian, The 28, 38, 208, 213, 359, 388

Haiti 329; revolution 294

Hall-Duncan, Nancy 469, 471, 487

Hamilton, David 33, 483

Harper's Bazaar 480–481

Harper's Weekly — Journal of Civilization 394

haute couture 370, 443, 458–459

Haviv, Ron 153, *154*, 155, 157–159, 162n4, 162n5

Hawarden, Lady Constance 302, 533

Hay, Alexei 444, 450–453, *451*, *452*, *453*

Hearst, William Randolph 395

Heidegger, Martin 174n1, 174n3

Hercules 22

Hersh, Seymour 133–135, 138, 139n10

Hiller, Susan 30

Hinduism 87n10

Hine, Lewis 263n38, 496

historical distance 178, 184, 190, 191n3

Hitler 114

Hoak-Doering, Elizabeth 120, *177*

Høeg, Marie 111

Holland, Pat 27, 31, 36–38, 302–303, *306*, *308*, *310*, *312*, *315*
Hollywood 8, 375–376, 418–422, 427, 435
Holocaust 163n8, 183
Huffington Post 213
Hurricane Katrina 211
Hussein, Saddam 198, 210
Huttenlocher, Dan *346*; *Mapping the World's Photos* 345, *346*
Huyghe, Pierre 322; *School Spirit* 322

i-D magazine 482–483
Illustrated London News 394, 407n2
Illustrierte Zeitung 394
images: control over 134, 171, 188, 224, 267–270, 362, 400–401, 548
Imperfect Beauty 478, 483, *484*
imperialism 75, 383; cultural 46; US 150
India 73, 75–77, 83, 85, 86n1, 86n5, 86–87n6, 87n10, 87n16, 87n17, 433; Kolkata (Calcutta) 73–86, 86n6; Mumbai 74, 210
Indian Ocean: tsunami 211
Instagram 225, 227, *301*, 302, 339, 344, 347–348, 385, 388–389; culture 302
Internet 37, 120, 196–197, 199, 206, 213–214, 217, 303, 343, 349, 352–354, 362, 384–385, 388–389, 416, 437n16
intersubjective time 45
Iran 120, 210–219; 2009 uprising 213, 217, 219; Green Revolution 129; Tehran 120, 210, 212–213, 218
Iraq *117*, 119–120, 130, 134, 136–137, 148–149, *148*, 181, 194, 196–197, 199, 400; *see also* 9/11 terrorist attacks; Abu Ghraib prison; Hussein, Saddam; Iraq, War in; war on terror
Iraq, War in 142, 148, 210
Ireland 314, 429
ISIS 130
Islam 3, 118, 219
Israel 115, 119, 166, 174n6, 177, 183, 187, 189
Israeli–Palestinian conflict 166, 289
Italy 104, 375, 412, 416–417, 419–422, 424–425, 427, 437n4, 439n59; Rome 326, 417–419, 422–423, 425

Jaar, Alfredo 119, 137–138
Jagger, Mick 475, 479
Japan 70n6, 327, 343, 345; manga 345; Tokyo 327, 347

Jim Crow 245, 250, 252, 258, 260
Jobs, Steve 354
Johns, Jasper 500
Johnson, Christy 318, *319*, 325, *325*, 335, 337n3, 361; *Feast* 318, *319*, *325*, 337n3
Journal 395
journalism, sensational 396–397; *see also* documentary; photojournalism; press

Kacmaz, Mehmet *206*
Kant, Immanuel 150, 552
Käsebier, Gertrude 46
Kertesz, Andre 480
Khmer Rouge 500–501, 510–511
kill team photographs 119, 133–136, 138
King, Martin Luther, Jr. 63
King, Rodney: police violence against 211
Kipling, Rudyard 50, 64
Kleinberg, Jon *346*; *Mapping the World's Photos* 345, *346*
Klich, Kent 115
Knight, Nick 443–444, 450, 478, 482
Kodak 239, 302, 309, *312*, 326, 339, 354, 386, 548
Kodak culture 349, 381, 387
Kruger, Barbara 20
Kuhn, Annette 227, *277*, *278*, 313
Kuwayama, Teru 128–129

Labor Party (UK) 428
Lacan, Jacques 54, 63, 171, 226, 526n3
Lange, Dorothea 34, 188
Laos 142
Lartigue, Jacques Henri 479
Laurent, Michel *128*
Levinas, Emmanuel 132, 137
Lévi-Strauss, Claude 50, 74
L'Express 372
liberalism 33, 429
Life magazine 132, 142–144, *143*, 146, 151n5, 418–419, 437n7
L'Illustration 394
London Underground 7/7 bombings 129, 205, 210, 350
Longfellow, Henry Wadsworth 251
Loren, Sophia 425
L'Ouverture, Toussaint 294
Low, Shelly 294, *294*, *295*, 296–298
Lowell, Robert 133
lynching 198, 200, 252–253

McCullin, Donald 123–124, 126, *127*, 479
McDonaldization of society 387
Macedonia 156
McQueen, Alexander 443–444, 450, 483
McQueen, Steve 119, 136–138, 322
machine-readable bodies 10, 113–114
Madden, Robert *55*
Madonna 36; *Sex* 36
Magnum Photos 481, 485
Malcolm X 63
Manet 496, 498
Mann, Sally 9, 27–38, 39n10, 40n23, 40n31,
 41n42; *Immediate Family* 28, 32–36,
 40–41n31; *Popsicle Drips* 40n23; *At Twelve*
 39n10
Manolis, Andreas 180–182, *184*, 185–186
Manovich, Lev 303, *346*, 356
Mansfield, Jayne 422, *422*
Mao 281; Maoism 281–283
Mapplethorpe, Robert 9, 34, 232–235
Mark, Mary Ellen 482
Martin, Rosy 226, *238*, *240*, *241*, 313
martyrdom 182, 218–219
Marx 447, 526n3
Marxism 12, 491, 551
Mazzatenta, O. Louis 66
Means, Russell 46
media: discourse 219; frenzy 196, 199; news
 110, 118, 211–212, 215–219, 350, 411,
 414; online 4; Western (news) 86n2,
 210–212, 217, 219, 412; *see also* digital
 media; social media
Medusa 19, 22, 24–25
Meese Commission 23
Meisel, Steven 485–486
memory work 227, 273–279, 284–285, 285n3
metadata 303, 345, 359, 361–362, 535
Mexico 131, 180
Microsoft 354, 363n11, 377–379
Microsoft Cloud 374, 377–379
Middle East 65, 114, 118–119, 217–218
Miller, Alice 237, 241, 388
Milošević, Slobodan 155–156
misogyny 241
moblogging 357
modernism 11, 13, 40n23, 230, 335, 401,
 497–498, 543–544, 548–551; high 544;
 see also postmodernism
Modern Screen 418
Molinier, Pierre 451–453
MoMA *see* Museum of Modern Art

Mona Lisa 320
Monroe, Marilyn 422, 475
Morgan, Piers 197
Morin, Edgar 318, 322, 330, 333
Morrison, Toni 271
Morton, Andrew 415, 432–433
Moser, Don 143–144
Mumbai terrorist attack 210
Murdoch, Rupert 428–429, 431–432
Museum of Modern Art (MoMA) 127, 303,
 344, 497, 503–506, 508, 517n19, 542
Mussolini, Benito 419–420, 439n50, 440n84
Mutua, David *207*
Muybridge 496
Mwangi, Boniface *207*
Myanmar: anti-government demonstrations
 210

Nasser, Gamal Abdel 189
National Enquirer 427–428
National Examiner 427–428
National Geographic 9, 47, 53–69, *55*, *62*, *66*,
 69n1, 70n3
national identity 65, 261, 383, 389
National Portrait Gallery, London 471,
 474–476, 484
NATO 156
Navajo Nation 52n6
Nazism 114; Nazi regime 511; Nazis
 160–161, 510
Netherlands, the 421
networked image 303, 358, 362; folksonomy
 358; social life of 356–357; visibility of
 358–359; *see also* tagging
New Right 33
News of the World 27–28, 428
Newton, Helmut 471, 480, 482
New Wave cinema 375–376
New York City 11, 45, 47, 69n1, 194, 303,
 321, 326, 330, 332, 344–345, 375,
 394–398, 405, 407n7, 408n14, 417, 471,
 473, 475, 480–481, 485, 503, 505, 542;
 see also 9/11 terrorist attacks
New York Daily News 396–397, 407–408n9
New Yorker 133, 196–197, 199, 430
New York Public Library 495–496, 498
New York Review of Books 133, 383
New York Times 35, 129, 135–136, 139n29,
 198, 213, 339, 417, 428; *Midweek Pictorial*
 398; *Sunday Magazine* 407n6
Nhem Ein 500–501, 503–504, 508–514, 516

Nixon, Nicholas 320–321, 337n2; *The Brown Sisters* 320–321
Nixon, Richard 133
Nokia culture 349
Northern Ireland 124, 126, 429
Norway 111, 326–327, *327*, 399
Nude, the 8, 16, 18–19, 34
nudes 12, 18, 34, 444, 461, 543
nudity 34, 452; child 34; male 8; *see also* pornography

Obama, Barack 139n5, 212–213
Occupy resistance 206
October 135–136
Olympia 24–25
Onassis, Jacqueline Kennedy 427, 434
other, the 9, 14, 17, 45, 53, 58–64, 67, 71n12, 87n12, 124, 132–133, 135, 138, 149, 151n2, 159–160, 171, 318, 329; gaze of 60, 64–67
otherness 9, 46, 85, 170, 523

paedophilia 27, 32, 39n2
Page, Walter Hines 247–248, 251–253, 260
Palestine 162n6, 189; Israel-Palestine binary 177, 187; *see also* Israeli-Palestinian conflict
paparazzi (paparazzo) 402, 411–436, 436n2, 437n4, 437–438n17, 440n81
paparazzi photography 408n13, 411–436, 436n3
Paris 102, 111, *223*, 260–261, 326, 330, 411, 415–416, 434, 448, 468n1, 471, 480–482, 487n1, 490, 495; 1900 Exposition 260; *see also* fashion; *haute couture*
Parker-Bowles, Camilla 431, 433; Camillagate tapes 433
Parkinson, Norman 475–476, 478
patriarchy 9, 20, 30, 269, 491
Peace Corps 61
Penn, Irving 476, 478, 496, 512, 514
People 57, 428
People's Republic of China (PRC) 278–282, 284, 496; Cultural Revolution 280, 282–283; Tiananmen Square 218
Persian Gulf War 213
Philippines 70n6, 314–315
photo/photographic archives 61, 180, 315, 355, 492, 519–522, 528–537, 541
photo/photographic criticism 14, 345, 543

Photobucket 354
photo festival 501, 509–510; Arles 500–501, 503, 505–506, 508–512
photograph collections 400, 528, 535–536, 542
photographers: advertising 311, 478; amateur 341, 352, 417, 501; as artists 34, 467, 485, 505, 522, 542, 551; assault 417; as authority 408n16; black 229–235; British 226, 412, 480; colonial 65, 84; commercial 253, 302, 518–519, 524, 527n10; documentary 10, 73, 77, 87n9, 481–482, 485; embedded 128; female/women 20, 37–38, 103, 302; high-street 308; independent 479–480, 485; indigenous 45, 87n14; Italian 417, 427; journalistic 175n21; Leftist 46; magazine 255; male 70n5, 78, 233, 235, 461; nature 245; news 395, 411, 417, 420; official 432, 501; portrait 111; postcard 100; press 87n9, 171, 181, 397; professional 87n8, 111, 120, 129, 131, 197, 205, 225, 268, 270, 344, 352, 510; progressive 46; studio 438n34; as subject 403–404; surrealist 451; tabloid 412, 434; tourist 106; untrained 27–28, 34; US 480, 485; vernacular 353, 357; war 129; Western 65, 86n6; white 45, 232, 235; wildlife 247; as witness 145, 147; *see also* fashion photographer; gaze, the; *paparazzi (paparazzo)*
photographic/photography theory 73, 177, 362, 541, 549–551
photographic Pietà 177–190; Greek Cypriot relatives of missing persons 180–182; Mothers of the Plaza del Mayo 180–181; National League of POW/MIA Families 180–181; *see also* embedded photos
photographic violence 153–161
Photographs from S-21 500–506, *502*, 508–509, 511, 514, 517n11, 517n19
photographs: action 402–403, 417; candid 402–403, 405; celebrity 401–402, 412–413; digital 201, 350, 351, 353, 360; erotic 103; eyewitness 205; family 29, 31–32, 37, 40n31, 47–48, 153, 158, 160–162, 227, 265, 273, 275–277, 282, 284, 305, *306*, 307–308, 314, 332–333, 353, 400–401, 525; file 401–403; identification 289–290, 297–298; industrial 525; in libraries

495–496; in museums 496–497; news event 402–404; paparazzi 414–417, 423, 437n16; passport 184, 227, 287–298; performance 401–402; personal 52n6, 161, 176, 180–181, 186, 188, 227, 273, 275–277, 279, 332, 341, 353, 355, 361; plain 401; sports action 408n12; vernacular 319–320, 333, 362; wallet 286n5; war 123–124, 126; wedding *308*; *see also* daguerreotypes; postcards/postcard imagery

photography: as agreement 165–172; amateur 73, 110, 277, 302, 307, 354; art 33–34, 194, 370, 467, 476, 478, 524, 548–550, 554n6; as art 542; black 229, 231, 233, 235; black and white 33, 374–375; celebrity 412–413; and citizenship 289; citizenry of 188; civil contract of 120, 166, 168, 171–173, 187, 289, 297–298; colonial 75, 82, 86n3; and commodification of people 315; conflict 150; digital 105, 120, 201–202, 349–362; documentary 229, 399, 406, 407n7, 412–413, 437–438n17, 486; domestic 28, 30–33, 224, 277, 282; editorial 412, 482; embedded distance in 178–179, 190; family 30–31, 275, 282, 285, 307, 309, 311, 313–314, 316–317; fine art 467, 549; historical distance in 178, 184, 190, 191n3; home 381, 387; and identity construction 104–105; invention of 31, 35, 165–166, 169–170, 174n10, 174n12, 175n18, 398; mass-amateurisation of 351; nature 253; news 118, 403, 413; personal 2, 225–226, 349, 356, 358, 360, 362, 386; popular 94, 239, 341, 349, 351, 393; print-based 352; promotional 412; public 351; screen-based 352; silver-based 201; snapshot 309, 349–350, 360; social 344–345, 348; spectator of 172; surveillance 412–413, 415; temporal dislocation in 178; tourist 73–74, 83, 85, 90–107; travel 75; as universal language 521–522; vernacular 90, 303, 335, 341, 344, 362, 505, 508; war 115, 126, 481; wildlife 253–254; *see also* fashion photography/imagery; food photography; paparazzi photography; portraiture/portrait photography

photojournalism 2, 118–121, 141–151, 183, 205, 247, 249, 253, 369, 393–407, 407–408n9, 412–414, 416, 482, 511; citizen 120, 210–220; investigative 427; paparazzi 369; and tabloids 393–407; *see also* documentary; photo-reportage; press

Photoplay 418, 440n82

photo-reportage 120, 350, 395, 501

photo-therapy 226, 236–243

Picasa 91, 96, 98, 100, 354

pictorialism 11

Pinochet, Augusto 137–138

Pinterest 343, 389

Pius XII 421, 439n52

Pol Pot 500–501, 509

pornography 23–24, 27, 36, 453; vs. art 28, 34; child 27–28, 34–35, 37; vs. nudity 34; sex/sexual 383–384; social economy of 23; *see also* food porn(ography); gastro porn

Porry-Pastorel, Adolfo 417; Veda photo agency 417

Porsche Panamera 374, 376–377

portrait parlé (spoken portrait) 289–290

portraiture/portrait photography 2, 22, 47, 59, 86–87n6, 87n19, 101–102, 261, 282, 414; self- 105, 294, 296–298, 319, 328, 330, 343, 350; *see also* selfie

postcards/postcard imagery 42–43, *44*, 46, 68, 90–93, 95–98, *99*, 100–102, 106, 375, 475, 544; of lynching scenes 200

postmodernism 22, 40n23, 335, 497–498, 548, 554n3

Poynter, Phil *367*, 448–449

Presley, Elvis 416

press: daily 393–395, 397–399, 402, 406, 543; periodical 393–394; picture 394–395, 523; picture magazines 395, 398–399; tabloid 369, 393–394, 396–407, 408n11, 408n12, 411–414, 433, 436n3; western 394, 398, 407n1; yellow 395; *see also names of individual magazines and newspapers*; tabloids

Primoli, Giusseppe Napoleone 416–417

prosumerism 387–388

psychoanalysis 2, 8, 11–12, 14, 16, 224, 274, 551; Freudian 15–16, 94

Pulitzer, Joseph 395

Pulitzer Prize 118, 131

Puranen, Jorma *489*, 490

race 11, 46, 54, 64, 113–114, 162n6, 226, 230, 236, 238–240, 267, 298, 314–315,

381, 499n4; in America 247, 249–252, 262n16; London riots 426

racism 45, 114–115, 162n6, 230, 241, 248, 250–251, 253, 261, 270, 294, 314; racial profiling 10, 110

Rampersad, Arnold 249, 262n17

Rather, Dan 196–197

Rauschenberg, Robert 498

Ray, Man 476, 480–481

Reagan, Ronald 430, 499n4

realism 229–231, 323, 372, 403, 406, 462–463, 498; anti- 230; instrumental 525; neo- 424, 440n70; photographic 398, 522; sentimental 525

Reed, Roland W. 46

Renaissance 1, 384, 424, 461

representation, politics of 224, 268

Richter, Gerhard 321, 350

Ricoeur, Paul 531

Riefenstahl, Leni 114, 511, 527n8; *Olympia* 114

Riis, Jacob 263n38, 496

Rixon, Annica Karlsson 112

Rock of Aphrodite 91, 95–98, *99*, 100–106, *101*

Rogoff, Irit 1

Roman Catholic Church 419

Romero, George 292

Rosenthal, Joe 217

Rosier, Bruno 319, 329–330, *331*, 332, 335; *Un état des lieux ou La mémoire des parallèles* 319, 329–330, *331*

Rosler, Martha 151n8, 437–438n17, 480

Rumsfeld, Donald 134

Ruscha, Ed 321, 343, 498

Saatchi, Charles 29, 32, 482

Saatchi Gallery 27, 29

Said, Edward 84

Salavon, James 345

Scandinavia 110, 408n11

Schäffer, Mary 42–51, *44*

Schmid, Joachim 303, 341–343, *340*, *342*; *Other People's Photographs* *340*, 341, *342*, 343

Scorsese, Martin 375

Scotland 316

Screen magazine 230

Secchiaroli, Tazio 417–418

Second World War *see* World War II

security: and biometrics 113, 287; cameras 403; forces 217; guards 415; homeland 135; politics 215–217; privatised 309; threats 212

selfie 178, 388

September 11 terrorist attacks *see* 9/11 terrorist attacks

Serbia 155–157, 162

sexism 115

Shedden, Leslie 518–519, 522, 524–525

Sherman, Cindy 7, 9, 22–25, 482, 485

Simpson, O. J. 428

Simpson, Wallis 435

Sioux 47–48

Slovenia 155–156

smartphone 110, 128, 339, 380–382, 384, 387–389

Smugmug 356, 358

snapshot aesthetic 318, 343, 493

snapshot culture 2, 4, 302

snapshots 29, 37, 39n19, 92, 101, 227, 240, 266–268, 270–272, 286n5, 303, 305, 307, 309, 311, 313, 317, 321, 325–326, 332–333, 349–350, 356–357, 395, 417; family 321, 521; Polaroid 64, 481; smartphone 339

Snow, Denyse 332

Snow, Dimple F. 333, *334*, *336*, 337

Snow, Michael 319, 332–337, *334*, *336*, ; *Michael Snow/A Survey* 319, 332–333; *Scraps for the Soldiers* 319, 333, *334*, 335–337, *336*

social media 3, 118–119, 126–127, 131, 190, 208, 214, 224–225, 302, 339–341, 343, 347, 369, 382, 385, 389; economy 387; platforms 382, 385

social memory 273, 519

social networking 356, 389; sites 213, 339, 350, 356, 388

Soltan, Neda Agha 129, 210–213, 216–218, 220, 220n1

Sontag, Susan 54, 67, 76, 86, 91, 115, 118–119, 133, 137, 158, 178, 183, 189, 245, 320, 527n8

Sorrenti, Mario 485–486

South Africa 114

South Korea 70n6, 341, 343

South Vietnam 142, 144–145; Saigon 63, 142, 144, *515*

Spain 395, 495–496; Civil War 496

Spanish American War 178, 395
Spence, Jo 31–32, 37–38, 226, *238*, 302,
 313, 480
Stacey, Adam 350–351, 363n4
Star 427–428
Steichen, Edward 407n7, 468n1, 471, 505, 548
Stieglitz, Alfred 15, 20n13, 355, 468n1, 497,
 549
Stoney Indians 47
Stowe, Harriet Beecher 251
Strand, Paul 548–549
Strong, Roy 469, 471, 475–476, 478,
 483–484, 487
Sturges, Jack 33
Stylianou-Lambert, Theopisti 9, *103, 104*
Sultan, Larry 485
Sun 428–429
Sunday Express 428
Sunday Mirror 428, 434
surrealism 229–230, 322, 335, 407–408n9,
 451, 548
surveillance 59, 64, 86, 111–115, 303,
 415–416; aesthetics 114; border 3; camera
 111, 415; counter- 113, 115; culture 110;
 images 110; modes of 10; photography
 412–413, 415; self- 115; society 111;
 studies 112; technologies 113, 403, 437n10
Sweden 110, 399, 408n11
Syria 118, 129–131, 208–209; civil war 206

tabloid culture 411, 436
tabloids 28–29, 396–397, 401–406, 408n10,
 408n11, 412, 416, 427–431, 433–435;
 supermarket 427–428, 437n16; *see also*
 names of individual tabloids
tagging 209, 358–359, 362, 389
Tan, Fiona 318, 322, 325–327, *327*, 335; *Vox*
 Populi: Norway 318, 326–327, *327*, 337n3
Tate Gallery 478
Taylor, Elizabeth 422, 425–427, *426*, 440n84
Technicolor 379
Teller, Juergen 483, 485
temporal dislocation 178
Teresa, Mother 83
terrorist attacks: 9/11 terrorist attacks 136,
 174n6, 210, 514; London Underground
 129, 205, 210, 350; Mumbai 210
Testino, Mario 475, 484–485
Thatcher, Margaret 33, 428–430, 436,
 441n106, 442n142

theatre of the self 240
Third World 54, 63, 65, 71, 76, 83
Thomas, Lowell, Jr. *62*, 262n23
Thurm, John *99*
Tibet 534–535; Tibet Album Project 536,
 538n34
Tiffany 374–376
Time magazine 130–131, 345, 442n134, 471;
 Lightbox 130–131
tourism 47, 63, 74–76, 83, 85, 90, 92,
 94–95, 97, 103, 316, 329–330, 349, 389,
 551; gastro 382; industry 501
Tron, Ngwyen Thi 142–144, *143*, 151n5, 151n8
Tumblr 389
Twitter 110, 213–214, 219, 225

U.K. *see* United Kingdom
UN *see* United Nations
United Kingdom 3, 136–137, 156, 197, 318,
 287, 475, 478–479, 482, 492, 538n34;
 Identity and Passport Service 287
United Nations 156, 181, 183
United States 3, 59, 61, 63, 69n1, 132,
 134–137, 142, 144–145, 149–151,
 174n6, *179*, 180–181, 185, 264n49,
 267, 271, 277, 287, 314, 329, 345,
 395–396, 398–399, 407n3, 411–412,
 414, 418, 420–421, 427, 430, 438n33,
 439n59, 469, 479, 522–523, 527n8;
 Atlanta 249–250, 252, 262–263n27;
 Black Belt 226, 245, 247, 249–250,
 253, 257–258, 260; Chicago 397–398;
 Dougherty County, Georgia 247, 249,
 254–255, 262–263n27; National League
 of POW/MIA Families 180–181; Second
 Amendment 135; U.S. Department of
 State 287; U.S. Marines 127–129, *127*;
 U.S. Supreme Court 135; *see also* New
 York City
U.S. *see* United States
user generated content (UGC) 120, 211,
 380, 387–389
Ushahidi 208
Út, Nick 194, 217

Van de Ven, Ariadne 10, *78, 79, 80, 81*
Venus 24, 71n10, 98
vernacular 318–320, 323, 326, 329,
 335, 337n1; photographers 353, 357;
 photographs 319–320, 333, 362;

photography 90, 303, 335, 341, 344, 362, 505, 508
Vertov, Dziga 167, *346*, 347–348; *Man with a Movie Camera 346*, 347–348
Victoria and Albert Museum (V&A) 469, 476–479, 481, 483, 486, 533
Vietnam *see* South Vietnam; Vietnam War
Vietnam War 63, 126, 131–134, 142–147, *143*; My Lai massacre 131–133, 151n5; Tet Offensive 63, *127*, 142
visual codes 467
visuality 29, 141, 147, 150, 151n3, 382; food 383–384
visual literacy 2, 362, 381; illiteracy 69
Vogue 471, 475, 480, 482–483, 486
voyeurism 8–9, 14–16, 18, 47, 58, 63, 66, 68, 76, 110, 112, 115, 210, 420, 431, 524
Vroman, Edward 46

Wall, Jeff 324, 350
war crimes 212, 513
Warhol, Andy 498
war on terror 110, 133, 135–136, 139n5, 149
Washington, Booker T. 249, 252–253, 257–258, 260, 263n31; Atlanta Compromise speech 257–258; Tuskegee Institute 252, 260
Washington, George 248–249, *248*, 256, 258, 263–264n18
Washington Post 199
Web 2.0 210–211, 217, 219–220, 356, 363n10, 388

Weber, Bruce 476
Weber, Max 285n1
West, the 59, 61, 63–64, 68, 73, 76–77, 82–83, 86, 86n1, 86n3, 87n13, 147, 150, 218, 279, 282, 551; non-Western world 61, 69n1; Western world 174n5, 481–482
Weston, Edward 8–9, 11–20, *13*, *16*, *19*, 20n13, 21n16, 34, 40n20, 40n23, 540, 545n1, 548–549; Day Books 11–12, 14; contact printing 17
white supremacy 245, 247, 249, 253, 256, 261–262n15, 267, 270
WikiLeaks 134
Williamson, Judith 4, 368
Wilson, Charis 12, 18
Windsors 430–432, 435–436
W magazine 485
Woolf, Virginia 118
World 395–396
World's Work, The 245, *246*, 247–254, *248*, *254*, 256, *256*, *257*, 258, *259*, 260, 262–263n27, 263n38
World War I 252, 333, 398, 419, 522
World War II 63, 69n1, 71n10, 160, 183, 214, 329, 412, 421, 437n7, 496, 522, 549
World Wide Web 356, 441n98, 551

YouTube 120, 206, 212–213, 389

Zeega 209
Zoto 356